BRITISH GENRES

MARCIA LANDY

BRITISH GENRES
Cinema and Society, 1930-1960

PRINCETON UNIVERSITY PRESS

Library of Congress Cataloging-in-Publication Data
Landy, Marcia, 1931–
British genres : cinema and society, 1930–1960 / Marcia Landy.
p. cm.
Includes bibliographical references and index.
Filmography: p.
ISBN 0-691-03176-2 (cl) — ISBN 0-691-00836-1 (pb)
1. Motion pictures—Great Britain—History. 2. Film genres.
3. Motion picture plays—Great Britain—History and criticism.
4. Motion pictures—Social aspects—Great Britain. I. Title.
PN1993.5.G7L36 1991
302.23′43′0941—dc20 91-4354

This book has been composed in Linotron Sabon

Princeton University Press books are printed on acid-free paper,
and meet the guidelines for permanence and durability of the
Committee on Production Guidelines for Book Longevity
of the Council on Library Resources

Printed in the United States of America
by Princeton University Press,
Princeton, New Jersey

10 9 8 7 6 5 4 3 2 1

10 9 8 7 6 5 4 3 2 1
(Pbk.)

For Stan

Contents

Illustrations

Acknowledgments

I AM DEEPLY indebted to Lucy Fischer, who read and commented on the manuscript as it developed. With great generosity, Dana Polan, too, has read several versions of the work and made numerous suggestions for improvement. I also want to thank Antonia Lant, who took time out of a very hectic schedule to read several chapters and to give me extensive comments on my writing. Elaine Burrows of the National Film Archive was a gracious and copious source of information on British films, and I am grateful to her and to Jackie Morris for making films accessible to me and for making the screening of them so enjoyable. I am also indebted to Katherine Loughney and Madeline Matz at the Library of Congress, who were always available with helpful information and to arrange screenings at my convenience. Similarly, Charles Silver and Ron Magliozzi of the Museum of Modern Art patiently responded to numerous queries and facilitated screenings. Without grants from the American Philosophical Society and the American Council of Learned Societies, I would not have been able to travel to these collections. Philip E. Smith, Chairman of the University of Pittsburgh English Department, was supportive in the last stages of the work when I needed modest financial assistance, as were Wilfrid Dehnick, Director of the University of Pittsburgh Office of Research, Mary Louise Briscoe, Dean of the College of Arts and Sciences, and Alberta Sbragia, Director of Western European Studies, University Center for International Studies. David Bothner was helpful in recording data on the films. In countless ways, and with grace, humor, and care, Amy Villarejo made possible the final preparation of the manuscript. I am extremely grateful to Joanna Hitchcock, Executive Editor of Humanities at Princeton University Press, for her patience and encouragement. Above all, I want to thank Stanley Shostak for his friendship, his encouragement, his sharing with me the pleasure of screening numerous British films, his insightful comments on the films, and his critical reading of the manuscript.

Author's Note

IN THE OFTEN difficult matter of dating the British films, I have used Denis Gifford's *The British Film Catalogue, 1895–1985: A Reference Guide* (Newton Abbot: David and Charles, 1986). Wherever possible, Gifford gives the date of initial exhibition of a film. In the case of Hollywood and European films, I have depended on Leslie Halliwell, *Halliwell's Film and Video Guide*, 6th ed. (New York: Charles Scribner's Sons, 1987). Halliwell dates the films by year of release. For further corroboration on feature films of the 1930s, I have consulted Rachael Low, *The History of the British Film, 1929–1939: Film Making in 1930s Britain* (London: Allen and Unwin, 1985).

BRITISH GENRES

THIS BOOK is a study of British cinema and its relationship to British society through an examination of feature films produced between 1930 and 1960. The justification for writing a book on British cinema is made more easily today than it would have been a decade ago. Critics have recognized that an important part of cinema history has been overlooked and misrepresented. In an effort to correct the distortions and silences surrounding British cinema history, scholars have undertaken a reexamination of all phases of the British film apparatus: the relationships between British and American producers, the character and nature of directors, the studios that have been central to the development of British cinema, the role of censorship, the relations between cinema and state, the specific character of the films produced, and the nature of the ideological discourse embedded in the narratives. I am heavily dependent on these studies, and in my discussion of British genres, I attempt to synthesize many of their insights.

The movement to forge new perspectives on British film production has been a response to the long-standing critical neglect of British film production, which had been stigmatized as being uncinematic and tied too closely to the theater and to the novel.[1] In contrast to Hollywood films, the British cinema had been labeled "amorphous" and "uninteresting,"[2] and lacking in social relevance.[3] A predilection for realist representation led certain critics to favor only those texts that were "founded on fact" and "lifelike." The feature films singled out for praise were described as addressing immediate and everyday experience in recognizable fashion. Furthermore, the films were accused of being unpopular with British audiences, while popular and commercially successful films such as the Gainsborough melodramas and the Hammer horror films were accused of being sensationalist and escapist—familiar labels often applied to texts that are heavily dependent on a formulaic construction. In particular, the documentary work of John Grierson and his group have been deemed in histories of cinema Britain's major and original contribution to the art of cinema, whereas the feature films have generally been regarded as pale reflections of Hollywood and evidence of how the films do not represent British life. These judgments, proceeding from a conception of realism that is heavily dependent on the belief that "serious" and straightforward

representation of actual social conditions is, in fact, a measure of the "real," obscured the fact that the "real" is not an essence inherent in phenomena but the product of a social consensus about the nature of reality. The call for a mode of representation of life "as it is really lived" is a socially constructed value with its own history and biases, its own conventions and rules, and its rejection of phenomena that do not fit its norms. As John Hill states, "No work can ever simply reveal reality. Realism, no less than any other type of art, depends on conventions, conventions which, in this case, have successfully achieved the status of being accepted as 'realistic'."[4] In the chapters that follow, and particularly in my final chapter on "social problem" films, beginning with the assumption that realism is a socially constructed category, I examine those texts that have been regarded as escapist and unrealistic and I expose their filmic conventions as implicated in the social "real."

The effect of validating documentary realism as the ultimate test of a text's social and aesthetic efficacy was to denigrate those texts that appeared blatantly stylized and artificial, most particularly the genre film. The product of the studio system of filmmaking, with its typical characters, standard plots, and familiar narrative conventions, remained in disrepute until critics began, through the study of Hollywood film, to identify the British genre film's relationship to earlier canons of realism, especially as rooted in the nineteenth-century novel. While the novel had been studied in this context, the British film had not. Genre films were associated with much-despised popular culture and with the masses with which they were identified. Produced in standardized fashion with an emphasis on formulaic modes of representation, the films of the genre system appeared to be remote from the notion of individual creativity so highly prized in the assessment of high culture.[5] The critical disregard of, if not contempt for, the popular cinema can be traced to the tendency to regard the works of mass culture as irretrievably mired in commerce, and, therefore, as totally manipulative and trivial. In Theodor Adorno's terms, the products of mass culture "allow only that to remain which serves society's equivocal purposes."[6] In this context, the genre system could be seen as a total capitulation to the profit motive, precluding the possibility of regarding it as expressive of profound cultural contradictions and resistances.

A less monolithic and negative response to mass culture has evolved in recent years. The study of genre has sought to analyze the ways in which mass cultural productions are part of a meaningful system of social exchange in which the audience, rather than being the passive consumer of these texts, is an integral element in their production and reception. The texts are not static instances of the superimposition of standardized atti-

tudes foisted on innocent audiences but exemplary of a dynamic interplay between producer, director, text, and audience. The values exemplified in the cinema of genres are not mere reproductions of a single dominant ideology but the result of many cultural and economic factors, not the least of which is the commercial cinema's capacity to address the aspirations of their audiences, even if only in the interests of commerce. Thomas Schatz has described genre as a "coherent, value-laden system,"[7] recognizable through its typification of iconography, plot, character, place, and situation, but he acknowledges that this system with its values is inextricably tied to social forces and that these forces are not ahistorical and unchanging but rather sensitive to social change. The value system to which Schatz alludes is not totally coherent. In Antonio Gramsci's notion of common sense and folklore, values are disjointed and episodic, representing attitudes derived from the past alongside new and changing perceptions.[8] The texts are a collage of residual and emergent elements that speak to both the lived and the imaginary circumstances of their audiences.

I assume the films to be speaking in a language of conflicting attitudes and values that provide insights into British culture and ideologies. The films produce identifiable images from the psychic and social landscape, and, in varying degrees, a recognition of obstacles to the gratification of needs. The images may not bear an immediate resemblance to everyday reality, but the films reveal that the cinema of genres is not ideology talking to itself. No one would claim that the films produced an oppositional discourse that profoundly altered British life, but they reveal the contradictory aspects of consensus, and, moreover, that the cinema was increasingly capable of representing conflicts that would later become the basis for a different ordering of experience. Why, then, were genre films considered trivial?

For critics such as Theodor Adorno and, more recently, Jean Baudrillard, fascism and mass culture are closely allied and seen as more indicative of the degeneration of cultural life than of political struggle. Adorno's concern was, in large part, to map out cultural changes wrought by late capitalism. He saw culture as a battleground for the hearts and minds of people, and the failure of traditional culture in the face of the "culture industry" as the final stage in the dialectic of culture and barbarism. Fueling the current postmodernist position, Adorno inveighed that "there are no more ideologies in the authentic sense of false consciousness, only advertisements for the world through its duplication and the provocative lie which does not seek belief but commands silence. . . . By relinquishing its own particularity, culture has also relinquished the salt of truth, which once consisted in its opposition to other particularities."[9] For

Baudrillard, too, the masses withdraw into silence and passivity.[10] For both these critics, mass culture is considered affirmative, leaving little room for opposition.

Exploring and challenging these antagonisms toward and misrecognitions of mass culture, Andreas Huyssen and Tania Modleski find them to be rooted in gender distinctions which associate high culture with masculine and mass culture with feminine pursuits.[11] A study of popular culture from the nineteenth century to the present reveals a pejorative equation between the masses and woman. Negative conceptions of mass culture, identified with the female Other, have served as a prop of bourgeois ideology rather than as an adequate assessment of modern cultural life. The idea of the spurious pleasures of mass culture is linked, in part, to the dichotomy between pleasure and work characteristic of attitudes ingrained in industrial society. The intensified division of labor generated by industrialism, with its implications for sexual politics, was anticipated by Gramsci. In his notes on "Americanism and Fordism," Gramsci suggested that industrialization not only equates physical labor with animality but seeks to develop prohibitions to control sexuality, prohibitions which are of enormous import for cultural practices. In the process, females are inevitably the losers, whether they are from the upper or from the working class, since both these classes are associated with "reproductive function" or with "sport." "The new industrialism wants monogamy," he wrote, "it wants the man as worker not to squander his nervous energies in the disorderly and stimulating pursuit of occasional sexual satisfaction."[12] His analysis of the phenomenon of the movie star, of prohibition in the 1920s, and of various state efforts to control sexuality reveal that he was not naive about the encroachments of the state on private life, nor of the role of mass culture in the struggle for hegemony.[13]

Gramsci's comments invite a reexamination and historicizing not only of cinema in relation to industrialization, but, more importantly, of the critical assumptions that have informed studies of mass culture. The disregard of the cinema of genres was part of a larger ideological conflict inextricably tied to the belief in the antithetical nature of modernism and mass culture, and the advocates of realism echoed the familiar hierarchialized opposition between the two, based on the alleged autonomy of modernist production. "The autonomy of the modernist work of art, after all," writes Huyssen, "is always the result of . . . resistance to the seductive lure of mass culture, abstention from the pleasure of trying to please a larger audience, suppression of everything that might be threatening to the rigorous demands of being modern and at the edge of time. . . . The lure of mass culture . . . has traditionally been described as the threat of losing oneself in dreams and delusions and of merely consuming rather than producing. Thus, despite its undeniable adversary

stance toward bourgeois society, the modernist aesthetic and its rigorous work ethic ... seem in some fundamental way to be located on the side of that society's reality principle, rather than on that of the pleasure principle."[14] The rejection of the pleasure principle constitutes a fundamental contradiction, for, while it attempts to challenge notions of conformity, it reproduces bourgeois ideology's insistence on the separation between work and pleasure, a separation which serves to maintain patriarchy and power. The major charge leveled at the mass cinema has focused on its offering false promises and pleasures to its audiences, fixing spectators in a position of subjection to oedipal fantasies.

Recent work on film melodrama has sought to challenge this opposition between reality and pleasure. Most clearly identified with escapism and emotionalism, melodrama offers the possibility of understanding how the genre system makes contact with audience needs, not merely in the interests of conformity but as challenges to it. "Melodrama," Christine Gledhill writes, "addresses us within the limitations of the status quo, of the ideologically permissible. It acknowledges demands inadmissible in the codes of social, psychological, and political discourse. If melodrama can only end in the place where it began, not having a programmatic analysis for the future, its possibilities lie in the double acknowledgement of how things are in a given historical conjuncture, and of the primary desires and resistances contained within it. This is important not only for understanding what we want to change but the strengths and weaknesses of where we come from."[15] Her comments on melodrama can be extended to an analysis of other British genres beyond the highly successful Gainsborough melodramas.

In his influential "Tales of Sound and Fury: Observations on the Family Melodrama," Thomas Elsaesser identified this much maligned genre with periods of social repression. He saw the style of the films as addressing contemporary social pressures in highly coded form expressed through music, decor, setting, and excessiveness of gesture.[16] His analysis of melodrama is dependent on a reading of psychoanalysis that links subjectivity to history, providing access to films that have eluded critics in their search for a relationship between popular genres and social organization. Melodrama's antirealist tendencies can, as in the dream landscape and the language of hysteria, be read as symptomatic of social formations involving the body, the formation of the gendered subject, and issues of power and repression. Rather than situating the spectator in a familiar space, the films often use their conventions and codes to call into question the taken-for-granted quality of social institutions and of the individuals positioned within them.

For the spectator, pleasure resides in the validation of desires and of the constraints placed on their realization. The dichotomy between pleas-

ure and reality is thus inherent in the very structure of the texts, and the critical refusal to address the pleasures of these texts must be attributed in large part to the persistence of unexamined discourses of power that derive from sexual politics. However, the texts, in their oblique and distorted fashion—often in spite of themselves—remind us that this power is not total. The neglect of the British genre film on the grounds of its formulaic quality, its unwillingness to challenge the spectator, and its encouragement of spurious pleasures must be ascribed to the refusal to confront the ways in which mass cultural texts harbor knowledge of unresolved conflicts and desires. As long as the texts are regarded as mired in the totalizing domain of affirmative culture, as long as they are relegated to otherness, it is impossible to do more than examine them as seductive or malignant instruments of dominant structures. A perspective that resists a unitary reading of these films, that recognizes their embattled positions and acknowledges that these positions are a response to, not merely an evasion of, social conflicts, may serve us better in understanding the politics of the British cinema and its relation to mass cultural representation.

Thus, the critical study of genre constitutes an attempt to redress the impact of mass culture. In their initial studies of genre, critics stressed the commonality of certain motifs in literary and cinematic works, focusing exclusively on the formal text and paying little or no attention to these motifs as social discourse. Characters, plot, and language revealed the operations of repetition at work in narratives. Auteur criticism helped to introduce elements of variation and more personal concerns into the study of genre, which in turn has paved the way for an understanding of the interactions between continuity and change. More recently, auteur criticism has been reevaluated to allow for the ways in which the industry and censorship practices must also be understood as playing a determining role. The genre system is the consequence of an ensemble of effects that are part of the complex, and uneven and unequal, interplay between industry, auteur, narrative, and audience. These convergences are not homologous but need to be examined for their relative weight and significance in relation to other elements.[17] There are a number of determinants in the functioning of genre. The author, who may be the director but may also be a studio or a star, uses conventions as a "channel" to communicate particular themes and motifs, and can use conventions and codes to "inflect them, so as to express his/her own vision in the differences set up between the expected playings out of the convention and the new twists s/he develops—a vision expressed in counterpoint."[18] Or the author can use the genre as a way of channeling "personal expression, preventing its dissolution in an excess of individualism and incomprehensibility."[19] In terms of their conditions of production, the identity of their

producers, the ways they handle the conventions of genre, and the audiences to which they are addressed, genre films participate in the construction of social meaning even though they seem to be far removed from everyday reality. According to Rick Altman, "genres are like a key addressed to the audience, a key to the codes contained in the simultaneously transmitted texts. Precisely because they don't appear to be emitted by the industry, but rather to arise independently from the conflation of a series of similar texts, genres never give the impression of limiting the audience's freedom. Yet, because they make it easy to understand the text in a particular predetermined way, genres always make it less likely that a film will be construed in a different, non-generic way."[20] While genres are, as Altman suggests, complicit with their audiences in offering "a key to the codes contained in the simultaneously transmitted texts," recent critics have, in fact, produced readings that also provide a clue to the nongeneric dimensions of these films that are available to critically sensitive readers. The assumption that audiences have no access to the nongeneric aspects of the system deserves examination, since such a view implies that spectators are unchanging and completely immersed in the viewing process, unaware of the obvious contradictions between the generic representation and their own experiences of the world outside the film.

Along with its restrictive nature, the other important aspect of genre is its historicity, and its relationship to specific material practices. Genre is not an essential and impersonal structure outside of history. The conventions and codes associated with particular genres are part of a familiar landscape and an immediate, if not everyday, context. The spectator not only plays a role in the production of meaning but also plays an economic role in the perpetuation and decline of various genres, and if the texts do not speak to the spectator's needs and aspirations, they are consigned to oblivion. Positive audience response results in further reproduction, or modification, of genres to suit contemporary realities. Conscious of their own role as entertainment, genre films incorporate an intertextual awareness of their repetitive strategies as a means of creating a bond with their audiences. Moreover, since the films are produced by different individuals, written by various writers, acted in by different stars, and produced at different times, it is possible to gauge the genre's innovative as well as repetitive qualities and to relate these to historical and ideological concerns. The existence of variations is important also in identifying how the genre confronts the constraint of reproducing itself while also accommodating the need to revivify formulas.

The genre system's sensitivity to historical and ideological changes can be detected in a genre's specific handling of its iconography, character, plot, and mise-en-scène. As Thomas Schatz states, "although each genre represents a distinct problem-solving strategy that repeatedly addresses

basic cultural contradictions, genres are not blindly supportive of the cultural status quo. The genre film's resolution may reinforce the ideology of the larger society, but the nature and articulation of the dramatic conflicts leading to that climax cannot be ignored."[21] While genre films are deeply embedded in the dominant culture, they are, like the culture itself, not monolithic. Though largely identified as films that legitimate traditional values, genres are not seamless and untroubled in their treatment of sexuality, gender, and class. In the case of certain British auteurs such as Alfred Hitchcock, Thorold Dickinson, and Michael Powell, who worked with specific genres, the conjunction of personal vision and formula produces a self-conscious presentation which exposes rather than suppresses cultural conflicts. But there are other keys to the complexity of genre representation.

In even the most straightforward representations and legitimations of existing social relations in British genres, there are indications in the text and in the circumstances governing production of how the text has been compromised to present a unified and uncomplicated narrative. Recent work in narrative theory and psychoanalysis has exploded the notion of the unified text. The text has come to be regarded rather as the site of unresolved conflict and a multiplicity of voices, and feminist theory has been particularly rewarding for identifying the ways in which gender and sexuality are central to the constitution of the text though this is often not immediately apparent. The conventions and the positioning of the spectator in the genre film are intimately linked to fantasies about and practices relating to gender identity and sexuality. By exposing the ways in which female and male identity is constructed through these films, it is possible to understand the social basis of these texts. Sexual difference is a structuring principle in the British genre film, and all of the genres discussed—the historical film, the war film, the film of empire, melodrama, the woman's film, comedy, the horror film, and the social problem film—bear the signs of this difference.

The British commercial cinema from the 1930s to the 1960s can be characterized as working within the genre system. The dominant British genres of the 1930s were melodramas, historical films, musicals, comedies, and films of empire. World War II precipitated an unprecedented time of growth for the British cinema, characterized by the rise in popularity of the war film; this genre was to remain significant into the postwar era. During the war years and in the immediate postwar period, melodramas and historical films were also popular. While Ealing Studios experimented with a number of genres, the comedies were by far the most successful in the 1950s. The horror film did not really mature until the late 1950s, and while there were some "social problem" films in the 1930s and 1940s, they would not become prominent until the 1950s, in

the hands of such directors and writers as Basil Dearden and J. Lee Thompson.

British genres owe much to their Hollywood counterparts, but the reverse is also true. The Hollywood cinema, in its Anglophilia and in its eclecticism, is greatly indebted to British narrative and, more generally, British culture. A close inspection of British films reveals that while the films of empire bear a rough similarity to the American western in their preoccupation with national destiny, the exceptional protagonist who overcomes the forces of disorder and barbarism, the portrayal of native peoples, and the conflict between the individual and the community, the differences between the two genres are equally striking. In the British films, the character types, the conceptions of the individual and of the community, the sense of history and of national mission, and the different objectives and terms of production create genres not captured by a mere comparison to Hollywood genres. The same can be said of British comedies, historical films, war films, and melodramas. British genres are more than an abstract system of formulas, conventions, and codes that are universally applicable. National identity, social history, and ideology play a central role in their formation. Moreover, budgetary considerations, as well as particular studios, directors, stars, and literary sources, are determining factors in differentiating British genre production from Hollywood's. For these reasons, the genre system is, finally, neither universal nor unhistorical. While international comparisons can illuminate the tendency in the commercial cinema to deploy the genre system as a convenient and economically profitable way of developing a film language that can generate a sense of familiarity and of shared values and attitudes, in the final analysis, the genres will be highly dependent on specific cultural conditions. In discussing British genres, therefore, I direct my attention to the ways in which these genres are culturally specific. Similarly, my analysis of British genres is also dependent on identifying changes over time. By focusing on three decades of British filmmaking—1930 through 1960—I indicate the ways in which the genres have shaped and also have been shaped by historical and ideological changes.

The thirty-year period that I have chosen to examine coincides with the rise of fascism in Europe, the hopes and defeats of the international working class, World War II, and the cold war. The 1930s in Britain, under the brief leadership of the Labor party with Prime Minister Ramsay MacDonald, then under a coalition government, and finally under the leadership of the Conservatives, was a period that saw the introduction of national planning, social welfare initiatives, private industrial recovery, the resurgence of trade unionism, high unemployment in the early 1930s, and decreasing unemployment in the last years of the decade. George VI's ascent to the throne in 1936 restored prestige and stability to the monar-

chy after the conflicts surrounding the abdication of Edward VIII. Political attitudes ran the gamut from flirtations with fascism in the early years of the decade to the engagement with communism until the coming of the war, when national unity became the overarching theme. As in other European countries and in the United States, the gradual movement in England toward compromise and consensus was related both to the need to make concessions to the workers and the need to restructure capital and industry. While dominant social values and attitudes in the 1930s were basically conservative, significant changes were taking place in political and economic attitudes toward state intervention in private life, the nature and composition of the family, the growth of mass culture, and the extension of the power of trade unions. "By 1939," writes John Stevenson, "the government had already taken on many new responsibilities."[22]

The coming of World War II, therefore, was not so much a radical break with the interwar period as it was a consolidation of social and political practices, with some significant exceptions brought on by the state of national emergency. According to Arthur Marwick, "the most important effect of the war was to speed up the trend toward collectivism; and collectivism, in the form of nationalization and socialization, continued to be a basic tenet of government to the end of the forties."[23] The war not only was advantageous to the expansion of government services, but stimulated the growth of science, technology, and the social sciences and the extension of mass culture, the groundwork for which had already been laid in the interwar years. The Americanization of British culture continued. Broadcasting, journalism, and the cinema enjoyed unprecedented popularity and were integrated into everyday life. The war accelerated government responsibility in all areas—family planning, health care, housing, education, and the growth of science and technology.

The war was to create challenges to family life as women moved into the work force and assumed greater economic and social responsibilities in the public sphere. The separation of families due to conscription, the daily threat to personal survival, and the need to mobilize collectively against an external enemy to promote internal security and morale created a collective ethos which was exemplified in government propaganda, the radio speeches of Prime Minister Winston Churchill, and the character of much documentary and commercial film production during the war years. The war years also witnessed movements for independence on the part of "overseas territories acquired over the centuries by a fine mixture of naked aggression, commercial ambition, evangelical zeal, commonsense, hypocrisy, and sheer absence of mind,"[24] movements which were to acquire a sense of urgency during the 1950s and 1960s. On the national front, the immediate postwar era boasted an increase in welfare benefits under the Labour government, which was to be continued under

the Conservatives, who assumed power in 1951. While the Conservatives did not radically alter the directions established by Labour, the character of British political and social life was, in fact, transformed. Apathy on the part of the electorate had replaced the sense of urgency, shared purpose, and feelings of national unity celebrated during the war years. The coronation of Elizabeth II in 1953 did not, in spite of the official rhetoric of the time, mark the beginning of a new era, but, as is evident in the documentary *A Queen Is Crowned* (1953), suggested rather an attempt to turn back the clock and celebrate a past vision of English power and cultural hegemony. This regression, however, was not untroubled but rather was evidence that traditional social formations were not easily recoverable.

The new affluence by the mid-1950s was an important factor in eroding a vision of English tradition, continuity, and stability. Greater economic and social mobility of women and of young people became a cause for concern on the part of government and the media, as well as an indication that women's ties to the domestic sphere had, in fact, changed. The forms in which the dominant concerns were expressed were not openly repressive, but resentment was expressed in the language of social improvement derived largely from the social sciences. Concern with the welfare of the family and with sexual behavior were central and were expressed first in the Beveridge Report of the war years (1942) and later in the Wolfenden Committee Report on Homosexual Offenses and Prostitution (1957). The emphasis on juvenile delinquency, the presumed deleterious effects of women's greater independence, family instability, and permissive sexual mores was evident in the media and in the continuing growth of the fields of social work and sociology. The 1950s also saw an increase in racial conflict, labor unrest characterized by numerous strikes, and the cold war preoccupation with nuclear politics, centering particularly on the threat presented by the Soviet Union and the possibility of nuclear war.

The British cinema played an important role in shaping these cultural attitudes. In spite of assertions about the relative ineffectuality of the British cinema to address British cultural conflicts, an examination of the films from this thirty-year period reveal that the films (1) are not mere reflections of the cultural and political events discussed above, (2) are part of that history, and, above all, (3) offer significant clues to tensions and contradictions in relation to such issues as historicism, notions of community, gender, social class, and sexuality. It has been customary to think of the genre films of the 1930s—the musicals, comedies, historical films, films of empire, and melodramas—as reproducing a conservative ideology through their emphasis on tradition, continuity, and social decorum. An examination of the films, however, reveals that the genre films are less concerned with selling a particular form of ideology than with selling a

film. Therefore, to read the films for their ostensible social meaning without taking into account the operations and restrictions of the generic formulas and codes is to misrepresent and underestimate the ways in which the films function as social exchange. Similarly, the films of the war years can be read straightforwardly as calling for a more democratic vision of class relationships, a greater concern for the conflicts confronting the "gentle sex," a closer examination of the relationship between the public and private spheres, and an engagement with the everyday conflicts of "ordinary people" in this "people's war." While the films articulate such concerns as part of their conscious contribution to the legitimation of an ideology of national unity and identity, they too, like the films of the pre–World War II era, are not untroubled but reveal ideological tensions arising from the attempt to mask social differences. The films of the postwar period, too, are a fruitful source for examining profound contradictions in the private sphere, contradictions which expose fundamental tensions in the public and private spheres and work against the grain of efforts to recover traditional values. The focus on family melodramas and social problem films is indicative of the social and cultural displacement of political concerns onto the terrain of family life. The horror and science fiction films further reveal pervasive sexual and social conflicts.

This book is predicated on the assumption that a study of British genres offers a rich and diverse view of British cinema and society. Consonant with the work that has been done on the Gainsborough melodramas and the Ealing comedies and melodramas, I view the films as dramatizing cultural contradictions, particularly relating to questions of social identity. A fruitful way of identifying an important facet of the character and preoccupations of British film production lies in its ambivalence, in a certain tension between its overt and deeper structures. According to Charles Barr, "Often there is an eloquent and poignant disjunction between surface drama, as observed in talk and action, and interior drama, which may be conveyed through the eyes (cf. Hitchcock and Penn) and/or through expressive gaps in the film's narrative structure, creating a strong sense of something *other* that is being repressed, or sought in vain."[25] This "something *other*" is, as I hope to demonstrate, the locus of audience interaction with the film, where the audience makes contact with representations of power but also with disturbances in power relations. These disturbances are meaningful; they represent the clash between personal desire and social expectations.

My analysis of dominant British genres—historical films, films of empire, war films, women's films, melodramas, comedies, horror films, and social problem films—proceeds in conjunction with a discussion of the films' conditions of production, distribution, exhibition, and censorship, and the position of the director and stars. Furthermore, a comprehensive

study of British cinema has to account for more than "British classics" and a restrictive emphasis on the work of a handful of directors and studios. That history has also to include those popular genre films specifically designed to make a profit both in Britain and in the United States, as exemplified in the work of Gainsborough and Hammer. My book makes no claim to be a history of the British cinema from 1930 to 1960. Nor do I claim to exhaustively explore the history and theory of genre production. I concentrate on prolific and exemplary British film genres in order to explore how they are instrumental in shaping the culture's conception of itself and not simply mirrors of external historical forces.

Chapter 1 offers a general sense of British film production, including financial and industrial modes of organization and crises, the role of censorship, and the contributions of studios, directors, and stars, for the thirty-year period. The chapters that follow focus on those genres which I believe are most characteristic of how British cinema through genre production was a significant force in cultural representations, negotiating images of gender, sexuality, family, class, race, nation, and history. Chapter 2 focuses on the historical film and on how historical events and biographical subjects are represented and misrepresented in the British films. The events may take place in the Renaissance, the eighteenth and nineteenth centuries, or even in a modern context. The historical films are, on the surface, similar to the films of empire, the locus of British attitudes of social conservatism and therefore the site also of inevitable contradictions in the development of images of continuity, tradition, and justice. Historical films assume a number of forms—costume dramas, adventure films, spectacles, national epics, literary adaptations, and allegories. Often the lines between these types blur. Films such as *The Young Mr. Pitt* (1942) and *The Lady with a Lamp* (1951) purport to be biographical films, focusing as they do on the life, times, and actions of the central figure. Yet both films use their biographical subjects as exemplaries of national aspirations and as vehicles of special pleas for a particular form of socially responsible action. In the case of *The Young Mr. Pitt*, the film uses history also as an allegory, drawing connections between the Napoleonic era and the rise of fascism and arguing for the defeat of the "dictator." In the portrayal of the historical figure, the iconography of the actors is often linked to painting and statuary. While the character would seem to define the actor, in these films it is the actor who defines, assumes the identity of, the particular historical figure.

The films are structured in linear fashion, following the chronology of a life. They move, if not from youth to old age, through a time of adversity to one of triumph. Though they may have a romantic element, this is usually subordinated to the social commitment. The historical figure is the source of all actions. Chronology marks the stages in the narrative,

and the action proceeds in terms of encounters with a malevolent opposition and with loyal and supportive followers. Illness or aging presents the one obstacle that the hero cannot overcome, and death, when portrayed, becomes the means for apotheosis and the commemoration of heroic deeds. The use of documents, books, paintings, and maps (photographs and newsreels in the case of films involving more recent history) provides legitimation. Often, too, the crowd is used to convey the rising or falling fortunes of the historical figure as well as to inscribe potential forms of identification for the external audience. In many of the Korda films, especially the costume dramas, the emphasis is on spectacle, on opulent surroundings, elaborate costumes, and mise-en-scène.

Chapters 3 and 4 focus on films of empire and war and espionage films. The 1930s films of empire are clothed in the garb of adventure, emphasizing the exoticism of non-European cultures, primarily African. The main dilemma is the conflict between black and white men, between Western rationalism and native primitivism. The protagonist is the white representative of the ruling class in England who seeks to establish a bastion of civilization in the "dark continent" with the help of only a handful of white colleagues. Indigenous forces defend the power of the white father and his law against the unruly claims of other natives who are misled either by unscrupulous European forces or by other tribesmen who seek to undermine white rule. The innocent existence of the natives is presented as disrupted not through imperialism but through adventurers who have brought them drink and encouraged rebellion. In the postwar era, these films developed a liberal representation toward the indigenous people in such works as *Men of Two Worlds* (1946) and *Where No Vultures Fly* (1951), in which altruism, not merely power, is the mainspring of relations between the different peoples. The war films of World War I and the espionage films of the pre–World War II years are discussed in Chapter 3, while Chapter 4 focuses mainly on the styles and strategies of the war and propaganda films of World War II and the cold war. The war films—films of morale, combat, and the home front—have their own sets of conventions and codes. They often bear a striking resemblance to films produced in both the United States and in Italy during the war years, although their deviations offer a clue to the representations and discourses that are characteristic of British wartime culture.

Chapter 5 is an examination of the woman's film, its dominant narrative patterns, iconography, and modes of address. Focusing on a female protagonist, the films dramatize the conflict between female desire and cultural restraints. These films structure and control (or subvert) our ways of looking at the female body. There appear to be certain constants in the representation of woman's film, especially in the use of doubling and the polarization of characters and moral attitudes. Docile and rebel-

lious females are opposed to each other, as are acquiescent and domineering males. Female desire is still the focal point of the narratives, taking the form of the conflict between romance and career and exploring the failure of one or another or both. Obstacles to female pleasure arise from without and from within the person. External obstacles take the form of forbidding parental or authority figures, usually male. Internal resistance to conformity is dramatized as pathological dependency, alcoholism, and psychologically unbalanced behavior. Illness also plays a role as the text dramatizes the ways in which the female body becomes the site of internal conflict. Coming at a moment in history at which women were beginning to gain economic independence, divorce was on the rise, and women were learning that they could do work that had been the province of men, these films dramatize a tension between the conventional positioning of women and the entertainment of alternatives.

Chapter 6 examines those melodramas that address questions of male identity. If the maternal figure is more a shadow than a realized character, the paternal figure looms large, appearing in a number of guises, in the films of the 1930s and 1940s as a figure of familial and institutional authority, a benign representative of the law, of colonial administration, and of the educational system. In the 1950s films he is presented more ambiguously, his power challenged, his authority eroded, and his virility in question. This chapter examines the iconography of the various male figures, the ways in which they are positioned in the narrative in relation to conventional or marginal sexual, class, and racial attitudes. As in the postwar American feature films, issues of generational difference, authority, paternalism—more broadly, a whole way of life replete with values of service, merit, obedience, discipline, and respect—are at stake in the interactions between men. The protagonist in these films is often the landscape itself as the embodiment of tradition and a way of life. The relationships are centered in the public sphere, the realm of action, as opposed to the private sphere. Not all of the relationships are characterized by community and male solidarity in the face of external obstacles. There are also antagonistic relations, and one can discern in these relations more profound, even sexualized, conflicts. On the surface, though, the hostility appears to derive from traditional conflicts involving issues of authority, competition, and competence.

Chapter 7 explores the family melodrama. The issues involved in these films are disputes over inheritance, proper and improper class alliances, arranged marriages and elopement, legitimacy and illegitimacy, the conflict over power in the private sphere, and the burden, if not the failure, of the family. In many of the pre–World War II and postwar melodramas, the family is presented as the shrine, the basis of all other social relations and the vital source of proper attitudes toward sexuality, work,

and continuity. For example, *This Happy Breed* (1944), *Hungry Hill* (1947), and *Blanche Fury* (1948) ostensibly legitimate such a position but are unable to sustain familialism. Though their resolutions may work toward the reconciliation of conflicting elements, usually of a patriarchal nature, the endings cannot sustain the psychological and economic contradictions posed. The major differences between the prewar and postwar films resides in growing tensions exposed in the later texts. The conjoined problems of youth, gender identity, race, and social class erupt in the postwar cinema even when there are attempts to dramatize modes of containment.

Chapter 8 examines different expressions of comedy, with special emphasis on the ways the comedies portray class and sexual conflict, regional characteristics, and generational differences. In the romantic comedies of the 1930s, so often reminiscent of the European "white telephone" films, the emphasis seems to be on the upper classes and on sexual intrigue, the vagaries of a Don Juan who seeks to undermine conventional familial relations or the potentially disruptive possibilities of a female who departs alarmingly from expectations of chastity, as in *The Divorce of Lady X* (1938). By contrast, the comedian comedies of Gracie Fields and George Formby feature regional and working-class characters and situations. Comic conflict often arises from unemployment, economic threat to the community, and personal incompetence. In addition, films such as Will Hay's *Oh, Mr. Porter!* (1937), *Convict 99* (1938), *Old Bones of the River* (1938), *Hey! Hey! U.S.A.!* (1938), and *My Learned Friend* (1943) pit the bumbling of the hero against the incompetence of institutions (schools, prisons, colonialism), and, in the final analysis, the protagonist's ineptness exposes institutional practices. These films, as well as the Old Mother Riley films, are the closest to the type of comedy that flourished in the music hall. The films are not tightly structured but episodic, filled with gags and verbal and physical play, and their targets cover the gamut of British social life. The musical comedies of Jessie Matthews are more tightly structured and conscious of themselves as entertainment. In them, the audience is made conscious of the ways in which entertainment is related to commerce. The heroine's struggle borders on a violation of established sexual and legal norms. The world she inhabits is not a utopian one, but a highly competitive one in which the individual may succeed but society remains the same. However, in her struggle to succeed and overcome social barriers, the protagonist exposes constraints governing female behavior.

In the postwar era, Ealing comedy offered new formulas. *Hue and Cry* (1947), *Passport to Pimlico* (1949), and *Whisky Galore!* (1949) presented vital images of a community in transition. The comedies continued into the late 1950s with such films as *The Titfield Thunderbolt* (1953),

The Ladykillers (1955) and *The Lavender Hill Mob* (1951). The protagonists of these films are not individual comedians but a collection of individuals who expose the rigidity of conventional morality and attempt to subvert the Law and its representatives. Most of the Ealing comedies rely on either an interdiction that must be resisted or a discovery that momentarily—not permanently—upsets and transforms the community. The films offer a gallery of British types in recognizable British settings. The comedies of Frank Launder and Sidney Gilliat also present images of a world turned upside down in a carnivalesque atmosphere. These comedies depend on a gallery of eccentric characters who overturn conventional expectations; however, unlike the Ealing comedies, the characters in these films are broad caricatures and the narratives are more likely to address sexual conflict. *The Rake's Progress* (1945), *Folly to Be Wise* (1952), and *The Constant Husband* (1955) involve the violation of marital norms, focusing particularly on the mischief-making potential of public exposure of sexual conflict. In more bawdy fashion, the Carry On series begun in the late 1950s with such films as *Carry On Sergeant* (1958) and *Carry On Nurse* (1959) derives its comedy from unashamedly exposing and undermining sexual stereotypes, although, here again, as their titles indicate, the films lampoon institutional roles. These films are relentless in exposing sexual and class relations, and, as Marion Jordan indicates, "The distorted cartoon world which they mock is one which would deny sexuality and physicality, and insist on pudeur, reticence, a romantic view of love and an imposed orderliness. They oppose this world with the deliberate bad taste of rude words and farting elephants."[26] In contrast to the carnivalesque treatment of public institutions, family comedies of the 1940s and 1950s focused on the conflicts and constraints of domestic life, paying increasing attention to the disaffections of the young. British comedy thus ranges from the satiric to the farcical, from the broad rough-and-ready music hall treatment to the delicacy of genteel satire, but an overview of the comedies reveals a consensus around the tenuousness of the relationship between the public and private spheres as they affect conceptions of power, authority, sexuality, and power.

Chapter 9 is a treatment of science fiction and horror films. The 1930s and 1940s British cinema was not distinguished for its development of these genres—a situation that can, in large part, be attributed to stringent censorship of both direct and indirect varieties. The post–World War II era compensated for this lack as more science fiction and horror films began to appear. Hammer Films, along with several independent producers stimulated by the success of such Hammer films as *The Quatermass Xperiment* (1955), *Quatermass II* (1957), *The Curse of Frankenstein* (1957), and *Dracula* (1958), were responsible for the sudden popularity

of the genre in Britain as well as internationally. Structurally, the films share many characteristics with the Gainsborough costume films: their emphasis on doubling, binary oppositions, Victorian settings, and, especially, their preoccupation with cruelty and violence. Made predominantly in Technicolor, the Hammer horror films, in particular, exuded a sensuality which critics have often compared to that of the Marquis de Sade. In the science fiction genre, the British cinema, while not as prolific in this area as Hollywood or the Japanese, managed to produce films that addressed a divided world, the dangers of science and technology, and the fear of nuclear apocalypse.

Chapter 10 is an analysis of the "social problem" film as a category removed from the melodramas. Drawing on the heritage of realism in Britain as well as on Italian neorealism, these films are structured around demarcated social issues. As Hill argues, "it was in the period 1956–63 that this type of film became most prominent and topics such as juvenile delinquency, prostitution, homosexuality and race became standard preoccupations."[27] The dominant characteristic of these films is their descriptive and rhetorical nature. That the social problem films foreground young people to a very great extent, that these young people frequently are drawn from the working classes or from minority groups, and that the conflicts presented frequently involve the law all seem to testify to the broad interest in addressing the concerns of hitherto neglected or marginal groups. No doubt, another impetus for this type of problem film was the need to find a new form of entertainment that would bring waning audiences back to the cinema.

While these films appear to project ostensible social concerns, an examination of their narrative structure, characterization, and visual style reveals that the dominant strategies employed in them are designed to produce an affective rather than analytical treatment of the "problems" presented. Such films as *Good Time Girl* (1948), *The Blue Lamp* (1950), *I Believe in You* (1952), *The Weak and the Wicked* (1954), *Yield to the Night* (1956), *Sapphire* (1959), and *Victim* (1961) present marginalized figures as objects of inspection, interrogation, and correction. Oppositions are set up between the corrigible and the incorrigible, and the key to correction is frequently a policeman, a social worker, an employment counselor, or a prison correction officer. Frequently the films employ a voice-over narration belonging to the penitent offender or to a responsible law officer. At the same time that the films set about "recording" the unstable environment, they also—particularly those films that deal with women offenders—introduce elements of voyeurism.

The offender's behavior is attributed to generalized sources: bad influences, an impoverished environment, poor family relations. But the real "offender" appears to be unruly desire, most often expressed in sex-

ual terms, and the narrative trajectory moves in the direction of "civiliz-ing" the offender, assimilating him or her into respectable society. On the one hand, the films seem to follow a predictable middle-class ideology insofar as they assume the wholesomeness of family life, the respectability of work, and the need for mature guidance into these channels. On the other hand, screening the films in the 1980s, the viewer can identify the now-stylized elements that are structured around the dramas of conver-sion. What the films now make clear is that the identification of a "social problem" is a dead giveaway of the presence of a disciplinary discourse. And, as John Hill suggests, the texts reveal the power and threat of sexu-ality which they seek to contain. The representations of disruptive sexual-ity as embodied in the figures of socially marginalized figures unintention-ally subverts the narrative itself, now eliciting more empathy for the offender than for the agents of correction. Above all, what the films indi-cate is the pervasiveness of middle-class ideology, of the persistence of social conservatism clothed in the guise of a liberalizing rhetoric.

My discussion in the following chapters situates the film texts within a historical context, but I argue that the films are not merely a reflection of British reality. Rather, they are, in Jean Luc Godard's term, the "reality of a reflection." They are themselves part of the process of shaping attitudes, values, and beliefs common to British culture and society as well as indic-ative of underlying resistances to dominant ideological discourses. The Gramscian notion of hegemony is particularly useful for understanding the role of popular culture in the process of social and cultural legitima-tion. In Geoff Hurd's words, "*Negotiation* and *consent* are key terms for understanding the concept of hegemony. Whereas some interpretations of society insist that ideas are somehow 'imposed from above' and others argue that ideas, beliefs and so on are 'free floating', hegemony involves an understanding of the ways in which, through a series of struggles and conflicts, a certain 'compromise equilibrium' is formed between compet-ing classes. Hegemony therefore designates an *active* process, a constant struggle for leadership conducted on many fronts."[28] The examination of British genres that follows is predicated on the assumption that the films are particularly revealing of the contestation over hegemony which ex-presses itself as much in the private sphere as in the public arena.

British Cinema History

HISTORIES of British cinema have emphasized the fluctuating fortunes of the industry, often at the expense of its achievements. After early successes in the area of technology, the cinema was beset by a number of problems: inadequate confidence in the industry, weak incentives for investment, and American hegemony after the Great War. The cinema in Britain began as an artisanal form of production which expanded unimpeded by large financial interests. As Michael Chanan says, initially "cinematography was more than a means of mechanical reproduction. In creating so suddenly a huge and hungry following, the primary characteristic of the film, in its early days, was the sense, and the fact, of unsatisfied demand. The *sense* of unsatisfied demand lay in the baffling fact that, like the primary, basic material needs of human existence—for food, clothing, a dwelling and warmth—the demand for the cinema seemed to anticipate the particular means of satisfying it."[1]

British entrepreneurs had not arrived at any standardized methods in the creation of equipment, nor was there any strict division of labor in the areas of production, distribution, and exhibition. The making of film was still a family affair, dependent on local support. By the time the realization dawned that the film industry would need larger infusions of capital and more rationalized modes of production, the Americans had swept the field. World War I was instrumental in establishing American hegemony. While Britain, like other European powers, had to divert financial and technical resources toward the war effort, Hollywood producers took advantage of the shortage of films and of film equipment to inundate the European market with their own products. In the area of exhibition, there were more American than British films available to be shown and profits to be made in Britain by exhibiting them. The Americans produced more films, made them less expensively, and could distribute them at lower costs in foreign countries, having recovered costs in their own large markets. Furthermore, the vertical organization of the American film industry by the mid-1920s was in place, and the Americans, by means of a number of strategies such as block booking and blind booking, could consolidate their monopoly.

The British, like the other Europeans, learned to their disadvantage that cinema was an international phenomenon and that the United States had, in the entertainment industry, colonized them. That the British and Americans shared a common language only made the situation more critical. The effects of this situation were that "the British cinema, such as it was, lost its self-confidence. It was unable to sell in the American market, and in other foreign markets was forced to compete against the Americans on unfavorable terms. . . . British film-makers quite simply developed an inferiority complex. This was a typical effect of neo-imperialism in the cultural sphere: cultural imperialism."[2] Rather than encouraging investors, the economic and cultural dependency of the British cinema on Hollywood retarded development. This situation is roughly comparable to the dilemma of Third World filmmakers forced to compete with the Hollywood films that now flood their countries. The state intervened to alter the picture somewhat, but never to the great advantage of the British industry.

Every decade saw the enactment of legislation designed to mitigate the prejudice against British films and to encourage indigenous production. The industry and the government sought to develop a system that would establish a ratio for the production and exhibition of British films in relation to foreign productions. According to the 1927 Cinematograph Act, to qualify under the established quota system as British, the film had to be authored by a British subject, the studio scenes filmed in the British Empire, and at least seventy percent of the labor costs paid to British subjects. Of course, this did not eliminate the possibility of an American company's financing a production under these terms. The 1930s saw the rise of the "quota quickie," a pejorative term for shoddily constructed and technically inferior films financed cheaply to meet the required quota for exhibition of indigenous films established by British law.[3] These films, however, did offer work to aspiring filmmakers such as Michael Powell. The 1938 act sought to address the problem of poor-quality British films by establishing a minimum cost requirement for registration that could ensure adequate budgeting for the production and, hopefully, eliminate low production standards. The general effect of both cinematographic acts was, in balance, not as helpful as the outward signs of the growth of companies and cinemas seem to suggest. The 1927, 1938, and 1947 acts did not solve the problem of Hollywood dominance. Despite moments of prosperity and profit, the history of British film production is one of unmitigated dependence on America and of cultural imperialism.[4]

With the coming of sound, the British cinema, like other European cinemas, had to undergo massive changes in equipment, personnel, and financing. The effects of the changeover were seen in the disappearance of many of the cheap quota companies, who could not afford the ex-

penses entailed, though by no means did the coming of sound curtail the quota quickies. The early 1930s saw the rise of film as "big business" with the production of international features through the efforts of Sir Alexander Korda and his London Films. Studios such as British International made a profit, and Gaumont-British managed to stay afloat. The quota legislation ensured that there was a demand for British films, and many of these companies cashed in on that demand. World War II was also to improve dramatically the quality of British films, owing to a number of factors—American-British cooperation, the insatiable demand of wartime audiences for films, and the existence of an ideology of consensus and cooperation in the face of threats to the nation and to personal survival. Robert Murphy cites the popularity of *In Which We Serve* (1942), which "grossed $1.8 million in America," and "British films ranging from realist war dramas like *49th Parallel* (U.S. title: *The Invaders*) and *Target for Tonight* to escapist melodramas such as *The Man in Grey* and *Madonna of the Seven Moons* rivalled the top Hollywood pictures in popularity with British audiences."[5]

Margaret Dickinson identifies three issues that have consistently plagued the British cinema: "the dominant influence of America; the monopoly exercised by the major British interests; and the lack of a stable domestic production industry." Though World War II was a prosperous time for the British film industry, the period from the 1940s to the 1960s witnessed extreme changes as cinema was transformed from an influential mass medium to "a minority entertainment and a sideline of the leisure industry."[6] After an unsuccessful attempt to challenge American competition and carve out a share for himself in the American market, J. Arthur Rank, a dominant and dominating figure in British film production from the 1930s, settled for cooperation with American interests, and the 1950s saw greater Anglo-American production in big-budget films than low-budget films. More than ever, the British cinema was firmly in the hands of Hollywood, a Hollywood that was itself struggling to maintain its leadership in the entertainment industry. Moreover, the cinema now had to contend with yet another competitor: television.

While the market directly influences the kinds of films produced, there are other and equally important controlling factors to be considered. Censorship determines what the public can and cannot see. As in the United States, various local authorities, religious groups, and political constituencies in Britain began early to agitate for the creation of a body that could outline and control the representation of certain subjects in the cinema. Direct governmental intervention was, for some, the most desirable way to set up a supervisory apparatus. For others, internal surveillance by the filmmakers was preferable. A compromise position called for a semi-autonomous body made up of representatives from the industry

and the government. In 1912, the British Board of Film Censors was finally composed of representatives of the trade, with the chair appointed by the home secretary and supported financially by those seeking to get a certificate that would permit their films to be exhibited.

The first censorship regulations other than safety regulations concerned the representation of nudity and the materialization of Jesus Christ. By 1914, other restrictions were added, involving such things as indecorous dancing, cruelty to animals, vulgarity and impropriety of dress, scenes suggesting indelicate marital relations, gruesome murders or wartime mutilation, morbid death scenes, cruelty to women, scenes tending to disparage public characters and institutions, medical operations, drunken scenes carried to excess, painful scenes in connection with insanity, suicides, incestuous relations, native customs abhorrent to British ideas, and, during wartime, the disposition of troops and other information calculated to enlighten the enemy.[7] In 1915, other items were added to the list of prohibitions, concerning the portrayal of industrial relations, the religious beliefs of Indian nationals and the maltreatment of natives, antagonistic relations between capital and labor, scenes holding up the monarchy to contempt or ridicule, scenes bringing into disrepute British prestige in the empire, controversial politics, drugs, men and women in bed together, prostitution and procuration, prolonged fight and struggle scenes, and the effects of venereal disease. More sensitive areas concerned the positive representation of the Communist Revolution and, more generally, films sympathetic to the Soviet Union.[8] Still other areas included the unauthorized use of royal names and public personalities, scenes calculated to inflame racial hatred, the American form of criminal interrogation (the "third degree"), doubtful characters exalted into heroes, advocacy of free love, and the portrayal of the sacrificing of a woman's virtue as laudable.[9] If interracial marriages were shown, one or another of the couple would die or the marriage was shown to result in failure. Real institutions were not to be identified; hence the college in *A Yank at Oxford* (1938) has no specific name. Words like "bloody" and "bastard" were not to be used. Gangster films were frequently cut, and horror films banned.

Nicholas Pronay and Jeremy Croft describe the board in the following manner: "Theoretically, the Board's certificate only served the purpose of advising local authorities, which actually possessed the power to permit or ban the exhibition of a film in the cinemas of their district, as to the suitability of the film concerned. In practice, after a few, although much publicized, assertions of independence by some local authorities during the 1920s, the Home Office had succeeded in inducing all of them to require the possession of a BBFC Certificate as a precondition of exhibition."[10] The Cinematograph Exhibitors declared that its members could

only show films with the BBFC certificate. The only way around these restrictions was to belong to a cinema club or to have private access to a copy of a film that had not been passed.

Given the list of censorable items, it is important to see that any reading of British films must take into account not only the subjects selected for representation, but also the absence of many subjects. Moreover, the filmmakers often had to resort to indirect discourse in order to circumvent the censor's axe, adopting conventions that would suggest the film's moral disavowal of certain attitudes and actions offensive to the censor: killing off illegitimate children and adulterous women, punishing lawbreakers, resolving unresolvable marital conflicts, and producing ellipses in explicitly sexual material. In general, according to Pronay and Croft, the system operated through negative constraints "with well-defined 'Don'ts.' As long as filmmakers avoided all the subjects proscribed by the ninety-eight rules . . . they were free to make films about whatever they wished."[11]

There was no need to develop an elaborate censorship apparatus with the coming of World War II: "All that was necessary was, firstly, to close the loopholes which had deliberately been left open before the war for films that could only be shown to an intellectual minority behind the closed doors of cinema societies and the like, and, secondly, to introduce some new categories relating to the military security needs of wartime."[12] The closing of the loopholes, however, also brought with it more stringent and extensive forms of control involving such issues as who could have access to film stock, favoring of certain filmmakers over others, and preferences for certain themes over others. On the positive side, some of the prewar regulations were relaxed, as in the case of the representation of industrial relations, the treatment of marital problems, the portrayal of a foreign government in a disparaging light, and the impersonation of actual individuals.

The preparation of scripts was not merely a matter between the writer and the studio, subject to the producer's approval—the censors played an integral part in the determination of the text, even to the point of choosing which scripts would see the light of day and which would not. The case for wartime censorship was legitimated in the name of raising cultural standards as well as creating positive civilian morale. The operations of the BBFC and later the Ministry of Information imposed restrictions on an industry that was only too familiar with economic and cultural constraints. Moreover, the existence of the board is a specific instance of the collaboration of state and private institutions in the interests of political control. In the public arena, the overtly political nature of British censorship was evident in its restrictions on the portrayal of class conflict, resistances and rebellions against the state, and criticism of gov-

ernment policies, especially during times of crisis. In the private sphere, the restrictions governing sexual behavior and morality were equally political. The existence of censorship serves as a reminder that, in spite of the asseverations of free speech and private property, British state and civil apparatuses were zealous in curtailing both in the interests of social and political conformity. British censorship practices must, then, be seen as an integral force in determining not only the parameters of British film production but the arena of acceptable social attitudes and values that are articulated, ignored, or subverted.

In determining the specific character of film texts, the role of the director must also be accorded a position in the ensemble of relations that govern film production. The auteur theory has been subject to a good deal of criticism recently because of the way it accords primacy to the director as the author of a text and slights the roles of producers, studios, writers, stars, and camerapersons as well as the determining roles of censorship and the genre system. Janet Wolff asserts that "the author as a fixed, uniform and unconstituted creative source has indeed died. . . . But the author, now understood as constituted in language, ideology, and social relations, retains a central relevance."[13] In certain instances in British cinema, it is possible to identify styles, themes, and ideological predilections with particular directors, but, as Christine Saxton has argued, "the author is a juncture of multiple codes (representational, narrative, iconographic, cinematic, cultural) and multiple practices (production, promotion, reading, critical reading, theoretical analysis). The collective voice generated by this nexus of codes and practices and manifested as the author-function, is ultimately imbued with a culturally defined world view that invades every aspect of the film's representation."[14] In the case of British cinema, there are groups of films in which the voice seems to be predominantly that of the director, and in which the director's presence can be read as orchestrating cultural concerns through his (rarely her) agency. However, even where the text is identified with the voice of the director, this voice must be understood as an "authorizing force . . . nothing other than a predication of the representation." The following discussion of directors is predicated on this assumption.

With the exception of Muriel Box and Wendy Toye, women directors are conspicuously missing from the roster of feature film directors. The most prominent directors in the first thirty years of British sound film are Alexander Korda, Anthony Asquith, Victor Saville, Alfred Hitchcock, Michael Powell and Emeric Pressburger, Frank Launder and Sidney Gilliat, Roy and John Boulting, David Lean, Carol Reed, Thorold Dickinson, Basil Dearden, Alexander Mackendrick, Robert Hamer, Leslie Arliss, Ronald Neame, Anthony Pelissier, Arthur Crabtree, Compton Bennett, J. Lee Thompson, and Terence Fisher. Of these, Asquith, Hitch-

cock, Powell and Pressburger, Dickinson, Lean, Reed, the Boulting brothers, and Dearden are most closely identified with films in which the director's voice is prominent, whereas the other directors are more closely associated with studio styles. These directors worked in a number of genres, and their work represents a compromise between the demands of the studios, the specific genres in which they worked, and their own personal preoccupations. Their work also manifests a high quality of production and, taken together, reveals the still-to-be-discovered riches of British filmmaking.

Anthony Asquith, whose films span the silent and sound cinema, worked in several genres: thrillers, war films, musicals, historical films, and comedies, often based on literary adaptations. Asquith experimented with editing and lighting techniques. His renditions of George Bernard Shaw—*Pygmalion* (1938), *The Doctor's Dilemma* (1959), and *The Millionairess* (1960)—express Asquith's liberal ideology, a middle-class emphasis on self-improvement, altruism, a hope for the gradual betterment of society, and the importance of community. His wartime *The Demi-Paradise* (1943) celebrates national and international unity and British humor and determination in the face of catastrophe. In his treatment of gender relations, there is a preoccupation with the failure of heterosexual relationships. The divisive role of women in his films is best exemplified in such films as *The Woman in Question* (1950) and *The Browning Version* (1951). Relations among men are evanescent but less destructive, as dramatized in *Tell England* (1931).

Victor Saville began his work in film as a producer and later turned to directing with such musicals as *Evergreen* (1934), *First a Girl* (1935), and *It's Love Again* (1936), films that helped to establish Jessie Matthews as a star. Saville's films are particularly representative of the efforts of British filmmakers to create a popular British cinema, one that is dependent on genre production.[15] His musicals are of the backstage variety, playing self-consciously with the idea of entertainment as impersonation, fraud, and commerce and producing a flexible boundary between "life" and "entertainment." The films focus on the female star's conflicts with career and romance, role-playing and authenticity, and sexual identity. The texts were often remakes of German films such as *Privatsekretärin* (1931), which became *Sunshine Susie* (1931), and *Viktor und Viktoria* (1934), which became *First a Girl*. Other Saville films were based on popular plays and novels. *South Riding* (1938), based on the novel by Winifred Holtby, is a melodrama which Jeffrey Richards and Anthony Aldgate describe as "a film with literary pretensions and aspirations to do more than simply entertain."[16] Taking place in a small English community and focusing on political and private intrigues, the film is a period picture of the various British classes, emphasizes the internal as well as

external landscape of England, and selects certain "social problems of the time"—education, health care, housing, poverty, familial relations, and local government. Saville was also the producer of two highly successful British-American collaborative films (through MGM-British), *The Citadel* (1938) and *Goodbye, Mr. Chips* (1939). After *Chips*, he worked in Hollywood for a decade, with moderate success.

Alfred Hitchcock's *Blackmail* (1929), a film identified as one of the first British sound films, is, like Asquith's early work, a self-conscious probing of the cinematic medium, playing with lighting, montage, mise-en-scène, and sound. The psychological treatment of character and incident associated with the German cinema predominates in films such as *The Lodger* (1926), *Blackmail*, and *Sabotage* (1936), with their emphasis on obsession, guilt, sexual harassment, transgression, and the law. Hitchcock's venture into musicals with *Waltzes from Vienna* (1934), in spite of his own disclaimers and those of his critics, deserves consideration for the ways it departs from the conventional techniques used for musical biographies at the time. *The 39 Steps* (1935), *The Lady Vanishes* (1938), and also *Sabotage* are, as Tom Ryall indicates, exemplary of the thriller genre. In Hitchcock's films, the psychological element predominates and the element of menace grows from the inevitable destabilization of a commonplace environment.[17] The conspiratorial element in the films is intertwined with a romantic element involving a heterosexual couple; the unraveling of the conspiracy often becomes the means for uniting the couple. The conventional elements of disguise, impersonation, chase, and rescue are inextricably bound to sexual elements, having the effect of transposing the external intrigue to an internal psychological register. The style of the films—their editing, use of sound, and positioning of the spectator—emphasizes conflict involving the desire to see, hear, know about, and commit sexual transgression.[18] The British quality of Hitchcock's films extends beyond the use of certain settings, including familiar landmarks like the music hall or the British Museum, to include British stereotypes in his landladies, milkmen, tram conductors, and traveling salesmen.

Michael Powell's work also combined the rigors of genre with more idiosyncratic concerns. His first experience in filmmaking came through his association with Rex Ingram. Powell worked for Alexander Korda on *The Thief of Bagdad* (1940), starring Sabu, and was to use Sabu again in his postwar film *Black Narcissus* (1947). An admirer of American cinema and culture, his work in "quota quickies" such as *Her Last Affaire* (1935) as well as his collaborative work with Korda is characterized by a flamboyance of style, an emphasis on the romantic, on visual spectacle, on physical energy, and on landscape. It was *The Edge of the World* (1937) that brought Powell the contract with London Films. The film, reminis-

cent of Flaherty's *Man of Aran* (1934) in its use of location shooting and
its emphasis on the conflicts of island life, has a more elaborate narrative
and avoids the nostalgia of the Flaherty film. London Films brought Pow-
ell into contact with Emeric Pressburger, with whom he was to work on
many films, sharing the titles of director, writer, and producer. The genres
associated with this team include war films, fantasies, melodramas, and
musical dramas. Their highly successful war films include *49th Parallel*
(1941), *One of Our Aircraft Is Missing* (1942), *The Life and Death of
Colonel Blimp* (1943), *A Canterbury Tale* (1944), and *A Matter of Life
and Death* (1946).

While these films address polemical issues such as the hazards of com-
bat, wartime morale, the nature of the "enemy," the contrast between the
traditional upper-class military establishment as represented by Colonel
Candy and the "new army," and the nature of postwar existence, they are
adventure or romance narratives. The films, with the exception of *The
Lion Has Wings* (1939), to which Powell only contributed, depend on
fast-paced action, an experimentation with narrative structure, and an
exploration of the technological and symbolic valences of color. The gen-
eral direction of Powell's work has been away from a realistic aesthetic,
although Powell has insisted on fidelity in location shots, often braving
hazards in order to get the desired footage. Of Powell's work, Raymond
Durgnat has said, "Had Powell and the cinema, and Technicolor, flour-
ished in the first half of the nineteenth century instead of the twentieth,
the period, in fact, of Romanticism encountering Victorian realism, Pow-
ell might have been working with the cultural grain instead of against it.
His cravings are audacious, constant, uncertain, he turns this way and
that, restlessly seeking out different genres, styles, symbols."[19] Durgnat's
comments, while complimentary, portray Powell's work as unfocused,
when, in fact, most of Powell's films are romantic melodramas rooted in
a consistent concern with the effects of repression and sexual conflict.
Black Narcissus (1947), starring Deborah Kerr, dramatizes the deleteri-
ous effects of sexual abstinence on a group of nuns in the Himalayas; in
The Red Shoes (1948) the conflict between creativity and domesticity de-
stroys the heroine, while in *Gone to Earth* (1950) the heroine is destroyed
by male domination associated with the violation of nature. *Peeping Tom*
(1960) is a reflexive Freudian essay on filmmaking, equating the camera
and tripod with the male sexual organ, voyeurism with filmmaking,
filmmaking with aggression, aggression with male violence, and patriar-
chy with violence against females.

Another team, Frank Launder and Sidney Gilliat, have been responsi-
ble for numerous comedies and thrillers. They began as scriptwriters, first
combined writing and directing with the film *Millions Like Us* (1943).
They got their start in the cinema of the 1930s doing what Geoff Brown

describes as "lowbrow comic vehicles," comedy drawn from the popular arena, and many quota quickies.[20] They wrote the scripts for such thrillers as *The Lady Vanishes* (1938) and *Night Train to Munich* (1940) and Reed's *The Young Mr. Pitt* (1942). The Will Hay comedies, too, bear their imprint—*Good Morning, Boys* (1937), *Oh, Mr. Porter!* (1937), *Convict 99* (1938), *Old Bones of the River* (1938). During the war, they scripted Asquith's *We Dive at Dawn* (1943). Of their films, Durgnat writes: "Their partial autonomy from the consensus may well be linked with the cultural patrimony betrayed by their specialties (farce; life on or below the lower-middle-class level; and Celtic topics) . . . their consistent freshness and mischief, their cheerful lightly-and-slightly anarchism, their relaxed romping in and out of the system's little ideological loopholes and bye-ways, is always a welcome break from the rigid routines and closures which characterize so many films."[21]

They also directed films separately. *Waterloo Road* (1945), a film that dealt with the issue of working-class survival during wartime, was directed and scripted by Gilliat. He also directed *The Rake's Progress* (1945), scripted by Launder and himself, shifting his focus to upper-class characters and situations. *Green for Danger* (1946) was Gilliat's venture into detective narratives. The film takes place in the hospital, where a police inspector, played by Alastair Sim, seeks to uncover who murdered a patient in surgery. The film's protagonist is an upper-class bounder who finally finds his niche in wartime. Launder's *I See a Dark Stranger* (1946), starring Deborah Kerr, is a comedy/thriller film about a young Irish woman whose pro-Irish sentiments involve her in espionage against the British. Launder returned to the Irish setting with *Captain Boycott* (1947), a period film that dramatizes the plight of Irish peasants in the nineteenth century. Launder's first color film was *The Blue Lagoon* (1949), a narrative of shipwreck that portrays the coming of age of young people in a natural setting removed from the corruptions of civilization. The series of school comedies starring Alastair Sim—*The Happiest Days of Your Life* (1950), *The Belles of St. Trinian's* (1954), *Blue Murder at St. Trinian's* (1957)—directed by Launder was a great success. In *Lady Godiva Rides Again* (1952) Launder cast a critical eye on the world of entertainment and advertising.

The work of Carol Reed spans several decades and covers several genres—comedy, melodrama, and thriller. *The Stars Look Down* (1939) is an early example of a social problem film. The film is the saga of a miner, played by Michael Redgrave, who seeks to better himself through education in order to help his fellow miners but is obstructed by a woman, by the social institutions, by the mine owners, and by rapacious members of his own class. It takes a tragedy in the mines to recall him to his commitment to the miners. He is the archetypal Reed male figure, degraded by

circumstances, although, unlike later protagonists, he overcomes his self-destructive tendencies. Reed's *The Young Mr. Pitt* (1942), a wartime historical film, follows the career of the political figure as he fights against the forces of expediency and appeasement. The film, made on the eve of World War II, links historical allegory and propaganda. More directly in line with the war effort, *The Way Ahead* (1944) dramatizes the way in which men are prepared for combat, men from different classes and different outlooks who become united in their common purpose. In 1941 Reed directed *Kipps*, based on the H. G. Wells novel. Kipps, a draper's assistant, begins to follow a course of self-betterment after having come into a small inheritance. He is almost ruined by an upper-class woman but is eventually united with a woman of his own class.

The postwar film *The Fallen Idol* (1948), starring Ralph Richardson, is a domestic melodrama. The film does not idealize youth as innocent but portrays a young boy trapped in the lies and violence that surround him. *Odd Man Out* (1947), starring James Mason, perhaps one of Reed's better-known works (along with *The Third Man* [1949]), deals with the politics of betrayal. The Irish protagonist is hunted down and finally destroyed. *The Man Between* (1953), another film of political intrigue using the divided city of Berlin as its setting, is, like *The Third Man*, a drama of the cold war, of paranoia, and of disillusionment. Reed's work utilizes international casts—Orson Welles and Joseph Cotten in *The Third Man*, Sophia Loren and William Holden in *The Key* (1958)— and major British stars such as Trevor Howard, a perennial Reed actor. *The Key* takes place in wartime, but the experiences of the men are not idealized. Instead, the film, based on the Jan de Hartog novel, plumbs the unheroic aspects of war. In the face of death, the men experience a loss of personal boundaries and an unpleasant sense of their interchangeability, symbolized in the passing of the woman (objectified as the key) from hand to hand. Reed's version of Joseph Conrad's *The Outcast of the Islands* (1951) stars Trevor Howard as the outcast, a failure whom Reed follows to his ultimate degradation. The world portrayed in the film, particularly through the character of Almayer (Robert Morley), is violent and destructive.

Thorold Dickinson's directorial work, as opposed to that of Hitchcock, Lean, and, more recently, Powell, is often praised but little analyzed.[22] Roy Armes links his work to that of Michael Powell, regarding both directors as "individualists." Durgnat contrasts Dickinson with Anthony Asquith, finding that "if Asquith typifies English liberalism at its most open, Dickinson's liberalism impels itself toward the radical pole. Whereas Asquith remains within the ambit of home counties gentlemanliness, Dickinson, of not dissimilar generation and background, arrives at an internationalist perspective."[23] Dickinson's work tends toward the

melodramatic. His *Gaslight* (1940), starring Diana Wynyard and Anton Walbrook (later remade in Hollywood with Charles Boyer and Ingrid Bergman), is a psychological study of a woman driven to the brink of madness. Compulsion, sexual conflict, and male domination are also characteristic of Dickinson's earlier *The High Command* (1937). During the war, he made a historical film about Disraeli, *The Prime Minister* (1941), and the controversial *The Next of Kin* (1942), dramatizing the dire consequences of "loose talk," which the censors (and Winston Churchill) ironically felt was too close to actual events, if not damaging to morale.

Tackling colonialism, Dickinson made *Men of Two Worlds* (1946), which portrays the return to Africa of a black pianist and the conflict, as the title suggests, between the native and Western cultures. His *The Queen of Spades* (1949), based on the Pushkin story, is another exploration of compulsion, male ambition, and misogyny which plays with visual effects, lighting, superimpositions, and camera angles to portray the ways in which obsessions arising from unrealized desire and class snobbery poison personal and social relations. *Secret People* (1952) focuses on international intrigue and particularly the compulsions of left radicalism that destroy the very ideas and behaviors that the struggle for change is supposed to liberate. The treatment of character, as in Dickinson's films, is based on the conflict between the public and private spheres, between desire and perceived social objectives, channeling the individual in those directions that are personally and socially divisive and self-defeating.

David Lean, unlike Dickinson, is a director whose career is associated largely with international rather than British production in such blockbusters as *The Bridge on the River Kwai* (1957), *Ryan's Daughter* (1970), *Lawrence of Arabia* (1962), *Doctor Zhivago* (1965), and *A Passage to India* (1984). However, his early melodramas and war films were made on a more modest scale and explore domestic and patriotic themes. His cooperation with Noël Coward early in his career produced such films as *In Which We Serve* (1942), a saga combining a portrayal of the dangers and heroism of life at sea and the familial relations of the men involved. *This Happy Breed* (1944) was the archetype of the family chronicle set in the context of changing social relations during the interwar period and later World War II. *Blithe Spirit* (1945) is an exploration of marital conflict developed through an invocation of the supernatural.

Lean's most famous and successful film of the 1940s is a melodrama, *Brief Encounter* (1945), which focuses on the romantic conflict of a middle-class housewife, torn between desire and domestic duty. Roy Armes views this film as prefiguring the characteristic Lean preoccupation with a "refused love affair and the surrender to inhibition," which is also char-

acteristic of *The Passionate Friends* (1949) and the later *Summer Madness* (1955).[24] His *Great Expectations* (1946) and *Oliver Twist* (1948) have been critically acclaimed as the best cinematic renditions of Dickens, utilizing the visual medium to great advantage in the portrayal of character and theme. *Hobson's Choice* (1954), starring Charles Laughton and Brenda de Banzie, involves the conflict between a father and daughter that results in the defeat of an autocrat and the substitution of a more modern, middle-class ethos of economic and domestic success. Lean's films move from the private dramas of female desire and familial conflict, the desire for fulfillment and the intrusion of social realities, to the external dramas of male fantasy and heroism, set in exotic and remote locales, with action overwhelming the element of personal conflict. The casts of the later films, like the settings, are international, and the personal conflicts are portrayed as having global consequences.

The films of Roy and John Boulting, ranging from historical films and melodramas to satires, are often political allegories. During World War II they made *Pastor Hall* (1940), modeled on the German religious figure Pastor Niemoeller. They also made documentary films about the war in Africa and in Asia, while *Journey Together* (1945), a blend of documentary and fiction, focuses on the trials of a young man who wants passionately to be a flier but must settle for being a navigator. The film utilizes the narrative convention characteristic of many of the war films of bringing together men of different classes in the interest of wartime unity. *The Guinea Pig* (1948) portrays the struggles of a working-class young man to break into the world of the public school and hence into the upper class. In the spirit of the war era and the early Labourite period, the work explores the opening up of educational possibilities for young men like Jack Read, and, as Richards and Aldgate have indicated, "The standpoint of the film is mainly one of consensus, of the modification of existing institutions to accommodate a wider spectrum of the population, of evolutionary rather than revolutionary change."[25]

Their postwar films, like many films of that period, are characterized by a dissolution of idealism and a critical tone about the state of postwar society, bordering on the social problem mode of presentation. In *Fame Is the Spur* (1947), starring Michael Redgrave, the hero begins with a sense of purpose in relation to political reform, but the film charts the ways in which *realpolitik*, compromise, and the lure of success undermine the desire for social change. In *Brighton Rock* (1947) the male protagonist and the woman he exploits are the victims of economic and cultural marginalization. The society portrayed is sinister and paranoid and prefigures the more paranoid world of *Seven Days to Noon* (1950) and the cold war text par excellence, *High Treason* (1951). Scientists and po-

litical reformers are either naive or traitors, or, unwittingly, both; the people in the society are self-seeking and sinister; women are victims, crazed, or failures with a spark of human kindness.

The film that most characterizes the Boultings' work in satire is *I'm All Right Jack* (1959). In encyclopedic fashion, the film attacks British institutions—industry, neocolonialism, labor unions, advertising, news reportage, political protest, and family relations. The protagonist, played by Ian Carmichael, an actor who consistently plays the part of the perennial ingenu, is exemplary of young people ill-prepared to meet the exigencies of the corporate society. The Boultings' films capture the sense in which postwar British society is, at best, a world of compromises and, at worst, a world of exploitation, betrayal, conspiracy, and self-interest characteristic of 1950s films.

Basil Dearden, on the other hand, is associated with social problem films, films that seek to identify and address social conflicts.[26] The characters in his films are of two sorts—figures of marginality, represented by male and female social offenders, and meliorative figures, represented by social workers and the police. Immediately after the war *The Captive Heart* (1946), starring Michael Redgrave, appeared. This film, involving life in a prisoner-of-war camp, dramatizes the consequences of the protagonist's assuming the identity of a dead man, but the film more properly addresses the effects of the war and the problematic transition to domestic life. Associated with Ealing Studios, his work bears the marks of Ealing's social and political concerns. *The Blue Lamp* (1950) portrays juvenile delinquents whose rebelliousness is linked to an economically and culturally deprived environment. In opposition to the criminal world, the film portrays the benign world of the police station. Comfortable fatherly figures like P.C. Dixon are represented as the cohesive element in the community. The police are associated with the benign and personalized application of justice rather than with the purely disciplinary aspects of the law. Social workers are also pitted against street elements in *I Believe in You* (1952). *The Gentle Gunman* (1952) returns to a concern expressed in *Halfway House*—"the Irish question." *The Gentle Gunman* explores the violent passions generated by the IRA, identifying its fanaticism with a drive toward death, and pleading for a respite from the extreme attitudes generated by both the organization and the British. *Sapphire* (1959) tackles the problem of race relations, taking the death of a young black woman as the pretext for an investigation of racial issues, and *Victim* (1959) explores homosexuality, a topic rarely dealt with in the British cinema prior to the 1950s. *The Ship That Died of Shame* (1955) is an allegory of contemporary society that portrays the characters as having lost their sense of purpose and community after the war by succumbing to a life of criminality.

J. Lee Thompson is another director who worked in the melodramatic mode with emphasis on particular social problems, locating his narratives in the experiences of marginal and working-class characters. *The Weak and the Wicked* (1954) portrays women in prison, tracing their transgressions and rehabilitation; *Yield to the Night* (1956), starring Diana Dors, examines capital punishment through the dramatization of a woman confronting death and reliving her past. Thompson's films are distinguished by strong female protagonists, a style that plays with moral perspective, and a tension between documentary realism and visual strategies of alienation and distancing.

Muriel Box, working in a predominantly male medium, was associated first with Gainsborough Pictures. She served as scenario editor for such films as *The Years Between* (1946), *Jassy* (1947), *Good Time Girl* (1948), and *Boys in Brown* (1949), films that feature social problems and particularly the plight of "marginal" women. In her capacity as scenario editor she was responsible for selecting many of the successful melodramas and historical films produced at Gainsborough studios during the 1940s, in particular those films that have been designated "women's films." Her own direction credits reveal her exploration of genres—comedies, melodramas, and social problem films. The comedies, *To Dorothy a Son* (1954), *Simon and Laura* (1955), and *The Truth About Women* (1958), the police drama, *Street Corner* (1953), the thriller, *Eyewitness* (1956), and *Too Young to Love* (1959), a social problem film concerning teenage prostitution, further reveal her concern for developing women's issues. While she did not see her films as polemic, her feminist concerns are manifest in the way she focuses on female characters trapped in poverty, violent and negligent familial relations, and constraining marital relations. In the context of the 1950s cinema, devoted so often to reestablishing the family and women's position within domesticity, her films, while set in a similar context, provide a different perspective from which to examine the effects on women of the ideological changes from the war era to the postwar period. Wendy Toye, another female director, was, prior to directing feature films, a dancer and a stage director who also produced prize-winning short films. In 1954 she codirected the thriller *Three Cases of Murder* (1954), which was followed by three films that she directed alone: *Raising a Riot* and *All for Mary* (1954), and *True as a Turtle* (1956).

Other determinants on the films arise from the culture at large as well as from the nature of commercial film production. The star phenomenon is an important site for the convergence of economic, aesthetic, and cultural considerations. The character played by the star is laden with an ideological significance that extends far beyond the manifest content of the film. The star communicates cultural conceptions of beauty, fashion,

desire, conformist versus deviant behavior, success and failure, morality, class, race, regional difference, life-style, and sexual difference. As Richard Dyer states, "star images function crucially in relation to contradictions within and between ideologies, which they seek variously to 'manage' or resolve. In exceptional cases, it has been argued that certain stars, far from managing contradictions, either expose them or embody an alternative or oppositional ideological position (itself usually contradictory) to dominant ideology."[27] The reading of the text may be altered radically when certain stars step into conventional roles and there is a clash between the prescribed role and the image of the star in that role, calling attention to the unresolved conflicts in the text.

The British cinema was not without its own stars during the years from 1930 to 1960. The impact of these stars on British culture has yet to be assessed, since most of the work on stars has dealt with Hollywood cinema. It seems that the star system never functioned in Britain to the extent that it did in Hollywood, nor in the same manner. It is probably inaccurate to refer to many popular British actors as stars, although some of them, often through their contacts with Hollywood, such as Vivien Leigh, Laurence Olivier, and Rex Harrison, have been associated with the aura of Hollywood stardom. Gracie Fields, Robert Donat, and Leslie Howard were extremely popular British stars and successful in Hollywood at some point in their careers. In general, British stars were more associated with particular kinds of roles than with physical characteristics, personality, or notoriety. As in the Hollywood cinema, stars were typecast. For example, Margaret Lockwood was often associated with aggressive, even villainous roles, and Patricia Roc was more likely to appear as an ingenue. Deborah Kerr, tired of her chaste roles in British cinema, claimed to be relieved when she was offered the role of a sexual siren in *From Here to Eternity* (1953).[28] Dirk Bogarde was cast for a long time either in delinquent roles or in light comedy, as in the Doctor series, until *Victim* (1961).

Margaret Rutherford was the quintessential eccentric in such films as *Blithe Spirit* (1945), *The Happiest Days of Your Life* (1950), and *I'm All Right Jack* (1959), while Jack Hawkins was the sturdy, benign military officer in film after film. The combination of Anna Neagle and Michael Wilding in the Herbert Wilcox productions provided audiences entry to upper-class fantasies. Neagle often played aristocratic figures or women who were inherently aristocratic though from humble origins. She was also associated with such historical figures as Nurse Edith Cavell and Florence Nightingale. Wilding was her male lead in musicals, historical films, and the wartime melodrama *Piccadilly Incident* (1946). Michael Redgrave was associated, for the most part, with roles that cast him as a champion of liberal causes often led astray by women, personal compro-

mise, or the lure of fame, as in *The Stars Look Down* (1939), *The Years Between* (1946), and *Fame Is the Spur* (1947). John Mills was first associated with the working-class ingenu and then assigned parts that placed him in the role of a military or civil authority. In the 1950s he was often viewed in the role of unjustly accused or guilt-ridden victim, as in *The Long Memory* (1953).

One of the most popular male stars was Robert Donat, who was frequently cast in romantic roles as knight-errant to the leading lady, as in *Knight Without Armour* (1937).[29] He also played characters with social responsibility, as in *The Citadel* (1938) and *The Winslow Boy* (1948). In the wartime film *Perfect Strangers* (1945) he was cast untypically as a dull and routinized husband who is transformed by the war and by his wife. In such films as *49th Parallel* (1941), *Pimpernel Smith* (1941), and *The First of the Few* (1942) Leslie Howard's image was that of the quintessential Englishman. On the other hand, Laurence Olivier's roles ranged from romantic leads to weighty historical figures and Shakespearean roles. Like Ralph Richardson, Michael Redgrave, and John Gielgud, Olivier is a dual star of theater and cinema.

These actors are evidence of the abiding interconnection in Britain between cinema and theater, which affects the kinds of roles they play and may even account, in part, for their flexibility of roles and longevity. Their theater connections give them a certain legitimacy, in contrast to those stars who are associated exclusively with the cinema. Much more than the Hollywood cinema, British cinema has always maintained a strong link with the theater, not only through its use of actors from the theater but also in its dependence on stage plays.[30] The popular music hall also played a significant role in the formation of British cinema, contributing such stars as Will Hay, Gracie Fields, George Formby, and Arthur Lucan to the cinema of the 1930s and 1940s.[31]

In World War II cinema, actors such as Ralph Richardson, Laurence Olivier, and Leslie Howard, in particular, served as male models of stability, endurance, and courage in a time of crisis.[32] Female actresses of the era, however, did not occupy the same exalted position. In the 1940s, "British film actresses were not at this time produced as 'stars' to anything like the same extent as their American counterparts. There was no star system until the Rank 'charm school', the 'Company of Youth', was set up when Sydney Box joined Rank in 1946; it was closed down in 1949 because 'we couldn't even find another Margaret Lockwood'. Both Phyllis Calvert and Margaret Lockwood, two of Britain's most popular actresses, were uninterested in glamour."[33] According to Sue Aspinall, the image projected by these actresses in appearance and behavior was middle class. In no way, even in the melodramatic Gainsborough roles, could the actresses be said to openly challenge female sexuality any more than

could their Hollywood counterparts, although the roles they played were fraught with sexual conflict. By and large, female roles were restricted to the domestic arena, with the exception of a few war films such as *Millions Like Us* (1943) and *Two Thousand Women* (1944).

The situation changed in the late 1940s and the 1950s with actresses such as Diana Dors[34] and Joan Collins, who were willing to follow the route to Hollywood. Unlike the middle-class images of actresses such as Margaret Lockwood, Anna Neagle, Ann Todd, and Phyllis Calvert, these women were often cast in working-class roles and were willing to project female sexuality onto the screen. Dors's personal life was public, and her screen roles and publicity were fused. The image of male sexuality was also to change and diversify through the postwar stars with such figures as Dirk Bogarde in the 1950s and later Richard Harris, Richard Burton, and Albert Finney. The image of male sexuality projected in the early British sound cinema involved conflicts over identity, particularly concerning issues of competence, assimilation into the proper family and class position, and acceptance of institutional responsibility. While the films reveal underlying tensions in the characters' struggle to conform to social expectations, the overt emphasis is on the viability and necessity of that accommodation. With the exception of his comedies in the 1950s and early 1960s, Bogarde's films often project a rebellion against the traditional expectations of male representation, a rebellion that seems to lie at the heart of the unresolved conflicts concerning class and sexuality, conflicts that had been explored in the 1940s in James Mason's roles with such films as *The Man in Grey* (1943) and *The Seventh Veil* (1945). In the 1950s, Christopher Lee and Peter Cushing introduced new images of male sexuality through the horror films produced by Hammer Films.

As in the Hollywood cinema, British genres were associated with particular studios and producers. An examination of these producers validates the notion that the subjects, styles, and ideological orientation of cinema are not the sole province of the individual author. The producers helped to keep alive perennial conflicts in the British cinema: whether British films should appeal to British audiences or be international in orientation, realistic or melodramatic, lavish or modest. In the 1930s Alexander Korda was a major force in British production as entrepreneur, producer, and director. His London Films company was associated with historical films, films of empire, and comedies aimed at an international market. The films were expensively mounted and starred such actors as Laurence Olivier, Merle Oberon, Vivien Leigh, Charles Laughton, and Flora Robson. Working with his brothers Zoltan and Vincent, Korda sometimes directed and more often produced historical films, light comedies, imperial films, and even science fiction films based on the work of H. G. Wells, whom he admired. The Korda formula for success was, as

Jeffrey Richards says, "patriotism with profit." Comedies such as *The Divorce of Lady X* (1938) were concerned with the domestic foibles of the upper classes. The historical films, such as the extremely popular *The Private Life of Henry VIII* (1933) and the less popular *Catherine the Great* (1934), rely on spectacle and bedroom politics. Imperial films "such as *Sanders of the River* (1935), *The Drum* (1938) and *The Four Feathers* (1939) celebrated the administration and defence of the British Empire."[35] At the end of the 1930s, Korda's ambitious and expensive operations came to an end, and, by the end of World War II, he no longer produced films. His operations were absorbed by J. Arthur Rank, who built up his own, more enduring, cinema empire.[36] Although he began in production in the 1930s, his profits were derived largely from exhibition. Unlike Korda, he had very little experience with the cinema. A religious man, his first venture was into religious films; he later extended his concerns to the making of children's films. He was not highly educated, nor was he an intellectual, but he managed to provide opportunities for many British directors, actors, and technicians. By the early 1940s, Rank owned such major studios as Elstree, Denham, and Pinewood, and was instrumental in sponsoring independent companies such as Two Cities Films and directors such as Michael Powell and Emeric Pressburger, David Lean, and Launder and Gilliat, all of whom formed companies under the Rank aegis.

In 1941 J. Arthur Rank acquired the Gaumont-British Corporation and along with it Gainsborough Pictures, which had been under the supervision of Michael Balcon in the early 1930s. Balcon, a major force in British film production, aligned himself with a philosophy of filmmaking that favored particularly British productions that were modestly produced, as represented by his later direction of Ealing Studios. When Balcon left Gainsborough in 1936, the direction of the studio fell to Edward Black and Maurice Ostrer. Under Black's supervision, primarily, Gainsborough earned a reputation for turning out commercially successful films. Black was also instrumental during the war in turning the tide away from war films toward entertainment.[37] Black and later Sydney Box, who succeeded Ostrer in 1947 as producers, were responsible for the type of films that came to be associated with the Gainsborough signature. Along with Muriel Box as scenario editor and Betty Box as producer, Gainsborough was able to produce films that were successful not only in Britain but internationally. The films depended on a combination of tight budgeting, a repertoire of stars such as Phyllis Calvert, Margaret Lockwood, James Mason, and Stewart Granger, and scripts that were often based on popular novels. The style and point of view of the Gainsborough melodramas are the result of collaboration between producers, directors, scenarists, art directors, and stars.

Directors associated with Gainsborough, such figures as Arthur
Crabtree, Leslie Arliss, Bernard Knowles, and Compton Bennett, cannot
be considered the primary authorial voices in the films. Bennett, for ex-
ample, who directed two of the most interesting Gainsborough films—
The Seventh Veil (1945) and *Daybreak* (1948)—worked closely with the
producers, the art directors, the scriptwriters, and the stars, and the
primary effect of the films must be seen as the product of collaborative
effort. *The Seventh Veil*, starring Ann Todd and James Mason, involves
the Svengali-like relationship between a young woman pianist and her
guardian, the young woman's attempts to rebel against him, and the in-
terventions of psychiatry to resolve the conflict. *Daybreak* is a film noir
with a complicated narrative. Starring Eric Portman and Ann Todd, the
film involves a man with three identities—hangman, barge owner, and
barber—which collide with one another. On finding his wife unfaithful to
him, he frames her lover. Unable to pursue the role of executioner in
relation to the man, he confesses his guilt and commits suicide. Gains-
borough's *Dear Murderer* (1947), another revenge melodrama, directed
by Arthur Crabtree, also stars Portman. The film portrays an obsessively
jealous husband who murders his wife's lover in the "perfect crime,"
only to learn later that she is perennially unfaithful. She finally revenges
herself on him. Arthur Crabtree was also involved in the popular costume
melodramas. His *Madonna of the Seven Moons* (1944) and *Caravan*
(1946) portray characters struggling against the constraints of upper-
class life to seek personal freedom and sexual pleasure. The highly suc-
cessful costume melodramas *The Man in Grey* (1943) and *The Wicked
Lady* (1945) were directed by Leslie Arliss. The coherence of point of
view, however, of these films, is traceable less to these individual directors
than to the overall narrative consistency and "look" of the Gainsborough
films. These films are instances of the studio itself functioning as the filmic
auteur.

Films such as *The Man in Grey, Madonna of the Seven Moons, The
Wicked Lady, Caravan, Hungry Hill* (1947), *Jassy* (1947), and *Blanche
Fury* (1948) are set in remote, exotic, and aristocratic environments. The
melodramas specialize in familial intrigue, and particularly on the desires
and conflicts of women in their attempt to escape the constraining effects
of traditional sex roles. These films come the closest to deserving the ap-
pellation of "woman's film." Moreover, the issue of sexual conflict is
fused with that of social class. One of the women, usually played by Mar-
garet Lockwood, is frequently an interloper ruthlessly pushing her way
up the social ladder at the expense of a more aristocratic female, fre-
quently played by Patricia Roc. The films are addressed to the female
spectator and view events from her perspective.[38] Along with the costume
melodramas, Gainsborough also produced melodramas set in a contem-

porary context, such as *They Were Sisters* (1945) and *Love Story* (1944), with the same stars. As the titles indicate, these women's films focus on relationships among women, romantic fantasies and disillusionments, and familial conflicts. The films, based on popular novels by women writers, were representative of the Gainsborough style, which depended on historical settings, formulaic treatment of character and situation, and a scenario involving sexuality and violence. According to Sue Aspinall, "The formula, which was to be repeated in all of the films of the cycle, seemed to be based on the conflict between two different types of woman. One woman represents the virtues of marriage and duty, the other, unrestrained libido."[39] These films deviate from the conventional images of female service and domesticity conveyed in so many British films. While the films were popular with audiences, the critics found them unrealistic and trite, if not sensational, objections similar to those leveled at Hammer Films a decade later.

The 1940s were the high point of these melodramas. Robert Murphy writes that "as the 40s drew to a close, the British film industry entered into a decline from which it never really recovered. . . . Box and Gainsborough were to be transplanted to Pinewood, but as with Ealing at Boreham Wood Gainsborough enjoyed only a brief half-way life away from its natural environment. As John Davis established his ascendancy over the Rank Organization he instituted a policy of safe, unadventurous conformity, and it was left to the small independent Hammer Company to resurrect that visceral vitality which had characterized the Gainsborough melodramas of the 40s."[40] The waning of Gainsborough melodramas can also be attributed to the growing social constraints in the postwar era concerning governmental and popular attempts to resurrect conventional attitudes toward women, the nuclear family, and sexuality.

The other major studio was Ealing, which since 1929 and under the directorship of Basil Dean had featured the comic talents of such stars as Gracie Fields, Will Hay, and George Formby. In 1938, when Michael Balcon took over as head of production on the eve of war, new directions were instituted that were to make the Ealing films known not only in Britain but internationally. Under Balcon in 1944 an agreement was signed with J. Arthur Rank, whose monopoly in cinema included production, exhibition, and distribution, to provide first 50 percent and later 75 percent of the company's finances and to distribute the films. During the war, Ealing was associated with films that strongly endorsed the war ethos, focusing on themes relating to British national identity. The postwar films, the most profitable and well-known of Ealing productions, especially the comedies, were in harmony with Balcon's conception of British cinema. In characterizing the works of Ealing Studios, critics have identified an ethos emphasizing the idea of community, a reaction against

strong central authority, a humanistic plea for more individual responsibility, and a philosophy of self-help.[41] It is often noted that several of the Ealing filmmakers, such as Alberto Cavalcanti and Harry Watt, had previous documentary experience, and their films are often praised for their fidelity to locale. Whether Ealing's films are of the social problem variety, such as *The Blue Lamp* (1950) or *I Believe in You* (1952), or situated in remote Australia or Africa, as in Watt's *The Overlanders* (1946) and *Where No Vultures Fly* (1951), a recognizable formula emerges. Individuals are confronted with an unfeeling bureaucracy in their altruistic attempts to eradicate a social injustice. They are called upon to form their own alliances and find their own solutions, and they are single-handedly responsible for overcoming the inefficiency or indifference of existing authority. Ealing has been described as a "family" business. Many of the films are preoccupied with the thematics of family and community, and the projected audience seems to be created in that image. In this respect, the films would seem to address Rank's abiding concern for the moral quality of cinema as shown by his emphasis on the production of religious films and films oriented toward children and the family.[42]

The Ealing comedies, popular in Britain, the European continent, and the United States, spanning a twenty-year period of British cinema from the 1940s through the 1950s, and the social problem films of the postwar era project their own sense of the "real." As one critic describes it, "Ealing's concern, seems to dictate that the problems it explores through comedy should be the problems of living in the real world; the network of inhibitions and censorship that it is necessary, or seems necessary to set up and *accept* for people to live contentedly. . . . To show that the real world is worth living in you have to show that an unreal world is not, and you have therefore to resolve the problem of the plot in the comic narrative by restoring the real world."[43] Charles Barr indicates, however, that within the monolith known as Ealing Studios, "the team with a spirit," there was room for variation, exemplified in the works of individual directors.[44]

In a completely different direction, Hammer Films achieved success in the 1950s with movies that are the antithesis of the films described above. Like Ealing, Hammer was a modest operation. Working on a tight budget under the direction of Sir James Carreras, utilizing an ensemble of directors such as Terence Fisher and Val Guest, writers such as Jimmy Sangster, and technicians such as Phil Leakey, Hammer was able to create a distinct style. While Ealing was dependent on the Rank Organization for financing and distribution, Hammer forged alliances with Hollywood companies. Despite similarities in their modes of production, the companies differ dramatically in the type of films produced. As Vincent Porter states, "Balcon wanted to make pictures that brought documentary natu-

ralism to the screen during the war, and, later on, acted as ambassadors of the British people. Carreras, on the other hand, simply wanted to turn out fairy tales—many designed to frighten, to horrify, or to shock." Designed for a mass audience and unashamedly committed to commercial profit, the Hammer films carry on the explorations of sexuality and social nonconformity characteristic of the Gainsborough films.[45]

Hammer movies make no pretense of being social problem films or genteel films that overtly address the "problems of living." Highly stylized, the Hammer texts, like the Gainsborough films (Terence Fisher had worked for Gainsborough), capitalize on classics of horror and science fiction. In their imaginative use of mise-en-scène, in the strength of characterization, exemplified especially by the work of Peter Cushing and Christopher Lee, they play with issues, as David Pirie has noted, that resurrect Gothic narratives with their emphasis on sexuality, aggression, and dominance and submission, their willingness to challenge complacent views of behavior.[46] According to Raymond Durgnat, "Hammer's 'grand series' owed their success to a chemistry of moods: physical atrocity interacting with moral irony + dandy coldness + sensuousness + Victorian nostalgias = Victorian materialism."[47]

The idea of sorting history into decades, into units of time that mark ruptures and transitions, is a mode of history writing common also to cinema history. The problem with periodizing is that it forces the creation of boundaries, stressing differences and hence obfuscating the uneven and subtle nature of continuity and change. In the case of the British cinema, many of the genres and themes of earlier British cinema do not disappear, nor do many of the earlier stars, but what is discernible is different emphases in the treatment of social conflicts and gender representation. For example, the issue of male authority does not disappear but manifests itself in more troubled terms in the films of the late 1940s and 1950s. Issues of empire do not disappear either, but are modulated in the 1950s to account for conflicts and new strategies for confronting unruly subjects desiring independence. Working-class figures and issues appear more regularly after the populist emphasis of the war years, but they are treated ambiguously. Class divisions still remain firmly in place. In the 1930s and 1940s, working-class relations, when presented at all, portray the struggle for success, as in *St. Martin's Lane* (1938), which features the world of the buskers and portrays the protagonist (Vivien Leigh) as rising in society and leaving the street world behind her. Or, as in comedies such as *Sing as We Go* (1934), *Oh, Mr. Porter!* (1937), and *Keep Smiling* (1938), the working class manages to confront adversity, incompetence, and indifference, and smiles or sings. In a social problem film like *The Proud Valley* (1940), there is a sustained emphasis on the tribulations of miners, as there is in *The Stars Look Down* (1939), with an effort to

portray the harshness of that life, but the films utilize a pattern of self-
sacrifice and martyrdom to blunt the edges of the conflict. In *First a Girl*
(1935) a working-class girl, played by Jessie Matthews, resorts to imper-
sonation in order to succeed in the theater, a not uncommon pattern in
her other musicals, and she succeeds and marries upward.

Historical films such as *The Iron Duke* (1934) recover the image of the
ruling class in George Arliss's portrayal of Wellington as military hero
and statesman. Wilcox's *Victoria the Great* (1937) presents an idealized
portrait of female service within a historical context. *Fire over England*
(1937) constructs a heroic image of Elizabeth I and her England. Korda's
The Private Life of Henry VIII (1933) and Paul Czinner's *Catherine the
Great* (1934) offer historical fantasy windows on the world of royalty.
The Private Life of Don Juan (1934), also a Korda film, resurrects the
ubiquitous Don Juan figure of the era, who, of course, is disciplined into
marriage. Korda's *Sanders of the River* (1935), *Elephant Boy* (1937), *The
Drum* (1938), and *The Four Feathers* (1939) capitalize on the greatness
and spectacle of empire, the heroism, intrepidity, and courage of the men
who represent the benign workings of imperial rule. The foibles of the
upper classes are also represented in films such as *The Divorce of Lady X*
(1938) and *Her Last Affaire* (1935), films that come close to belonging to
the "white telephone" genre. The films capitalize on marital or familial
conflicts in a lavish setting and with an emphasis on fashion, spectacle,
and voyeurism. These genre films of the pre–World War II era have been
generally regarded as promoting a conservative (and middle-class) image
of Britain to itself and to the outside world, containing very little that
overtly challenges the status quo. However, this view can be sustained
only if one assumes that films are primarily ideological and not commer-
cial. As Stephen G. Jones says, "For films to be a commercial success they
had to be receptive to working-class tastes and demands."[48] The come-
dian comedies, starring such personalities as Gracie Fields, Will Hay,
George Formby, and Arthur Lucan, as well as many melodramas and
historical films of the 1930s, support the view not only that the popular
cinema aimed at composite audiences but that the films themselves were
not ideologically monolithic.

The war era introduced changes in the treatment of social class, famil-
ial relations, work, and conceptions of national solidarity. The govern-
ment and the industry promoted films that could provide both propa-
ganda and entertainment and could be used to mitigate the harshness of
life—the threat of bombs, the separation of families, the dangers to the
men and women in the services, the shortages of food and other necessi-
ties. The films of the late 1930s and early 1940s address themselves indi-
rectly or directly to the inevitability and the privations of war. A film like
The Young Mr. Pitt (1942), for example, comments in allegorical fashion

on the necessity and rationale for the war, and the farsightedness, sense of service, and competence of British leadership as embodied in the figure of Pitt. The films exhibit an eclecticism in style and content, seeking to reconcile social classes, sexual differences, and even realist techniques with genre formulas.

The war film takes a number of directions in addition to the traditional association of the war film with combat. Films of morale and legitimation were produced throughout the war, focusing on the home front and the front line, domestic and political conflicts, personal and collective struggle, and national and international concerns. Alexander Korda's *The Lion Has Wings* (1939) utilizes the mixed mode of fiction and documentary to dramatize Britain's wartime readiness in its personnel, technology, and morale. Noël Coward's popular *In Which We Serve* (1942) set a pattern of linking the fate of different social classes through the exigency of war. By following three families and intersecting their paths, the film attempts to disperse its narrative concerns, although Captain Kinross, played by Coward himself, is the embodiment of semiregal authority modeled on the maritime exploits of Lord Louis Mountbatten. *The 49th Parallel* (1941), starring Laurence Olivier, Eric Portman, Leslie Howard, Anton Walbrook, and Raymond Massey, is a piece of anti-Nazi propaganda which celebrates British values and links the fate of Britain to that of her colonies. *The Next of Kin* (1942), directed by Thorold Dickinson, a film that ran into difficulty with the censors, constructs the narrative around the revelation of a military secret and the negative consequences resulting from disclosure. Powell and Pressburger's *The Life and Death of Colonel Blimp* (1943), starring Roger Livesey and Deborah Kerr, dramatizes the conflict between the traditional military ethos and the kind of soldier produced by a new kind of warfare. *Millions Like Us* (1943), produced and directed by Frank Launder and Sidney Gilliat, also introduces representatives from different classes, and the dominating figure in the film is not upper-class Anne Crawford but working-class Patricia Roc. The bulk of the film takes place in an aircraft factory. Work and domestic life are integrated through the conflicts and relations experienced by the main characters. Unlike so many of the war films that focus on the heroism and sufferings of men, this film concentrates on the position of women. Leslie Howard's *The Gentle Sex* (1943) also follows the lives of a group of women representing different social classes, attitudes, and values who volunteer for the women's army. *Waterloo Road* (1945), starring Alastair Sim, John Mills, and Joy Shelton, is a film that avoids the trials and tribulations of the middle classes or the celebration of the combined efforts of classes. It focuses on a working-class environment and does not idealize the hardships of the war in the realm of personal relationships, where infidelity, black marketeering, and frustrations over un-

comfortably close living conditions create abundant conflicts. In a more middle-class context, a film that confronts personal changes wrought by the war is *Perfect Strangers* (1945), starring Robert Donat and Deborah Kerr, who play unromantic, timid people, married to each other and buried in routine until they each join the service, he the Navy, she the WRENS. As a consequence of their wartime experiences—the training, the meeting of new people, the confrontation of danger—they are no longer willing to resume their former life when they return to each other. Similarly, *The Years Between* (1946) focuses on the return of a presumed-dead husband (Michael Redgrave) who finds his wife not only engaged to another man but sitting in his seat in Parliament. In their struggle to create a war-affirming ideology, the propaganda films, films of combat, and home front films reveal the impossibility of reconciling the conflicts posed between past and present, tradition and change, genre and realism.

The cinema of the late 1940s and 1950s continued to engage in social issues, but with more of an emphasis on social unrest and a critical look at prevailing social institutions, touching on familial conflicts, women's conflicts with the law, racialism, juvenile delinquency, and prostitution in such films as *Good Time Girl* (1948), *The Blue Lamp* (1950), *I Believe in You* (1952), *Turn the Key Softly* (1953), *The Weak and the Wicked* (1954), *Sapphire* (1959), and *Yield to the Night* (1956). Various types of institutions were investigated—the schools, the courts, social work, marriage, women's prisons, capital punishment—and there was an attempt to reproduce the cadences of regional and working-class dialects. These social problem films, adopting a quasi-documentary format, were filmed on location. The texts tend to place great emphasis on crime, often linking it to the breakdown of the family. The concern for the changing position of women in society can be detected in the greater emphasis on woman lawbreakers as well as in the greater emphasis on the breakdown of male authority. The films convey a sense of disappointment that the war did not substantially alter society, if not a nostalgia for the communal sense of the war effort. They also address issues of political subversion and other cold war concerns about communists, the destructive aspects of science and technology, and the loss of community.

In general, the films of the 1950s, even when they attempt to resolve social unrest, cannot conceal the underlying tensions centering around the precariousness of authority. John Mills's portrayal in *The Long Memory* (1953) of a man trying desperately to preserve his sanity and adjust to the exigencies of middle-class work and social relations is representative of many male portrayals of the time. The paranoia characterizing the cold war is best exemplified in the Boultings' *Seven Days to Noon* (1950) and *High Treason* (1951). Sexual conflict that poisons personal relations, as in Asquith's *The Browning Version* (1951), is also characteristic of many

of the films. The irretrievable loss of a sense of national identity is played out in the postwar films. The politics of consensus and opportunism are the butt of satire in *I'm All Right Jack* (1959) and *Left, Right and Centre* (1959). The demise of traditional forms of entertainment is linked to social unrest in such films as *Meet Mr. Lucifer* (1953) and *Eyewitness* (1956).

Of the postwar decade, Arthur Marwick affirms, "The 'social revolution' had created a tremendous expansion in opportunity to lead the good life; but at the same time some of the problems militating against that life increased in seriousness."[49] For example, nationalization did not do much to increase social equality; "the men at the top remained the same, and the ordinary workman had little sense of 'communal' ownership."[50] Little had altered in British class structure. Society was still characterized by the threefold class division: upper or ruling class, middle class, and working class, although material conditions had vastly improved for the latter. According to John Hill, " 'Butskellism' . . . was the term coined by *The Economist* to register the similarity of economic policy pursued by the Tory and Labour Chancellors and correctly identified the convergence which was beginning to emerge in the political arena. How this occurred can again be related to the question of affluence. For the Tories, the generals of the 'new affluence', their successful adaptation to and management of a mixed economy seemed to prove, without recourse to traditional moral claims of the superiority of the market and private ownership, their superior fitness to run a welfare capitalist system. . . . as put more succinctly by Macmillan himself, 'the class war is over and we have won'. It was a verdict that Labour itself seemed compelled to accept."[51] The films of the 1950s do not endorse this optimism. Rather, they express an uneasiness about the quality of life in both the private and public spheres. Though they may strive to address modes of reconciliation and containment, they are far more eloquent in dramatizing social failures.

The sociological concerns expressed in these films were, in part, related to the rise of sociology as a discipline in the postwar era and to a recognition of the changes wrought by the war, especially the new emphasis on scientific knowledge as a force for social management. The acknowledgment and researching of changes in socialization were part of a larger effort to confront, if not reverse, changes in family structure, women's roles, generational differences, sexual morality, and patterns of social responsibility that had become apparent during the war years and in the immediate postwar era. The social problem films are not a conscious platform for legitimating these concerns, but the issues that the films highlight are similar to the concerns expressed not only in the Wolfenden Report (1957) on homosexuality and prostitution, but in the earlier Beveridge Report (1943) on the family and the status of women, whose terms of

dispensing allowances and grants reinforced traditional notions of the family, child-rearing, and female responsibility. The ostensible intent of legislation was the amelioration of economic and social hardships, but the actual impact of the reports and the legislation that grew from them could be read, in Michel Foucault's terms, as an instance of the modern tendency to discipline and punish in the guise of liberalization through regulating the private sphere.

The genre films of the postwar era, because of their ostensible social concerns, have been equated with realism. For example, Roy Armes states that "*Sapphire* (1959), *Victim* (1961) and *Life for Ruth* (1962) all toyed with real social issues in a way that seemed quite daring for the time."[52] The appearance of *Room at the Top* (1959), *Saturday Night and Sunday Morning* (1960), *The Loneliness of the Long Distance Runner* (1962), and *This Sporting Life* (1963) was regarded by some critics as evidence of British cinema's entering a new, mature phase, described by one critic as the "first step in the British cinema's rebirth and return to reality."[53] The films were lauded for their use of working-class subjects, location settings, and emphasis on everyday life, qualities associated with the Grierson documentary movement. These critical assessments were predicated on the assumptions (1) that realism is an unchanging essential phenomenon, (2) that realism is superior to genre production, (3) that the strengths of British cinema reside in realism, and (4) that films are a "reflection" of life. The narrative of British cinema history, therefore, which relied on these criteria, created a chronology that led from the escapist genre productions of the 1930s, to the reclamation of the cinema by the Grierson documentary movement, to the increasing tendency toward realism manifested in the late 1950s and 1960s.

Traditional histories of the British cinema and of the British documentary movement isolate the work of John Grierson and the other filmmakers associated with the Empire Marketing Board (later the General Post Office Unit, and, during the war, the Crown Film Unit) from other forms of independent and commercial filmmaking.[54] Speaking of the Grierson documentary movement, Don Macpherson states that "it has constantly been represented as somehow 'essentially British' in a way which has paralysed any thought of alternative developments. Drawing on the poetic realism of Flaherty and the concern for working people from contemporary Soviet filmmakers, Grierson forged a state-subsidised propaganda machine under a National Government urging a paternalistic social democratic view of non-conflictive politics under a 'strong' but 'benevolent' state."[55] Relying on a humanist model of art linked to education, the Empire Marketing Board and General Post Office Unit presented an image of British society that was in many ways not so distinct from the images embedded in the commercial films of the time, an idealized picture

of workers who, though experiencing hardship, have the best interests of the present society at heart and are united in a common national purpose. Films such as *Industrial Britain* (1931), *Housing Problems* (1935), *Drifters* (1929), *Song of Ceylon* (1934), *Coalface* (1935), *Night Mail* (1936), and wartime documentaries such as *Fires Were Started* (1942) and *Target for Tonight* (1941) focus on work and workers in peacetime and war. The images are designed to raise the self-respect and dignity of the working man, but, as Stuart Hood indicates, the films "were also open to criticism in that they avoided a number of critical questions about wages and conditions, while making what are in their own way condescending comments on the dignity of labour."[56]

The highly stylized Griersonian films tended to depersonalize the workers, presenting them as poster figures in celebratory poses. The narration focuses on the activity of the workers, their creativity, their contribution to the dynamism of British industrial life. In *Song of Ceylon*, the vision of empire shares with *Sanders of the River* (1935) images of the worthiness, rightness, and productivity of colonialism, leaving unspoken the conflicts generated in the indigenous culture. While the documentary movement presented audiences with an image of British life not usually presented in commercial cinema, the films revealed their strong propagandistic cast, their interest in maintaining the values and attitudes associated with the dominant culture. Moreover, the films garnered attention at the expense of other films to the left—the 1930s *Workers' Newsreels*, *The Peace Film* (1936), *Hell Unltd* (1936), *The Defence of Madrid* (1936), *Peace and Plenty* (1939)—that sought to address domestic and international politics and economics in more militant as well as more experimental fashion and were produced by such groups as Kino and the Film and Photo Workers' League, groups that could not rely on government sponsorship.

The canonizing of the Grierson model was not merely an indication of a predilection for the "real" but the construction of a criterion whereby the real could be measured and secured. Even on the grounds of these films' "reflecting" certain social conditions, it is clear that they create their own sense of reality. These much-praised films can be seen to employ their own formulas, stereotypes, and conventions, which are socially constructed versions of reality and need to be seen as ideologically sensitive, as are their critical evaluations. What we see is another instance in which ideology and aesthetics converge, where, in Walter Benjamin's terms, aesthetics is also politics. An examination of many of the denigrated British prewar genre films—the historical films, films of empire, melodramas, espionage films, and comedies—reveals that they share many ideological positions with the Grierson documentary movement, although they are more oblique in their address of social issues. Many of

the genre films, precisely because of their formulaic nature and their stylization, provide a critique of conditions in a different register. For example, melodrama, "taking its stand in the material world of everyday reality and lived experience, and acknowledging the limitations of the conventions of language and representation . . . proceeds to force into aesthetic presence identity, value and plenitude of meaning."[57]

The dichotomy between genre production and realism, then, needs to be reexamined. Why were the popular Gainsborough melodramas and Hammer horror films slighted for so long? Why, apart from Ealing comedy, has there been so little work on British film comedy? Why has the historical film been ignored? I suggested in my introductory comments that a partial answer to these questions lies in the widespread bias against popular culture. Another answer lies in traditional assumptions about realism, assumptions that have been called into question in the last decades. The most pervasive assumption, that films reflect reality, has been challenged. Films are part of reality, and the genre films shape conceptions of reality and, in certain instances, invoke alternative conceptions. By recognizing the power of representation, it is possible to conceive of altering representations of power. Moreover, in a more specific vein, by shifting our meaning of the real, it is possible to see that genre films from Hitchcock's British thrillers to the postwar social problem film never abandon the "real"; they afford different perspectives on it, since the success of the genre film depends on its creating the illusion of the "real" world. For example, Tom Ryall has commented on "the 'realist' elements in Hitchcock's British films," especially on the "authenticity of the 'everyday locales' and the 'authentic minor characters, maids, policemen, shopkeepers, and commercial travelers populating the films.'"[58] The British genre films from the 1930s through the 1950s, as we shall see in the succeeding chapters, offer their own versions of the "real," in some cases through creating a sense of authenticity of locale, in others through codes that govern the representation of an interior landscape and of fantasy. The chapters that follow explore the changing face of British genre production. I see genre as sensitive to and interacting with changing social conditions and changing audiences, though operating within the same ideological and aesthetic constraints that govern so-called realist texts.

The Historical Film

THE HISTORICAL film is a major British genre. From *The Private Life of Henry VIII* (1933) to *Gandhi* (1982), this genre has been popular and often financially lucrative. It has served to dramatize myths of national identity, monarchy, empire, personal heroism, and consensus. It has also served to call these same myths into question. The genre has not received the same critical attention accorded to other genres, but like other genres, the historical film has a specific identity and employs a number of conventions and codes that define its character. These films take history as their subject, foregrounding it conspicuously and self-consciously, employing it for propaganda, spectacle, or analysis. The conscious attention paid to historicizing, to employing historical personages, subjects, and settings, seems to be central to the development of the sound cinema and identified with popular and often stereotypical attitudes involving class, race, gender, kinship, work, war, and peace. In this respect, the British cinema is not unique in the production of historical films. The historical film is deeply intertwined with myths of the nation that are integral to most national film cultures. The periods selected are usually those moments in the history of the nation that are considered central to the formation of national identity. In the case of British cinema, apart from the war films, the largest number of historical films are set in the Renaissance and the eighteenth and nineteenth centuries. However, producers did not restrict themselves to incidents from British history and the British monarchy but also drew on European subjects with such films as *Catherine the Great* (1934) and *Rembrandt* (1936). The use of actresses such as Flora Robson and Anna Neagle, associated with British heroines, tended to domesticate foreign personalities and appropriate them for national purposes.

In addition to the films that strive to reproduce the ambience of a particular period, there are also costume dramas that use historical characters and context more loosely but strive nonetheless to create a sense of national identity. As a genre, the historical film depends on specific events drawn from national histories and the lives of famous personages, while the costume drama often uses fictional protagonists, and is not so strictly tied to historical events.[1] Moreover, both types of film are often mixed

with other genres such as melodramas, comedies, adventure films, and even musicals. Historical films, according to Jean Gili, are of three types: those that feature the lives of famous individuals, those that tie fictional protagonists to a specific historical context by dramatizing the socialization of the individuals and their assimilation into the collectivity, and those costume dramas that use fictional protagonists in indeterminate historical settings.[2] The objective of the historical film is rarely the accurate and "objective" re-creation of the past. The films' selection of a past moment in time is usually linked to contemporary attitudes or events, implying a critique of the present, a favorable or unfavorable comparison of past and present. The important contribution of these films to factual history is complex. The films are not history in the same sense that one would regard traditional historiography, but they do generate a knowledge of the past that is intimately tied to the ideology of the given moment in which they are produced, an ideology that is an amalgam of meanings related to issues of power, community, and continuity. While they often focus on public figures and on moments of crisis, they also provide an insight into more immediate and private concerns touching the lives of individuals, the nature of everyday existence, and the relationship between the public and private spheres in ways often inaccessible to traditional historical writing. Moreover, through the ways they inscribe their historical subjects, the films also reveal how historical meaning is constructed, even to the extent of exposing their strategies for producing knowledge about the past and its relation to the present.

In the evolution of the cinema, the historical film was associated with the Italian spectacles of the silent era, and with such films as D. W. Griffith's *Birth of a Nation* (1915) and *Intolerance* (1916), Abel Gance's *Napoléon* (1927), and Eisenstein's *October* (1928). In spite of their different styles and differing ideological perspectives, these films are linked by the attempt to make history the protagonist of the film. Whether the history is embodied in the figures of exceptional individuals or in the masses, the films offer history as the motor of the narrative. Whether the characters are offered as the moving force of history or whether they are the instruments through which history is realized, the historical film treats the relationship between real and fictional events. As Hayden White says, "Historiography is an especially good ground on which to consider the nature of narration and narrativity because it is here that our desire for the imaginary, the possible, must contest with the imperatives of the real, the actual."[3] The contestation of the real and the imaginary in the historical film has frequently provided the basis for judgment in favor of the former. The feature films have usually been regarded as travesties of history. The traditional demarcation between fiction and fact has led to the determination that the historical film, like all genre films, functions solely

in the realm of the imaginary, and is, therefore, a distortion of reality. Such a judgment has obscured the ways in which these films in their selection of protagonists, events, use of images, sound, and spectacle function as a form of folklore, and, like folklore, provide a clue to the desires, dreams, and collective fantasies which, rather than providing an escape from history, offer a means for understanding the ways in which social power is both exercised and undermined.

According to Paul Monaco, "Movies function as one element in the broader fantasy life of any collectivity to which they appeal. The collectivity is, in the twentieth century, quintessentially, nationally determined."[4] And the media are the quintessential vehicle through which these fantasies have been propagated. The media have played a dominant role in the development of twentieth-century consciousness. However, the films' ties to history are not direct, even when the films purport to be historicizing. The historical films are no more of a reflection of reality than melodramas and comedies. The key to their meaning lies, rather, in the particular ways in which the films deploy history for ends that are largely inaccessible to direct verification of their links to social events. The crux, therefore, is not to seek a correspondence with factual events but more generally to explore how the films conform to or disrupt popular discourses. In Gramsci's sense of folklore, these discourses are based on narratives that are a collage of truisms, clichés, common sense, and popular wisdom based on the lived experience of individuals and groups confronting exigencies of survival. This shared knowledge is episodic and disjointed, freely combining elements of the past with aspirations for the future.[5] In the attempt to obliterate difference and create a sense of common purpose, folklore and myth, owing to their discontinuous nature, also embed a sense of the incompatibility of their component elements. On the one hand, past knowledge functions as a guide to survival; on the other, it is an ever-present reminder of unresolved conflicts.

In making contact with its audiences, the historical film is unabashed in its appropriation of folklore, and it works unceasingly to make history contemporaneous. History is often invoked as a judgment on present events. The period films work in allegorical fashion to dramatize contemporary reality by making an analogue with the remote past in the interests of continuity, or, conversely, the history may serve as an excuse to be critical where direct discourse may fail. Thus, history may act in subversive fashion to undermine dominant and prevalent attitudes. For example, increasingly in the Italian cinema of the early 1940s, the historical film, which had earlier been associated with developing and celebrating the mythology of fascism, became an instrument for undermining Fascist ideology.[6] In the case of the British biographical films that were produced in the mid-1930s and early 1940s, the thinly veiled allegories were easily

accessible as part of an effort to create a climate in which war was not only inevitable but comprehensible and in which all British citizens had to unite in order to save a beleaguered culture.

In other films, historical context masks more private issues. The "keyhole" view of history associated with Alexander Korda's historical films of the 1930s allows for the play of spectacle and eroticism, much as in the case of the films of Ernst Lubitsch, which, no doubt, exercised an influence on Korda. The private lives of exceptional individuals allow a voyeuristic glimpse into the boudoir without violating decorum and propriety. In the Korda historical films of the 1930s, monarchy plays an important role, but the emphasis is, for the most part, on the private life of the individual, as in *The Private Life of Henry VIII* (1933) and *Catherine the Great* (1934). Jeffrey Richards suggests that the focus on the personal aspects of monarchy "has two effects. It avoids concentration on real issues, social, political, economic, religious problems that might cause controversy, invite censorial intervention or affect profitability. But it also caters for the need ordinary people apparently have to know about the private lives of the famous."[7] These films may not be political in terms of the public issues raised by Richards, but they are political in a more subtle way involving issues of gender and sexual identity. While the films appear to be speaking in a public language, addressing themselves to commonly known events and personages, they seek to translate the conflicts into more immediate personal and often psychological terms that are accessible to the audience. This process accounts, in part, for the charge that the films are distortions of history.

To a greater or lesser degree, the propaganda film is drawn to history for dramatizing the need for continuity and consensus around familiar images and events, as in the case of *Fire over England* (1937), which celebrates the defeat of the Spanish Armada and the greatness of the court of Elizabeth I. The costume dramas, with their blending of history and fiction, often select a particular period of history as a pretext for adventure and intrigue. Such films might gravitate toward foreign settings, as in the case of *The Cardinal* (1936), set during the Italian Renaissance, or *The Scarlet Pimpernel* (1934), set in France during the Revolution of 1789. The historical setting is the medium for spectacle, adventure, and swashbuckling. Though the costume dramas mix fictional and historical personages in a particular period context, and though they may stress adventure and spectacle, they are not free of ideological and political concerns. In the case of *The Scarlet Pimpernel*, the political and social events are used to dramatize specific class and social attitudes that exemplify the British national ethos consonant with the ideological concerns of the 1930s. The costume dramas make no apologies for their deviation from conventional histories, since their concerns are broadly polemic. They

have no need to legitimate their borrowings. Their sense of the era is determined by the particular character of the protagonists and antagonists rather than by concrete events. The costume drama may also use historical setting as a pretext to examine conflicts in the domestic or personal sphere. These films dramatize issues of gender and sexuality, which have no home in a contemporary context. The most successful were produced by Gainsborough Pictures in the 1940s, and will be considered separately in the chapters on melodrama.

In general, the British historical film during the 1930s and 1940s was popular with audiences on both sides of the ocean. Though Hollywood produced three different versions of the life of Lincoln in the 1930s, beginning with Griffith's *Abraham Lincoln* (1930) and ending with John Ford's *Young Mr. Lincoln* (1939), various dramas based on revolutionary history, one of the most popular being *Drums Along the Mohawk* (1939), and the epic costume drama of the Civil War *Gone with the Wind* (1939), many Hollywood historical films involved foreign personages, represented in such films as *Voltaire* (1933), *Queen Christina* (1933), *House of Rothschild* (1934), *Mayerling* (1935), and *The Life of Emile Zola* (1937). British subjects were a particularly popular source for Hollywood films, and the decade saw productions of *Mary of Scotland* (1936), *Clive of India* (1934), *The Great Garrick* (1937), and *The Private Lives of Elizabeth and Essex* (1939). Moreover, many of the actors in these films were British, enlisted from the growing British colony in Hollywood, including George Arliss, Ronald Colman, C. Aubrey Smith, Basil Rathbone, Nigel Bruce, and Anna Lee. If in Hollywood the historical film was the product largely of foreign directors treating European and British history, the British cinema was inclined to draw largely on its own history, with some notable exceptions produced by the Korda studios. The Hollywood films based on British history show how British culture, through the cinema, had made an impact outside of Britain.

The most familiar type of historical film, exemplified by *The Private Life of Henry VIII* (1933), *The Iron Duke* (1934), and *Victoria the Great* (1937), takes the form of a biography in which an important historical personage becomes the mainspring of the action. The structure of these films varies. In some cases, the films assume an organic structure and, beginning with the youth of an individual, portray incidents that feature the protagonist's exceptional qualities, particularly obstacles that stand in the way of the realization of their objectives or gifts. The narratives pose a conflict between "normal" romantic desire and the demands of social and political position. The films select incidents that dramatize the protagonist's successful overcoming of impediments, leading to a period of success. Material success is often presented as problematic and is often transformed into moral victory. In these cases, the chronology of the film

will often carry the character into old age, ending with a deathbed scene and with a memorializing of the central figure. Films that eschew a fidelity to a linear chronology may begin with a particular crisis in the life of the individual and, through flashback, include some material about the protagonist's earlier life.

The emphasis on chronology is inextricable from conceptions of the body. The body comes to signify pleasure and threat, associated with the quest for desire and fulfillment but also with engulfment and death. While the costumes may situate the protagonists in the realm of public power, highlighting their exceptional qualities and their transcendence of temporality, the films do not remain exclusively in the public sphere but alternate, to a greater or lesser degree, between the public and the private. Removed from the formal world of spectacle and situated in a private space, the protagonist becomes human and the viewer can entertain a bond with him or her. The interplay between extraordinariness and ordinariness, power and the momentary divestment of power, the spectacular and the mundane, is thus dependent on materializing the body through a focus on conflicts over gratification and renunciation of desire. This strategy becomes especially evident in the films that feature female monarchs.

The biographical film varies in its choice of stars to play famous personages. In some cases, there is an attempt to cast an individual who bears some similarity to the historical subject. In other instances, a balance is effected between a fidelity to the image of the historical figure as presented through paintings, prints, and written records, the demands of spectacle, and the star's own physical appearance. In other cases, the star determines the role without any regard for historical compromises. As with other genres, certain stars are associated with the biographical film. The Hollywood biographical film came to be associated with George Arliss, Paul Muni, and Henry Fonda, while the British films were particularly associated with Charles Laughton, Robert Donat, Laurence Olivier, and Flora Robson. The films also portray documents, prints, and paintings. Costumes are often reproductions of originals. To enhance the aura of verisimilitude, public events that have been memorialized in paintings and prints may be alluded to by creating a tableau sense of the original event, particularly in those films that seek to emphasize the public nature of the individual's life, especially in the case of political figures. Patriotic films make an attempt to balance the public and private lives of the subject. The private aspect of the biography enhances the public image of the protagonist by stressing the degree of personal sacrifice required of the individual in order to realize the collective good.

In the films that feature artistic subjects—painters, actresses, and musicians—the emphasis is usually on the hardships of creativity, the obstacles placed in the path of the creative artist by uncomprehending patrons

and audiences, the struggle to gain recognition, eventual acceptance, and only rarely the decline into obscurity, as in the case of Korda's production of *Rembrandt* (1936). In the case of musicians, as in *The Great Mr. Handel* (1942), the element of performance is interwoven with the private drama and personal conflicts. Frequently, the life of the artist is presented in terms of the opposition between conformity and nonconformity. In some instances, the subject of the film is denied the gratification of personal relationships as a way of dramatizing the necessity of the sybaritic life demanded of the exceptionally creative person. Moreover, especially in the films produced during World War II, these creative figures come to represent the preeminence of British culture over the barbarism of the enemy.

Religious figures, pioneers in particular professions, and inventors are also popular subjects for historical films. The films use these individuals for a number of purposes. During the period immediately preceding World War II, biographies were directed toward the creation of a milieu that stressed national moral imperatives and a state of preparedness for war. The life of the exemplary individual offered a way of highlighting particular patriotic attitudes and contributions in the area of science and technology. Much less overtly psychological than the films featuring artistic personages, these narratives were geared toward representing the personal sacrifices and exemplary actions of the protagonists in the interests of the public welfare. In the case of most of the biographical films of the interwar period, the point of view presented is primarily one of individualism, in which the protagonist represents a view of agency in history as depending on the existence and actions of these exceptional individuals. Their intelligence, unstinting service, competence, and creativity make their success possible. Moreover, their success is inextricable from socially approved notions of self-discipline, service, and national welfare, though the films may reveal tensions and contradictions between socially sanctioned behavior and personal desire.

In the late 1930s and during the years of World War II, there is a shift in emphasis in the look and ideology of the British historical film. Not only did the acting become less theatrical and more naturalistic, but the emphasis on ordinary people, "the people as stars," became more prominent.[8] The films sought to dramatize collective effort in a more aggressive fashion. While the protagonist was not "the masses as hero" in Eisenstein's sense, the people do play a more prominent role in such films as *Penn of Pennsylvania* (1941), *The Prime Minister* (1941), and *The Young Mr. Pitt* (1942), films produced during World War II when the emphasis was on consensus. Visually, the representation of crowds is foregrounded and in some instances provides a choric commentary on the actions of the protagonist. Moreover, the protagonist's actions are frequently tied to

the interests of ordinary working people. The ideology of the films is a benevolent populism in which the ruling classes are portrayed as interacting with and responsive to the will of the people. Moreover, according to Nigel Mace, "Patriotically making allowances . . . star-struck and impressed by honestly-meant—if somewhat dubious—historical parallels, the reviewers and perhaps the public were induced to accept as entertainment a new cinematic historiography compounded not only of historical subjects but also of the stuff of current history. . . . What is remarkable is that both subjects produced not many but only one tradition of British political and social history in the wartime cinema, which harnessed the dynamic of Whig history to the Tory cause and enshrined true Conservatism in the unrepresentative Churchillian myth of the national past."[9]

In the postwar era and into the 1950s, while there are examples of historical films, and especially films that treat World War II as part of the historical past (see Chapter 4), these films (*The Cruel Sea* [1953], *The Colditz Story* [1955], and *The Dam Busters* [1955]) are more concerned with issues of male identity and power, troubled adjustment, underlying sexual conflict, the breakdown of consensus, the failure of performance, and the tenuousness of the male group. Even where they may seek to resurrect the ethos of war, sacrifice, and heroism, they call into question past historical imperatives. In the case of historical texts that seek to resurrect traditional myths of national identity such as Ealing's *Scott of the Antarctic* (1948) and Wilcox's *The Lady with a Lamp* (1951), the films are more interesting for the ways in which they expose the personal failures of the protagonists and for the disjunctions between individual and collective aspirations. Conspicuously silent on specific political conflicts of the time, lending themselves rather to a mythologized treatment that tends to erase historical specificity, the films are revealing of profound conflicts situated in the present. The nostalgia for the past masks the failure of meaningful relationships in the present, especially those involving the male group. An examination of representations in the historical film from the 1930s to 1960 exposes significant changes in values in a genre that presents itself as immutable and based on enduring attitudes.

THE HISTORICAL FILM IN THE 1930s

The Public and Private Lives of Monarchs and National Heroes

The resurgence of the historical film in most national cinemas after a decline in the 1920s can be traced, in part, to the coming of sound and its potential for enhancing dialogue, music, and historical verisimilitude. Producers and directors ransacked popular genres in an effort to find congenial and profitable texts, and the British cinema was no exception.

In the 1930s, the British film that broke the barriers to the American market was, in fact, a historical film—*The Private Life of Henry VIII* (1933), produced and directed by Alexander Korda. According to Rachael Low, this film "was to prove a milestone not only for London Film Productions but for the British industry itself, for it was so successful not only in Britain but internationally that it inspired new confidence in British production."[10] The film made a handsome profit for Korda and became the progenitor of a host of historical films. Starring Charles Laughton (who won an Oscar for his performance), Merle Oberon, Elsa Lanchester, and Robert Donat, the film completely neglected the public elements in Henry's life, adhering to the promise of the title to give a private view of the monarch. Even in this respect, the film restricts its look into his private life to the sphere of his womanizing as it chronicles the series of wives who pass through his boudoir.

Beginning with his execution of Anne Boleyn and ending with his domestication under Catherine Parr, the film develops a pathetic trajectory of the monarch, who is shown to have had little success in the selection of his wives. The public politics of his marriages is diverted by domestic intrigue as the film emphasizes his victimization at the hands of unfaithful, sickly, uninterested, or shrewish women. At the outset of the film, he is portrayed as a powerful man, while at the end he is shown as aged and browbeaten. The private life formula serves the function of mythologizing monarchs (or any upper-class individual), while it also humanizes them.[11] The film is self-conscious about its voyeuristic orientation. Beginning in the boudoir and returning periodically to punctuate the changes in the wives by the changes in the bed linen, the film invites the spectator into the most private recesses of the monarch's life. The particular issue at stake appears to be the monarch's ability to sustain his relations with the women in his life. The private life is here, as in *The Private Life of Don Juan* (1934), confined to the issue of his sexuality. In a sense, this type of historical film shares a place with the Italian white telephone films of the 1930s, which sought to penetrate the elegant boudoirs of the rich with their satin sheets, white telephones, and sexual intrigues. In the bedroom scenes, the execution scenes, the scenes of romantic intrigue between Thomas Culpepper and Catherine Howard, and the feast scenes, the film makes a point of calling attention to the courtiers and servants who are positioned as spectators to the personal vicissitudes of the monarch.

Spectatorship becomes the dominant strategy for implicating the audience in the narratives concerning the lives of the great. The role of the crowd is to observe, although the film makes a distinction between the undifferentiated masses who observe the outdoor scene of Anne Boleyn's execution and the more discriminate observers within the palace, personal servants who are portrayed as deeply identified with the fate of their

exceptional masters and function as censors, closing the bedroom doors, for example, on too intimate an inspection of the boudoir. The gossip concerning the affairs of the king is a matter for courtier and servant alike. But the servants, such as the cook and the barber, serve as bawdy comic commentary on the affairs of the household, providing a link between commoner and illustrious personage and emphasizing the audience's distance from and yet proximity to the protagonists. While this film emphasizes splendor, the settings are not the major means for creating spectacle. Spare in furniture and accoutrements, with the exception of the bed and feast tables, the sense of splendor in the film comes from another source—the painted scenery, the costumes, and the hairdos. In particular, the film modestly includes entertainment, feasts, and sports as a way of identifying the pastimes and rhythms of life of royalty.

In the character of Henry, Laughton's extremely stylized performance creates sufficient distance from the historical figure to maintain the sense of his difference from ordinary mortals, while another aspect of his performance hinges on his falling into a childlike and naive persona that creates a disjunction between the representations of public and private life. In general, Laughton's performance calls attention to the film as a masquerade. Both he and the women appear to be self-consciously playing at being historical figures, giving the masquerade a more interesting dimension than the mere re-creation of historical figures. The keyhole type of historical film, which depends on the aestheticizing of historical figures and events, is accomplished through the film's exploiting elements of eroticism—but not in a mode that is commonly regarded as sensual in the portrayal of male and female relations. Eroticism in this film is a matter of the eye, and it focuses on the female figures as seen through the leering eye of the monarch, who may desire but may never really consummate that desire. Thus he is shown in his "private life" not as a sexual profligate but, on the contrary, as "always the victim of feminine wiles, the universal male dupe, the eternal henpecked husband writ large."[12]

In this type of biographical film, history is a story of sexuality but, more particularly, of unfulfilled desire. The great figures of the past join league with the humble audience in sharing the elusiveness of desire. Class differences appear to be leveled through the focus on sexual difference. The film links females to nature through sex, birth, and death and establishes that their power is great enough to reduce the power of a king. By portraying the private life of the king, the film grants women power in the domestic sphere, power great enough to finally reduce even a king to impotence. The private life formula yields a portrait of a man struggling to maintain his potency and succumbing to the tyrannical rule of women. The portrait of the monarch is not a celebration of the public exploits of the king, and the film certainly does not seem to be concerned with patri-

otism and the greatness of the nation. By focusing on his vulnerability, the film humanizes the monarch, making monarchy more accessible. Moreover, Laughton's irreverent treatment of Henry also allows for a laugh at the expense of the monarch, thus avoiding the sentimentality that often accompanies portraits of the rich and famous. In contrast to Wilcox's *Victoria the Great* (1937), Korda's film, Laughton's performance in particular, undercuts and subverts the high seriousness and rhetoric often associated with many historical films. The Korda film affirms that history can be presented in terms of immediacy and proximity for the contemporary spectator through its blending of the remote and exotic with the familiar and mundane.

Korda's production of *Catherine the Great* (1934), directed by Paul Czinner and starring Elisabeth Bergner, Flora Robson, and Douglas Fairbanks, Jr., a lavish spectacle in the vein of other Korda costume dramas, also uses history to develop a behind-the-scenes view of the court intrigues prior to the rise of Catherine. The trajectory of the film is guided by sexual politics. Peter is a misogynist, and the film portrays his conflicts with his aunt, the czarina, and his wife, Catherine. Catherine is shown evolving into the figure of a queen, but her desire for love is finally subordinated to her queenly responsibilities. She begins as a naive young woman and undergoes a transformation during the course of the film. Vainly seeking to adjust to her conjugal role, she learns that there is little that she can do to pacify the rage and insecurity of her mad husband (Douglas Fairbanks, Jr.), the future czar, who finally must be eliminated against her wishes. The largest share of the narrative revolves around her struggle to be a fit mate to him, and the drama in the film is generated out of her personal humiliation at his hands. In contrast to the Empress Elizabeth of Russia (Flora Robson), who is presented as morally and sexually unscrupulous, Catherine's emergence as a queen is associated with strict morality and with the renunciation of sexuality. The private life formula serves in the final analysis to dramatize the incompatibility for women of personal desire and power. For their complicity with power, the women are disciplined through personal deprivation. Catherine's transformation into the "little mother" is portrayed in the final scenes as a bitter submission to the will of the people. Rather than totally submerging the female monarch in her public role, the final images of Catherine, constrained in her role, surrounded by her courtiers, reinforces a tension in the film between desire and duty.

More than the other Korda spectacles, this film seems most geared toward developing the characters of its female protagonists. Flora Robson as the queen mother is totally mistrustful of men, using them as mere lovers or imperiously ordering them to obey her wishes. While Elizabeth articulates her sense of the relations between men and women as compet-

itive, political, and antagonistic, Catherine seeks to overcome antagonism in the name of love and appeasement. Peter accuses her of wanting power, and the narrative does not invalidate his accusation, although it portrays her use of power in conciliatory rather than conflictual terms. The motivation for the conflict between him and the czarina is ambiguous, appearing to stem from his mistrust of women, his mental imbalance, and his specific rebellion against a female ruler's authority. Catherine, on the other hand, uses more subtle ploys to win him over and placate him, which only increases his resentment toward her.

As Catherine, Bergner appears at first quite naive and childlike, inclined toward romanticism and fantasies about love and marriage. After marriage, she attempts to fulfill the role of wife and also that of royal consort in the face of public humiliation. Her costumes are subdued, and her appearance in regimental uniform and her gestures tend to be boyish rather than seductive. Her behavior, more than that of other women in the film, is filled with contradictions. She wants power but also wants love; she recognizes that she is abused but seeks to pacify the abuser; she wants to be a wife but becomes instead the agent of her husband's destruction. These contradictions are "resolved" in her transformation from individual woman to symbol. As the conspirators tell her, she is their ruler, not Peter, and when she emerges as the czarina at Peter's expense, she identifies herself thus: "I am a woman like your mother and sisters. It is a bad wife who leaves her husband because he has been cruel, but it is a good mother who will fight everyone to save her children. You are my children. I come to you as the mother of all Russia. And I will fight for you as you will fight for me, and I will bring you victory." She rages at her advisors like an angry mother when she discovers that her orders have been disobeyed in Peter's assassination. Reading the film backward, one can trace the inevitability of Catherine's emergence as the mother of Russia. All the clues are in place. She does not describe herself as attractive to men and has doubts about her "femininity." These doubts are confirmed in her marital failure. Female power is redefined in terms of motherhood and the negation of sexuality. In the final analysis, the film reaffirms patriotism and duty, the subordination of personal desire to the public weal. In contrast to *The Private Life of Henry VIII*, in this film, private life becomes public.

Also in contrast to the private life formula, Korda applied yet another, more overtly patriotic and public, model in *Fire over England* (1937). By the late 1930s, the historical film in both the United States and England was deployed for more blatantly propagandistic purposes as the possibility of war became imminent. Directed by William K. Howard, produced by Erich Pommer, a German emigré from the Nazis, and starring Flora Robson as Queen Elizabeth, the film is of the swashbuckling

variety, using history to generate a sense of intrigue, adventure, and spec-
tacle in the interests of patriotism. The public and political issues are in-
termingled with the romantic, making the film more akin to the films of
empire (see Chapter 3). The film's uses of history have more of a propa-
gandistic and patriotic ring than the previous films, evoking parallels be-
tween the threat of the Spanish Armada under Philip I and the threat of
Nazi aggression.

The court is portrayed as dominated by the awesome figure of Queen
Elizabeth, who is, in the words of the film, England personified. In her
public encounters with the Spanish ambassador and with her courtiers,
she exemplifies restraint and diplomacy. Her courtiers, Leicester (Leslie
Banks) and Michael Ingolby (Laurence Olivier) are totally devoted to her,
and she in turn rewards them handsomely for their service. In her rela-
tions with the elderly Burleigh, she reveals herself as capable of compas-
sion and tenderness, while with her younger serving women she is a ty-
rant. The public figure and the private woman are shown to be in conflict
with one another. In the privacy of her chamber, Elizabeth rails against
her aging and resents the presence of younger women who remind her of
this. As in the other Korda films, generational differences play an impor-
tant role in the film. The mirror scene in which Elizabeth scans her aging
face serves to personalize the figure of the queen, distinguishing between
her private and public roles. In this film, the public figure triumphs over
the private one, the symbol over the female, although the private images
are never fully eclipsed. The images of the aging monarch in her boudoir
are a reminder of "the constructed nature of symbolic power. . . . Repro-
ductive chance dramatically demonstrates to monarchical subjects the
connection between their fates and the biological body of their rulers."[13]
That the monarch is a female, and an aging female, underscores this con-
nection between the ruler's body and mortality.

The film is divided between scenes in Spain and in England, involving
attempts to thwart the Spanish Armada. Michael loses his father on a
mission to Spain when they are beset by the Spanish. Their ship is burned
and the elder Ingolby turned over to the Inquisition. The son is spared
through the assistance of a Spanish nobleman, Don Miguel. Michael is
wounded and nursed back to health by Don Miguel and his daughter,
Elena. When Michael learns that his father has been burned at the stake,
he repudiates his rescuers and returns to England. Impersonating Sir
Henry Vane, a spy who is apprehended by Leicester, Michael returns to
Spain and successfully outsmarts King Philip, avoids exposure and cap-
ture, acquires the names of members of a conspiracy against Elizabeth,
and returns to England. The queen spares the conspirators in a scene
designed to portray her magnanimity. Coming before them unarmed, she
challenges the traitors to kill her, but the men refuse. They are given a

chance to redeem themselves by fighting against the Spaniards. After the defeat of the Armada, Elizabeth joins with her subjects in a prayer of thanksgiving for their victory in a scene that endows nationalism with religious significance and anticipates the film's final victory celebration.

Elizabeth's dominating figure overshadows the other women in the film, and the issue of romance takes second place to the public concern over the Armada. The conflict between duty and desire is focused in the figure of Elizabeth, although the other characters are not exempt from this conflict. Characteristic of the historical films' dependence on polarization, the film is structured around a series of oppositions—foreigner and Englishman, Spanish and English monarchs, and youth and old age. Philip is cloistered and obsessive in his desire to conquer England. By contrast, Elizabeth is in close contact with her subjects and is generous in her public life though obsessive in her personal affairs. In spite of her courtiers' urgings, she refuses to plunder the Spanish ships as they have plundered English ships. She is the consummate representative of British society imbued with justice, magnanimity, compassion, wisdom, and discipline. However, the Spaniards are not portrayed in excessively villainous terms. The sardonic and joyless figure of Philip, the allusions to the Inquisition and to the obstruction of British shipping, and the battle scenes constitute the extent of the film's description of the "enemy." Primarily through the images of Elizabeth, the film identifies the nature of the threats confronting England and demonstrates its ability to surmount national dangers.

The film enlists spectacle to generate patriotism. The sets of the palace, the battle scenes aboard the ships, the burning of the Armada, the throne room scenes, and the processionals highlighting the majesty of the queen invoke the myth of British power and greatness. The figure of Elizabeth serves to create a sense of history as spectacle. Unlike Laughton's portrait of Henry VIII, Robson's Elizabeth re-creates the splendor of monarchy, the queen as an exceptional figure who becomes more rather than less mystical by also being an aging, petulant woman. Her petulance and vanity work for rather than against her power, since she is portrayed as sacrificing (like Korda's Rembrandt) worldly vanity to a higher cause. Her gestures, her movements, her physiognomy, reinforced by her elaborate and stiff costumes and her dramatic makeup, call attention to the notion of monarchy as theater. In Walter Benjamin's sense, history is aestheticized, rendered as art rather than politics, and the queen herself is the consummate figure of artfulness. The implied analogy between past and present political events is easily lost in the fascination with the exotic re-creation of Elizabethan splendor and the figures of the court and Elizabeth in particular.

Korda was not the only director-producer to undertake a historical film that features monarchy. *Tudor Rose* (1936), directed by Robert Ste-

venson and made at Gainsborough, turned again to earlier British history for its subject matter and again to the figure of a queen. Starring Nova Pilbeam as Lady Jane Grey, the film covers the intrigues that set the young queen on the throne of England for nine days (10–19 July 1553) and her subsequent execution (1554). The film begins with a death scene. As Henry VIII lies dying, his courtiers, particularly Edward and Thomas Seymour (Felix Aylmer and Leslie Perrins) and the earl of Warwick (Sir Cedric Hardwicke), are already intriguing over a successor. Henry designates his son as his heir and places a curse on the man who betrays him. Warwick is willing to allow the Seymours to gain the upper hand on the assumption that they will ultimately fail and he will have his chance for power. Edward VI thus becomes the next king of England and Edward Seymour makes himself the regent. With the connivance of Warwick, Thomas and his brother fall out. Thomas convinces Lady Jane Grey's parents to allow her to come to London. Ambitious for her daughter, Jane's mother (Martita Hunt) permits her to go with Thomas, although her father (Miles Malleson) is less sanguine about the move. Both Seymours end on the block, and Warwick moves ahead with his plans. He marries Lady Jane Grey to his son, Dudley (John Mills), and when the young king dies, he has Lady Jane declared as Queen, thus violating the express deathbed wishes of Henry VIII. The forces of Mary Tudor (Gwen Ffrancon-Davies) succeed in defeating Warwick in battle, and Jane and her husband are executed.

The events in the film follow inexorably from the deathbed scene and the curse of the dying monarch. One after another, the claimants to power are eliminated. Lady Jane is a victim in the struggle for power. She is used by the illegitimate forces of power who would defy sanctioned authority and succession. Villainy is associated primarily with the abuse of the young and with the violation of familial bonds: Edward Seymour uses his position as regent to manipulate the young Edward and to destroy his brother. Thomas Dudley uses Jane as a pawn in the struggle against his brother. Warwick's machinations involve the Seymours, his own son, and Lady Jane.

Unlike the Korda films, *Tudor Rose* remains outside the boudoir, choosing rather to emphasize political conspiracy and the struggle for power. The world portrayed in the film is one in which men prey on each other, youth is sacrificed to the ambition of older men, and the public good must triumph over personal self-interest. The portrayal of the two young monarchs stresses their immaturity. Edward plays at being king but is more interested in weapons as toys. The film absolves Jane of ambition, portraying her as a naive girl who, like Edward, has no sense of nor interest in the workings of power. The most poignant scenes in the film involve the increasing entrapment of the young woman, whose life and death exemplify the tragic consequences of violating the will of the dying

king. Social disorder in the form of familial and public rebellion is the
consequence for not adhering to authority and the law of primogeniture.

The film is organized episodically around the various "acts" leading to
the execution of the couple. The film begins and ends with death scenes.
The episodes are developed by a series of contrasts between youth and
age, country and city, personal desire and duty, and, above all, legitimacy
and illegitimacy. History is invoked for the purpose of reaffirming the
status quo, for denigrating attempts to upset the established order. The
notion of the effectiveness of the king's curse creates a sense of history as
operating through supernatural forces. Human agency counts for little.
The film offers a negative image of human behavior in its dichotomizing
the unscrupulous power-seekers and their innocent victims. The image of
human frailty exemplified through the protagonist lends even more credi-
bility to the appeal to legitimacy in order to constrain personal ambition
and desire.

In the late 1930s, the historical films of director-producer Herbert
Wilcox, starring his wife, Anna Neagle, were to vie with the ambitious
Korda spectacles. Wilcox made *Victoria the Great* (1937) at Denham,
Korda's studio, under a company called Imperator Films. Covering the
years of the queen's accession to the death of Prince Albert, the film con-
centrates largely on the domestic side of the queen's life. The perform-
ances are highly mannered and the film attempts visually and aurally to
convey an impression of pomp and high seriousness. The narrative selects
episodes in the monarch's life beginning with the death of the reigning
king and Victoria's coronation. The second episode begins with the plan-
ning of her marriage. Prince Albert is selected as her consort and the film
develops the courtship from a relationship of antagonism to one of ro-
mance, ending with their honeymoon. The next episode concerns her set-
tling into the affairs of state and her refusal to involve Albert in her work.
Albert's illness and death marks the next phase of the drama, and the final
sequence portrays Victoria bereft of Albert, mourning and withdrawn
but eventually returning to her role as public figure.

Punctuating different segments of the film are various public events
and rituals, including Victoria's coronation, marriage, public appear-
ances, review of her guards, and balls, the crowds outside Buckingham
Palace, her review of the peers from various parts of the empire, and the
Diamond Jubilee. The film does not convey the "naughtiness" and voy-
eurism characteristic of the Korda films. In keeping with the myth of Vic-
torianism it portrays, the life of the queen is portrayed in elevated and
decorous terms. One can hardly compare this version of the queen's per-
sonal life to other historical films that offer a glimpse into the private lives
of royalty. The ritualistic treatment of *Victoria* lends itself to making the
queen an object of reverence for the internal and external audience.

The historical events portrayed include the Peterboro Riots, the Repeal of the Corn Laws, and near war with the United States. After some resistance, Victoria is shown as involving the prince consort in affairs of state, and their point of view is portrayed as deep concern for the sufferings of the poor and the desire for peace with other countries. The monarchy is celebrated for its liberalizing tendencies, its sense of duty and responsibility toward its subjects, its extension of the boundaries of Britain to include the empire, and its sense of progress, of keeping up with the times, as epitomized in the images of the steam engine as well as the emphasis on photography. Through the allusions to photography, the film calls attention to itself as the recorder of events, commenting on its virtuosity in the shift from black and white to Technicolor in the Jubilee sequences.

Anna Neagle's mannered acting is designed to elevate and create a decorous distance from the regal figure rather than make her familiar. Neagle's role in this film is not different from her roles in later Wilcox films. The actress looks and behaves according to preconceptions and myths of 1930s female gentility. Her demeanor, not unlike that of the other British female stars of the era, such as Deborah Kerr and Phyllis Calvert, is restrained. Her status is defined by rather stiff body movements, a walk that is measured, giving her the impression of gliding, and gestures and looks that are imperious. Her expensive costumes are fashionable but decorous, unlike the sexually provocative costumes of the 1940s Gainsborough melodramas. Her image is matronly. The images of her aging enhance her maternal status and humanize the more threatening aspects of her powerful position. The men in the films are dwarfed by her presence. As actress and as character, she monopolizes the screen.

Films about Victoria were well received by audiences and served the purpose of enhancing the prestige of a monarchy that had been threatened by the Prince of Wales's relationship with the divorcée Mrs. Wallis Simpson, and finally his forced abdication in 1937 when he insisted on marrying her. Up until the abdication crisis, the monarchy had enjoyed unlimited prestige. With the coronation of George VI, the crisis was over and the monarchy was again secure in popular regard. Wilcox's films were certainly instrumental in the restoration of confidence in the royal family. The success of *Victoria* led to another film of the monarch, *Sixty Glorious Years* (1938), also starring Anna Neagle and directed by Wilcox under the Imperator company. With this second film, the company was given access to the royal palace and grounds. This film is a historical pageant selecting public events during the queen's reign and, while interweaving personal episodes, largely concentrates on these public aspects.

Both films on Victoria have an affinity with such films of empire as *Sanders of the River* (1935), *The Drum* (1938), and *The Four Feathers* (1939) in creating a sense of the power and correctness of British institu-

tions and of British foreign and domestic policies. In the two Wilcox films, the queen is the symbol of an age that bears her name, but there are intended parallels with the present, addressing the importance and benevolence of the monarchy and identifying it with an England that is capable of responding to any contingency, a country that is powerful but not acquisitive. The film's sense of history is, like other Wilcox vehicles, nationalistic and pro-monarchical. Invoking the figure of Victoria is intended to reinforce the sense of continuity and tradition invested in the monarchy characteristic of historical films of the 1930s. However, while these films may seem unabashedly patriotic, they are not merely rhetorical platforms. Through spectacle, they address viewers, particularly female viewers when the protagonist is female, with a vision of "the absolute power of monarchy" and hence of female power: "Although the romance with a courtier often figures in the action, the fascination for women would have to do with the court intrigue, the wild adventure, the fabulous wealth, and the unchallenged position these monarchs would have enjoyed, often represented in such fictional accounts as the fame and adoration of their people."[14]

National heroes are a perennial subject of fascination in the historical film, and Saville's *The Iron Duke* (1934) dramatizes political and military intrigue during the Napoleonic era. Selective in its treatment of Wellington, the film focuses on one year in his life, the year of his defeat of Napoleon. More than seeking to create an accurate sense of Wellington's life and times, the film is preoccupied with creating a sense of patriotism and spectacle.[15] The famous ball scene on the eve of Napoleon's defeat is one of the most elaborate in the film, and the Waterloo settings are distinguished by tableau effects and superimpositions of Wellington, though the scenes of combat themselves are truncated and conventionally shot. In the vein of other historical films of the time, *The Iron Duke* also depends on the prestige and iconography of its star, George Arliss, to assure historical credibility. Arliss was associated with both Hollywood and British historical films, having appeared in *Voltaire* (1933) and *The House of Rothschild* (1934).

The film begins with the Congress of Vienna and news of Napoleon's escape from Elba. Wellington's character is revealed to be above factionalism, and his comment on the monarchs at the congress is, "Every king for himself and the devil take the hindmost." He incurs the enmity of Louis XVIII's niece (Gladys Cooper). A friend of the duchess of Richmond, Wellington encourages the duchess, despite the Napoleonic threat, to hold a ball. His strategy is to play a waiting game with Napoleon. At the duchess's house, he meets Lady Frances Webster (Lesley Wareing), who is entranced with him. She later becomes a pawn in attempts to undermine him. After the crucial battle, Wellington returns to

his headquarters to learn how many of his men he has lost, commenting wearily that "except for defeat there's nothing more tragic than victory." His dialogue is characterized by a frequent use of aphorisms. For example, learning that he cannot go home but must remain in Europe as a statesman and negotiate the terms of peace, he laments, "If only it were as easy to make peace as to make war."

While in Paris, he sees Frances again. Louis's niece decides that she can discredit Wellington through Frances. By scheming with a newspaper reporter, Bates (Emlyn Williams), she sees to it that a scandalous story about Wellington and Frances is published. The duke tells Frances to return to England, where his understanding wife (Ellaline Terriss) takes her in. When Wellington arrives home, he makes peace with the young woman's jealous and irate husband. Again Wellington returns to Paris, hoping to save the life of Marshal Ney, who is threatened with execution along with other supporters of Napoleon. However, Wellington arrives too late to save Ney's life. Angrily, he confronts Louis and his unscrupulous niece and warns them that if they are not careful they will share the fate of Louis XVI and Marie Antoinette, reminding them that the times when people were treated as serfs are over. He wins his case before Louis, who agrees to democratic concessions. Wellington has one more hurdle to overcome before he can retire as he claims he wishes to do—he must appear before the House of Lords to answer charges against him. In a tableau scene set in the House of Lords, he asserts that England has reaped the rewards of his work. He claims that Britain has gained little materially in proportion to the sacrifices she has made, but the reward for him and for England lies in the attainment of the purpose for which England fought "the peace of Europe and the salvation of the world from exampled tyranny." He leaves the House and joins his family in the carriage as the crowd cheers.

The Iron Duke is distinguished by its emphasis on peace. Wellington as the exemplary Englishman is portrayed more as diplomat than as warrior. In contrast to the militancy of The Young Mr. Pitt (1942), The Iron Duke stresses the importance of diplomacy and negotiations. The film also conveys a populist motif, a concern for an alteration of absolutist methods. The French represent the obstacle to more democratic rule, while Wellington (and the images of the crowds in the film) conveys the need to alter traditional autocratic methods. The film also verbally stresses an international perspective, although it looks as if the British are the only ones—through the figure of Wellington—that seek the freedom of Europe. Among Wellington's virtues, the film portrays his marital fidelity: he is a family man rather than a womanizer, even though temptations are placed in his path. The relationship between Wellington and Lady Frances lends credibility to the protagonist's charm and his fascination

for women. However, his relationships are never intimate but always presented before an audience. Even his interactions with Lady Frances are, for the most part, open to the eyes and ears of others. Wellington's domestic relations are presented through set tableaux of family life and not in terms of any significant interactions between husband and wife.

The Iron Duke is a morality play in which the English are the dominant players. If the film seeks to draw parallels between the past and present, the closest parallels seem to be the fear of the recurrence of tyranny and the need for international unity. The film's insistence on treating the French fairly and not saddling them with punitive measures implies a parallel with the treatment of Germany after World War I and its demoralizing effects on German society.[16] The emphasis on the conference table and on the need to curb the French autocratic figures constitutes a plea for a diplomacy that would avert the possibility of war in the present. The film seems unusual for the time in making an idealistic plea for the countries of Europe to put aside differences, national enmities, and ambitions in the interests of peace. In contrast to the films featuring monarchs as protagonists, which play with the relationship between the public and private spheres, *The Iron Duke* subordinates romance, counting on fascination with the figure of Wellington and the element of intrigue to snare its audiences.

Portraits of Artists and Composers

Some historical films were vehicles for musical stars. The sound cinema of the 1930s offered opportunities for singers and musicians to star in biographical and opera films and in musicals. The Italian director Carmine Gallone did an epic biography of Giuseppe Verdi. Alfred Hitchcock was also involved in this form of the biographical film, and his *Waltzes from Vienna* (1934), made for Gaumont-British, takes Johann Strauss, Jr., as its subject. The film concerns one period of the composer's life, his struggle for recognition, and history becomes relevant only as a way of establishing Strauss's identity and claim to success. The dominant conflict is between fathers and their offspring. Strauss's father has no confidence in his son's claims to being a composer. Schani (Esmond Knight) also has difficulty in his romance with Resi (Jessie Matthews), the pastry cook's daughter. Her father is insistent on the need to carry on the tradition of the business from generation to generation and has no patience with the young musician. Triangulation also complicates the plot as the younger Johann becomes involved with the countess, Helga (Fay Compton), who wants to be his patron and incurs the jealousy and wrath of Resi. The plot is further complicated by the jealousy of the count. Like a Viennese operetta, the film intermingles disguises, intrigues, domestic conflict, lovers' quarrels and reconciliations, and forbidding parental figures. All of the

characters, including the young composer, are presented as pretentious and manipulative for their own ends.

The dominant strategy in the film, one that seems to identify it with Hitchcock, is its emphasis on looking. The opening of the film calls attention to spectatorship as the crowd is filmed watching outside the burning bakery and attention is focused on Resi and Strauss in the upper part of the building, oblivious to the confusion below. The countess becomes a voyeur as she observes Resi and Johann singing. Resi in turn is presented as spying on the countess and Johann. The count spies on his wife. The maids in their house spy on both of them, and the camera spies on the characters in compromising positions. The element of performance associated with the young Strauss is accompanied by many shots of the internal audience. Characters are not only caught as they spy on others but also caught eavesdropping. The dressing and undressing of the females in Madame's dressmaking establishment and Resi's exposure to the public minus her gown add to the risqué elements of the film, further enlisting the gaze of the spectators. Like other historical films, *Waltzes from Vienna* also plays with the peccadilloes of the upper classes, stressing their infidelity and promiscuity, and the historical setting enhances the sense of voyeurism, the peep show into the past and into the private lives of the nobility. The most notable flight of fancy other than the painted sets and the costumes is a musical number in which the "Blue Danube" waltz accompanies baking in the pastry kitchen.

Paul L. Stein, a German emigré to England, made *Blossom Time* (1934), starring the opera singer Richard Tauber as Franz Schubert. According to Rachael Low, "The film was a major event for the company [BIP], costing far more than its other films, with crowd scenes and some large and decorative baroque sets. . . . The film was carried by its distinguished star, and was considered both artistic and box-office."[17] Low's comments can be validated by examining other musical biographies of the time. For example, the talents of Beniamino Gigli at the height of his opera career were enlisted for Carmine Gallone's biographical film *Giuseppe Verdi* (1938), and the stars were more often the drawing cards for the films than the historical subjects.

Blossom Time begins with Rudi, Count Hohenberg (Carl Esmond), preparing for a ball. Rudi cannot dance, and as a member of the archduchess's regiment, not to be able to dance is a mark of failure, since the archduchess (Athene Seyler) supports the regiment in order to have young men to dance with. At the home of the dancing-master where Rudi goes to improve his style, he meets and falls in love with Vicki (Jane Baxter). Franz Schubert, who plays the piano for the dancing-master, is also in love with Vicki, and he secretly buys her a dress she desires. Losing the note that Franz has written to her, she thinks that the dress is a gift from

Rudi. Unaware of Vicki's love for Rudi, Franz goes to ask her father for Vicki's hand but is told that she must marry upward. He tells the father that he too will be important and begins to demonstrate ambition by writing new songs and arranging for a concert. At the last minute, the singer loses his voice and Franz sings, to great acclaim. He finally proposes to Vicki, but she tells him that she loves Rudi, who will have to resign from his regiment if he marries her. Franz puts aside his romantic ambitions and assists the beleaguered couple. After Vicki and Franz are arrested for making fun of the archduchess in order to gain her attention, they are given an audience with her. Having herself suffered unrequited love for a man below her in station, the archduchess allows Rudi to remain in the regiment after marriage.

The film makes no attempt to conjure up a historically precise sense of an era. The costumes and the scenery are designed to produce a sense of spectacle through the ballroom scenes, the concerts, and the interior of the archduchess's palace. The romance between the dancing-master's daughter and the prince is the stuff of operetta. The film plays loosely with the biography of the composer, making him an intermediary in the romance between Vicki and Rudi. Unrequited love becomes the basis for Schubert's creativity and his desire for success. He appears more as a kindly father than a romantic figure. His character and, by extension, his music become the means of reconciling the romantic conflict. His love for Vicki is presented as selfless—if he cannot have Vicki, he can see to it that she has what she wants. The image of the artist here resembles many other artistic portraits of the 1930s in which the artist is presented as a desexualized incarnation of creativity (rather like Lauritz Melchior in the Hollywood films of the 1940s). Moreover, as in the Hitchcock film, creativity and unrequited love are related, and the artist, like the film, becomes the intermediary for struggling lovers. By desexualizing the artist and pitting him against the aristocratic and dashing Rudi, the film pits two conceptions of male identity and two types of male-female relationships. Vicki's choice of Rudi over Schubert thus privileges heterosexual sexuality, leaving ambiguous the sexual identity of the composer.

Musicians were not the only subjects for biographical films focusing on artists. Painters were of some, though lesser, interest, and Charles Laughton was to play yet another historical figure in the Korda biography of the Dutch painter Rembrandt. After the success of *Henry VIII*, Korda sought another vehicle for Laughton. For a while he entertained the idea of a *Cyrano de Bergerac*, but, having always wanted to do a film about Rembrandt, he settled on the life of the painter. Of Laughton's performing style, Low says, "A powerful personality, his obesity limited the parts he could play and he had many mannerisms—the mutter, the

jerkily averted head, the side-squinting eye, the closed mouth in the pudgy face as the audience waits and waits for the words to come. Korda was one of the only producers in the British film industry of sufficient stature to build stars and control images, and in this film he secured a performance of great dignity as the ageing genius from his temperamental and difficult star."[18] Low's comments can be read as a commentary on the interrelationship between producer and star in the genre film, and especially in the "biopic," which is heavily dependent on the personality of the actor to create the role of the historical figure.

Directed by Korda and also starring Elsa Lanchester and Gertrude Lawrence, *Rembrandt* (1936) followed a slightly different trajectory from that of *The Private Life of Henry VIII*. The film does not develop the organic biographical mode of progressing from youth to old age, if not death. Rather, it selects those events that are illustrative of the painter's last years, focusing on the issues of aging and failure, motifs characteristic also of *The Private Life of Henry VIII* and *The Private Life of Don Juan* (1934). The film is framed by the death of two women: his wife, Henrikje, and his mistress, Geertke. The death of his wife is the prologue to the chronicle of his adversities—the turn in his artistic fortunes when his patrons reject his departure from the style of painting his subjects in a position favorable to their status and his involvement with his housekeeper, Geertke (Gertrude Lawrence), who is presented as tormenting him for having abandoned his successful way of life. The motif of money is central to the film. As the introductory titles announce, "No millionaire is worth the money the work of Rembrandt would realise if offered for sale." Rembrandt's greatness is measured monetarily. The suffering of his later years is also measured monetarily (in the absence of money), but the ironic contrast is set up between the value of his work and the suffering of his later life. *Rembrandt* invokes the myth of the struggling artist as a pretext for exploring the issue of disintegrating male identity, a motif central to many of Korda's films. The film sets up oppositions between success and failure, youth and old age, and the coda of the film, the allusion to the struggles of the aging biblical heroes Saul and David, and the proverbial wisdom of *Ecclesiastes*, is in the vein of biological determinism. Rembrandt is portrayed as being undone by the death of the woman who is his talisman and by his own aging. Like a morality play, the film comments on the vanity of human wishes at the same time that it plays with the figure of the great man, invoking history as the ultimate judge of success or failure.

Rembrandt's failure is mystified in the romantic ideology of the suffering and misunderstood artist, but its actual source is linked to women and to aging and loss of power. In the final sequences, when he is invited to

join a party celebrating a student's success, Rembrandt becomes exemplary of an individual who negates the fruits of success associated with youth and sensuality. But in its adoption of Rembrandt as its subject, the film uses his position as a historical figure to affirm what he negates: the efficacy of his efforts, which can be measured in his fame and the monetary value of his work. The film utilizes images from his paintings to reinforce its historicity. The settings by Vincent Korda also seek to evoke the effect of Dutch painting of the period, and the costuming, as in the other Korda historical films, also serves to invoke a general sense of the period as well as the look of Rembrandt's paintings. As in his other historical films, Korda was working with a formula that was to be the signature of his own work: the biographical text that becomes a pretext for conflicts concerning male identity, the use of female figures who mark the stages of the protagonist's defeat, the use of history to distance the audience from a facile identification with the protagonists in order to maintain their exceptionality, and the introduction of biological inevitability to create appropriate points of connection between spectator and historical character. In the repeated use of certain stars, Korda also created a sense of expectation from film to film.

In the biographical film, and especially in those featuring artists, the texts call attention to their constructed nature in their reflexive references to the other arts—in *The Private Life of Henry VIII*, singing, in *The Private Life of Don Juan*, writing, and in *Rembrandt*, painting. There is no concerted effort to foreground "real" events, although the films often adhere loosely to familiar and dramatic moments in the protagonist's life. Rather, the films create their own fictions, especially as these involve recreations of the personal histories of the artists in the context of popular images of struggle, failure and success, and romance. The history of the times is marked by the trajectory of the artist's development. The self-enclosed, highly patterned nature of the films directs the contemporary viewer's attention to those aspects that seem to conform to the "private" world of fantasy and sentiment. The idea of self-representation is best expressed in the final scene of the film when Rembrandt paints his portrait while looking at his mirror image. The spectator of these historical films is asked to stand in the wings of the theater of history and observe the construction and dissolution of the image, much as Rembrandt confronts his own image.

In general, the historical films are not populist in mediating class differences, and, in their treatment of gender difference, distinctions are drawn between the public and the domestic sphere, between male and female domains, although the historical film, more than domestic drama, allows for the foregrounding of women in more public roles. When contrasted

with the films that treat male subjects, it is obvious that sexual difference is evident in the ways that *Catherine the Great, Fire over England,* and *Victoria the Great* seek to domesticate the protagonists through the deployment of maternal symbols.

WORLD WAR II AND THE BIOGRAPHICAL FILM

Religious Figures

In the 1940s, the historical film was enlisted in the war effort as an instrument of propaganda and of escapism. Along with the highly popular Gainsborough costume melodramas, a series of biographical films was made that sought to combine entertainment and subtle political instruction. Like the Italian cinema of the Fascist era, but in more modest numbers, British filmmakers used prominent historical figures in allegorical fashion to celebrate Britain's cultural achievements, to stress the contrast between democracy and fascism, and to provide models of individuals who succeeded in overcoming political and social adversity. Unlike the historical films and costume dramas of the 1930s, these films consistently have more pointed political, if not propagandistic, objectives. The playfulness of the Korda spectaculars gives way to a more serious, more blatantly public and patriotic treatment of their subjects. Such films as *Penn of Pennsylvania* (1941), *The Great Mr. Handel* (1942), *The Prime Minister* (1941) and *The Young Mr. Pitt* (1942) in varying degrees dramatize internal political conflict among dissenting factions that need to be harmonized, stress the overcoming of differences in the interests of unity, and portray the sacrifices of the protagonists as they choose the difficult path of adhering to principles at personal expense.

Penn of Pennsylvania, directed by Lance Comfort and produced by British National Pictures, focuses on the trials of William Penn as he seeks to adhere to a religious philosophy that is abhorrent to the upper classes. Consonant with many of the films of the war era, this film seeks to broaden its class emphasis and to stress the democratic nature of British society, its protection of the rights of dissidents and its concern for the underprivileged. The film sets up a contrast between the licentious British court and the puritanical zeal of one of the founders of Quakerism. The king is portrayed as a womanizer surrounded by unscrupulous and opportunistic men. Penn (Clifford Evans) is portrayed as a man who has dedicated his life and fortune to converting others to the path of brotherly love. He seeks refuge in the house of William Pennington, where he meets and converts Gugliema (Deborah Kerr) to the inner light while at the same time chastising the cavalier attitude of the men who surround her.

Penn is portrayed as a reincarnation of Jesus seeking in mendicant fashion to arouse others to the religious and political necessity of freedom of speech.

The nature of his opposition to the upper classes is best dramatized when he is arrested for preaching seditious ideas and brought before the court, denied the right to defend himself, and deprived the right to be judged by a jury of his peers. The judge tries unsuccessfully to coerce the jury to produce a verdict of guilty, but the jury refuses to be intimidated and is also incarcerated. Through the agency of the king, Penn and the jury are freed from Newgate, and Penn is free to marry Guli. After harassment by antagonists to their cause, Penn decides to go to America to create a settlement where, he says, "freedom of thought and liberty of conscience would be the birthright of every man, and laws would be just because they look to the life of Christ." Penn goes to Charles II to collect a debt that the monarch owed his father, but Penn does not want money; he wants land in America. The king, portrayed more sympathetically than his courtiers and servants of the law, agrees to the settlement. Penn leaves England without Gugliema, promising to come for her when the way is clearer. In America, he is portrayed as winning the affection and respect of the Indians and of working to create his city of Philadelphia, the City of Brotherly Love. When he returns to England, he finds his wife seriously ill and he almost succumbs to his feelings of sorrow when she dies, but his men convince him that he must carry on with his work in America. The remainder of the film portrays his return to America and provides a montage of his past accomplishments. The final sequence shows him as an old man, reading his correspondence with his wife. He reads the following: "In essentials unity, in non-essentials liberty. In all things charity. Out of our unity will come the greater unity of Europe and the world."

The figure of Penn is offered as the example of the freedom-loving Englishman, and the film is primarily a plea for tolerance and unity against the enemies of justice. The film suggests a parallel with Penn's enemies and the Germans, who are portrayed as having no respect for law, especially for the democratic jury system and for the right to practice one's religion without harassment. The choice of Penn as the protagonist also introduces the alliance between America and England characteristic of other war films such as those by Powell and Pressburger. America is seen in complimentary terms as the realization of Penn's religious and political dreams and as an ally in the struggle against the enemies of freedom. The film reiterates scenes that suggest a parallel between the opponents of religious toleration and fascism. It also seeks to develop the idea of overcoming differences in the interests of unity. The film plays down the aspect of war, since the Quakers are advocates of nonviolence, and stresses

notions of martyrdom and conversion as the keys to developing peace and cooperation. The only scenes of aggression are those aimed at Penn, the oppressed Quakers, and the Indians. The film is insistent on the need for sacrifice and martyrdom to defeat the opponents of democracy. However, Penn is portrayed as capable of confronting and defeating his enemies through force as well as through spiritual means. The religious and internationalist theme predominates over the nationalist one. Penn, a totally committed teacher, preacher, and leader, never abandons his public mission, not even for his wife. The position of the female is also idealized. Gugliema's role is transformed into one of exemplary service. She is presented as stoic in the face of her own suffering and fused to her husband's values and beliefs. Even her death seems instrumental as a strategy to heighten Penn's sufferings. Gugliema's illness and demise reinforce the image of Penn's loneliness and sacrifice. He must carry on his great work alone, without the solace provided by his wife. In this film, the individual is subordinated to history. Penn is presented as an instrument of history in establishing the imperatives of freedom and tolerance against the forces of injustice.

Pastor Hall (1940), using contemporary events, pits the Nazis against the religious figure of Pastor Hall, loosely modeled after the German pastor Martin Niemoeller, who in the 1930s repudiated the Nazis after initially supporting them. The conflict is between religion and politics, Christianity and nazism. The introduction to the film raises the question of authenticity and the uses of history: "The story of the individuals in Europe during the last decade has shown how much more potent is truth when compared to fiction. *Pastor Hall* is based on authentic verified facts. To the day when it may be shown in Germany. . . ." The printed title conveys several problems that the film will try to solve. The major one is the conflict between truth and fiction. The film purports to verify the facts. By implication, the enemy is the purveyor of fiction. Because the events of the film take place a decade earlier, the film allows the spectator knowledge superior to that of the characters. For example, the SS attack on the SA and the murder of the SA men is known to the audience by the reference to Roehm, though the mother does not have any sense of what will happen to her son.

At the outset, the narrative sets up the young people as incipient victims of the Nazis but as blinded to the essence of nazism. The older people are cautious but disbelieving, and Hall himself will have to learn about the brutality of the Nazis. The rhythm of the narrative changes dramatically with the entry of Storm Trooper, Gerte (Marius Goring), who has come to clean up the town, to get rid of Communists, Socialists, Jews, and enemies of the state. The pastor (Wilfrid Lawson) continues to deliver sermons that are critical of Nazi ideology, and he is warned by Gerte to

curb his criticism. Hall says he cannot be silent. The film begins to accumulate incidents that are damning to the Nazis. A mother receives the ashes of her son, shot as a traitor during the SS conflict with the SA. A young woman returns from a labor camp, pregnant, disillusioned, and ashamed. Unable to bear her shame, she commits suicide. Finally, Hall is arrested and taken to a prison camp, where he watches others tortured and is himself subjected to physical brutality. With the help of Heinrich Degan (Bernard Miles), an SS officer who remembers the pastor with affection, he is taken out of the camp. Gerte comes to the house to get Hall, and Hall's friend, General Grotjahn (Sir Seymour Hicks), resists him. He wants Hall to escape, but the pastor, bathed in the light of the streaming sun, decides to lecture to his congregation. The last sequence of the film shows him reading from Saint Paul "to put on the whole armor of God . . . to stand against the devils." He speaks of his voice as "a sword to fight against evil things." As the Nazis close in, he ends his sermon and walks toward them, passing members of his congregation who continue to sing a hymn as he goes to his death.

The film's propaganda derives its power from the way it escalates the scenes involving Nazi violation of basic institutions, conventions, and myths in Western culture—respect for the elderly, responsibility of parents for their children, protection of the helpless, toleration for differing religious and political practices, female chastity, the link between marriage and sexual reproduction, and, as in the case of Hall, freedom of speech. In line with the desired propaganda campaigns of 1941, the film emphasizes Nazi atrocities in the community and in the concentration camps and starkly differentiates the Nazis from their victims. In its structure, *Pastor Hall* is modeled on a "structure of apprenticeship" in which "the typical individual moves from ignorance to knowledge and from passivity to action."[19] This biographical narrative develops a case against adversaries by accumulating grievances which enlighten the protagonist about the nature of his adversaries. As he witnesses the atrocities, Hall attempts to use his position as pastor to halt the abuses, but this is insufficient to produce a resolution. The words of Saint Paul, the practices of the religious life, the accumulated weight of tradition behind the Christian act of martyrdom itself, are dramatized as superior weapons in the struggle against the Nazis, which, as represented in the prophetic figure of the pastor, will ultimately defeat the enemy as enemies of Christianity have been defeated in the past.

Political Biographies

The year 1941 was a vintage year for biographical pictures, witnessing the appearance also of Thorold Dickinson's *The Prime Minister*, a film focusing on the career of Disraeli. John Gielgud plays the role of Disraeli and Diana Wynyard, who had appeared in Dickinson's *Gaslight* (1940),

was cast as Mary Anne, Disraeli's love and his wife. The narrative seeks to interweave the private life of the protagonist with his public life, and the film strives to make the history of the Victorian period consonant with contemporary events. Beginning with an image of Disraeli as a novelist, a man-about-town, and a darling of the female sex, the film portrays his conversion into a statesman. His successes are traced to the efforts of women. Mary Anne urges him to assume his real identity as a man of action and run for Parliament. Between the counsel of Mary Anne and that of Queen Victoria (Fay Compton), Disraeli abandons his pedantry and affectations and garners the respect of the men who had earlier laughed at him as he gave his maiden speech in Parliament. The next segment of the film portrays his rise to power, until by 1868 he was, to quote the film, "the undisputed leader" when Gladstone joined the Liberals. Disraeli's political position is differentiated from Gladstone's in his greater concern for the poor, and his emphasis on the dangerous alliance of Russia, Austria, and Germany and the need for Britain to strengthen its weakened army and navy. His role in acquiring the Suez as a naval base is also emphasized. At the height of his power and popularity, Mary Anne dies, and he decides to resign, but Victoria now assumes Mary Anne's encouraging role. She tells him that Bismarck is a threat and that she needs a man with his maturity to guide her. Germany is marching against France, and Russia is on the move in the Balkans.

A montage of shots of maps, globes, and newspaper headlines dramatizes European areas of conflict, and Disraeli is shown to resist appeasement offers suggested by Gladstone. He says that he "knows these dictators who are always in a hurry and without humility in their hearts." The only way to deal with them, he says, is by force. His particular concern is to mobilize and support countries like Turkey in an effort to counteract the power of the alliance and hence curb their aggrandizement. Disraeli prevails and the film ends with the vindication of his policies. Knighted by Victoria and cheered by the crowds, Disraeli is portrayed at the end of the film as having overcome all of the obstacles that earlier had stood in the way of his political career—his pompousness, his marginality in the political establishment, the loss of his wife's support with her death, and powerful opposition to his domestic and foreign policies. Disraeli emerges in the film as a national hero and a surrogate figure for Churchill. The speeches on appeasement and the references to the threat of Germany, Austria, and Russia and the need for preparedness indicate that the film is seeking to make parallels between the past and the present. The plea for the integrity of Turkey links the earlier fate of Turkey to the present fate of the European countries overrun by the Nazis.

The film was not a major success.[20] Following the conventional movements of the biographical film, *The Prime Minister* selects dramatic and melodramatic moments in the subject's life, involving his personal rela-

tionships and public position. In the realm of the domestic sphere, Dickinson selects only those aspects of Disraeli's relationship with Mary Anne that are conducive to dramatizing the transformation of the private man into the public figure. Her actions are motivated solely by her desire to advance his career, and the illness that leads to her death is portrayed merely through intercuts with Disraeli's public performances. More is implied than actually said in Disraeli's early portrait as a fop. Women become the means for him to realize his public role. His tenuous relationship to other men is mitigated by the advice and encouragement given him by the two women. His political conversion also serves to enhance the image of Disraeli as a leader who is vilified and who has to fight to gain the recognition he deserves. Although his Jewishness is not mentioned, it is a structuring absence, given not only the reality of anti-Semitism in British culture but also the existence of rabid anti-Semitism among the Fascists.

Despite Dickinson's antipathy to the film, *The Prime Minister* is one of the more interesting historical films in its treatment of power and politics. Disraeli is shown as evolving into a position of power, stages of his success marked by conflict and resistance. This suggests a split between Disraeli's private predilections and his public person, which redeems his portrait from excessive piety and pomposity, but this disjunction is not developed.[21] Rather, the film addresses Disraeli's public struggles for liberal reform, in contrast to his opponents, who represent conservatism and, more particularly, appeasement. Like other historical films of the era, the film is an allegory. The parallels between Disraeli and Churchill and Gladstone and Chamberlain dramatize major political differences at the heart of contemporary British society involving the war and necessary changes in the social structure, particularly greater participation of the working class in politics.[22]

Like *The Prime Minister*, *The Young Mr. Pitt* (1942), directed by Carol Reed, also seeks to use history in admonitory fashion to draw parallels between past and present. The film was an ambitious war production and took twenty-three weeks to shoot. The expenditure of time and money was rewarded, for the film was a critical and financial success. The figure of William Pitt the younger, as played by Robert Donat, is, unlike Disraeli, an unchanging character. If the previous historical films can be described as utilizing the structure of apprenticeship whereby the protagonist is converted from passivity to action, this film adopts the structure of confrontation, in which the actions of an unchanging protagonist are meant to be exemplary of the community's struggles to overcome adversaries. The film adopts the biological pattern of following the protagonist from childhood to advanced age and death. In the scene with his father early in the film, the audience is shown the positive paternal influence on the young boy, and the father's words echo throughout the film.

Of Pitt's portrait, Frank Launder, who worked on the script with Sidney Gilliat, had this to say: "The battles that Sidney and I fought with Carol Reed, Robert Donat, and Ted Black were in the main aimed by us at showing the human imperfections of William Pitt, and giving Charles James Fox a place in the sun. We lost all along the line. Pitt became a paragon of virtue, which he certainly was not, and the part of Fox, by far the more interesting character, was whittled down to give more footage to the heroic Pitt."[23] Gilliat also describes the difficulties with Ted Black, the producer, who had strange notions of historical accuracy. In the titles, Pitt's speeches are claimed to be authentic, though they were actually written by Black as well as Launder and Gilliat. Moreover, Viscount Castlerosse, who was hired by the studio to "ensure historical accuracy," recounted clubroom anecdotes that were not usable. The point is, however, that timeliness in the development of parallels between past and present, not historical accuracy, took precedence.

The film concentrates first on Pitt's efforts at domestic reform and then on his foreign policy. His major opponent is Charles James Fox (Robert Morley), a cynical and opportunistic politician who refuses to join Pitt in his movement for reform. Fox is portrayed as a party man who controls a clique of the establishment, whereas Pitt, with the aid of Wilberforce (John Mills), is presented as a man of the people, getting his support from the "common man." The thin, ascetic-looking Donat is pitted against the corpulent figure of Fox. As in many films of the war years, there is a serious effort to portray the closeness of the people to their leaders, and also the closeness of the British to their allies. Pitt's father sets the tone when he delivers a pro-American speech in Parliament. In contrast, Pitt's maiden speech in Parliament is a debacle as the men mock him and obstruct him from speaking. His opponents are cast as old and grotesque figures.

The other major antagonist in the film is Napoleon (Herbert Lom). The narrative develops Pitt's rise to power and influence with the rise of Napoleon. The intrigues of French diplomats such as Talleyrand are designed to parallel Hitler's machinations with the British. Talleyrand's speeches echo Nazi rhetoric as he offers England the opportunity to share the domination of the world with France. Pitt is put in the position of appearing as a warmonger as he warns against France's territorial ambitions, whereas Fox minimizes the French danger. At first Pitt is successful in gaining the confidence of the people as his warnings about France appear to be justified, but then the people begin to tire of the war and Pitt loses his popularity. He retreats from politics, and those who favor appeasement of France assume power. He returns when it is clear that war is inevitable and that the country needs a more militant leadership. Pitt is shown as sacrificing everything, his personal life with Eleanor Eden (Phyllis Calvert), his private finances, and finally his health, in his total dedica-

tion to his country. Unstinting, he undertakes the struggle against the French. In spite of opposition against his choice of Nelson as admiral of the navy, Pitt's judgment is vindicated by the Battle of Trafalgar. The film is organized around a number of oppositions—youth and old age, autocracy and populism, public duty and personal sacrifice, tyranny and democracy. King George III is presented in benevolent terms, shown to be consistently supportive of Pitt, if somewhat bumbling. This benevolent and very human portrayal was meant, no doubt, to contrast him with the rigid figures of Talleyrand and Napoleon, and, by implication, the European leaders of nazism.

Consonant with many of the other war films, both combat and home front films, the film strives for a documentary effect—both in its use of voice-over throughout the film, identifying, commenting on, and judging events, and especially in the montage scenes, which dramatize the changing face of Britain with an emphasis on new finances, a new navy, and new machinery with which to fight the war. The historical parallels are developed through the central characters and more explicitly through speeches, in which the language echoes 1940s British as well as Nazi rhetoric. Past history is sacrificed to present history, and the image of Pitt is tailored to suit the present need for images of leadership that could mobilize public sentiment as well as offer counterimages to the Nazi leadership. Pitt's alcoholism and homosexuality are downplayed, though not entirely eradicated. Buffeted by the whims of other politicians, by the perfidiousness of the enemy, and by the fickleness of the people, Pitt, as portrayed by Donat, is understanding, self-sacrificing, generous, and forgiving, an example of all that is best in the character of the English. In contrast to the figure of Disraeli in *The Prime Minister*, Pitt is turned into a monument to the ideal British character, a parable for the times.

Propaganda and High Culture

Classical composers, even German composers, could provide patriotic material and testimony to the superiority of British culture. *The Great Mr. Handel* (1942), directed by Norman Walker, uses the German-born composer to play with the motif of a German who becomes an Englishman, and a better Englishman than most. The idea of using a German as the protagonist may seem incongruous given the state of hostilities, but it enhances the film's propagandistic direction by stressing Handel's loyalty to his adopted home in spite of personal adversity. For some of the audience, the film might have served, too, as a reminder of the historical connections between Germany and England as represented by the royal family. The Technicolor film does not cover the span of Handel's (Wilfrid Lawson) life, but chooses the period of his life when he is out of favor with the court. The film is a parable of strength in the face of adversity,

presenting an image of the great man who cannot be made to conform to the whims of the mediocre. Handel's great enemy is the prince of Wales himself, who does not like Handel or his operas. The audience begins to drift away from Handel's operas, and what performances there are are disrupted by rowdies who have been hired by the prince. But not everyone has lost faith in the composer. The singer, Mrs. Cibber (Elizabeth Allan), the impresario, Heidegger (Morris Harvey), and his servant, Phineas (Hay Petrie), are devoted to him. Handel, burdened by creditors, displays a philanthropic spirit when he saves the two sons of a fellow musician, dead of starvation. His religious sentiments become more evident as he falls into adversity. The turning point of the film comes when he is asked by Jennens (A. E. Matthews) to do the score for *The Messiah,* "a work dealing with the promise and coming of our Lord." He becomes obsessed with finishing the work and will neither eat nor sleep, despite the urgings of Phineas, and the remainder of the film is devoted to his writing intercut with tableau scenes from the Bible along with music from *The Messiah*, ending with lyrics that apply to the portrait of the composer: "He was despised and rejected. A man of sorrows and acquainted with grief." The film ends with the "Hallelujah Chorus" at a royal performance as the king rises, and with the title, "Seest a just man diligent in his business. He shall stand before kings."

Handel as the exemplary figure of the diligent man who overcomes all kinds of disasters seems particularly appropriate for a 1942 film, for it highlights the notion prevalent at the time of keeping going and of the need for a religious vision as a means of sustenance. The film portrays Handel as a difficult man, although his harshness is portrayed as springing from his exceptional nature, his dedication to his art. His is an idealized portrait of a great artist not tainted by commerce, and his greatness comes to be associated with a religious vision that is associated with personal deprivation and hard work. The character of the composer appears to change in the film. At the time of his writing *The Messiah*, he appears to undergo a religious conversion. The film isolates the protagonist from his detractors and from society and laboriously dramatizes each phase of the composition of his famous music. The tableaux become visual and aural correlatives of the creative process as well as of his deepening religious ecstasy. Religion and creativity are thus identified as constitutive of national identity. Moreover, Handel is presented as a man of the people, identified with the masses rather than with the court.

The acting and the uses of performance are operatic. The film makes no pretense to realism but uses the historical settings as a way of augmenting the moral and spiritual tone of the film. The notion of performance and audience is integral to the film. People, especially servants, stop on the street to listen to the singing that comes from Handel's house, others sing

as they walk along the streets, and at the finale the internal audience and composer are united. As box office revenues indicated, *The Great Mr. Handel* was not a financial success. The poor response to the film may have been due to several factors—its openly didactic nature, its struggle to find a language to communicate both religious and creative experience, and the highly stylized mode of acting required to convey the historical and spiritual perspective.

The historical plays of Shakespeare on film were to prove more popular. Laurence Olivier's production of Shakespeare's *Henry V* (1945) was a success in both Britain and the United States. Olivier was to put Shakespeare on film again in 1948 with *Hamlet* and then with *Richard III* in 1955. In the case of the latter films, the political and historical dimensions are subordinated to Olivier's attempts to offer a more subjective treatment of the protagonists. In *Henry V*, however, history, spectacle, and propaganda predominate. Moreover, the uses of history in the film operate on two levels: politically and culturally. Not only does the film strive to make parallels between the rise to power of the young monarch and his victory over the French at Agincourt and the contemporary wartime situation, but the use of the Shakespearean text provides another historical dimension. The theater of the past is transformed into the cinema and offered to the mass audience. Through its being set in the Globe Theater as a framing device, the film is self-conscious about bringing the Elizabethan theater and Shakespearean production to a contemporary audience, thus signifying the cultural heritage of the past. The film's success was due no doubt to its attempt to popularize Shakespeare, to make relevant the events of the past for a contemporary context, its sumptuous settings and costumes, its star-studded cast, and its mingling of romance and battle scenes. The film as epic spectacle offered an alternative to audiences becoming weary of war films.

POST–WORLD WAR II BIOGRAPHIES

Poets, Explorers, and Public Servants

The biographical film was not exhausted in the postwar cinema, which saw the resurrection of British historical figures, more Olivier productions of Shakespeare on film, and remakes of costume dramas. Gainsborough also produced straightforward historical dramas in the postwar era, although they were not as successful as the earlier costume melodramas. According to Robin Cross, "entertainment values took a back seat to historical truth and the results were incredibly dull."[24] David Macdonald, who had directed one of the more popular melodramas, *The Brothers* (1947), also directed *The Bad Lord Byron* (1949), a film that

focuses on the escapades of the famous poet. Using the format of a trial to recount the affairs of Byron, the film invites the audience to judge the character of its subjects. The film begins in Greece with Byron (Dennis Price), who is involved in the Greek struggle for independence. Byron is dying, but he gets news from England commending his leadership and informing him that people have raised a substantial subscription for the Greek campaign. The film then dissolves to a courtroom where the poet's reputation is on trial. His relations with women is the specific area under investigation.

Lady Caroline Lamb (Joan Greenwood) testifies to his character, asserting that he was a monster as a husband, and the film selects episodes to dramatize their incompatibility. The conflict concerns her desire to reform him and his refusal to be reformed. But Augusta Leigh (Linden Travers) is called to the stand, and her testimony is an attempt to explain Byron's behavior. She defends the poet by saying, "It's no good to keep a needle in a cage, to expect a poet to behave like other men." Byron's friend John Hobhouse (Raymond Lovell) is also called to the stand, and he addresses Byron's reputation as a poet as well as the poet's relationship to Teresa Giuccioli (Mai Zetterling). The film flashes back to Byron's success on the publication of *Childe Harold* and then to his life in Venice with the countess. Their relationship is presented as consonant with the nonconformist character of the poet. Their romance is intense but brief. She appears on the witness stand to speak on his behalf, recounting their love affair, Byron's political involvements during the risorgimento, and the couple's final parting as he went off to fight for Greek independence. The final sequences return to the courtroom. The judge, formerly shrouded in darkness, is revealed to be Byron.

The episodic structuring of the film, which moves from courtroom to flashback, from inviting the spectator to be a voyeur to inviting him to be a juror, are awkwardly juxtaposed. According to one critic at the time, "The opening sequences of the film jump tediously from one thing to another, and the sudden contrasts of austere courtroom with elaborate Regency settings, though they are well photographed, are disconcerting in the extreme. The various testimonies are disconnected, and often it takes a moment to place them chronologically. The film's real weakness, however, is that Dennis Price is not convincing as Byron; he does not show the fascination that would make his supposed power over women credible. . . ."[25] Moreover, the lavish sets serve to dwarf the characters, and the total effect of the film is an undermining of the usual complexity of relationships in costume melodramas and especially of the female point of view. If in films such as *The Man in Grey* (1943) and *The Wicked Lady* (1945) the texts function to both undermine and recover patriarchal prerogatives, *The Bad Lord Byron* attempts only to recover them. Character,

dialogue, and setting portray a world of glittering aristocracy, class privilege, and individualism. While verbally questioning these values, the film reinforces them through spectacle. The portrayal of women (visually likened to wild animals) ranges from the hysterical and shrewish to the romantic image of Countess Giuccoli, who is the reincarnation of the ideal woman. These portrayals make women unreliable witnesses in the judgment of the romantic poet and freedom fighter. The portrayal of the Greeks and the Italians suffers from the familiar filmic stereotyping of foreigners.

The sexual exploits of Lord Byron as played by Dennis Price are not shown; thus the invitation to the audience to become voyeurs is undermined. He appears more as the male harassed by women, lending legitimacy to a view of the character of Byron (if not of the film) as misogynistic. The film, like many of the postwar melodramas, seems to want to express a more subversive intent in relation to the male identity of its protagonist but frustrates this possibility by portraying his relationships with women in highly conventional situations. If anything, the film appears divided in its historical project. On the one hand, it seeks to resurrect a fascinating historical figure, while on the other it literally lays him to rest. It seeks on the one hand to involve the audience in historical judgment, while on the other it frustrates possibilities for this kind of involvement. Its ambivalence about its historical subject anticipates many of the postwar films that are poised between past and present.

Ealing produced its version of the historical film in *Scott of the Antarctic* (1948), directed by Charles Frend. Like the baroque *The Bad Lord Byron*, this film appears to want to recover past images of heroism; however, the ambivalent treatment of the protagonist undermines any straightforward celebration of social commitment. Played by John Mills, Scott is portrayed as obsessive in his quest to plant the British flag on the South Pole, and his competitiveness with Amundsen and his Norwegian team threatens to cast his motives in personal rather than national terms. The film spans the planning of the expedition, the repeated failures and then success of Scott in gaining funds and approval for his mission, and, above all, the stage-by-stage progress of the journey, which results in the death of Scott and his men.

According to Charles Barr, "It is a story of a failure. Given the choice of subject, this is inevitable. What is more significant is the way the failure is presented. Scott's team is beaten to the South Pole by the rival Norwegian expedition and then fails to survive the return journey. Both failures result from an outlook which is essentially amateurish: Scott is shown making crucial decisions of selection and planning in an arbitrary or sentimental way. Nevertheless, one has no sense that the film 'detects' him in this, concerned as it is to present him with due reverence as a British

hero."[26] The film's treatment of failure stands in contrast to the many war films that address failure as momentary, serving as an incentive to future victory. Here the film seems, like the memorials to the members of the expedition, to enshrine and bury past exploits. Consonant with so many of the films of the postwar era that call into question unself-conscious sacrifice and duty, *Scott of the Antarctic* emphasizes personal struggle rather than collective effort. The tension between the images of the men's physical suffering and the film's refusal to relent in its insistence on the totality of Scott's commitment, and the obsessive highlighting of the beautiful but cruel Antarctic terrain, serve to undermine a reading of the film as a straightforward enactment of the positive benefits of heroism and martyrdom.

Praising the "beautiful documentary footage" and the score by Ralph Vaughn Williams, George Perry finds that the film exemplifies the Ealing ideology of collectivity, the subordination of the individual to "the greater good of everyone."[27] But the more interesting aesthetic and ideological aspects of the film reside in its unwitting subversion of its formal and ideological concerns. Instead of presenting an unambiguous portrait of a national hero, *Scott of the Antarctic* exposes the failure of the protagonist and the terms of that failure: obsessive and inept male competitiveness divorced from the usual imagistic and rhetorical trappings of national glory.

Frank Launder's *Captain Boycott* (1947) appears more overtly critical of British history. But with Stewart Granger as Hugh Davin, the leader of the Irish opposition to Boycott, Irish heroism is constructed along British lines. The film covers the period of the rise of the Irish Land League and its efforts to organize the peasantry. The Land League is portrayed as recommending peaceful measures in fighting evictions of the tenantry, insisting on the ostracism of persons who move into the homes of evicted tenants. However, the efforts of the Land League are threatened by impatient peasants who seek more violent measures against Boycott and his bailiff (Mervyn Johns). Parnell as head of the Land League is accused of sapping the vitality of the country. Finally, Boycott is defeated by his tenants when they refuse to work for him. He has troops brought in to bring in his harvest, but the crops are spoiled, and Hugh defeats Boycott in a horse race. The conflict is personalized by introducing a farmer, Mark Killain (Niall MacGinnis), and his daughter, Anne (Kathleen Ryan), who violate the Land League's injunction to the villagers to not rent the homes of evicted tenants. The father and daughter take a cottage from which a tenant has been forcibly evicted. Hugh finds himself in the painful position of supporting the ostracism against the pair but of defending the woman he loves. Anne's father's sympathies are with the landlord. She comes to realize the danger of her situation, but her father

is unyielding and is finally killed in a fight with the men of the parish. The mob now turns on Anne. Hugh defends her against the angry men, but the priest (Alastair Sim) intervenes and prevails. The final words in the film are his as he articulates the policy of the parish: "In the future, if any offends, ostracize, isolate, boycott him." The union of Hugh and the priest ensures that the threat of violence will be contained, a strategy that is familiar in other films treating Irish subjects such as *The Gentle Gunman* (1952) and *Shake Hands with the Devil* (1959),[28] in which, through the conventional melodramatic ploy of protecting a defenseless woman against the mob, the legitimacy of violent opposition is further defused. The unspoken link between the contemporary IRA and the militancy of the mob are not lost on the audience, nor is the repudiation of violence.

In the postwar period, Herbert Wilcox and Anna Neagle returned to the historical film with a biography of Florence Nightingale, *The Lady with a Lamp* (1951). Modeled on *Victoria the Great* (1937), Anna Neagle's role spans the life and career of Florence Nightingale from her efforts as a young woman to become a nurse to old age, when she is finally awarded the Order of Merit, the first woman to be so honored. The film follows the rubric of the conventional historical drama—romance as opposed to commitment to a noble cause, obstacles to the protagonist's achievement of her goals, personal sacrifice, recognition after hardship, and honor in old age. The film employs setting—the big houses of Lea Hurst and Broadlands—as it employs character, to provide the necessary spectacle and involvement with the protagonist and her struggles as well as to portray her sense of noblesse oblige. She is portrayed as the mediator between rich and poor, privileged and underprivileged.

The treatment of the personal aspects of Florence Nightingale's character is common in representations of female accomplishment. The protagonist is a model of heroic service to her nation. In spite of her family's insistence that she marry, Florence places her "calling" above personal affections. Yet the portrait of the protagonist is not untroubled. The film introduces disruptive connotations that undermine a straightforward reading. The extended conflict between Mrs. Nightingale, Florence's sister, Parthenope, and Florence concerns the charge of "unnaturalness," the implication that Florence is abnormal by not marrying, a charge that the film seems never to dispel. The absence of a romantic element, along with her horror at the prospect of marriage, could serve to reinforce the image of her liberation from conventional standards of female behavior; however, it only serves to heighten the sense of her deviance. Florence's relationship to Lord Herbert (Michael Wilding) is presented as a chaste friendship, while her relationships to the men in military service and the government are presented as antagonistic. And the key term used to characterize her behavior, by both herself and others, is *discipline*. The cumu-

lative effect of her relations with both men and women perpetuates a seeming connection between professional women and sexual inadequacy. The seed planted at the outset about the suppression of certain "natural" inclinations is not eliminated from the film.

Like other postwar films, with their ambivalent portrayals of women's status, this film seems rife with compromises. Women in public life are portrayed as having to sacrifice their personal desires and their femininity in order to excel in the world of men. The film's celebration of Nightingale's achievements is also undercut in its lingering on her personal isolation. As in so many films featuring women, the final image of the female is one of isolation and entrapment in the home. *The Lady with a Lamp* is, like *Scott of the Antarctic*, indicative of certain conservative ideological tendencies at work in the postwar films, tendencies that tend to produce films of willed social cohesiveness through the evocation of past national heroes. However, the film is also revealing of conflicts for women between the domestic and public spheres, an inevitable part of representations of women in the postwar era.

The postwar era was also a time to remake earlier successful films. The impetus to do this can be traced, in part, to the many efforts to revive an ailing industry; it can also be attributed to a retreat from contemporary complexity, but, as can be seen from *The Bad Lord Byron* and *Scott of the Antarctic*, the films also produced their own critique of past and present. To judge by such films as *The Lady with a Lamp*, *Captain Boycott*, and the earlier and popular *Victoria the Great* and *Sixty Glorious Years* as well as such films of empire as *The Four Feathers* and *The Drum*, the nineteenth century is a major source for historical films, costume dramas, and melodramas. Given this penchant for the Victorian era and also the tendency in the early 1950s to remake popular British and Hollywood films, a new version of *Tom Brown's Schooldays* (1951) is predictable. The film had been made earlier in Hollywood (1940) with Sir Cedric Hardwicke in the role of Dr. Thomas Arnold, Edward Arnold as Mr. Brown, and Freddie Bartholomew as Tom. The film, directed by Gordon Parry, focuses on the plight of a young man at Rugby to assimilate into the school routine and his suffering at the hands of the older boys. The headmaster, Dr. Thomas Arnold, the father of Matthew Arnold, is portrayed as a liberal reformer who seeks to change the social relations of the boys in the school.

His liberalization involves conceptions of religion, humanism, a leveling of caste, status, and age distinctions among the boys, a breaking of the power of the senior boys, who wielded more power over the younger boys than the teachers and the headmaster, and a softening of physical discipline in favor of morality and a code of honor. Young Brown (John Howard Davies) finds himself at the mercy of upperclassman East (John

Charlesworth), but he is able to stand up to him. East is eventually con-
verted through his encounters with Brown, and Brown is more threatened
by Flashman (John Forrest), who tortures him. After being physically
trounced by Brown and the other boys, Flashman retaliates by getting
Brown in trouble with Dr. Arnold (Robert Newton). Brown is accused by
the headmaster of being responsible for the serious illness of young
Arthur, who was assigned to Tom by the doctor as a charge. However,
the doctor realizes that Flashman is the culprit and dismisses him.

The Hollywood film, directed by Robert Stevenson, focuses more on
the figure of Dr. Arnold and his conflicts with parents and alumni in
establishing his reforms, portraying him as directly involved with every
aspect of the young men's actions. The role of Tom's father is also fea-
tured more prominently in the American version, and the relationships
among the boys are more intense. The British version is episodic, and
both Dr. Arnold's and Mr. Brown's roles are reduced, with the focus
more squarely on the conflict among the young men. This later film
stresses the sense of place, of architecture, and of history, and particularly
the struggle between tradition and change. Dr. Arnold figures most prom-
inently at the end of the film as Arthur's life is held in the balance and
Tom is faced with the possibility of expulsion and with the moral burden
of having failed in his responsibility.

The British film stressed such 1950s themes as the male's relationship
to authority, religious and moral values, and the concern with the male
group and male identity that was so much a part of the many tragic melo-
dramas as well as of the war films which continued to make their appear-
ance. Moreover, the emphasis on education was both a social concern
and an image in many British films, including *The Guinea Pig* (1948) and
The Browning Version (1951). Thomas Hughes' novel and its nineteenth-
century context become a pretext for returning to the past and making
contact with a particular tradition of moral reform within a highly class-
bound institution. Brian Desmond Hurst's contribution as producer
would seem to reside in the preoccupation, as in other Hurst films, such
as *On the Night of the Fire* (1939) and *Hungry Hill* (1947), with those
characters who are the victims of social and economic exploitation. His
work also inscribes religious and moral values which are violated and for
which retribution is required. *Tom Brown's Schooldays* uses its historical
context to address the increasingly popular concern in the 1950s of the
malaise of youth, suggesting a more benign environment for their own as
well as the social good. The focus on male identity and relationships
seems to be a popular subject which the school setting in this film en-
hances and develops.

An unusual appropriation of the historical film is *Beau Brummell*
(1954), which portrays the tempestuous relationship between the future

George IV (Peter Ustinov) and the protagonist of the film's title (Stewart Granger). The setting and the costumes of the film are lavish. Elizabeth Taylor is cast as Lady Patricia, the ostensible object of Brummell's affections. The narrative begins with the exercises of the the prince's regiment, where Brummell and the prince first spar with one another over the outrageousness of the regimental uniform. Brummell is dismissed from the regiment and lives by his wits with the help of his serving man (James Hayter). When he becomes involved in politics and is further critical of the prince's exercise of authority and power, George calls for him, and Brummell offers advice to the prince about how to circumvent Pitt and Parliament. From that moment the men are inseparable, though Lady Patricia warns Brummell that the prince is fickle. The men fall out over Brummell's suggestion that the prince have his father declared insane so that he can become regent and marry his mistress, Mrs. Fitzherbert (Rosemary Harris). The prince loses his nerve, and the plan fails. He accuses Brummell of poor advice, and the men separate. Brummell, who has lived lavishly a few steps ahead of his creditors, thanks to his relationship with royalty, is forced to flee to France. He lives in poverty, becomes consumptive, and, as he lies dying, is reconciled with his friend, now the king of England.

The film includes such historical figures as Pitt and Lord Byron, but the history of the film is subordinated to the unconsummated romance between Lady Patricia and Brummell. While the conflict between her and Brummell concerns her desire for security, she functions as a diversion from the main narrative, which is the fluctuating relationship of the prince and Brummell. The film portrays Brummell as a charming nonconformist who advocates conspicuous consumption. His nonconformity is associated with the exercise of power in the interests of hedonism. The relationship between Brummell and George is tempestuous, consisting of conflict, reconciliation, further conflict, and finally ultimate reconciliation. During the time of friendship, the film suggests a close bond, if not fusion, between the two men. George is completely under the spell of his friend. The aftermath of the fateful quarrel shows each man waiting for the other to relent, and the extended deathbed scene is presented in operatic terms as the king sits by the bedside of the expiring Brummell and mourns his passing. The film makes little of the historical events of the time but concentrates on the private life of the future king and portrays him as being content and playful only when his friend is beside him.

The women in the film, both Mrs. Fitzherbert and Lady Patricia, are relatively insignificant, serving mainly to highlight the men's parallel situation. Brummell takes the role not only of advisor to the king but of confidant as he listens to the king's personal woes when his mistress leaves him, and, conversely, Brummell reveals his troubles with Lady Pa-

tricia to the king. The film's association of clothing, furniture, and interior decoration with Brummell, and George's emulation of Brummell's taste, provides a further way of dramatizing the bond between the two men, which is portrayed as different from usual male relationships. The film does not end with the traditional union of the lady and her lover, but with the deathbed scene between the monarch and his loyal friend. History is used in *Beau Brummell* to create the distance and spectacle necessary to explore the subject of intimate male relationships and male preoccupations—a subject that would have been difficult to address in the context of the 1930s and the war years. However, it is also clear that the film, while probing more deeply into the subject, can still only flirt with male intimacy.

The Festival of Britain of 1951, sponsored by the government to celebrate British accomplishments in the arts, and the coronation of Elizabeth II in 1952 were responsible for the appearance of a number of historical films. Among them, *The Magic Box* (1951), directed by John Boulting, was an attempt to celebrate British cinema and to enshrine the figure of William Friese-Greene as one of the founding fathers of the cinema, but neither cinema history nor the film itself has succeeded in elevating him to that position. The film was made in Technicolor with a cast consisting of major British film actors in cameo appearances. Starring Robert Donat as William Friese-Greene, the film is a record of Friese-Greene's failures as an inventor and as a married man. Narrated by Margaret Johnston, playing Edith, Friese-Greene's second wife, the structure of the film is episodic, covering different periods of the inventor's personal life and career. The final sequence of the film involves his visit to a film conference in 1921. As he is about to expire, he speaks eloquently of the cinema, telling the representatives of the film industry that they must not be discouraged but must keep on making films. The film's use of Friese-Greene's history is designed to parallel contemporary problems in British filmmaking—the need for personal and financial sacrifice, the lack of recognition for British production, and the constant problem of how to make films that are commercially viable. The film's emphasis on Friese-Greene's failures are an unusual way to celebrate British cultural accomplishment. Friese-Greene's exhortatory speech about keeping the cinema afloat hardly mitigates the numerous instances of failure that the film records. Contrary to the optimistic uses of British history in the cinema of the 1930s and 1940s, the historical films of the 1950s cannot conceal deep cultural problems.

Though not ostensibly a fiction film, the documentary *A Queen Is Crowned* (1953), narrated by Laurence Olivier, which appeared two years after *The Magic Box*, was indicative of many attempts in the 1950s

cinema to recover images of national identity through the evocation of history. This tightly edited film was a media event, celebrating the coronation of Elizabeth II. Verbally and visually, the film calls attention to the monumental nature of the historical moment, stressing symbols from the past through images of architecture, clothing, and ritual. The early part of the film ties the day's events to notions of nationhood, empire, town, and country. Capitalizing on the spectacle of the royal figures, the film lingers on the jewels, the crown and scepter, the clothing, the carriages, and the processions. The sonorous "voice of God" narration, which is solely Olivier's, is highly rhetorical. The music is religious and patriotic. The camera records the enthusiastic crowds along the street and directs the spectator's gaze to the numerous close shots of the future queen and her nobles. The procession of heads of government and troops from various corners of the world resurrects memories of the former power of Britain at a time of dwindling power and prestige. While the coronation ritual is verbally linked by the narration to tradition and continuity, the style reveals another agenda. The spectator is made aware of the opulence of the occasion, the monetary value of places, objects, and garments, and the exalted position of the personalities involved. Tradition is harnessed to commerce. The voyeuristic camera seeks out the major actors and brings the spectator into a privileged position in relation to them. The spectacle reveals more about contemporary history and the 1950s emphasis on affluence than about Britain's glorious past.

A reading of the historical films of this thirty-year span of British cinema reveals that portrayals of history were not monolithic even in the pre–World War II era. Not all of the films of the 1930s were preoccupied with British myths of tradition, continuity, justice and fair play, and benevolent authority figures. The portrayals of monarchs, national heroes, and creative individuals reveal certain tensions between the public and private spheres, involving issues of gender, if not class, conflict. However, the historical films that sought to dramatize a stable, ordered, and class-stratified world gave way to different representations in the historical films produced during the war years as the nation (and the cinema) confronted the need to develop a populist rhetoric that addressed the need to mobilize the masses. The subjects of the films varied, and national heroes were not merely aristocrats but religious figures, scientists, and inventors. Moreover, the linking of performance and merit rather than heredity and upper-class prerogatives was also more pronounced. Although the historical film continued to be produced in the postwar era, and although these films are still addressing familiar myths of national greatness and continuity, their treatment of narrative material, their particular use of stars, and their greater emphasis on psychologizing expose the tenuousness of

the traditions they seek to evoke. In spite of the attempts on the part of many of the films to recapture a sense of community and commitment, the films often reveal the fragility of their attempts to recover traditional values and attitudes, as in *The Bad Lord Byron, Scott of the Antarctic,* and *The Magic Box,* films that question the achievements of their protagonists and hence of the ethos that produced them.

Empire, War, and Espionage Films

FILMS OF EMPIRE

FILMS that celebrate patriotism and myths of national identity are a staple of most national cinemas. The American western and the Japanese samurai film are probably the most enduring of the genres that enact the establishment of law, order, and community. These "genres of order" are characterized by the presence of "an individual male protagonist, generally a redeemer figure, who is the focus of dramatic conflicts within a setting of contested space. As such, the hero mediates conflicts inherent within his milieu. Conflicts within these genres are externalized, translated into violence, and usually resolved through the elimination of some threat to the social order."[1] The closest British counterpart to the western genre and its celebration of American myths is the film of empire, which, with its own set of equally potent cultural myths, celebrates the triumph of British law, order, and civilization over barbarism. The most successful of the films of empire were produced by Alexander Korda. Although these films never had the mass appeal or the durability of the American western, the films of empire were both popular and commercially profitable in Britain and the United States. If the western deployed the popular mythology of westward expansionism, the colonization of the American Indian, and the appropriation of the frontier couched in religious and nationalist terms (America as the New Eden and the Virgin Land), the empire film translated expansionism, colonization, and commerce into a spectacle of benevolence of high-minded heroes acting in the name of royal prerogatives, culture against anarchy, and the white man's burden.

According to Roy Armes, "The imperial spirit of these films—particularly *Sanders of the River*—is totally out of touch with present day sentiments. . . . Even at the time, however, these films were more an expression of an official rhetoric than a deep-seated popular mood and their lofty sentiments were not shared by those who might have been expected to go out and serve the imperial cause."[2] However, the popularity of these films (even today) testifies to the audience's fascination with the world they created. The 1930s saw a flourishing of the genre in such British films as *Sanders of the River* (1935), *King Solomon's Mines* (1937), *The*

Drum (1938), and *The Four Feathers* (1939), as well as Hollywood versions of various Kipling narratives. The Hollywood cinema, with its Anglophile sentiments as well as its community of British expatriate stars, helped to reinforce and legitimate British imperial myths of the 1930s. Moreover, as Jeffrey Richards and Anthony Aldgate indicate, "what the empire stood for was distilled by Hollywood screenwriters from the works of Kipling and his imitators, either directly or indirectly. The extent of the pro-British propaganda that they therefore contained is evidenced by the banning in Mussolini's Italy of the Hollywood films *Lives of a Bengal Lancer*, *Charge of the Light Brigade*, *Clive of India*, and *Lloyds of London*, specifically because of their pro-British slant."[3] The popularity of these films in the 1930s can be attributed to several factors—the cinematic appeal of exoticism and adventure, the conservatism of the times in spite of the rise of radicalism, and the continuing resonance of nineteenth-century myths of national destiny. While associated primarily with the 1930s, the empire film continued to be produced well into the 1950s, though the treatment of the conflicts, the presentation of native life, and the blatant expansionism were altered to suit the exigencies of the changing times, introducing a liberal slant in the guise of benevolent interventionism, as exemplified by such films as *Where No Vultures Fly* (1951), *The Seekers* (1954), *West of Zanzibar* (1954), and *Simba* (1955).

Like the American western, the dominant conflict in the empire film is between savagery and civilization, although the British film does not exalt the rugged self-made individual. The British hero is exemplary of the values of his class and, more broadly, of his culture. He is a member of the upper class, a representative of the best of the British public schools. Either he is unswerving in his commitments and dedicated to the mission of providing responsible law, order, and a system of morality based on British values, or he undergoes a conversion whereby he discovers the imperatives of the British imperial project after having questioned or evaded his responsibility. The protagonist's position would seem to place the films of empire in Schatz's taxonomy of genres of order. The British hero, however, is not outside the community but rather is its agent, in contradistinction to the hero of the western, and violence in the British films is attributed primarily to the antagonists.

The antagonists are, for the most part, the inhabitants of the country, although occasionally they are Europeans. The indigenous people are of three dominant strains: the childlike natives who are easily misled by false promises of land and power, those who remain loyal to the British masters, and the unscrupulous native leaders who seek to oust the British authority and establish their own power. In the African films, they are usually tribal chiefs. In the Indian films, they are princes who are disaffected and seek to overthrow, if not kill, the ruler who is legitimated by

the British. While the empire is presented benevolently as the purveyor of reason, justice, and peace, the protagonist must usually resort to violence in order to quell the antagonists after "reason" fails, but, unlike the Hollywood western, the scenes of violence are more infrequent and less bloodthirsty. Moreover, the ritualized and individualized confrontation of the protagonist with the enemies of civilization—the Indian, the Eastern dandy, the brutal landgrabber—is also altered in the British film of empire. The British protagonist not only seeks to avoid conflict and to solve problems with the aid of the law, but he is also positioned as the primary agent and administrator of a system of justice that transcends his individualism. He is not the renegade and outlaw fighting against both the oppressive forces of established society and the forces of "barbarism." The antithesis between the civilized West and the untamed East is represented as an antithesis between culture and anarchy. There is little nostalgia in the British film of empire for the open spaces of the wilderness until the 1950s, when the struggle is portrayed in terms of the greedy exploitation of "foreigners" and natives of the land and of wildlife, as in *Where No Vultures Fly*.

The women represented in these films are generally of three varieties: the white woman who is related to the garrison commander and affianced, if not married, to the protagonist, the daughter of an explorer or adventurer lost in the depths of the wilderness who comes to free her father and enlists the aid of the protagonist, and the native woman who is an ally of the chief antagonist and a troublemaker. The dance hall hostess and prostitute of the Hollywood western are conspicuously absent. The British women are identified, if not overidentified, with the aims of the protagonist, but they are not associated in any way with the indigenous community. Rather, they are associated either with home or with their temporary quarters in the garrison. The native women, when presented, are rarely individuated. More commonly, they are shown in a group as laughing at the unfamiliar white man, as performing exotic dances, and as having no identity aside from their physical presence. If, like Lilongo in *Sanders of the River*, they are singled out, they look more like the white women, and their aims are portrayed as consonant with the British.

The landscape of the films heightens the exotic treatment of the natives, emphasizing the splendor of the palaces of Oriental potentates, or, in the case of Africa, tents filled with animal skins, masks, and warlike implements. The desert, the jungle, and the river are the focal points of encounter and conflict. These places signify the threat of nature associated with the treachery of the natives. In the jungle episodes, the natives are frequently presented as camouflaged by the foliage and as springing out unexpectedly to attack the British. The costuming also heightens the remoteness and exoticism of the landscape. Indians and Egyptians are swathed

in silks, turbans, and jewels or else clothed in filthy rags. The African natives are dressed in feathers and animal skins, when not presented as half-clothed savages. As the representatives of law and order, the protagonists are garbed for the most part impeccably in their uniforms, which serve to identify them as agents of Britain.

The films are highly dependent on spectacle, one source of which is the exoticism of the alien culture, expressed through physical appearance, scanty or colorful clothing, and rituals. All of the films contain at least one scene of dances performed by "natives." In the Indian films, the dancers are usually female and serve as a distraction from the intrigue that takes place during the performance. In the African films, the dances are of several varieties: ceremonial dances of greeting to indicate the dancers' subservience to and respect for the rulers, dances of sacrifice that portray the bloodthirsty nature of the "savage" people, and dances designed to rouse the warlike spirit of the natives as they prepare to attack. The white settlers, as in the American western, are also portrayed as dancing, but, in contrast to the natives, their social dances (usually at a ball) are emblematic of orderliness, restraint, and decorum. The costumes, the native language (which is never translated), and the rituals presented are designed to enhance the sense of spectacle and of difference. The other source of spectacle is the British martial music, military reviews, processions, and colorful uniforms used in the film.

Tribal customs and the nature of tribal life are never examined, and the effects of colonialism are seen only in the ways in which the people accept or resist the decrees of the administrator. The films portray a timeless primitive world in which the only change that takes place is in the sporadic rebellion of the natives, which, when quelled, restores the authority of the British rulers and the primacy of British "civilization" over the indigenous culture. Moreover, as Jeffrey Richards states, "There is no reflection of the fact that the Empire was in a constant state of flux during the interwar years, evolving toward something quite different—the Commonwealth, the concept of a world-wide community of nations in free and voluntary association."[4] Setting aside the questionable issue of Commonwealth freedom and voluntarism, Richards' assertions of the flux characteristic of the time is also evident, if submerged, in the films. These films are not totally silent about their strategies. Through their stereotypes the viewer can detect underlying and often unspoken conflicts. It is all too easy to dismiss their overt political practices on behalf of traditional attitudes toward imperialism and to overlook how their formulaic constructions of conflict between races mask more fundamental and unconscious attitudes toward male identity, sexuality, family, and the male group.

The person most associated with the production and the success of the imperial films was Alexander Korda. He was assisted by his brothers

Zoltan and Vincent, though Zoltan and he had differences about how to present the Africans. According to Michael Korda, "His [Zoltan's] earlier movies about Africa had been struggles between Zoli's own desire to show the reality of the Africans' lives and aspirations in the bondage of colonialism and Alex's determination to present films that would present the Empire to the audience in a positive and patriotic light."[5] According to Jeffrey Richards, the Korda empire films are an instance of mixing "patriotism with profit." His efforts to attract large audiences in England and America were based on a view of cinema as a successful commercial venture, and to that end he made pictures that could compete with the Hollywood flair for spectacle, using stars, lavish settings, and popular scripts often based on novels that dramatized tradition, the lives of the upper classes, and the greatness of the British Empire.

PRE–WORLD WAR II FILMS OF EMPIRE

Sanders of the River (1935), directed by Zoltan Korda and based on the novel of the popular writer Edgar Wallace, was one of the first of the Korda empire films and contains many of the now-familiar elements of the genre. The film, starring Paul Robeson, is both a celebration of colonialism and an oblique demystification of the stereotypes and attitudes upon which empire films are based. The film differs from other films of empire in its greater focus on the governing of the territories than merely on conflict and combat with the natives and foreigners who threaten the harmony of British rule. The narrative is simple. Sanders (Leslie Banks) rules over his territory in West Africa as a benevolent father. He is presented as abhorring slavery, gunrunning, and the delivery of alcohol to the natives. "Lord Sandi" is the prototype of the colonial administrator. A product of the British public schools and its avowed ethos of fair play, duty, and responsibility, he rules over the natives not only like a father but as a surrogate for the king of England. He is not in Africa for profit, like the other white men who manipulate the natives and encourage them to turn against Sanders and hence British rule. The white men stir up a local chief, King Mofalaba, but Sanders, with the help of a loyal native, Bosambo (Paul Robeson), whom he elevates to the position of chief, is able to defeat Mofalaba and again command the loyalty of the natives.

Robeson later repudiated the film, saying that it was a slanderous portrayal of the blacks which presented them as submissive under British rule. Originally he had felt that, with Zoltan Korda directing, the film would present a more accurate depiction of African life, and he was disappointed with the final result. The figure of Bosambo is crucial to the film insofar as Sanders is dependent on his loyalty to rule the territory effectively and Bosambo is dependent on Sanders for his position. Sand-

ers not only makes him a chief but sanctions his marriage to Lilongo and instructs him in the ways of monogamy. In Richard Dyer's terms, Robeson plays the "'good African' with whom the whites can work."[6] He is the exceptional black man, trained by the whites, the indispensable intermediary for guaranteeing the success of the colonial project. Bosambo is contrasted to King Mofalaba, who is associated with the jungle and with savagery, with not having the benefits of white religion and morality. Mofalaba's rebellion is not associated with any legitimate grievances of the natives, but portrayed as the product of primitivism, of living in a state of nature without benefit of Christian grace, and of not having the intelligence to differentiate between good and bad whites. In Sanders' confrontations with the chiefs, including Bosambo and Mofalaba, his major weapon is language. His strategy of publicly exposing the misdeeds of the chiefs through the tongue-lashing he administers at the palavers reinforces his position as a disciplinary figure who publicly exposes the chiefs to shame. When Sanders goes home to marry, the territory reverts to savagery, and when he returns, the drums say, "The law is back." The imagery of the film, the footage that Zoltan Korda shot in Africa of landscape and wildlife, the images of the river and the jungle, while lending a certain authenticity to the film, also serve to reinforce the association of the Africans with nature and with wildlife. Although Bosambo is set apart from his own people—his domestic life in his tent resembles that of a British middle-class household, his wife (Nina Mae McKinney) does not resemble the other native women—in his obsequiousness to Sanders he is, to a certain extent, also identified with the primitive life, especially in his womanizing, which has to be controlled by Sanders.

Sanders' language and behavior are associated with the Old Testament. Like the God of the Israelites, he metes out favors and punishment: "I am Sandi who gives you the law." In his person, he is able to quell the raging natives, though guns are also helpful. In the emphasis on Sanders' ability to control the territory, the film also suggests that colonialism is really quite economical if the right men can be found to administer it. But, as Richards and Aldgate write, "There is an implicit subtext in the apparent fragility of British rule given that it collapses the moment Sanders leaves the scene."[7] There are also moments when the film seems to be laughing at itself. When Sanders orders the men to palaver, the dialogue between the chiefs and Sandi backfires as the men reveal not only their mistrust of him but also that they are laughing at his posturing. Robeson, in particular, delivers his lines in a way that alerts the critical viewer that the only way Sandi can be addressed is in a mocking, subservient manner. Bosambo's assertion that he has learned that a good ruler is to be loved not feared is delivered in a way that makes his barbed statement appear disingenuous. For its time, the film appeared to deliver a liberal message of cooperation between ruler and ruled, dramatizing the economic effi-

ciency of a system based on cooperation. Half a century later, the film can be read not only for what it exposes about discourses of public power but for what it reveals about the sexual economy of imperialism in its eroticizing of the black man, turning him into an interdicted object of desire who must be either neutralized or destroyed.

Three years later, Marcel Varnel directed *Old Bones of the River* (1938), starring Will Hay, along with his comic foils Moore Marriott and Graham Moffatt, who had appeared with him in *Oh, Mr. Porter!* (1937). As the title *Old Bones of the River* suggests, there is a connection between the Sanders film and this comedy, which portrays a missionary-educator belonging to the TWIRP (Teaching and Welfare Institution for Reforming Pagans) who comes to Africa on a "white man's burden" mission and creates mayhem in the territory. The film parodies *Sanders of the River*, beginning with an inflated prologue: "Darkest Africa where in primeval surroundings amidst crocodile-infested waters, a handful of Englishmen rule half a million natives." Benjamin Tibbetts (Will Hay) arrives in the territory with Bosambo (Robert Adams), who is returning from England and is plotting to take over the tribe from his brother. Commissioner Sanders, ill from fever, is returning to England and leaving the command in the hands of Captain Hamilton (Jack Livesey). Tibbetts attempts to "educate" the natives, but the natives know more than he does. There is antagonism in his teaching, and the young men throw darts at his map of Africa. But he is undaunted in his willingness to be of service. When Hamilton falls ill of malaria, Tibbetts takes over his position and sets out on the river to collect the taxes due the British government. He is accompanied by Harbottle (Moore Marriott) and Albert (Graham Moffatt), who are totally unscrupulous and incompetent. His visits to the various tribes provide an opportunity to portray the tribesmen's resistance to taxes, his own incongruous efforts to explain the reasons and methods of taxation, and his futile attempts to threaten the natives in the name of Lord Sandi. His severest trial arises when he comes to Bosambo's brother's tribe and finds himself embroiled in conflict between the two brothers. He escapes with a baby he has saved from a sacrificial ritual and returns to the garrison, where he and his two companions fight off the angry natives. After he has successfully defeated the natives, he accidentally sets off a mine, which destroys the garrison.

The language parodies the stilted language of the Korda film. The narrative also undercuts the notion of the docility of the educated native. Bosambo is the source of trouble as he returns to foment opposition among the natives. The notion of the British mission bringing civilization to the black man is constantly undercut by Tibbetts' ignorance, ineptness, and inability to rationalize British customs to the natives. When he tries to explain the income tax laws to them, he is frustrated by his inability to define the term, *emoluments*. The natives' clever evasion of taxes provides

another instance in which they appear more intelligent than their white masters but also as victimized by regulations that are not in their best interest. The comic trio of Tibbetts, Harbottle, and Albert drives home the ridiculousness and ineptness of the white man's mission in Africa. Tibbetts and his colleagues destroy the rebellious Bosambo and his tribesmen, as prescribed by the formula of the empire films, but this patriotic action is subverted by the trio's unwitting destruction of the garrison. Several stereotypes associated with the empire film—the clear physical separation between whites and blacks, and the image of white male superiority and power—are violated. The scenes in which Tibbetts bathes, diapers, and tells a story to the native baby recall *Sanders* but in inverted fashion. Tibbetts' domesticity violates the image of the impeccable governor, and the fact that the baby is black undermines the usual divisions between the British and the natives. Through parody the film undercuts the rationality of missionary work and colonial administration and provides a critique of imperialism and of the empire film.

In *King Solomon's Mines* (1937), directed by Robert Stevenson, Robeson appears again as an African chief, Umbopa, in an adventure narrative based on an H. Rider Haggard novel. This popular narrative, remade in 1950 (directed by Compton Bennett and starring Deborah Kerr and Stewart Granger) and again in 1985 (directed by J. Lee Thompson and starring Richard Chamberlain and Sharon Stone), is more typical of the genre, with the classic journey into the jungle, the quest for treasure, the fusion of adventure and romance, and the presentation of the natives as inseparable from the natural landscape. The narrative itself, like H. Rider Haggard's novels, is built on familiar genre formulas that mask colonizing attitudes. The idea of the journey into the interior is presented as the archetypal trial in the wilderness, stressing the dangers of nature and of hostile people who are presented as different, savage, and superstitious. The white men's superiority is signaled by their command of language (Quartermaine keeps a journal), their superior knowledge of nature, their ability to harness the physical strength of the natives for their own purposes, and their desire for knowledge at any cost. Above all, the film's fascination with the exotic and the unusual is exemplified in the images of landscape, capitalizing on the otherness and mysteriousness of this world. The narrative functions to mystify differences while making the audience conscious throughout of the necessity of difference to the enterprise of imperialism and its representations.

In the Stevenson version, the Robeson character is less childlike than in *Sanders*, although he is still portrayed as the ally of the whites in opposition to his own people. Umbopa attaches himself to the wagon of the white hunter, Allan Quartermaine, and allies himself with a young Irishwoman, Kathy O'Brien (Anna Lee), who is determined to follow her father to the north country to seek diamonds. The company consists of

Quartermaine (Sir Cedric Hardwicke), two Englishmen seeking adventure, Sir Henry Curtis (John Loder) and Commander Good (Roland Young), Kathy, and Umbopa, who leads them through the desert and into the country of his people. When they arrive at their destination, they are victimized by Twala (Robert Adams), the chief of the tribe. Umbopa turns out to be the legitimate heir to the throne, and he strikes a bargain with the whites to help them get their diamonds from the mine in exchange for their support against Twala. What is required of the white man is his performance of a greater feat of magic than the tribe's witch doctor, the aged crone Gagool, can perform. The "magic" of the white man's weapons and his superior knowledge of a coming eclipse of the sun results in the death of Twala and the installation of Umbopa as the new ruler. Umbopa then guides them through the mines, using his powerful body to free a huge boulder, allowing them to escape from the raging volcano in which they are trapped.

Of the straightforward empire films, *The Four Feathers* (1939) was the most successful. Shot in the Sudan, the film dramatizes the conversion and heroism of a young man, Harry Faversham (John Clements), who refuses to stay in his regiment and fight in the Sudan with Lord Kitchener's army. His fellow officers, his fiancée (June Duprez), and her father accuse him of cowardice, to which he finally admits. He leaves England for the Sudan, where he impersonates a mute tribesman and follows his regiment. He thereby saves the lives of his comrades and returns to England a hero.

Harry is presented first as a young boy who prefers reading poetry to engaging in masculine exploits. His father enlists the help of a physician, Dr. Sutton (Frederick Culley) to help give the boy a sense of duty to nation. At a reunion, the father and his military colleagues recount examples of heroism and of cowardice for the benefit of the boy, and they drink a toast to him: "May he be the bravest of the Favershams." The boy is shown in semidarkness, looking fearfully at paintings of his male ancestors as he is observed by Dr. Sutton, who comes to him and offers to help him if he is ever in need.

The film jumps ahead a decade to Harry as a young soldier. Unlike his colleagues, he does not welcome the invitation to join Lord Kitchener in the Sudan. He resigns from his regiment, determined to devote his time to domestic affairs on the estate, and he is rejected by his colleagues, who send him white feathers (signifying cowardice). He is also rejected by his fiancée and ostracized by her father for his rejection of his father's world of male dominance and violence. His conversion to heroism is the consequence of his ostracism and alienation from the male community. He confesses to his one friend, Dr. Sutton, that he has not resigned from his regiment out of principle but out of fear. With Sutton's support, he sets out on the journey to the Sudan that will vindicate his name. The role of

the physician who has accepted the father's request to watch over Harry reinforces the equation of the denial of masculinity with illness, and Harry's recuperation of his name and the family tradition is seen as a sign of health. The political issues are submerged in the exotic landscape of Egypt, in the lavish military reviews and battles, and in the scenes of intrigue as Harry makes his way to the North Surrey regiment to save Captain John Dorrance, and then Willoughby and Burroughs, from a native prison. His final act of heroism is raising the British flag over the garrison at Omduran. He is reintegrated into the family with the full approval and admiration of General Burroughs (C. Aubrey Smith) and of his daughter, Ethne, whom Harry is now free to marry. Ethne is portrayed strictly as her father's daughter (there are no mothers in the film) and completely identified with his sense of honor, duty, and self-sacrifice.

The dialogue in the film is minimal. Where there is dialogue, it concerns either the repetition of the familiar narrative as repeated several times by General Burroughs of his heroism in the Crimea, or the rhetoric of bravery and self-sacrifice. Faversham poses as a mute, and the film thus emphasizes action over words. Harry abandons his poetic inclinations and his desires for a modest life of domesticity to prove himself through action. The narrative leaves no space for questioning its conception of manhood. To question is to be a coward and a betrayer of tradition and duty. The film establishes the treachery of the Khalifa and the Dervishes not through dialogue but through visualizing their intimidating numbers, their attacks on the defenseless British regiment, their cruelty to their prisoners, their warlike posture, and their general physical differences from the clean-cut British protagonists.

The British environment is portrayed through "gorgeous and opulent scenes of upper-class life in Victorian England." As Rachael Low states, "The colour was particularly fine, the rich colours and dark panelling and leather of the English country house contrasting with the parched dun color of the earth and the delicate duck egg blue skies of Sudan."[8] The location settings present a mute commentary on the contrast between the wealth, tradition, and beauty of the life defended by the army and the arid, physically destructive, and threatening world of the Sudan, reinforced through the scenes in which Dorrance wanders in the desert, blinded by the sun. The figure of Dorrance is open to interpretation. On the one hand, he is portrayed as an exemplary figure of service and self-sacrifice. On the other, his blindness can be read against the grain as exemplifying the blind and unexamined values of patriotism and colonialism that the film ostensibly seeks to uphold. More specifically and in a more psychoanalytic vein, his blindness intersects with the film's oedipal concerns involving successful and unsuccessful paternal and filial relations.

The Four Feathers was remade by Zoltan Korda in 1955 by enlarging old footage to cinemascope size. The film is faithful to the original narrative, though the battle scenes are more extended and the scenes of landscape more prominent in the large-screen format. The remake of the original film is timely and ironic in retrospect considering the ill-starred attempt to resurrect imperial power in the Suez crisis, which brought down the government of Anthony Eden in the following year. Starring Anthony Steel as Harry Faversham and Lawrence Harvey as John Dorrance, Mary Ure as Mary Willoughby and James Robertson Justice in the C. Aubrey Smith role, the characters are less stylized and posturing than in the earlier version, and the melodramatic gesture is toned down. But the film continues to affirm traditional values of honor, tradition, duty, the fulfillment of paternal expectations, and the cohesiveness of the male community. Moreover, the film does not seem to make the concessions that other 1950s films make to the changing times and the liberalization of familial and colonial relations. Rather, it appears to legitimate the relations of force that imperialism seeks to mask.

Elephant Boy (1937) offers yet a different model of the empire film, one that assumes the presence of the British and focuses on the initiation rites of a young native boy. Starring Sabu (discovered by Robert Flaherty) in the first of many successful films designed to highlight his youthful innocence, *Elephant Boy* was shot in India and initially photographed and directed by Robert Flaherty for Alexander Korda. Korda was a great admirer of Flaherty, and when Flaherty, unable to fund projects in Hollywood and in need of money, came to Korda, Korda was lavish in his promises to provide the filmmaker with money and projects. The association was not a smooth one, and Zoltan Korda finally finished the film using the Flaherty footage. Based on the Kipling novel *Toomai of the Elephants*, the film is not an overt imperialistic epic involving conflict between natives and Britishers. Rather, the film assumes cooperation between the two, and focuses on the boy. Dramatizing a boy's initiation into manhood, *Elephant Boy* portrays Toomai's struggle to fill his dead father's shoes. The white sahib is present, however, in the figure of the elephant hunter, Peterson (Walter Hudd), who comes at a time when the elephant herds are not accessible and enlists the Indians' aid in the quest to locate the animals. Peterson permits the boy to come along on the expedition. The other Indians tease him, telling him that he will become a great hunter when he sees the elephants dance. The boy's father is killed by a tiger, and the elephant Kala Nag goes into mourning, becoming unmanageable. The Indians want to kill him, and reluctantly Peterson agrees. Before the slaughter of the elephant can take place, Toomai and Kala Nag disappear into the jungle. The men organize to find him, but the boy manages to find the elephant herd and sees them dancing as they

gather together. When the men find Toomai, he leads them to the herd. Kala Nag is spared and, in front of the other men, Peterson pronounces Toomai a great hunter. He tells him that the elephants will know their master, and he praises Kala Nag. The men all bow down before the boy.

The natural setting of the film, as in other imperial epics, is not mere adornment. Flaherty's magnificent shots of the jungle and particularly of the elephants are edited by Charles Crichton so as to fuse Sabu with the landscape. He is presented as a child of nature and his prowess with the elephants as "natural." Moreover, the enterprise of elephant hunting is also naturalized in this fashion as the elephants are portrayed as needing sympathetic and disciplined treatment at the hands of masters who can anticipate their behavior. The appropriation of nature is evident in several ways: in the white hunter's mission to get forty elephants, in his mastery over the Indian hunters, in the boy's competence in finding the animals, and in the film's photography, which "captures" the foreign terrain, selecting those aspects of nature that are "wild" and juxtaposing them to scenes of the men mastering the untamed elephants. Another set of contrasts is at work in the portrayal of the white hunter as opposed to the mature Indian men. Sabu is the intermediary between them and nature, just as the white man is the intermediary between the natives and the British crown. The men are impatient and willing to sacrifice Kala Nag, but it is the boy's actions and the sympathetic support of the white hunter that are instrumental in reconciling conflict. In the trials and initiations that Toomai experiences, it is the white man who understands and guides him and the white man who names him and pronounces him a man. Toomai thus becomes superior to the other natives.

The film's imperialism and ethnocentrism are more immediate and personal than in *Sanders*, exemplifying those aspects of native life that are characteristic of western modes of representing Third World cultures. Using a young boy like Sabu serves to make the image of the natives more attractive. He is photographed, as are women, voyeuristically, the camera capitalizing on his face and body, on the grace of his movement. His youth enhances the usual association of the natives with childlike qualities. He is, moreover, pliable, and amenable to the instructions and desires of the older and wiser white man. The narrative itself, like so many of Kipling's works, selects those aspects of native life that are ritualistic and removed from the collective life of the culture. And, as in many ethnographic films of a similar variety (such as Flaherty's *Man of Aran*), the film emphasizes male activities. Women are absent or relegated to the background.

A year later, the Kordas returned to the Indian landscape with *The Drum* (1938). This film, based on the highly popular imperialistic epics of

A.E.W. Mason, again features Sabu, this time as a young Indian prince, Azim, who is devoted to the British. His father had been a loyal subject of the British, but Prince Ghul (Raymond Massey), in league with Moslem fanatics, kills the old ruler and takes over the territory. He dreams of restoring the Old Moghul empire and of the conquest of the lands now held by the British. Before Azim escapes from the palace, he meets a young drummer boy, Bill Holder, from whom he takes some lessons on the drum. The boys swear friendship and work out a signal to warn each other of trouble. The young prince is pursued but finds himself finally in the home of Carruthers (Roger Livesey), who has married the governor's daughter (Valerie Hobson) and is to be sent to the town of Tokot in command of the garrison. The family and Azim return to the territory, where Ghul plans to entrap them at a banquet. Carruthers, knowing of the danger, heroically accepts the invitation, and, by means of the drum, the boy's signals save the day, and the British are victorious over Ghul and his men.

The most striking aspect of this film is the way spectacle works to deflect from the actual political conflicts. The film is a good example of Orientalism as described by Edward Said: "From at least the end of the eighteenth century until our own day, modern Occidental reactions to Islam have been dominated by a simplified way of thinking that may be called Orientalist. The general basis of Orientalist thought is an imaginative and yet drastically polarized geography dividing the world into two unequal parts, the largest, 'different' one called the Orient, the other, also known as 'our' world, called the Occident or the West."[9] Orientalism can be seen in the numerous ways in which the British and the Indians are polarized, in the emphasis on the exoticism of the Arabian Nights setting, the elaborateness of the Indian costumes, and the emphasis on scenes of intrigue and fighting. Low claims that "in the thirties the cinema public as a whole accepted such films as drama, not as expressions of approval for illiberal attitudes or racial exploitation."[10] The major characters in the film—Carruthers, Azim, Holder, Prince Ghul, and Carruther's wife—are familiar types in the empire film. Carruthers is another variation on Sanders, Prince Ghul a Chief Mofalaba, and Azim a younger, more tractable version of Bosambo.

The major conflict in the film involves Prince Ghul's desire to restore the old days when the British were not in India, countered by the British insistence (with less rhetoric than in *Sanders*) on their prerogative to rule. The film reveals correctly that in order to do so effectively, they must have rulers like Azim and must dispose of threats to British power like Ghul. But, since the dream of an Old Moghul empire has no substance in the film, and since Ghul is the typical hero of melodrama, he fulfills the generalized characteristics of the villain without any unnecessary strain on the

imagination. As in *Elephant Boy*, *The Drum* too focuses on the ritual of initiation whereby the young prince assumes attitudes proper to British rule through the guidance of men like Carruthers. Azim's relationship to Bill Holder associates him in egalitarian fashion with the British, but to adopt this position is to denigrate his highborn position and his relationship to his own people.

The fairy-tale world of *The Thief of Bagdad* (1940), directed by Michael Powell, among others, seems far removed from these films that identify with a particular locale and a particular moment in the history of imperialism, yet the film nonetheless shares many characteristics with the films of empire in its cinematic appropriation of the Orient. The film involves the archetypes of romance and fantasy—a beautiful princess, a dispossessed king who must reinstate himself and defeat a wicked vizier who has usurped his position, magical spells and objects that can defeat the forces of evil and bring the lovers together. The film's Arabian Nights atmosphere is enhanced by Technicolor, which highlights the lavishness of the costumes and the sumptuousness of the palaces and of the magical world discovered by Sabu in his fabulous travels. The characters—the princess (June Duprez), the vizier (Conrad Veidt), the king (John Justin), the street thief (Sabu), and the genie (Rex Ingram)—move through the film as puppets or figures in a dream. What they say is less important than how they look. The symbolism of the "All-Seeing Eye," which Sabu steals, is germane to an understanding of the film's status as spectacle. The fascination with the remote and the exotic, associated with magic and superstition, is communicated through the spectacle. The film self-consciously resists any traffic with realist techniques and the appearance of everyday reality. The Orient, the site of otherness, is evident in the images. Both Duprez and Sabu are photographed in a fashion usually reserved for women and foreigners, in poses designed to highlight their physical attractiveness and to heighten the sense of sexual and cultural difference in a way that makes them exotic and appealing. The narrative resolves itself with the restoration of the king through the efforts of the little beggar, who is unstinting in his loyalty and service to his king. Thus the film, like the other Korda epics, celebrates aristocracy, responsible authority, exceptional human beings, and the defeat of illegitimate seekers of power.

FILMS OF EMPIRE IN WORLD WAR II AND AFTER

Critics have often cited the 1940s as the golden age of British cinema. Not only did the production standards of the films rise, but there was an attempt to create films of recognizable British life, as opposed to Korda's

internationally geared epics and romances. With the coming of the war in 1940, the issue of the role of cinema in relation to the war effort became a government and industry concern. After the initial closing of the movie houses by the government, there was a realization of the importance of entertainment as both a morale booster and a source of propaganda. In fact, Korda's empire films provided an example of cinema as propaganda and entertainment. If the empire formulas, with their Victorian attitudes and class positions, changed somewhat, this was in some measure due to the creation of new attitudes of social solidarity so necessary to the success of the war effort.

Prior to the war, the Colonial Office had been eager to create films that projected a benign image of British rule in Africa, and films such as *Sanders of the River* were geared toward that objective.[11] In 1939, through the impetus of the Ministry of Information, the Colonial Film Unit was formed for the express purpose of creating films that would stimulate colonial cooperation in the war effort, to mitigate criticism of British colonial rule. Although some instructional films were made, the largest category of films shown consisted of war propaganda films. These included information films explaining aspects of the war, films that stressed the necessary sacrifices demanded of the British as well as the colonials as a result of material shortages and changed living conditions, and films that encouraged and praised the colonials for their efforts.[12] In the arena of feature films, Rosaleen Smyth states that "in the campaign to project a favorable image of Britain as a colonial power, the Colonial Office, dissatisfied with the documentary approach of *Men of Africa*, decided to commission a full-length feature film *Men of Two Worlds* (1946) which went into production in 1943."[13] This Technicolor film (1946), directed by Thorold Dickinson, a director whose films were quite different from those of the Kordas, concerns a young black pianist, Kisenga (Robert Adams), who feels committed to return to Africa to teach his people. His reintegration into the community is resisted by members of his tribe, including his mother and sister, who are threatened by his European ways and prefer to retain their traditional way of life. The witch doctor, Magole (Orlando Martins), is the most resistant to the efforts of District Commissioner Randall (Eric Portman), Dr. Catherine Munro (Phyllis Calvert), and Professor Gollner (Arnold Marle) to combat the African sleeping sickness by relocating the tribe to a safer habitat. Magole stirs up the tribe to acts of vengeance through his magic and almost destroys Kisenga. He tells Kisenga that he is an African and wants to live like Africans. The only people he hates are those, like Kisenga, who "pretend to be like white men."

During the struggles of the British community to reeducate the Africans, they are visited by a woman writer who has written about Africa.

Mrs. Upjohn claims that the Africans have the souls of primitives, and she extols instinct over education. She sees the Africans happily working as cheap laborers, and admonishes the commissioner, telling him, "There are worse things than hookworm." Her position is criticized by the commissioner, who is able, with the help of Dr. Munro, to defeat Magole and save Kisenga. Thus the Africans and the whites work together in the interests of saving the tribe. According to Smyth, "Some educated Africans found this simplistic theme 'offensive', with its 'conventional conflict between the familiar caricature of traditional Africa and the new era—claiming to be progressive—ushered in by a colonial power.'"[14]

It is interesting to compare this film with *Sanders of the River*. The omniscient Lord Sandi is replaced by District Commissioner Randall, who is less concerned with law and order and ostensibly more concerned with the health and welfare of the natives. The childlike and easily manipulated Bosambo is replaced by another intermediary, Kisenga, who has had the "benefits" of a British education and is portrayed as speaking to the British in more personal and familiar fashion. The issue of modernization rather than overt colonization speaks in more timely fashion to the situation of the Africans, although it is clearly a case again of the "sophisticated" Europeans versus the "ignorant" and superstitious natives. The opposing position, that of Magole, is made to appear destructive and evil, as having no meaningful basis in the cultural life of the tribe. The film portrays the life of the Litu as primitive, harking back to the Stone Age, and in its zeal to emphasize the benefits of European knowledge and technology, the film reproduces the ethnocentrism of the 1930s films of empire. There is an attempt to tone down the exoticism of those earlier films in presenting the tribal rituals, but inevitably the film lapses into the familiar image of the frenzied natives dancing in the firelight and the ubiquitous drumbeats representing the ancient blood rhythms of the African to which Kisenga almost reverts. As in *Sanders* and *King Solomon's Mines*, the Western sounds of the music of the educated African are juxtaposed to the native African music. Even in the area of culture, it appears that Kisenga is to be an instrument in the eradication of the old customs.

The portrayal of women alters the female stereotypes of the empire film somewhat. Dr. Munro is a physician, not merely the wife or daughter of the governor who supports the official position unquestioningly. Mrs. Upjohn is presented as having a retrograde and primitivistic notion of Africans which is, like Magole's, purposefully slanted to rhetorically dismiss arguments that oppose "progress." Kisenga's mother and sister are allowed a voice in the film, though they too are proved to be impressionable and wrong in their appeals to Kisenga to return to their way of life. In the final analysis, the film seeks to inject a liberalizing element into colonial discourse, but, as Durgnat says, "if this movie is a little thin for

its scope it's because of its too straightforward identification of the Western with the likeable, disinterested, rational and uncomplicatedly progressive."[15] The film bears the scars not only of its polemic objectives, but also of its unexamined assumptions about black and white relationships, about African culture, and about the "benefits" of Europeanization.

Men of Two Worlds is a harbinger of other postwar films that sought to dramatize colonialism and to counterbalance the more blatant portrayals of the 1930s. Most conspicuous among these films are two Ealing productions directed by Harry Watt, *Where No Vultures Fly* (1951) and *West of Zanzibar* (1954). Both films deal with the concern over the destruction of the elephants by ivory traders. Thus, the focus of the films is not conquest of land but the benevolence of the isolated Britisher in preserving the African natural environment and traditional patterns of life. In *Where No Vultures Fly*, a popular and commercially successful Ealing film,[16] Bob Payton (Anthony Steel), a game warden in Kenya, protects the animals of the territory from rapacious white and native hunters. Determined to fight the ivory hunters, Payton resigns from his job and struggles to develop a national park to protect the animals. The film, based on the memoirs of Mervyn Cowie, portrays Payton's struggles with the British authorities, the wealthy instigators of the ivory traffic who exploit the tribesmen and indiscriminately kill the elephants. Payton is successful in tracking down the offenders and bringing them to justice.

The style of the film is, like many Ealing films and many 1940s nonfiction films, built on the shots of landscape and of animals and on the voice-over narration that seeks to "explain" and narrate the events as in an illustrated lecture. Payton is identified with nature and its preservation. His posture as the benevolent white man who seeks to preserve the African culture is never questioned. His benevolent motives for ridding the land of exploiters are taken for granted. He is the positive representation of the new colonialist who administers in the interests of the land. But he is still the figure of authority who makes decisions for the Africans. Significantly, his altruism is on behalf of the animals and not the tribesmen. The Africans are presented as either silent servants, unscrupulous chiefs who have been bought by the ivory hunters, or loyal but silent aides in Payton's searching out of the ringleaders. They need to be instructed in what is best for them, since they seem incapable of knowing on their own what to say or do. The film replays a dominant theme of empire films and, more generally, films that portray indigenous peoples: their inability to speak for themselves.

The film's treatment of Payton's wife (Dinah Sheridan) parallels the treatment of the natives. She is presented as antagonistic to the way of life he chooses for them. She rails against their primitive living conditions, the dangers to which she and her son are subjected, but he silences her objec-

tions, insisting on the importance of his mission, until she is finally re-
duced to assisting him in his endeavors. While the film ostensibly lauds
Payton in his efforts to preserve the land and to use the natives to assist
him in his objective, it also betrays its kinship with the films of empire in
its presentation of the white man as the savior and guide of the Africans.
The film also reveals that the earlier notions of conquest and the theme of
law and order have been softened in the 1950s to project a new image of
stewardship.

West of Zanzibar more directly involves the lives of tribesmen as Bob
Payton (Anthony Steel) again battles ivory traders. The problem of
poaching is traced to the dispossessed tribesmen who live in the towns
and are prey to the blandishments of unscrupulous whites. Payton begins
a journey to the towns to locate the ringleaders, only to discover that even
representatives of the law are unable to stop these marauders. Conse-
quently, he decides to take justice into his own hands, and, with the help
of a native chief whose authority has been disregarded by the young
men in his tribe, tracks down the criminals. The death of the chief unites
the tribesmen and they turn against the ivory trader, who is brought to
justice.

The issue of law and order seems more prominent in this film than in
Where No Vultures Fly. The tradition, however, of the power of institu-
tional law no longer prevails. Paralleling the increasing emphasis in the
American western on vigilante justice, *West of Zanzibar* pits Bob Payton
against the impotent, indifferent, or corrupt representatives of the law.
The film's preoccupation is with male identity—with Payton's and with
the old chief's—and with Payton's restoration of tribal dignity through
the agency of the white man. While the film presents itself on the level of
verbal discourse as sympathetic to the plight of the uprooted Africans, the
style of the film subverts this attitude, making the Africans out to be help-
less children who cannot manage their own affairs. It is not surprising,
therefore, that the film was banned in Kenya. Consonant with so many of
the Ealing films, *West of Zanzibar* focuses on the issue of a community in
need of regeneration not through institutional change but through the
work of a few well-meaning individuals who, through right-mindedness
and personal sacrifice, set matters right.

The confrontation of colonizer and colonized, of European and non-
Westerner, is treated more ambiguously in Ken Annakin's *The Seekers*
(1954). Blatantly adopting the American western formula in a New Zea-
land context, the film is set in the nineteenth century. A British ship ar-
rives on an island in New Zealand. The captain of the ship conducts an
illicit trade in shrunken heads with natives. Using Philip Wayne as an
intermediary, he smuggles the booty into England. The authorities dis-
cover the contraband goods and Wayne is given the choice of prison or

exile. He chooses exile and with his new wife (Glynis Johns) returns to New Zealand, where he makes a new life for himself, has a family, builds a community, and prospers. Relations between the white community and the natives are harmonious until Wayne has sexual relations with the chief's wife. Practicing the Christian virtue of mercy enjoined on him by Wayne's wife, the chief refrains from punishing the woman, though the narrative kills her off during a battle between the warring tribes. The dichotomy between the two women—the European representing domesticity, motherhood, and spirituality, the indigenous woman, sensuality—reenacts the fundamental divisions characteristic of European binary thought. The film portrays the destructive consequences of violence and repressed sexuality as the entire adult white community is wiped out in the conflict between the warring factions. The only survivor is the Wayne baby, found by the chief, Honge Tepe (Inia Te Wiata), who adopts the child.

The familiar motif of the noble savage is reproduced in this film. In contrast to Western culture, the world of the tribesmen is presented as more humane, more closely aligned with nature, more concerned with the question of aggression and violence. The adult society of the white man is shown to be a violation of nature akin to the insubordinate natives. The white woman is presented as a civilizing force, blending Christianity with the native customs. On the one hand, the film denigrates European culture as it is represented through the behavior of the men on the island and in England. But, on the other hand, the film extols those values that the European culture, through Christianity, finds exemplary. The natives are good because they resemble Christians. The survival of the white child, who reminds us of the infant Jesus, recalls the prophecy of peace at the beginning of the film. While the film is critical of European society, it cannot escape its colonizing mentality, which uses the natives to represent its own internal conflicts over sexuality, violence, and aggression.

The films of the 1950s continue to exploit colonial themes, although they are modulated to address changing imperial relations. Brian Desmond Hurst's 1955 film *Simba*, set in Kenya during the Mau Mau uprising, at first situates the white protagonist, Allan Howard (Dirk Bogarde), and the educated black doctor, Karanja (Earl Cameron), outside the political conflicts between the Mau Mau and the enraged white community. Howard arrives in Kenya to discover that his brother, a committed friend of the blacks, has been murdered by the Mau Mau. He falls in love with Mary Crawford (Virginia McKenna), who advocates, like the white doctor (Joseph Tomelty), a policy of friendship with the majority of blacks also terrorized by the Mau Mau. Allan and Mary's relationship founders on their difference of attitude toward the African doctor. Allan suspects him of being in league with the Mau Mau, and she insists that he has to

learn to trust the blacks. When her mother and father are brutally assaulted in their home, Mary's mother refuses to let the black physician come near her. After Mary's parents' death, Karanja informs the authorities that his father is a leader of the Mau Mau. Both Karanja and his father are killed as the natives converge for an attack on Howard's farm. The police arrive in time to save Howard, Mary, and a black child, Joshua, whom Howard has taken in. Karanja dies, cursing his people and saying that they are not worthy of being saved. The last image of the film is of the child, Joshua.

The film dramatizes the failure of moderate positions as exemplified by Mary and Karanja. The final sequences of the police hunting down the Mau Mau portray an unmitigated state of violence and anarchy. The isolated image of the white man and woman with the black child can be read as signifying the marginality of the white liberal. It can also be interpreted as the promise of a new relationship in the future with a different generation of Africans. By transposing the political conflict between the blacks and whites to a more personal register and examining the ways in which the white community has been portrayed in the film, it is possible to see that the film is using the Africans to explore British conflicts. The most curious scene in the film, and one that could merely be written off as poorly acted, is the love scene between Mary and Allan. The lovemaking is characterized by the couple's awkward grasping of one another as she refuses his offer of marriage, insisting that their attitudes toward the blacks separate them. Her relationship with Dr. Karanja is equally awkward as he comes to beg for her friendship, acknowledging his own complicity in not informing on his father sooner, for which he feels guilty.

The film flirts with a relationship between the white woman and the black man, but kills Karanja off as if to finally negate the possibility of a sexual liaison between the two. The parentless young black boy, Joshua, who looks down at the body of the dead man, is offered as a less threatening surrogate for Karanja, who has occupied a disturbing position in the film. Despised by the police, mistrusted by members of the white community, and rejected by his father, he portrays the contradictory position of the educated black man. His death signifies the destruction of the efficacy and power of the black intermediary so necessary in earlier films for the maintenance of cooperation between the tribesmen and the whites. The film acknowledges the destructive effects of imperialism and the virulence of racism through the martyrdom of this moderate black figure, but, on the other hand, it reveals its fears and reservations about future relations between Britisher and African. The narrative focuses on the whites in their struggle to adjust to inevitable social changes, and, in the treatment of Karanja, throws obstacles in the way of union with or even understanding of the Africans. While the film is critical of blatant forms of

racism, in the name of abhorrence of violence, it falls prey itself to a condescending treatment of rebellious tribesmen similar to earlier representations of Africans.

Most of the British films of empire and colonialism are associated with regions of the globe remote from England—India, Burma, New Zealand, and Australia—but they are occasionally set in regions closer to home. While topics involving Ireland and the issue of republicanism were censorable in the 1930s and 1940s, and while the British cinema cannot boast a large number of films treating the historical conflict between Britain and Ireland, there have been some British films that were acceptable since they did not present a revolutionary image of the Irish republican struggle. In the films produced during World War II, such as *Halfway House* (1944), directed by Basil Dearden, the emphasis was on the need for Irish-British cooperation, a critique of Irish neutrality during the war, and a plea for the putting aside of enmity in the confrontation of a common enemy. *I See a Dark Stranger* reiterates this motif.

In the postwar era, one of the few films to tackle British exploitation in Ireland was Launder's *Captain Boycott* (1947). Films such as Reed's *Odd Man Out* (1947), while again undertaking Irish politics, distort the nature of Irish republicanism in their focus on the melodrama of betrayal. Brian Desmond Hurst's costume drama *Hungry Hill* (1947) comes somewhat closer to dramatizing the grievances of the Irish people through its portrayal of English landlords. The 1950s, too, was not particularly distinguished by films that addressed British-Irish relations, and when they did they were most likely to concentrate on the negative aspects of the IRA, the self-defeating nature of the Irish and their misplaced encouragement of violence. In 1952, Ealing Studios produced *The Gentle Gunman*, directed by Basil Dearden and starring John Mills and Dirk Bogarde. In this film, the IRA is presented as uncaring, violent terrorists in much the same way that the natives in the African films were presented. If the Irish are not presented as childlike, they are portrayed as fanatical, mad, or violent.

In *The Gentle Gunman*, a converted terrorist (John Mills) struggles to save his brother from the grips of the IRA. The film opens outside a house as two men are heard arguing about an IRA bombing. The Irish doctor tells his English friend, "You have to be an Irishman to see the point of setting off a bomb in a crowded tube station." The Englishman argues that there is a difference between gunmen and soldiers. The scene then shifts to England as a young man (Dirk Bogarde) comes to an apartment house to collect a bomb to be placed in a tube station. He is thwarted by his brother, Terry (Mills), who tells him, "There are better ways of serving your country than dying for it." Terry is marked as an informer, a target for IRA retaliation. In Ireland, a young man, Johnny (James Ken-

ney), is eager to serve the cause, although his mother begs him to stay out of trouble. In spite of his mother's warnings, Johnny agrees to help the men get information about an Irish political prisoner. He is badly wounded in a scuffle between the police and the IRA and taken to Dr. Brannigan (Joseph Tomelty), who tries to save his life. Returning to Ireland, Terry is vilified by his former fiancée, Maureen (Elizabeth Sellars), who throughout the film is portrayed as fanatical about the necessity of struggle, sacrifice, and death. Molly, Johnny's mother, accuses her of "being in love with death."

The film includes several typical cops-and-robbers scenes of confrontations, stressing the lawlessness, authoritarianism, folly, cold-bloodedness, and incompetence of the IRA. They are shown as attacking children, blindly using and causing the death of young men like Johnny, and sacrificing innocent lives for "the cause." Terry finally manages to wean his brother from this way of life. In many ways, the film, like so many of the empire films that mystify the political issues, seems to be using the overt politics to explore more immediate concerns or fears about conventional conceptions of manhood and male bonding. The issue of cowardice is tied to a predominant theme of the 1950s films, the concern with male identity. The relationship of the two brothers is juxtaposed to the relationship of the gunmen, and it is the gunmen's relationship that prevails.

The film precludes any possibility of heterosexual love. John Hill comments that "the film's rejection of violence necessarily requires a rejection of Maureen, and the sexuality she has to offer. . . . In the absence of any other young female characters in the film, the rejection of Maureen becomes tantamount to a rejection of female sexuality *per se*. It is the restoration of male camaraderie which closes off the narrative and in a way, moreover, that is ambivalently homosexual, especially given the Bogarde persona."[17] Hill validates that the film's overt political issues mask a more fundamental form of sexual politics in which, contrary to the ethos of films of war, intrigue, and adventure, the "brothers" are in retreat from traditional conceptions of maleness, violence, and aggression but the film can articulate these only through its relegation of women to the roles of impotent mothers or threatening and castrating partners.

Shake Hands with the Devil (1959) also takes as its subject the world of the IRA. A young Irish-American (Don Murray) who is studying in Dublin to be a physician is drawn into the civil war. He becomes involved in the retaliatory kidnapping of the daughter of a British official, Jennifer (Dana Wynter), as a consequence of the jailing of one of the IRA supporters, an upper-class Anglo-Irishwoman. Kerry functions as an outsider, an ambivalent witness to the internal affairs of the IRA. He is presented as an observer to the destruction of innocent people, finally turning his back on the leaders of the struggle. He tells the zealot Lenihan (James Cagney) that "no war is worth winning if you forget mercy." Unlike in *The Gentle*

Gunman, the women in this film, Jennifer and Kitty (Glynis Johns), offer alternatives to violence, but they are also victims of brutality. Kitty, who has earlier exposed Lenihan as desiring her and denying his desire, is brutally murdered by him as an informer. Kerry abandons his loyalty to the IRA to save Jennifer. Personal relationships are portrayed as taking precedence over political struggle. Nonetheless, politics is associated with passion, whereas personal relationships are linked to quietism, the quelling of destructive desires generated by wholehearted commitment. Lenihan is portrayed as a self-denying figure whose fanaticism is linked to his misogyny. His unwillingness to compromise becomes associated with his vengeful treatment of both women and his recoiling from sexual relations. His relationship to the men, and to Kerry in particular, cannot be sullied by women. His brutal insistence on excluding women from the deliberations of the IRA reveals his fear of women's pollution, his fear of sullying his relationship to the men with the taint of female sexuality. His pumping bullets into Kitty as she walks toward him has the quality of an orgasmic release, denied him on the beach when she emerges from the water after her swim, explicitly equating death and sexuality.

The film seems to be echoing a familiar myth of the Irish as worshipping death. The effects of colonialism are thus seen to be traceable to the attitudes of the colonized and not their colonizers. Kerry's disavowal of Lenihan is couched in the context of oedipal struggle. By killing his father surrogate, Kerry is able to disavow the values with which Lenihan was associated and to acquire a new identity. Moreover, by making Kerry an Irish-American, the text exonerates his behavior in killing the Irish leader. The film plays with traditional fears about the Irish, and, like the other films of empire, resorts to the strategy of portraying the antagonists not only as fanatical but as sexually threatening as well. The motives for the struggle against the British are, as in the films involving imperialism in Africa, mystified, attributed to "natural" defects stemming from violence and aggression related to sexual repression or promiscuity. The political issues are displaced onto the personal and the romantic realms. The protagonist's conversion is cast in a melodramatic context that depends on the portrayal of the conflict as a Manichean struggle between justice, fair play, and decency on the one hand, and coercion, brutality, and a perverse sense of loyalty on the other. As in classical melodrama, the female figures are the bearers of culture and civilization, and the violence perpetrated against them provides the necessary underpinning to dramatize the barbarism of the IRA. The film is instructive specifically in the ways in which it portrays the strategies for maintaining British hegemony, involving the deracination of the protagonist and his initiation into more "civilized" forms of behavior.

If the films of the 1930s portray a male protagonist who learns to accept his social fate, seeing himself as a link in the chain of service and

command that legitimates his use of power, the films of the 1950s seem to be uneasy with their male protagonists. Above all, the 1930s ethos of clear-cut commitment in the name of higher ideals is now placed in the mouths of fanatics. For example, when Lenihan tells Kerry that "we're fighting uniforms, not faces," and Kerry rejects this position, the film reveals how far it has moved from a stance of confidence in the political efficacy of imperialism to one of seeking legitimation through the deployment of more personal, psychological, and familial appeals.

WAR FILMS: WORLD WAR I

Films portraying combat or intrigue set during World War I are less abundant than those involving World War II. The films of the 1930s that concern the Great War are closely akin to the ideology of the empire films. They do not question the values associated with fighting and dying but assume a community of shared values inherited from the past and worthy of defending. They deplore the carnage of war, although they do not question the necessity of duty. Anthony Asquith's *Tell England* (1931; remade by Peter Weir in 1981 as *Gallipoli*), a film begun as a silent film to which sound was later added, is the saga of two well-bred young men, Edgar (Carl Harbord) and Rupert (Tony Bruce) who go to fight in Gallipoli. The opening sequences of the film stress their upper-class background, their close relationship to their parents, and their athletic prowess. The young men's identification with competitive sports is developed in scenes of them at a swimming meet. The camera pans the cheering spectators and Edgar's proud mother (Fay Compton) and friend. The sequences emphasize a connection between sports, the public school, and male camaraderie. The meet provides another link in the chain of incidents that Asquith enumerates to emphasize the youth and physical attractiveness of the men. With the coming of the war, both Edgar and Rupert are conscripted. When Rupert is questioned by an officer about his background, he informs him that he did modern studies, while Edgar is a classicist. The officer asks Edgar to recite the lines from the monument at Thermopylae, "Passerby, tell Sparta that we die here obedient to her command."

When Edgar and Rupert learn that they are going to Gallipoli, they inform their families. The scene of Rupert with his father is understated as the father offers him a drink as a mark of their adult relationship, whereas Edgar's visit with his mother is emotional, portraying the mother's anguish over her son's departure. The film jumps to extended scenes of carnage as the British ships arrive at Gallipoli and the men attempt to come ashore in the face of Turkish gunfire. The camaraderie of the officers on the ship contrasts starkly with the scenes of war that fol-

low. When the captain dies, Rupert is put in command, and his relations with Edgar begin to deteriorate as Rupert questions Edgar's courage. On a mission the next day, Edgar redeems himself by fighting bravely, only to be mortally wounded. The film ends with the image of a monument on which is inscribed, "Tell England, ye who pass this monument, we died for her and here we rest content."

According to Rachael Low, "the strangled patrician characterisation and dialogue and the true-blue patriotism seemed out of date."[18] In a similar vein, Raymond Durgnat finds that "*Tell England* . . . evokes, delicately, the beauties of the Edwardian order."[19] But it is, after all, the classicist, Edgar, who dies. Despite the film's nostalgia and muted sentiment, *Tell England* poignantly dramatizes the relationship between the two young men, and the development of their friendship is as important as, if not more overriding than, the scenes of combat. Edgar's death at the end ostensibly represents the waste of war and the futility of sacrifice. More fundamentally, though, the film seems to signal the familiar equation between love and death. As in other films with their female-male relations, this drama of two young upper-class men situates their "romance" within the context of war and portrays the ultimate futility of the friendship.

Although the film seems to thrive on sentiments that are consonant with conventional Edwardian, patrician attitudes toward behavior, there are more interesting and personal undercurrents involving male relationships. The film does not even hint at a romantic element. Rather, the camera lovingly lavishes attention on the men, implying a closeness that seems more important than either's relationship to his parents or to the war. *Tell England* is exemplary of the films of war and empire in its emphasis on mateship. The relationship between the men under trial conditions is more important than the actual battle scenes. While, in many combat films, battle scenes are crucial for representing the consummate trial for the protagonist, Asquith's film highlights the effects of combat on the two young men. Domestic scenes are presented not only to contrast with the rigors of war but to stress the bond between the men. Hence, the protagonists are provided with a sense of identity that redeems them from the charge of unmotivated violence.

Characteristic of the war film, *Tell England* eschews an analytic treatment of the causes of the war and of the political or moral issues involved in the conflict. History is abrogated in favor of broader melodramatic categories of good and evil to distinguish between "sides," conveyed in the iconography of hero and villain. The film relies on the audience's identification with the protagonists rather than the issues. The debacle of Gallipoli is subordinated to the personal issues, the struggles of the men to survive under brutal conditions and particularly their conflicts with each other. Their closeness is portrayed less through the verbal inter-

changes than through the way the camera lingers on each and on the two men together. In the language of silent cinema, the film registers their fascination with each other and their mutual dependency even under hostile circumstances.

In *Tell England*, the British are the focal point, and the film avoids personalizing the enemy. Instead, only the British characters are developed, as well as the relationships among the men under conditions of stress. In Asquith's film as well as in the war film generally, the conflicts center around the personal redemption of the hero, who becomes reconciled to a sense of duty and to his relations with his comrades. He redeems himself from the charge of fear or cowardice in the eyes of his comrades. The films often involve a close relationship between two men, one of whom dies. This death serves to separate the men, much as lovers in the romantic melodrama are parted, thus keeping the memory "forever young" as well as precluding future intimacy. While the battle scenes and the death of the young men may portray the horrors of war, the emphasis is on male bonding.

Women are part of the background, usually invoked through flashback, and associated with a past that the young man must leave behind. The figure of the mother, while cryptic and stereotyped in her devotion to the son, also carries other meanings. As Simone de Beauvoir writes in another context, "The fact is a man most often wins against his mother's will the trophies which she dreamed of gaining as personal adornments. . . . In order to justify his life—and that of his mother—he must go onward, transcend his life, toward certain ends and aims; and to attain them he is led to risk his health, to court danger."[20] Her statements are a reminder that the role of the mother, though truncated, is crucial to the film and as important to the development of the young men as the set and stagey scene of the farewell between Rupert and his father. Although the paternal figure may serve as the final court of appeal to affirm a young man's sacrifice, the films are not totally silent about the mother-son bond, and in the Asquith film, this relationship seems more emotional and less stereotyped, more integral to the development of the young men.

The mother-son relationship recurs in a similar vein in *Forever England* (1935), directed by Walter Forde with Anthony Asquith as the second unit director. This film is also set in World War I and deals with the symbolic union of father and son with the mother as the intermediary in that process, a common motif in the war film. The film was remade in 1953 as *Single-Handed* with Wendy Hiller, Jeffrey Hunter, and Michael Rennie. *Forever England* begins in 1893 with the whirlwind affair of a working-class woman (Betty Balfour) and a young naval officer (Barry McKay). Lieutenant Somerville returns to active service after Elizabeth refuses to marry him, claiming that she is below his station in life. She has

a son, Albert (John Mills), who becomes a seaman as a consequence of her indoctrinating him with the values of the Royal Navy. Albert becomes an exemplary seaman and distinguishes himself when, at the cost of his life, he single-handedly escapes from a German ship where he has been held captive and holds the men at bay with his gun until a British ship arrives. The captain of the British ship is his father, who learns of his paternity when he finds a timepiece that he had given Elizabeth among the dead seaman's belongings.

The narrative is built on the postponement of the recognition scene. The pocket watch which becomes the link between father and son had belonged to Somerville's grandfather and father, also naval men, and becomes the signifier of the oedipal conflict. The romance between the man and woman which is not consummated in marriage is overshadowed by the romance between the mother and the son. When he comes home on leave, he teases her about women but then tells her that she is "his girl" when she appears upset over the possibility that he has found a young woman. Before he leaves for duty again, she gives him the pocket watch Somerville had entrusted to her. She withholds the father's identity from her son, merely telling Albert that "he passed out of our lives." After she gives Albert the watch, she disappears from the narrative. The pocket watch remains as the only reminder of the mother's presence and relationship to the young man, but assumes greater importance as the instrument for uniting father and son. It is also the token of legitimacy. In his act of heroic sacrifice, the son becomes legitimate. By giving Albert the watch, the mother has also broken the tie between herself and her son, handing him over to the father. The son never learns his father's identity. Paternity for the son is an abstraction, associated with the navy and unquestioning service. Thus, the film not only establishes the mother as the figure who nurtures and relinquishes a heroic son, but reveals the father's prior claim in his reappropriation of the watch. The film's actual project is not the son's recognition of the father but the father's recognition of the son. The film's emphasis on fathers and sons is reinforced by the parallel between Somerville's loss of his son and the German captain's loss of his. Heroic duty, patriotism, and service are the ostensible values of the film, but in taking on the issue of paternity, the film, like many war films, establishes the necessary and familiar equation of family legitimacy, service, and patriarchy.

ESPIONAGE FILMS AND THE COMING OF WORLD WAR II

The interwar cinema became increasingly attuned to the possibility of another war. In both historical and contemporary settings, films of espionage began to address foreign threats to national security and the need for

preparedness. The espionage film, while a genre in its own right, is often dissociated from the films related to war, and yet many of the films of the late 1930s capitalize on an atmosphere of uncertainty, paranoia, and physical and verbal belligerence. The narrative is geared to exposing the threatening identity of the foreign agents, their aggressive quest for information harmful to the British, and especially their violence. Then they are captured. After working for Michael Balcon, Victor Saville joined Somlo Productions in 1936, funded by Alexander Korda. The first film produced by the company was *Dark Journey* (1937), an espionage film starring Vivien Leigh as Madeleine, a double agent in World War I, who passes herself off as a German sympathizer while actually delivering important military secrets to the French and British. Conrad Veidt as Baron von Marvitz poses as a German playboy who has been discredited as a traitor by his people, while he is, in fact, working for the Germans. The two fall in love, but Madeleine's duty to the cause is greater than her love, and she is instrumental in the baron's capture.

Like Korda films, *Dark Journey* is a star vehicle highlighting Leigh and Veidt.[21] Characteristic of the espionage film, the female is treated as a mysterious, exotic object of desire whose motives are ambiguous. The photography plays up Leigh's beauty, and her role as a dress designer allows for scenes that show her in various costumes, making spectacle coequal with adventure and intrigue. Before her identity is known, she is presented as a femme fatale, a mysterious Mata Hari. Her romantic involvement with Veidt follows the Korda formula of providing a voyeuristic look into the world of the upper classes. She is a successful designer, he, a suave playboy aristocrat. The film capitalizes as well on Veidt's foreignness, his worldliness, and, above all, the enigmas surrounding his status and actions. The couple provides the necessary ingredients of sexual conflict, spectacle, and suspense required of espionage films. The film adheres to the classic outline of the espionage film. In this formula, the action usually involves a journey by train and boat in which information and confidences are exchanged. The travelers are frequently in disguise, and the sense of dependability of character is eroded in a world where deceit and impersonation flourish. The aura of espionage is enhanced by the attractiveness of both protagonists and antagonists. The environment is usually an international one, though the emphasis is on the issue of national identity and national traits as the final lines are drawn between friendly and hostile forces. A montage of maps and other secret devices also emphasizes, as it does in *Dark Journey,* the sinister qualities of espionage.

There is little attempt, however, to indicate what is at stake in the war. Hostilities are dramatized by the attack on ships, but the enemy, unlike antagonists in combat films, is not presented as crassly brutal but as

clever, if not witty and urbane. The knowledge that the Germans are the "enemy" again depends on the audience's prior and superficial knowledge of the circumstances of the war. More important, though, are the various scenes of chase and escape in which the protagonist is at least threatened with capture, if not momentarily captured. These narratives are dependent on the exchange of information, and much of the film is occupied with establishing the credibility of the informant as crucial to the safety and survival of the protagonist. The element of romance further complicates the narrative. The romantic element not only adds to the aura of secrecy and intrigue surrounding the problem of acquiring the necessary knowledge to defeat the enemy but also situates the conflicts in the context of power struggles not only among men but also between men and women. The investigative process serves to define identity, legitimacy, and power in social and sexual terms.

In his study *Alfred Hitchcock and the British Cinema*, Tom Ryall states that "during the years from the Quota Act to 1933, spy pictures appeared intermittently in the schedules of a number of British companies but it is between 1934 and 1938 that they begin to appear with any degree of regularity."[22] Hitchcock was to contribute significantly to the rise of such films. Ryall situates such Hitchcock films as *The Man Who Knew Too Much* (1934), *The 39 Steps* (1935), *Sabotage* (1936), *Secret Agent* (1936), and *The Lady Vanishes* (1938) within the genre of espionage/ thriller films. His contributions in the 1930s helped raise the quality of this genre.

Hitchcock's work has been discussed mainly from the perspective of auteurist criticism, "with its sense of film maker as creator, as visionary and as moralist."[23] In focusing on the unique contributions of Hitchcock's "vision," critics have disregarded the ways in which films are a collective enterprise, determined also by the stars, the writers, the economics of production, and the genre conventions in which the films are made. Most particularly, the case of Hitchcock is a challenging one for the critic who seeks to situate production within the context of a national cinema. By isolating Hitchcock from other British filmmakers, critics misrepresent both his work and the work of other British filmmakers. An analysis of Hitchcock's British films reveals limitations in the strict application of auteur theory. In identifying films with the director's unique and personal vision, there is a suppression of those qualities and attitudes in his work that are more broadly characteristic of the British cinema and British genres. By derogating the genre work of the 1930s and 1940s and elevating the realist mode to a prominent position, critics have often overlooked those qualities which have "some claim to national distinctiveness and which can be regarded as an embodiment of specifically English character traits and preoccupations."[24]

In *The 39 Steps*, made for Balcon and based on John Buchan's popular stories concerning espionage during World War I, the film's locale is particularly English. In the initial scenes, the film captures the aura of the music hall environment and caricatures its largely working-class audience preoccupied with problems of everyday life.[25] The scene on the train after Miss Anabella Smith's (Lucie Mannheim) murder in Hannay's (Robert Donat) apartment features a prim clergyman who listens to a salesman featuring his wares of women's undergarments and serves to highlight the film's preoccupation with female clothing. The atmosphere of the train station and the crowded railway carriage allow scope to focus on various British types, a feature also of Walter Forde's thriller *Rome Express* (1932). The scene in the Scottish countryside as Hannay escapes his pursuers is also reminiscent of Asquith's *A Cottage on Dartmoor* (1930). The crofter's cottage as well as the crusty character of the crofter himself (John Laurie) are built on stereotypes of Scottish country life, as are the owners of the inn in which Hannay and Pamela (Madeleine Carroll) find themselves. Two scenes in particular merge context and adventure—Hannay's joining of the Salvation Army procession to escape his pursuers, and his attempt to hide at a political meeting where he poses as the speaker of the evening and sways the audience. The ending at the London Palladium features a more sedate picture of British entertainment but also reinforces the film's penchant for providing an "authentic" milieu. In all of the scenes in which the audience is highlighted, the film makes an attempt to create a sense of individuals as social types.

The physical characteristics as well as the behavior of the film's major characters belong also to the developing pantheon of British cinema types. Robert Donat lives up to his screen image as the epitome of the English gentleman, although the film identifies him as a Canadian. His masquerading for Pamela as a bloodthirsty criminal, the heir of a long line of criminals, violates both his star persona and Hannay's character. Madeleine Carroll, who was, like Donat, also becoming familiar to American audiences, embodies the stereotypical qualities of the upperclass Englishwoman—cool, reserved, ladylike, and self-righteous—while Lucie Mannheim, the foreign female, is associated with a shady past and is highly emotional. It has become commonplace to discuss Hitchcock's penchant for cool, blonde leading ladies, but he shares this predilection with other British filmmakers of the period for stars characterized by Sue Aspinall as possessing "the kind of poise that comes from knowing one's place in the world and from expecting respect."[26]

As in other Hitchcock films, the position of the female provides a clue to the film's more subversive implications which link the public aspects of espionage to sexual politics. The conflict between Pamela and Hannay runs parallel to the search for the conspirators and also concerns ques-

tions of identity and power. While Pamela believes Hannay to be a noto-rious criminal, Hannay must guard against her subversion of his efforts to locate the master criminal. The bedroom scene in which the two are yoked together under the pretense of being man and wife, yet another instance of misrepresentation, dramatizes the sense in which Hannay's world is fraught with threats to his identity posed especially by a female. The narrative is constructed according to the requirements of the espio-nage thriller. The particular generic characteristic of the espionage film is its preoccupation with exposing secrets, with the gaining of access to withheld information. This preoccupation with knowledge is epitomized in the figure of Mr. Memory, whom we meet performing in the music hall and who becomes a linchpin in the struggle to gain access to information.

Most particularly, the film involves the discovery of identity. Initially the question of identity revolves around Hannay and Miss Smith as he questions her in predictable fashion to discover who she is and to test the probity of her words. Having established by her death the veracity of her statements, Hannay then becomes the focal point of the narrative. His credibility is not in doubt for the external audience, which has been priv-ileged to witness that he is an innocent bystander involved, in spite of himself, in the tracking down of the conspirators. His identity is misper-ceived, however, by everyone else, including Pamela. Her appearance and behavior guarantee that she is on the side of the law, but, like the police, she too confuses Hannay's and the conspirators' identities. In this respect, the film fulfills a prime requisite of the espionage thriller, the transmission of the sense in which the threat to society is pervasive and arising from an atmosphere of mistrust which makes everyone vulnerable to misrecogni-tion in both the public and private spheres. Before the "truth" can emerge, there has to be a sorting out of "fact" from "fiction," and the emphasis on the element of performance before an audience first clouds and then resolves the problem through the intervention of figures who serve the purpose of detection. As Ryall indicates, "the world of the spy thriller centres on the perceptions of the central figure, the hero, and this usually means a world perceived as mysterious, conspiratorial, poten-tially evil and paranoia-inducing."[27]

The specific details of the spies' motives or strategies are withheld. Ini-tially the film tells us that the "enemy" is planning to blow up England once a certain secret falls into the hands of the wrong people, but the film moves seamlessly from episode to episode, concentrating on the chase and encounter scenes and giving little information about the history, mo-tives, and antecedents of the spies. In relation to the audience, the espio-nage film fuses concern about factual information with the paranoid at-mosphere of uncertainty. The audience, deflected from curiosity about the real nature of the antagonists, is preoccupied with their struggle,

driven to see and to know what will happen to them and seeking relief and satisfaction from the threats confronting the protagonists. If the film addresses the politics of the time, this address is only indirect and general-ized; the film eludes a straightforward allegorizing of characters and events. The film conjures up an atmosphere of paranoia and mistrust that can only be read as paralleling in a vague way the malaise of the pre–World War II period. The characters' conflicts center more on immediate physical and psychic threats to the individual than on a confrontation with specifically identifiable political situations. As many critics have noted, Hitchcock's politics in all of his films, thrillers and espionage films alike, are most illuminating for what they expose about the private sphere, particularly about gender relations and sexual transgression, the eruption of private desire into the public arena. While the films adopt the narrative strategy of exposing and punishing hostile forces, they are more challenging for the ways in which they adopt familiar, and hence un-threatening, genre conventions to undermine prevailing social attitudes.

Late in the decade, these espionage films not only increased but became more sensitive to specific political issues. According to Aldgate and Richards, "spy films appeared to predominate throughout most of 1939."[28] The American director Tim Whelan, under contract to Korda, was selected to direct *Q Planes*. Censorship inhibited the specific por-trayal of the enemy as German, and so the identity of the spies, despite their foreign accents, remains ambiguous. *Q Planes* (1939) involves the mysterious disappearance of specially designed aircraft. Major Ham-mond (Ralph Richardson) of the secret service insists that the planes are missing owing to sabotage, but finds himself thwarted at every turn by the stupidity of the industrialist manufacturing the planes, the resistance of the government to assisting in the discovery of espionage, the treacherous activity of British employees, and the impatience and notoriety of the press.

The film combines intrigue and humor, a characteristic of many espio-nage and thriller films, since their investigative process depends as much on verbal aggression and stereotyping of characters as it does on physical threats. Through verbal diminution, the espionage film isolates those fig-ures who represent obstructions to knowledge and action. As Hammond marches through the film with his ubiquitous umbrella, he exposes the complacency, resistance, and wrong-headedness of most of the individu-als he encounters. As the film nears its resolution, Hammond insists that he is absolutely right, that everyone else is wrong. While he represents the crusading figure who finally pieces together the information necessary to expose the acts of espionage, Tony McVane (Laurence Olivier) provides the necessary leadership and brawn to capture the ship that has been bringing down the planes. Valerie Hobson as Hammond's sister, Kay, is

an intrepid and fast-talking newspaper reporter who brings in the news. She and McVane are portrayed as the inevitable antagonists who eventually fall in love. She is instrumental in providing her brother with the information about the ship, although she fails to stop him from taking up another doomed plane.

The character of Hammond is the prototype of the urbane secret service man who functions independently, even in opposition to his superiors. His umbrella, which he carries everywhere, seems to be a satiric allusion to Chamberlain. His dogmatic insistence on being right constitutes a further parallel. The two women in the film are presented as more obstructive than helpful. Hammond's friend Daphne is associated with the telephone and with a message that she tries to deliver to him that is never communicated. Kay is shown to be meddling, if not wrong, until she learns to follow orders. In this man's world governed by the quest for information and suitable action, women are a nuisance factor, even at their most ideal. The film dramatizes men's need to acknowledge a danger to national security and to act appropriately.

Historical settings are pretexts for espionage. Elvey's *The Spy of Napoleon* (1936) takes place in France under Louis Napoleon. Threatened by the impending Franco-Prussian War, Louis Napoleon (Frank Vosper) enlists the help of a young woman, Eloise (Dolly Haas), his illegitimate daughter, to spy for him against the Germans. She is married to a young nobleman who has been sentenced to death for plotting against the emperor. The young man, Gerard de Lancy (Richard Barthelmess), is offered his life in exchange for permanent exile. Eloise is given a title so that she can move freely in society and thereby discover plots against the emperor. The couple meet again on the Continent, where they become embroiled with the Germans and learn that the Germans are negotiating with the American, Gatling, for a new gun and that France will stand alone, deserted by Italy and Austria, in a war against Germany. They attempt to get this information to the emperor, but they are betrayed by his advisors. The French lose the war and the emperor is forced to surrender to Bismarck. The opposition in the film between the French and the Germans invites a parallel between the 1870s and the 1930s and seems to be a warning about the military designs of the Germans. The emperor and his chief of police, preoccupied with subversion at home, neglect to take seriously the real threat and, as a consequence, are caught unprepared. The emperor is presented as a well-meaning but tragic man who is unable to cope with internal and external threats to his nation.

A much more popular costume drama, made two years earlier than *The Spy of Napoleon* and featuring espionage, was *The Scarlet Pimpernel* (1934), starring Leslie Howard and Merle Oberon and directed by Harold Young. (The film was remade in 1950 as *The Elusive Pimpernel* with

David Niven and Margaret Leighton as stars.) The film was to be the basis for a more contemporary version of the same story, *Pimpernel Smith* (1941), also starring Leslie Howard. The 1934 film, produced by Alexander Korda, was based on the novel by Baroness Orczy and concerns the attempts of an English nobleman, Sir Percy Blakeney, to save French aristocrats from the guillotine during the French Revolution. Assuming the mysterious identity of the Scarlet Pimpernel, under many disguises he invades French territory and abducts threatened aristocrats from under the nose of the French authorities. His wife, Marguerite (Merle Oberon), does not know of Sir Percy's activities and believes that he is nothing but a fop, the role he chooses to play to cover his identity as patriot. The relationship between husband and wife is further strained by Sir Percy's belief that his wife has betrayed aristocrats to Robespierre and his followers, in particular to Chauvelin (Raymond Massey), who is a fanatical supporter of the Revolution. Marguerite finally discovers her husband's identity as the Pimpernel and seeks to save him from Chauvelin, to whom she has unwittingly delivered information about the Pimpernel's arrival in France. Sir Percy and his men, however, are able to undermine Chauvelin, save more aristocrats, and escape again to England.

The film is structured by the antagonism between Blakeney and Chauvelin, who has come to England to trap the Pimpernel. A ball is the setting for intrigue as Marguerite is blackmailed by Chauvelin in an attempt to extort information about the Pimpernel. The history serves, as in the other Korda films, to emphasize the prerogatives of the British upper classes, who are made to appear glamorous in contrast to the toothless and bloated characters who represent the revolutionary masses. Both Merle Oberon and Leslie Howard are often filmed in close-up through filters, thus highlighting their uniqueness and beauty. The sense of spectacle in the film is generated through their appearance and behavior—their physiognomy, costume, and gesture.

The motif of saving victims from the Revolution becomes a pretext for portraying the familiar competitiveness between Englishmen and foreigners, with the foreigners getting the worse end of the stick. British nationalism surfaces in this contrast between French and English as the French are shown to have lost control of their society. The French revolutionaries are shown to be mean-spirited, inflexible, and, above all, bores. By contrast, the Englishman as exemplified by Sir Percy is the consummate image of gallantry and wit in both his public and private conduct. His scrupulous sense of duty does not stop with his ferreting out of public enemies but extends to his exacting comparable behavior from his wife. The issue of class is uppermost here in the iconography of the characters as well as in their behavior. The film does not question the saving of the aristocrats. It

takes for granted that the Pimpernel is doing the right thing, and it portrays, moreover, the superiority of the aristocrats over the plebeians. Not only are the aristocrats more beautiful but they are more cultured. Even in his role as a fop, Sir Percy is able to outsmart his duller colleagues. His greatest weapon is not a lethal instrument but his cleverness and wit. The Pimpernel is related to the protagonist of the films of empire. He is the incarnation of the consummate British gentleman.

THE ESPIONAGE FILM AND WORLD WAR II

With the coming of World War II and the mobilizing of the British film industry to create films that would combine entertainment and propaganda, espionage films were molded to suit the exigencies of war. The identities of the antagonists became more specific as an iconography and a rhetoric of nazism emerged. These wartime espionage films involved such situations as the gaining of important military information, the penetration of enemy territory for the destruction of secret installations, and the rescue of important military personnel, scientists, and intellectuals. The protagonists are often members of the secret service, military men assigned to a special mission, or committed intellectuals working with the government for the war effort.

Combining humor, intrigue, romance, and didacticism in the interests of creating an effective propaganda vehicle, Leslie Howard's *Pimpernel Smith* (1941) attempts to follow the earlier *Scarlet Pimpernel*, transposing the conflict between aristocrats and the "rabble" to one between British intellectuals and Nazi barbarians. In the film he assumes a double identity as an absentminded professor of antiquity and as "The Shadow," an intrepid rescuer of German intellectuals from the clutches of the Nazis. Taking a group of students with him for the ostensible purpose of archaeological work, Smith assists in rescuing anti-Fascist artists, journalists, and intellectuals. He meets Ludmilla Koslowski (Mary Morris), whose father has been imprisoned by the Nazis and who has been coerced by General von Graum (Francis L. Sullivan) to spy on Smith. The two fall in love and, as a consequence, Smith abandons his negative attitudes toward women. He rescues Ludmilla from von Graum's clutches and is almost trapped himself but manages to evade his captors.

The film hinges on the opposition between barbarism and civilization. As a professor of antiquity, Smith represents the best of Western culture, art, philosophy, and literature, in contrast to von Graum, whom he describes as a "doomed captain of murderers." Von Graum praises the new German god of violence: to him, violence means power, and through power, strength, and violence the Germans will rule the world. Smith's

attachment to a statue of Aphrodite symbolizes his quest for perfection. In the rescue motif, in pitting the professor against the Nazis, the film exposes the Nazi police state and its aggrandizing designs and also sets up an alternative in the figure of the professor—in his profession, physical appearance, dialogue, and especially wit. His lean, ascetic appearance is contrasted with that of the corpulent von Graum. His self-control and discipline contrasts with von Graum's obsessiveness and arbitrariness. His sense of humor contrasts with the Germans' inability to understand humor. Although he reads British literature, von Graum cannot understand the humor of Lewis Carroll, Edward Lear, or P. G. Wodehouse. As in Asquith's *The Demi-Paradise* (1943), humor is presented as the secret of English survival, and, as Aldgate and Richards indicate, "the English secret weapon . . . the essential quality that separates a civilized society from an uncivilized one."[29] The other "secret weapon" is Howard himself, whose persona in this film, in Michael Powell's *49th Parallel* (1941), and in most of his roles in British and Hollywood cinema is synonymous with the consummately civilized and urbane Englishman—soft-spoken, cultured, and passionately committed to justice.

However, the film seeks to redeem the professor from perfection by revealing his impatience with women, his inability to understand or tolerate their presence. His misogyny appears in several sequences—when he corrects the teacher and young girls looking at his Aphrodite, when he insults the female students in his class, and when he mistakes Ludmilla's identity. If the espionage film portrays a world on the verge of dissolution, threatened by the forces of darkness, *Pimpernel Smith* makes nazism the incarnation of that paranoid and violent world. Professor Smith incarnates not only the civilized human being but the notion that Western culture is the highest flowering of civilization, beginning with the Greeks and ending with the English. Unlike the populist orientation of the films of Launder and Gilliat, *Pimpernel Smith* is a document of the middle classes, drawing on the liberal humanism of Englishmen like Matthew Arnold and on their fear of anarchy.

The handling of information in this film is different from in many of the espionage thrillers. There is no ambiguity about who the enemy is or what he represents. There appears to be little that the professor as "The Shadow" does not know. There are no mysterious political figures to be exposed. The film, however, poses a different enigma, involving Ludmilla and the professor's relations to women. Ludmilla becomes the vehicle for humanizing the professor and challenging his misogyny. The face powder that she leaves in his room and that he replaces becomes the symbol of Ludmilla's sexuality, which later is identified with her dependency and human imperfections. The professor's competence and mastery are thus finally extended to his relations with women. The encounters be-

tween Smith and Ludmilla are, on one level, meant to contrast with the overbearing behavior of the Nazis, who toy with Ludmilla for the information that they can extort, but they are also indicative of the hermeneutic practices of the espionage film, which attempts to differentiate forms of knowledge and hence of power. By saving Ludmilla and her father, the professor, as the emblem of British manhood, is presented as chivalric but redeemed from the frigid perfection that he is earlier presented as admiring.

Secret Mission (1942), directed by Harold French, is another espionage drama involving a rescue mission. Three British army men accompanied by a Frenchman belonging to the Resistance, Raoul de Carnet (James Mason), are assigned to go to occupied France to save an imprisoned fellow officer and get information about German munitions stockpiles. They are constantly threatened by exposure to the Nazis, and the men go their separate ways to protect themselves. Raoul, who is from the area, takes Peter (Hugh Williams) with him and introduces him to his family. His sister, Michele (Carla Lehmann), opposes his work in the Resistance and wants him to remain on the farm. She is angry about their acts of sabotage, claiming that they create problems for the French, and she offers to get him papers from the Germans. Raoul refuses her offer. He and the other men plan a way to get two of their men into German headquarters. The captain (Roland Culver) and Peter disguise themselves as champagne merchants whose objective is to supply the German army with champagne. While the Nazis are out of the room, they photograph installations. The general, who is suspicious, says that the men are not merchants but spies from the Gestapo. The men succeed in getting out of the headquarters without being detected. One of the other men on their mission, Nobby Clark (Michael Wilding) gets further information on German fortifications, and the men manage their escape. In a battle with the Nazis, Raoul is shot. Bitter over the death of her brother, Michele refuses to help the British, but when Peter is endangered she comes to his aid. For a second time, the British penetrate Nazi headquarters, managing to free their comrade, MacKenzie. Now converted to the Resistance, Michele decides to stay in France, and helps the men to escape.

The film incorporates several conventions characteristic of the wartime espionage film—cooperation between the French and the British, the element of romance, the use of disguises and impersonation, particularly British impersonation of Nazis in order to gain access to information, and scenes highlighting the physical dangers to which the men are exposed, including Nazi intimidation of villagers, and their martyrdom. The rural setting serves to heighten the sense of the Nazis as polluters of the natural environment. The role of Michele introduces the domestic element, the preservation of the home in the face of wartime devastation and the ne-

cessity of conversion to national ideals. She is presented at first as refusing to accept the necessity of espionage and subversion, but is brought with Peter's guidance to the realization of the importance of eliminating the Nazis. The Nazis are presented as gullible, suspicious, and bureaucratic, but they are not presented as mere bloodthirsty villains, thus making plausible the British ruses to get into headquarters. The focal point is gaining access to information and rescuing a comrade rather than engaging the Nazis in combat. The film thus serves the purpose of propagandizing the necessary wartime transformations of daily life, and sets up a predictable conflict between the female's attachment to family and wartime exigencies that demand change.

An Ealing film that addresses both intentional and unintentional forms of espionage, *The Next of Kin* (1942), portrays the ubiquity of saboteurs and the consequence of "loose talk" for the war effort. Originally, the War Office was not pleased with the treatment that Dickinson and Angus Macphail, the story supervisor for Ealing Studios, submitted. Moreover, Dickinson's politics were considered suspect, since he had made a film in support of the republican cause in Spain. The film was made, and Dickinson again got into trouble with various members of the military and the government, including Winston Churchill, who worried that showing the negative effects of sabotage would be injurious to public morale. Others worried about pointing a finger at top-level personnel, but the film was finally approved, and the response from the critics and British audiences was gratifying.

The film is a propaganda film, dramatizing the dangers and reality of enemy espionage and the need for more circumspect attitudes toward social communication given the exceptional conditions generated by the war. The British are presented as trusting and open and therefore as needing a new orientation under the present circumstances. A good part of the film focuses on the different ways in which casual treatment of information can result in the betrayal of secrets. Moreover, the possibility of espionage in all areas of British life is driven home. As in all espionage films, the focus in this film is not primarily on combat but on ways of controlling information. The narrative hinges on a secretly planned attack on the French coastal town of Norville, which requires cooperation between the French Resistance and the English army. As the film unfolds, the various personnel involved directly or indirectly with the plan are followed.

A new officer assigned to the Tenth Chilterns, Major Richards (Reginald Tate), discovers laxness in military discipline, causing him to insist on the need for security and the imposition of censorship. The men are shown in their leisure time talking freely, thus dramatizing the difficulty but also the necessity of being constantly vigilant about what one says. Other than the loose talk that takes place in the bar, the greatest lapses of

language occur in intimate relations between men and women. An actress is able to extort information from a young lieutenant, and a young Belgian woman, Beppie Leemans (Nova Pilbeam), who is coerced to work for a German spy, Barratt, also betrays information about troop movements. She becomes involved with a private and is coerced by Barratt to reveal information that Johnny has given her about his regiment. When she discovers that she has been deceived by Barratt, she kills him and then is killed herself by a German agent. Further information about the raid is acquired through a concatenation of events that ultimately involve the acquisition on the part of the Germans of aerial photographs of the French terrain. The final sequences of the film show the attack itself, which is no longer a surprise and results in a costly loss of lives. The extended and heavy combat scenes in these last sequences consolidate the groundwork laid throughout the film. The correlation between lax security and carnage is unambiguous, as is the familiar link between women and inappropriate speech.

The action takes place in a number of different contexts, beginning and ending in France, taking a detour to Germany, and highlighting several British locations. Similarly, and most unusually, the film does not have a protagonist who is able to avert the disastrous consequences of mismanaged information. *The Next of Kin* violates certain conventions of the espionage film—most particularly in the absence of the exceptional individual who knows and therefore can control the flow of information. By confounding distinctions between friend and enemy, showing that a friend can become an enemy, the film accomplishes its objective of portraying a world that has changed, in which traditional terms of trust must be abrogated. People who may appear quite harmless, such as "Ma" (Mary Clare), can really be pernicious, and those individuals who appear to be on the right side can suddenly become dangerous. The responsibility for the "leaks" is not attributed to one person or a small group, but the film distributes responsibility among the Nazis, among the British officers as well as the lower ranks who do not take their military roles seriously enough, and among the women who for profit or under duress serve the enemy. Unlike the "noir" thriller, in which the untrustworthy and paranoid world brooks no challenge, *The Next of Kin* attempts to locate the sources of the disaffection, implying that amelioration is possible and necessary.

Through dialogue, the use of maps, setting, and character development, *The Next of Kin* strives to make concrete its concerns over control of information. The overall structure of the film, the interlocked vignettes of intrigue, build to the final eruption in battle. Combining fictional and documentary footage, the film depends on conventional expectations of the espionage film involving access to knowledge. The initial scenes in the

church, as a Frenchwoman and a French spy for the British exchange information under the benevolent eye of a priest, and under the suspicious eye of a German soldier, as well as other scenes involving surreptitious encounters, dramatize rather than merely explicate the nature and importance of watchfulness and restraint. The film draws on familiar associations concerning women. In all instances, from malevolent to accidental, the women are connected to the tragic consequence of violating silence, perpetuating the uneasy relationship between women and language in which women are seen either as outside language or as subverters of culture.

Frank Launder also made a contribution to the espionage film *I See a Dark Stranger* (1946). This film originated during the war and features a female protagonist, an Irishwoman. Along with Sidney Gilliat, Launder had been responsible for two of the most interesting war films featuring primarily female casts—*Millions Like Us* (1943) and *Two Thousand Women* (1944). *I See a Dark Stranger* is also set during wartime and uses espionage as a means for developing an issue that weaves in and out of certain British war films—the question of Ireland's hostility toward the English and Irish neutrality during the war, alluded to in other films such as Dearden's *Halfway House* (1944). The film's focus on international intrigue—Irish neutrality, German belligerence, and British retaliation—is tied to the classic formulas and strategies of the spy thriller—the young man who is unwittingly implicated in the intrigue through his involvement with a woman, the inevitable antagonism between the male and the female, the situating of that antagonism within a larger framework of hostilities, and the general aura of institutional untrustworthiness, which places an additional burden on the protagonists to do what is appropriate. The setting is also typical—trains and hotels in particular are the locus of the intrigue. As in Hitchcock, the climax comes during a public scene, giving reign to total confusion, which is clarified and resolved by the end of the film. In the final analysis, the Irish question is resolved in the removal of the German threat and the union of the Irishwoman and the Britisher.

I See a Dark Stranger is, in the words of the film's voice-over, "the story of a very strange character named Bridie Quilty." Launched at the time of J. Arthur Rank's attempt to move into the American market, the film won Deborah Kerr the New York Critics' Award for best actress and was popular with audiences in Britain and the United States. The film begins during World War II and reverts through flashback to the year 1937, to an Irish village called Ballygarry and the familiar landmark of the Irish pub. Bridie is a young girl when she hears her father talking of his heroic exploits against the English, rehearsing past tragedies and victories. They sing, and Bridie mouths the words as the men sing an IRA

song, "Kelly, the Boy from Killane," in a manner that suggests that the men's voices flow through her. The film employs a voice-over to indicate time passage and to provide an ironic commentary on the events, particularly on the villagers' and Bridie's behavior. In 1944, Bridie leaves her village to go to Dublin. Her encounters with the English, as with an Englishman on the train, are intended to expose her gullibility and prejudice. She sees a handsome, elderly man and admires him until she sees him reading *The Economist*, which provokes a new response: "Business. That's all the English ever think about." She also describes the lower classes as arrogant and acting "as if they own the earth."

In Dublin, she contacts a member of the IRA, Michael Callahan (Brefni O'Rorke), in an attempt to join the group. He attempts to dissuade her, saying that the Irish are no longer at war with the English, reminding her of the 1921 treaty, and urging a political solution: "Nowadays things are settled in constitutional fashion." Angrily, she tells him that he has grown old and soft. She finds a position working in a hotel in an English village where a statue of Oliver Cromwell is mysteriously defaced shortly after her arrival. Miller (Raymond Huntley), a spy for the Germans, is a guest in the hotel, and Bridie, in her war against the English, has joined forces with him. Another guest, a young officer in the Royal Artillery, David Baynes (Trevor Howard), takes a personal interest in Bridie. While Baynes is in the hotel, Miller arrives secretly and is shot, and Bridie takes over Miller's mission. Her first act is to divert Baynes, whom she suspects of being an intelligence officer, so that a German prisoner may escape. The prisoner, however, is successfully taken away from under the noses of his captors, but a chase ensues and he is shot. After disposing of Miller's body, Bridie sets out for the Isle of Man to retrieve a valuable notebook filled with German secrets; however, when she gets the notebook and reads it, she realizes that she holds the fate of the English in her hands. Followed by the Germans and by British intelligence officers, she burns the notebook and confesses her spying activities to David, who helps her to evade the authorities. They escape to Northern Ireland, where, as she is about to give herself up to be interned, they hear of D-Day and the cessation of hostilities. The film ends in a quarrel between Bridie and David when she refuses to stay at the Cromwell Arms.

The Irish characters in the film, including Bridie, are presented as naive and easily misled. The film plays with familiar Irish stereotypes—drinking, singing, excessive nostalgia, boasting, storytelling, and false bravado. The humor in the film is generated from the misguided behavior of the Irish, redeemed only through Bridie's conversion and particularly through her romantic attachment to an Englishman. As if to mitigate the image of Irish incompetence, the film introduces two bumbling but well-intentioned intelligence officers, Goodhusband and Spanswick (Garry

Marsh and Tom MacAulay). The Irish situation is further diluted as the
danger to England of German espionage becomes more apparent through
Bridie's efforts. Bridie thus represents the struggle for a new Ireland,
freed, as the film portrays it, from a fanatical and misguided attachment
to the past, aware of the need for flexibility and compromise in the face of
a common enemy. Her marriage to David represents that compromise,
although it also suggests in their quarreling over whether she will stay in
the Cromwell Arms that the former Irish belligerence has been domesti-
cated, turned into a family tiff.

The films discussed in this chapter—the films of empire, the war films,
and the espionage films—share certain narrative strategies. Consonant
with genre films generally, these films involve a tension between equilib-
rium and disequilibrium, order and disorder; however, unlike the histori-
cal film, with its emphasis on spectacle and power, these films are depend-
ent on "figurations of physical violence" related specifically to external
threats "in terms of the Law. Disequilibrium is inaugurated by violence
which marks the process of the elements disrupted and which constitutes
the means whereby order is finally (re)established."[30] The films belong to
genres of order, involving the restitution of the Law, due largely to the
protagonist's efforts.[31]

The protagonists of these films are predominantly male, and the male
authority figure becomes the carrier of values of service, competence, a
strongly developed sense of national mission and justice, and a belief in
the benevolence of British institutions. For the most part, the women in
these films occupy a minor role, serving as intermediaries in the achieve-
ment of the protagonist's goals. The films remain within the orbit of pub-
lic events as the characters subordinate personal conflicts to public aspi-
rations. In the case of the empire films, the natives are the instigators of
violence, while the white European is the representative of the Law,
which finally overwhelms and destroys the disruptive elements. In many
instances, physical violence is accompanied by verbal combat. In the case
of the war films of World War I, the enemy is less clearly delineated and
physical violence is a major threat. Moreover, in these films there is a less
clearly developed sense of the enemy and a greater emphasis on the im-
portance of maintaining male integrity as a survival strategy. Success may
entail personal annihilation, but the success will be determined by the
protagonist's willingness to accept his own demise in order to redeem the
beleaguered community.

In the case of the espionage film, additional elements, involving ques-
tions of knowledge, come into play. The protagonist is placed in a posi-
tion from which the nature of the enemy is not clear at the outset. The
violence is diffuse, and the task of the protagonist is to identify the insti-
gators of violence in order to eliminate them. While this schematic outline

of these genres insists on the commonality of an externalized violence, it is clear that too rigid a dichotomy between external and internal threats to the stability of the group effaces the possibility that these genres are eclectic and also sensitive to change. For example, the war films and the espionage films allow for the introduction of melodramatic elements that blur the purely legalistic aspects and inject issues of sexuality and sexual difference to complicate, if not call into question, the restitution of order or to shift the terms of the conflict from the public onto the private sphere. The next chapter, which examines the various forms of the war film produced during World War II, the immediate postwar era, and the cold war, will explore how British genres undergo a metamorphosis in their struggle to maintain familiar narrative strategies while adjusting to change.

The War Film in War and Peace

WORLD WAR II AND THE WAR FILM

WAR FILMS are a fertile source of information not only about official attitudes toward the war but also about underlying anxieties and contradictions created by wartime conditions. In discussing the Hollywood war film, Dana Polan has argued that a too rigid separation between the war film and the postwar cinema obscures the fact that the war films, while working to create a sense of collectivity and unity, contain signs of the breakdown of classic representations: "With the war, narrative finds a solution to the problems of representing history in a coherent framework *while* discovering that it can do so only at the cost of repressions and distortions that come bursting out under moments of narrative stress."[1] The British films are subject to the same tensions, tensions that will intensify in the aftermath of the war. These tensions can be seen in the various forms that the war film takes: propaganda films, combat films, and films that dramatize home front conflicts.

The war films are not merely a resurrection of the films of empire and of World War I, though there are elements of continuity in the ways in which World War II is mythologized. The war films are exemplary of new discourses created by the exigencies of World War II. Everyday life was substantially altered by the blackouts, evacuations, bombings, shortages, rationing, separation of families, and mobilization of women for work in the new battle zone, "the home front." The conscription of men and women into military service, the attendant separations, and the anxieties about safety had to be rationalized and assimilated. With the advent of the war in September 1939, the British government was confronted with massive social and economic restructuring. According to John Stevenson, "The basic problem for the government was very similar to that of the previous war—how to utilize resources to the maximum and allocate them in the most effective way. The experience of the Great War was followed and the government acquired powers to control almost every aspect of life."[2] The government was involved in conscription to the armed forces, taxation to provide the monies for war production, the regulation and relocation of workers, rationing of food and other necessi-

ties to avert dangerous shortages, and the creation of social services. The concern for social reform had already been articulated in the interwar years, but World War II "also created a special environment which helps to explain the enthusiastic reception of plans for social reform and provided the setting for the Beveridge Report."[3]

The "special environment" responsible for creating demands for social welfare was generated not out of pure altruism but out of the need to maintain a high level of civilian morale in the face of necessary hardships. The Beveridge Report's (1942) emphasis on employment, housing, the eradication of poverty and disease, and educational issues that it sought to address was as much an ideological document as it was a blueprint for actual social change. As Stevenson indicates, "the tone of the Report was radical, particularly in Beveridge's expressed desire . . . to give a new sense of purpose to democracy, to promote national solidarity, and to define the goals of the war."[4] Beveridge provides an example of the ways in which the state propaganda machine worked to foster a sense of wartime unity by creating a climate of common purpose, interests, and concerns among all classes.

Most significantly, the government was zealous in creating other avenues for propaganda that could capture the hearts and minds of the people. According to Aldgate and Richards, "The story of the British cinema of the Second World War is inextricably linked with that of the Ministry of Information. It was the Ministry's function, after all, to 'present the national case to the public at home and abroad', and to this end it was responsible for the 'preparation and issue of National Propaganda', as well as for 'the issue of "news" and for such control of information issued to the public as may be demanded by the needs of security'."[5] The Films Division under the aegis of the MoI was responsible for seeing to it that the cinema was an important instrument for the advancement of propaganda needs. Other than its role as an instrument of direct censorship and as a producer of propaganda and training films, the Films Division was also responsible for allocating scarce resources to commercial filmmakers for the creation of entertainment films as well as articulating guidelines for effective propaganda. As was the case in Germany and Italy, covert propaganda was considered superior to blatant propaganda; the preference was for films that concealed their propaganda under the rubric of entertainment. The kinds of films sponsored by the Films Division in the early years were war films, exalting the national military service, addressing the issue of preparedness, and celebrating the heroic sacrifices and endeavors of the fighting men. By late 1942, the British Film Producers Association complained about the predominance of war films, and the Films Division relented to the degree that it allowed for the creation of studio films that dealt with subjects other than the war, though with the

caveat that such films were to foster positive images of British life and attitudes.

The problems encountered in the production of war films were manifold, involving issues of censorship, the cooperation and interference of the MoI, the need for approval or disapproval of high military or government officials sometimes reaching all the way to the prime minister, and the gaining of access to newsreel footage. An examination of the production difficulties of *The Next of Kin* (1942) and *The Life and Death of Colonel Blimp* (1943) reveals the difficulties entailed in producing films that touched on delicate issues of national security and morale.[6] In particular, the history of the MoI reveals the impossibility of arriving at a unitary conception of acceptable and unacceptable propaganda while at the same time satisfying the requirements for entertainment and security needs. The history also reveals that there was no static and monolithic sense of wartime ideology, but that the ideology changed to suit changing circumstances. Since the censorship that existed prior to the war was sufficiently comprehensive to address most problems, the MoI had only to strengthen certain loopholes relating to national security involving such issues as disclosure of information relating to espionage and counterespionage activities, secret weapons, the treatment of prisoners of war, and the escape of personnel from enemy territory. It was also the case that certain prewar censorship guidelines were relaxed, as in films dealing with labor issues.[7]

After the government's initial closing of the cinemas on 3 September 1939, out of concern for public safety, and their reopening shortly thereafter, the first war film to make its appearance was Alexander Korda's *The Lion Has Wings* (1939), starring Ralph Richardson and Merle Oberon. The film was hastily put together to coincide with the declaration of war. Utilizing newsreel footage, segments from other patriotic Korda films, location shots involving scenes of combat, and scenes with the film's actors highlighting the impact of the war on the citizenry and their willing response, the film is an effort at answering the question of why England is at war and at reassuring the audience of England's readiness to accept the challenge.[8] The conventions utilized by the film—the use of an engaging male narrator, documentary footage, the linking of home front scenes and combat, the rigid dichotomy between friend and foe, and the expression of total commitment to the war effort to give a sense of national solidarity and preparedness—were to be better developed in later war films. The film, while gaining broad circulation, was considered by critics to be too blatantly propagandistic. In particular, its awkward attempts to suture documentary and fiction, a staple of many of the war films, were to be greatly improved upon in the films that followed. If for no other reason, the film was useful in getting across

the need to develop an appropriate and engaging film language for the genre.

From 1940 to the end of the war, the war film was refined. Of the various types of films, other than the espionage dramas discussed in Chapter 3, the most common were dramas inculcating a wartime ethos, fusing narrative and polemic, films involving conflicts between different branches of the service, home front dramas, rescue films, and training camp dramas. In the postwar era, prisoner-of-war dramas proliferated. While the formulas for these types varied, there were certain motifs common to all: the emphasis on national unity in a time of crisis, on the war as a "people's war" involving civilians as well as the armed forces, the need to overcome class and ethnic differences in the interests of the collectivity, and Allied unity. These motifs were not unique to the British cinema; they can be documented in the Hollywood cinema of the war years in films such as *Dive Bomber* (1941), *Bataan* (1943), *So Proudly We Hail* (1943), *Guadalcanal Diary* (1943), *Air Force* (1943), *Action in the North Atlantic* (1943), and *The Moon Is Down* (1943). American films such as *Mrs. Miniver* (1942), *This Above All* (1942), and *Journey for Margaret* (1942) helped to reinforce not only the national but the international dimensions of the war, including British-American cooperation and mutual dependence.

In the war films' attempts to create a sense of national and international solidarity, new narrative strategies were adopted. For example, unlike in the biographical films and costume dramas, the focus is no longer exclusively on one protagonist, but narrative interest is dispersed among a group of characters, and the structure of the films, rather than being tightly unified as in the classic model, is episodic, allowing the film to encompass multiple narratives. Furthermore, the characters are not homogeneous but represent different segments of society, social classes, and regional backgrounds. Gradually, workers, including women workers, were introduced into the films, although, as Christine Gledhill and Gillian Swanson indicate, representations of women were as contradictory as they were in the Hollywood cinema of that time. The problem posed for the discourse of wartime unity involved the handling of questions of difference, which is nowhere more striking than in representations of women. On the one hand, women as workers were part of the general mobilization and, as such, vital to the sense of national unity. On the other hand, such a strategy opened the door to the threatening consequences of acknowledging women's new role in the public sphere. In the case of women, then, it was imperative to establish a model that would represent unity overcoming differences, and this model involved the equation of motherhood and "nationhood": "The image of woman was used to *define* the concept of the nation as a unity overcoming differences,

coming, in fact, in a chain of corresponding models, to stand in for this concept: nation-community-family-mother. Through their roles as mothers women, located in the home as distinct from work, became a mythical centre, expressing family, and hence national, unity."[9]

Similarly, representations of social class were addressed so as to stress a sense of community based on personal affiliations and commonality of purpose and to deflect attention away from the more material issues of differences in wealth, status, and power. Hence, the films frequently focus on emotional conflicts—relations among the men, between home and battlefront, family and temporary comrades. In charting how many of the films address their audiences, Andrew Higson finds that they "address the individual spectator in the cinema as a member of a collective body—the national audience—who can be integrated into the community represented on the screen by means of both empathic identification with the characters and a recognition of the 'types' on the screen as 'ordinary people' like themselves."[10]

In their movement between documentary modes of representation and fiction, the films seek to fuse the private and the public, the personal and the collective. Melodrama is inescapable and functions to invest impersonal events with psychic and moral meaning. Hence, concepts of family, community, and nation are constantly invoked as a way of overcoming the disruptions that must also be represented. This, however, poses ideological problems. The need for coherence and resolution of the conflicts is in tension with the need to portray the discontinuities produced by the war, and the texts can never fully resolve and contain the sense of contingency. Moreover, personal gratification must be addressed, but always in the context of postponement. As the films speak to the desires of the audiences, they must do so in a language that defers present realization, a strategy that requires constant reaffirmation and reassurance in order to mask the gap between wish and fulfillment. In this sense, the films are constantly in danger of exposing their contradictions and must work hard to overcome the sense of impermanence and threat by creating a sense of immediacy and urgency.

Toward these ends, the films depend on a spectrum of characters with whom various members of the audience can identify, as well as characters who had to be marginalized. The protagonists in the former category are not merely exceptional heroes but more often ordinary people confronted with exceptional circumstances to which they rise. In the films of combat, along with the standard figures of predictable heroism, this group includes the terrified young recruit who in his rawness and fear threatens to endanger himself and his comrades. Through the patience and confidence of his elders and superiors, he is finally able to perform his tasks. Another

familiar figure is the cynical recruit with no personal commitment to the war. He either undergoes a conversion or is eliminated from the narrative through death. Bonding between younger and older males is common, although most of the men are of indeterminate age. The focus too is on the enlisted men, and there is usually only a handful of officers. These films adhere to the narrative strategies of the genres of order, with their focus on physical violence, contestation over space, and the protagonist as a redeemer—but with modifications. The demands of propaganda, of creating a sense of urgency, common purpose, and high morale, necessitate a substituting of multiple protagonists for the singular redeemer and of introducing affective concerns that are preconditions of confronting threats to society and to individual security. In short, the conflicts need to be made personal.

Especially in the home front films, in which women are more in evidence, the family plays a crucial role. The figure of the mother assumes prominence, but the films also feature the stabilizing presence of a male figure who is in some instances an older man, in others, a serviceman on leave, and in still others, a young man who is deferred from the service and who works at a vital home front job. The younger women are portrayed as struggling with the transition from the home to war work and, more personally, with the conflict between sexual desire and familial responsibility. Often, when women are portrayed, the overarching tension between gratification and its postponement is most pronounced. Some films address the situation of women directly—*The Gentle Sex* (1943), *Millions Like Us* (1943), and *Two Thousand Women* (see Chapter 5), which highlight the problems and contradictions created for women by the war around the "dual mobilisation of 'woman' as a symbolic figure contributing to the reorganisation of relations between men (families, generations, classes), and as a figure invoking those discourses capable of the differentiated address to women required by wartime fictional 'propaganda'."[11]

The presentation of the enemy is not monolithic either. Not all of the films portray Nazis to any significant extent, and when they are present, the portrayals are often cryptic, relying on a shorthand derived from traditional and melodramatic images of villainy to which are superimposed images from the storehouse of propaganda developed to stereotype the current enemy. This is most often true of the combat films that are more concerned to portray the threats to the fighting men than to address broader issues of cultural threat. In a few instances, as in Powell and Pressburger's *49th Parallel* (1941), an effort is made to explore enemy motivation in some detail. These films are different from both the combat films and the home front films, which dramatize more immediate threats

to the everyday survival of the community. Rather, they are concerned to escalate the conflict, to globalize it in terms of external and internal threats to British culture, if not more generally to Western culture.

The War Film as Legitimation

Among the earliest of the British films that sought to legitimize the war and to address questions of national and international unity, *49th Parallel* is one of the exemplary films that encompass many of the issues that were to become identified with the "people's war" and its representations. The film is important not only because it contains all of the formulas that would come to be associated with the wartime narratives but also because it attempts to humanize the enemy, in contrast to the many films that merely caricatured the Nazis, if they were represented at all. This film is particularly revealing of the ways in which consensus was created, how popular images and myths were being constructed in the interests of mobilizing audiences. Of the making of the film, Powell says, "The Treasury of course were madly against this and hated this film. Imagine at the time when we came back [from Canada]—France was falling, the Battle of Britain was looming—and here's some bastard that wants £50,000 or £80,000 to go and make a film in Canada. I told Duff Cooper what the scope of the film was, that we'd got promises from Laurence Olivier, Elizabeth Bergner [later replaced by Glynis Johns], Leslie Howard, Anton Walbrook, to each appear in episodes of the film, and showed him a rough story with a map of Canada. In the end, Duff Cooper stood up and said to the Treasury, 'Finance must not stand in the way of this project'."[12] Powell's comments betray the sense of urgency that animated the creation and execution of the war films.

As a familiar self-legitimizing device of the war film, the film employs an opening voice-over narration that establishes the narrative's self-interest as it refers to the 49th Parallel as "the only undefended frontier in the world," thus aligning itself with the need to defend that frontier. The use of maps, the aerial views of the terrain, and the footage involving the Indian parade in Winnipeg are as much designed to appeal to North American audiences as to dramatize the idea of the vastness of this frontier and its identification with the British cause. The film's emphasis on unity extends beyond the national borders of England to include Canada and the United States. All of the resources of genre narrative are utilized in parabolic fashion to make wartime rhetoric familiar and legitimate.

The continuity in the film is provided by the Nazis, whose submarine has been destroyed off the Canadian coast and who cross the country in their effort to avoid capture. Each of the episodes entails a confrontation with protagonists who serve to articulate different aspects of the demo-

cratic way of life as against Nazi authoritarianism and brutality. The first community that the Nazis encounter is at Hudson's Bay, where they meet a trapper, Johnnie (Laurence Olivier), who is naive about the nature of the Nazi war machine and skeptical about all governments. With the Nazis' arrival, the film begins its work of eliminating skepticism about the nature of the enemy. With the die-hard Lieutenant Hirth (Eric Portman) as their spokesman, the Nazis play on French-Canadian separatism, promising freedom for French Canada. Johnnie insists that they are not in need of liberation: they have their own institutions. He is shot by the Nazis. The Nazis then board a plane with Lieutenant Kuhnecke (Raymond Lovell) at the controls. The film develops the motif of the tenuous relations among the Nazis, built on hostility and authoritarianism. Kuhnecke, who has not checked to make sure that there is enough petrol in the tank, is badgered by Hirth. The plane crashes and Kuhnecke dies, reducing the number of the group by yet another, and the men find their way to a Hutterite community led by Peter (Anton Walbrook). Germans themselves, the Hutterites are utterly unsympathetic to the Nazi objectives, having come to Canada for economic reasons and to enjoy an atmosphere of religious tolerance. Vogel, a baker, wants to remain with the Hutterites but is shot summarily by Hirth, and the remaining men go on the road again. They lose another of their band to the Royal Mounted Police, leaving only two—Hirth and Lohrmann (John Chandos). Their next encounter is in the woods with a cultivated Englishman, Philip Armstrong Scott (Leslie Howard), in whose tent are paintings by Picasso and Matisse. Scott talks to the Germans of Mann's *Magic Mountain* and of Hemingway's writings, but the Germans call the English "rotten to the core" and "degenerates." In turn, Scott calls the Germans "entertaining gangsters," arrogant and stupid. The Germans retaliate by slashing his paintings. With the help of the Indians, Scott finally confronts Lohrmann, showing that the struggle is a struggle of "one armed superman against one unarmed decadent democrat." Hirth is the only man left. He hides on a train, where he meets a disillusioned Canadian deserter, Andy Brock (Raymond Massey), who has joined the army to "knock hell out of Germans" but has so far seen no action. In response to Hirth's Nazi polemics, Brock's patriotism rises and he delivers an impassioned speech on freedom, which he defines as the right to complain about conditions. Brock is instrumental in having Hirth captured by the Canadians, and thus he realizes his importance to the winning of the war.

The narrative is organized around a linear movement through space, and landscape assumes a prominent role. The vast expanse of Canada stands in contrast to the Germany described and exemplified by the Nazis. The trajectory of the film functions to portray the stage-by-stage elimination of the Nazi menace. It also provides the narrative with the

opportunity to develop, in different contexts, the collection of diverse attitudes that is antithetical to the monolithic and obsessive attitudes of the Germans. Each episode presents a different personality, a different perspective, and a different set of attitudes, as if to demonstrate unity in diversity, but the irony is that the diversity is representative of unity, whereas the totalitarianism of the Nazis is revealed as fragmented and disintegrative. The protagonists stand for variations on the same values— freedom, independence, resistance to coercion, a sense of collectivity based on the loose and voluntary confederation of individuals, a belief in the civilizing attributes of high culture, a sense of responsibility for the "underdog," and an antipathy to violence. Violence is spawned by the enemy. The antagonists are portrayed as rabidly aggressive, as "degenerate gangsters," and as having no respect for property or for culture. Working man and intellectual are linked in the attempt to dramatize a common purpose and bond in spite of differences in individual background and social class. The obliteration of class differences is possible also because the film is structured by the binary opposition between the forces of civilization and the forces of barbarism. In the face of this dichotomy, other differences recede. The overriding distinction in the film is the opposition between culture and barbarism, as exposed most starkly in the episode in which Scott confronts the hatred and destructiveness of Hirth and Lohrmann. The rhetoric he employs to describe the Nazis is representative of the evolving wartime rhetoric. By labeling their actions criminal, by identifying them as gangsters, the film provides a further network of associations by which to identify the Germans as "the enemy." The retaliation by Scott, by Brock, and by the customs official is legitimated in the name of self-defense, law, and the eradication of a pestilence. *49th Parallel* utilizes the resources of the war film: the inevitable confrontation with enemies of order who are the instigators of violence, recourse to violence to stem violence, and protagonists whose motives are tested and identified as altruistic. Ultimately, the intellectual and the "average man" share a common commitment to culture. Females and romance have a limited role to play in a film that features male aggression. The references throughout the film to the Nazis as gangsters serves more than a polemic function. It identifies the war narrative with the gangster film and hence with conflicts concerning law and order.

Powell's work was important in the reshaping of genre practices. In his war films, the narrative serves as a springboard in the creation of themes and images that can legitimize the hardships of war. For example, the drama of fliers shot down in enemy territory and struggling to find their way home became a particularly compelling theme during the war years. Powell and Pressburger tried their hand with this type of drama in the extremely popular *One of Our Aircraft Is Missing* (1942), with script by

Emeric Pressburger. Describing the genesis of the film, Powell states, "All of our pictures arose from thinking along the lines of what was happening now or what was going to happen. We hadn't finished the *49th Parallel* when I said to Emeric, 'Doesn't it interest you—the title *One of Our Aircraft Failed to Return?*' which was the current phrase on the radio at the time."[13] The film opens at a control tower with the announcement of a missing plane, then shifts to an image that was to be repeated in *A Matter of Life and Death* of an unpiloted plane racing through the sky. The narrative returns to the aerodrome as a crew readies for the mission. The men on the plane represent different segments of British society who are shot down in Holland. With the help of sympathetic Dutch people, including children, a priest and members of his family and congregation, and a young woman who pretends to be a Nazi sympathizer (Googie Withers), they are smuggled out of the country after several dangerous encounters with the Nazis and Nazi collaborators.

One of Our Aircraft Is Missing was shot in England in the fens of East Anglia and in Lincolnshire, where past trade with the Dutch had left its mark on the character of the environment. The early sequences of the film have a documentary quality associated with the training films of the time. The scenes in Holland are designed as a "pilgrimage" which, as in *49th Parallel*, takes the men on an odyssey through the country, thus allowing the filmmakers to focus on different personalities—of the fliers and of those characters who represent the Dutch. The film's patriotic agenda concerns the issue of unity. The crew are presented as confronting and resolving issues of leadership and survival. The class and generational differences among the crew are resolved in their collective interest. The film also stresses unity among those Dutch who resist the Nazis as well as unity between the Dutch and the British.

Several women figure prominently in the film, although romantic entanglements are not developed. Else Meertens (Pamela Brown) first brings them to the community and tests their authenticity. Jo Van Dieren (Joyce Redman) is their guide on their trek to the coast, and, finally, Jo De Vries hides them until they can escape. In place of the romance element, the film substitutes the motif of male solidarity and friendship, and the choice of several rather than one female guide reinforces the motif of unity. The insertion of a love story would have deflected from the film's collective orientation, since frequently in the combat and rescue films sexual entanglements are presented as the forces that disrupt and undermine the male group. Characteristic of Powell and Pressburger's war films, the film adopts the linear structure of a journey, allegorizes the characters, attempts to integrate adventure and edification, and inflates the rescue to the point where it becomes emblematic of global commitment to the war. Civilization hangs in the balance in the efforts to save the men.

While *One of Our Aircraft Is Missing* concerns the issue of collective international cooperation in the saving of RAF fliers, and *49th Parallel* specifically involves friendship between Americans and British, *The Life and Death of Colonel Blimp* (1943) is more encyclopedic, addressing issues of past and present, tradition and innovation, in dramatizing the social changes wrought by the present war. The film became the occasion for complex censorship maneuvers that offer insight into the difficulty of having to satisfy several constituencies—the War Office, the MoI, and Winston Churchill himself. According to Nicholas Pronay and Jeremy Croft, the War Office had already asked the MoI to suppress the film on the grounds that "it would give the Blimp perception of the Army Officer a new lease on life at a time when it is already dying of inanition."[14] Churchill himself was opposed to the film, feeling that it would have an adverse effect on morale, but was finally persuaded to lift the ban, and the film was finally shown to large audiences to great acclaim.

The Blimp figure, based on a cartoon character created by David Low, was a caricature of the traditional upper-class British officer often portrayed by C. Aubrey Smith in Hollywood films, and *Blimp* undertook "to tackle the existing stereotypes of the stuffy, undemocratic 'red-coats' image of the British Army which existed in North American perceptions, and to show that, while there had been some grounds for believing in the existence of these stereotypes in the past, a new generation had changed all this in substance, even if, externally, some of the traditional forms continued."[15] Clive Candy (Roger Livesey), unlike the Low caricature, is "a more amiable, loveable, and generally understandable character. He is proved a fool, to be sure, and out of touch with the immense changes going on around him, but those are his worst sins. He is quite harmless, and Powell and Pressburger show, particularly in the flashback scenes, that he is meant to be construed as a bit of an outsider and a loner throughout."[16] That Candy's character can be viewed as "harmless" underscores the way the film successfully negotiates issues of upper-class life and tradition so as to make them appear anachronistic, while, in fact, the film portrays a way of life that continued to hold sway in British society during and after the war. The film makes accommodations to the populist rhetoric of the time while still preserving a fascination with the past.

The film begins in the present as a young officer, Lieutenant "Spud" Wilson (James McKechnie), and his men plan a surprise attack during simulated military maneuvers. The men storm the Royal Bathers Club, where they find Colonel Candy in the steam bath. He and Wilson grapple with each other and end up in the water as the scene dissolves to the past with Candy as a young officer returning from the Boer War. Through a letter from Edith Hunter (Deborah Kerr) to a friend, he learns of virulent anti-British propaganda spread by the Germans. Impulsively and against

the advice of his superior officer, he goes to Germany, where he meets Edith and finds himself involved in a duel with a young German officer, Theo Kretschmar-Schuldorff (Anton Walbrook). The duel is presented in highly ritualized fashion according to traditional codes, though neither man is particularly eager to fight. Both men are wounded and find themselves in the same nursing home, where they become friends. Theo and Edith fall in love and decide to marry, while Candy returns to England, discovering too late that he was in love with Edith. He drowns his sorrow by hunting in Africa, his exploits communicated through a montage of titles of place names and trophies accumulating on a wall. The outbreak of World War I finds him in France, where he meets Barbara, also played by Deborah Kerr, who reminds him of Edith. After the war, the two marry, and their life is portrayed as genteel and philanthropic. Later, with the rise of nazism, Theo, a widower whose sons are Nazis, seeks refuge in England. Candy's wife also has died, and the only woman in his life is his driver, Angela, the third role played by Deborah Kerr.

Candy, now retired, is presented as increasingly marginalized. His radio broadcast is canceled because his sentiments are out of touch with the times. He still maintains that "it is better to accept defeat than fight unfairly," but Theo tells him that "if you preach the rules of the game, they will laugh at you." Candy insists that Britain fought fairly in the last war and won, to which Theo responds, "You didn't win. We lost. . . . You forgot to learn the moral. You have to be educated to be a sportsman in peace and war. This is not a gentleman's war." Candy's attachment to the past is presented as an obstacle to understanding the new conditions produced by the present war. The film dramatizes the passing of class privilege, a myth that is also entertained in other war films of the era. As in Renoir's *The Grand Illusion* (1937), this film portrays the demise of past codes of war and seeks to make an appeal to the audience across class lines. By making Candy a sympathetic but befuddled character, the film suggests that the values of sportsmanship were not altogether wrongheaded but rather are inappropriate in confronting an enemy who does not abide by "the rules of the game." The new soldier is the creation of the modern world.

The Life and Death of Colonel Blimp adopts various ploys to complicate the question of wartime ideology, including subverting the usual expectations of a war film. Eclectic in its fusion of history, romance, and army life, it cannot be easily classified. The film is not a romance, nor does it highlight the physical rigors of combat or life on the home front, although it contains all of these elements. The framing of the conflict between Spud and Candy, while relegated to the beginning and end of the film, is the prime strategy for developing the opposition between tradition and modernity. The romantic elements, which are consigned to flash-

backs, are subordinated to this conflict. Candy's fixation on the past is emphasized through these flashbacks, and the use of Deborah Kerr to portray all of the women in Candy's life serves to highlight this fixation, marking the various passages in his life, especially the sense of the changing times. The primary tensions, however, are among the men. While the representations of women emphasize sameness, except for their clothing and occupations, the film establishes differences between German and Englishman, past and present, ritual combat and modern warfare, young men and old men. The film also develops the role of language as a divisive force. Edith is a language teacher who realizes the limitations of the language she teaches. The issue of language surfaces again in the scene in which the Germans refuse to give information about their positions and Candy allows them their silence, whereas their lips are unlocked through the use of physical force by a South African officer. Theo makes fun of the Englishman's antiquated descriptions of the Germans, and the film portrays differences between the Yanks' and Britishers' ways of speaking, which are representative of their differing attitudes toward war. Above all, Candy's faith in the sanctity of the Englishman's word is held up to critical scrutiny. Visually, the film capitalizes on difference. For example, the ritualized treatment of the dueling scene in its use of choreographed and overhead shots makes it look archaic, in contrast to the hectic and disorganized scenes of the mock maneuvers. The film self-consciously exploits difference in the interests of establishing an acceptable sense of national unity, a dominant strategy of Powell's war films but also a dominant strategy of British wartime ideology. While *Blimp* ends with a "reconciliation" of sorts between Spud and Candy facilitated by both Theo and Angela, its preoccupation with difference, particularly generational difference, problematizes the text, since the age differential is insurmountable. *Blimp* thus introduces elements that threaten to undermine consensus.

In a very different style, Powell and Pressburger tackled the issue of national identity on the home front in *A Canterbury Tale* (1944), creating a text that addresses reasons for fighting the war, but specifically in terms of a national culture that is worth defending. As the title suggests, the film is an homage to Chaucer and to England. Set during World War II, it follows several pilgrims on their way to Canterbury who are in need of regeneration. The cathedral itself is a central feature of the film as the site of conversion. The film begins with images of the cathedral and of a page of Chaucer's poem as a male voice on the soundtrack reads from the text. The myth of rural England is exemplified through shots of the landscape and architecture of the village of Chillingbourne: "The England evoked by *A Canterbury Tale* is the England of Chaucer and Shakespeare, a rural England of half-timbered cottages and stately country houses, quiet, leafy

churchyards and rich hopfields, an England whose spirit resides in Tho-
mas Colpeper, gentleman farmer, magistrate and archaeologist, a man
who understands her nature and seeks to communicate her values."[17] The
landscape had a personal meaning for Powell, who was revisiting scenes
from his own history.[18] In its attempts to portray the beauties of England
and to preserve a sense of community, the film invokes the homely virtues
of work and, unlike *The Life and Death of Colonel Blimp*, the nature and
necessity of continuity rather than dramatic change. Where the film di-
verges from a mere polemic on these values is in its emphasis on the trans-
forming power of vision.

Three "pilgrims," Bob Johnson (Sgt. John Sweet, U.S. Army), Alison
Smith (Sheila Sim), and Peter Gibbs (Dennis Price), meet in Canterbury
and, while of different nationalities and gender, are united through the
overcoming of past experiences of loss or disappointment. The plot be-
comes complicated when Alison has glue dumped on her head as she and
the English and American sergeants are making their way to the village.
One axis of the film involves uncovering the identity of the "Glue Man,"
who turns out to be the Justice of the Peace (Eric Portman), and the agent
responsible for the three pilgrims' transformations. His act of aggression
against young females seems consonant with the film's conservatism. As
he later tells the pilgrims, he is concerned to save young soldiers from the
distractions of young women, which keep them from appreciating what
is of enduring value in English life. Through his agency, the American is
transformed as he discovers that British culture is not so alien from his
own (another instance of Powell and Pressburger's emphasis on Anglo-
American unity). It is Colpepper who informs Alison that her fiancé,
whom she thought dead, is still alive. The organist, the least susceptible to
Colpeper's charms, achieves his desire of playing serious organ music in
the church through Colpeper's assistance. Colpeper magically restores a
sense of hope to the characters by connecting them to their past history,
literally making them see things to which they had been blind.

The film is eclectic in its thematics and style. The motif of conversion
appears quite traditional, as does the emphasis on the transforming
power of place, but the film's style, in the context of British filmmaking of
the time, seems quite different from that of other films. The film's self-
reflexivity, its consciousness of itself and of the role of spectatorship, can
be seen in the emphasis on slide shows, photography, and music and on
Eric Portman's role as a guide (like the filmmakers themselves) who ena-
bles his audience to see the familiar world in new terms. The opposition
between past and present is dramatized visually. Canterbury Cathedral
and the rural landscape are juxtaposed with images that are reminders of
war—the vehicles, the figures in uniform, the technology itself that is re-
sponsible for reproducing this world of the past (including the film).

While the characters appear to correspond to the representation of characters in a realist context, the way they are handled subverts that realism. The three pilgrims and Colpeper are presented as flattened, more as allegorical figures than as developed characters. Attention is deflected onto the drama, the journey itself, and the values in conflict that need resolution. Whereas in other home front films the narratives and narration serve to create a sense of identification with the war effort based on immediate images of wartime life, this film seems to invite a different form of involvement, based on the characters' and the audience's willingness to be transformed through traditional images of British life.

The final Powell and Pressburger war film, *A Matter of Life and Death* (1946), also explores the effects of war on British society and the quality of life in the future. The film opens with a voice-over: "This is a story of two worlds, the one we know and the other which exists only in the mind of a young airman whose life and imagination have been violently shaped by war. Any resemblance to any other world known or unknown is purely coincidental." The frequent use of voice-over in the war films establishes a link between fiction and documentary forms, a technique allied to the inclusion of newsreel footage in feature films. However, in the Powell and Pressburger film this device seems to function in ironic fashion, creating a sense of unfamiliarity and distance rather than the customary reassurance of an omniscient narrator. The first images in the film are of outer space as the announcer moves closer to the planet Earth, which is announced by a cacophany of voices in different languages.

This film repeats the image of the plane flying through the air without a crew. David Niven plays the role of the one young airman who is still alive but has only minutes to live as his plane races toward destruction. He makes radio contact with land and talks to a young American woman, June (Kim Hunter), who is on duty, informing her that he is about to crash. He recites poetry to her and declares his love. Falling to earth, he miraculously lands on a beach, where he finds her. The scene shifts to heaven and from Technicolor to black and white. The knowledge of a missing soul becomes known, and the machinery is set in motion to reclaim Peter. A Frenchman, Conductor 71 (Marius Goring), who died during the French Revolution, is responsible for the loss of Peter and therefore for finding him again and restoring him to his rightful place in heaven. Peter's relationship to June develops, but she is concerned about what she interprets as his distraction during the times when he claims to be in contact with his heavenly messenger. Her concern leads her to a brain surgeon, Dr. Reeves (Roger Livesey), who diagnoses a brain tumor and suggests immediate surgery. In danger of being reclaimed by heaven through the machinations of Conductor 71, Peter gets permission to appeal his case to the high court, and is told that he must get a defense

attorney, who may be any great man from ancient times to the present. Before Peter can make up his mind, and before Dr. Reeves can operate on him, the doctor is killed in a motorcycle accident as he races to the hospital. Peter chooses Reeves as his defense, and the scenes in the hospital are intercut with the courtroom scenes, in which his prosecutor, an American, Abraham Farlan (Raymond Massey) rails against the English. The audience in the courtroom is composed of men and women of different nationalities who have died in all the wars of history. The selection of the jury further develops the prosecutor's antipathy to the English, but Reeves is instrumental in moving the appeal to higher ground, involving love and romance. His argument is that Peter's love for June is the crucial issue. Had Peter been collected before he met her, they never would have fallen in love. The jury asks to hear June, who offers her life in place of Peter's. The judge rules in favor of Peter and June.

This film, like so many films of Powell's (especially *The Thief of Bagdad*), centers around the occult. The playful opposition between heaven and Earth is only one of a number of oppositions that structure the film, including life versus death, physical distance versus proximity, past versus present, dream versus "reality," Britisher versus American, man versus woman, Technicolor versus black and white, and documentary film style versus fiction. John Ellis notes how the initial sequences portraying the love affair between June and Peter are presented as "a disruption of the harmony of the universe, where all events make sense, and no events involve the spectator."[19] Stylistically, the film undermines the absoluteness of unity, the unity of its own narrative and of all the oppositions that it poses. As in *A Canterbury Tale*, perhaps even more insistently, the question of specularity inserts itself. Ironically, the man and woman fall in love without ever seeing each other. Peter is an object of surveillance for both June and the doctor. Conductor 71 has made his "mistake" in not seeing Peter properly. The "audience" in the courtroom is also a surrogate for the external audience, and the film calls attention to itself as a film in its mixing of black and white and Technicolor and in its use of distancing strategies based on a knowledge of but then a violation of conventional narrative expectations. The scene in which Peter is being wheeled into surgery is like a shot from Dreyer's *Vampyr* (1931), where the camera is placed at the level of the prone person and focuses on the object of his vision. The film's playing with the notion of "two worlds" can be rationalized as the protagonist's hallucinations.

A Matter of Life and Death can be read in several ways. It is the story of a survivor who has earned his right to survive. It is a polemic on the necessity of Anglo-American relations. As a love story, insisting on romantic love as the basis of male-female relationships, the film also seeks to establish the priority of meaningful personal heterosexual relation-

ships in the postwar world. In its satirizing of bureaucracy, the film can be construed as a critique of socialism and the welfare state. The film's insistence on specularity, however, calls into question these tidy interpretations. The emphasis on looking invites speculation on the process of representation itself. Fundamentally, John Ellis says, "what the film does, then, is to question the very basis of the analysis of films in terms of 'content' that is, the effect of reality which is usually produced silently through the operation of one discursive form with one position of intelligibility and truth."[20] Unlike so many of the other films of the war era, but like so many of Powell and Pressburger's films, the style of A Matter of Life and Death asks the spectator to reconsider accepted notions of identity, belief, and genre. As these films demonstrate, the formulas, styles, and conventions of the war films varied, though Powell and Pressburger, like other filmmakers, attempted to live up to the MoI's criteria of propaganda and entertainment, to generate images of British life that could produce a sense of national unity and competence. Their war films provide insight into how wartime ideology was constituted and consolidated.

Romance and Combat

Of the more conventional types of war films, a popular formula involved the conflict between love and war, thus allowing for an interplay between the home front and the combat zone. Brian Desmond Hurst's *Dangerous Moonlight* (1941) stars Anton Walbrook as a Polish flier committed to freeing his Nazi-occupied homeland. According to Robin Cross, the extremely popular film was "an old-fashioned romance dressed up in wartime clothing."[21] Cross's terse comment acknowledges that the film adopts the familiar conventions of melodrama to enhance its focus on the personal conflicts created by the war: endangered romance, obsessional behavior, preoccupation with the past and with memory, expressive music, and illness and recovery. The film begins in the present with the protagonist, Stefan (Anton Walbrook), a pianist, suffering from amnesia. A physician (Cecil Parker) tries to restore his memory by playing the Warsaw Concerto, music associated with the protagonist, and the music accompanies a flashback to Poland in 1939 during a bombing. Stefan meets a reporter, Carole (Sally Gray), and they fall in love but are separated by the war. They do not meet again until Stefan, now exiled from his country, comes to New York for a concert; they renew their relationship and are married. Stefan plays concerts but is eager to return to combat. Carole, who wants him to remain in the States, withholds information from him about the formation of a Polish squadron in England, and they separate in anger. She reminds him that he is a musician, and that he cannot throw away his gift "because of a stupid patriotic notion." With his close friend Mike, an Irishman (Derrick de Marney) who wants to

fight against the Nazis, he resumes flying. Mike dies, and Stefan is wounded and loses his memory. Carole, remorseful for her behavior in the past, joins him in the clinic, where his memory is restored and the two are reconciled. The focal point of the film is not the woman, but Stefan. He is portrayed as a romantic figure—a dashing aviator, a talented pianist, a patriot, and an object of desire. He turns his back on wealth, fame, and the woman he loves in order to serve his country. The music—the Warsaw Concerto and the *Polonaise*—is linked to the values of nationalism and the romanticizing of patriotism. The romantic aviator figures prominently in the war narrative. Already familiar in the literature and film of World War I, the aviator, a symbol of modernity, becomes the ultimate war hero. In the cinema of World War II, in the visual arts of the 1930s, and in the British films that focus on the Royal Air Force, he is representative of the glamour associated with technology and with devil-may-care and heroic actions. The other men in the film, Mike and Carole's father, are supportive of Stefan's need to serve, while Carole is presented as a spoiled young heiress in the tradition of the Hollywood cinema. That she is an American also serves, along with the references to Poland, to internationalize the issue of the war, as does the equation between the bombing of Poland and that of London. Carole's remorse over resisting Stefan's desire to return to the service seems to be an oblique commentary on American neutrality.

Amnesia also comes to signify more than psychic trauma. The curing of Stefan's amnesia is linked to the broader thematic of the film, the importance of memory. In his cure, Stefan is reconnected to his duty, but he is also reconnected to Carole. While the film shows the tension between the private and public spheres, it seeks to mediate the conflict through affective identification. Music is the bond between the man and the woman. Mike's sacrifice serves also to mediate the conflict between them. Thus, the personal drama merges with the film's political objectives. In his examination of the Hollywood wartime narrative, Dana Polan finds that "concretizing commitment through narratives centered on specific characters can encourage the spectator's own inscription into the narrative. In the war-affirmative narrative especially, it is not so much psychological desire (as Bellour would have it) as national responsibility that drives enunciation."[22] These statements are equally applicable to the British wartime narrative.

The war film thrives on narratives of conversion, especially of cynical individuals (mostly male) who are transformed through their experiences of the consequences of war. In Ealing's *Ships with Wings* (1941), directed by Sergei Nolbandov, the protagonist, Stacey (John Clements), is a rash, devil-may-care aviator who is dismissed from the air force, charged with being responsible for the death of an inexperienced pilot. Also, while

courting the admiral's daughter, Celia (Jane Baxter), the sister of the man
who dies, he has been carrying on an affair with another woman, Kay
(Ann Todd). In disgrace, he leaves England, finding work as a pilot for a
small Greek air ferry located on one of the Greek islands. Kay follows him
there as the war begins to escalate. The owner of the airline is killed, as is
Kay. Her death alters Stacey, who becomes totally dedicated to destroy-
ing the Germans. Stacey is reunited with his comrades and given a chance
to prove his patriotism, which he does when, in a death dive, he destroys
an important target.

His conversion is based on guilt, his responsibility for the death of one
man and, more importantly, the death of a woman whom he has not
treated well. He learns to love her and, in her loss, he surrenders himself
to the cause. He also reinstates himself in the male group as he clears his
name and reputation. The romance in this film serves as the catalyst for
his conversion, signifying his total immersion in the war and his aban-
donment of personal desire. Romantic love functions to dramatize the
necessity of loss. Women disrupt the male community and are eliminated,
and the initial conflict over possession of Celia is the vehicle for generat-
ing the events that separate the three aviator comrades. In spite of its
Hollywood features and its "novelletish" orientation,[23] or perhaps be-
cause of them, the film captures many of the myths common to the war-
time films of combat—the tenuousness of desire, a sense of fate and
doom, and, most importantly, the link between heroism and death. The
film's melodramatic excessiveness, its "theatricality,"[24] exposes the ten-
sion between wartime service and personal desire.

Family and Nation

In Which We Serve (1942) exemplifies the successful use of certain basic
formulas that are now traditional in the war film, formulas that link fam-
ily, community, and nation. The linking of the home front and the com-
bat zone is designed to emphasize the primacy of the war and the priority
of concern for the fighting men. The home front serves as the font of
positive memories that sustain the fighting men. The film does not ques-
tion sacrifice but accepts it. As the captain says about the deaths of the
men on his ship, "If they had to die, what a way to go." When Walter
(Bernard Miles) learns of the death of his wife and mother-in-law, he
remembers his manners and congratulates Shorty (John Mills) on the
birth of Freda's (Kay Walsh) child before he exits to mourn privately.
Death and mourning provide the opportunity to test the mettle of the
characters at home and in combat.

The use of newsreel and documentary footage as well as the attempt to
create a sense of immediacy about the battle scenes are familiar strategies
in these films, and critics of the time were quick to point out lapses from

this mode of realism. *In Which We Serve* attempts to provide an encyclo-pedic sense of the society. The film's emphasis on class solidarity and on minimizing class differences and portraying common interests, concerns, and interactions is increasingly common in other war films produced both in Hollywood and in Britain, as is evident in such Hollywood films as *So Proudly We Hail* (1943) and such British films as *One of Our Air-craft Is Missing, Millions Like Us, The Gentle Sex*, and *Two Thousand Women*. The language seeks to minimize difference and fuse all social elements against a "common enemy." Images of Christian religious serv-ices, scenes of births, deaths, and marriages, familiar urban and rural landmarks, the radio as people listen to the voice of the prime minister, and newspaper montages serve to situate events in a recognizable and everyday context.

The major portion of *In Which We Serve* involves the sinking of the HMS *Torrin* during the Battle of Crete. As the men float in the raft await-ing rescue, the survivors recollect their lives at home and the events prior to the attack, which destroys the ship. The events in the film are based on the war experiences in Crete of Lord Louis Mountbatten. Kinross, played by Noël Coward, is the fictional reincarnation of the war hero. Coward had some trouble in realizing this film. While Mountbatten was suppor-tive of the idea, Coward had problems with the MoI, which resisted the notion of Coward playing the lead. Coward was associated with light and witty comedy. His reputation was, and remained for the most part, that of a sophisticated member of international café society. He was asking to play the role not only of a war hero but of a war hero modeled on a member of the royal family. The austerity of Kinross's character, his regal bearing, may be due in part to Coward's attempt to silence objections to his playing the role. As the captain of the ship, Coward portrays Kinross as a model officer, impeccable, concerned for his men, a disciplinarian but not a tyrant, who asks for a happy and efficient crew. As a family man, he is portrayed as remote but affectionate, leaving domestic affairs to his wife (Celia Johnson). The captain is photographed in positions that set him above his men as he speaks to them of duty and responsibility and metes out praise and reprimand. In short, Coward portrays him as a pa-ternal, magisterial figure, consonant with the 1940s photographic por-trayal of such figures as Churchill and Roosevelt, while downplaying any erotic relationship between Kinross and his wife.

Two other characters are singled out in the film. Ordinary Seaman Shorty Blake (John Mills) is the representative of all the young men whose lives are changed by the war. He meets and marries Freda, who is related to the third of the prominent characters, Chief Petty Officer Hardy (Ber-nard Miles). Shorty epitomizes the courage and indefatigability of the men, in contrast to the young stoker (Richard Attenborough), who de-

serts his position. Hardy too is exemplary of the sturdiness of the British fighting man. He sustains the blows of losing his wife and mother-in-law and survives to help others.

Females are presented in the context of family and as performing their domestic role of keeping the family together in the absence of the male. Kinross's wife, in a Christmas toast, articulates her secondary place in her husband's affections, saying that she shares a "friendly" rivalry with his ship. Mrs. Hardy (Joyce Carey) and her mother are portrayed as engaging in friendly familial conflicts but united as a domestic unit; however, their elimination from the narrative suggests that their household differs from the others in the film in being dominated by women. Freda is saved from destruction by virtue of her bearing a child. In the working-class family, Mrs. Blake (Kathleen Harrison) is presented as totally devoted to her husband and son. The women are thus portrayed as the backbone of British domestic life, keeping the family intact, a bridge between the home front and the war front. But, in spite of the film's emphasis on commonality and unity, families call attention to obvious and unbridgeable differences in background and sensibility. The striking differences portrayed between the women who serve the men and the men who serve the navy also undercut the film's project of subduing difference.

Asquith's *The Demi-Paradise* (1943), starring Laurence Olivier and featuring Penelope Dudley Ward, Felix Aylmer, and Margaret Rutherford, also provides images of the British family but takes as its major propagandistic task the relationship between Britain and the Soviet Union. It ostensibly celebrates cooperation between the two nations, but the film is actually a celebration of the superiority of British culture and society. It addresses issues of community, family life, and British ingenuity, glorifying England through the eyes of a Soviet inventor who has come to Britain to perfect an icebreaker propeller for ships that should prove useful in the war effort. Engineer Ivan Kouznetsoff (Laurence Olivier) is at first repelled by the casual way in which the British conduct their affairs. He has difficulty, like von Graum in *Pimpernel Smith*, in appreciating the British sense of humor. Ivan develops a relationship with Ann (Penelope Dudley Ward), the granddaughter of Runalow (Felix Aylmer), chairman of the shipyards, but the couple quarrel over British music hall humor. Ivan comes finally to appreciate British life and culture before he returns to his own country without Ann.

Through Ivan's perspective the film provides vignettes of British institutions—Hyde Park, the upper-class family, teas, historical pageants, eccentrics like Miss Rowena Ventnor (Margaret Rutherford), music halls, charities, and industrial competence. Moreover, Ivan is able to solve the problem of the propellers, which has eluded Runalow and himself. In that most familiar of British places, the British railway station, while drinking

the familiar British cup of tea, he discovers the source of the problem. When Ivan returns home, he takes not only his propeller but a gift from the local community to the Russian people. In gratitude, he addresses the British as "my friends" and as a "great people," telling them that "most of the world thinks you care only about money," but he has found that "they care about crickets, nightingales, and jobs well done." He adds that though the world sees them as hypocritical, he finds them warm and friendly. Moreover, he says that it is probably their sense of humor that is their greatest asset. Ivan identifies their sense of humor with their "tolerance." The film thus blatantly celebrates the British virtues of industriousness, tenacity, persistence in problem solving, and a conditional willingness to accept outsiders into the community.

The text reveals its preoccupation with gentility in its allusions to literature, as exemplified in the Shakespearean title, Ivan's quoting from "To a Skylark," the allusions to A. E. Houseman and to "English melancholy," Ivan's gift of *Crime and Punishment* to Miss Winnie, the emphasis on Mozart, and the cello music broadcast in the garden as the bombs fall. The odyssey takes Ivan through different aspects of British life—the family, the workplace, the theater, and village life. Through Ann, he is also initiated into romance. Their romance is blocked as he returns to Russia and she serves her country. But, as David Lusted writes, "however much the film declares itself for alliance between nations, it cannot bring itself to countenance sexual union—especially with its leading daughter. It is as if its fear of miscegenation haunts the film's narrative structure."[25] While the idea of community in the film is based on the need to dramatize cooperation between the two nations, it can do this only through effacing differences between the British and the Russians, which only serves to call attention to difference in the interests of British dominance. Like many films of the period, *The Demi-Paradise* reveals the tenuousness of the consensus it has constructed. Its unwillingness to sanction a romantic relationship between the representatives of two different cultures is particularly revealing of the film's entrapment in a rhetoric that insists on traditional patterns of social life that obstruct the very changes that the film entertains. In this respect, *The Demi-Paradise* exemplifies contradictions generated by wartime ideology.

Dramas of Basic Training and Discipline

The motif of bringing together a group of men from different backgrounds into a community is a central motif in Carol Reed's *The Way Ahead* (1944), a Two Cities film. The British Army is the focus of this film, which stars David Niven. The film opens with the civilian setting and then shifts to an army camp and to the basic training of these individuals who come from different backgrounds—a department store clerk

(Raymond Huntley), an employee of his (Hugh Burden), a farmer (John Laurie), a furnace stoker (Stanley Holloway), and a worker (Jimmy Hanley). The training of the fighting man (and to a lesser extent of the fighting woman), a subject of many documentaries, was also incorporated into fiction films. The sergeant (Billy Hartnell) is perceived by his men to be the major source of oppression. The men cannot understand his emphasis on discipline and seek to undermine his authority through their complaints to Lieutenant Perry (Niven). Perry, a garage owner in civilian life, listens sympathetically but is aware of the necessity for discipline and is imbued with the history and tradition of the regiment. After stringent training and several failures in mock combat, the men come around and begin to fulfill Perry's prediction that they will turn out well. They demonstrate the efficacy of their training when they are sent to take part in the invasion of North Africa, displaying courage and collectivity when their ship is attacked and later in battle with the Germans.

Set in 1940, the film addresses the issue of the war's mobilization of men for whom professional military life was alien, a situation that was representative of the general mobilization of a society in wartime where people must confront tasks for which they have not been prepared. The men are shown to be amenable to learning, competent as a consequence of their dedicated and disciplined training, and capable of heroism. By making a film about the British Army, as opposed to the more familiar RAF and Royal Navy films, the filmmakers were also celebrating a less glamorous aspect of the national services—the infantry. Through the introduction of the Gillingham household to which the men are invited, the film also portrays how the British private sector plays a role in raising the morale of the serviceman. The conversion of the civilians involves the acceptance of the need to internalize survival skills and also to confront possible sacrifice and death. The training entails not only the assimilation of specific skills but the appreciation and internalization of discipline and the necessity of following orders. In the portrayal of the growing solidarity among the men, which also involves a new attitude toward their officers, the film seeks to personalize the issue of discipline, redeeming it from mere adherence to orders. War narratives like *The Way Ahead* are dramas of conversion, but unlike traditional conversion patterns, which focus on a single character, this film focuses on transformations of the group.

John Boulting's *Journey Together* (1945), dedicated "to the few who trained the many," is also a conversion film, but in contrast to *The Way Ahead*, it makes one character the focal point of change. Consonant with the strategies of the training film, this film stresses education, the acquisition of skills and attitudes necessary to the winning of the war, maintaining the populist motif of many films in their focus on individuals of differ-

ent classes and backgrounds. The film also addresses Anglo-American cooperation. The initial scenes of *Journey Together* involve the difficulties of Wilton (Richard Attenborough), a car mechanic who wants desperately to be a flier but does not meet the educational requirements, having left school at age fourteen. Along with two other RAF recruits at the Air Crew Reception Center, Aynesworth (Jack Watling) and Smith (David Tomlinson), Wilton confronts the first phases of training and assignment.

Unlike Wilton, Aynesworth is a member of the upper class, Cambridge-educated, and he tells Wilton, "You make me feel like a bloated plutocrat. Anyway, we're in the same boat now." He is inept in his studies, whereas Wilton does superbly and even helps Aynesworth. Having passed their initial tests, the men are transferred to a flying grading school where their skills will be assessed before they are assigned to appropriate tasks. Aynesworth succeeds as a pilot, but Wilton has difficulty landing his plane. Nonetheless, he and Aynesworth are assigned as pilots, while Smith is selected as a bombardier. The two pilots are sent to Mesa, Arizona, for training, where they are assigned to instructor Dean McWilliams (Edward G. Robinson). There, McWilliams, a father figure to the men, provides both rigorous training and personal support. Aynesworth passes his flying tests, but Wilton still cannot land, in spite of McWilliams' attempts to help him overcome his problems. He is sent to school to be a navigator, but is disappointed and bored with his assignment. Because he cannot take the role of navigator seriously, he jeopardizes the life of his crew. On a subsequent mission with Aynesworth, who has turned up at the same airfield, Wilton is selected as the navigator, though none of the men have confidence in his abilities, claiming that he will bring them bad luck. Wilton is able to communicate precise instructions to the control tower and the men are saved after being forced to abandon their burning plane. Wilton finally understands the importance of the navigator's role and of working cooperatively with others.

The film has two sections—one involving the dramatization of the stages of induction, testing, training, and selection, and the other involving Wilton's overcoming disappointment and learning the values of teamwork. The film presents class differences, but only to minimize them in favor of "natural" talents and dispositions. The "journey together" thus involves the union of different classes, different nationalities, and different skills in the interests of the war. Cooperation, not competition, is stressed. For example, the usual glamour associated with flying is downplayed in order to develop the notion of teamwork. The emphasis is on competence, but the ordering of jobs into a hierarchy is disdained. All jobs are designated as important. The film's stress on education is consonant with the government's stated goal of improving educational oppor-

tunities. And *Journey Together* itself seems to be an effort at educating through the merging of documentary and fiction.

The world portrayed in the film is a man's world. The only woman in the film is McWilliams' wife (Bessie Love), and she is solely associated with the provision of meals for the fliers. The narrative does not contain any romantic interest; what matters is the relationships among the men, which are determined by their sense of collectivity and their increasing competence. The film is concerned less to portray actual combat than to develop the pragmatic aspects of the men's work, the consequences it has not only for the individual involved but for everyone else in his group and in the society. Though the film focuses on the motif of collectivity, it is the role of the individual that is singled out for examination, and, in this case, Attenborough's role, a familiar one for the actor, is the pivotal one. He is the one character who does not easily conform. Not only is he distinguished by virtue of his working-class origins, but he does not want to occupy what he considers a subordinate position, one deprived of recognition, and the film, in spite of its rhetoric of teamwork, reveals that it is the pressure of the male group, not any intrinsic sense of the importance of the work, that finally produces his conformity.

Men in Combat

The imperiled submarine crew was a popular narrative source for dramatizing the valor of the fighting men. The emphasis was as much on the issue of survival as on destroying the enemy. Many war films focused on the machinery, equipment, and environment of the submarine as well as on scenes of combat and survival. *We Dive at Dawn* (1943), directed by Anthony Asquith and starring John Mills, dramatizes the British hunt for a German submarine, the *Brandenburg*, by the *Sea Tiger*. The film begins with the departure of the submarine from port. Aboard the sub, prior to combat, the men share information about their civilian lives. The plot becomes complicated when the men rescue some Germans, from whom they try to get information about the whereabouts of the German submarine. One of the Germans is cooperative, and for this he is hounded and killed by a comrade. The British discover that they must ram their way through a dangerous mine field. In scenes designed to dramatize the competence of the men, the dangers under which they labor, and the equipment with which they work, the film dramatizes the *Sea Tiger*'s destruction of the *Brandenburg*. The *Sea Tiger* is hit, and the sub begins to lose oil. The men bring the sub to a Danish island to refuel, where they are forced to confront the Germans. In hand-to-hand combat, they defeat them and escape, but not without the loss of many men. The *Sea Tiger* returns to Britain and the captain and crew receive commendations for the destruction of the enemy ship.

The men in the film are representative of different regional and class backgrounds, befitting the motif of democratic cooperation fostered by the MoI. The film downplays verbal dialogue, stressing instead the non-verbal ways in which the men learn to live and survive together. The men's world is one of action, not words. Hobson (Eric Portman), who is bitter about women as a result of his wife's leaving him, for example, does not allow his disappointment to affect his performance. While the film draws connections between home front and combat zone, its predominant concern seems to be portraying male bonding and solidarity under threatening conditions. The film affirms several things simultaneously: that life on a submarine is dangerous but British seamen are able to confront the dangers, and that they are ingenious in fighting for their survival and undeterred in "getting the job done." The submarine itself functions, as in so many of the war films, as a home away from home. It signifies the spiritual values that bind the men to each other, but these values are a hybrid of the temporary and the permanent. On the one hand, life on the submarine is presented as impermanent, linked to the exigencies of the war; on the other, the values represented by the men and the cause for which they struggle are portrayed as timeless. A hallmark of the war film, this conjunction signals the need to create a sense of stability at the same time that it represents disruption and discontinuity. In similar fashion, the films of combat will attempt to straddle the sense in which the conditions of hardship under which the men struggle are exceptional yet familiar.

As in Hollywood films such as *Action in the North Atlantic* (1943), the Merchant Navy too provided the opportunity to dramatize military service. In 1940, the Crown Film Unit, the former General Post Office Unit responsible for many of the prewar government documentaries and later situated in the MoI along with the Army Film Unit, had produced a documentary on the Merchant Navy, *Merchant Seamen*. This film was followed in 1942 by another documentary, *Western Approaches* (1944), produced by Ian Dalrymple for the Crown Film Unit with MoI financing. The film celebrated the heroism of the Royal Navy and the convoys that escort the large ships out to sea. Charles Frend's *San Demetrio London* (1943) is dedicated to the officers and men of the British Merchant Navy. Set in 1940, the film begins with the *San Demetrio* setting out for Galveston, Texas, to get oil. While in Texas, the captain picks up two more crew members, one of whom is a rather unlikeable and abrasive American (Robert Beatty). On the return to England, the ship is attacked and the men are ordered to abandon it. Some of the men in the lifeboats are saved. One of the boats goes astray, and the men struggle to fend for themselves until they can be rescued. They see a ship and think that their rescue is at hand, only to learn that it is their own ship, the *San Demetrio*, which has not sunk after all. They board it and set about making it oper-

able. Food and water supplies are low, but through their ingenuity, sacrifice, and hard work they are able to operate the ship again, although one of their men, Greaser John Boyle (Mervyn Johns), dies in the process. The Yank, the men learn, is a jack-of-all-trades, and proves indispensable to their rescue. Having no navigating equipment, they find themselves ultimately off the coast of Ireland. They refuse help, insisting on bringing the ship into harbor by themselves. They are decorated and given unexpected salvage money for the ship.

The film personifies the ship, which in its survival after a brutal attack becomes a symbol of the endurance of the men and, by extension, of Britain. The filmmakers had practical objectives for the film: "Balcon regarded *San Demetrio London* not only as an epic story of endeavor but also as a way of reminding the public of the perils of Merchant Navy service."[26] The men are meant to constitute a microcosm of British society as they cooperate under conditions of hardship, sharing food, avoiding quarrels, making decisions democratically, and caring tenderly for a sick and dying comrade. The relationship between Boyle and Messboy James Jamieson (Gordon Jackson) is common in the war film, in which two men often bond, one guarding and nursing the other. This form of mateship appears under peacetime conditions only in films of institutional life.

Yank is a character type often associated with Americans. He represents the cynical and marginal character who proves himself in the course of conflict. Moreover, as an American, he comes to symbolize Anglo-American cooperation. Through him, among others, the film addresses the issue of mutual dependency and material deprivation in the hardships of the men aboard the battered ship. The ship, the men on it, and the ways in which they confront adversity and manage to remain calm and resourceful come to represent the strength and character of the British nation as perceived by the filmmakers. Unlike the films that link the home front to the combat zone, the action remains focused on the community aboard the life raft and later aboard ship, but like other combat films, this film creates a sense of family among the men, with some of them actually adopting a nurturant role toward the others.

Home Front Morale and Preparedness

A major issue of the war films, whether involving the battlefront or the home front, was that of morale. This issue involved not only the fighting men but also civilians; a particular danger among them, along with "loose talk," was defeatism. Defeatism was not merely the sentiment that the war would be lost or that the sacrifices demanded were too great, but was manifested in the loss of personal direction. Wartime rhetoric had to avoid easy optimism as well as defeatism, holding out promise but also stressing threats facing the individual and society. A wartime Ealing film that involves an imperiled community is the Cavalcanti film *Went the*

Day Well? (1942), based on a short story by Graham Greene, "The Lieu-
tenant Died Last." This film is predicated on the idea that enemy agents
disguised as friendly forces could invade a typical British town with the
help of the local fifth column. The invaded village is caught unawares and
forced to rely on its own resources. In retrospect, it is difficult to envision
such a situation being taken seriously, and yet these attitudes were central
to wartime experiences.

The film opens as a man beckons the viewer to the village of Bramley.
A fourteenth-century church is visible, and people can be heard singing
hymns. A man (Mervyn Johns) points to three graves and talks of the
Battle of Bramley in May 1942. The voice-over continues to explain that
"we would have laughed if you had told us we had a real live German
with us." A group of British officers arrive, but it is soon apparent to the
external audience (but not to the villagers) that the men are masquerading
as Britishers. Gradually, by means of lies and force, the men billet them-
selves in the town and begin to create a state of panic and terror among
the inhabitants. At first the people are stunned, and some disbelieving,
but gradually the knowledge of the occupation is shared by all. The most
perfidious figure is the local squire, Winsford (Leslie Banks), whom
everyone has cause to trust, and who plays a double game. One by one,
many of the people in the village are rendered ineffectual or are killed.
The vicar, who attempts to warn of the invasion, is shot in cold blood.
After many futile attempts, word is gotten out, but the main efforts in
repulsing the Germans are those of the villagers themselves. The vicar's
daughter (Valerie Taylor) is finally responsible for killing the perfidious
squire. The film is narrated in flashback, as if the war were over and the
events resolved, thus reducing some of the threat of an invasion.

Taking a peaceful English village and turning it into a battleground is
an appropriate trope insofar as the English village is not only a place but
also a state of mind, a national symbol, a signifier of all that is English.
The attack on this place enhances the sense of the enemy's barbarity. One
also gets a sense of the seriousness of the war, and, amidst all types of
conventional war films, this one stands out as vividly dramatizing reasons
for the war, the necessity of a state of preparedness. The slow awakening
of the community, its unsuccessful attempts to mobilize, and its eventual
cohesion dramatically portray the need for collectivity but also the need
to rethink traditional images of trust. The character of the squire, for
example, in literature and British mythology has been regarded as a most
exemplary British figure, and in this film he is the traitor. Moreover, there
is intertextual significance in the roles played by Basil Sydney and Leslie
Banks, actors associated with images of leadership and service. The film
thus suggests cultural changes in the representation of authority.[27] With
regard to other characters, this film adheres to the populist tendency of
many of the other war films in identifying the village's saviors with tradi-

tionally marginal characters—a poacher, a young boy, and a woman—rather than members of the upper class.

Films like Basil Dearden's *Halfway House* (1944) address the generational, marital, and property conflicts of a representative group of people, conflicts that cause the individual to lose hope and succumb to defeatism. The halfway house is not really an actual place so much as a psychological state. The film is another conversion drama, involving a group of disparate individuals who, like the pilgrims in *A Canterbury Tale*, are in need of spiritual and psychic regeneration. The characters include a retired navy captain (Tom Walls) and his wife (Françoise Rosay) who have lived under strained conditions since the death of their son in the war. The wife's desperation has led her to experiment with the occult, which leads to her husband's disaffection. Another couple (Richard Bird and Valerie White) are on the verge of getting a divorce. Their daughter (Sally Ann Howes), upset by their rift, is zealous in trying to reconcile them. A music conductor (Esmond Knight) who has only six months to live, a young Irishman and his female friend (Pat McGrath and Philippa Hiatt) who differ about the war, and a couple of crooks, black marketeers, and war profiteers also belong to the party.

Rhys (Mervyn Johns) and his daughter (Glynis Johns) run an establishment where everything seems out of date by a year. The two turn out to be ghosts and the house a phantasm, for it had been burned down a year before. As a result of encounters with the house and with the proprietor and his daughter, the musician becomes reconciled to his death; the two warring couples reconcile; and the Irishman begins to realize that he must compromise his political principles in the interests of the war and of his personal life. The criminal, Fortescue, determines to "go straight." Through confronting their possible deaths, the people begin to value life. As Rhys, the landlord, says, "Perhaps you couldn't see where you were going. You needed a pause to look at yourselves."

The film is didactic in attempting to convey its existentialist point of view of "seizing life," which means, in the context of the film, living in a morally responsible fashion with a sense of the integrity of the family, a respect for law, and a sense of self-discipline. Above all, through their encounters with one another, the initially separate people are brought together in a community, a typical theme of Ealing Studios. Setting the resolutions aside, the film is more notable for its exposure of conflicts surrounding personal relationships, allegiances, and man's confrontation with death than for its spiritual cures. The film exposes the tenuousness of consensus and the existence of social problems that even the danger of war could not suppress. The strain of deferring personal problems for the public interest is also explored.

Ealing's *Johnny Frenchman* (1945), directed by Charles Frend with screenplay by T.E.B Clarke, is characteristic of many of Ealing Studios'

aims as articulated by Michael Balcon, its head and voice during wartime and during the immediate postwar era.[28] The action takes place in 1939 and centers around rivalry between Cornish and Breton fishing villages. A romantic element is introduced between the harbormaster's daughter, Sue (Patricia Roc), and one of the fishermen, Bob Tremayne (Ralph Michael). Bob wants to marry Sue, but she falls in love with the son of Florrie (Françoise Rosay), the articulate leader of the Breton fishermen. The warring factions reconcile when Yan (Paul Dupuis) helps to save a catch, and Florrie invites the village to a French feast day. The festival, with its processions, feasting, and sport, is a symbol of unity between the two different cultures despite their ongoing competitiveness. The temporary peace is again shattered by the men's competition over Sue, but with the war in 1940 and with the French-German armistice, the villages again unite. The Bretons, with Florrie at their head, smuggle British soldiers to safety. On one of these trips, Yan sees Sue again, and they marry, in spite of her father's opposition. Florrie is instrumental in reconciling Sue with her father and assumes a dominant role in helping to lay to rest ancient conflicts between the Bretons and the Cornish.

Other than its motif of international cooperation and its emphasis on the collective endeavors and unity of both communities, the film has the familiar look of an Ealing film in its use of authentic locales to portray both the Breton and Cornish communities, which are the film's real protagonists. The scenes of the fishing boats and the men at work in particular are reminiscent of British documentaries of the era. The film's emphasis on village behavior—courtship patterns, family life, and ceremonials—also creates a documentary aura. The romance is presented not in terms of intimacy and intensity but as a sibling relationship, symbolic of the union of the two communities. The portrayal of the women, as in so many Ealing films, is characterized by their position as figures of reconciliation. Françoise Rosay's role, however, provides a sense of vitality often missing in other Ealing films that foreground women characters. She was one of a host of non-British actresses including Odile Versois, Simone Signoret, and Mai Zetterling who were to appear in British postwar cinema, redeeming the rather standard images of British women in the British war films as retiring wives and mothers. In this film wartime is a pretext for the dramatization of issues of community—cooperation as opposed to competition, generational reconciliation, and so on—issues that were, as the decade progressed, to be presented as highly problematic.

Elegies

In the last years of the war, the public was beginning to tire of war films, but Anthony Asquith's film about the RAF, *The Way to the Stars* (1945), proved to be an exception. It was an extremely popular film. The pro-

ducer was Anatole de Grunwald and the screenplay was by Terence Ratti-
gan, with whom Asquith had worked on *The Demi-Paradise* and other
films. The film opens with an image of a deserted RAF station as the
voice-over comments, "This was the nerve center of an airfield, and it is
now derelict. No more happy landings. . . . Now sheep are returning to
this field, which is inscribed in Doomsday Book." The film reverts to
1940. A new man, Peter Penrose (John Mills), arrives at the station and
is assigned to a room with David Archdale (Michael Redgrave), a recipi-
ent of the Distinguished Flying Cross. The men go out on a mission, but
Peter makes a bad landing. David is critical of his flying but tells him that
he will make a good pilot. David is in love with the woman who manages
the local inn, Toddy (Rosamund John), and they marry. Shortly after
their child is born, David is killed returning from a mission. In his grief
over David, Peter decides to reject a young woman, Iris (Renee Asherson),
whom he has been wooing.

The Americans arrive with their "Flying Fortresses" and their brash
ways. One of them, Johnny Hollis (Douglass Montgomery), becomes
friendly with Toddy. He talks of his wife and children, and becomes inter-
ested in her and in providing entertainment for children in the commu-
nity. He is assigned to return home to the States to become a flying in-
structor but wants to remain in England and fly. On his return from a
mission, he is ordered to bail out of his damaged ship. He chooses to
guide the plane safely into the airfield rather than crash, and he is killed.
Peter decides that he cannot evade life and proposes to Iris. *The Way to
the Stars* does not focus on combat scenes, and the deaths of Archdale and
Hollis are examined only as they affect others. The heroics of battle take
second place to the understated heroics exhibited by those who survive.
As the news of loss is communicated, the characters who are recipients of
the information are shown assimilating and accepting its inevitability
rather than experiencing the rage and loss associated with mourning.
Twice Toddy is struck by loss—first of her husband and then of the Amer-
ican with whom she has become friendly—but in each instance she re-
mains stoically composed. The legacy from her husband is a poem,
"Johnny in the Clouds," which is, like the film, an elegy for those who
have died, but the emphasis in the film, as in all elegies, is on the assimila-
tion of mourning and the necessity of seizing happiness. The elegiac qual-
ity of the film extends beyond the immediate narrative to the larger losses
due to the war, becoming a memorial for both the British and the Ameri-
can dead. David's lighter, which Toddy gives to Johnny, creates a bond
between the two dead fliers and the woman who was involved with both
men. Johnny's death also counteracts the negative images of the Ameri-
cans, who are presented as loud, rude, and effusive in comparison to the
British. This film, like *San Demetrio London* and other films featuring

Americans, is antipathetic to American behavior but seeks also to miti-
gate that antipathy by calling attention to American contributions and
sacrifices.

The film rehearses the past and explores the future. The past is associ-
ated with the sacrifices of the war, but the future with Toddy's child, with
the other schoolchildren, and with Iris and Peter's relationship. As in
other Asquith war films, the women do not play central roles. They are
seen as representatives of continuity, supportive of the men and accepting
of the inevitability of death and sacrifice, with the exception of Iris's aunt,
who is portrayed as self-seeking, petulant, and snobbish. The film ad-
dresses an important dimension of all the war films—the end of the war
and the ambivalent sense of being suspended between past and future. In
elegiac terms, the film seeks to memorialize sacrifice while at the same
time allowing for the possibility of continuity, a motif raised in many of
the war films but only as a question. Asquith's film highlights this issue,
if only to confront it in ambivalent and traditional terms.

THE POSTWAR WAR FILM

War films did not disappear with the advent of peace. Audiences saw
films that had been made during the final years of the war, those that
addressed subjects not possible under wartime strictures, and those that
addressed the war, directly or indirectly, in relation to the tenuous peace
that followed. During the remainder of the decade, and into the next
decade, war films or films set during the war were very much in evidence.
If the war had crimped the popularity and viability of the heroic images
of the 1930s and set in their place a more populist mythology, the post-
war films appear increasingly to question and challenge, if not lament, the
war ethos of national unity, collective effort, and competence. The issue
of cooperation among different nationalities so prominent in the war
films of Powell and Pressburger persists into the postwar era. Films of
combat continued to be made, and there was a rash of prisoner-of-war
dramas and films dramatizing daring rescues. Ealing Studios was a major
source of such films. While Rank was attempting to realize his expansive
designs on the American market with his high-budget productions, Bal-
con opted for films on a smaller scale, less expensive productions that
would continue to be representative of British values, customs, and
attitudes. The postwar Ealing films constitute efforts on the part of the
company to establish a balance between familiar narratives and modest
experimentation with new directions.[29] The war films coexist with the
comedies that were to bring Ealing productions to the attention of inter-
national audiences.

Against the Wind (1948), yet another Ealing Studio contribution to the postwar preoccupation with wartime narratives, stars Simone Signoret. Directed by Charles Crichton, the story involves a British team of saboteurs who are trained in England and go to German-occupied Belgium to rescue a countryman. The team includes a Frenchwoman, Michele (Signoret); a Canadian priest, Father Phillip (Robert Beatty); an Irishman, Max Cronk (Jack Warner); a Scot, Johnny Duncan (Gordon Jackson); a young woman, Julie (Gisela Preville), who is in love with the priest; and Emile (John Slater), whose wife has been abducted by the Nazis. Michele, who has experienced losses in the war, initiates the men into the work of sabotage. Aspects of the group's training for sabotage are developed, and the group learns that it cannot allow sentiment to interfere with its objectives: duty comes first. On the team's arrival in Belgium, Julie is killed when her parachute catches on a tree. When the group takes shelter in the countryside, Michele discovers that Max is a traitor and shoots him in cold blood. More difficulties arise when Johnny develops a toothache and has to be taken to a dentist. He cannot speak the language, and Michele and the others are afraid that he will be arrested if detected by the Nazis. Their plans to rescue their comrade are also jeopardized after an RAF raid hits the prison where the man is being held and the Nazis remove the prisoners. One of their group, Jacques, is taken away by the Nazis before Johnny's eyes. Emile is killed by the Nazis. The final scenes of the film involve the successful rescue and escape attempt in a lengthy chase sequence.

The film invokes the theme of international cooperation but actually stresses conflict more than solidarity. The traitor in the film, Max, is the only one who sees relationships in terms of commerce; the others are presented as having a sense of collective responsibility and affection for one another. Ironically, the traitors in the film express more analytic and less rhetorical sentiments about the war. The Irishwoman links the war to the ill-gotten gains of British colonialism, and Max describes it as related to commerce though mystified as duty, but these characters are denigrated and eliminated and the ethos of self-sacrifice elevated. While the film is one of intrigue and adventure, it looks backward to the exceptional conditions and relationships developed during the war. The plastic surgery that Emile receives to disguise himself and the scenes of trial and cooperation that the team experiences are meant to represent the idea of new identities forged as a result of the war, but the film is more challenging finally for the ways in which it dramatizes threats to consensus.

Prisoner-of-War Dramas

The war dramas of the 1950s often take the form of the prisoner-of-war drama, in which the narrative centers on the male relationships that emerge in the efforts to escape from Nazi prison camps. The films do not

linger on the character of the Nazis, who are usually presented as humorless bureaucrats and incompetents; rather, they dramatize relationships among the prisoners and their ingenious schemes for outwitting their captors and gaining their freedom. The appearance of such films must surely be traced not only to the opportunity finally to address those aspects of the war that were subject to censorship in order to maintain morale but also to the difficulty of making a transition into peacetime society and finding appropriate subjects. Moreover, the films, like the postwar cinema generally, seem to be addressed to the returned serviceman in their preoccupation with the psychic conflicts engendered by war and the return to civilian life. Ealing's *The Captive Heart* (1946), directed by Basil Dearden, which appeared at the end of the war, addressed the experiences of prison camp life. Involving the stories of not one but several inmates, the film, dedicated to the prisoners of war, merges the lives of the men with the lives of the people at home and dramatizes inevitable changes wrought by the war. One of the major motifs in the film is the need to adopt a more accepting view of non-British nationals. Hasek (Michael Redgrave) is a Czech who assumes the identity of a dead British officer in order to survive. In the process, he becomes involved with the dead man's wife (Rachel Kempson). After the war, Hasek and she come together. Another of the inmates, Stephen (Derek Bond), resolves his tenuous relationship with a woman.

The film intercuts recollections of home with the current hardships of prison camp life. The solidarity of the men is evidenced by the way in which they are willing to risk their own lives and sacrifice their freedom in order to help Hasek escape. The film attempts to re-create different elements of life in the camp—meals, regimentation, Nazi inspections, acts of mutual help, entertainment, and sports. The standard scene from most prison camp films, best exemplified by *The Grand Illusion* (1937), of men dressed as women to entertain their colleagues is also included. The prison camp is a microcosm containing different segments of British society, different classes as well as different nationalities. The film ends with the various men returning home to begin a new life in peacetime. The final sequence involves actual footage of the mass celebrations after the war, and it is against this background that the relations of the different characters are posed. The film is a conversion drama centering mainly on Hasek, who assumes a new identity and a new life, symbolically representing the "new man" who has emerged from the war.

Unlike *The Captive Heart*, which interweaves romance with prison camp life, other films focus exclusively on prison life and the hazards of escape. One of the first of these dramas is *The Wooden Horse* (1950), directed by Jack Lee, who had produced wartime documentaries. (In the late 1940s and 1950s Lee was responsible for directing such films as *The Woman in the Hall* [1947], which dramatizes the nefarious schemes of a

mother who almost ruins the lives of her two daughters, and *Once a Jolly Swagman* [1948], a film that portrays the world of motorcycle racers, exploring the exploitation of working-class young men by their managers and by sensation-driven audiences.) *The Wooden Horse* focuses on the ingenious escape of some British prisoners of war from a prison camp for officers, but its more covert agenda is the examination of male solidarity. The idea of creating a vaulting horse to divert their German captors while the men dig a tunnel under the playing field becomes a pretext for exploring relations among the men. Peter (Leo Genn) has difficulty convincing some of the other officers of the workability of their wooden horse scheme. The men's habituation to prison routine has made them complacent.

Peter finally prevails and wins the dissenting officers over to his plan, and one section of the film comes to an end with the successful escape of Peter, John (Anthony Steel), and Phil (David Tomlinson). The next segment of the film involves their escape from enemy-occupied territory without being detected. In order to do this, they must contact sympathetic civilians who can bring them to safety. Peter and John separate from Phil and the two men seek shelter. During this time, John becomes quarrelsome and suspicious about Peter's plans. However, the men are able to overcome the stresses of life on the run, primarily as a consequence of Peter's stabilizing presence, and they make contact with members of the French Resistance who help them get to Denmark, where they are assisted by a young Swedish man and his sister to escape to Sweden. In Sweden, they are united with their third comrade. Escape and life on the run are portrayed as ends in themselves. The nostalgia for home is verbalized merely in the desire for basic physical comforts. The idea of escaping, which the film's prologue states is "the constant hope of every prisoner of war—if not indeed his duty" is dissociated from any sense of the war or of home. Allusions or flashbacks to what awaits the men at home are as conspicuously absent from this world as women. Moreover, the film's use of officers as the protagonists contrasts sharply with the populist orientation of the war films made during the war.

The Colditz Story (1955), directed by Guy Hamilton for British Lion, offers another variation on the prisoner-of-war narrative. The all-male cast headed by John Mills and Eric Portman rehearses the numerous attempts of British as well as French, Dutch, and Polish officers to escape in 1940 from the the heavily guarded Colditz Castle in Germany (evoking memories of *The Grand Illusion*). The film's major motif, like that of *The Wooden Horse,* is the familiar issue of solidarity among the men and confines itself to cooperation among British officers. Rather than focusing on one ingenious strategy for escape, as in *The Wooden Horse, The Colditz Story* downplays the specific logistics of escape, concentrating on

the relationships of the men to each other and emphasizing the ways in which they struggle to accept group discipline as a means of attaining their freedom. The film reenacts the traditional values of male competence, leadership, competition, and discipline. The wartime context is negligible and hence the motives for the men's imprisonment are mystified. Voided of any specific context, the film addresses the generalized sense in which men are perennially captives and must struggle to assert themselves. The issue in contention seems to be one of male power and the need for discipline in male relationships.

Burma in 1943 is the setting for another prisoner-of-war drama, David Lean's *The Bridge on the River Kwai* (1957). This Technicolor widescreen drama represents the international dimension of Lean's work and is far removed from the private world of his earlier British melodramas. The film is a variation on the conventional prisoner-of-war drama. The emphasis is not on escape or on the relationships among the prisoners but predominantly on the relationship between the captive British officers and the Japanese. The film uses the war setting as a pretext. The building of a bridge that would connect the Bangkok-Rangoon Railway is the specific vehicle for the film's examination of differing codes of male behavior. Colonel Nicholson (Alec Guinness) is the upholder of British codes of privilege, honor, tradition, and competence. A model for his men, he refuses to work by their sides, insisting that according to the Geneva code on prisoners of war, officers are exempt from manual labor, and he endures extreme hardship to establish his position. Almost mystical, he is enthusiastic about his work, takes pride in his job, and inhabits the ritual and rhetoric of his position unaware of contradictions. His opponent, Saito (Sessue Hayakawa), an educated man, upholds a different code, which also stresses a sense of personal honor. He hates the British, who he claims have no sense of shame or pride, but he needs them to build a bridge. Nicholson undertakes the task, saying, "We'll show them what a British soldier is capable of." In his efficiency, he manages to humble Saito, who becomes more withdrawn and silent.

The doctor offers another perspective on the situation, telling Nicholson, "This is not a game of cricket. He is mad, your colonel, quite mad," and the final word in the film is his: "Madness." He offers the perspective of survival. As a medical man, he diagnoses the wartime situation in psychological terms. Warden (Jack Hawkins) represents another type of British officer. An Oxford don in peacetime, he adopts a more pragmatic and more stoic attitude toward his position. Shears (William Holden), an American, tells Warden that he and Nicholson are two of a kind. They know how to die by the rules "when the only important thing is to live like a human being." None of the leading characters in the film provides a vantage point from which to understand the creation and then

destruction of this bridge and the men who are involved. Each of the men's positions is undercut by the next, the fragmentation of focus on the characters serving to deflect identification with any single character.

The style of the film, its wide-screen format, and its visual emphasis on setting call attention to context as much as character. The focus seems to be on the loss of a sense of unity rather than on the heroics of a particular character or group. Not only does the film seem to question the values that were taken for granted in the war years, but it also seems to question the codes by which men act. High-sounding notions of morality and principle are undercut in the film's confrontation of violence and waste. *The Bridge on the River Kwai* is a rewriting not only of the war but of traditional conceptions of male behavior. In contrast to *The Colditz Story*, the Lean film provides a context for investigating the traditional ethos of service, sacrifice, and blind discipline. Consonant with the films of the cold war, the film seems to undermine prevailing notions of commitment, but offers nothing in their place. Like most prisoner-of-war dramas, the film offers no space for fantasies of home. If it contains any romance, it resides in the relations between Saito and Nicholson, the intense affect generated by their opposing, yet similar, positions.

Postwar Combat Films

One of the more critically successful and commercially profitable of the 1950s war films was Ealing's *The Cruel Sea* (1953). Directed by Charles Frend, the film enacts the Battle of the Atlantic from the perspective of the struggles of the men aboard the HMS *Compass Rose*. Based on Nicholas Monsarrat's highly successful novel, the film, which promises to be an antiwar film, becomes a re-creation of the ethos generated by the hardships of war. It interweaves personal relationships on land with the trials of the men aboard the ship, but the relations with women are schematic. Virginia McKenna plays the conventional female of the war film, loyal, affectionate, and attentive to the needs and desires of a serviceman (Donald Sinden). Moira Lister, on the other hand, plays the self-serving and disloyal seductress who has no sense of the trials and dangers confronting her husband (Denholm Elliott). The film's dominant interests lie elsewhere in the relationships among the men, and particularly between the captain and his second-in-command.

Among the numerous scenes dramatizing representative wartime conflicts are the captain's concern about the inexperience of his men, the presence of officers who are detrimental to the morale and collectivity of the men, the difficulty of the training to detect submarine threats, combat with submarines which, despite the rigors of training, are hard to detect, and rescue operations. The high point of the film is the captain's decision to bomb an enemy submarine, which will also kill British sailors from

another ship floating in the water and appealing for rescue. His men turn against him, although he redeems himself later as he makes the decision to attack a U-boat against the advice of his men, including his first officer. He is portrayed as pushing himself to the breaking point, unsupported by his crew, exhausted, and beginning to doubt himself. The attack is successful, and this time he rescues German sailors. The issue of male competence is foregrounded in the captain's relation to his inexperienced crew, the first lieutenant's imperious relation to the new junior officers, and the captain's to his first-in-command and to the crew at large. Hawkins is weighed down with the heavy responsibilities entailed by being a commander of men, and while the film portrays threats to his command, he is revealed as ultimately adequate to the task of leadership reinforced by the supportive role of his second-in-command, Lockhart. His relationship to Lockhart is developed, in part, to expose his stress and to dramatize differences between a man who can command and one who is more comfortable in the position of subordinate, but their relationship offers the affect absent in the other male relationships portrayed in the film.

While *The Cruel Sea* emphasizes self-discipline and control, and can be described as another example of the typical Ealing "emotional restraint" in the presentation of the vicissitudes of male leadership, momentary lapses provide a clue to what is being restrained and withheld.[30] The tender scene in which Lockhart administers to his tense and tired captain contrasts vividly with the more conventional action scenes involving the captain's relations to the other men, suggesting that behind the conventional "stiff upper lip" stance are more deep-seated fears, if not desires, concerning male identity which are potentially disruptive to the very roles that are being enacted. In this role, Hawkins, who was to become an icon of the exemplary British officer—a figure of self-discipline, a benign disciplinarian, a dependable servant of his country, an image of virility, and a "man's man" as opposed to a romantic figure—is allowed a greater latitude of character, not only in his uncertainties but in his relationship to another man.

By the late 1950s, films could puncture the sanctity of wartime myths and consign them to the same category as other socially committed positions. Launder and Gilliat's *Left, Right and Centre* (1959) or the Boulting brothers' *Private's Progress* (1956) or their *I'm All Right Jack* (1959) are characteristic of the debunking tendencies that were becoming increasingly evident. *Private's Progress*, set during the war, satirizes not only the bureaucratic apparatus of the national service generated by the war effort but also, by implication, the war film, undermining platitudes about bravery, self-sacrifice, and commitment of both volunteers and officers. Its portrayal of the war as an opportunity for profiteering, exemplified by Major Tracepurcell's (Dennis Price) scheme to rob art treasures from the

Germans which the Germans themselves have robbed from their captives, sounds a different note among the various films devoted to resurrecting wartime ideology. The maintenance of high-sounding principles is presented as ludicrous. The film shares with much of the cold war rhetoric a cynicism toward liberal humanism as well as toward all forms of affirmative political positions, and its popularity may be due in large part to this point of view as well as its stellar cast and its technical proficiency.

Women and Romance

So many of the British postwar films that resurrect the war are prone to presenting the women as faithless creatures, as negligible, or as insubstantial, focusing on the male group as it seeks to rehearse the past and relocate in the present. However, *The Purple Plain* (1954), a Two Cities Technicolor wide-screen film directed by Robert Parrish, an American, with a screenplay by Eric Ambler, features two prominent female figures and a strong romantic component. The film's protagonist, Forrester (Gregory Peck), is a Canadian who is fighting in Burma in 1945. The war has brought him to the point where he has begun to hallucinate and to fight like a robot. The Britishers in his company describe him as a "raving lunatic" and the doctor takes him under his wing and introduces him to Anna, a young Burmese woman (Win Min Than), who works with a Scottish missionary, Miss McNab (Brenda de Banzie). The scenes of male strife are intercut with romantic scenes between Gregory Peck and Win Min Than.

The film employs techniques designed to draw attention to the subjective responses of the protagonist to the past and to his immediate environment. Peck is filmed through netting, heightening the sense of the war as hallucination. He is shown falling asleep and slipping into the past, and the hazy perspective reinforces the film's preoccupation with madness and sanity. Events are shown from his perspective, as when he observes a young native boy playing with a salamander until he finally kills it. With his introduction to Anna, the style changes so that events are shown from the perspective of a third person. He is told by Miss McNab that the Burmese are "not like us. They do not keep everything inside," and Anna, with whom he falls in love, tells him, "Here we bury the dead in the earth, not in our hearts."

On a flying mission, the plane develops engine trouble, landing the men in enemy territory. A new set of conflicts begin between Forrester and one of the men, Blore (Maurice Denham), who is the epitome of British respectability and repression. The third man on the plane is the navigator, who is badly burned and cannot manage alone. Blore insists that they wait until they are rescued, though Forrester reminds him that the Japanese will spot them if they remain by the plane and that their best

chance for safety is to make a stretcher for the wounded man and make their way to British territory. As in a nightmare, Blore keeps obstructing their advance, claiming that their situation is hopeless and telling Forrester that he is mad. He interprets his madness as arising from Forrester's not having a home and a wife, as he has. Eventually Blore escapes and commits suicide, but Forrester makes it to safety and sees to it that the navigator is rescued.

The film insists on exploring not only the state of mind of the protagonist but the relations between the men, and its primary agenda seems to be the undermining of British-Western repression, characterized by Blore, who is obsessive and hysterical. The dominant motif is one of therapy, introduced by the doctor and Miss McNab but represented by Anna. In order to advance its therapeutic concerns, the film indulges in Orientalism, which, in Edward Said's terms, "depends for its strategy on . . . flexible *positional* superiority, which puts the Westerner in a whole series of possible relationships with the Orient without ever losing him the relative upper hand."[31] The Burmese are presented as childlike, demonstrative, and attuned to the present rather than the past or future. Anna serves Forrester, entertains him, shares her wisdom with him, and finally offers her love. The first half of the film is thus a prologue to the second; Forrester is "healed" and able to survive. Like a conversion drama, it portrays him as asleep until awakened by Anna into a different sense of manliness and relationships. The sequence in which Forrester comes and lies down beside the sleeping Anna seems quite unusual as an ending. The film begins with Forrester asleep; it ends with him again going to sleep. Sleep plays an important role in the film in relation to the issue of sanity and madness and the contrast between Western activity and Eastern passivity. The fake ruby that Forrester carries with him that is associated with Anna seems also to be related to the film's blurring of dreaming and wakefulness. The film sets up a conflict between romance and duty, opposing the male group to the heterosexual couple, with the values weighted against the male group. Unlike many postwar films that rehearse the war, in this film the romantic sequences are in effect a criticism of the harsh and depersonalized world of male duty.

Carol Reed's *The Key* (1958) follows a trajectory familiar to the viewer of the postwar film in its preoccupation with troubled male identity. Wartime experiences are reenacted, no longer in the context of "addressing the nation" but rather to address the question of personal survival and the psychic consequences of threat to the individual's sense of self. Based on the Jan de Hartog novel *Stella*, the film explores the dangerous work of men in the salvage service who went out to rescue damaged ships. As the prologue indicates, "Tugs were inadequately armed and virtually defenseless against attack by plane or submarine. At one time, every rescue

mission undertaken by the men who manned these tiny rescue ships was, in effect, a suicide mission." Two of the men involved in the salvage work are Chris (Trevor Howard) and David (William Holden), a Canadian, and it is through Chris that David learns of Stella and the apartment. Stella (Sophia Loren) has been passed along with the key to her apartment from one man in the salvage service to the next, the rule being that the key is shared with another so that if the present owner does not return, the next may take occupancy. David becomes the possessor of the key from Chris, and when Chris dies, he moves in. Aware of the fatalism of the men in the service, he seeks to overcome it and find happiness with Stella, but he begins to succumb to the same fears about his end, associating Stella herself with the "bad luck" that she brings.

Captain Van Dam (Oscar Homolka), one of the skippers, identifies women, alcohol, and sexuality with bad luck and offers religion as an alternative. Ironically, he is killed when a building is bombed during a service he is conducting. David tries to shake the sense of fatality that the film both develops and seems to want to undermine. In its structure, repetition becomes a device in as well as a subject of the film, underlining the film's questioning of determinism. In speaking of the men who have come through the apartment, Chris says, "We're all the same man and I don't know which one." Stella's treatment of him offends David because she treats him the same as all the others. When Stella tells him not to go on a mission, he says, "It's not true. I'm not like the others. I'm not going to die, not tonight anyway." But he is shaken and passes the key to Kane (Kieron Moore), a man with whom he has had antagonistic relations. He returns from his mission of saving a foolhardy American crew to find Kane in the apartment but no Stella.

The film alternates between scenes of rescue and scenes in the apartment, and the link between the two is the woman and the fear of death. The Canadian seems to avoid the fatal equation between women and bad luck, but the British and the Dutch seem infected with superstition. In this respect, the film seems to be using the contingency and danger of war to explore sexuality. Stella appears not as an individual but as an incarnation of the Great Mother who is associated with both procreation and death. She seems to be "the key" to the men's sense of their loss of individuality. As in Reed's other films, the focus seems to be on the dissolution of male psychic boundaries. The men struggle to resist but, like Chris, they succumb. His death turns out to be more the product of self-destructiveness than of determinism. David is presented as resisting the frame of mind that produces a sense of fatalism and personal dissolution. In this process, Stella is more a symptom of the fear of loss of control than a protagonist. The film raises the question of the degree of control these

men have over their bodies, their desires, and their actions. The external
enemy is secondary, if not irrelevant, to the internal enemy, the men's
shaky perceptions about their power. The war drama has now become a
psychological drama; the past, and the war in particular, an occasion for
an examination of male malaise.

THE COLD WAR: SUBVERSION AND ESPIONAGE

In contrast to the films that rehearse the war years and vacillate between
investigation and nostalgia, seeking to retrieve the wartime sense of col-
lectivity, another group of films acknowledges international tensions and
situates personal malaise within that context. These films capitalize on
uncertainty about the fate of humanity and project fears onto an enemy
who is usually a foreigner, most likely vaguely identified as Eastern Euro-
pean, occasionally Russian. Like the film noir, these texts are darkly lit
and play with images of reflection, mazes, labyrinths, and revolving ob-
jects. The question of identity between friend and foe is uncertain, al-
though there is no ambiguity about the existence of an enemy who gradu-
ally materializes. The films take place in urban contexts, although secret
operations are also associated with the countryside. The mystery is asso-
ciated with information that can either harm or help a particular gov-
ernment, and the agents in the films either are employed by the govern-
ment or, as in the case of espionage films, are drawn into the conflict
through their desire to get personal information, find a missing friend, or
rescue an individual. Professional people—scientists, physicians, and
lawyers as well as secret service men—are both the protagonists and the
antagonists in these films.

 How much do these cold war films contribute to an understanding of
British culture in the postwar era? British society in the 1950s has been
characterized by Arthur Marwick as "a time of consolidation, in which
nothing very dramatic is achieved, but in which the great changes of the
immediate post-war years are allowed slowly to seep through society."[32]
Postwar British society was characterized, on the one hand, by economic
decline, inflation, and rising unemployment, an erosion of controls estab-
lished by the Labour government, no substantial changes in the distribu-
tion of wealth, the gradual loss of the empire, and a rise in international
tensions. On the other hand, the period also saw a rise in real income for
workers, a growing affluence as seen in the acquisition of commodities, a
broadening of the middle classes, and a diminution of the working class.
Moreover, as John Stevenson indicates, "No one could ignore the rise of
a science and technology which brought faster travel, broadcasting, new

medicines, and new, more destructive weapons of war."[33] The sense of optimism concerning the capability of technology to improve the quality of life was balanced by an awareness of the capability of technology to produce mass destruction. Correspondingly, the Americanization of British society made itself felt in the development and advertising of commodities as well as in changing patterns of social relations.

In the specific case of the British cinema, American colonization was evident in the failure of the cinema to compete successfully in the American market. According to Margaret Dickinson and Sarah Street, the postwar British cinema is characterized by the growth of monopolies, with the Rank Organization in the lead, and by the continued, if not greater, entrenchment of Hollywood as well as by the drastic decline in the cinemagoing audience.[34] British film production in terms of both financing and film themes and styles became more than ever dependent on America.

Historians and film critics describe the temper of the times as one of apathy, which translates into a greater emphasis on personal needs and desires, a sense of complacency accompanied by a disillusionment with grandiose social schemes and reforms, and a conservative political temper. "Butskellism" was the term coined for the erosion of differences that increasingly came to characterize economic and social policies. A conflation of the names of the Labour Chancellor of the Exchequer, Hugh Gaitskell, and his successor, the Conservative R. A. Butler, the term signified the essential sameness of the two parties' economic policies.[35] Rather than celebrating the growing affluence of the era, the cinema of the 1950s exposes the contradictions arising from this affluence and also the paranoid mentality characteristic of the cold war.

Carol Reed's *The Third Man* (1949) is one of the most well known of the cold war films. Set in Vienna, a city divided as a consequence of the defeat of the Axis powers, the Graham Greene novel is transformed into a stylistically elaborate film of intrigue featuring two Americans—the writer Holly Martins (Joseph Cotten) and the racketeer Harry Lime (Orson Welles). The international cast includes Alida Valli as the object of both Martins' and Lime's romantic desires and Trevor Howard as Major Callaway. The film involves a quest motif which centers on Lime. Martins follows a number of clues relating to the ostensible death of his friend Lime. Callaway seeks to bring Lime to justice for the traffic of adulterated penicillin that has caused the death and maiming of many children. The Russians seek Anna to return her to the Eastern sector, and later Martins, learning of Lime's activities, tracks him down and kills him.

The noir style of *The Third Man* is linked to a view of the world that is "paranoid, claustrophobic, hopeless, doomed, predetermined by the past, without clear moral or personal identity. . . . The visual style conveys this mood through expressive use of darkness: both real, in predom-

inantly underlit and night-time scenes, and psychologically through shadows and claustrophobic compositions which overwhelm the character in exterior as well as interior settings."[36] Shots are angular and disorienting, and shot compositions are unbalanced like the minds of the characters. The image of a maze or labyrinth, so familiar to noir films, is replaced by the revolving Ferris wheel where Joseph Cotten finally encounters his friend. Mirror and window shots frame the characters and signify entrapment. The atmosphere of the Reed film is one of surveillance, where characters are framed in positions of surveying and being surveyed. The city is an extension of the characters' personal and interpersonal divisions. Vienna as a historical and fictional entity comes to represent a shadowy, malevolent world of predators and innocent victims. The dark, narrow streets, the dark doorways, the sewers are places of danger and destruction. Nightclubs are the locus of intrigue, the haunts of people who are marginal and untrustworthy. Women are portrayed as threatening, untrustworthy, and of shady origins.

The male characters also undermine traditional notions of heroism. The character of Harry Lime undercuts the classic image of the naive but basically benevolent American. Martins, whose quest is the conventional one for self-discovery, from innocence to knowledge, is, like the external audience, forced to confront deceit and corruption. The figure of Callaway, the hardboiled officer who succeeds in convincing Martins that Lime is a destructive force, while associated with the clear-cut world of crime and punishment, is limited in combating the overwhelming atmosphere of corruption dominating this postwar environment. The use of American actors and international settings and the adoption of the noir style are all further indications of the British cinema's urge to capture international audiences as well of the greater internationalization of national cinemas. *The Third Man* was incredibly successful. Its theme music was a hit record, and Welles also did a spin-off of the film for BBC radio.

In *The Man Between* (1953), Reed turned to another divided city, Berlin, to present a film of intrigue. Actual shots of the city's sectors, images of barbed wire, and pictures of Stalin and Lenin mark the divide between East and West and dramatize the "iron curtain" that will also separate the lovers. Susan (Claire Bloom) arrives in the city to visit her brother, Martin (Geoffrey Toone), and his German wife, Bettina (Hildegarde Neff), and while there she becomes involved with "the man between," Ivo Kern (James Mason), who is blackmailed into working for the East German Communists. Susan learns that Bettina had formerly been married to Ivo but, thinking that he was dead, remarried. Ivo becomes interested in Susan, at first only to use her as a decoy to get Bettina and other West Germans to return to the East. Susan, who is unwilling to believe that Ivo is merely using her, is mistaken for Bettina and abducted by the Commu-

nists, who have coerced Ivo to work for them. Ivo rescues her; the two fall in love, but he is shot helping her to cross into the western sector.

The Man Between, more than *The Third Man*, focuses on the dangers of the Communist threat. In the former film, the Russians constituted only one threatening element. In *The Man Between*, they are the major danger. The posters of Lenin and Stalin, the slogans on the walls, the sinister nature of the East German agents, the crowded streets of the East German sector where Susan and Ivo are trapped, the bombed buildings that are reminders of the devastation of the war are the exterior signs of the fragility of interior relationships. Communism is identified as gangsterism, and the Communists take on the appearances and gestures of criminals. Their motivation is unimportant. The audience is asked to accept their malevolence, as it is asked to accept the benevolence of the well-meaning protagonists. The cryptic nature of the signs identifying the Communists must also be predicated on the prior knowledge of the audience to make the connections between crime and communism.

The cold war films are also preoccupied with science and technology, with the control of information, particularly with the competition between East and West for scientific supremacy. Of the films that feature scientists and the struggle to gain technological hegemony, one of the few that feature a woman scientist is *Highly Dangerous* (1950), directed by Roy Baker and starring Margaret Lockwood in a semi-comic role. She is asked to travel as a governmental representative to Eastern Europe in order to acquire information about biological warfare. The film is unusual in its making the secret agent a professional woman. She is portrayed as patriotic and intrepid in the accomplishment of her goals. Her colleague is an American, Bill Casey (Dane Clark), a journalist in trouble with his editor, who accompanies her on the dangerous mission of penetrating the highly secret installations where the biological research is being conducted. They experience all the classic obstacles in the accomplishment of the mission—intimidation by a highly ruthless chief of police, the disappearance and death of friendly agents, interrogation and drugging by the enemy, and the inevitable breathless chase and flight to safety. The conflict in the film is between the freedom-loving democrats from the West and the harshly authoritarian Eastern European. The film shows that there is no rest from the enemies of democracy, who could just as well be Nazis as Communists. The ultimate compliment to the British way of life is the contrast between the humane inefficiency of British life and the inhumane efficiency of life in the East. Moreover, the film makes a point of contrasting the personalized relations of the West with the depersonalized relations of the Eastern sector. The British virtue of "muddling through" is juxtaposed to Communist efficiency, a position reminiscent of the war films in their distinction between democracy and Nazi

totalitarianism. The film also portrays a crossover in male and female relationships as the woman comes to depend more on the man to rescue her. Casey is presented at first as lacking in initiative, ingenuity, and principle, but after they confront the dangers at the biological stations, he emerges as the stronger of the two.

Frank Launder and Sidney Gilliat adopted espionage formulas in *State Secret* (1950). Though the film was originally conceived of during the war as an attack on fascism, it emerged as an archetypal cold war narrative. Douglas Fairbanks, Jr., stars as a physician, Dr. John Marlowe, who is invited to a mythical Eastern European country, Vosnia, to attend the ailing dictator, General Niva. When the general dies, a look-alike is substituted, but Marlowe is not allowed to leave the country with the knowledge that he has of the fraud, and the film becomes an intense chase instigated by the number one man in the police, Colonel Galcon (Jack Hawkins), to prevent Marlowe from escaping. On Marlowe's odyssey, he meets a performer, Lisa (Glynis Johns), who is part English, and, after many harrowing episodes, they are delivered to safety. Dr. Marlowe's reproach to a reticent and frightened Lisa, who does not want to be implicated, is central to the mood of the narrative: "You people live in a miasma of distrust." The sense of life in the country is portrayed as similar to fascism with its emphasis on the ubiquity of surveillance, the Big Brother role of the media, the role of spectacle to keep the masses pacified, and the aura of mistrust in the ambiguity of personal relationships.

Organized around the chase and capture of the doctor and Lisa, the narrative moves into a flashback to recount the events that have brought them to their impasse and then returns to the present and their escape. The evolving relationship between Lisa and the doctor is treated ambiguously, culminating in the final sequence on the train in which Lisa confronts the fact that she has lost everything. She and the doctor have nothing in common, and she fears that she is going to be ill. She is portrayed as having no control over her situation, as implicated in spite of herself, and as nothing but a pawn in the doctor's escape, thus casting doubt on the values that she has been asked to endorse.

In *High Treason* (1951), Roy Boulting confronted the cold war on the "home front" and identified the enemy as Communists and misguided and malevolent fellow travelers. The film begins with sabotage on the London docks and expands to the planned destruction by the saboteurs of the Battersea Power Station. The saboteurs are not merely foreign agents but persons involved in respectable positions in British society, including a government official, a member of Parliament, an art dealer, and a former serviceman. Reformers are portrayed as dupes who allow themselves to be misled by foreign ideologies in the hope of a better world. In the case of the ex-serviceman, he was converted to "the cause"

during the war, but the film portrays his gradual disillusionment with the sordid and destructive techniques of the Communists, until he is brought to the point of martyrdom when he finally thwarts the Communists and dies heroically. Elected officials like the M.P. are more insidious, exploiting their constituents with high-sounding speeches and the appearance of personal concern. Many of the Communists, as in other cold war films, are debased intellectuals and artists. Their "front" is a college where they read classic texts on revolutionary struggle and speak about "bourgeois deviation," "democratic discipline," and a "correct political approach."

The positive figures in the film, like the young dupe's mother and brother, are presented as patriotic, able to recollect the war and enshrine the memory of the sacrifices of the war against fascism. Ultimately, an equation is drawn between being a patriotic war hero and doing the right thing for British society. The film is exemplary in dramatizing the postwar condition as one of cynicism, opportunism, threat, and the loss of the collective and patriotic ethos of the war years. The film exudes a sense of paranoia, a preoccupation with the misapplication of power and authority. The landscape of a city is unstable; threat lurks within and without. Places normally associated with the commonplace functioning of everyday life become places of danger. The fragility of a mass society is dramatized in the selection of a power station that services all aspects of the city's needs as the target of destruction. Of the film, Raymond Durgnat says, "Almost McCarthyite in its witch-hunt, and no doubt heartily regretted, now, by its perpetrators, it's something of a collector's piece, weirdly testifying to the hysteric current of its time."[37]

The conflict between East and West can take the form of an oedipal drama. The malevolent paternal figure is Eastern European, seeking to prevent a union between East and West. *The Young Lovers* (1954), directed by Anthony Asquith, relies on this scenario, portraying a romance between a woman from the East who falls in love with a Britisher. Their love is obstructed at every turn by her father. The film begins with a ballet performance at Covent Garden, where the young lovers meet. At first, Anna (Odile Versois) is reticent about entering into a relationship with Ted (David Knight), but their relationship flowers despite the fact that she is the daughter of a diplomat immersed in cold war intrigue and Ted is the son of the American ambassador. The lovers are both surveyed and hounded by representatives of their governments, each believing that the other is spying for their respective countries. Neither of them wants to renounce their country, but the situation becomes desperate when Anna learns that she is pregnant with Ted's child and is ordered home by the embassy. They finally find a boat and set out to sea but encounter a storm. The boat is demolished, and the pursuers find a note from Anna to her father stating, "I am running away because you will not believe we are

innocent. You say that the world is divided in two. We cannot escape that fact, but we are going to try. You who live in separate worlds, you cannot believe in innocence. You cannot believe in love." The final sound in the film is the music of *Swan Lake*.

The typical opposition between hostile and bureaucratic East and democratic West is tempered, and both sides are presented as sinister and dehumanizing. The consequences of the paranoid atmosphere make themselves felt in personal relationships. The enemy is not individual governments but the atmosphere of mistrust that infects all. In the case of both governments, the subordination of the individual to the state is stressed; thus the theme of individual impotence so characteristic of these cold war espionage films is reiterated. The use of the ballet music of *Swan Lake* as a coda seems, as in other Asquith films, to portray the world of culture as a leveler of difference, in the same way that love levels political opposition. The film, which dramatizes the homelessness of the pair, literally setting them adrift, seems to locate the tragedy of relationships in the lack of a centering institution. Family has failed. The state has become an enemy, and, as the film indicates, in a world divided in two, there is "no third place." In melodramatic fashion, these "children" become orphans in the monolithic struggle between East and West. Moreover, by having Anna become pregnant, in this environment the film raises the threat to the future generations. Like the other cold war texts, the film captures the sense of the virulence of political differences and the atmosphere of paranoia, and attempts through an affective treatment to heighten the tragedy.

Reading the films from World War II against the films of the postwar era reveals how far the British cinema was retreating from narratives of national aspiration and unity. The war narratives were preoccupied with the immediate necessity of transforming everyday life to meet the massive challenges created by the war. These challenges produced forms of representation that could address the separation of families, the potential and actual loss of loved ones, the threat of personal annihilation, the adjustment to new rhythms of life abroad and on the home front, the development of agencies and resources to meet new conditions, and anxiety over the shape of life after the war. The propaganda films, the combat and home front films, films of espionage, and others, in addressing these issues, developed a language that could confront and manage these new circumstances; they constitute a rich resource for understanding the creation of consensus. At the same time, in retrospect, they provide insight into the unresolved conflicts generated by the war, the tenuous nature of alliances, allegiance, and relationships.

Rather than being monolithic and closed expressions of a war ideology, these films are powerful representations of a society in flux. The postwar films that rehearse the war or capitalize on the cold war are not

radically disjunctive but draw on tensions already exposed in the wartime narratives. If the films produced during the war introduced science and technology, these postwar films dramatize the powerful dangers posed by science. The enemy, too, is no longer easily marked as the outsider, but exists in the midst of former zones of safety—the family, the school, and even the government. Personal identity and personal loyalty are at risk; in short, the element of trust, already eroded, is shown to be further eroded. Violence threatens to erupt in both public and private spheres. Representations of women and of the family are a site of contradiction and conflict. While many of the films focus on the issue of male identity and male relationships, females are frequently absent, relegated to the background, or presented as disruptive. These films reveal the struggle to produce new forms of knowledge in a context of inherited myths and the emergence of new patterns.

The Woman's Film

MELODRAMA is a major genre in the British cinema, and, like its Hollywood counterpart, it provides a significant index to cultural aspirations, dreams, and fantasies. Although for purposes of narrative classification melodrama can be distinguished from war films, films of empire, horror films, and social problem films, there is a sense in which it is intrinsic to all these genres. In its moral polarities, its preoccupation with sentiment, its focus on violence and spectacles of suffering and vindication, and especially its translation of public conflicts into the language of individual struggle, melodrama constitutes a worldview which encodes the transformation from a hierarchially organized and aristocratic society to one based on fluid social and personal relationships and on individual merit. The "melodramatic imagination" is linked to modern views of the world, and is particularly associated with the rise of the bourgeoisie, privileging individual enterprise, affective family ties in contrast to strong public bonds, and the importance of cultivating proper attitudes toward the self and society based on personal integrity and authenticity.

While the common denominator in melodrama, including British melodrama, is sentiment, the representation of events in individual, personal, and affective terms, sentiment is never dissociated from morality but serves in place of external power and force to ensure that justice will prevail. As Peter Brooks maintains, melodrama "takes as its concern and raison d'être the location, expression, and imposition of basic ethical and psychic truths. It says them over and over in clear language, it rehearses their conflicts and combats, it reënacts the menace of evil and the eventual triumph of morality made operative and evident. While its social implications may be variously revolutionary or conservative, it is in all cases radically democratic, striving to make its representations clear and legible to everyone."[1] Melodrama is, then, the result of an attempt to make sense of a secularized world that has devalued life. In Brooks's sense, melodrama is more than just a formal genre. It is symptomatic of a worldview associated with the rise of the bourgeoisie in the eighteenth century. This worldview has persisted to the present, altering with the changing position of the bourgeoisie from struggle to ascendancy. Initially, melodrama

emphasized social victimization and subversion, later on, containment
and conformity, representing the disjunction between self and others, de-
sire and realization, justice and injustice.

The persistent focus in melodrama on the domestic sphere can be
traced to the tendency to represent the private bourgeois family as a spir-
itual and moral enclave set apart from the corruptions of society. In fact,
by the nineteenth century, the family was no such haven but rather a
major institution in the regulation of social attitudes. In Michel Fou-
cault's terms, "the family organization, precisely to the extent that it was
insular and heteromorphous with respect to the other power mecha-
nisms, was used to support the great 'maneuvers' employed for the
Malthusian control of the birthrate, for the populationist incitements, for
the medicalization of sex and the psychiatrization of its nongenital
forms."[2] Foucault thus identifies the family as a major force in the disci-
pline and regulation of the broader social sphere rather than as a separate
and protected private arena. Hence, the preoccupation in melodrama
with familial relations is not symptomatic of an escape from the public
sphere. Rather, melodrama acknowledges the interrelationship of the
public and private spheres, the increasing encroachment of the external
world and its power onto the privacy of the home. In its transposition of
the public and the private, melodrama enacts a process that is at the basis
of familial ideology and hence at the basis of patriarchy. The preoccupa-
tion with family, sex, and sexuality is inseparable from prevailing dis-
courses of religion, medicine, education, law, and gender positioning.
One can expect in melodrama, the representation par excellence of this
ideology, to find familiar figures expressed in benign or malevolent
terms—the priest and pastor, the physician, the teacher, the lawyer and
the judge. Father, Mother, and Child are at the center of these discourses,
and melodramatic texts vary in the dramatic emphasis and focus that they
place on one or another of these figures within the family constellation.
"Part of what defines melodrama as a form," says E. Ann Kaplan, "is its
concern explicitly with Oedipal issues—illicit love relationships (overtly
or incipiently incestuous), mother-child relationships, husband-wife rela-
tionships, father-son relationships. . . ."[3]

Expressions of melodrama from the nineteenth century to the present
are not monolithic and unchanging but dramatize different, often critical,
moments in social history and in relations of power. While recent film
criticism has singled out the family melodrama, especially in the works of
such Hollywood directors as Douglas Sirk, Vincente Minnelli, and
Nicholas Ray, feminist critics have argued that distinctions should be
made between the woman's film, the family melodrama, and the tragic
melodrama. The oedipal conflict is central to all of these narratives, but

the films vary in the ways that they enact the oedipal conflict. What distinguishes the woman's film from the family melodrama or the tragic melodrama is the position of the protagonist. In the woman's film, the female protagonist represents a different case in the oedipal drama. Her position is not symmetrical to the male's. Her relationship to power is constrained within patriarchy, and her struggle to express her desires is viewed as subversive from the perspective of those who align themselves with patriarchy, but the texts offer a window into the world of female identity, desire, and sexuality. The woman's melodrama focuses on the heroine's desire to take her mother's place. The female protagonist is often placed in a situation which she neither understands nor can control. She must constantly test the validity and status of her knowledge. "The heroine's transgression resides in her desire to act against socially accepted definitions of femininity. Work or career is set against socially accepted definitions of femininity, bringing her face to face with society. Work or a career is set against maternity and the family, and the heroine often gives up both for the sake of love, the 'grand passion'. . . . The heroine suffers for her transgression, sometimes with death, but her humiliations are small-scale and domestic compared with the tragic hero's epic downfall."[4]

The female protagonist is seen from a number of perspectives depicting her movement toward self-discovery and her relationships to spouse, lovers, other women, and children. The foregrounding of maternal relations often takes precedence over other forms of familial conflict. In the woman's film, too, the presence of the female star is a determining factor, "serving as an anchor to identification, drawing the spectator 'close' to this 'person' and encouraging empathy. . . ."[5] What E. Ann Kaplan has termed the "Master Mother Discourse" is responsible for such paradigms in the woman's film as the "saintly, all-nurturing, self-sacrificing 'Angel in the House' or the cruel Mother, who is sadistic and jealous. The few variations—such as the heroic Mother type, the vain silly Mother, or the possessive, smothering one—are mere gradations from the basic figures."[6] The female protagonist as mother, daughter, and wife is essential to domestic drama, but her representation has been skewed through the suppression of female subjectivity. The mother is usually viewed from the perspective of children, of a male physician, or of a more culturally acceptable mother surrogate. Conflicts are less frequent between mothers and daughters than between fathers and sons or fathers and daughters. Laura Mulvey has argued that "the workings of patriarchy, the mould of feminine unconscious it produces, have left women largely without a voice, gagged and deprived of outlets (of a kind supplied, for instance, by male art) in spite of the crucial social and ideological functions women are called upon to perform."[7] The challenge, therefore, confronting the

critic is to uncover the ways that women speak to each other under and through patriarchy.

Molly Haskell's *From Reverence to Rape* was one of the first texts to direct attention to the representation of women in film and in particular to the devalued nature of melodramatic films.[8] She set forth the characteristics of what she called the "woman's film," and recent work by feminist critics on the woman's film have expanded on and complicated her observations. Most writers on the woman's film concur with Haskell's description of the designation "woman's film" as a culturally pejorative one, since there is no corresponding term for films that center on male conflicts. Melodrama as a general category has been dubbed feminine,[9] while realism and modernism have been identified as masculine; the woman's film has been considered a particularly lowbrow form, associated with mass culture and with women's world in particular. Not only does the woman's film contain the familiar melodramatic formulas—expressive melos, an emphasis on clichéd and excessive body language, stylized characters, the splitting and polarizing of character traits, symbolic landscapes that resemble dreams—but these films foreground female trials and tribulations. The sources are frequently novels, short stories, and magazine articles by female writers, and the range of female representations includes the figures of mother, daughter, wife, entertainer, adventuress, femme fatale, courtesan, and prostitute. The conflict between the domestic and public spheres is a dominant one, the issues of work and career most often assuming a contradictory position.

The female protagonist is usually middle class in status and behavior. The films present upper-class women as exemplary figures or as failures, but they also feature "ordinary women whose options have been foreclosed by children or age" as well as women who transcend their constraining circumstances and become extraordinary. Sacrifice, affliction, choice, and competition are at the basis of the narrative.[10] The conflicts often entail choices between love and duty, husbands and children, lovers and husbands, career and marriage. Another form of the woman's film, what Haskell termed "affliction" films, focuses on the illness of the protagonist, an illness that is symbolic of her inability to conform. She either dies from her affliction or is "cured" by a physician, thus enabling her to lead a "normal" domestic life. Two other variations include those films that hinge on the protagonist's choice of a mate and those that involve competition with other women through which they discover that they are less interested in the male object of competition than in each other. Feminist critics have charted the strategies of these films and have noted how their medical discourse is especially revealing of the ways in which women are passively positioned in the narratives, placed under the controlling surveillance of the physician just as they are similarly positioned

by the male director for the cinematic spectator. Images of female muteness, blindness, or other physical impairment are common in the films and suggest that female language is inscribed on the body. Certain images recur in these films—windows, portraits, staircases, attic rooms, restrictive clothing—which suggest female entrapment and claustrophobia as well as fractured identity.

Going beyond an analysis of the images in the films and their narrative structures, feminists have sought to construct a notion of female spectatorship to account both for the ways in which women are positioned and viewed within the woman's films and the ways in which they might be regarded by audiences. As Mary Ann Doane says, "As a discourse addressed to women, what kind of viewing process does the 'woman's film' attempt to activate? A crucial issue is the very possibility of constructing a 'female spectator,' given the cinema's dependence on voyeurism and fetishism.[11] Because of its focus on familial relations and the domestic sphere, its frequent foregrounding of female protagonists, its antirealist, highly coded, and excessive nature of representation, the woman's film has lent itself to an exploration of the ways in which the subjectivity of the female protagonist is constructed by the text. The visual style of the melodramatic texts betrays how sexual difference is culturally constructed, not biologically determined.

The exploration of femininity as a negative sign has led feminist critics to explore the marks of negativity and silence. It has also led them to explore the "archaic forms of expressivity" that mark female exclusion. In particular, women's exclusion and subordination are expressed through vision. Woman has been viewed as the object of the gaze, her subordination manifest in the ways she is "regarded" by the culture. But visibility is not the only way in which woman is differentiated and excluded from power. The woman's film, owing to its focus on subjectivity, its preoccupation with issues of seeing and not seeing, and with bodily symptoms in general, exposes woman's entrapment not only in patriarchy but also in psychoanalysis as both a regimen and mode of explanation for cultural representations of women.

In addressing the appeal of psychoanalytic paradigms in the study of cinema, Tania Modleski has argued that "current film theory tends to agree with Roland Barthes that all traditional narratives re-enact the male Oedipal crisis. For this crisis to be successfully resolved, the argument runs, feminine sexuality must undergo a complete suppression, feminine desire, an utter silencing, so there is nothing left for the feminist critic to do but outline the process by which this silencing is inscribed in the text. While I do not mean to underestimate the strength of this position—we do, after all, live in a patriarchal society—I believe that we occasionally encounter a film which adopts a feminine viewpoint and allows the

woman's voice to speak (if only in a whisper), articulating her discontent with the patriarchal order."[12] Modleski argues for a more flexible conception of representation. She introduces into her discussion of the text that necessary element of "experience," the experiences of the author as well as of the spectator, which are not unified and totally determined but fragmented and discontinuous, characterized by conflict and self-doubt, by conscious and unconscious subversion, and, above all, by the inevitable contradictions that arise in representations of power. Power entails the suppression, but not necessarily the forgetting, of the means whereby it maintains itself at the expense of others. The woman's film is thus an important site at which to locate the suppression of female sexuality, but also at which to identify an alternative female discourse that subverts or resists dominant expressions of power.

The British cinema of the 1930s produced some woman's films, although the larger share of narratives involved male protagonists in dramas of initiation and conversion. An examination of the British melodramas from the 1930s through the 1950s reveals the superabundance of father-son conflicts, in contrast to Hollywood and the French and Italian cinemas. The explanation lies only partially in the fact that the British production has been mainly in the hands of men, with the exception of such women as Muriel Box, Betty Box, and Wendy Toye. Camera work, too, has been a male domain, and the censors have been mainly men. The explanation lies also in the structure of British middle-class culture, which has been heavily weighted toward segregating the sexes from childhood through young adulthood. Of the thematics of much of British film production, Raymond Durgnat says that "it is the theme of the heavy father resigning his authority—a theme currently prominent throughout Western culture—and on the other hand, a perpetuation, by the elimination of women, of the all-male club. . . . The feeling of growing up as something that goes on between boys and men, not involving, or only very elliptically, a feminine presence."[13] In contrast to the overarching British preoccupation with melodramas of male identity, the Hollywood cinema of the 1930s produced a large group of women's films, starring such actresses as Katherine Hepburn, Rosalind Russell, Greta Garbo, Barbara Stanwyck, and Bette Davis. The most familiar of these films are *Alice Adams* (1935), *Craig's Wife* (1936), *Camille* (1936), *Stella Dallas* (1937), *Jezebel* (1938), and *Dark Victory* (1939). Unlike the British women's films of the 1930s, the Hollywood women's films are more emotionally and stylistically excessive in their treatment of women's conflicts, cover a larger range of everyday problems confronting women, and are more likely to situate their narratives in a contemporary context, although there are examples of costume dramas.

The British cinema's preoccupation with male identity, privilege, and

bonding notwithstanding, it is possible to locate instances in the 1930s of
the woman's film that challenge the heavy male orientation of British
cinema. Such films as *Illegal* (1932), *Evensong* (1934), *Evergreen* (1934),
and *A Stolen Life* (1937) address female conflicts concerning career, do-
mesticity, maternity, marriage, and aging. The situation changed in the
1940s, and more woman's films were produced. During the war, such
British films as *The Gentle Sex* (1943), *Millions Like Us* (1943), *Two
Thousand Women* (1944), and *Perfect Strangers* (1945) offered audi-
ences representations of women struggling outside the home, assuming a
necessary role in the "total war," and confronting contradictions be-
tween traditional expectations and new personal and social possibilities.
However, the heyday of the British woman's film, in contrast to the Hol-
lywood women's films of the 1930s, was the 1940s production of popu-
lar costume dramas by Gainsborough Pictures such as *Fanny by Gaslight*
(1944), *The Wicked Lady* (1945), and *Caravan* (1946). Two exemplary
women's films set in a contemporary context are *Love Story* (1944) and
They Were Sisters (1945). These films are not mere imitations of Holly-
wood women's films but constitute a unique contribution to women's
representation and to the development of British cinema.

Robert Murphy recalls how "from mid 1943—ironically when the tide
of war had turned and British films were able to celebrate real rather than
fictitious victories—there were murmurings in the trade press that the
public was sick of war films and wanted escapism. Maurice Ostrer, the
most vociferous advocate of this policy, announced early that Gainsbor-
ough would be concentrating on entertainment."[14] The women's costume
dramas were made on modest budgets, though they had an expensive
look. The sets were designed by people who were conscious of the neces-
sity for both artistic effect and economy, and, as Maurice Carter, who
was the art director at Gainsborough in 1938, stated in an interview with
Sue Harper, the British tradition of decor design "developed from the
German and not the American tradition . . . it came up from UFA, and
Craig and Appia. Appia was there with Korda and the rest of them. We
were very much influenced by films such as *Dr. Mabuse*. They were de-
sign dominated."[15] The popularity of these films was a result of a number
of factors: the work of indigenous and imaginative artists, the presence of
new faces on the screen in actors such as Margaret Lockwood, Jean Kent,
James Mason, and Stewart Granger, and exotic narratives that evoked
sexual fantasies but also, despite the remoteness of the settings, touched
on everyday conflicts concerning women's experience.

The costumes were not designed as reproductions of period clothing
but were rather a blend of history, current fashion, and notions of glam-
our. The plunging neckline, so worrisome to the American censor, was an
essential ingredient of the British costume drama. Consonant with the

film's emphasis on history as "the site of sensual pleasure," the costumes too are meant to be evocative and not "realistic." And, as Sue Harper indicates, "The costume genre itself permitted the expression of ideas about history and sexuality which were impossible in existing, more 're-spectable' signifying systems."[16] The costumes in the films were also an antidote to the wearing of uniforms and the severe suits and dresses that were characteristic of the wartime and immediate postwar situation. The narratives themselves were often based on popular novels such as those by Lady Eleanor Smith and, in contrast to the wartime histories and biog-raphies, not only emphasized female characters but addressed sexual and domestic conflict. "One reason for the cycle's popularity," writes Harper, "was its representation, through 'costume narrative', of a female sexual-ity denied expression through conventional social forms and signifying systems."[17] The narratives involved rebellious females, often played by Margaret Lockwood, conflicts over class and status, and, above all, the quest of the female characters for adventure. These films were geared to predominantly female audiences, and, as such, are representative of the woman's film, which focuses on female protagonists.

Whether set in a contemporary or a historical context, these women's films portray women divided against themselves, facing mutually con-flicting demands. The women are either paragons of virtue and respecta-bility or violators of social conventions. In certain instances illness serves as a metaphor for their uneasy relationship to the world of conventional expectation. Such issues as mother-daughter relations are occasionally raised, and, in most cases, the uneasy relationship between men and women is resolved through death or marriage. But the resolutions of the films never quite conceal the unresolvable conflicts. In contrast to the representations of female solidarity in films such as *Two Thousand Women*, the female characters are often divided against each other as a consequence of competition for a man.

The characters alternate between upper-class women stifled by their milieu and lower-class women seeking to acquire wealth and respectabil-ity. Gypsy women are often present. The genre of the woman's film owes its existence in part to the tradition of the Gothic novel, works often written by women and focusing on women's oppression. The women in these works are portrayed as independent, striking out on their own out of economic necessity or the desire to alter their present way of life and find romance. The men are portrayed as either cruel or domineering. Pa-ternal figure surrogates are usually the source of the women's suffering. The men to whom the women are married are often converted spiritually or brought low by infirmity, as is Mr. Rochester in *Jane Eyre*, thereby becoming better companions. The technique of splitting female character-istics is paralleled by a similar splitting of the male. As Tania Modleski

affirms, "Feminists (as well as traditional psychoanalysts) have frequently cited the male tendency to divide women into two opposing and unreconcilable classes: the 'spiritualized' mother and the whore. But there is also a corresponding tendency in women to divide men into two classes: the omnipotent, domineering, aloof male and the gentle, but passive and fairly ineffectual male."[18] In some instances, these qualities contend in one character; in others, they are represented by two different characters.

The Gainsborough woman's film has a highly stylized mode of representation—polarized characters and situations, intense musical punctuation, arousal of affect in the spectator, the creation of a mise-en-scène that appears a suspension from the ordinary environment, a strange juxtaposition of the "ordinary" and the "exceptional," the use of gesture as well as place as indicators of feelings and attitudes. In short, one expects to allegorize and extrapolate in melodrama. The form is congenial to women's representation, perhaps even more so than realistic or pseudo-documentary styles when it comes to portraying women's psyche and the ways in which the psychological and the social interact. There is certainly an element of distancing in the costume melodramas; this may carry over to the contemporary melodramas that schematize relations and, through their narrative repetitions, call attention to the underlying conflicts in a way that descriptive realist films that focus on social problems could not.

The costume melodramas and the melodramas set in a contemporary context such as *They Were Sisters* (1945) share certain formulas; these formulas operate like the dream censor to screen the more subversive aspects of the conflicts presented. Not only in relation to women but also in relation to men's representation, the melodramas explore the thorny question of identity unencumbered by the strictures that govern the realist mode, where men are cast in the mold of dominant notions of masculinity. The melodramas, owing to their preoccupation with transgression, their schematization of behavior, their tendency to exaggerate in the interests of heightening affect, enhance the possibility of exploring the interiority of the subject, of finding a language that can bring to light unnameable desires and conflicts and get behind the superficial manifestations of women's containment within the cycle of marriage and reproduction. Melodramatic characters are not fully rounded characters, and they are not psychologically complex. They are identifiable by their polarized nature, their representation of specific moral qualities, their likeness to the split figures in dreams, and their relation to fantasies. Their stylized and excessive representation of character and situation works to mask social conflicts, but these stylistic qualities provide the raw material for an understanding of female subjection and even resistance.

The films discussed in this section span the 1930s, the World War II

period, the immediate postwar era, and the 1950s. They represent a number of variations on the British woman's film ranging from entertainer films and maternal melodramas, to costume dramas and domestic dramas. This thirty-year period of cinema reveals that, while representation of women in marriage and motherhood travels a continuum, the attitudes about women's roles fluctuate during the wartime years, exposing deep conflicts between the public and private spheres. By the late 1940s and the 1950s, films featuring women, such as *The Loves of Joanna Godden* (1947), *The Woman in the Hall* (1947), and *This Was a Woman* (1948), will portray discontented and destructive women who must be disciplined. Fortunately, these films are not merely legitimations of traditional attitudes governing women's position under patriarchy but provide glimpses of other attitudes and aspirations.

THE WOMAN'S FILM IN THE 1930s

The Entertainer Film

Of the films of the 1930s, the melodramas featuring female entertainers offer the most complex and contradictory representations of women. In these films, the female characters are not nurturant figures. In fact, they are often wayward and flout conventions. Female identity is central to the narrative, and the world of entertainment allows women to be portrayed outside the domestic sphere. The conflict between performance and courtship may be present, though it is not always paramount. *Evensong* (1934), directed by Victor Saville, involves a singer, Irela (Evelyn Laye), who escapes from her father and his insistence that she lead a "normal" domestic life and avoid the sin and scandal of the world of entertainment. She runs away with her pianist (Emlyn Williams), actually living with him in Paris without marrying him. The film portrays the conflict between his narcissism and her desire to have a career, and his envy of her to the point where he nearly kills her. She puts herself in the hands of a male manager, Kober (Fritz Kortner), who promises her worldwide success, at the price of a renunciation of desire. She meets a prince with whom she falls in love, but Kober, his family, and war intervene to prevent the marriage. Her life then becomes a steady rise to the top of the operatic profession until she is overtaken by a new prima donna and her career (and the film) ends.

The producer of *Evensong* was Michael Balcon, who had, the previous year, signed a new contract with Gainsborough. The directors who worked at Shepherd's Bush and Islington were Victor Saville, Walter Forde, and Maurice Elvey, and "Balcon had an impressive team of editors and cameramen from America and the continent as well as from Brit-

ain."[19] Balcon's strategy was to create stars who would not be raided by Hollywood or be primarily associated with the British theater. He found such a star in Jessie Matthews, but he failed to turn Evelyn Laye into a star. In contrast to Jessie Matthews, whose image was boyish and energetic, Laye was more staid, restrained, and feminine. Moreover, whereas the Jessie Matthews musicals subordinate romance to performance, *Evensong* probes the personal conflicts of the female protagonist in ways that conflict with spectacle. Based on a fictional biography of the opera singer Nellie Melba,[20] *Evensong* does not merely follow the predictable trajectory from obscurity to success, but goes beyond this trite formula to portray the loss of that success, to show the aging singer bereft of the gratifications of admiration, applause, and romance. A prologue at the outset of the film objectifies talent: "Every now and then the gods bestow the gift of a glorious voice on some mortal—not as a personal possession, but as the means of offering untold happiness to the rest of the world. Such a treasure becomes a ceaseless responsibility—a jewel to be guarded with pride—to be displayed with humility. How far Irela of the golden voice succeeded—only her life can tell." The film, like other Saville films, does not present an untroubled narration. The woman is not represented as arriving at a compromise either with her "gift" or with her desires. For that matter, her gender and sexuality are continuously in conflict with her "golden voice."

The film treats success as a burden as it shows the distancing of the protagonist from others and the frustration of her female desire. Renunciation of desire is the price she pays for her fame. She has no voice of her own; her gift belongs to her manager and to the public. The agent of her success is a father figure who has never been interested in her as a woman but "has given his life for her." The final scenes of the film portray the diva as totally succumbing to narcissism in her bitterness over aging. She puts on a crown, listens to a record of her singing, drowning out the voice of a young opera singer, and expires. If she is the pseudocenter of the filmic discourse, the instrument not only of the narrative father figure, Kober, but of Saville himself, she is also a figure of conflict. The narrative foregrounds those elements that are most revealing of women's dilemma: the lures of romanticism, the exchange of success for desire, and, above all, the loneliness of aging. Irela's aging is equated with "losing her voice," and losing her voice, with death itself. *Evensong* reproduces what appears to be a cliché, namely, that success isn't all that it's cracked up to be, but the film veers in a different direction, addressing more fundamental female conflicts.

Specifically in relation to the issue of the aging entertainer, the film foregrounds the issue of spectatorship. Laye is presented often in extreme close-up as the object of the internal and external audience's gaze, but at

the end she is displayed alone confronting her image in the mirror, deprived of her admirers, reduced to self-admiration. The external audience cannot help but be conscious of this contrast as well as of its own scrutiny of an aging and desperate figure. The spectacle of the aging prima donna bereft of romance, of her voice, of her audience, and of her beauty introduces disturbing elements into the conventional trajectory of the rags-to-riches narrative. While she comes from humble origins, the usual trials on the road to attaining stardom are less important than the conflict between desire and success. *Evensong* constitutes a departure from the dominant representations of women in the British cinema of the 1930s as untroubled figures of service and especially of family stability. The protagonist violates a number of taboos. She lives with a man out of wedlock; she does not marry her prince and live happily ever after; and she does not disappear from sight at the peak of her success. By 1930s standards, she does not even fit the model of the entertainer who can flout conventions easily, using economic necessity as her excuse. The romantic element in the film is minimal, barely satisfying the formula for romantic interest demanded of the films of the time. In one sense Irela is, like the representations of so many entertainers, punished for her voice and for her career by being deprived of love. Saville's inclusion of the scenes involving her aging are also unusual for the time.

Another Saville film that features a female entertainer but involves mother-daughter relations is *Evergreen* (1934). This film is a blend of musical and melodrama, typically blurring the boundaries between entertainment and the world beyond the stage.[21] The choreographer was Buddy Bradley, an American who was responsible for introducing "the infinitely extendable stage into British films, in which performers are seen on a realistic stage which then proceeds to lose its proscenium arch and expand at will."[22] This description of the stage serves to illuminate the way *Evergreen* works, beginning in a context of verisimilitude and expanding into an exploration of the fantasies associated with the female entertainer. Jessie Matthews plays two roles, mother and daughter. The mother, Harriet Green, is an Edwardian singer who is on the point of giving up her career to marry a nobleman when her past catches up with her in the unexpected return of a man with whom she had had a child. The man is a blackmailer and an exploiter. Recognizing that he will never leave her alone, Harriet senior leaves her child with an older woman who has attended her in the theater and disappears to South Africa. The film shifts to the present with the daughter, Harriet junior, fully grown and in search of a career in the theater. Unsuccessful until she meets a young publicity man who has the idea of her impersonating her mother, of bringing a still-youthful Harriet Green back after these many years, she

now becomes enmeshed in the consequences of that impersonation. The men from her mother's past return, both the nobleman whom she was to marry and Harriet junior's father. In order to escape detection, Harriet is forced to present her young man as her son. The two of them now perform an act as Harriet Green and Son, but, having fallen in love with her "son," she begins to rebel, and, during a performance number, strips off her Edwardian clothes and her tightly coiffed wig, exposing her body for the first time while singing "Over My Shoulder Goes One Care." The audience protests, until the director (Sonnie Hale) pleads with them to give her a chance on her own merit, blaming her impersonation on economic exigency. In the courtroom scene with a shaft of light over her head like a halo, she is exonerated from the crime of impersonation, and the film ends with the principals united on a platform above the revolving female chorus.

The narrative adopts several strategies that undermine a simplistic reading of *Evergreen* as mere escapism. The film plays reflexively with the idea of entertainment. In moving from the Edwardian era and the music hall to the contemporary theater, *Evergreen* celebrates both change and continuity, a popular thematic of British 1930s films. Harriet senior belongs to another generation, to another form of entertainment associated with the music hall, and to another moral context. Harriet junior's relinquishment of the maternal persona and her appearance as herself are associated with the celebration of entertainment and the recognition of the necessity of its changing forms. The daughter impersonating the mother has fundamental significance in the narrative. The mother is first eliminated, associated as she is with transgressive behavior. Through the daughter's impersonation, she is resurrected, only to be rejected once again. Harriet's re-creation of her mother and then her rejection of that re-creation is a classic enactment of mother-daughter relations that end in separation.

Writing of maternal melodramas, Mary Ann Doane asserts, "Motherhood is marginalized, situated on the cusp of culture. . . . The price to be paid for the child's social success is the mother's descent into anonymity, the negation of her identity (quite frequently this descent is justified by the narrative on the surface by making her an unwed, and hence explicitly guilty, mother)."[23] Harriet Green's disappearance becomes, as it were, the retribution for her social transgression, and the daughter's disavowal of her mother's persona is consonant with cultural attitudes concerning motherhood. The scene in which Harriet junior literally throws off the garments of the maternal masquerade is like a striptease as she takes off layer after layer of clothing on the stage, exposing her body for all to see. The mother is associated with all that weighs the daughter down, with the

impersonation that prevents her from being herself. The film makes a link between clothing and identity, presenting the Edwardian high-necked dresses associated with the mother as a form of bondage. The final production number recapitulates the striptease motif as the dancers fling off, as Harriet junior did earlier, their long dresses while singing the same song she had sung. But being herself requires that Harriet expose herself as the object of the audience's gaze, as spectacle. Moreover, the exposure is legitimated by her entering into a relationship with a man. The final shots of the film reveal her hand with an engagement ring and then show her coupled with the young man. The narrative makes a further equation between the exposure of the body and the role of the female entertainer. Harriet junior now personifies the female entertainer who, unlike her Edwardian mother, displays herself.

With the help of her young man, she is able, once she has disavowed the impersonation, to rid herself of her ne'er-do-well father and also of Lord Staines, to whom she had, like her mother, become engaged. Thus the taint of incest suggested in her being the mother of Lord Staines's son, as she claims, and then being barred from having a relationship with the young man, is also eradicated. Not only is every vestige of her relationship to her mother erased, but she is now able to enter into "normal" heterosexual relations. The film thus effects several linkages involving women's success: that success is defined as abandonment of the mother and the unconventional past with which she is associated. Performance is tied to oedipal fantasies, and for the female, the fantasy entails first embodying the past through identification with the mother and then rejecting her on the pretext of fraudulent impersonation. The courtroom scene at the end of the film is visually fused to the scene of exposure on the stage and the manager's plea to the audience for mercy. While this scene may seem to be a conventional strategy to legitimate entertainment and the transgressions of this film in particular, it has a more fundamental significance in relation to the oedipal drama; it provides further reinforcement for the connection between the Law and the exclusion of the mother in favor of the daughter and monogamy. The elimination of the mother (like the title of the film) may also be a way of saying that an aging actress is an unacceptable spectacle. The daughter maintains the illusion of perpetual youth. If this film is one of the more successful Jessie Matthews films, this has a great deal to do with the way in which the narrative embodies the myth of female sexuality and gender identification. As in *Evensong*, Saville has built the narrative on central contradictions surrounding women's position. Though the film recapitulates many of the class and gender attitudes of the 1930s British cinema in the subordination of the workers, the emphasis on respectability and social status, and the domestic containment of the female, its focus on the maternal dilemma and on the relation-

ship between mothers and daughters differentiates it from the many other melodramas of the time.

The Maternal Melodrama

In comparison with the Hollywood and European cinemas with their plethora of maternal melodramas, the British cinema offers few instances of this genre. Films such as *Back Street* (1932) and *Madame X* (1937) and their variants (*Blonde Venus* [1932]) are rare. In the maternal melodrama, as Christian Viviani states, "a woman is separated from her child, falls from her social class, and founders in disgrace."[24] The 1932 film *Illegal*, starring Isobel Elsom and Ivor Barnard and featuring a woman with two female children who is married to a man who has gambled away her small inheritance from a prior marriage, is a version of this type of woman's film. Evelyn (Isobel Elsom) gives her profligate second husband, Dean (D. A. Clarke-Smith), the remainder of her money and sends him away. Through one of her husband's gambling cronies, she receives enough money to open a small nightclub that features gambling and drinking. Her sole objective is to provide her daughters with the best education and social connections possible, and to that end she agrees never to visit them at school, to keep the school's reputation unsullied by not allowing her connections to be made known. She tells the headmistress, "Gambling and drink has cheated them out of their place in the world, and, rightly or wrongly, I said to myself, drink and gambling should put them back where they belong." When she is finally arrested for her illegal activities, her daughters, Dorothy (Margot Grahame) and Ann (Moira Lynd), take over the running of the club by eliminating the gambling. Dean reappears and tries to seduce his stepdaughter, Dorothy, who kills him and then dies in an automobile accident. The other daughter, Ann, marries an aristocrat. Alone, the mother sets fire to the club in the final sequence of the film.

The mother's relationship to her children is presented as one of self-sacrifice. Her relationship to men, both her husband and Albert, is one of hostility or of indifference. While her husband is the typical melodramatic reprobate and seducer, Albert (Ivor Barnard), a member of the working class, assumes a protective role toward her. Albert becomes her partner in the nightclub and, in contrast to the cavalier behavior of her husband, totally subordinates his desires to hers. He cooks for her, tends her wounds, minds the children, and helps her set up her business. The scenario couples them as the custodians of youth, while the stepfather is envisaged as the perverter of domestic relationships. The illegality in the film is identified with him and with Dorothy, who is portrayed as a seductress. As the featured entertainer in the nightclub, she sings about love and transgression. While Ann is a defender of the mother's values and

behavior, Dorothy rebels against the mother. The mother is thus the care-
taker of the daughter's socialization.

The incest motif, which leads to the death of the stepfather and the
daughter, represents the violation of the mother-child bond. Dorothy is
punished for her relations with her stepfather, while Ann is rewarded for
her loyalty to her mother. And her loyalty to her mother is the prelude to
her successful relations with an upper-class man whom she will wed. The
incest motif is linked to the father, who, early in the film as he leaves the
apartment, casts a lascivious look upon the two young girls, who close
the door on him. In the seduction scene between Dorothy and her stepfa-
ther, she refers to him as a "horrible, bestial, filthy beast"; he asks her,
"Am I different to any other man you entertain at night?"

The idea of the Law serves a dual function in the film. It is linked on the
one hand with the violation of social conventions associated with gam-
bling and drinking, but it is also associated, on the other hand, with the
violation of the incest taboo. The mother is presented as both the violator
of social laws and the upholder of cultural laws. She pays for her social
transgressions by going to prison and with the death of her daughter, but
she is rewarded for her maternal constancy and sacrifice by the legitimacy
of the other daughter. Alone at the end of the film, she has no occupation,
no male companionship, and no daughters. The mother's role is thus por-
trayed, as in so many of the Hollywood maternal melodramas, in terms
of discipline and progressive isolation. The scenes in prison foreshadow
her marginalization. When Albert tells her that she should be proud of
herself, she responds, "For breaking the law? The law is just one's con-
science put into words. They both have to be settled with in the end."

The Twinning Film

Women's position underwent significant changes as a result of World
War I, the feminist movement, suffrage, greater employment opportuni-
ties, and changing patterns of sexuality.[25] John Stevenson comments on
how "the most obvious changes lay in the dress and appearance of
women . . . mirrored by a loosening of . . . social restraints."[26] However,
in spite of growing alternatives for women, "many traditional attitudes
remained."[27] Women were employed in "female" jobs, and newspapers
and magazines still extolled the virtues of the domestic sphere. The melo-
dramas of the 1930s are similarly ambivalent in their representations of
women. The device of doubling so frequent in melodrama represents
divided attitudes about women's position as well as internal divisions
in women's consciousness in relation to tradition and modernity, love
and career, independence and marriage. A Stolen Life (1939), directed by
Paul Czinner, Elisabeth Bergner's husband, is a film that capitalizes on
woman's self-division through the conventional ploy of twinning.[28] (The
film was remade in Hollywood in 1946 and starred Bette Davis.) Bergner

plays the parts of both Martina and Sylvina. The film begins by creating confusion in the spectator about the women's identity. Martina is scolded by Alex McKenzie (Michael Redgrave), an explorer, for trying to climb a mountain without proper training and clothing, and in a short time she acquires both with his help. The twin sister, Sylvina, does not enter the scene until Martina has aroused Alex's interest. Then Sylvina, the more flirtatious of the two sisters, steals him away from Martina. Sylvina's physicality is fascinating to men, but her attractiveness to them is not based merely on her seductiveness but also on her transgressive behavior. Martina is closer to her father and her aunt, who prefer her to Sylvina, while Alex prefers Sylvina, though his friends warn him that he is making a mistake.

After his marriage to Sylvina, Alex goes off on an expedition and Martina comes to stay with Sylvina, who takes advantage of her husband's absence to have affairs with other men. By now, the film has sorted out the sisters and assigned a more sedate, monogamous attitude to Martina and an attitude of promiscuity and indifference to social conventions to Sylvina. Sylvina is, as one can expect, eliminated from the story after she defies a warning not to take the sailboat out too far because of a brewing storm. The boat containing the two sisters capsizes and Sylvina is drowned. In the hospital Martina is wrongly identified as Sylvina, and she does not disavow the identification but begins to live as Sylvina. Only her father recognizes her as Martina, and he warns her against impersonating her sister. She, however, is determined to try out her sister's life and finds herself mired in the intricacies of her sister's extramarital affairs. She also learns to her surprise when Alex returns that he wants a divorce from her. With her identity restored as Martina, she and Alex are united.

Both women are associated with nature, but whereas Martina is hesitant in the face of danger, Sylvina defies it, braving the storm and being destroyed by it. The split between the women, as is characteristic of films that involve twinning, stands for two profoundly different attitudes toward men, the female body, sexuality, and monogamy. Sylvina is associated with masculine pursuits. She is interested in a man who masters nature, a mountain climber and a man whose work places him in the company of men most of the time. Martina is associated with traditional femininity. She has a sense of familial responsibility and is willing to subordinate her desires to a man. Twinning is used as a metaphor for women's conflict over societal demands in the form of obedience versus insubordination, masculine versus feminine identification, as these are posed within a single individual. In the figure of Sylvina, promiscuous behavior must be eliminated in the interests of monogamy. In the scenes following the drowning in which Martina assumes her sister's identity, the spectator sees most forcefully the impossibility of Martina's living a

life other than the one decreed by her father and the demands of family. By killing off the promiscuous sister, the film seeks to suppress the bisexual aspect of female sexuality, channeling it in the exclusive direction of femininity; however, the strategy of twinning allows for an expression of a divided female psyche. The death of Sylvina does not ultimately resolve conflicts. Rather, her elimination from the narrative becomes evident as a disciplinary strategy, both through her death and through Martina's uncomfortable adoption of her sister's identity.

WORLD WAR II AND THE WOMAN'S FILM

Women in Groups

Sue Aspinall states that "the realist films of the early 1940s were trying to provide a more faithful reflection of common experiences than British fictional films had hitherto attempted."[29] Films such as *Millions Like Us*, *The Gentle Sex*, and *Two Thousand Women* portrayed contributions of women to the war effort and images of women's collectivity and competence. *The Gentle Sex* (1943) adapts the familiar formulas used in a male film such as *The Way Ahead* but focuses on the conscription, training, and acclimatization of women to a new and demanding way of life. The women form relations with other women and perform vital activities under stress in an efficient manner, though the film cannot resist including romantic entanglements with men. The women's separation from civilian life is handled through scenes of individual parting at the train station, filtered through the ubiquitous commentary of Leslie Howard, which adds an uncomfortable condescending element to the narrative. His parting comments are, "Let's give in at least and admit we really are proud of you, you strange, wonderful, incalculable creatures. The world we shape is going to be a better world because you are helping to shape it. Silence, gentlemen, I give you a toast. The gentle sex."

In its focus on different women, the film breaks down the exclusive preoccupation with one dominant character so typical of prewar films. Moreover, the women are representative of different classes in the same way that many of the male war films seek to provide a picture of cooperation across class lines. By introducing an older woman who was active during World War I, the film indicates the historical antecedents of women's involvement in war as well as the sense that this involvement arises under exceptional circumstances. The question raised by the film, as articulated by several of the characters, concerns change—whether the world after the war will return to former patterns or whether society will alter its direction, specifically in relation to sexuality and women's position. While the nature of the desired changes remains ambiguous, there is the implication that the war's promotion of greater equality in sexual and

class relationships is of primary concern. This question is one that will reappear in many of the films of the period.

Frank Launder and Sidney Gilliat, whose first feature was *Millions Like Us* (1943), had this to say of the film, which was commissioned by the MoI: "We were very impressed with the fate—if you like to call it that—of the conscripted woman, the mobile woman."[30] Unlike the relationship between the government and the film industry in Hollywood, the British Ministry of Information, in addition to exercising control over the content of wartime films along with the British Board of Film Censors, also made equipment available and financially supported the production of certain feature films. Moreover, while certain subjects continued to be censored along prewar lines, there was a relaxation in some areas, particularly in the portrayal of workers. Like *Two Thousand Women* and other films made during the war, as Richards and Aldgate comment, this film showed how "British filmmakers were now able to approach topics which they would have been warned off in the thirties."[31] According to Launder, "We shot as much as we could in actual factories, hostels, and gunsites. For the dance hall scene we had real serving soldiers, airmen and firemen—lent us for a couple of days by the services."[32] A mixture of documentary footage and fictional narration, the film sets up a series of contrasts between home and work, abundance and scarcity, familial unity and separation, prewar forms of leisure and relationship and changing wartime patterns. The emphasis on the changing face of the society is conveyed in the images of mobility, the conscription of the women, the scenes of their training as they learn to do work that had formerly been the province of men, and the growing solidarity among women of different classes and backgrounds.

Millions Like Us alternates between scenes of work and scenes of leisure. The dances, the concerts, the pub scenes, and Fred and Celia's honeymoon trip to Eastgate dramatize the way, even in wartime, life continues and people adjust to change. As in *The Gentle Sex*, the film portrays romantic entanglements. In one instance, the man dies; in the other, the relationship is called into question because of differing class positions. Also like *The Gentle Sex*, the film asks whether the world will be different after the war or whether the prewar pattern of class and sexual relationships will be restored. The question extends to the patterns of the women's lives. Is the war merely a temporary disruption, or will the wartime experience have an impact on their lives—in the breaking of familial ties, moving out of the home, living collectively with others, and working at nondomestic labor?

Of the three films that portray the collective life of women, *Two Thousand Women* (1944) seems to delve the deepest into personal relationships among women. It also avoids the formulaic heterosexual romance which usually involves the death of a soldier and a woman's grief and

stoicism. Directed by Frank Launder for Gainsborough Pictures, the film stars Flora Robson, Anne Crawford, Patricia Roc, Phyllis Calvert, Jean Kent, and Renée Houston. The setting is an internment camp for prisoners of the Germans. The women represented are not only of different social classes, but of different occupations as well, ranging from nuns and nurses to stripteasers. The women are also of different ages and varied physical appearance. The film does not stress romance. Though one of the male fliers hidden in the fortress by the women falls in love with Rosemary (Patricia Roc), she does not succumb to his proposal. Another woman, Bridie (Jean Kent), who is obviously willing to do anything to get a man, is rejected by men and women alike for her collaboration with the enemy.

The most unconventional, though elliptically presented, relationship is between Muriel Manningford (Flora Robson) and her friend Claire (Muriel Aked), who refuse to be parted. They turn out to be the heroines of the group, in contrast to Bridie, who thinks only of a German sergeant and then later of a British flier. With the exception of the German spy in their midst and the snobbish Mrs. Latimer, the women are portrayed in less stereotypical terms than usual. The narrative itself takes classic formulas common to the male prison camp dramas and transforms them by substituting the exploits of the women. The women stand up to the enemy, outwit their jailers, and help two British fliers to escape, with a minimum of tears and hysteria. They organize entertainment, too: in place of the usual female impersonation acts of the conventional prison camp drama, the women do male impersonations. They are mutually supportive in the face of the privations of the internment camp. In the scene in which the arriving women are brought to their rooms and baths are prepared, the film avoids the temptation of voyeurism. The female body is not fetishized. Instead of the usual male perspective on the female, women are seen through each other's eyes. Moreover, Freda (Phyllis Calvert) assumes a leadership role in which she is supported by other women. In fact, while the women pair with each other, they are also part of a larger collectivity. Women's mobilization is an outgrowth of mutual support rather than externally enforced service. Finally, the grapevine, usually presented as evidence of women's garrulousness, is here presented as a survival strategy, as when the women warn each other of the spy in their midst.

The cinema also ventured tentatively into the ways that the national services might be effecting changes in women's domestic life, and *Perfect Strangers* (1945), directed and produced by Alexander Korda and starring Deborah Kerr and Robert Donat, portrays the "before" and "after" of a marriage affected by the war. According to Sue Aspinall, "*Perfect Strangers* . . . was one of the few British films to deal explicitly with these

changes in women's consciousness wrought by the war."[33] Husband and wife both join the service, meet new people, and alter their attitudes toward themselves and each other. The Wilsons' prewar life is mired in an unquestioning adherence to marital routine. Cathy (Deborah Kerr) fixes breakfast and sends her husband, Robert (Robert Donat), to work. He fixes the barometer, hangs his umbrella on his arm, and sets off to work, where he is a reticent and undemanding employee. Military service transforms them both. They become younger and more attractive in appearance. Both are tempted to try other relationships. She becomes more independent and gradually learns to express her needs and desires. When they come together again, they are more forthright and aggressive toward each other.

The war is seen as an agent of personal conversion, enabling women and men to see the limitations of their prewar life. Former dissatisfactions surface, and new perceptions are articulated. *Perfect Strangers* focuses on the inevitable changes in personal relationships wrought by the war and suggests that the future will be different from the prewar past. But wherein lies the difference? In Cathy's case, her physical appearance is altered. She is no longer the sniffling, shambling housewife. She is assertive to the point of endangering her marriage. Divorce is averted and the couple enters into a new, more romantic relationship with one another. In the final scene, as they look out at the ruins of London, they talk of rebuilding. The ruined landscape is a metaphor for their past relationship, which has been destroyed. But the image of the ruins also raises the question of what will be rebuilt. If their reconciliation contains any hints of their "new life" ahead, it seems to imply that although many institutional structures will appear to be different, the basic forms will remain intact. Aspinall comments, "Although the film does go some way towards investigating these changes, its humour and playful comparisons of husband and wife are evasions of the real incompatibilities, conflicts and tensions created because of women's new consciousness."[34] In its focus on the couple's conversion, the film abandons the other relationships formed by the characters, as it does the question of how the new affective ties will survive the war.

GAINSBOROUGH AND RELATED MELODRAMAS

The Costume Drama as Woman's Film

During the war and in the late 1940s, the melodramas produced by Gainsborough Pictures provide yet another perspective on the contradictions of women's position during World War II and in the immediate postwar era. The Gainsborough women's pictures were part of an effort

to produce quality films that were commercially profitable. They sought to appeal to the female spectator to "dramatise contemporary sexual and emotional conflicts of women's lives" as well as present British social ideals.[35] Not only are women the center of these films, but the point of view appears more explicitly feminine. While the resolutions often seek to recover female domesticity, disciplining the women who violate social mores, the films are daring in their willingness to explore constraints on women.

Unlike the historical films, which claim to reenact the lives and actions of prominent individuals, the costume dramas are fictional and play loosely with historical contexts, transposing history into romance. The films' remote historical settings allow for greater latitude in dramatizing departures from conventional femininity. These films portray conflicts surrounding choice of sexual partners, marriage, motherhood, and female companionship. The films play up the existence of a dual discourse which, on the one hand, sought to dramatize social changes affecting women while, on the other, maintaining a continuity with traditional values. War propaganda generated a rhetoric of wide-scale changes affecting society in general, and women in particular, but the actual situation appears different considering the actual amount of changes wrought by the war.[36] Social welfare policies affecting workers and women, as exemplified in the Beveridge Report, the blueprint for the social welfare state, did not drastically alter the nature of the British class structure or redistribute wealth to any significant degree. John Stevenson states that "while by 1945 women had made important steps toward emancipating themselves in some directions, in certain areas very little had changed."[37] Very few women were in positions of responsibility, and the bulk of employed women were in unskilled jobs. Male trade unionists were resistant to women organizing on their behalf, and, much as in the United States, a growing literature on the importance of traditional female duties began to appear, advocating love, marriage, motherhood, and a "female sensibility." The Gainsborough films occur at the intersection of these attitudes, conveying tensions between change and continuity.

The Man in Grey (1943), based on the novel of Lady Eleanor Smith, is a classic example of Gainsborough costume drama in its Gothic form. The great success of the film with audiences and critics encouraged Gainsborough to turn out more films along the same lines. The Gothic elements include the old manor house, a brooding and cruel lord, the imprisonment of a high-born woman in this forbidding world, the presence of the supernatural in the form of a Gypsy, and animism. The film functions by means of polarization and splitting. The two major female protagonists are split between the highborn and privileged woman, Clarissa (Phyllis Calvert), and the poor, orphaned, but ambitious and worldly

woman, Hesther (Margaret Lockwood). The two types of men are repre-
sented by the highborn and unscrupulous Lord Rohan (James Mason)
and the socially ambiguous but romantic Rokeby (Stewart Granger).
Oppositions between male and female, blonde and brunette, spirituality
and sexuality, whiteness and blackness, desire and social inhibition run
through the film. Hesther and Clarissa are different by virtue of their
history, their social class, and their ambitions. The film can be considered
a woman's picture, not only because of the female protagonists and the
female conflicts that it foregrounds, but also by virtue of the multiple
perspectives in the narration, which shift the focus from one female char-
acter to another rather than concentrating tightly on a single character.
Hesther and Clarissa represent two different but related types of female
subordination. Associated with marginal characters like Rokeby, the
Gypsy woman, and the black page, Clarissa's world is a feminine one of
acceptance and trust, whereas Hesther's world is a phallic one of seduc-
tion, aggression, and the quest for power. Clarissa is associated with so-
cial legitimacy, with marital and familial responsibility. Hesther is an
adventuress. Bereft of social status, she attempts to usurp Clarissa's posi-
tion. The contrast between the two women is based on psychological as
well as class differences: "The marriageable woman is invariably an aris-
tocrat, whilst the sexual woman is from a lower class. . . . Female sexual
appetite is associated with being outside the upper class, and with the
kind of rootless woman who has no claim to marriageability. The aristo-
cratic women, on the other hand, lack all sexual feelings in their mar-
riages of convenience."[38] In the end, both women are thwarted in their
desires. Thinking that Rohan will marry her if Clarissa is dead, Hesther
murders her. Hesther is in turn killed by Rohan, who destroys her in the
name of legitimacy, patriarchy, and the law of primogeniture.

The contrast between the natural gentleman and the unnatural aristo-
cratic cad also presents the same class contradictions. The upper-class
Rohan prefers lower-class women. He despises Clarissa's pliability and
sentimentality. As he tells Clarissa on their wedding night, he married her
because he must have an heir, but after fulfilling their connubial obliga-
tions, they need not live in the same quarters. His demeanor toward his
wife is correct but distant. His roughness and physicality come out in his
relationship with Hesther. He sees her as a woman of spirit, complement-
ing his own aristocratic rejection of middle-class morality and sentiment,
and their contacts are characterized by passion and by physical aggres-
sion, leading finally to his beating her to death after he learns of her mur-
der of Clarissa. Whereas many narratives present the benevolent face of
the authority figure, in *The Man in Grey* he is powerful and cruel, though
physically attractive. The film is unrelenting in its portrayal of the ingre-
dient of cruelty inherent in male-female relationships. Rokeby, on the

other hand, is attracted to an upper-class woman, whom he treats with gentleness and affection. Recognizing Hesther's insidious machinations against Clarissa, he, like the Gypsy woman and the black servant Toby, struggles to save her. The film is complicated by these divisions, dramatizing the impossibility of reconciling sexual desire and social legitimacy.

The success of *The Man in Grey* was dependent on the creation of a definitive visual style, developed by the art department of Gainsborough, which "viewed history as a source of sensual pleasures, as the original novels had done."[39] The sets and the costumes were not produced with an eye to authenticity. As Sue Harper suggests, "The affective, spectacular aspects of *mise en scène* are foregrounded, to produce a vision of 'history' as a country where only feelings reside, not socio-political conflicts. The potency of this for a war-time audience requires little elaboration."[40] Similarly, the costuming, makeup, and coiffures of the characters were orchestrated to enhance the affective elements. The stars who appeared in these films were equally responsible for the films' popularity. Margaret Lockwood projected an "image of a woman who was not part of the upper-class establishment. Although she was by no means working-class she did not possess the kind of poise which comes from knowing one's place in the world and from expecting respect. There was an edge of bravado and insecurity to her personality as she appeared on film."[41] James Mason's appearance in these melodramas also signaled a new emphasis on sexuality, and "played an important part in breaking through the customary gentility of British film acting. He was distinctly unlike the majority of British male screen actors at the time. . . . They were, above all else, gentlemen. Their sexuality was less apparent, whilst Mason's radiated through his deep vocal tones and concentrated, intense presence."[42] The stars thus played a major role in contributing to the overall look of the Gainsborough melodramas with their iconoclastic treatment of sexuality and social class.

Gainsborough's 1944 costume melodrama *Fanny by Gaslight*, directed by Anthony Asquith, is a female initiation drama. The narrative is constructed around threatened female virtue, and, like the familiar protagonists of romance, the protagonist is called upon to confront one obstacle after another in her path of self-discovery. The mysteries surrounding her identity begin when she is a child. While playing with a friend one day, Fanny (Phyllis Calvert) discovers a brothel in the basement of her home. This is her birthday, and a strange man comes to visit and gives her a valuable pin as a present. Her adopted father, William Hopwood (John Laurie), discovering that she has been to the "Shades," dispatches her to school. When Fanny returns home again, she witnesses her stepfather trampled to death by Lord Manderstoke's (James Mason) horse. Hopwood had denied him entrance to the Shades. Her stepfather's death is

followed by her mother's. Thus, Fanny becomes the archetypal orphan of romance, forced to forge a new identity for herself.

According to her mother's plans, Fanny finally meets her real father, Clive Seymour (Stuart Lindsell), an important cabinet minister, but their relationship must be kept secret. Seymour's wife, Alicia (Margaretta Scott), unaware of Fanny's identity, takes her as a lady's maid. The innocent Fanny is initiated into Alicia's world of lovers and intrigues, though she maintains her upright morality. When Alicia goes away, Fanny and her father go away to their country house for a brief holiday, where they ride, fish, and play chess. Returning to town, Fanny plunges into a miserable life as Alicia's maid and again sees Hopwood's murderer, Lord Manderstoke, with whom Alicia is having an affair. When Alicia asks Seymour for a divorce to marry Manderstoke, he refuses, and she threatens to expose his "affair" with Fanny. He commits suicide, and again Fanny loses a father.

Fanny goes to stay at an inn where she works, and she falls in love with her father's solicitor, Harry Somerford (Stewart Granger). His mother and sister (he, too, is fatherless) are adamantly opposed to the marriage, warning him that he will ruin his career. For the sake of his future, Fanny disappears. She tries unsuccessfully to find work and is reduced to poverty and finds herself on the verge of prostitution. Harry finds her again, and the two take a holiday to Paris. While there, they again meet Manderstoke, who has become the lover of Fanny's cousin, Lucy. Manderstoke challenges Harry to a duel. He is killed, and Harry is seriously wounded. Kate arrives to tend her brother and forbids Fanny entrance to the sickroom in spite of the doctor's claim that Fanny is keeping him alive. Fanny confronts Kate, accusing her of being frustrated and lonely, and willing to let Harry die rather than see him married to her. No longer concerned with social appearances, Fanny defies Kate and vows to marry Harry and bear his children.

This film can be read as a straightforward legitimation of middle-class morality and the idealization of the female as the stabilizer of familial values. The film presents the threatening of respectable family relations by female promiscuity. Fanny is the victim of her mother's earlier sexual impropriety. The Hopwoods' comfortable Victorian house sits atop a brothel, suggesting the threatening proximity of brothel to middle-class family. The Seymour family is similarly destroyed by the wife's promiscuity. Fanny's cousin, unlike Fanny, is also portrayed as promiscuous. The film is not, however, as straightforward as these examples of straying female virtue might seem to suggest. Female suffering is traced not to the women's actions but to Manderstoke, the aristocrat. His sensuality, cruelty, and indifference to social conventions are a source of fascination for the women he seduces who are rendered completely helpless before his

charms. He offers a striking contrast to the other male figures in the film, who are weak and ineffectual. While he represents the arrogant, lawless, and sadistic side of male power, he is also physically attractive, and the women who associate with him are freed from conventional constraints. Fanny resists his charms, preferring the more romantic, pliable, and chivalrous Harry. Nonetheless, this film, like *The Man in Grey,* invests sexuality with power, and, rather than marginalizing it totally, allows it to be seen in its attractive as well as destructive forms.

Manderstoke is not the only source of conflict. The film also challenges middle-class constraints. The Somerford mother and daughter represent normality, respectability, and class integrity, and the film is critical of their values, portraying their treatment of Harry as overprotective and stifling of his desires. In schematizing disruptive sexuality as associated with aristocratic excess and repressive sexuality as associated with the middle class, the film attempts to situate Fanny as the mediator between these extremes. The film's bias toward democratic merit, articulated by Harry, is offered as the antidote to rigid and stultifying class stratification, paralleling the war ethos, which sought to downplay class differences and offer a more flexible image of social relations. *Fanny by Gaslight* likewise offers a compromise on the issue of female subjectivity. Fanny is presented as heroically struggling to resist her mother's fate and persisting in her independence, even at the cost of suffering. She gains a voice when she defies Kate, though her actions are circumscribed within the arena of service, marriage, and motherhood.

The focal point of *Madonna of the Seven Moons* (1944), directed by Arthur Crabtree, is not marriage but mother-daughter relations. This film is structured around numerous oppositions, involving past and present, traditional and modern attitudes toward sexuality, action and paralysis, older and younger women, respectability and deviance, and repression and open sexuality. The film treats the typical melodramatic enigma of identity, with the issue of doubling or split identity focusing on a woman (Phyllis Calvert). In one incarnation, as Maddalena, she is the wife of a respectable Italian banker; in her other incarnation, she is Rosanna, the passionate lover of a Gypsy thief, Nino (Stewart Granger). The protagonist's self-division is traced back to her sheltered upbringing in a convent, where she is raped by a peasant. She remains in the convent until she reaches a marriageable age. The film picks up her story many years later when her daughter, Angela, is an adult. A contrast is posed between the constrictions of the mother's life and the daughter's freer attitudes. Maddalena is presented as a moral prude, shocked when her daughter brings a man home. She is excessively religious, and her nunlike clothing is exemplary of her exaggerated sense of decorum and constraint. Her relationship with Angela is strained, since she cannot appreciate her daugh-

ter's values and beliefs, finding them offensive to her own religious and moral sensibility. Angela tries to bring her mother into her world, counseling her on clothing, makeup, and jewelry. At a party for Angela, Maddalena suffers a breakdown, faints, and has to be taken to bed. When she awakens, she assumes her other identity as Rosanna. Dressed as a Gypsy with peasant blouse and skirt, bracelets, and long dangling earrings, looking like a seductive Carmen, Rosanna reenacts an earlier disappearance and returns to her lover. Everything about Rosanna is the antithesis of what the audience had been led to believe about Maddalena's behavior and appearance. Rosanna is sensual, assumes an active role with her lover, and appears to have an ambivalent attitude toward religion, finding herself unable to enter a church. Maddalena's conflicts are identified with Catholicism. Her virginal attitudes, distaste for sexuality, and isolation from her family are linked to her upbringing at the convent school and to the rape, an event never again alluded to in the film.

The daughter assumes an active role in the second part of the film as she seeks to locate her mother. She adopts the position of a detective, piecing together clues about her mother's identity (not without risk to herself), and is successful in tracing her. In the vein of the maternal melodrama, the final act of the mother is to sacrifice herself to give her daughter life. Angela, unlike her mother, is presented as untouched by the divisions that plagued her mother concerning sexuality. The contradiction between desire and control is represented by the final image of Maddalena-Rosanna's corpse, with both the cross and the rose resting on her breast. As in many women's films, the mother must be disposed of so that the daughter may live a different kind of life. The daughter, who has been closer to her father, is now free to pursue her life untroubled by the question of her mother's identity. It has been argued that Angela is representative of a more progressive life-style for women than her mother, but Sue Aspinall finds that the film's "proposal of a modern 'enlightened' sexuality as the solution to the dilemma of the virgin/whore/mother/mistress dichotomy fails satisfactorily to resolve the contradiction. This new sexuality is still romantic marriage, dressed in modern, less class-bound clothes."[43] Where the film captures the sense of female subjection is in the portrayal of Rosanna's hysterical symptoms. Characteristic of many of the women's films, illness is the strategy for expressing resistance to the physical, psychic, and moral constraints of women's lives. In the films that portray mental or physical illness, "the symptom gives access to, makes readable, the work of repression and hence indicates the process of transition from one symptom in the psychical apparatus to another. In a way, the symptom can be seen as manifesting the severity of the repression of the force of energy attached to the repressed idea which 'breaks

through' to the surface."[44] In the case of Maddalena, her symptoms represent one way in which her body manages to elude the control of her husband and family doctor by becoming a text to be read for its symptoms rather than an object of erotic contemplation. Moreover, the male protagonists' inability to interpret, explain, or cure those symptoms indicates the limits of male control of the female body.[45]

The Wicked Lady (1945) is bolder in its treatment of female sexuality. Instead of the suffering female as protagonist and the male sadistic antagonist, the film stars Margaret Lockwood as Barbara, who violates all of the conventional expectations of women. She plays a female adventuress who steals her best friend's fiancé and marries him, tires of him quickly, seeks adventure disguised as a highwayman, has an affair with Jerry Jackson (James Mason), a notorious highwayman, tortures and kills a moralistic servant who has learned her secret, falls in love with another man, Kit (Michael Rennie), and dies at his hands after killing Jackson. Her wickedness lies in her hedonism, her contempt for the law and private property, and her lack of sentiment. She holds in disrespect all the values that are upheld by polite society.

The film is built on the classic chain of unfulfilled relations. Caroline (Patricia Roc) loves Sir Ralph (Griffith Jones), who loves Barbara, who loves Kit. The narrative makes clear-cut oppositions between Barbara and Caroline, between chaste and passionate females. Sue Harper has commented that their wardrobes and hairdos provide the clues to their personas. For example, "the film signals two sorts of female sexuality by carefully differentiating between the two wedding veils. Roc's has cuddlesome, kittenish 'ears', whereas Lockwood's is a mantilla, redolent of passion."[46] The film also makes clear contrasts between the men. Ralph is assigned to the category of ineffectual males so familiar in the Gainsborough melodramas. Jerry Jackson belongs to the category of passionate, witty, and unsentimental men. Kit, like Rokeby in *The Man in Grey*, is the fantasy figure of romance, the tender rescuer. Barbara consigns Ralph to irrelevance, competes and fights with Jackson without mastering him, and is unable to realize her love for Kit. In her relationships with men, Barbara acts out vengeful fantasies toward them as well as romantic fantasies of sexual freedom. Her double life as mistress of the house and as male highwayman captures the sense of all women's leading dual lives. Her adventurous escapades are also motivated in part by the desire to find sexual stimulation and economic independence.

While Barbara appears unsentimental and exempt from conventional notions of loyalty, she maintains an attachment to her dead mother. At first, she recklessly gambles away a brooch that had been her mother's, but the brooch becomes the pretext for her taking to the highway and reclaiming it during a raid. Commenting on the significance of this

brooch in relation to the identity of the protagonist, Sue Harper suggests that Barbara is "identified with the mother—rather than the father—principle."[47] Barbara's identification with the mother principle expresses itself in her protean behavior and in her lack of a sense of boundaries. She differs from Caroline, who occupies a maternal role, one of service, sacrifice, and a commitment to upholding the virtues of home and family. Barbara shares none of these qualities, and is therefore eliminated from the narrative, rejected by all as the subverter of social stability, upper-class cohesiveness, and domestic rectitude. In accounting for the popularity of such a film, Harper finds that the costume drama provided the female viewer a vision of "a female sexuality denied expression through conventional signifying systems."[48] On every level of production, the Gainsborough costume melodramas are geared to the elaboration of fantasies clothed in the guise of history.

In contrast to *The Wicked Lady*, whose primary focus is on defiant womanhood, *Caravan* (1946), directed by Arthur Crabtree, adheres to the formula of the ideal romance as described by Janice Radway. In these narratives the female is removed from "a familiar, comfortable realm usually associated with her childhood and her family."[49] She comes under the sway of a malevolent aristocratic male who is cruel to her, but finds another, more gentle, male who is kind to her. Through malevolence on the part of the aristocratic male and misunderstanding on the part of the hero, she is separated from her lover. After a number of vicissitudes, the lover destroys the aristocratic male, and the couple is reunited. In some romances, the protagonist undergoes a conversion. In others, such as *Caravan*, the male figure is split between villain and rescuer.

Based on the popular novel of Lady Eleanor Smith, *Caravan* is set in two locales, Spain and England, and contrasts two women, the highborn Oriana (Anne Crawford) and the Gypsy Rosal (Jean Kent). The film pits a struggling writer, Richard (Stewart Granger), against an evil aristocrat, Sir Francis (Dennis Price). The couple is separated and, through the evil machinations of Sir Francis, Richard is left for dead. Richard is saved by Rosal, who falls in love with him. When he learns that Oriana has married Sir Francis, he marries Rosal. Aware that Richard does not love her, that he has always loved Oriana, Rosal sacrifices her life to save Richard. The forces of justice triumph in the end as Richard finally defeats Sir Francis and puts an end to his scheming and abuse of Oriana.

Class oppositions assert themselves from the outset, and Oriana, like the aristocratic pure lady of the fairy tale, becomes the source of conflict and competition between an upper-class and a lower-class male. She prefers the lower-class male, who is associated with the gypsies. The upper classes are presented as dissolute, capricious, malevolent, and grasping,

218 CHAPTER FIVE

and the conflict between Richard and Sir Francis fuses issues of sexuality, virility, and morality. The women are similarly polarized. Oriana, the blonde, fair woman of romance, is pitted against the Gypsy woman Rosal. Oriana is the wife, Rosal the mistress. Rosal's marriage to Richard is illegitimate, since it is performed under false pretences. She has taken advantage of Richard's illness and amnesia. Oriana, too, has not married Sir Francis willingly. Oriana is associated with family and with chastity, whereas Rosal, the Gypsy, is associated with dancing and unrestrained sexuality. She is, like Richard, lowborn. He is also associated with physicality, with action, adventure, and passion, in contrast to Sir Francis's punitive and constraining attitudes and actions. But it appears that the union of equals is only momentary, as Richard is placed in the position of rescuer of the upper-class Oriana.

The deaths of Rosal and Sir Richard eliminate two major threats to the heroine: unrestrained sexuality and total engulfment by the male figure. The lower-class female and the aristocratic male represent deviations from conventional sexuality and, as such, are obstacles in the path leading to conventional marriage. Sympathy is generated for the romantic lovers slated for conventional marriage, but the intensity in the narrative derives from the characters who are marked for destruction. The narrative both entertains the realization of sexual pleasure and at the same time legitimates marriage and domesticity. The film's opposition between Spain and England is similarly an opposition between freedom and restraint. As Sue Harper indicates, "*Caravan's* 'Spanish' scenery is an uncivilised wilderness, while the sets indicate a more cultivated disorder. The interiors are crammed with random exotica, spasmodically concealed by darkness."[50] Thus history takes a back seat to fantasy.

Contemporary reviewers had unkind things to say about the film. One found that "no situation dear to melodrama has been left out, and it is a tribute to the cast that none of them sounds quite as embarrassed by the dialogue as you'd expect them to be."[51] Another carped, "This particular caravan does not rest until it has completed the round of cinematic clichés."[52] A third critic mused, "Isn't it queer that we English, who make such good films just now that the Americans clamour to come over and make them with us, should feel a need to make these village hall charades every now and then."[53] These critical comments testify to the low esteem in which the woman's film has been held, and also to the strong bias against texts that depart from the conventions of social realism.

While the Gainsborough melodramas portray women rebelling against the strictures of domesticity, few of them take as their sole protagonist the marginal woman who is associated with a Bohemian form of existence. Narratives featuring such women can be traced to nineteenth-century

Paris: "That classical narratives in the mid-nineteenth century began to focus on the erring woman and her relationship to society is no accident ... the industrial revolution inevitably produced a disturbance in sex roles as the whole fabric of society underwent dramatic change."[54] The entrenchment of the nuclear family was resisted in France and Britain by the sons of wealthy industrialists who sought a life of adventure in the capital cities and their pleasures with demimondaines and prostitutes. The literature of the time, however, focuses less on these women than on educated women from the upper classes who were financially constrained and forced to depend on the support of a wealthy man, offering companionship as well as sexual pleasure to their patron. The relationship between the artist and these courtesans became the basis of many novels and short stories.

Carnival (1946), directed by Stanley Haynes for Two Cities Films, focuses on the relationship between a dancer, Jenny Pearl (Sally Gray), and an artist, Maurice Avery (Michael Wilding). The melodrama, based on a novel by Compton Mackenzie, had been made earlier in 1932 as one of the first sound films for British Instructional Films, but "the film got a lukewarm critical reception, and was a box-office failure."[55] The 1930s version highlights theme rather than character, stressing the conflict between conventional and Bohemian life but downplaying sexual conflict. In the Compton Bennett version the film raises the issue of Jenny's class and sexual identity as prefigured in a quarrel between her mother and three respectable aunts who, like the proverbial three fairies, quarrel about her future. The aunts feel that she should have a better upbringing than she will receive in a lower-class setting with an economically irresponsible father, a theater performer who is addicted to alcohol. Her mother, Florrie (Catherine Lacey), was swept off her feet by him, although she later became disenchanted with marriage. The aunts prophesy a bad end for Jenny. Thus, Jenny's history begins discordantly as exemplified in her parents' marriage, their contrasting backgrounds, and their different attitudes toward respectability.

Jenny becomes a dancer, with her father's approval, but her mother grows increasingly concerned about Jenny's morality, wanting her to marry and abandon the debased environment of the theater. Defying her embittered mother, who feels that she has wasted her life, Jenny meets Maurice and falls in love with him. An artist, he scorns conventional marriage, seeing it as destructive to his creativity. Though she relinquishes her career to be with him, he treats her affections indifferently, exploiting her as a model for his work and leaving her abruptly to go to Spain. The world of art turns out to be as constraining for her as her family was. When Maurice leaves her, she moves out of her home, tired

of her mother's moral tirades, and resumes her relationships with other men. When her mother dies, she assumes responsibility for her lame sister, May, and marries Mr. Trewhalla (Bernard Miles), who promises a life of peace and quiet in the country. Trewhalla describes himself as not understanding or approving of the theater world, in which old men peep and leer at women dancers. He sees city folk as mired in sin. When he and the two women come to the Trewhalla home in Cornwall, Jenny learns that his promises of a peaceful life were lies. Totally subjugated to his mother, who disapproves of the marriage and goads Trewhalla into disciplining Jenny, urging him to be firm like his father, Trewhalla tortures Jenny. Her every movement is watched suspiciously, and she is given no peace as son and mother rail against her. Maurice returns, ready now to marry Jenny, but Trewhalla shoots her as she walks with Maurice on the beach.

The shots of Jenny in the natural landscape serve as an ironic commentary on references to nature throughout the film. Jenny taunts her mother with the accusation that her demands are unnatural. The role of painting in the film raises the question of what is "natural" as opposed to artificial. Mrs. Trewhalla feels that it is wicked to "copy nature." Jenny Pearl seeks to express her desires, only to find herself thwarted from every direction—by her family, Maurice, and finally the Trewhallas. She is a pawn, an intermediary between nature and culture, and she is destroyed. Her desires are not considered natural but immoral. The older women in the film associate sexual desire with prostitution and loose living. Jenny's fears center around the fear of aging and dying before she has really lived. What to others appears as most natural—family, romantic love, sexual relations, life in the country—is, in the context of the film, not only unnatural but frustrating to natural desire. And as the bearer of desire, Jenny Pearl is punished.

The film's trajectory from her birth and the prophecy of her aunts to her death underscores the impossibility of her situation. The object of others' desire, she becomes a prize to be contended for and then destroyed. There is no happy ending to this fairy tale, in which the woman's fate is determined from the outset. The film adopts a sympathetic attitude toward her, presenting her as the sacrificial victim, the signifier for a society that, in the name of morality, family, and respectability, is corrupt and destructive. Jenny is portrayed as misunderstood by the artist as well. She is more a symbol of despised aestheticism than a portrait of female subjection. The victim of rigid bourgeois morality, class conflict, and sexual repression, she is the classical alter ego of male representation, prized for what her beauty symbolizes. Like a painting, she is a pleasurable object of contemplation. Throughout the film, she remains a spectacle viewed from the perspective of the male, an object of the male gaze. Consonant with its

aestheticism, the film does not reject specularity; rather, it rejects the characters who deny others the pleasure of looking.

The Contemporary Woman's Film

Gainsborough Pictures produced not only costume dramas but also melodramas set in a contemporary context, such as *Love Story* (1944), directed by Leslie Arliss. The central figure is a pianist (Margaret Lockwood), and music plays a prominent role in defining the melodramatic context. Lockwood, as Lissa, is an independent woman who learns that she has a fatal illness. She abandons her career, moves to the country, meets a man, Kit (Stewart Granger), and falls in love. Unfortunately, the man she falls in love with is himself laboring under a physical disability: he is on the verge of becoming blind as a result of war injuries. The element of triangulation develops with the appearance of Judy (Patricia Roc), an old friend of Kit's. As the narrative develops, the conflict shifts from Kit's refusal to become involved with Lissa to Judy's competition with Lissa for possession of his love.

Kit has been unwilling to undergo an eye operation because the chances of his survival are slight. He is discouraged from having the operation by Judy, but Lissa convinces him to take the chance, promising Judy that she will leave if Kit regains his sight. The possessiveness of the one woman is pitted against the self-sacrifice of the other. True to her promise, Lissa resumes her concertizing, this time for the troops, and Judy and Kit are engaged to be married. Knowing nothing of Lissa's sacrifice, Kit feels bitter toward her, thinking she has abandoned him. Judy does nothing to correct his erroneous assumption. But an older man at the hotel convinces Judy to tell the truth, and the lovers are reunited for the brief time remaining to Lissa.

Kit is the pawn of the two women, whose competition for him constitutes a reversal of the usual triangulation between two men and a woman. The wounded war hero is the object of desire, but the issue of the women's competition is complicated. The film does not present the usual dichotomy between the domestic female and the career woman; both women have careers. Judy is a theater director, Lissa a pianist. Thus, the conflict is shifted from the level of social roles onto a psychological plane. The struggle between the women concerns the question of who would be the better mate for the man. The women are differentiated. Judy is unable under pressure of her concern for Kit to direct *The Tempest*, whereas Lissa is able to perform her music. Associated with music and with nature, particularly the sea and rocks, Lissa represents emotional liberation, whereas Judy is associated with verbal language and with control. She is made to appear devious and possessive. However, as in so many women's films that feature illness, Lissa's union with Kit is linked to her impending

death. The emphasis on illness and death serves to foreground the conflict between stability and contingency so central to wartime life.

Like *The Tempest*, with its Prospero, *Love Story* has its father figure, Tom (Tom Walls), who guides events. Through his intervention, Kit acts heroically once again, Judy steps aside and allows Lissa to be united with Kit, and Lissa is rewarded for her sacrifices and compensated for her fatal condition. There are no maternal figures in this film (Tom's wife is dead), though Lissa's actions appear suspiciously like maternal sacrifice. In one sense, Kit's infirmity reduces him to childlike status, and, like the competing women claiming their child before King Solomon, the "natural" mother is the self-sacrificing one. The film plays with a number of motifs which seem to sit uncomfortably with each other: independence and dependence, self-sacrifice and self-realization, sexual desire and maternal nurture, physical infirmity and the desire for health. In these conflicts, as well as in the shifting perspectives between Lissa and Judy, the film projects a female point of view, dividing its focus between competing notions of female identity and desire.

Another melodrama in a contemporary setting that focuses on relations among women is *They Were Sisters* (1945), a Gainsborough woman's film directed by Arthur Crabtree. This film dramatizes the impossible position in which women are placed by the conflict between their own desires and the expectations of others. Pam Cook describes the film as "a woman's picture which deals with the problem of the constitution of the ideal family, posing its problem in terms of making the right choice of love object."[56] Like many other women's pictures, it is schematic, involving three sisters, two of whom represent extremes of femininity while the third is a mediatory figure. The men they marry are equally polarized. Charlotte (Dulcie Gray) is the totally submissive sister who allows herself to be bullied, abused, humiliated, and silenced by Geoffrey (James Mason), her husband. When she seeks to escape, he persuades her to stay, only to be cruel to her again. During one of his attempts to temporarily lessen his cruelty toward her, she runs out of the house and is struck down by an automobile. Her role dramatizes one extreme of female character: suggestibility, masochism, and the absence of a strong ego. She recalls the Victorian middle-class woman who tries to be the angel in the house but is forced to be the madwoman in the attic.

In contrast, Vera (Anne Crawford) represents the modern, independent woman who scorns conventional relationships. Brian (Barrie Livesey), the man she marries, is Geoffrey's opposite. He earns Vera's contempt for his pliability and permissiveness. If Charlotte overvalues marriage and overestimates her dependence on family, Vera undervalues and underestimates the importance of marriage and family ties. She is finally disciplined to proper familial attitudes through the temporary loss of her lover and her daughter. The implication is that, now that she has

met a man who can dominate her, she will settle down to domesticity. The third sister, Lucy (Phyllis Calvert), represents compromise to the demands of family. Having lost her own child, she is a mother surrogate to her sister's children, an incarnation of the Great Mother, concerned less with herself than with family well-being. She tries to save her sisters and works to make her marriage a success. She and her husband, William (Peter Murray Hill), spend time working together on their house and garden. Her husband articulates Lucy's position as ordinary rather than exceptional, as following a philosophy of making the best of things by muddling through. The last image of the film is of the extended family, with William quoting, "God's in his heaven, all's right with the world."

Charlotte's self-destructiveness and Vera's restlessness are not eradicated by William's clichés or by the responsible image of domesticity offered by Lucy and William. The images of the two women unable to conform to the demands of family life sit uncomfortably with the film's formulaic solutions. But the film does dramatize, especially through Charlotte's situation, the impossibility of trying to make the best of family life. The alternative the film has to offer—self-discipline, familial responsibility, and maternal sacrifice—are in Charlotte's case clearly unworkable. Through Charlotte, and to a lesser degree Vera, the film is redeemed from platitude and prescription. The most striking sections of the film involve Charlotte. Her husband's humiliation of her before her children, his toying with her sanity, his refusal to relinquish her, her alcoholism, and her retreat into herself unbalance the tripartite structure of the film and hence call into question Lucy's role as intermediary. The film seems to argue consciously for a more enlightened attitude toward marriage. The alternative to the asymmetrical relations of both Charlotte's and Vera's marriages is presented through Lucy and William, but their desexualized relationship, symbolized by their lack of progeny, does not address the disrupting presence of unfulfilled female desire. Lucy's role, in particular, is illuminating for the ways in which she seeks to ameliorate Charlotte's dilemma, indicative of contemporary "solutions" to female discontent. She enlists the aid of a psychoanalyst to protect Lucy from Geoffrey; she also fights Geoffrey in court and exposes his cruelty, thus breaking his hold over his eldest daughter, who now recognizes his maltreatment of her mother; and she creates a proper familial environment for the children of her sisters. Thus she enlists the major institutional forces in the society to ensure the stability of the family. With the sisters eliminated, one dead and one banished to South Africa, and with Geoff contained by the law and Brian exiled to America, the film abandons its schema of tripling and moves into the "ordinary" world, leaving the one family—Lucy, William, and the children. The ending is a Gainsborough convention which accords with the endings of many women's films and

novels. The disruptive figures are eliminated and the external everyday world is reinstated with modifications.

The film explores women's consciousness divided between past and present, memory and immediacy, and especially between self-realization and the exigencies of conformity. The film is a disjointed and episodic pastiche—in Antonio Gramsci's notion of common sense and folklore, "a fragmentary collection of ideas and opinions."[57] It jumbles together the many issues it dramatizes, resolving conflict by eliminating Charlotte, rationalizing Vera's behavior, and directly confronting, through Lucy, the contradictions of conformity. The presentation of Charlotte's situation dramatizes both women's oppression and modes of survival and resistance under patriarchy. It is the vehicle for Lucy's challenge to and victory over Geoff's destructive treatment of women and children. While one can see that the film functions to ameliorate the position of women within the familiar domestic space, it is also obvious that this restoration is partial. In its intersecting and conflicting representations, the film exemplifies a commonsense perspective according to which the knowledge of women's history is scrambled and obscure and strategies for survival coexist with strategies that do not admit of resolution within the framework of the "social propaganda" presented.

They Were Sisters not only intersects with the long history of women's thwarted aspirations and desires, it also evokes a number of historically specific events characteristic of British wartime experiences. The film can be read for the ways it evoked for its 1940s female spectators such concrete experiences as the adoption of war victims, the homeless, and orphans. The war is also obliquely evoked in the opening shots of the film with a montage of images of women's fashions after World War I. The Gainsborough emphasis on women's clothing and hairstyles speaks also to the drabness of the wartime uniforms worn by many women as well as to the scarcity of consumer commodities. Also, William's description of Lucy's "muddling through" echoes a phrase common to this period of upheaval and threats to personal security and family stability. Geoff's cruelty to Charlotte and to his children, his authoritarianism, evoke images current at the time of Fascist dictatorial figures. The wartime deemphasis of social class in the interests of national unity is also indirectly addressed in the portrayal of Geoff, whose drive for power and status is antithetical to any sense of collectivity, community, or egalitarianism. Lucy can be seen as an incarnation of the "nurturing mother [who] became the linchpin in conceptualising national unity . . . a mythical centre, expressing family, and hence national, unity."[58]

They Were Sisters dramatizes concerns common to the literature and films of wartime about the shape of postwar society, and high among these concerns, with the anticipated return of the men from service, was the question of women's place. The film seeks to reinvest the nuclear fam-

ily with power by banishing threats to its stability through Lucy, whose marriage to William grafts values from the past—loyalty to family, tending one's own garden, and, above all, concern for the new generation—to the present need for new accommodations for women within the confines of the domestic sphere. The contrasts between Lucy and her sisters and among the men are doubly charged. On the one hand, they serve as a link to immediate historical and social needs as dictated by the culture; on the other, they reveal quite blatantly that the woman is positioned yet again as an instrumentality and, even more, the disparity between the magnitude of the conflicts presented and the inadequacy of the attempts at recuperation of the family.

William's final speech, in which he alludes to "millions like us" and especially to "muddling through," is indicative of the film's attempts to valorize practical concerns and the primacy of everyday interests. Through Lucy, the film associates women with the family and nature, and with gardening in particular (a traditional metaphor in English literature representing the maintenance of social order), and, by extension, with nurturing qualities. Moreover, the emphasis on the family, property, and law, especially as centered in Lucy's support of Charlotte and her defeat of Geoff, are further indications of the ways in which the film works within the sphere of the everyday while seeking to alter its more repressive aspects.

The psychoanalyst plays a subsidiary role in *They Were Sisters*. In *The Seventh Veil* (1945), he becomes central. Directed by Compton Bennett, the film is produced in Gainsborough's flamboyant style with an emphasis on extraordinariness rather than ordinariness, hysteria rather than restraint, and exaggeration rather than realism. Francesca (Ann Todd) is the proverbial orphan of melodrama. Adopted by her uncle Nicholas, this unwanted female child is reared to become a great artist, like Nicholas's mother. Nicholas (James Mason), resentful of his mother's rejection, her running off with a lover rather than facing the responsibilities of marital life, acts out his punishment on his defenseless niece. In the name of art and excellence, he subjects her to his tyrannical discipline until she is able to become a successful concert pianist. This melodrama bears affinity to the fairy tale. An ugly duckling turns into a swan, wins acclaim, and must choose her Prince Charming. She has three suitors. There is also a symbolic rebirth in the water. Francesca's attempted drowning becomes the means to her rebirth, for with the help of the magical figure of the psychoanalyst she is brought to a new sense of herself and of Nicholas.

The film is replete with father figures—Francesca's suitors, the psychoanalyst—all competing for Francesca. Mother figures are absent except as they appear in Francesca's childhood in the guise of her disciplinary schoolmistresses. She is bereft of a female figure with whom she can identify and bond. The doctor is the one who unravels Francesca's oedipal

attachment to Nicholas, thus enabling Francesca to return to him not as a child but voluntarily as a woman. Nicholas must work through his negative attachment to his mother. Francesca, who has taken his mother's place in his life, exacerbates his mistrust of women. By seeking to escape with an American musician (and later with a painter), she seems to be reproducing Nicholas's mother's rejection. She awakens his rage, which takes the form of physical violence toward her as he raps her hands with his cane. Nicholas's brutality, however, does not directly trigger her psychosis. Her traumatic fear over loss of the use of her hands arises after an automobile accident following her running away with an artist (Albert Lieven) whom Nicholas has commissioned to paint her portrait.

As in so many women's films, the doctor is responsible for returning the woman to society. *The Seventh Veil* depends on the discourse of psychoanalysis to dramatize women's relationship to language and female identity. Francesca recounts her story to the psychoanalyst and through his intervention is restored both to her music and to Nicholas. Through hypnosis, the physician brings her into language which enables her to recognize her dependence on Nicholas as the one who shapes her, gives her direction, and represents the voice of society. Significantly, Francesca chooses the man who enables her to continue with her career. Her "cure" is less dependent on verbal than on nonverbal language—music, hypnosis, and vision. The film affirms Mary Ann Doane's description of the role of psychoanalysis in the woman's film: "It is not the speech between psychoanalyst and patient which acts as the medium of recovery. Rather, through *seeing* her past (and presumably reliving it more intensely than one could through the mediation of language), the patient understands herself, and her own behavior is given an explanation."[59]

The film's emphasis on mental trauma and psychoanalytic therapy has several implications. It serves to dramatize the postwar dilemma and growing cultural concerns having to do with the threat of women's independence. It specifically serves to reveal the role of medical institutions in the process of normalizing women's position.[60] At the same time, the film also exposes both the nature of the disciplinary operations of psychoanalysis and the symptoms that it seeks to redirect. In Francesca's case, she is presented as the object of male doctors' scrutiny, exposed as helpless before their inquisition. The spectator is thus made aware of their power and her dependence. But the doctors' omnipotent position is undercut by her own gaze at them. Nicholas's surveillance of Francesca and her returning his gaze serve to undercut the naturalness of her subordinate position.

The film problematizes women's relationship to language. Nicholas gives Francesca speech and direction, assumes her voice, and even harnesses her musical expression. Her refusal to speak and to play after her accident and separation from Nicholas portray her as bereft of both ver-

bal and nonverbal language without the male figure. When she seeks to express herself, she can only speak through the symptoms of her illness. As intermediary, the psychoanalyst provides her with a language and hence is instrumental in restoring her to Nicholas. Her choice of Nicholas does not constitute a happy ending. Rather, it underscores the impossibility of other alternatives that position her outside of language. Another aspect of language and representation alluded to by the film is the differences between cinema and "real life." Cinema is seen as gratifying desire; reality as the recognition of restraints. Francesca's desires are aligned with cinema, but her choices are aligned with the reality principle. In making this distinction, the film expresses a divided sense about women's social positioning.

While Gainsborough was a major source of women's films, one of the most commercially successful and popular British films of the 1940s was David Lean's *Brief Encounter* (1945), a Twin Cities production. Instead of the exotic and sensual landscapes, the excessive character portrayal, and the Manichean and highly stylized world of Gainsborough costume melodramas, Lean's film is set in more ordinary surroundings, and the focal point is the protagonist's inner world. Unlike the studio orientation of Gainsborough, *Brief Encounter* is heavily dependent on the director's personal preoccupations. The heroine, Laura Jesson (Celia Johnson), a respectable married woman with two children, gets a cinder in her eye while waiting for a train after her weekly shopping trip. The man who removes the cinder, Alec Harvey (Trevor Howard), turns out to be a physician. They begin to meet illicitly until she realizes that they must face up to their marital responsibilities. The film is told in flashback in Laura Jesson's voice, and it is clear from the very first moments that it does not matter whether the relationship Laura is describing has ever actually happened. What matters is that she has a life apart from her husband. The implication is that women cherish a private fantasy life, that their lives are split between the romantic and the banal. Romanticism in this film involves going to the movies on Thursdays to see such films as *Flames of Passion*. Laura's fantasies about Alec and herself are likewise couched in Hollywood images that contrast sharply with her life—scenes on a boat, riding in a convertible with a flowing scarf, alone with her lover on a desert island—but they do not actually involve flames of passion any more than in the apartment scene when the owner of the apartment returns prematurely and expresses his distaste for what he considers to be a sordid encounter.

The repetition of Rachmaninoff's second piano concerto belongs, too, to Laura's chaste fantasies. It is the music that arouses her—music accompanies her narration, evokes her memories—but the most disturbing sound in the film is the sound of laughter. Laura and Alec's relationship is linked to their common bond of laughter at the strange little woman

who plays the cello. When Laura talks to her husband, she laughs as she minimizes her activities and seeks to allay her feelings of guilt. Increasingly her laughter begins to border on tears and hysteria as she narrates her story, and it appears that the laughter is the tell-tale sign of her inability to bring together her inner and outer existence. But the film actually does not appear to be talking to or about women. In its emphasis on films, on performance, on recollection, it seems to be an example of a phenomenon described by Claire Johnston of making it appear that the subject is female when in fact the woman is the "pseudocenter of the filmic discourse."[61] The way in which Laura is treated in the text—silenced by the women she encounters, constrained by her marital and maternal responsibilities, forced to live in her mind and talk to herself—seems to suggest that she is another instance of the woman whose words never get public expression except through the male text.

The film reproduces the plight of the female seeking a voice, while at the same time silencing her as it constructs a world of conventional morality in which female desire is inhibited. In its use of memory and recollection, the film suggests that the telling is all. The enactment of the fantasy is better than fulfillment. Romance seems to be engendered by deprivation. There is no question that the film portrays the woman's domain as stultifying, if not hostile, but, in the final analysis, it aestheticizes the pain, making that pain the basis of pleasure, namely, the pleasure of telling a story that would not be half as interesting if it had a "happy ending." Unlike *Love Story*, which loses control of its point of view, this film seeks to retain its hold on the narration, betraying itself in the speaker's hysteria and paralysis. The film alternates between stasis and movement. Laura's domestic life is confined to one room in the house and to her seated position, reinforcing the sense of female paralysis as she recollects and recounts events. Only those moments of recollection in which Laura relives her affair with Alec are characterized by physical movement. In temporal and spatial terms, the entire film is narrated from her chair in the sitting room. The disjunction between sound and image, between Laura's narration and the narrated events, also reinforces the same sense of disjunction that speaks to women's self-division.

THE POSTWAR WOMAN'S FILM

Women's films portray rebellious women, women who do not conform to the stereotype of supportive maternal or conjugal behavior. They are at war with men and with domesticity, and guilty of having desires and of seeking gratification. While marriage and family life may be presented in *They Were Sisters* as women's domain and as the guarantor of tradition and stability, these films also reveal the claustrophobia of domesticity.

The private sphere is a prison which headstrong women seek to subvert or escape. The popularity and timeliness of domestic melodrama is not surprising given the media emphasis on women's sphere and the increased privatization of family life attributable to rising incomes, changes in housing, and increasing mobility. According to John Stevenson, "these tendencies reinforced ideals of domesticity and private life which, ultimately, frustrated the fuller emancipation of women."[6] The melodramas portray the greater drive toward personal relations within the family, but they also portray those forces that undermine the realization of these ideals.

The mid- and late 1940s provide striking instances of the transformation of the woman's film into film noir. *Bedelia* (1946), written by Vera Caspary, the author also of the novel *Laura*, and directed by Lance Comfort, is a portrait of a femme fatale, the dangerous disruptor of domestic harmony. The film stars Margaret Lockwood, who was breaking British box office records in the mid-1940s. *Bedelia* opens with a typical film noir strategy: the image of a painting of a woman and a man's voice describing Bedelia as the film moves into a flashback. The voice says: "This was Bedelia, beautiful and scheming. She radiated a curious innocence, eager to fascinate those she attracted like a poisonous flower." The speaker is a detective intent on discovering Bedelia's identity and bringing her to justice. Bedelia rises in the world by marrying men, poisoning them, and getting their insurance money. As she puts poison in the men's food, she uses the traditional woman's vehicle of nurturing to destroy the men she hates. The film begins in France but ends in an English village where Bedelia comes to live with her husband Charley (Ian Hunter). Transplanted to the English pastoral environment, she is represented as the snake in the garden. She resents her husband's association with Ellen, a professional woman, but puts herself forward as the perfect wife, a good cook, gracious at parties, and eager to help her husband, giving no clue to any malevolent intentions. Followed by the detective, posing as a painter, her scheme to poison Charley is thwarted; instead, Charley forces her to take the poison intended for him.

To Bedelia, her latest husband, Charley, is naive and childlike, representing a world very different from her past, a world of "jam and sweets everyday." His business and domestic life are identified with tradition and family continuity. In the environment of British village life, she is presented as an interloper, a poisoning presence. By marrying the outsider, Bedelia, Charley has entered into a misalliance with a woman, something no one in his family has ever done. He excuses himself by saying that he "loved a woman that never existed." In this film, as in Hollywood's *Leave Her To Heaven* (1945), the overtly domestic female is the disrupter of family and tradition, whereas the independent working woman, Ellen, is identified with its stability and continuity—a concession

to changing notions of femininity. The film recapitulates the dangers of excessive femininity, while it affirms the importance of family. Bedelia's motive for poisoning is not linked, as in the case of many femme fatales, to her excessive love for men. On the contrary, her motive is hatred of men. Her scheming and aggressiveness take the form of a desire for property, money, and jewels. Her vehicles of revenge are the pocketbook and the stomach, the traditional ways in which females can exercise domestic power.

On the one hand, the film can be read as a parable of housewifery gone amok. On the other, it can be read as the inevitable outgrowth of a female's resistance to domestication. In other ways, Bedelia's character seems to be a reaction to conventional treatments of women. For example, she resents being photographed and painted, which on the level of the narrative indicates that she is resisting exposure. On a psychological level, she is resisting being looked at. She tells Charley, "Haven't you something better? You have me." If *Bedelia* is a "love story gone bad," it dramatizes the "impossible position of women in relation to desire in a patriarchal society."[63] Reviewers objected to Lockwood's portrayal of the femme fatale, lamenting her lack of extreme villainy.[64] On the contrary, it is Bedelia's ordinariness that makes her "sordid" domestic schemes typical rather than exceptional.

This Was a Woman (1948), starring Sonia Dresdel, who was to play the overbearing wife of Ralph Richardson in *The Fallen Idol* (1948), presents another portrait of female disaffection, this time focusing on motherhood. Dresdel plays a powerful and controlling female, reluctant to let her children go, dissatisfied with her husband, and willing to go to extreme lengths to get her way. This film anticipates such Hollywood melodramas as *Harriet Craig* (1950) and *Queen Bee* (1955). The mother, Sylvia Russell, has created the aura of the perfect home, as commented on by her husband's successful friend, Austin Penrose (Cyril Raymond). As in many women's films, the house assumes significance in the narrative as an extension of the maternal figure. Viewed through her perspective, the rooms in the house are shown in balanced shots as if to signify Sylvia's tight management of the domestic sphere. The daughter, Fenella (Barbara White), however, describes the house as a "spider's web," and from the perspective of the other family members, the rooms are seen as asymmetrical, indicating the characters' discomfort in their surroundings.

Sylvia's contempt for her husband's ordinariness, his lack of ambition, and his love for animals and flowers is expressed in criticisms of the way he performs his duties. Finally, she has his dog destroyed (after seeing it leap onto the table to eat) and cuts his favorite flowers in the greenhouse, both harbingers of his eventual murder. She schemes to destroy Fenella's marriage to a young doctor, Val (Julian Dallas), filling her with horror stories about male sexuality. She uses Effie, the maid (Celia Lipton), as a

decoy to seduce Fenella's husband, dressing Effie up so that Mrs. Holmes, her mother, comments, "You do look a sight. She never dolled me up to look like that." Sylvia also gives Effie sexy French and British novels to read, including *Lady Chatterley's Lover*, which causes Terry, the son, to describe Effie as "a dirty little cat." Sylvia succeeds in causing a rift between Val and Fenella. Sexual relations between the young couple become strained when Fenella refuses her husband's affections. He, in turn, allows himself to be seduced by Effie, and Fenella witnesses the pair kissing. Thus Sylvia's objectives of separating her daughter from Val are accomplished.

When an old friend of Russell's comes to visit, Sylvia not only sets out to seduce him but begins gradually to poison her husband, after sending her children on a cruise. On that cruise, Terry acts as a psychiatrist to Fenella, seeking to reconcile her to marriage. He comes increasingly to assume the position of the doctor-healer of women's films. He and Fenella return to find their father expiring of a mysterious illness. Terry finds poison in his mother's cabinet and confronts her with the crime. After condemning her to a "life of solitude," he turns her over to the law. The film recapitulates the fear of the engulfing mother. The overpossessive, ambitious mother almost destroys her family but is finally caught and disciplined. She is rejected by Austin Powers, the man for whom she killed her husband, and discovers that Powers only cared for her as a symbol of domesticity, as the creator of a perfect environment. She is abandoned by her daughter, who is reconciled to her husband, and she is exposed and punished by her son. Ultimately, she is punished by the law. Significantly, when Terry delivers his sentence, it is in the room she describes as her own room in the house. The dominant image of Sylvia in the film is of her on the staircase, at the window, and in the doorway, watching others.

Read from Sylvia's perspective, the film portrays her desire for power as stemming from her sense of incompleteness, her desperate need to hold onto her children, and her fear of isolation. Her marriage is a mismatch in which not only are the roles reversed, but goals are inverted. She exercises power in the ways open to domestic females—within the house, through her children, and through men—but the film makes it very clear in her confrontation with her son that her power has to be destroyed, and he, like Orestes, curtails her power in the name of the father and in the name of justice. Ultimately, she is sequestered to a place where she will no longer be able to exercise power. In these final angry scenes, sympathy shifts from the son's point of view to that of the woman standing in the shadows, condemned to the maternal fate of impotence and solitude.

Increasingly after the war, presentations of independent women become less prominent, and when they exist, as in Ealing's *The Loves of Joanna Godden* (1947), women's competence is called into question.

Starring Googie Withers, another star identified with strong female roles, the film begins with feminist potential. The heroine is portrayed after her father's death as running the family farm on her own. She rejects a suitor (John McCallum), undertakes a series of innovative reforms in order to run the farm on a more profitable basis, and cares for her younger sister, Ellen (Jean Kent), whom she sends to an exclusive women's school. She stands up to the ridicule of her male workers and to other farmers in the community but is beset by disaster when her livestock die as a result of her experimentation with new breeding techniques and when the man to whom she is engaged drowns. Her sister returns home and, having had an education above her status, provided at great sacrifice by Joanna, refuses to settle down to life on the farm, and instead marries Arthur, the man Joanna has come to love. Eventually, Ellen runs away with a wealthy man in the community, and Joanna and Arthur are finally united.

Reading backward in the film, one can see that the finger of blame is pointed at Joanna. Her indulgent treatment of Ellen is rewarded by Ellen's rebellion, ingratitude, and refusal to share Joanna's life. Ellen's disastrous marriage to Arthur can be traced to Joanna's initial refusal to marry him. While Joanna's independence is made to look attractive as she battles with Arthur and the community to run things in her own way, her schemes only lead to one disaster after another. Unlike the Gainsborough melodramas, this film exemplifies what Charles Barr has called Ealing's typical "constraint on energy, meaning sexuality and violence."[65] Joanna's prodigious energy is curtailed. Step by step, the narrative forecloses on Joanna's desires, disciplining and humbling her, and finally fulfilling her father's desire, prescribed in his will, for her to marry Arthur.

In a more exotic vein, Powell and Pressburger also tackled a woman's film. *Black Narcissus* (1947) is set in Tibet and presents an Orientalist's picture of the mysterious East, where a group of nuns have come to serve the populace and to fight against what they consider superstition and ignorance. The nuns, headed by Deborah Kerr as Sister Clodagh, supported by Flora Robson, Kathleen Byron, and Jean Simmons, among others, are portrayed as victims of their background and religion. Each has a tale to tell of thwarted desires, and one in particular, Sister Mary (Kathleen Byron), becomes deranged and homicidal. The nuns, and by implication their religion, are ill-suited to this world. They are contrasted to the native woman, Kanji (Jean Simmons), who knows that she wants the young prince and how to succeed in seducing him. The nuns are also contrasted to the Englishman, Dean (David Farrar), who survives because he has no attachments and no expectations.

The women are portrayed as subordinating sexuality to service, and the narrative appears to punish them by making them misguided instruments of service. They are made to appear intruders in a setting that valorizes nature—the wind, the tangled foliage, the lush vegetation, and the

dramatic changes in weather. In their treatment of the indigenous population, the nuns too refuse to accept the centuries-old ways in which the people have adjusted to life in this part of the world. In one sense, the film seems to be a variation on the films of empire, with the women occupying the repressive position normally reserved for the English governors. And it is this position which the film dissects, using the women as a pretext to explore sexual repression.

The film challenges conventional notions of morality and sexual behavior, using the nuns to critique the Westerner's attitude of superiority to another, non-European culture, but it adopts a language that is reminiscent of the films of empire. The natives are presented as childlike and devious. The Tibetan world has all the earmarks of the "mysterious East." The film's portayal of Tibetan culture as archaic, exotic, and despotic is also familiar. In its desire to romanticize this corner of the world, the film uses the British women in contradictory fashion. It portrays them as the victims of a form of discipline and renunciation that is disjunctive with the natural world they encounter. The portraits are not unsympathetic, but they are problematic. They, like the Orientalism of the film, are presented in an all-too-familiar fashion. They are reincarnations of the archetypal frustrated spinster who, when confonted by passion, cannot control herself and disintegrates. Only the inarticulate, physical Kanji and the other native women escape, and they laugh at the nuns. The film suggests that this culture, so alien to the Westerner, cannot be mastered or controlled, and that the only way to adjust to it is to succumb to its beauty and customs. The nuns appear incapable, until too late, of gaining this type of wisdom, which again seems to be linked to the notion of the inscrutability of the Oriental. Dean, who functions as an interpreter and intermediary between the nuns and the natives, has access to the knowledge that these women lack and can acquire only at great expense to themselves. The film does, however, dramatize, in spite of itself, the contradictions of women's position. In this context, they belong neither in nature nor in culture. This film is revealing of the changing modes of representation of women in the postwar era. Women's discontent, as well as women's anomalous position, is evident. The emphasis on sexuality will become more insistent, along with an oblique, though sometimes direct, critique of women as agents of repression.

THE WOMAN'S FILM IN THE 1950s

The 1950s saw a decline in female attendance at the cinema. As Sue Aspinall indicates, "it is hard to disentangle cause and effect here: did women go less often to the cinema because of their new duties to their husbands and children; because there were fewer entertainments to enjoy now that

the war was over; or because there were fewer films that appealed to them? The decline in the number of new 'women's' pictures did not start until about 1949; in startling synchronization with the decline in the female audience. By the early 1950s, fewer melodramas and serious dramas with central female characters were being made."[66] The films that portrayed women set them in the context of the family, and a motif of what Raymond Durgnat describes as "marriage fatigue" was evident. Melodramas, as well as comedies and satires, situated women within the context of the family and portrayed family life as chaotic and fragile.

The eclipse of the woman's film can be seen in Anthony Pelissier's *A Personal Affair* (1953). The protagonist, Stephen (Leo Genn), is an English teacher who arouses passion in one of his female students (Glynis Johns). He gives her extra lessons, presumably unaware of her love for him, which makes Kay (Gene Tierney), his wife, jealous. The young woman, Barbara, disappears, and Stephen is accused of having caused her demise. He is ostracized by the community, vilified by the girls, investigated by the police, and tormented by his wife until the girl returns.

Barbara's family consists of her mother, father, and an aunt who is obsessed with sex and is largely responsible for the rumors about the illicit relationship of the teacher and his pupil. Her rage is traced to sexual repression, which comes out in excessive moralizing. The mother is presented as living only for her child as she verges on madness as a result of the presumed loss of the child. Kay is presented as having no interest in the community or in women's activities. She lives only for her husband and is afraid of being alone. She shares with Evelyn the responsibility for her husband's difficulties, for she believes that he has had a relationship with Barbara. Her solution is finally to commit suicide, but Stephen saves her.

The issue of sexuality is more overt in this film than in many others. In this small community, it appears that women's repressed sexuality is the disruptive force both within the family and in the town. Women are made the scapegoats for the failing of the community. While the male protagonist's conflicts are in the foreground, and he is the one who is on trial and must assume an investigative role in order to acquit himself of the charges of seduction of a minor and possible murder, the film exposes female discontents, attributing their causes to neurosis and frustration. In spite of the caricatures of female possessiveness and paranoia, the film reveals the underlying basis for women's disaffection, their boredom, their excessive preoccupation with matters of the heart, with the confining world of the family, and with the banal tasks they are called upon to do.

Another challenging portrait of a woman trapped in domesticity is J. Lee Thompson's *Woman in a Dressing Gown* (1957). The film was scripted by Ted Willis, whose work in television and film in the 1950s

was associated with the movement toward social realism and especially the social problem film (see Chapter 10). This film has a very familiar and simple plot: the struggle of a man to escape his marriage and the struggle of his wife to maintain their relationship. The husband, Jim (Anthony Quayle), is a rather ineffectual character who is the pawn of two very different women—Amy (Yvonne Mitchell), a disorganized housewife who momentarily and unsuccessfully rouses herself when she learns that her husband wants a divorce, and Georgie (Sylvia Syms), a working woman whose life is tidy and who is committed to resisting the kind of life that Amy leads. The polarization of the women and the triangulation involving the two women and the man is consonant with many 1950s melodramas. What distinguishes this melodrama is its insistent focus on Amy's world. The sights and sounds of Amy's life are communicated by the blaring sounds of the radio, which she plays incessantly and which drown out the demands of her husband and son (Andrew Ray). Her frenetic housekeeping activities—cooking, laundry, sewing—are orchestrated to the music.

The images of the women and the shots of the apartment, the streets, and the dock are frequently presented through obstructions. Repeatedly, the camera moves through a window (often with bars) in order to violate private space. Moreover, characters are frequently shot with objects—tables, shelves, bottles, laundry—intervening between spectator and character. These objects serve to call attention to the constraining world inhabited by all of the characters, but especially Amy. Characteristic of melodrama, the dialogue is predictable. Amy promises to do better, uttering clichés to reassure herself and Jim that their marriage is viable; Georgie's clichés involve pep talks to Jim about the need for him to escape the banality of his life; and the son, too, expresses clichéd sentiments when he angrily confronts Georgie and asks her what kind of a woman she is to break up a marriage. Where the film touches a central nerve in the portrayal of women is in their problematic access to language. Amy's entrapment is most successfully negotiated in the tension between sound and image. The visualization of her milieu, her desperate effort to alter her appearance only to be thwarted by the rain and the indifference of the crowds of people when she seeks shelter, her drunken attempts to prepare for the arrival of Jim and Georgie, stand in contrast to her pathetic promises to reform and her pleas to save the marriage. This contrast redeems the film from presenting yet another portrait of a flawed and grotesque "mad" housewife.

Thus, an examination of the British cinema's treatment of women's issues and female protagonists from the 1930s through the 1950s presents a range of attitudes. Given the representation of women as objects of desire and as threat, the films nonetheless offer insights into the contra-

dictions of women's situation under patriarchy. While the largest share of British 1930s films are male dramas focusing on the public sphere and on adventure, action, and male initiation, there are films of this period that address women's issues, if only in skewed fashion.

The portrayal of such dominant and extraordinary female entertainers as Jessie Matthews, of such monarchs as Elizabeth I and Catherine of Russia, and the few films that focus on the domestic sphere expose the ways in which women are defined by and constrained by the maternal position, family, romance, and service. These films, however, are not uniformly celebrations of women's traditional roles but also expose the limitations of women's private and public positions. The films of World War II, and especially those addressed to women, the melodramas and the films that portray women as active participants in the war effort, provide a fuller sense of the potential of women to escape the domestic sphere, while often revealing an anxiety about the changes brought about by the war.

The melodramas of the 1940s, in particular, delve the deepest into the irreconcilable demands confronting women as they seek to express their desires through film. In the postwar period, however, a change is clearly visible. On the one hand, there are the numerous films that express anxiety about women's sexuality and their movements toward autonomy. In the 1950s, not only do the male melodrama and the family melodrama overtake the woman's film, but these melodramas are addressed primarily to men and dramatize male vulnerability, a vulnerability often traced to men's tenuous relationships with women. These films are symptomatic of a profound social malaise concerning generational, class, and gender conflicts that are often displaced onto women and the family.

Tragic Melodramas

MELODRAMAS that center on male conflicts are more numerous than women's films, and the British cinema's output of these tragic melodramas has been especially prolific. (The distinction between women's films and tragic melodramas can be determined by the ways in which female or male protagonists are positioned in the narrative, especially in relation to action or affect, power or impotence, and, most importantly, authority. However, the problem of deciphering the treatment of sexual difference is not so simple. It is necessary to uncover the specific ways in which the films center, de-center, or "pseudocenter" male and female experience. For example, films with a female protagonist may reveal a discourse that is largely male, with the female functioning as a surrogate for male inhibitions and prohibitions, an expected situation given the dominance of male filmmaking.) Conversely, representations of men can be read to subvert dominant notions of sexual difference through such strategies as the adoption of female behavior and attitudes and even, in more extreme cases, through female impersonation.

As Pam Cook suggests,

> The distinction between masculine and feminine points-of-view is not always easy to maintain, particularly in melodrama where there is often a softening of sexual difference, and a merging of masculinity and femininity. Also, the construction of point-of-view in cinema is a complex process which is not simply reducible to identification with characters. Here in talking about the construction of a female point of view, I am referring to the ways in which, in the women's picture, the female protagonist's perspective is presented through a combination of first-person (subjective) and third-person (objective) strategies roughly equivalent to those used in novels. In practice the distinction between tragic melodrama and women's melodrama is not clear-cut; to imply that a masculine point-of-view predominates in tragic melodrama is not to suggest that it does not also offer feminine points-of-view, and vice versa in the women's melodrama, or that real spectators really identify with one or the other according to their sex.[1]

Conflict in the tragic melodrama centers on the pivotal role of the male figure in the oedipal drama. He finds himself in opposition to his world,

but this opposition takes different forms, forms more dependent on his character than on fate, though he may confuse the two. The narrative is impelled by his challenge to a father figure or his surrogate, and the protagonist's suffering takes the form of a quest for vindication of the social order, a reign of virtue and justice in a world where meaning appears tenuous and contingent. If the language of tragedy relies on metaphors of blindness and insight, then melodrama relies on "the text of muteness . . . since melodrama is about expression."[2]

In Peter Brooks' terms, melodrama "is motivated by a totally coherent ambition to stage a drama of articulation, a drama that has as its true stakes the recognition and triumph of the sign of virtue."[3] The contingent world confronted by the protagonist is one of extreme moral polarities not at all beyond good and evil. His struggle, like earlier dramas of religious conversion, is couched in highly personal and psychic terms as he grapples with his own guilt and desires. The narratives portray protagonists who are "alienated from society, unable to act to change it, trapped in a closed world of domestic property relations where power rests in kinship structures and patterns of inheritance."[4] The typical male conflicts then concern issues of power residing in primogeniture, property, the law, legitimacy, and respectability, but these are displaced onto the affective realm, where the conflicts concern self-discovery, identity, thwarted sexuality, and the drive for recognition and for moral integrity.

In the pursuit of moral integrity, the melodramas "concentrate on the point of view of the victim. . . . The critique—the questions of 'evil', of responsibility—is firmly placed on a social and existential level, away from the arbitrary and finally obtuse logic of private motives and individualised psychology. This is why the melodrama, at its most accomplished, seems capable of reproducing more directly than other genres the patterns of domination and exploitation existing in a given society, especially the relation between psychology, morality and class-consciousness, by emphasising so clearly an emotional dynamic whose social correlative is a network of external forces directed oppressingly inward, and with which the characters unwittingly collude to become their agents."[5] This discussion of melodrama is particularly relevant for an understanding of tragic melodrama, where the primary conflict is the male oedipal drama in which the protagonist seeks to challenge the paternal figure or his surrogate: "The tragic hero is brought low, redeeming himself through a new-found humility. He becomes aware of his guilt and the reasons for his suffering."[6] The protagonist's world is often characterized by discharge of emotional excess through violence.

The tragic British film melodramas of the 1930s fluctuate between those narratives of initiation and conversion that dramatize successful trials of masculine figures and those that dramatize failure to meet con-

ventional standards of performance in the domestic sphere and in the
world of work. Dramas of initiation such as *Kipps* (1941) and *There
Ain't No Justice* (1939) portray the hero's exploits, often in chronological
fashion, as he moves through innocence, error, and finally to a sense of
his proper place in the social order. By contrast, dramas of conversion
portray a dramatic reversal in the protagonist's behavior after confront-
ing situations that convince him of the need for a change of heart as in
South Riding (1938). Not all of the films resolve the protagonist's con-
flicts. In *The Proud Valley* (1940) and *On the Night of the Fire* (1939)
marginal figures are destroyed.

As we have seen in the films of empire, the British cinema of the 1930s
reveals very few instances of the physically forceful, supervirile male hero
so characteristic of American cinema. Ruggedness would seem out of
place in these upper-middle-class dramas, in which too much brawn is
vulgar, perhaps because associated with the working-class male. Gener-
ally, the protagonists are middle class, though there are exceptions in
such films as *They Drive by Night* (1938), *The Stars Look Down* (1939),
and *There Ain't No Justice*. The emphasis is more on wit and ingenuity
than on physical prowess, owing in part to censorship strictures govern-
ing representations of violence, but even more to the British cinema's
overwhelming focus on middle-class protagonists, in contrast to Holly-
wood cinema. In the case of those narratives featuring working-class and
lower-middle-class men, one is more likely to find physically forceful
male characters, though even here middle-class conceptions of gentility
often prevail, as in *The Stars Look Down*. This situation will change in
the postwar era, which is characterized by a greater emphasis on male
violence.

The protagonists are deeply divided in their allegiances, mired in con-
flicts over loyalty, honor, and duty. Class conflict, when evident, is "re-
solved" in several ways: killing the character (*The Proud Valley*), assimi-
lating him into his own community after a period of flirtation with the
upper classes through an affair of the heart (*There Ain't No Justice*), or
granting him entry into the middle or upper classes (a situation reserved
more for women than for men in the British cinema, e.g., *The Courtneys
of Curzon Street* [1947]). The social conflicts are most often expressed on
the psychic plane, involving questions of male identity and sexuality. In
many of these films, the female characters, where present, are split be-
tween different expressions of the femme fatale and the domesticated fe-
male, neither of which seem to function in more than instrumental terms
as obstructions or enhancements to the protagonist's plight. Generally,
male-female relationships are fraught with conflict, and heterosexual
coupling, where evident, is tenuous at best. In many of the postwar films,
in particular, the motif of troubled male identity manifests itself not only

in heterosexual relationships fraught with sexual conflict but also in films that increasingly explore, if only covertly, men's relationships with each other.

Sexuality is not expressed overtly but must be read through the power relations dramatized in the text, and sexuality, according to Michel Foucault, "appears rather as an especially dense transfer point for relations of power: between men and women, young people and old people, parents and offspring, teachers and students, priests and laity, an administration and a population. Sexuality is not the most intractable element in power relations, but rather one of those endowed with the greatest instrumentality: useful for the greatest number of maneuvers and capable of serving as a point of support, as a linchpin, for the most varied strategies."[7] Foucault's linking of sexuality and power led him and a number of critics influenced by his forays into the history of sexuality "to investigate the role of particular apparatuses, such as the medical, psychiatric, social welfare, charity and legal institutions, in shaping sexualities."[8] To this list may be added the importance of the cinema as a dominant force in the construction of male cultural identity and also in its deconstruction. This chapter explores the troubling and often neglected issue of the ways in which male identity and sexuality have been expressed in British tragic melodramas from 1930 to 1960 through the representations of certain character types, their relationship to the institutions portrayed in the films, and the images used to evoke connections between power and sexuality.

Current psychoanalytic theory opened the door to more historically sensitive ways of understanding the role of sexuality in culture and of rescuing it from strict biologism. Feminist studies have challenged the anatomical destiny of females, their position in reproduction, in mothering, and the restraints on their sexuality. Through establishing the constituted and constitutive nature of sexuality and gender difference, the notion that these are the inevitable result of natural law has been eroded.[9] The cinema has played a role, too, in legitimizing and calling into question monolithic notions of masculinity. Masculinity, like femininity, is the consequence of social and historical determinations, and the tragic melodramas of the postwar era in Britain are an especially dense field to explore varied, shifting, and troubled notions of male identity. Behind the familiarized representations of conventional masculinity lurk images that will call into question the exclusiveness and inevitability of heterosexuality, though these images will be represented in terms that will not violate the audience's sense of "normality." For example, for a male to select as a love object a person of the same sex is to expose the terror at the heart of sexual difference: that difference is a social construction and not a biological fact. The maintenance of strict sexual differences functions as

a way of erasing the possibility of sexual alternatives. This erasure serves
to keep intact a host of social imperatives affecting both sexes including
marriage, the family, reproduction, and social production. As Caroline
Sheldon writes: "Modern capitalism depends on the heterosexual family
unit to produce workers already alienated by the experience of lack of
power (in childhood) and by a strictly defined sexuality. For exploited
men, the power of men over women and children substitutes for control
over their own fates. Traditionally, homosexuality operates in this system
as the *criminal element*—both as a warning to those stepping out of line
and a method of containment of anti-social (anti-heterosexual) tenden-
cies."[10] For men as well as women, the configuration of homosexuality as
a deviation from "natural" heterosexual tendencies functions ideologi-
cally to control and discipline both sexes. The nature of this control and
discipline is evident in the male melodramas, which can only speak
obliquely about male relationships that do not conform to prevailing con-
ceptions of masculinity and heterosexuality. The conflicts in the male
melodramas, involving men in couples or in groups, will be located in a
familiar male context—military settings, schools, prisons, mines, the
sports arena. Where the protagonist's behavior deviates from social ex-
pectations, the Law will be invoked to correct or discipline the offender.

Stereotypes associated with ways of speaking, acting, and looking are
a gauge of adherence to or deviation from prevailing norms of class,
gender, and racial identification. These stereotypes, found in common
discourse, in literature, and in art, are a further means of detecting differ-
ence, legitimizing norms, or, in some instances, subverting norms. In lo-
cating notions of masculinity, therefore, it is not sufficient to rely on the
outward manifestation and reproduction of dominant notions of male-
ness such as aggressivity, physical strength, and sexual prowess in rela-
tion to women. As in the case of locating a female discourse, an examina-
tion of male stereotypes can function to expose the constructed nature
of gendered behavior as a coded form of representation which may be
saying more than, if not the reverse of, familiar dominant attitudes. Thus,
it may be possible to see that representations of maleness can, behind
their self-evident appearance, be dynamic. They may unconsciously or
self-consciously parody traditional attitudes. For a number of reasons,
not the least of which is censorship, references to sexuality are often
coded, not immediately apparent through the formulas and naturaliza-
tion techniques upon which representations of sexuality and gender dif-
ference depend. And this is where cultural production plays a role in both
the legitimation and subversion of prevailing attitudes toward gender
representation.

The "real man" is identified by his exercise of emotional restraint and
aggressiveness, but even more by his resistance to their opposites—

emotional excessiveness and passivity. For a male to expose weakness openly and to make public his inadequacies is to emulate denigrated attitudes in the culture identified with female behavior. For example, in talking about the behavior of working-class males, Richard Hoggart describes how "the man who is able to growl is also able to defend; he has something of the cock about him. Hence, rough boys are often admired; the head-shaking over them is as proud as it is rueful—' 'e's a real *lad*', people say."[11] However, the pre-1960s British melodrama offers an array of male figures that violate conceptions of the "real man" even in portrayals of working-class males. Other than the many representations of the young initiate who, through ritual and ordeal, is brought into the male group by affirming the wisdom of the father and of the father surrogate and the avenging son who must clear the father's name, the British cinema boasts its share of Don Juans, reprobates, cads, and tormented, haunted males. By 1961, with *Victim*, the British cinema will come even closer to representing hitherto marginalized males.

In talking about representations of men, Vito Russo affirms, "The idea that there was such a thing as a real man made the creation of the sissy inevitable. Men who were perceived to be 'like women' were simply mama's boys, reflections of an overabundance of female influence. It became the theme of scores of films to save the weakling youth and restore his manhood."[12] The "vast mythology" to which Russo refers becomes a clue to identifying the underlying fears and threats embedded in the discourse of male sexuality, not the least of which is the oedipal conflict relating to the male's inability to separate from the mother, resistance to identification with the father, and the corresponding fear that such behavior is a sign of dreaded homosexuality or, at least, a troubled heterosexuality. Thus, behind the seemingly unproblematic construct of the "real man" and his obverse, the feminized male, lie a host of problematic attitudes concerning male identity and sexuality.

Similarly, the Don Juan figure that plays such a prominent role in literature, theater, and cinema is not merely an instance of a pathological male unable to develop meaningful relationships with women, but conceals a host of contradictory assumptions about monogamy, sexual competence, and masculinity. Representations of homosexuals have been repressed in the cinema despite the fact that the cinema, like the theater, has often been a haven for gay men. In certain texts, the problematics of male sexuality and identification are forced into the mold of female impersonation. The troubled nature of male sexuality can, however, be revealed, in the dramas of male conversion, in the numerous Don Juan narratives, and in the male tragedies that seek to come to terms with the insoluble conflicts of men within the constraints of patriarchy. As in the case of the women's pictures, which are highly stylized and removed from

realist modes of representation, the tragic melodramas offer the most striking examples of the inadequacy and contradictions of conceptions of masculinity.

The British commercial melodramas of the 1930s, especially adventure melodramas like *The High Command* (1937), appear on the surface to be unproblematic. They feature male heroes whose behavior affirms the ethos of service, physical prowess, and ties of loyalty to father figures. The setting for the films is generally British but may be an exotic region in the British Isles, Africa, or India. The point of view is predominantly, though not exclusively, male, and the narrative conflicts involve issues of generational conflict with benevolent or malevolent paternal figures. The classic oedipal drama of challenging the father's authority is resolved through the protagonist's reconciliation with the father, thus affirming paternal power and authority. In instances where the protagonist is the paternal figure, as in *Sanders of the River*, the conflict focuses on his capacity to maintain his power and serve as a model of authority. More restrained than Hollywood protagonists, the British protagonists depend on their wits and on a gentlemanly code of honor, resorting to violence only when all else fails. Romance is implied but little dramatized as the conflict seems less between men and women than between men in their struggle for mastery—not so much mastery of each other as mastery of an alien group. Romance is thus displaced by male aggression, attributed not to the hero but to the savagery of non-Westerners or of outlaws. Moreover, in these films, the enemy is rarely female. Yet the association of the enemy with physicality, stealth, and "primitive" instincts resembles the traditional fear of pollution by the female. Thus the threat that confronts the heroes of these adventure melodramas is rarely as simple as the portrayal of the perfidious Arab, Indian, or African would suggest. These archetypal dramas tap profound anxieties about male identity represented by the dreaded Other.

Other kinds of narrative conflicts presented in the British male melodramas of the 1930s involve father-son relations, the vindication by the son of the father's name or by the father of the son, Don Juanism, the trials of men with nature, conflicts over personal and family honor, conversion and sacrifice, the struggle of young working-class males for power and status, and marginal figures trapped in conventional situations. Melodrama was also injected into the war films, which focused on the personal conflicts of men as they struggled with other men in combat or with their relationships to women at home. The issues uppermost in these films involve the assimilation of the men into the group and their affirmation of their temporary roles. The postwar films, those that we have seen concerning the reconstruction of the war but also those that focus on civilian life, offer variations on themes of alienation and per-

sonal dislocation of social misfits, rebellious young men, hunted men, and men who are afflicted. The 1950s were rich in such dramas, including also films featuring young boys who are victimized and destroyed by paternal and sometimes maternal figures. The figure of the rake is another figure resistant to conventional male roles. These types of narratives were not restricted to British cinema but were also produced in abundance in Hollywood, judging by such films as *Rebel Without a Cause* (1955) and *East of Eden* (1955). James Dean and Marlon Brando were associated with many of these films, and in Britain, Dirk Bogarde became a cultural icon of nonconformity. The tragic melodramas of the 1950s, especially those that feature Bogarde, anticipate the 1960s cinema and its motifs of resistance to conformity and tradition, as exemplified in such films as Lindsay Anderson's *If . . .* (1969). These films are closely linked to the social problem film, discussed separately in the final chapter.

TRAGIC MELODRAMAS IN THE 1930s

Fathers and Sons

In the tragic melodramas, the struggle for self-mastery not only is measured by the distance between the protagonist and dreaded images of otherness, but is tied particularly to the paternal figure and often to the son's vindication of the family name and honor. Michael Powell's *Her Last Affaire* (1935), a "quota film" (films produced to satisfy the Cinematograph Act passed in 1927 aimed at protecting and encouraging British film production), was based on a successful stage melodrama.[13] The film is set in England. Alan Heriot (Hugh Williams), the secretary of a prominent politician, Sir Julian Weyre (Francis L. Sullivan), seeks to clear his father's name. His father had been imprisoned for a crime which the son believes he did not commit, and he sets out to prove his father's innocence. Sir Julian refuses to investigate Alan's claim that Alan's father was innocent and to allow Alan to marry his daughter, Judith (Sophie Stewart). The sexually promiscuous figure in this film is Weyre's wife, Lady Avril (Viola Keats), who is the cause of Alan's father's imprisonment and death. Pretending to have an affair with her, Alan goes off to a country inn with her, where he plans to extort a confession from her about his father. Avril has a weak heart and must take medication, and on this trip she expires. Afraid that he will be discovered and accused of her death, Alan flees.

The film features three father figures—Weyre, Robb, a religious fanatic innkeeper (John Laurie), and Alan's absent father. Weyre and Robb are concerned to maintain the appearance of respectability to the point of overlooking actual legal transgressions. Alan is pitted against these male

figures, and with the women's help his position is legitimized. While a promiscuous woman, Avril, is at the root of undermining legitimacy, it is also women, Judith and Effie (Googie Withers), who uncover the "crime" and save the man. Through the women's exposure of evidence establishing the innocence of Alan's father, the father is vindicated and the son inherits the mantle of respectability. He can lay claim to the woman he loves, for his status is no longer questionable, and his career lies open before him. Alan's innocence and integrity are not enough to guarantee his success; he also requires the proper credentials, most particularly the legitimacy of a family name. Moreover, the son's investigation of his paternal identity is reinforced by the inevitable confrontation with and antagonism toward another paternal figure, Lord Weyre, who seeks to obstruct him in his quest. His vindication is built also on his having to overcome other and more threatening father figures. Male identity and legitimacy are thus seen to require female intervention and support in order to redeem the protagonist in the eyes of the Law.

Melodrama relies on secrets which threaten to destroy the protagonist unless he can either maintain silence, eliminate threats to exposure, or redress the "crime" that has been hidden. Thorold Dickinson's *The High Command* (1937) stars an eccentric actor, Lionel Atwill, associated with American horror films and images of demonic manipulation, as Sir John Savage, a man with a secret. The narrative begins in 1921 with the Irish Civil War and with Savage's shooting in self-defense of a fellow officer who has accused him (correctly) of having sexual relations with his wife. Savage tries to cover up the crime, but it is detected by a medical officer, Carson, who recognizes the bullet as coming from Savage's gun. The film moves ahead to 1937, when Savage is doing service in West Africa. The medical officer, an unsavory man, having blackmailed Savage all these years, comes to the community and is mysteriously killed. A cousin of Carson's, Heverell (James Mason), who has been having an affair with the wife of an officious local businessman, Cloam (Steven Geray), is accused of the crime. Ultimately, Savage is able to piece together that the killer is Cloam and tricks Cloam into a confession that costs Savage his life.

The other male characters in the film are also flawed but less honorable than Savage. Cloam, the volatile merchant, is an egoist, preoccupied with slights to his status in the community, quick to assert his prerogatives. He has violated his marriage, exploited a native woman as his mistress, and is willing to bully, lie, and cheat to achieve his objectives. Carson, the blackmailer, is equally unscrupulous. By contrast, Savage is presented in more contradictory terms as a diligent servant of his nation, a man who takes justice into his own hands by killing the man who abuses the woman he loves, and a man who lives by the code of honor, so that when

he is exposed, he takes his own life. Though a woman appears to be the indirect instigator of the actions, causing Carson to commit blackmail and Savage and Cloam to commit murder, the film's interest lies with the men as they prey on each other. Dickinson seems to be fascinated with the compulsions that drive men, compulsions which he was to explore in even greater detail and complexity in such films as *Gaslight* (1940) and *The Queen of Spades* (1949). The role of women in this film is typical of many tragic melodramas; they are identified as the primary source of disruption and good for maintaining the code of honor, but the focus is on the men's conflicts with one another.

While reenacting the oedipal conflict between two young men and their fathers, Michael Powell's sucessful *The Edge of the World* (1937) introduces a very different conception of masculinity. His films are exceptional in that they introduce protagonists more often found in American cinema, the physically powerful male in conflict with other men and with nature. The actors in the film—John Laurie, Finlay Currie, and Niall MacGinnis—are typical of the more rugged image of male sexuality in Powell's melodramas.[14] In contrast to the personalities and physical appearance of leading actors in the British cinema of the 1930s such as Hugh Williams, Leslie Banks, and Robert Donat with their cultivated, gentlemanly, and gentle demeanor, Powell's actors are characterized by energy and volatility, and his narratives by a focus on action and adventure.

This film, often compared in its treatment of locale with Flaherty's *Man of Aran* (1934), makes nature a protagonist. A blend of ethnography and melodrama, the film's emphasis on nature serves to dramatize the character and passing of a traditional culture that had met the needs of the people for centuries but has become redundant in the face of modernization. Nature does not have a stereotypical female valence but signifies male virility and potency. The film's portrayal of the rugged terrain of the island of Foula is tied to the conflicts between fathers and sons, to competition and conflict between men. The struggle between Peter Manson (John Laurie) and James Gray (Finlay Currie), and between their sons, Bobby Manson (Eric Berry) and Andrew Gray (Niall MacGinnis), is recounted in flashback by Andrew as he brings some visitors to Foula.

The traditional culture of the island is centered in the church, in the men's parliament, and in the patterns of work. The culture is called into question by Bobby, who feels that with the shrinking population and the hardships of life on the island it is time to think of resettling on the mainland. He and Andrew clash, and they propose deciding the fate of the island through a traditional physical trial—a race to the top of a treacherous mountain. Bobby is killed, and his father will no longer speak to Andrew, nor will he allow him to court his daughter, Ruth. After a great

storm during which Andrew has to go to the mainland to get medical help for his child and Ruth's, the people decide to leave the island, although Peter Manson is killed as he attempts to save a bird egg.

The film is organized around the opposition between nature and culture as presented in the framing of rituals in the context of the natural setting. The extended sequences of the inhabitants walking to the church with the grandmother sitting on the hill watching their progress, the frightening intensity of the two men as they race to the top of the mountain with the men in the boats observing, the lengthy funeral scene as the body is carried through the island, and Andrew's struggle in the storm to get help from the mainland dramatize how these rituals are inextricably bound to this wild environment and how the environment exacts its toll. The external environment is also an index to men's passions, which are not easily susceptible to restraint but erupt like natural catastrophes. The men's world is intimately tied to a mastery of nature, and modernity is blamed for destroying the traditional male culture. The women are subordinated to the men's struggles to survive and establish their place in this changing world. The men act, while the women observe. The film is an elegy for a way of life which, though dangerous, tested the male character, and the fate of the women is dependent on the men's success in overcoming threats to their own physical and psychic integrity.

Don Juanism

Not all of the male melodramas are quite so straightforward in their presentation of the male quest for legitimacy, honor, or service. There are also those that feature a male protagonist who seeks to escape the conventional demands of domesticity. In these films, the position of women is more prominently and ambivalently featured. Instead of the oedipal drama with the father, the oedipal conflict manifests itself in the combative relationship between the sexes. The figure of Don Juan is a familiar protagonist in this type of drama, and in the British cinema of the 1930s, Alexander Korda was the director and producer par excellence of this type of film. *The Private Life of Don Juan* (1934), starring Douglas Fairbanks, is no exception. The narrative stresses the last days of the aging womanizer before he is forced to settle down to enforced monogamy.[15] Imposture is central to the narrative. The real Don Juan is overtaken by a competitor masquerading as the Don. In a fracas, the imposter is killed and the body is identified as the Don's. Enjoying his "death," he decides to rusticate himself, leaving his amorous exploits behind, but when he learns that an unauthorized and scandalous version of his life has been written, he attempts to "return" to his former life and vindicate himself. On his return, he is no longer recognized as the great lover. If he is recognized at all, it is only as a harmless father figure.

He is disciplined for his dissolute life by marriage to the only woman who holds the key to his identity. By portraying the aged Don Juan, the film deglamorizes the legendary womanizer. The life of Don Juan is shown as exhausting and dangerous as he races to live up to his reputation as a woman's man. By employing the motif of imposture as well as the storybook narration of Don Juan's exploits, the film distinguishes between the fantasy of Don Juanism and the actual demands of trying to live up to that fantasy. Moreover, Don Juan is revealed finally to have no real identity apart from marriage. He is placed between impossible alternatives: the endless quest to prove his potency with women or the submission to the discipline of monogamy under the rule of one woman. The women who pursue him expect him to live up to his reputation as a lover, but they also want to possess him. As Doña Dolores says, "Every woman wants a Don Juan, not a husband." While Don Juan escapes the multitudes of desiring women, he is portrayed as having to maintain his amorous stance for one woman. Voracious sexual appetite is attributed to the female, while the male is presented as doomed to exhaust himself in the process of gratifying her desire. While the Korda films may tend toward variations of Don Juanism, the figure of Don Juan, associated with the aristocracy, is not a major one in British culture,[16] nor in the predominantly middle-class British cinema.

If male infidelity is at issue, it is more frequently associated with middle-class romantic love[17] between men and women, and the mainspring of the narrative depends on triangulation, not on multiple affairs as in Don Juanism. The Korda production *Men Are Not Gods* (1936), directed by Austrian emigré Walter Reisch and starring Miriam Hopkins, Gertrude Lawrence, Sebastian Shaw, and Rex Harrison, is a backstage melodrama drawing on *Othello* to develop the motif of womanizing and marital infidelity. Ann (Miriam Hopkins), a newspaperwoman, saves Edmond Davey from her boss's scathing review of Davey's first night performance of *Othello* by substituting a positive review when his distraught wife, Barbara (Gertrude Lawrence), comes and begs her to save the play. Ann becomes friendly with the couple, and Davey falls in love with her, inviting her to become his mistress. Though she is madly in love with him, she cannot accept his offer when she learns from Barbara that she is carrying Davey's child. She tells him that she can no longer see him, but in a frenzy he plans to murder Barbara/Desdemona during the performance. Ann's screams during the murder scene disrupt the performance, and husband and wife are reunited in anticipation of parenthood.

The man is presented as bridling against the restraints of marriage, while the women are brought to appreciate the need to discipline him. Despite her love for Edmond, Ann becomes supportive of Barbara, particularly when she learns that the couple are to have a baby. Davey is pre-

sented as a genius who must be indulged up to the point where his behavior begins to violate the sanctity of family. The women's position is, as in many films of the 1930s, one of solidarity in keeping the wayward genius under control and thereby protecting the interests of marriage and family. What is decisive in the film is the issue of the male's role in procreation, because it is finally the knowledge of his becoming a father that is most instrumental in Davey's reconciliation with his wife and his acceptance of the restraints of marriage. Biology saves the day. His renunciation of his extramarital relations, his reconciliation with his wife, his symbolic rebirth through Ann's agency, mark his entry into fatherhood and responsibility. Here he finally finds his own voice, abandoning the theatrical language that had characterized his philandering.

Melodramas of Conversion and Initiation

A dominant form of the tragic melodrama is the narrative of conversion, in which the protagonist undergoes a series of trials that bring him through the stages of arrogance, humiliation, and despair to a proper sense of enlightenment on behalf of the community. One of the most successful of this type of 1930s British film is Saville's *South Riding* (1938), which Jeffrey Richards and Anthony Aldgate find "can be taken as symptomatic of the mainstream British cinema generally."[18] In Richards and Aldgate's terms, the film is symptomatic, because it clearly takes as its aim a projection of British institutions and provides a sense of the attitude of consensus which pervaded British cinema and culture of the 1930s. Making the community itself a protagonist, the film, based on Winifred Holtby's popular novel, portrays a number of British institutions ranging from the political structure of the South Riding County Council to the school, housing, and the family. In personalizing political and ideological concerns, the film uses such characters as the country squire Carne (Ralph Richardson), the teacher Sarah Burton (Edna Best), the squire's wife (Ann Todd) and his daughter, Midge (Glynis Johns), the socialist Astell (John Clements), the religious hypocrite Huggins (Edmund Gwenn), the unscrupulous business entrepreneur Snaith (Milton Rosmer), and the altruistic councilwoman Mrs. Beddows (Marie Lohr) to convey its vision of social corruption and regeneration.

According to Richards and Aldgate, the film melodrama, unlike the novel, relies on the strategy of compromise. In the course of the narrative, exchanges of attitudes among the characters result in the transformation of the community and individuals within it. Rigid characters are excluded from the reconciliation: "Compromise and consensus, in the best interests of society and the nation as a whole, are largely what the film of *South Riding* is about. And the 'moral' of the film, if one chooses to use such terms, is that nobody is above learning how to compromise if important

issues are at stake."[19] Those characters who sought to develop a housing
scheme for their own selfish ends are exposed as frauds. The socialist is
enlightened about *realpolitik*. The poor Holly family is helped through
the intervention of Sarah, and Carne's daughter is able to go to school
thanks to Sarah's efforts.

The least commented upon aspect of the film is its sexual politics,
which are its clearest claim to advocating compromise and consensus.
Carne's character is the focal point of this melodrama of conversion.
Carne's marriage to a woman who proves to be mentally unstable leads
to the near ruin of his house and his relationship with his daughter. The
incident that leads to his wife's hospitalization is her riding a horse into
the house and up the stairs when her husband does not come outside
immediately. Midge (Glynis Johns) is presented as in danger of inheriting
the mother's insanity. She cannot tolerate restraint. In a classic melodra-
matic scene, Midge is shown coming downstairs in her mother's dress,
emulating a portrait hanging in the living room. The father's fears that his
daughter will be like her mother are an impetus to his eventual transfor-
mation. The portrayal of the mother and daughter echoes the Gothic mel-
odrama with the mad wife and the young woman who (like the young
woman in the Du Maurier novel *Rebecca*) identifies herself with the dan-
gerous woman.

Sarah, who is associated with nurturing, is offered as a substitute for
the wife and as the savior of the daughter and later the husband. She
curbs Midge's excesses and saves Carne from suicide. She also helps
Carne to birth a calf, and, as a teacher, she becomes a mother surrogate
to the young women. With the help of another woman, Mrs. Beddows,
Sarah becomes the mediator between the family and society. She is the
key to fusing conservatism and change. In her person, she exemplifies the
possibility of becoming a member of the middle class, an option she
makes available to one of her students, Lydia, who loses her mother and
is threatened with having to leave school in order to care for the family.
Though Carne's women play an important role as agents of conversion,
the focal point is the squire. Through Sarah's efforts, Carne is reborn as
a "new man." His personal and public life are regenerated and he
emerges as the savior of the community, donating his estate for a housing
project and schools. "Thus," write Richards and Aldgate, "a fitting cli-
max is provided for a film which celebrates essentially the vision of Eng-
land as one happy, close-knit community, a vision of domestic harmony
and national integration to be found most often in British films of the
1930s."[20] The film portrays social relations in subjective terms as matters
of the heart, and matters of the heart are to be located in the image of
family, and particularly in the benevolence and authority of the paternal
figure. While *South Riding* has moments which link it to the woman's

film, particularly in the portrayal of Carne's wife and daughter, these discordant elements must be either eliminated from the narrative or converted to "domestic harmony" in the interests of paternal authority and, hence, community stability.

As *South Riding* demonstrates, the working-class male is rarely the protagonist of male melodramas of the early 1930s and, when portrayed, is often presented in a comic or condescending manner. Raymond Durgnat writes, "A middle-class cinema will tend to acknowledge the working class only (1) insofar as they accept, or are subservient to, middle-class ideals, (2) where they shade into the feckless and criminal stream, and (3) humorously. All these approaches can be concertina'd into one."[21] One notable exception is exemplified by Arthur Wood's tragic melodrama *They Drive by Night* (1938), which employs working-class characters and locale. The protagonist (Emlyn Williams) of this male melodrama has the misfortune upon leaving prison to find a former friend dead when he goes to visit her, and he is suspected of the crime. As in film noir, the motifs of manhunt and entrapment are central. The male is threatened in his person not only by forces outside society, represented by the crazed killer, Hoover (Ernest Thesiger), but also by the police. The film begins and ends with an execution, and it is the state's power over individuals that drives Shorty Matthews to run away, although he is innocent. He believes that he cannot expect fair treatment from the law, a perspective far different from many of the films of empire and from such films of consensus as *South Riding*.

In this film, the woman is not a femme fatale. Molly (Anna Konstam) is a dance hall hostess who helps Shorty evade the police after he saves her from the rapacious attack of a trucker. Molly is portrayed as a nurturing figure and as the agent of Shorty's conversion. She humanizes him and restores his trust in the world. Significantly, trust is identified within the framework of the film's sexual concerns. Molly serves the same function as Sarah Burton in *South Riding* of being a maternal female through whom the male is reborn. When Shorty goes on the run, he takes a ride with a trucker and finds himself in the midst of the trucker's world, a sadistic world in which women are regarded as "the curse of the road." Shorty's protection of Molly distinguishes him from these men as it later distinguishes him from the sex killer Hoover. The threat in the film is incarnated in the figure of Hoover, whose sexual identity is questionable, evidenced by his abnormal attachment to cats, his voyeurism, his fetishizing of female objects, and his violence against females. The film ends with Hoover's execution, which might have been Shorty's. The fate of the two men is intertwined, since Shorty is accused of doing what Hoover has done. The crime for which Shorty might have been wrongly punished is linked to women and sex. His real crime is in being marginal and there-

fore at the mercy of the law and criminals alike. In this respect, he is as helpless as the women he tries to protect. His conversion through Molly's agency redeems him from the curse of isolation, violence, and threatening sexuality. In spite of this affirmative ending, the film is most revealing for its representation of beleaguered male identity and for its portrayal of the dance hall hostesses and lorry girls.

Sports are another arena in which to explore working-class male conflicts, since the context reinforces a familiar equation between the working-class male and physicality. *There Ain't No Justice* (1939), directed by Pen Tennyson, shares an affinity with the American genre of boxing melodramas. Tennyson's film opens with the following dedication: "This film is dedicated to the small-time boxer who has too long been at the mercy of both managers and public. If it in any way helps those who are struggling to improve their lot we shall be more than happy." Like most boxing films, the narrative involves the exploitation of the young athlete by his manager. As in so many of the tragic melodramas that feature boxing, the women in the film are polarized. The domestic female is identified with family and nurturing and pitted against the femme fatale who is in search of sexual gratification from young, virile fighters. Tennyson's film differs from later American films such as *Body and Soul* (1947), in which the protagonist makes it to the top and is tempted by fame and money. In Tennyson's film, the protagonist is not commercially successful and does not enter the upper reaches of the boxing profession.

Tommy Mutch, played by Jimmy Hanley, an actor identified with working- and lower-middle-class characters, is enticed into the sport by economic necessity rather than by glory. In fact, the specific necessity arises from his sister's desperate plight as a result of her manipulation by a small-time crook who steals money from the cash register at her place of employment. Warned to return the money, she is nearly driven to suicide. Tommy's decision to fight is thus motivated by the desire to save her. The primary villain of the piece, however, is Tommy's manager, Sammy Sanders (Edward Chapman), who sees boxing as business rather than sport and manipulates young boxers for his own profit. Tommy successfully challenges Sanders rather than knuckling under to the manager's command to throw a fight. In his struggle, Tommy is supported by other men in the community who rouse themselves to attack their exploiters. Tommy's crusading actions are accounted for by his deep loyalty to family, to the point of self-sacrifice, and are inseparable from the battle he wages against social and economic exploitation. The film is structured around the hero's movement from a state of innocence to one of enlightenment; it is actually more a drama of initiation than of conversion. Tommy does not experience a dramatic reversal of attitudes; rather, he grows gradually into an awareness of his responsibility.

Boxing is the film's metaphor for intraclass and interclass conflict. Society is seen as the arena of economic and moral struggle in which the working class is asked to fight by the rules and to coerce their exploiters to live up to the rules of the game. The metaphor does not suggest any radical changes in social structure but rather, as the dedication suggests, an amelioration of working-class conditions. The use of boxing as a metaphor also serves to reinforce the image of the worker as physical rather than intellectual, using his brawn rather than his brains in the struggle against his oppressors. As in the case of most representations of women, the working-class male is generally represented outside of language, expressing himself through his body. The film's focus on the male body contrasts with the melodramas that foreground middle-class males. What makes this film different from middle-class male melodramas is the nature of the protagonist's transformation. The question of his male identity is not psychological or spiritual, depending on a change of heart. Rather, his identity hinges on action, on collectively identifying the sources of corruption and choosing to fight against them rather than submitting to them. The oedipal conflict is not located in the family but in the social world. The surrogate father figure is the entrepreneur who spoils the "game" for the young men, and Tommy must assume a paternal role in his family and in his class.

The protagonist in Carol Reed's *The Stars Look Down* (1939), a film about miners starring Michael Redgrave and Margaret Lockwood, recapitulates the characteristics of service associated with working-class protagonists but invites a more psychological reading than does *There Ain't No Justice*. Michael Redgrave's acting seems to set the style for a number of later British films in which working-class men are confronted with a number of temptations involving women, personal failure, and betrayal of class origins. The figures Redgrave usually plays are vulnerable, subject to humiliation, and bordering on masochism disguised as domestication, resignation, or duty. He is most in need of guidance, and guidance is what is most lacking. Based on a novel by A. J. Cronin, the film focuses on the hero's struggle to get a university education, which will enable him to improve the lot of the miners and their families in Scupper Flats. As Redgrave portrays Davy, he fits Richard Hoggart's description of the "scholarship boy" in *The Uses of Literacy*: "He has left his class, at least in spirit, by being in certain ways unusual; and he is still unusual in another class, too tense and overwound. Sometimes the working-classes and the middle-classes can laugh together. He rarely laughs; he smiles constrainedly with the corner of his mouth."[22] Davy's steady progress in his studies is interrupted when he meets Jenny (Margaret Lockwood), who is enamored of Joe (Emlyn Williams), a young man who will steal and lie to make his way to the top of the economic ladder. Davy and Joe are por-

trayed as polar opposites. Where Davy sees his life as one of service to the community, Joe seeks to escape his humble background and seize the pleasures that money can bring.

The narrative takes as its ostensible subject the economic oppression of the miners, but diverts the audience's attention onto the melodrama of Davy's conversion. In that struggle, women play a dominant, if largely negative, role in converting him to a proper sense of responsibility. The women in the film are polarized. On the one hand, Davy's mother is the guardian of the hearth, the source of family solidarity. On the other, Jenny's mother counsels escape from the maternal home, urging her daughter into marriage with Davy for the sake of appearances. Jenny marries him, but then rebels against the constraints of marriage. She is portrayed as contemptuous of Davy's desire to pass his examination. Jenny's role functions negatively as a goad to remind him of his impotence. After her marriage, Jenny is restless at home and dissatisfied with Davy, his parents, and their way of life. She complains about lack of money and being harassed by bill collectors. While Davy had been a dutiful son, Jenny subverts his relationship to his parents, his mother in particular. In short, Jenny taunts Davy with being a failure; the situation is exacerbated with the return of Joe, who parades his affluence. The turning point comes for Davy when he learns of Jenny's infidelity with Joe, and he leaves, but the larger test of his character looms as a consequence of the corruptness of the mine owner, who sends the men into the pits knowing that the conditions are unsafe. Davy struggles to have the mine closed, but he is unsuccessful and the men are trapped. His father dies in the catastrophe, and Davy returns home to his mother, ready to take his father's place and resume his service to the community. The family romance becomes a prerequisite to proper entry into the larger community. Moreover, pleasure is repudiated.

Underlying Davy's character are certain assumptions about working-class men, some of which seem to further validate the description of the scholarship boy as given by Hoggart. Davy is isolated from the community in his desire for an education, in the inevitable differences between himself and the other men, and in his untested zeal. The film places Jenny, Joe, and later the mine owner as anatagonists whom Davy must confront and overcome in order to function effectively. The symbolism of coming home at the end signifies Davy's acceptance of his position, his willingness to occupy the space left by his father. Through bitter experience he has learned his place.

The black man as hero is a rare phenomenon in the British cinema of the 1930s, with the exception of a handful of films which star Paul Robeson, such films as *Sanders of the River* (1935), *Song of Freedom* (1936), *Jericho* (1937), *King Solomon's Mines* (1937), and *The Proud Valley*

(1940). The black man is usually seen as a subordinate helper of the white man, en masse as one of a tribe of savages, or as a disruptive influence in a potentially harmonious community. *The Proud Valley,* also directed by Pen Tennyson, is set in a mining community in Wales, capturing the Depression sense of bleakness as it follows David Goliath's (Robeson) entry into the town, where he has come looking for work. His singing is heard by Dick, the choirmaster, also a miner, who enlists him for the choir, which is rehearsing for the Eisteddfodd. Dick also helps him to get work in the mine, where David has initial difficulty in gaining acceptance by the other workers. Rachael Low describes the film as "partly a vehicle for Robeson, partly a trouble-down-in-the-pit film, partly an unusually outspoken political film."[23] The film is concerned polemically with unemployment, with the plight of workers and of their community, and, as an afterthought, with the relation of mining to the impending war economy. When the pits are closed, David Goliath goes with a delegation of miners to London to plead for their reopening, though he himself remains apart from the group when they talk to the officials. The mine is reopened, but trouble still plagues the community in the unsafe conditions in which the men work. In the inevitable scene of a mining disaster, David sacrifices himself for a young miner. The film, as indicated by Robeson's biblical name, is an allegory in which Robeson is both the singer of psalms and a physical giant. The Welsh community is linked to the biblical world of the Israelites, which triumphs over the hostile forces of profit and nature. David's sacrifice enables the community to be united. Jeffrey Richards finds that "despite the climactic tragedy, the film's mood is one of essential optimism as David is integrated into the community and as the community itself is integrated into the nation with the onset of war."[24]

In spite of David's token acceptance, he is set apart from others in his color, his exceptional singing talent, his physical prowess, the greatness of his sacrifice, and the smallness of what he asks in return for his gifts. Whatever verbal polemic is established in behalf of the black man is undercut in the ways in which he is represented. He begins and ends the film as a disembodied voice, and he is absent at crucial points in the action, underscoring his role as an intermediary rather than as actor in his own right. Significantly, after his death, we see images of work that he has helped to make possible but in which he does not participate. There is not even a scene of burial and community mourning. His blackness, moreover, becomes a synecdoche for the blackness and grime of the miners rather than an issue in its own right. Richard Dyer, in accounting for Robeson's unusual success as a black star, describes his role in *The Proud Valley* in the following manner: "The film displays a white community's easy acceptance of a black worker, yet unconsciously demonstrates the terms of that acceptance. As far as work goes, David/Robeson can be one

of the men but neither a leader—he refuses to go in with the other men to see the Minister responsible for the mining—nor a survivor—when a group of men are trapped underground, it is he who lights the dynamite, knowing it will free the others and kill him. . . . He participates in his own subordination and sacrifice. . . . Not only in overall plot terms, but also in the construction of individual scenes, David/Robeson is also marginalised."[25]

This film, like other Robeson films, capitalizes on his huge size, making it an object of fascination, further distinguishing him from others in the community, and emphasizing his body, as is frequently done with blacks as with women. The idea of service and nurture, of serving as an intermediary rather than an active agent, also aligns the black man with women as a figure of sacrifice and subordination serving the ideals of family and community. Most particularly, in his death that others might live, he fulfills the familiar role of the black man (and women) as intermediary in the culture rather than autonomous agent. In all of these ways, he is neutralized, and any threat he might pose is effectively subdued.

Carol Reed offers a less fatalistic portrait of a male in his 1941 melodrama *Kipps*, based on the H. G. Wells novel and starring Michael Redgrave. The protagonist in this film is an oppressed young man apprenticed to a draper. Through his initiative and the aid of an unexpected inheritance, he finds himself engaged to a society woman, Helen Walsingham (Diana Wynyard), whose family has lost its money. He suffers her attempts to make him over into a man acceptable to her class. Her brother, Ronnie (Michael Wilding), invests Kipps's money and loses most of it, though Kipps has enough to buy a small draper's shop. He marries his childhood sweetheart, Ann (Phyllis Calvert), who has been working as a maid, and they create a modest, unpretentious, and comfortable family life for themselves. Money comes his way again when an actor, Chitterlow (Arthur Riscoe), whom Kipps had earlier befriended, comes to see him and shares the money that his success has brought him.

The film portrays Kipps's struggle to situate himself in society as precarious. The scenes in which he works as a lowly apprentice at Shalford's drapery shop are portrayed to make working-class life appear a prison. In order to improve himself, Kipps takes courses at the Folkestone Cultural Institute, a school that claims to offer cultural benefits to workers. The Institute's pretensions to culture mask the greed and exploitativeness of its director. The upper middle class is portrayed as shallow, conniving, and callous. The only characters who are exempt from a negative treatment are Chitterlow, who is reponsible for getting Kipps fired from his regimented job, and Ann. Chitterlow is an alternative to the grim and grasping characters who characterize the world Kipps inhabits. Ann, the woman he finally marries, also has no social pretensions. She does not

want to live in a grand house, have servants, or move in the upper strata of society.

Thus, the life of the working class is presented as monotonous and demeaning, and the life of the upper class as sterile and constraining. Kipps prefers finally to be with his own kind and to be independent. The film suggests, as do so many films of the era that treat the subject of upward mobility, that money does not necessarily buy happiness. The film does not return Kipp to his former condition as a worker but rather makes him a respectable shop owner in his own right, a family man with a wife who shares his work and personal life with him through both hardship and success. Ann reappears in the narrative just in time to rescue Kipps from a loveless marriage. And Chitterlow magically arrives with money to rescue the couple. Modest employment, a comfortable home, and a stable family life seem to provide an escape from an excessively profit-oriented society, which is unattractive at both extremes of the social ladder. Kipps is yet another version of the oppressed and struggling but ultimately victorious male so familiar in the British cinema of the 1930s and early 1940s. In the context of the wartime years, this film offers consolatory images of male endeavor, holding out the promise of upward mobility.

Unlike the melodramas that focus on the protagonist's successful confrontation with the oedipal conflict to assume a position of responsibility, authority, and recognition, *On the Night of the Fire* (1939), directed by Brian Desmond Hurst, focuses on the marginal male figure without restoring him to society. William K. Everson describes this film as Britain's "first bona fide film noir," stating that "*On the Night of the Fire* is 100% noir in its characters, its mood, and in its theme of entrapment—of one crime building, leading to blackmail and murder, and climaxing in despair all around."[26] The central figure, Will Kobling (Ralph Richardson), is a barber who steals £100. The money operates as a curse. First his wife, Kit (Diana Wynyard), discovers from the newspaper that the button found at the scene of the crime is identical to the button she is sewing on his coat. He confesses to her that he was sick of his work, and that he took the money for her and the baby. She confesses that she has been extravagant and that she owes the tailor, Pilleger, £74, and he gives her the money to pay his neighbor. Pilleger then discovers that the notes are from the series of stolen notes and blackmails Will, who confronts Pilleger. As they struggle, Will accidentally kills Pilleger. The only person who has seen Will with Pilleger is Crazy Lizzie (Mary Clare), a demented alcoholic.

Ironically, though a fire consumes a good part of the section of Kobling's neighborhood on the evening of the murder, the tailor's place and Will's shop are unscathed. Will is interrogated by the police, and his wife

begins to suspect him of the murder. He asks her to go away for a while with their child. She goes to stay with her sister, who is married to a successful prizefighter, and eventually she dies in an automobile accident. She is an important link in the chain of events that leads to Will's demise in her extravagance with clothes, her envy of and competition with her sister, and her complicity in using the stolen money to pay the debt to Pilleger.

Will is portrayed from the outset as a man desperate to escape his dreary surroundings, and the film is framed by his desperation. In the beginning of the film, he is shown gazing at a large ship in the harbor, and at the end, it is toward a ship that he walks before deciding to end his life. Immediately thereafter, the temptation presents itself to steal the money that he sees lying unguarded on a desk as he passes by the open window of an office building. The noir style of the film depends on expressionist lighting, tight framing of characters and objects, the use of mirrors, asymmetrical shot composition, angular shots, and a total effect of claustrophobia and entrapment. In this aversive environment, Will is further isolated by the neighborhood's inhabitants. In his walk down the street, he is whispered about and ridiculed. The neighbors are only too eager to believe that he is the criminal and to bring him to justice. The charwoman, Brigid (Sara Allgood), who works for him after his wife leaves, is unsympathetic and instrumental in fanning the rumors of his guilt. In general, the women in the film are threatening, from Crazy Lizzie, the beggarwoman who manages to always turn up at the most inauspicious times, to Will's own wife. The fire itself, which ironically creates havoc but does not demolish the traces of Will's crime, is another metaphor for his bad luck.

The police are not presented in particularly heroic terms and appear, like the other characters in the film, to be an integral part of an oppressive landscape. The most sympathetic figure in the film is, in fact, Kobling, whose defiance of conventional restraint and law seem justified in the context of the irrational world he inhabits. According to Everson, the aura of doom in the film is undercut by Richardson and Wynyard, who are not convincing as a lower-middle-class working couple: "Despite valiant efforts, reluctantly dropping an 'h' here and uttering an 'ain't' there, the Old Vic is inevitably omnipresent."[27] I would argue that it is precisely this sense of their difference from the others in the community that reinforces their marginality and tragic fate.

On the Night of the Fire is an unrelenting portrait of a male pursued and tormented by society for his transgression, but his crimes of theft and murder are not the central issues of the film. They are symptomatic of more fundamental conflicts leading back to his relationship with his wife. Her extravagance, her self-preoccupation, and her desire to emulate her

more successful sister are part of the chain of events that leads him first to steal and then to pay her debt to the tailor, leads the tailor to blackmail him, and ultimately leads to the murder that destroys the protagonist's ties to family and community. The film's language is charged with symbolic meaning, such as the tell-tale button that falls off his jacket during the theft, his occupation as a barber, and the fire itself. Like the French films of the late 1930s and early 1940s and the American noir films, this film does not present a safe and conformist picture of a male disciplined into family responsibility, respect for the law, and subservience to the community. His impotence does not lead him to a conversion through which he becomes adjusted to his fate. His sense of fatality drives him to seek the escape he finally finds in his death. Low describes this film as hovering "between realism and Grand Guignol."[28] Such a combination is not unusual in melodrama and film noir, in which the narratives are divided between restraint and psychological excess.

MELODRAMAS OF THE POSTWAR ERA AND THE 1950s

During the war years, tragic melodramas were set in the context of combat or of the home front and generally in the context of family. Like the films of empire before them, war films were geared toward affirming male competence, stoic endurance, sacrifice, and camaraderie. Such films as *In Which We Serve*, *The Way Ahead*, and *Journey Together* (see Chapter 4) attempt to provide a legitimation for service to the nation and a rationale for the inevitable sacrifices demanded by the war. The male group is portrayed as working harmoniously and efficiently, each man contributing his share. The group also functions as a means of emotional support for the individual men. However, the portrayal of men at war is not unproblematic. As Christine Geraghty writes, "even in these 40s films, there is a tension between the concerns of home—marriage, pregnancy, children—and the demands of war. . . . The commitment to the male group, which is the means of winning the war, is in the end paramount. . . . Male power, normally channelled into the war, has disrupted and destroyed the home. It is a forerunner, in the war years, of themes films made after the war will take up."[29]

Social Misfits and Malcontents

After the war, the representation of males was to become increasingly darker and more problematic, the possibility of overcoming social and personal obstacles more difficult. In Pelissier's satiric melodrama *The History of Mr. Polly* (1949), the young Alfred Polly (John Mills) is a dreamer, unfit for the world of commerce, which, as in *Kipps*, is por-

trayed as dehumanizing. He describes himself as a "social misfit." Like
Kipps, he inherits some money, but, unlike Kipps, he ends up being cor-
ralled into a loveless marriage with the nagging Miriam (Betty Ann Da-
vies), though he had fallen hopelessly in love with a young and beautiful
schoolgirl, Christabel (Sally Ann Howes), who makes him feel like a
knight. The small business that he buys turns out to be a failure, and he
sets fire to it. In saving an elderly woman from the fire, he becomes the
town hero and is once again reinstated in people's good graces. Looking
at himself in the mirror, he calls himself a hero and decides to leave: "One
good thing about your life: You can change it." He runs away from home
and finds a country inn run by The Plump Woman (Megs Jenkins). She
needs a hired hand, and in the country Polly finds himself. He protects her
from a menacing drunkard, Uncle Jim (Finlay Currie) and settles down to
a life of rural satisfaction. After coming back to the town to witness the
results of his absence, and discovering that he has been declared dead and
that his wife is nicely taken care of, he returns to his pleasant life in the
country.

The film is a conversion drama in which, after many trials, familiar
stages in the protagonist's quest for self-discovery, he finally achieves a
new identity. Throughout the film, he refuses to be initiated into the ritu-
als and customs of ordinary existence. The first stage of his conversion
occurs with the death of his father and his receipt of the inheritance,
which enables him to go into business and marry. The second stage in-
volves his struggles with his wife and the townspeople as they excoriate
him for his failures. The next stage involves his burning down of his
house, his saving of the old woman, and his escape. His discovery of the
pastoral world and his eliminating the figure of threat from it marks his
entry into a more satisfactory existence which his presumed death frees
him to enjoy. The old world has nothing redeeming about it, and the
alternative to its destructiveness and constraints is escape, finding a way
of life that is noncompetitive. The world of work and marriage is pre-
sented as grasping and regimented, and Polly as resistant to conformity.
He rejects conventional standards of success, refusing to live according to
the demands of others. His dreams of romance and of knight-errantry are
finally realized when he finds the inn and saves it from the rampaging
"giant," Uncle Jim. His return to town and his discovery of his "death"
permits him to live a life consonant with his romantic dreams.

Language is a key to establishing Polly's alienation from others and his
resistance to conformity. Completely without guile, he lacks the normal
accoutrements of male performance in society and is an affront to those
people who urge him to perform in conventional ways. His isolation is
revealed through his talking to himself. He also is guilty of malapropisms,
a sign of his own misidentification of people and events and his inability
to perform in accepted ways. The language issue is most pointed in the

inability of the husband and wife to talk to each other. Their relationship is characterized by abusive name-calling on the part of the wife and his long silences. The language of romance and chivalry associated with Polly's reading and with his interior monologues stands in direct contrast to the sordidness of the world he inhabits. The "happy ending" is a pastoral fantasy which in no way mitigates the harshness of the world that the film has portrayed, an urban world of brutality, materialism, and ambition.

A number of films portray men who are trapped and, in their desperation, create havoc in their personal and social relations,[30] adopting a psychological treatment to account for the protagonist's frustrations and rage. In *My Brother's Keeper* (1948), a Gainsborough melodrama set in a contemporary context, Jack Warner plays an ex-serviceman, George Martin, who escapes from jail with a frightened young man, Bill Stannard (George Cole). The film is organized around a manhunt. Martin is portrayed as a man with no sense of compassion or sentiment. His wife describes him as a divided personality. One half of his personality is charming and kind, the other angry and cruel. When a policeman suggests to his mother that he should have been disciplined, she responds, "He got it in the army." This reference to World War II is not unusual in the postwar cinema. In a number of films that do not directly rehearse the war, the male protagonists may be, in fact, like Martin, an ex–military man, or the film may rely on the audience's awareness that the conflicts of the protagonist, especially the host of disturbed male protagonists who inhabit the 1940s and 1950s cinema, may, like Martin, be victims of the war.

In his indifference to life, Martin lashes out indiscriminately against the law, his wife (Beatrice Varley), a former lover (Jane Hylton), and his poor frightened traveling companion. After a lengthy chase through the countryside, he is cornered and killed when he accidentally runs into a mine field. But if Martin is portrayed as a raging animal who is hunted down like a beast of prey, the police and the journalists are not presented as benevolent. The police efforts to capture him are intertwined with the portrait of predatory journalists who are eager to witness the chase and be the first to publicize the details. A young newlywed journalist, Waring (David Tomlinson), has his honeymoon interrupted by his editor, who wants Martin's story, and he joins with other journalists in ferreting out the criminal. The final sequence in which Martin is cornered is presented from the point of view of the observing crowd, and Mrs. Martin comments on how "all these people came to look at George." The film thus seems to implicate a voyeuristic, bloodthirsty society in the making of the criminal, and imply a sociological perspective which seeks to identify George Martin's dilemma as part of a larger "social problem." Responsibility seems to be located in the residual effects of the war, in media manipulation and the quest for notoriety, and in defective personal relations.

Martin's relationship to Bill is as important as his relationships to women, for it is marked by the same lack of trust, compassion, or tenderness, though these deficiencies are extended to the broader society. The film seems to anticipate the social problem film of the 1950s (see Chapter 10).

Thorold Dickinson's *The Queen of Spades* (1949), based on the Pushkin story, takes a more pointed psychological direction in its exploration of an obsessional and paranoid male. The film, like all of Dickinson's films, is highly stylized. The acting is exaggerated, and the film makes no pretense to portraying the conflicts in naturalistic terms. The mise-en-scène is ornate, and the costumes and makeup, especially the old countess's, call attention to the grotesque aspects of character. Anton Walbrook plays the role of the young ambitious engineer, Herman, and his acting, as in Dickinson's *Gaslight,* conveys the character's acute hysteria. As with the men in Dickinson's other films, Herman is portrayed in the grips of obsession. His victims are women who seem to obstruct him in his quest for wealth and recognition. His sense of failure, rage, and impotence are first exposed in his relations with men. Extremely conscious of his inferior social and economic status in comparison with other men in his regiment, his obsessive drive to wrest the secret of the cards from the countess is his way of finding the key to gaining power over others. In his room hangs a picture of Napoleon, and in his private fulminations he rants like a tyrant.

But the film is more than a portrait of social failure. In its elaborate symbolism, and particularly in its introduction of the supernatural, it is an exploration of the internal landscape of a man whose social and psychological limitations force him to experience, not overcome, the sterility and decadence of the world he inhabits. He exploits one woman and murders another to gain access to the secret of winning at cards only to find himself thwarted and totally humiliated before his laughing comrades as he is led away, screaming hysterically. The world of *The Queen of Spades* is, like its Russian source, a world of radical disjunctions between desire and its realization, will and fatality, fantasy and social inevitability.[31] In Durgnat's terms, "The romanticism of *Queen of Spades* enfolds a violently cold irony about ends and means, hallucinations and deceptions, disrupting identity and spinning man into an exiled nothingness like absurdity."[32]

The film calls into question the ways in which constructions of reality, including filmic representation, are built on a sense of lack. Behind all representation is the face of death. The protagonist's efforts to escape his class and his sense of impotence are exposed as futile and self-destructive efforts, not because of his social presumption but, more profoundly, because he is trapped in a network of cause and effect which is not amenable to individual will or magical solutions. At the heart of all is the countess's

grinning face in the cards, the face of an aged woman who appears to gloat over his humiliation and impotence. Like many of the postwar male melodramas in which the male identity is shown to disintegrate, this film links the dissolution of personality to hysteria, a condition normally attributed to the female and identified as having its roots in sexual repression. Herman's misogyny and his obsessive desire to fuse with the men are excessive, and his hysteria signals that his objectives run far deeper than just the issue of his social position in relation to the other men.

This film, like Dickinson's *Gaslight* (1940), a psychological thriller, vies with Hitchcock's films in its depth of exploration of sexual conflict. In *Gaslight* as in *The Queen of Spades*, the focus is on the power struggle between a man and a woman, and in each film, it is the man who finally crumbles. Moreover, increasingly in the British films of the late 1940s and 1950s, as in the Hollywood noir films of the same period, the male protagonist's humiliation is linked directly or indirectly to a woman. In this respect, Dickinson's *The Queen of Spades* is exemplary of this tendency, though exceptional in its portrayal of the complex nature of male castration fear.

Many British films of the period involve castration anxieties, alienation, betrayal, and hysteria. Carol Reed's *Outcast of the Islands* (1951) explores, through the Joseph Conrad text, the abasement and destruction of a male figure. Willems (Trevor Howard) is driven from the companionship of other men, and Captain Lingard tells him, "You are not a human being. You are something without a body that must be hidden. You are my shame." *Outcast of the Islands*, like *The Queen of Spades*, *My Brother's Keeper*, and *The Browning Version* (1951), exemplifies the British cinema's increasing concern with the problematic nature of masculinity and of male relationships, and the films starring Dirk Bogarde are an index to the changing iconography and attitudes toward men in the British cinema. Bogarde's "star persona serves as a register of social tensions, more precisely how these tensions cohere around the problem of masculinity. Bogarde's image, both in screen performances and the equally important off-screen publicity material, can, I think, be read as a series of attempts to find a new way of representing male sexuality. . . . One has only to set Bogarde against his contemporaries, the likes of Kenneth More and Richard Todd, to notice some significant differences. Unlike them, Bogarde seems always unhappy with existing norms of masculinity. Where they embody restraint, he strives for excess. Where they remain calm in a crisis, he goes to pieces."[33]

In *Once a Jolly Swagman* (1948), directed by Jack Lee, Bogarde starred as a motorcycle racer who is from the working class. The film is set before the war and focuses on the male world of the cyclist, a world which exploits working-class young men like Bill Fox. Bill's family is opposed to

his racing, preferring him to take a steady job that pays less. His brother, who has fought in Spain on the Republican side, lectures him on the rights of workers. The men at the raceway represent a spectrum of attitudes. Tommy, for example (Bonar Colleano), articulates a realistic attitude toward racing, regarding it as a business like any other. Lag Gibbon is almost destroyed physically and mentally because of his emotional overinvestment in the theatrical aspects of the sport. Bill is impressed by the money he earns and his ability to buy clothes and cars. He finds himself in a relationship with an upper-class woman, Dotty (Moira Lister), who in her apartment displays pictures of herself with Fascists and behaves dictatorially toward Bill. He leaves her and turns toward Lag's sister, Pat (Renee Asherson), who is the polar opposite of Dotty. Pat has a sense of family loyalty and tries to make a success of her marriage to Bill. When she realizes that Bill's obsession with the Speedway is greater than his concern for her, she leaves him, joins the WACS, and later seeks a divorce.

While avoiding some of the more blatant stereotypes of women, especially the sacrificial maternal female, the film is nonetheless a man's film, focusing on the many ways in which men are exploited and trapped through economic necessity, through prevailing conceptions of masculinity, and through the desire to escape working-class oppression. Through actual shots of racing, the dangers and thrills of the sport are emphasized, but what is also foregrounded is the issue of spectatorship, in particular, the bloodthirsty nature of the audiences who come to watch the dangerous races. One of the drivers comments that the crowd is waiting to see the performer torn to pieces, and there are many shots of young women looking on enraptured during the race. Images of Hitler and Mussolini are intercut with the performances, thus making a link between fascism, masculinity, and mass spectator sports.

Through his brother's tutelage, Bill becomes conscious of being exploited by the promoters, and he confronts them with the demand for more money and benefits. He seeks unsuccessfully to organize the racers so that they can have more control over their work. In disillusionment, he joins the army and, when he is mustered out, seeks out the wife of a buddy who died, thinking that he may be able to help her. She rejects his offer, saying that she will now work twice as hard to take care of her family. And when he sees his mother again, she lectures him on his lack of understanding of women. She talks of things that ruin men—war, material success, and the quest for excitement. Taking her advice, Bill tries to find a different type of work, but realizes that he is unskilled. He returns to the raceway, and races against a younger man. Though he wins, he decides to "pack it in" and "go straight." The final image of the film is of Bill and his wife walking out of the raceway together.

The film is most successful where it explores the male world of racing,

linking mass spectator sports to fascism to present a critique of British society. The world of racing, with its emphasis on speed and dangerous thrills, is a metaphor for male sexuality, which can be legitimately expressed through working-class males only in their flirtation with violence and self-immolation for profit, and their orgiastic effect on the female audiences in the film. In addressing the issue of mass culture, in linking it to fascism, to mass hysteria, and to female spectators, the film reproduces the threatening aspects of women's sexuality familiar to many films of the era. The film's conclusion, reconciling Bill first with his mother and later with his wife, does not compromise the powerful images that the film has created of working-class exploitation; it also reiterates a connection between working-class males and their mothers, the same kind of connection explored in *The Stars Look Down.*

Connections between male identity, sexuality, and fascism appear again in Henry Cornelius's *I Am a Camera* (1955).[34] The overt homosexuality of Christopher Isherwood's stories is altered in the film, though it remains as a subtext. The film begins in the present at a reception for a female author, where the protagonist, Christopher Isherwood (Laurence Harvey), discovers that the feted author is a woman, Sally Bowles (Julie Harris), whom he had known intimately in Berlin during the Weimar period. He recounts his adventures with Sally to a group of men. In flashback, the film portrays the adventures of Isherwood as a struggling author, his encounters with Sally, then a nightclub performer, and their unconventional relationship. Sally is a woman who lives for pleasure. Her relationships with men are presented as exploitative, although she and Christopher are not involved with one another sexually. The casting of Julie Harris, an actress not associated with sexually provocative roles, further complicates the film's treatment of sexuality, since in the cabaret scenes she appears more as a masquerade of femininity than as a sexual threat. The film further complicates the couple's relationship by introducing another couple, Fritz (Anton Diffring), a man in quest of a rich woman, and Natalie (Shelley Winters), an heiress. While Natalie is unashamedly Jewish, Fritz struggles to conceal his Jewish identity. The issue of his struggle over whether to reveal his guilty secret to Natalie is tied to the structuring absence of the film, the issue of Christopher's homosexuality.

Sally tells Christopher that she is pregnant, and after she contemplates an abortion Christopher makes the gallant gesture of offering to marry her. His psychic struggles over the impending marriage are literally nightmarish for him, and he is finally released from his commitment when Sally informs him that she is, after all, not pregnant. In this way the film eliminates the abortion from the literary text on which the film is based. Sally goes off to Paris and Christopher to Spain to do journalistic work, but they meet again years later when Sally is a celebrated author, and the

film returns to the present and their reunion as she again seeks shelter with him.

The selection of this story, with its setting in Weimar Germany, for a film in the mid-1950s raises questions about the film's motives. The film is not an innocent attempt to recapture the ambience of the war era. The Berlin settings are artificial, suggesting in their nondescriptness that the Berlin context serves as a pretext for other issues. The portrayal of Fritz and Natalie likewise seems negligible as a reminder of Nazi anti-Semitism, suggesting that their presence serves other narrative functions more closely allied to the film's preoccupation with sexual conflict and, more particularly, with issues of concealment and exposure. The portrayal of Sally is the crux of the film. Like many of the female portraits of the 1950s, her presence serves more to highlight the issue of male identity than to explore female conflicts. Her escapades, in particular her pregnancy, are snares set to develop a connection between Christopher's writing and the necessity of a sybaritic life. His role as an observer and commentator on the events of the time threatens to be compromised by the specter of domesticity raised by his chivaric offer to marry Sally, and, more specifically, by Sally's sexuality.

One of the most revealing scenes in the film, far more revealing than Christopher's and Fritz's role as spectators in Sally's nightclub performance, involves the treatment of Christopher's illness. Sally and one of her rich lovers arrange for him to be treated by an array of doctors and therapists. They give a party at which the ailing Christopher is taken from his bedroom, placed in hot and cold baths, set on electric contraptions, and laid on an examination table, covered only by a sheet as the male members of the party hover over him. This episode suggests that the real object of investigation is the much-abused male body. In the context of this film, the issue of covert homosexuality (a necessity, given 1950s censorship controls) appears to overwhelm the film's concern with nazism and anti-Semitism. However, the link between these and homosexuality is not negligible, since the issue of nazism is connected both to male violence and to female sexuality, which the protagonist experiences but seeks to escape. The film seeks to neutralize and contain the threat of female sexuality but does not succeed. The return of Sally at the end into the all-male environment, like the return of the repressed, signifies the difficulty of containment. Moreover, it reinforces the notion that the film's preoccupation with the past is really a pretext for examining the contemporary situation.

Film Noir

While the British cinema did not produce the same number of noir films as Hollywood in the 1940s, there are a respectable number of films that feature a male protagonist victimized by a femme fatale in claustrophobic

settings that highlight the instability and paranoid atmosphere of the environment. *Daybreak* (1948), directed by Compton Bennett, also belongs stylistically to the American and French film noir. The world of the film is dark, the characters unable to escape their pasts. Their lives are shrouded in ambiguity and defeat. Eddie Tribe/Mendover (Eric Portman) has three identities—as hangman, barber, and barge owner. He meets a young woman, Frankie (Ann Todd), who is drifting. They develop a relationship, and eventually marry. Having inherited a barge business from his father, he and Frankie settle on a boat. They have much in common. Both have lost their mothers, and both have hated their fathers. They express a desire to be kind to one another. She tries to occupy his mother's place on the barge and to compensate for the past. On the pretext of business, Eddie leaves home at those times when he must serve as hangman, but he does not inform her of his job. He hires a young man, Olaf (Maxwell Reed), to take care of the barges, and while he is gone, Olaf seduces Frankie. When Eddie discovers the couple together, Eddie and Olaf fight and Eddie is thrown overboard. The police assume him dead and take Olaf into custody. Frankie commits suicide. When he learns of her death, Eddie reveals his identity and saves Olaf from execution, finally committing suicide in his barber shop.

The film begins in the present with the impending execution of a man who we later learn is Olaf. By means of flashback, Eddie's story unfolds. It is appropriate that he recount the past in this fashion, since as the narrative proceeds, he is shown to be mired in his history. Frankie is also trapped in her past. She seeks to evoke the memory of Eddie's mother as she salvages objects that are associated with her. Eddie is a figure of mystery. He refuses to give the solicitor his address and occupation. He does not tell the people at the barber shop that he is a hangman, and he does not tell Frankie about his other occupations. His motivation and identity are also an enigma, as is his relationship with Frankie. As they get to know each other, Frankie tells him that she likes him when he's sorry— "A girl likes a man who asks nothing of her"—and he is not particularly responsive to her affection. Their interactions settle into something more akin to father-daughter relations than those of a couple. Childlike, she seeks to please him and succeeds for a short while. When he leaves to fulfill his obligations as hangman, he places her in the care of an elderly couple, from whom she escapes to go dancing with Olaf.

Olaf is the antithesis of Eddie. Young, cocksure, muscular, and vain, he combs his hair "like a film star," according to Frankie. Olaf is also a dancer, and it is through his dancing that he is able to seduce Frankie. Despite Frankie's pleas to Eddie to get rid of Olaf, Eddie not only keeps him on but persists in going on his trips as if waiting for Frankie to transgress. It is hardly coincidental that Olaf is obsessed with his hair and one of Eddie's identities is as a barber. Olaf's single-minded obsession with

his virility is juxtaposed to Eddie's ambiguous relationship to women and to his masculinity, which seems to be related to his secrecy about his identity. Eddie and Olaf are also fused in their corresponding roles as victim and executioner, until Eddie faces his guilt and becomes his own hangman in this oedipal drama. Finally, in relation to Frankie, Eddie comes to occupy the role he has detested, namely, that of the punitive father, which then brings together in a tragic moment of realization his public identity as hangman and his personal life. In a way that no sociological drama can explore because of its commitment to naturalism, this intense melodrama which makes no pretense to "realism" is able to explore divided male identity and the fear of and violence toward female sexuality. The protagonist's fate is linked to his father. His inheritance of the barge from his father leads him to marry Frankie, and his marriage to Frankie exposes his inadequacy as a lover. He is less aroused by his wife than by her infidelity and seeks to vent his passion against the other man, becoming the victim of his own machinations, both transgressor and executioner.

The Gainsborough melodrama *Dear Murderer* (1947), directed by Arthur Crabtree, also dramatizes the disruptive and threatening nature of female sexuality. Eric Portman, an actor associated with many suave but sinister roles, plays a cuckolded husband, Lee Warren, who decides to avenge his wife Vivien's (Greta Gynt) infidelity. Returning home from a business trip to America, he finds traces of his wife's love affair strewn around the apartment in the form of letters and flowers. He goes to Fenton's (Dennis Price) apartment and confronts his rival, forcing him to compose a suicide note and ignoring Fenton's assertions that he had broken off with Vivien. In the lengthy and intricate interaction between the murderer and his victim, Lee explains his motives and his method of murdering Fenton. Lee murders him in such a way that the death appears to be a suicide. As he leaves the apartment, he hears but is unseen by his wife and her new lover, Jimmy Martin (Maxwell Reed), who are using Fenton's place to meet clandestinely. Lee further gratifies his desire for revenge by now planting evidence to implicate his wife's lover in the crime. Martin is sent to prison. Lee's wife and Avis Fenton (Hazel Court), the sister of the deceased, who is also in love with the accused man, are zealous in his behalf. When Vivien learns that her husband is the murderer, she concocts her own revenge. She traps Lee into writing a confession note and then poisons him, hoping to be free to marry Martin. Before he dies, Lee reveals to the police inspector (Jack Warner) that Vivien has poisoned him, and she is arrested. Like many of the men portrayed in the 1940s melodramas, Lee is obsessional, but his obsession is fixated on his wife's lovers. Unable to free himself from his dependence on his wife, he focuses on the men in her life. The intricate interaction between the mur-

derer and his victim is far more developed than the relations between husband and wife. Lee seems to be more interested in Fenton than in Vivien, telling Fenton that he could almost like him, and the viewer's attention is diverted from the actual killing onto the relationship between aggressor and victim. Typical of film noir, the woman seems to be the source of unstable domestic and personal relations. The film can be seen as yet another variant on the misogyny so characteristic of the postwar films, but it can also be read against the grain as an indictment of the overvaluation of monogamous relationships. Lee will go to any length to maintain his relationship with his wife. His attachment to her and his superrational treatment of her make him a sympathetic character. Moreover, his inability to kill off the hydra heads of lovers in order to possess his wife, as well as his wife's murder of him, enhances his victimization. Reading the film in another way, it can also be seen that his jealously, insecurity, and possessiveness are clues to his wife's oppression.

The film is structured around doubling and mirroring devices. It begins and ends at the same entrance hall to the couple's apartment. Lee forces Fenton to write a note before Fenton dies; Vivien forces Lee to do the same before he dies. Lee's murder of Fenton is paralleled by Vivien's murder of him. The film highlights mirror shots. Vivien is often seen before her mirror, and her portrait is featured prominently in certain scenes. Avis and Vivien both vie for Jimmy Martin's affections. The sense of doubling and repetition reinforces the sense that there is no way out of the obsessional patterns that characterize relationships. The film's technique of mirroring events provides a clue to understanding the couple's dilemma. The husband and wife mirror for each other the constraints and impossibility of marriage. Her promiscuity and his possessiveness are counterparts. She seeks to escape through other men, and he ironically mirrors her involvement with these men, but through violence. Just as for the protagonist of *Daybreak*, the only solution to his obsession is death.

Afflicted and Hunted Men

That many British films of the late 1940s and early 1950s dramatize men in the throes of an identity crisis, confronted by psychological and social threats to their well-being and survival, is not surprising given the ex-serviceman's problems of readjustment to civilian life and concerns about the fate of marriage and the family. In many of these melodramas, the psychiatrist or physician is invoked in order to explain or to eradicate the antisocial, hostile, or psychotic tendencies displayed by men. The presence of the psychoanalyst and physician in the male melodramas of the late 1940s and 1950s calls attention to the problematics of male identity, corroborating also that, like the troublesome female portrayed in the womans film, the deviant male is also in need of correction. The narrative

often features an innocent man tormented and hunted for a crime he did not commit. The mechanism that drives the narrative is one of investigation. The investigator in this type of film is not usually a detective, but a man, in fact, threatened by the law. He must struggle valiantly to discover the real criminal. Tragedy is averted only through the faith and trust of a woman who aligns herself with the hunted man against hostile social institutions. Gone is the wartime image of solidarity among men. Gone, too, is the image of a trustworthy and unified community. Even home seems a claustrophobic and threatening environment.

In Roy Baker's *The October Man* (1947), Jim Ackland (John Mills) is portrayed as having undergone a trauma that has unsettled his mind. He is the survivor of a bus accident in which the child of friends has been killed. The drama of survival so central to the immediate postwar years is implied in his illness. The doctor (Felix Aylmer) is uncertain about Jim's recovery, saying that "if the world is kind to him in the next six months, he'll be all right." If not, Jim will be driven to a final breakdown or insanity. Jim takes a job as an industrial chemist, moves into a residential hotel that lodges a number of eccentrics, and meets a young woman, Jenny Carden (Joan Greenwood), with whom he falls in love. Molly (Kay Walsh), a young woman at the hotel who is having a relationship with a married man and had earlier shown attention to one of the male residents, Mr. Peachy (Edward Chapman), borrows money from Jim. She is found dead the following day. Owing to his experience in the mental hospital, Jim is considered a prime suspect and the police begin to hound him. He is also assaulted by Molly's lover, and the inhabitants of the hotel embellish stories of his criminality to the police. Moreover, Jenny's family cautions her to stay away from Jim until his name is cleared. Feeling totally isolated, Jim at first attempts to cut through the lies and vindicate himself. He then begins to crumble and contemplates suicide.

Jim's mental state is mirrored in his surroundings. The aversiveness of the physical environment is dramatized particularly in the portrayal of the hotel where Jim lives. His room is like a prison cell, and he is portrayed as unhinged by the sounds that assail him through the thin walls. An atmosphere of claustrophobia and mistrust permeates every locale. Typical of film noir, the film begins in darkness with the bus plunging through the night, and many of the scenes take place either at night or in low-lit indoor locales. The sense of the hero's entrapment is conveyed in numerous angular and framing shots. The overall appearance of the film reinforces the paranoid atmosphere, but the protagonist is not undone by the malevolence around him. Justice prevails and he is saved, though the image of his salvation hardly mitigates the dark and menacing world portrayed throughout the film. Aside from Jim, the film presents a rogue's gallery of male portraits—bullies, adulterers, voyeurs, paranoiacs, fright-

ened men, and conspirators. Their discontent centers on Jim as the crimi-
nal. Jim's having a record of mental illness leads to his marginalization,
which in turn leads to his identification as a criminal. His difference from
others is the enigma in the narrative. His conflicts are attributed to the
trauma of the child's death and his consequent guilt, but the crime of
which he is accused is related to his befriending the promiscuous Molly,
the antithesis of Jenny. As in many melodramas, the trauma he has suf-
fered seems to be a substitute for a more profound malaise. The inmates
of the hotel who project their own fantasies onto him are perhaps more
adept than the psychiatrist in identifying his conflicts as sexual and vio-
lent in nature. Where they err, however, is in interpreting his violence as
outwardly directed when, in effect, it is directed against himself.

The role of the physician in such melodramas as *The October Man*
and, even more, in the Gainsborough melodrama *The Upturned Glass*
(1947), directed by Lawrence Huntington, is not untroubled, but exposes
ambivalent attitudes toward the growing influence of psychoanalysis. In
particular, *The Upturned Glass* turns the tables on the usual presentation
of the physician, making him the source of the problem rather than of the
solution. The physician is played by James Mason, an actor rarely cast as
the gentle protagonist, as evident in his portrayals of sadistic sensualist
Lord Manderstoke in *Fanny by Gaslight*, the bored and cruel Marquis of
Rohan in *The Man in Grey*, the domineering uncle in *The Seventh Veil*,
and the manipulative and brutal husband who drives his wife to suicide
in *They Were Sisters*. In *The Upturned Glass* he plays a tormented man
who is driven to commit a crime. A brain surgeon and university lecturer,
Michael Joyce uses his own experiences with criminality as a case study
for a classroom of university students. The subject of his lecture is the
psychology of crime. Whereas in previous lectures he had talked about
crimes by abnormal people, he states that he will now present the ficti-
tious case of a normal person with a strong sense of justice who commits
a crime. The flashback begins with his allusion to his unhappy marriage,
his devotion to his work, and his loneliness. He falls in love with a
woman, Emma Wright (Rosamund John), who brings her daughter to
him for treatment, and he restores the child's eyesight. The woman is an
exemplary mother, completely devoted to her child. Her husband, a geol-
ogist, is working outside the country, and she must assume the heavy
burden of making life-and-death decisions for her child. Joyce helps her
through the ordeal and discovers that they share a love of music. When
they confess their love for each other, she decides to write to her husband
and ask for a divorce but then changes her mind, feeling that this would
be unfair.

Joyce does not see her again but hears of her death, and he begins to
piece together evidence that points to Kate Howard (Pamela Kellino), her

sister, as Emma's murderer, and Joyce's life becomes a single-minded quest to avenge Emma's death. He finally throws Kate out of the same window from which Emma had either fallen or been thrown. He hides Kate's body in his car and drives off. He is stopped on a fog-bound road by another doctor, Dr. Farrell (Brefni O'Rorke), who tells of a twelve-year-old girl wounded in an automobile accident and in danger of dying from a fractured skull. Forgetting about the body in his car and the need to escape, Joyce operates, though the patient's chances are slim, and saves the child's life. Farrell, who finds Joyce obsessional and paranoid, has no sentiment himself about losing patients and is cynical about Joyce's overidentification with them. The film returns to the lecture hall as the doctor seeks to rationalize his actions in the interests of justice.

The melodrama complicates the issue of normalcy. Joyce is presented, on the one hand, as saving the lives of two females, Emma's child and the young victim of a car accident. On the other hand, he is seen as capable of destroying another woman, of brutally killing her. The film explores this self-division. In his relationship to Emma and to his profession, he is gentle, competent, and dedicated. In his other social relationships, he is a megalomaniac who considers himself superior to others and competent to exact justice and to take the law into his own hands by exercising power over life and death. The film suggests that his instability can be traced to his tenuous relations with women. He is overidentified with Emma. Music is the bond between them; they both play the piano. She is unattainable and, in his own description, "simple" and "unaffected." Kate, on the other hand, is loud and flashy, overdressed, addicted to going to parties, and uninterested in being a surrogate mother to her young niece. Unlike Emma, she is seductive toward men. Joyce emerges as a misogynist obsessed with punishing a woman, and the film questions whether his behavior is, in fact, "normal."

The question of Joyce's normalcy remains ambiguous to the end. Dr. Farrell, who identifies Joyce's mental condition as "mad," belongs to the "real world," where motives are dissected in pragmatic, nonmelo-dramatic terms. Joyce, on the other hand, is mired in questions of moral-ity and justice. He rationalizes his behavior as "just," while the other physician condemns his actions in psychiatric terms as obsessional and paranoid. Farrell's diagnosis provides a way of accounting for Joyce's aberrant actions. But the film invites another reading that complicates Farrell's clinical diagnosis. In Joyce's excessive devotion to his work, his overidentification with females, his isolation from others, his failed mar-riage, and his aversion to aggressive females, his portrayal exposes pro-found areas of sexual conflict. Through Farrell, the film indicts him as a pathological case, but the actions of the protagonist himself expose the ambiguity surrounding the meaning of normality. The film seems subver-

sively to suggest that his misogyny is, in fact, not exceptional, that in his destruction of the promiscuous and aggressive female he is doing what society sanctions: eliminating the threat of the sexualized female. Like the "normal" male, he is acting in the interests of the family and of society.

Another unconventional exploration of criminality, Robert Hamer's *The Spider and the Fly* (1949), focuses on the complex interactions between two men, a criminal and a detective, whose relationship goes beyond their usual typification in crime detection films. The setting is France rather than England. French society is presented as corrupt and exploitative, peopled with incompetents. Criminality is seen not as warranting moral outrage but merely as the lack of intelligence. Inspector Fernand Maubert's (Eric Portman) motto is "Better a knave than a fool." The only people who are not knaves are the inspector and his superintelligent criminal antagonist, Phillipe de Ledocq (Guy Rolfe). The men share an admiration for each other's cleverness as well as desire for the same woman, Madeleine (Nadia Gray). Through a successful counterespionage caper, both men, though on opposite sides of the law, serve their country. The ironic pairing of criminal and law enforcement officer reinforces the film's elevation of intelligence as the saving quality, possessed by only a few in this untrustworthy world filled with informers, betrayers, and fools.

The style is reminiscent of film noir in its use of low-key lighting, the prevalence of mirrors, the tight framing of the characters, and the claustrophobic mise-en-scène. The strength of the film lies in its incisive verbal repartee and in the relationship between the two men. They are alike in their scorn for incompetence, their attraction to the same woman, and their superiority to the organized forces of society. The other officials they encounter are unimaginative, provincial, and concerned only with maintaining a correct appearance. When Ledocq confronts Maubert with the ambiguous statement "You like me yet you hound me," Maubert responds that he hates untidiness, but he is especially bothered by Ledocq's misuse of his talents. The relations between Ledocq, Maubert, and Madeleine are hardly conventional. The three figures are not the usual portraits of service, self-denial, and moral rectitude. They are not constructed in terms of conventional moral polarities. Their relations are characterized by mutual exploitativeness. Ledocq exploits Madeleine to save himself. While Maubert is attracted to her charm and intelligence, he also seeks to use her to trap Ledocq. She, in turn, seduces Maubert and other men for her own survival. Above all, Maubert's obsession with Ledocq goes far beyond his professional interests as an enforcer of the law. In contrast to critics who disparage the film, Charles Barr regards it as "one of the most moving of British films in its sympathetic analysis of emotional atrophy."[35] In fact, the film traces the source of this atrophy to the hypocrisy

and banality of conventional values. The characters dramatize the consequences of survival in a world where hypocrisy, incompetence, and violence are the rule.

This negative image of society is reproduced in *Hunted* (1952), directed by Charles Crichton, but if Hamer's film is characterized by emotional atrophy, Crichton's is characterized by emotional excess. Bogarde plays a criminal, Chris Lloyd, fleeing from the law who discovers a young boy also on the run. Robbie (Jon Whiteley) has accidentally set his house on fire, and, fearful of punishment, is hiding in the rubble. Chris decides to help him escape, and gradually the two are drawn into a relationship. At first, Chris is harsh with him as he was with his wife, but as they travel together, Chris becomes more protective. When Chris wishes to send the boy home, the boy balks, preferring to stay with him rather than return to the abusive home environment in which he has been terrorized. His tenderness and affection for the boy is manifested in his concern for Robbie's welfare, his attending to the boy's physical needs, and ultimately in his sacrificing himself to save the boy's life.

Chris Lloyd is portrayed sympathetically as a victim of a hostile and violent world. The boy is not merely an agent of conversion who returns the criminal to a sense of humanity, but represents to Chris/Bogarde an image of his own history. Chris had also left home at an early age, and, it is to be assumed, was also the victim of brutality. Chris's involvement with the boy and his growing affection for him thus symbolize his own psychic reconstruction. Furthermore, his relationship with the boy also dramatizes their bonding through their marginality. The film offers an unusual image of male tenderness and nurturing which heightens the sense of these characters' difference from the hostile, uncaring world which they must inhabit. The tender relationship of the outlaw and the child not only presents an alternative portrait of male bonding but also indicates how this type of contact is not characteristic of the world in which they live. Any idealized image of family in the film is also seriously undercut. Chris's wife, Magda (Elizabeth Sellars), is presented as weak and adulterous. Mrs. Sykes (Kay Walsh), their landlady for a night, is presented as acting out of misguided sentiment in reporting Chris to the police. The home from which Robbie escapes is presented as repressive and brutal, and Chris's brother is more concerned with being accepted in the community than with helping his brother in distress. Thus, Robbie and Chris's relationship, emerging as a consequence of their bonding through desperation, affords an image of caring and companionship not available within traditional domestic relations.

The presentation of an image of society in which the vulnerable individual is pitted against overwhelming and repressive forces, and in which salvation is possible only through personal relationships with the

few sympathetic people, is reiterated in Hamer's *The Long Memory* (1953). Phillip Davidson (John Mills) is wrongly accused of murder. Fay, a woman he loved (Elizabeth Sellars), is responsible for his imprisonment, having concealed evidence that would clear his name. Phillip emerges from prison years later, determined to seek revenge, to hunt down and destroy the real murderers and the people responsible for his imprisonment and the waste of his life. Bitter, he refuses the companionship of an elderly man who lives, like himself, on an abandoned ship. Later, he saves a young woman from rape but resists her attempts to develop a relationship.

Elsa (Eva Berg) is a displaced person whose village was burnt to the ground during the war. Insisting that Phillip is a good man, she stays on his boat despite his pleas for her to leave him alone. When she learns of his plans for revenge, she intervenes to stop him from punishing Fay. When he finally confronts Fay and the men involved in framing him, he relents, saying, "It's not worth it." He is saved by the old tramp and Elsa, and when the police offer to help him, Elsa tells them, "He does not need anything that you can do. He just needs to be left alone." The film rigidly demarcates the characters, distinguishing the trustworthy from the untrustworthy. Aside from a few marginal characters including Fay's husband, who resigns from the police force, and the reporter, Craig, who helps Phillip out of compassion rather than for a sensational story, the characters in the film are portrayed as corrupt and self-aggrandizing, if not criminal.

The protagonist's fixation on the past, his struggle to come to terms with the present, was not an uncommon motif in the 1950s. The war is part of the long memory evoked by the title. The figure of Elsa raises the memory of World War II and creates a link between wartime suffering and postwar malaise. Hence Elsa, as a victim of the war, is an appropriate comrade for Phillip. They both must exorcise the past. Moreover, the film's emphasis on the couple and the bleak portrayal of society appears also to be consonant with existing representations of a retreat from the public sphere into individual accommodations or to family.

The ingenu roles Mills played in the 1940s in such films as *In Which We Serve*, *Waterloo Road*, and *Great Expectations* are quite different from his 1950s appearances as a tormented and marginalized figure. In contrast to Mills, Dirk Bogarde's screen persona clearly marks him as a marginal figure, unwilling or unable to conform to conventional masculine behavior and performance. Despite his forays into comedy with such films as *Doctor in the House* and *Doctor at Sea*, he is most associated with rebellious characters. But his defiance is presented in sympathetic fashion. Even in *The Blue Lamp* (see Chapter 10), where he plays a cruel criminal, the text (and his acting) exposes his vulnerability. Similarly, in

the psychological melodrama *The Sleeping Tiger* (1954), directed by Joseph Losey (under a pseudonym, Victor Hanbury), Bogarde plays a disturbed, but not unregenerate, young thief, Frank Clements, who is brought into the home of a psychiatrist, Dr. Esmond (Alexander Knox), for rehabilitation. As in the woman's film, psychoanalysis is central to the process of rehabilitating the protagonist, but, also as in the woman's film, it succeeds only in destroying him. Bogarde's malaise and his defiant attitude toward society are attributed by the psychiatrist to the young man's father, who humiliated him, and to a stepmother, who played on his sense of guilt. His relations with Glenda (Alexis Smith), Dr. Esmond's wife, are a recapitulation of his oedipal conflict and of domestic relations in general. Esmond's relationship to his wife is problematic, and Glenda's relations with Frank are characterized by varying degrees of aggression and sexual desire.

Glenda is an American who expresses a belief in individual effort and self-improvement. She hates "hoodlums," finding that "a bad childhood is no excuse," and claiming in clichéd terms that she came from a broken home but made a life for herself just the same. She flaunts her superiority to Frank. But Frank is not a pathetic picture of a poor working-class boy driven to criminality. His family is middle class, and he has had the advantages brought by education and money. His malaise has different, more psychological causes, which the film probes. While the wife is indifferent to the husband's efforts to rehabilitate the young man and even subverts her husband's work, the psychiatrist is committed to his "experiment," establishing a regimen that is designed to make Frank responsible for his actions. Esmond's regimen fails until he assumes an active role by refusing the police permission to search the house, though he knows that Frank has hidden stolen goods there. This act is the crux in altering the relationship between the two men. Frank reveals that he had been in a similar situation with the law when he was younger but his father turned him over to the police. Frank now feels a bond with Esmond and determines that he will not continue his relationship with Glenda. Her passion and rage know no bounds. When Frank leaves the house, she finds him on the road and offers him the fatal ride as she drives them to their death through a poster of a tiger. Frank's "recuperation" has been thwarted, and the film refuses the familiar consolation of reconciliation and celebration for the reformed criminal.

In the early part of the film, a parallel is established between Frank and Glenda. As he abuses Sally, the maid, taunting, threatening, and humiliating her, so Glenda adopts a similar stance toward him. It later emerges that this is a repetition of his family's treatment of Frank. But while Frank alters and softens, Glenda becomes more demanding, possessive, and angry when thwarted. Once her controlled exterior crumbles, she be-

comes tigerish. She comes to represent the arrogant, repressive, and finally predatory aspects of a society that is gradually coming to resemble American society. Her husband's indifference and her own inability to handle the passion that she comes to experience softens her portrayal but does not mitigate the threat she poses to Frank. As in the woman's film, psychoanalysis assumes a contradictory position. On the one hand, it provides the customary vehicle for addressing and "explaining" marginality. Through psychoanalysis, the tenuousness of male identity is revealed, but, unlike many melodramas that feature psychoanalysis, *The Sleeping Tiger* does not explain away the characters' conflicts. Psychoanalysis becomes, rather, another symptom of problematic male identity expressed particularly through male-female sexual encounters where both the male physician and the patient are implicated.

Brothers

The altruistic, self-abnegating hero who fights against the entrenched forces of social corruption is resurrected in French's *My Brother Jonathan* (1948). Told in flashback, the film begins with the two brothers, Jonathan (Michael Denison), and Hal (Ronald Howard), vying for the hand of Edie Martyn (Beatrice Campbell). Hal is a brilliant student and sportsman with a great political career ahead of him. Jonathan, who always defers to his brother, is studying to become a surgeon, though his studies are cut short by his father's untimely death, and he chooses instead to go into general practice. He is poor at sports, at dancing, and at social graces generally. The oedipal conflict is revealed first through the portrayal of the parental figures: the father is weak, while the mother is domineering. The competition between the brothers is aggravated by the mother's preference for Hal over Jonathan. The ultimate blow to his mother is his brother's death in World War I. Jonathan resists her charge that the wrong son has died and patiently attempts to make her life bearable. When he learns that Edie will bear Hal's child, he marries her, though he has fallen in love with Rachel (Dulcie Gray).

Not only is Jonathan beset by familial responsibilities in the form of his mother and Edie, but he is also frustrated in his work by other physicians in the town who are unconcerned about the plight of the poor and refuse them places in the local hospital. He battles them and wins his case, thus making it possible to provide better medical care for the underprivileged in the community. Edie dies in childbirth, and Jonathan and Rachel marry. The text kills off the romantic and pleasure-seeking couple to make room for more socially conscious figures whose satisfaction is through work and service to others. *My Brother Jonathan* is exceptional in its adoption of the ethos of altruism and service. In its focus on Jonathan's familial and professional conflicts, it studiously avoids succumb-

ing to a psychological treatment. The obstacles he confronts are treated rather as necessary stages of his initiation into a life of service.

A more violent portrayal of paternal and sibling relationships is presented in David Macdonald's *The Brothers* (1947). Like Powell's earlier *Edge of the World*, this film portrays a society in transition and, in particular one that focuses on male competition and conflict. Set in Scotland on the isle of Skye at the beginning of the twentieth century, the film portrays the consequences of the coming of a young woman, Mary (Patricia Roc), to the home of Hector Macrea (Finlay Currie). Hector lives with his two sons, Fergus and Dugald (Maxwell Reed and John Laurie). The father's position is pivotal. He is not only the head of his immediate family, but he is also the patriarch of the entire community, acting as their judge and executioner in criminal cases. His authority is absolute. Both men are attracted to Mary, but, as long as the father lives, the brothers restrain their competitiveness with each other. When Hector dies, Dugald, wanting Mary to himself, betrays a promise to his father to give Mary to Fergus. His betrayal results in the death of both Mary and Fergus.

Women are negligible in this world. They are exchanged in marriage but have no power to make decisions. Hector's death, an indirect consequence of Mary's disruptive presence, is the result of clan warfare between the Macreas and the McFarishes. The fate of the sons, too, is related to Mary. Her love for Fergus, which is obstructed by Dugald, is aided by one of the men on the island, Aeneas McGrath (Will Fyffe), who takes the couple on a fishing outing. The outing ends in disaster when Fergus has to cut off his own finger when it is grabbed by a conger eel as he puts his hand in the water to get a lobster for Mary. Obsessed by her, Dugald is not only willing to cast out his unattractive wife, Angusina (Megs Jenkins), but he convinces Fergus of Mary's evil nature and extracts his brother's promise to kill her. Fergus takes her out on the boat and murders her, but also kills himself. The community exacts its vengeance for Fergus's denial of responsibility for his brother.

Female sexuality is again the disruptive force in this traditional community. Mary is not presented as malicious or manipulative. She is associated with nature, but nature is polarized. For men, nature is hostile; for women, it is a source of pleasure. Mary's sensual desires and her softness are set in sharp contrast to the harsh and violent lives of the men. *The Brothers* resembles the Hollywood western in its portrayal of the unrelenting opposition between nature and culture and of men struggling with nature and against their own desires, and in its unsentimental recognition of female sexuality as an enemy of male solidarity, which is built on the exclusion of the female.[36] Like the American westerns, too, this film has its share of violence, which is associated with the enactment of primal forms of aggression linked to sexuality. The film dramatizes how the patriarchal community depends for its continuity on the exclusion of

women. In spite of its treatment of archetypal themes and its dramatic use of authentic settings, critics attacked the film for its "sadism" and "grimness."[37] As with the Hammer films, the guardians of morality were watchful for violations of sexual and psychological decorum, and this film seems to have been rightly understood as an assault on conventional morals.

Portraits of Impotence

The Boultings' film *Fame Is the Spur* (1947) is one of the more overtly political melodramas of the era in its unrelenting exposure of the male quest for political power. The protagonist is portrayed as self-corrupted and corrupting of others in his rise to high political office. According to Richards and Aldgate, "The Boulting Brothers' film, then, set its face grimly against its principal character of Hamer Radshaw and allowed him no redeeming characteristics. He was not meant to be construed in any sense as the archetypal 'hero'."[38] The film portrays the rise of a young man inspired by the radicalism of the past. He is given a sword that his grandfather had wielded during the Peterloo Riots, and this sword accompanies him throughout his rise from obscurity to become a figure of power in the labor movement. He studies the writings of socialists and becomes an eloquent speaker, lecturing on the evils of poverty, social injustice, and oppression.

The film interweaves the rise of Hamer Radshaw (Michael Redgrave) with important historical developments from the 1870s to the 1930s. While the novel redeems its protagonist, dramatizing his inner conflicts as well as his public compromises, the film relentlessly exposes the ways in which Hamer betrays his ideals. Even in his youth, Hamer is portrayed as vain and pontificating, addicted to speechifying. Increasingly, as he is offered one position after another, he betrays his old comrades and even acts against the demands of the workers whose cause has placed him in the exalted position he occupies. At first, his wife, Ann (Rosamund John), is a colleague in his political struggles, but as she becomes more involved in suffragist issues, the couple drift apart. He calls her colleagues "crude agitators" and worries about the effect that her politics will have on his own political position. Her increasing radicalism leads her to demonstrate in the House of Commons, where Hamer is speaking, and later she goes on a hunger strike. Through the assistance of Lady Lettice (Carla Lehmann), Ann is released, but she subsequently becomes fatally ill. Before she dies, she urges Hamer to return to his early commitment to social justice.

Hamer does not follow her advice, and the next comrade that he alienates is Arnold Ryerson (Hugh Burden), who asks for Hamer's help to speak to striking miners. Arnold tells him that the men are angry and violence must be avoided at all costs. Hamer disregards Ryerson's advice

and delivers a militant speech, which leads the miners to riot and results in loss of life. Arnold is the last link to Hamer's past and the political causes he has verbally espoused but repeatedly betrayed. The final sequence shows an aged Hamer expiring in his study with the tarnished sword hanging near him. If the film is not a specific attack on Attlee and the Labour government, it is a portrait of the failure of personal and social commitment. The hope for a new society expressed in many of the wartime films is laid to rest in *Fame Is the Spur*. Both the private and public spheres are corrupted by a return to privilege and patriarchal prerogatives. That the protagonist is a spokesman for political change and for workers' rights makes the betrayal all the more striking.

The treatment of idealism and community service in the postwar era is usually more ambivalent than in the pre–World War II cinema. While the strong paternal figure is likely to be converted or eliminated from the narratives of the 1930s, in the postwar cinema the weak male figure is more frequently the object of concern and reformation. In *The Browning Version* (1951), directed by Anthony Asquith, the protagonist is the portrait of failure. Crocker-Harris, played by Michael Redgrave, is a teacher of classics who no longer commands the respect of his pupils, his colleagues, or his wife, Millie (Jean Kent). The students deride him; his colleagues treat him condescendingly; the headmaster bypasses him for promotions; and his wife carries on an affair with the science teacher, Frank Hunter (Nigel Patrick). Through the agency of a young student, Taplow (Brian Smith), who gifts Crocker-Harris with Browning's translation of *Agamemnon*, Crocker-Harris is able to separate from his wife and confront and publicly acknowledge his failure.

The film explores the protagonist's failure in both the public and private spheres. As a classics teacher, he is like a vestigial remnant of the past, in contrast to the virile and popular science teacher, and his failure as a pedagogue is traced to his unsuccessful marriage. His wife, who selects a more aggressive male as her sexual partner, is portrayed as responsible for her husband's low self-esteem. She is contemptuous of him and misses no opportunity to embarrass him in front of others. The film never develops the basis for her complaints but rather melodramatically casts her in the role of a castrating wife, offering her little sympathy; however, Redgrave's portrayal of Crocker-Harris's extreme self-abnegation allows the audience an understanding of the wife's philandering and of their incompatibility. That a young boy is the vehicle for restoring the protagonist to a sense of his manhood also suggests that sexuality, not his pedagogical shortcomings, is the real source of his misery. If the film exposes his repression as sexual, it also suggests that his pedantic relationship to the young men he teaches has been, like his marriage, a defense against his desires. The misogyny of Millie's portrayal is thus somewhat mitigated by

the recognition that the film has been exclusively preoccupied with Crocker-Harris's impotence. The marriage, and Millie's narcissistic, harsh, and castrating character, are symptomatic of more fundamental issues concerning male sexuality which are only hinted at in the teacher's conversion though his relationship with young Taplow.

In 1953, Hammer Films produced a film featuring a prizefighter, *The Flanagan Boy* (directed by Reginald Leborg), which inverts the values of the Tennyson film *There Ain't No Justice*. *The Flanagan Boy* offers a more psychologically complicated portrayal of its working-class protagonist. Johnny Flanagan (Tony Wright) is seduced by Lorna (Barbara Payton), the wife of fight promoter Guiseppe Vecchi (Frederick Valk), who, like the husband in Visconti's *Ossessione* (1942), though coarse, is a lover of opera. Also as in the Visconti film, the wife drives the lover to murder the husband. Lorna's relationship to her husband is characterized by revulsion and her relationship to Johnny by antagonism and sexual contact without tenderness. Though adjudged innocent, Johnny, unable to bear his guilt, commits suicide.

Sexuality plays a prominent role in Johnny's demise. Lorna's seductiveness is conveyed through her dancing. She dances erotically before the men, self-absorbed. When she and Johnny dance, the equation between dancing and sexuality is made even more explicit. Moreover, Johnny's fighting in the ring also involves dancing. The equation between dancing, sexuality, and violence is a negative one, productive of murder and suicide. Lorna becomes central to the narrative as the disruptive center of sexuality, violence, and death. Because of her, Johnny loses his fight and ultimately his life. Lorna is cursed by the Vecchi family, especially the mother, who is convinced of her guilt. Johnny is portrayed as innocent, victimized by his body and by passions he cannot understand. The Hammer film is less concerned with the issue of Johnny's exploitation as a fighter by his manager than with portraying a society in which sexuality can be expressed only through violence. Sexual relations between men and women are fated to end disastrously. Johnny's involvement with Lorna has the earmarks of classical tragedy as he is driven to commit murder and then is destroyed by his guilt, but, as is typical of melodrama, the film takes the more public aspects of social power, domination, and exploitation and transfers them to the private sphere.

The Rake

Another problematic male figure in the cinema of the 1940s and 1950s is the rake, a character often played by Rex Harrison. In his persona as a lady's man, Harrison is identified with middle- and upper-class roles. He is not a Don Juan, though he is a close relative of the libertine. The parts he plays, especially in such films as *The Constant Husband* (1955) and

The Rake's Progress (1945) directed by Gilliat, are rarely domesticated males. In *The Rake's Progress*, a film that ran into difficulty with the American censors because of the protagonist's loose morality, he portrays an upper-class roué who is unable to settle down to the domestic or professional demands placed on him. According to Sidney Gilliat, Vivian Kenway represents "the idea that there was no longer room, except maybe in war, for that kind of person. Fifty years before he'd have been sent to India, or dispatched to South Africa—there was always somewhere you could send the black sheep of the family to make good or otherwise. But by the 30s this no longer applied to anything like the same degree. There was no longer the old scope for adventure and exploration. A war in that sense supplied an opportunity for such persons, who are good at the sort of action which does not impose on them *too* much personal responsibility, but does allow certain gifts for enterprise and leadership to come out."[39]

Vivian Kenway is "sent down" for climbing the Martyr's Memorial at Oxford. He is sent by his family to a coffee plantation, where he fails, refusing to play the game of business profiteering. He returns to England and resumes his playboy existence. When asked by his father (Godfrey Tearle) what he would like to do, he responds, "Nothing." He and his friend Fogroy (Guy Middleton) find themselves in one scrape after another. Vivian seduces the wife of a university friend, a woman with whom he had earlier had a relationship, and finds himself in trouble with the husband. He turns to car racing, and while in Europe meets a Jewish woman, Rikki Krausner (Lilli Palmer), running from the Nazis, who asks him to marry her to help her get out of the country. She falls in love with him, and suffers his extravagance and infidelity, which lead her to attempt suicide. They are divorced. Vivian is then responsible for the death of his father in a car accident. Suffering guilt, Vivian disappears from society, but Jennifer Calthrop (Margaret Johnston), with whom he had an affair, seeks him out at a dance hall where he is paid to dance with women. Determined to rehabilitate him, Jennifer marries him. They settle down to marital routine, but, unable to sustain this life, Vivian escapes and joins the service, where he dies a hero's death.

This picaresque narrative, couched in the context of a vanishing class, looks critically at middle-class values of family and respectability. The rake's belonging to a dying class makes more palatable the film's broader critique of the world of middle-class morality with its emphasis on monogamy, heterosexuality, fidelity, family loyalty, and obedience to paternal dictates and the work ethic. His portrayal is aligned to those others that portray men who are uncomfortable within prevalent notions of masculinity. Unlike many of the other films that feature marginal male figures and attribute their marginality to female control or possessiveness,

The Rake's Progress presents the women as victims of the protagonist's resistance to patriarchy and conventional social codes. The rake's subversion of social relations is not consciously motivated; rather, his undisciplined behavior seems to be involuntary, almost obsessive in his quest to relieve boredom through adventure.

In *The Constant Husband* (1955), Rex Harrison again plays the role of dashing picaro. A victim of recurrent amnesia, he finds himself at the film's opening in a strange hotel room, without any marks of identity. "Who the devil are you?" he asks as he looks at himself in the mirror, and with the help of a physician, he sets out to discover his identity, which turns out to be complex. He is alternately playboy, car salesman, military man, sportsman, and husband of seven different women. As he pursues his past, the women return to claim their marital rights, and he is put on trial for bigamy. The courtroom audience consists of women—former wives and other doting females. He seeks to escape women, finding jail preferable to their demands, but since his crime was against women, he gets a woman, Miss Chesterman (Margaret Leighton), as his defender.

His attorney bases her defense of her client on the difference between the mental and the physical person, asking, "Can it be just that Doctor Jekyll should be punished for the sins of Mr. Hyde?" and wins her case, but the man with no name begs to be kept in jail, to be cut off "from the highways and byways of humanity." He wants isolation and silence. He is pursued and captured by his defender in the last moments of the film as he leaves prison. What distinguishes this film from many of the other films on men is its portrayal of the protagonist in terms more often associated with women. He is presented as the object of desire, subject to the gaze of females, gazing at himself, fragmented in his many identities, divided between mind and body, and seeking to escape the possessiveness and sexual desires of his pursuers. Unable to achieve integration, his identity has to be legislated in the courtroom and according to the dictates of monogamy.

As this review of male melodramas has revealed, the representations of men in the British cinema do not conform to any dominant and unitary conception of male identity. While a large preponderance of narratives are cast in the mold of the conversion drama, depending on the successful confrontation of the oedipal conflict through a reconciliation with the father or father surrogate figure, there are in fact a number of films that, in spite of their so-called happy endings, reveal the contradictions of this resolution as well as exposing resistance to the status quo. Furthermore, although the British cinema has been described as a middle-class cinema, focusing largely on the conflicts of the bourgeois male, these films feature working-class protagonists and males that do not conform to notions of middle-class respectability. The films of the 1940s and the 1950s increas-

ingly portray troubled males—criminals, psychopaths, hysterics, and sadists—who do not conform to the prescriptions for middle-class domesticity and service to the community.

Progressively, over the three decades and well into the 1960s, the male melodramas exhibit the tendency to reveal psychosocial conflicts, to address directly the question of sexual identity, the problematic nature of heterosexual relations, and the constraints of courtship and marriage. The women portrayed in these films are often presented as constituting a threat that has to be contained, often through violence. The world portrayed in these films is unstable and untrustworthy, and the male is placed in the precarious position of having to protect himself against the numerous threats to his physical or psychic integrity. In some of the films, particularly the Gainsborough melodramas, he may in fact be the source of unrest. Also, there is a notable shift in the group of actors who assume leading roles in the British cinema of these decades. Different notions of masculinity can be seen by contrasting Robert Donat and Leslie Howard with James Mason and Dirk Bogarde. The appeal of Howard and Donat lies in their restrained sexuality, slightly ascetic appearance, gentleness, and aura of dependability. Bogarde and Mason, on the other hand, are noted for their erotic cruelty, nervousness, and defiance of existing norms. Their roles testify to society's increasing concern with the loss of paternal authority and domestic harmony, the presence of generational and class conflict, and, above all, discontent with existing patterns of sexual behavior.

Family Melodramas

IN ONE SENSE, most of the films I have considered in the chapters on the woman's film and the tragic melodrama are family melodramas, since the problematic of home and the nuclear family haunts the narratives. For purposes of distinguishing the relative emphasis on female and male identity, differences in male and female point of view, I separated the woman's film and the tragic melodrama from films that isolate issues of family succession, legitimacy, and continuity. The films discussed in this chapter focus overtly on the family as an institution, and tend to subordinate individual conflict to the maintenance of the family unit. Variations are evident in the ways in which the films confront this issue. Some of the films are family chronicles, extending beyond one generation and attempting to situate the family fortunes in a historical context. Others emphasize the threatened extinction of a family, particularly an aristocratic family, and introduce, often with attendant violence, an outsider (most often a woman) who will resuscitate the family line. Still others address the issue of the "ghost in the house," the need to eradicate past "crimes" or stains on the family. In the films of the immediate postwar years, the issue of the impact of the war and the reconstruction of the family is uppermost. Increasingly, in the films of the 1950s, family tensions become more evident, though many films seek to hide them behind strategies of conversion or imposed discipline.

The family melodrama is no more static than any other genre, and one can chart tensions and changes from the 1930s to the 1960s in representations of the family, particularly in relation to patriarchal authority. Familial order and stability are linked to the larger social order by means of marriage, sexuality, and reproduction, which serve to perpetuate social institutions. In the domestic sphere, sexuality and its regulation have been central to the maintenance of domestic economy and patriarchal authority. In David Rodowick's terms, "As the lynch-pin on which narrative conflict must turn, the problem of familial authority and stability . . . establishes a frame of reference against which the logic and order of social relations are measured."[1] The preoccupation in family melodrama with the struggle to restore the beleaguered family is not merely symptomatic

of an escape from the public sphere. Rather, melodrama acknowledges the interrelationship of the public and private spheres, the increasing encroachment of the external world onto the privacy of the home. The concentration on the private sphere, the fusion of private and public concerns, is, moreover, characteristic of profound social transformations in modern British society and culture.

In the evolution of familialism, melodrama became an important form of expression, helping to shape representations of the family and especially of the bourgeois family. The fallen woman, the prostitute, the helpless woman beleaguered in her chastity, the brutal, alcoholic, and philandering husband and father, and the cruelly abandoned child all inhabit the landscape of the nineteenth-century and early twentieth century domestic melodramas from the theater to the cinema. These figures represent various obstacles to family stability and testify to a preoccupation with the "domestic ideal" and its fragility. Jeffrey Weeks writes that "the domestic ideal and its attendant images became a vital organising factor in the development of middle-classness, and in the creation of a differentiated class identity. It became, indeed, an expression of class confidence, both against the immoral aristocracy, and against the masses, apparently denied the joys of family life and prone to sexual immodesty, and vice."[2] The ideology of the bourgeois family was built on the foundation of sex difference, and was ultimately construed, even if by way of negative comparisons, to apply to all classes.

Issues of legitimacy, paternal authority, subordination of women and children, and inheritance were inextricably bound to questions of sexual normality. The linking of social and economic concerns to the body and sexuality served to naturalize relations. Sexuality outside the prescribed demands of the family was an affront not only to the family but to the society at large. It was considered abnormal or unnatural, disreputable, and a violation of the order of things. To address the domestic threats, social institutions were harnessed to adjudicate and to inculcate "normal" definitions of femininity and masculinity for all members of the family, including children. Female sexuality, male libertinism or impotence, autoeroticism, and homosexuality were thought to belong to the realm of the unnatural or abnormal, and individuals were expected to resist these perversions in the name of health and sanity. The ideology was not total and uncontested; however, so-called perversions were an expression of resistance to the exclusive preoccupation with heterosexuality and reproduction.

World Wars I and II were to intensify the movement toward greater liberalization of sexual attitudes and social roles at the same time that they were to strengthen tendencies toward recuperating earlier ideals. The increasing popularization of Freudian ideas was to serve both as rein-

forcement for familialism and as a critical reaction to it, contributing to the growing demands for sexual liberation. The economic independence of women, their experience of doing "men's" work, their growing sexual freedom, the possibility of alternative forms of nurture, and the reality of divorce challenged, if they did not drastically alter, traditional notions of women's position. In spite of pressures for reform, no radical revolution in marriage and sexuality had taken place. The legislation produced and the economic support meted out were largely in the interests of maintaining the nuclear family and restricting women to the sphere of marriage, reproduction, and maternal nurture.[3] The ideology of the period as articulated in books and popular magazines presents an image of femininity and an emphasis on marital harmony that testify to the concerns about revitalizing the family.[4] As Weeks writes, "The aim was quite clearly to reconcile perceived sexual and emotional needs with the institutions of monogamous marriage, and to use the new practices of welfarism, official and voluntary, to further this aim."[5] These practices reveal both the existence of threats to the family and efforts to mitigate those threats.

The British cinema of the 1930s through the 1950s boasts a large share of films that portray the family as the bulwark of society, as a major force in the creation of a sound national character. However, these films are not mere mouthpieces for the status quo; they bear the marks of repression inescapable in representations of the family. Their family portraits are no more monolithic than the world of the audiences they seek to address. In spite of their efforts at legitimation, the films invariably reveal tensions and contradictions. Despite overt portraits of the legitimation of the patriarchal nuclear family, the emphasis on the need for self-discipline, restraint, service, hierarchy, and continuity, the melodramas entertain departures from prized conventions. In Reed's *Laburnum Grove* (1936), family harmony is linked to images of counterfeiting. In other films, such as *Wings of the Morning* (1937), family legitimacy is threatened by outsiders who must be either eliminated or assimilated. In *Poison Pen* (1939), the family is threatened by the thwarted desires of a seemingly benign "spinster."

These domestic melodramas, unlike their nineteenth-century predecessors, are less concerned with the effects of poverty on the integrity of the family than with the psychic and moral conflicts of the characters. As David Rodowick has stated, "The domestic melodrama is attentive only to those problems which concern the family's internal security and economy, and therefore considers its authority to be restricted to issues of private power and patriarchal right. The power it reserves for itself is limited to rights of inheritance and the legitimation of social and sexual identities in which it reproduces its own network of authority."[6] Thus, the narratives will focus on the struggle of patriarchal figures to maintain

their position and, correspondingly, women and young people who are torn between rebellion and submission. Physical and psychic violence are inevitable. In the case of issues of inheritance and legitimacy, the films will eliminate false claimants to authority, establishing proper transmission of the family name. In cases of patriarchal authoritarianism, the films will either convert or eliminate the offender, replacing him with a more benign paternal figure.

The opposition between generations, classes, and sexes is central to the family melodrama. Especially in the domestic melodramas that feature generational conflict, the point of contention will involve traditional values against emergent ones, a conflict between old and new. As Richard de Cordova states, "An old order, with its links to a feudal past, is replaced by a new order, the bourgeois family. These two orders are not placed in direct conflict in such a way that the transition between them could be considered a revolution, however. The conflict itself is instead located in the old order itself, in a familial drama which must, because of its feudal underpinnings, display the tensions and contradictions of class difference."[7] From *Anthony Adverse* (1936) to *Home from the Hill* (1959), Hollywood family melodramas have often configured threats to the legitimacy of the family through the introduction of an outsider of questionable ancestry: orphans, illegitimate children, or representatives of the working class. Their role is to rejuvenate the family or to destroy it. The British cinema of the 1940s, especially in the costume melodramas, offered an array of films that were preoccupied with family legitimacy, such as *A Place of One's Own* (1945), *Jassy* (1947), and *Blanche Fury* (1948). The catastrophes that beset the family are numerous—usurpers, obstructive father figures, wayward heirs to the family fortune, past crimes that come to light, and natural disasters. In these films, the outsider is often a female who restores the family fortune. The protagonist's values are contrasted with the values associated with aristocracy, and her actions serve to introduce middle-class morality into a decadent and moribund world.

The middle-class family is again presented as beleaguered in such films as *The Holly and the Ivy* (1952), where, again, the redeemer of the home is a woman. In *The Winslow Boy* (1948), the family is threatened by the law, but in this film the father is the agent of family recuperation. If the British cinema did not offer films comparable to the 1950s family melodramas of Douglas Sirk, Vincente Minnelli, and Nicholas Ray, it offered instead the social problem film (see Chapter 10), which combines melodrama and social realism but situates family conflict within the orbit of other social institutions, especially the courts and correctional institutions. More akin to such Hollywood films as *Knock on Any Door* (1949) and *The Asphalt Jungle* (1950), the British social problem film deploys criminality and marginality as a pretext to explore disaffected youth. The

family occupies a niche within these films but is rarely the prime focus of attention, even when the finger is pointed at it as a source of conflict and tension. The working-class family is dealt with somewhat differently. Usually it is presented in the comic genre, but there are instances in the 1940s and 1950s where the films combine melodrama with comedy to address generational and sexual conflict. *Holiday Camp* (1947) and *Here Come the Huggetts* (1948) demonstrate the thin line between domestic comedy and melodrama.

In the British family melodramas that foreground women, female conflicts, though evident, are redirected toward the maintenance of the domestic sphere. The issue of female autonomy, the struggle against the figures of authority and power, and the concern with female desire and sexuality are muted, and, rather than dramatizing a resistance to patriarchy, these family melodramas portray a resistance to illegitimate and destructive threats to the integrity of the family unit. The representation of females consists primarily of their struggle to reconcile love and marriage, to find a desirable and acceptable partner and restore the family. The protagonist's trials often entail, through her efforts, the conversion of an indifferent and hostile male to a caring and gentle mate; in some instances, the replacement of the brutal male with one who is more attuned to the need for familial harmony; and in others, his elimination through death.

The trials of the male protagonist are associated primarily with the father, often a forbidding paternal figure with whom the legitimate or illegitimate offspring must contend. Frequently, the female will assume the role of avenger in the unequal conflict between father and son, siding with the beleaguered son. Where the patriarchal figures are domineering and dominating, their male offspring may be severely damaged by the repressive environment and unable to command authority, in which case it is left to the next generation to offer the hope of renewal. The female becomes the agent in supplanting the usurper with another male or with a male child who will rejuvenate the family line. Not uncommonly, a woman of the lower classes who has married into the family may be the one who establishes a new lineage, though sometimes at the expense of her own life. In some narratives, the overpossessive and devouring maternal figure is the source of conflict. After a series of violent encounters, the threatening and arbitrary power of the repressive maternal figure is overthrown, usually through violence, through the intervention of the law, and, as in *Agamemnon*, through the avenging son.

The emphasis on guilt, revenge, and purification in the family melodrama has some affinity with the horror film. In his discussion of the American horror film, Robin Wood examines how the genre thrives on repression; his comments are equally applicable to family melodrama.

Following Freud and Herbert Marcuse, Wood begins by suggesting that the culture is built on surplus repression in the interests of alienated labor and the patriarchal family, and that sexual energy is at the basis of this repression: "The 'ideal' inhabitant of our culture will be the individual whose sexuality (creativity) is fulfilled in the totally non-creative and non-fulfilling labor (whether in factory or office) to which our society dooms the overwhelming majority of its members."[8] Along with the repression of sexual energy, Wood notes specifically the repression of bisexuality and of female and child sexuality, which serves to legitimize the relegation of women, children, members of other races, and workers to the realm of monstrosity and otherness. This otherness will emerge in the horror film in its various representations of monstrosity. In *Poison Pen* (1939), *Laburnum Grove* (1936), *Pink String and Sealing Wax* (1945), and *Blanche Fury* (1948), criminality is associated with a violation of family stability and the figures responsible for the violation are marked as outlaws or as psychically deformed. The landscape and settings in many of these films are also related to the horror film through the personification of the house and through the introduction of ghostly voices from the past, as in *A Place of One's Own* (1945).

In many instances, the symbolization of the home is central. Often the house is personified in ways similar to its personification in the Gothic melodrama. Visually, the external image of the house, the use of internal space, and the use of objects within the house are extensions of the psychological conflicts involving the characters' struggle for power. In *Blanche Fury*, the crest over the door seems to be leering back at the characters and at the audience. Hence it is not surprising that the house is perceived as the agent of threat, if not of actual destructiveness. Moreover, space is often fragmented, perceived from a number of different perspectives by the contending characters. The house serves not only to limit the action to the domestic sphere, but as a character within the fiction, signifying the conflicts and the secrets that are indicators of external threats to the family. In Gothic melodrama, the house is often a surrogate for the female body, with the woman imprisoned in a repressive environment from which she struggles to escape. However, in many of the family melodramas situated in the past or in a contemporary setting, the house is more benign, and the dominant concern is expelling the malignant forces that haunt the house and prevent it from being "a place of one's own." The house is the repository of secrets associated with past crimes of the family, which are expiated through ritualistic housecleaning. In general, objects are charged with meanings that far exceed their literal significance.

The difference between the woman's film and the family melodrama resides largely in the figuration of the house and of patriarchal authority.

In the woman's film, the protagonist is female and the conflict concerns her struggles to free herself from the oppressiveness of the house and from the domination of a patriarchal figure. She strives to live her life freed from the constraints and restrictions of her environment. Issues of legitimacy, family continuity, and the expulsion of the negative forces that position her in subordination are less important than her own struggle to realize her desire. In the family melodrama, the female is more likely the agent of purgation, of the expulsion of the destructive forces that threaten domestic stability. In the Gothic variants of the woman's film, the house may represent the negative forces that the female protagonist is seeking to escape. In the family melodrama, the house often represents tendencies toward conservation, the preservation of the values of family stability and continuity at the expense of female desire and individuation.

THE FAMILY MELODRAMA IN THE 1930s

The Counterfeit Family

The family melodrama was not a major genre until the 1940s with the advent of the Gainsborough melodramas. Films that portray family conflict are as likely as not to regard the family with some skepticism. For example, Carol Reed's *Laburnum Grove* (1936) portrays a seemingly respectable middle-class family that turns out to be disreputable, not only because the man of the house, George Radfern (Edmund Gwenn), has been involved in forging and counterfeiting activities which he has concealed from his family for years, but also because the members of his family are presented, each in his or her own way, as equally disreputable. The Radfern family consists of Bernard (Cedric Hardwicke) and Lucy Baxley, sponging relatives of George and Dorothy Radfern, the Radfern's daughter, Elsie (Victoria Hopper), and her manipulative boyfriend, Harold (Francis James), who, like the Baxleys, machinates to get money from George. Bernard and Harold both hope to get George to help them set up in business. Bernard talks nostalgically of his days in Singapore, inventing stories about his importance and success. Harold wants to marry Elsie, go into business, and escape the dreary life associated with suburban existance in Laburnum Grove. Like the house in Gothic melodrama, the suburban house in this film comes to symbolize familial discontent. George scornfully talks about Laburnum Grove as "clean, free of scandals, with no screams in the night." Yet in the same context he admits to the Baxleys and Harold that he is a forger and counterfeiter.

The remainder of the film develops the consequences of George's confession. At first it appears that he is merely making up the story in order to avoid honoring the requests for money. The film plays cat-and-mouse

not only with the characters but also with the external audience, with the idea that someone who looks and acts so respectable, lives within respectable surroundings, and endorses the values of suburban life could be corrupt. The film also exposes the police, the enforcers of the law, as inept in uncovering criminality. They too are misled by the appearance of respectability. Most importantly, the film explodes notions of family solidarity, mutual interest, altruism, and harmony. Bernard and Lucy Baxley's relationship is openly hostile. He spends his time in bars, inventing stories of past achievements. They quarrel over his lying and his failure. George's wife is totally unaware of her husband's dual existence and calls him "a nice sleepy thing," a phrase not devoid of sexual significance. The daughter is portrayed as incapable of judging character, though she displays concern about the possibility of her father's fate as a criminal. She refuses at first to believe that Harold is only interested in her father's money but, with her mother's help, finally learns the truth. Bernard and Lucy leave the house in a rage, pretending outrage at George's criminality.

In its treatment of the inhabitants of Laburnum Grove—beginning with the church and ending with the police—the film probes the connection between money and suburban life, especially as the drive for money becomes the vehicle for cementing the relationships in the middle-class family and also the vehicle for breaking up the family. George's criminality as a forger and counterfeiter is the metaphor for the counterfeit quality of familial and social relationships in the community. Significantly, he and his wife are portrayed as the least concerned about his criminal activities, experiencing very little guilt over his transgressions. The characters who suffer the most guilt are suffering it less on George's account than on their own. While they are unable to recognize the counterfeit nature of their lives, they are able to experience guilt, finding themselves hounded by police even in imaginary situations. The relationships are more counterfeit than the money, and it is George's crime of counterfeiting that exposes their fraudulent lives. Instead of singling out either the male or female as obstructions to family solidarity, the film focuses on the family constellation, undermining all of the domestic roles and suggesting that none of them is sufficient to overcome the guilt, rage, and preoccupation with money that middle-class family life generates. The image of counterfeiting also has a more profound meaning in relation to the couples in the film. In each instance, their energy is consumed by the concern over illegality and hardly at all by the quality of familial relationships, none of which is portrayed as even minimally satisfactory.

Family and Heredity

Wings of the Morning (1937), Britain's first Technicolor film, has earned the reputation of a "pleasantly improbable romance."[9] On closer inspection, however, the film is not quite so pleasant nor improbable. It is con-

structed on pervasive attitudes in the Western family, particularly those relating to bloodlines and notions of succession. In discussing the evolution of the bourgeois family, Michel Foucault contrasts the aristocratic emphasis on ancestry and alliances through bloodlines to preserve its power and succession to bourgeois patterns of continuity. For the bourgeoisie, "'blood' was its sex. . . . The concern with genealogy became a preoccupation with heredity; but included in bourgeois marriages were not only economic imperatives and the rules of social homogeneity, not only the promises of inheritance, but the menaces of heredity."[10] The fear of family tainting was counteracted by the insistence on an "indefinite extension of strength, vigor, health, and life."[11] *Wings of the Morning* exemplifies these attitudes. In this film, the Gypsies who haunt the English landscape in literature and film melodrama are signifiers of vitality, associated with horses and with the question of mixed blood and family legitimacy.

The earl of Clontarf (Leslie Banks) meets and falls in love with a beautiful Gypsy woman, Maria (Annabella). He promises to protect the rights of the Gypsies on his land, and he brings her to his ancestral home, where she is received coldly by all except the lord's young cousin, Valentine. The lord is killed when he falls from a horse, and Maria is sent from the house, penniless and pregnant. An old Gypsy woman places the curse on Maria, saying, "You have cursed three generations. Mixed blood with blue blood can hurt much." By the fourth generation, the blood will be pure again, and Maria vows that no generation of hers will ever know the sadness of this place until that time comes. Thus an equation is made between miscegenation and the death of Lord Clontarf. The film moves ahead fifty years to Spain and to the great-granddaughter of Clontarf (Annabella), who is engaged to a Spanish nobleman. Maria, now an old woman (Irene Vanbrugh), complains of the Spanish Civil War, calling it a "mob revolution," which has destroyed her small fortune and her hopes for a fourth generation in Spain. She decides to return to Ireland to Destiny Bay, the haven for the Gypsies promised by Lord Clontarf. Her granddaughter, Maria (Annabella), disguised as a young boy, escapes to Ireland and joins her great-grandmother. In Ireland, she meets Kerry Gilfallen (Henry Fonda), a Canadian, nephew of Sir Valentine, and trades Wings, who was being trained as a racehorse by the older woman to win a dowry for her great-granddaughter, for several of his horses, thinking she is driving a hard bargain. When she returns to the camp, Maria tells her angrily, "And to you I looked for a fourth generation." Maria and Kerry fall in love, and after the race, in which Wings rides to victory, they are finally united.

The element of family purity is stressed in relation to the Clontarfs and to the Gypsies. Like the aristocrats, the elder Maria also endorses the idea of pure blood, selecting the younger Maria as the instrument to atone for

the miscegenation of Clontarf. The intimate connection between thoroughbred horses and thoroughbred females is established in several ways. When Clontarf first comes to the Gypsy camp and stops the Irish Constabulary from harassing the Gypsies, he sees Maria and appears to comment on her beauty, but it turns out that he is commenting on a horse that the Gypsies are about to sell. Later, when Kerry sees Wings, he remarks, "What a beautiful pair of eyes," as if he were talking about a woman. Maria's honor and fate are linked to the horse, which brings her and Kerry together. The horse serves as an indicator of breeding. In its emphasis on breeding and on an upper-class milieu, the film seems to espouse an upper-class ethos, and yet in the disciplining of Maria, seems finally to place greater value on family conformity and female subordination. Like many of the family melodramas that portray the union of the upper with the middle or lower classes, the emphasis rests on the bourgeoisification of the family as represented by Maria's marriage to Kerry.

The film presents the Gypsy women as more generous, beautiful, and sexual than the upper-class women, who are portrayed as snobbish and cruel. In order to domesticate the woman, the film puts the younger Maria through a series of trials, including that of male impersonation, before she can be pure enough to marry into the Clontarf family. The negative characters in the film are presented as lacking in breeding. The elder Maria is more class-conscious than her noble husband, recognizing that she does not belong on the estate, making no claims to the title, and vowing to return the line to pure blood once again. The Spanish Civil War is alluded to, but only in the context of Maria's complaints about the destruction of property and the burning of churches. The film itself, though situated in Ireland and concerned with the Irish nobility, makes no reference to Irish history or to the ways in which the Clontarf title was established. Ireland, like the realm of the Gypsies who inhabit Destiny Bay, is a land of fantasy. The narrative inverts the usual pattern of the dispossessed male claimant to the family estate, since it involves a female masquerading as a male and eventually being restored to her gender and sexuality through marriage. The motif of Gypsy aristocracy is the film's way of assimilating exceptional outsiders. The film is unambiguous in its emphasis on the importance of breeding and purity of bloodline in terms of family honor and fortune. Though *Wings of the Morning* focuses on the aristocracy, as do many of the costume and Gothic melodramas, the ideology of these films is geared toward the bourgeois family with an emphasis on the young people who redeem the honor of the house. Unlike in the Gothic melodramas, the house itself is not presented as threatening. Rather, the conflict arises from alien characters who enter the house and must be purified in order to protect the family.

By the late 1930s, with the new quota legislation, the film industry undertook to raise the quality and quantity of British production, and

Paul Stein's *Poison Pen* (1939) is indicative of improved production standards. The film does not merely reproduce traditional family values but exposes their constraints, especially in relation to women. The effectiveness of the film is due in large part to Flora Robson's performance as enraged spinster Mary Rider, sister to the vicar and a model of service and respectability in the community. When a rash of poison pen letters occurs accusing individuals in the town of sexual transgressions, she seems above suspicion. Her guilt is obvious only to the external audience in Mary's overly critical attitude toward her niece Ann's (Ann Todd) relationship to two young men, Peter (Cyril Chamberlain) and David (Geoffrey Toone). These men are the first to get the poison pen letters. Then more letters begin to appear. Connie Fately (Catherine Lacey) is driven to suicide over the allegations that she is the writer of the letters, and Sam Hurrin (Robert Newton) is driven to kill a shopkeeper, Len Griffin (Edward Chapman), whom the letters charge with having an illicit relationship with Hurrin's wife. This film exemplifies the frequent convergence of melodrama and horror. Like the horror film, *Poison Pen* creates a dual vision of the community. The vision of normalcy is represented by the vicar's family and the religious congregation. The "viper" in the bosom of the family, the spinster, is the "unnatural" female who poisons both the family and the community and must be eliminated.

All of the poison pen notes accuse the recipients of sexual infidelity. Not only are relationships threatened, but the community is transformed into a hostile environment where no one can be trusted. Ann quarrels with her fiancé, and her relationship with him is almost wrecked. The Hurrins' marriage is destroyed. The vicar tries to appeal to the community to be rational, totally unaware of the conflict within his own family. The police bring in a handwriting expert who identifies the letters as the work of a woman in her forties, educated, unhappily married or unmarried. While the spectator is put in the position of superior knowledge and already suspects Mary as the culprit, the narrative portrays the family as unsuspecting. Eventually the police identify Mary as the perpetrator of the letters through the old-fashioned pen that she uses to write them. In her confession to her brother she complains that she helped everyone year after year, but the children she helped were never hers. She has nothing and no one to care for, and she experiences an "aching emptiness." She turns on the vicar and tells him that she hated his pious drivel. Ann was all that she had, and she could not give her up. As her brother conducts a service in the church, she runs off and jumps from a cliff to her death.

Like *Laburnum Grove*, *Poison Pen* unmasks the myth of harmonious family life and service to others—but it does more. Mary's poison pen becomes her instrument of power, and Flora Robson's portrayal intensifies the pathos of a woman who is placed in the familiar position of figure of nurture but reacts to that position with resentment and rage. The pen

becomes the signifier of her displaced sexual desires. The phallic instrument functions as a means to retain Ann, her substitute child. That the head of a family is a religious figure only reinforces the traditional equation of women with religion and service, an equation that serves to keep them in a position of invisibility. Her letters expose familial conflict not only in her own home but in the homes of others as well. On the one hand, what is recapitulated is the familiar image of the unmarried woman as a souce of defilement and disruption in the home and the community. On the other hand, the film also portrays the woman's sense of powerlessness and her desperate attempt to hold onto her niece and, as she says, "the way things used to be."

The preoccupation of the letters with sexual matters points to a familiar assessment of the unmarried woman as sexually frustrated. Her poison pen letters also expose the "secrets" of the community and portray sexuality as a powder keg ready to ignite. The contrast between her vindictiveness and the vicar's moral purity only underlines her sense of isolation as well as the hypocrisy of village life. She serves as a vehicle to convey the disaffections of others, though the full weight of opprobrium is finally laid at her doorstep. Her own brother describes her as deranged. The clear-cut moral antitheses of the film do not allow for expressions of sympathy toward Mary even by members of her own family, but the text does portray the vicar as well as other villagers as polarized between the extremes of piety and rage, suffering themselves from the disease that her letters have exposed—sexual repression. Mary's figure is a variant on the destructive maternal figure, though in this case, maternal desires are thwarted and displaced onto other members of the family and of the community. Her expulsion from the home represents a double punishment. She is punished for being a spinster and for wrongly coveting the maternal role. She is also punished for reminding others of their own thwarted desires and familial discontents. In Robin Wood's terms, the female comes to be marginalized as the Other whose sexual desires are disruptive of "normal" domestic life.

WORLD WAR II AND FAMILY MELODRAMAS

Home Front Films

With the coming of World War II, the cinema began to place greater emphasis on working-class experiences and characters, especially in the context of the family. The ideology of familialism was central to the attempt to create a sense of unity and continuity. The preoccupation with the family served also to address social, economic, and sexual changes, but in personal rather than purely polemic terms. Family discourse could

be mobilized so as to divert attention away from issues of class inequities and power. It was possible now to entertain working-class subjects in a climate which encouraged populist rhetoric as a means of neutralizing social and sexual difference in the interests of a common goal. A film script that had been vetoed by the censor in the 1930s on account of its treatment of working-class discontents could finally be produced. *Love on the Dole* (1941), based on the novel by Walter Greenwood and directed by John Baxter, was passed by the British Board of Film Censors during the war.[12] Starring Deborah Kerr as Sally Hardcastle, the film portrays life during the Depression years and its effects on the family and community. The family is portrayed as economically oppressed when the father and son lose their jobs; and with the cutting of the dole the Hardcastle family enters very hard times. Sally wants to marry a fiery radical orator, Larry (Clifford Evans), but he is concerned about the feasibility of marriage on the dole, and she offers to live with him out of wedlock, telling him, "They can take away our jobs but not our love." Larry is subsequently killed in a demonstration. Sally's brother, Harry, begins to see a young woman, Helen (Joyce Howard), and when he wins money in a lottery takes her to Blackpool for a vacation, where they make plans to marry and have a family. Family relations in the Hardcastle home begin to deteriorate when Mr. Hardcastle refuses to allow Harry to bring Helen into the house after Harry reveals her pregnancy.

Helen and Harry go to stay in a rooming house, where she delivers her baby. After the delivery, the couple is told to leave. Unable to tolerate the bleakness of her family life or the grim effects of unemployment, Sally finally accepts the advances of a bookie, Sam Grundy (Frank Cellier), agreeing to move into his home as his "housekeeper." She returns to visit her family dressed in expensive clothes and furs. The women in the community, who act collectively throughout the film as a chorus commenting on the affairs of the community, are divided in their moral judgments of her behavior. Her mother is upset, lamenting, "We've always been respectable." Sally says that she is not ashamed, and one of the women comments, "You'd be a damned fool if you was." She talks of marriage as "a seven-days-a-week job with no pay." When Mr. Hardcastle arrives home, he tells Sally that she is not fit to be his daughter. Sally defies him, insisting she is not worried about what other people say. She asks him to look at her mother: "No man in the world could get me to look like that." The bitter conflict over economic necessity and familial respectability ends with an epilogue praising the magnificent response of working-class men and women to the war. Their reward must surely be a new Britain.

Through the familiar formulas of the embattled family, the out-of-wedlock pregnancy, prostitution, and the underworld, and making the female the violator of respectability, the film adopts traditional melodra-

matic devices to convey its social concerns. The concern with respectabil-
ity outweighs collective concerns; the film thus seems to suggest that fa-
milial conflict is the most heinous effect of prevailing social conditions.
Hardcastle is presented as rigid in his morality to the point of turning his
back on his own offspring. Nonetheless, his behavior serves to under-
score the connection between economic deprivation and family conflict,
and also to introduce another aspect of love on the dole, namely, that it
is governed also by sexual conflict. In Sally's defiance of her father, how-
ever, and in her decision to survive with Grundy rather than live a life of
martyrdom, the film does depart from the typical solution of the death of
the woman who has chosen to live an "immoral" life outside the family.

Love on the Dole offers an integrated view of family life and working-
class economic conditions. It focuses on the intraclass conflict of the
workers as, in their desperation, they prey upon each other. The film's
flirtation with social critique and with socialism is mystified in its preoc-
cupation with the immediate familial consequences of love on the dole.
The emphasis on morality and sentiment neutralizes the insoluble con-
flicts that the film poses, although it does not totally eradicate the pathos
of unemployment and life on the dole. The tacked-on patriotic ending
suggesting a "new Britain" where "never again must the unemployed be-
come the forgotten men of peace" provides a critical comment on society.
The events portrayed in the film are thus relegated to history. As one critic
remarks, "A heroine driven by poverty into prostitution, proved unac-
ceptable to the BBFC until 1941, when its anguished message about the
evil effects of unemployment had become redundant."[13]

The wartime family melodrama connected the family to the larger
community and the community to the nation. For example, in David
Lean's Technicolor film *This Happy Breed* (1944), which takes as its sub-
ject the lives of a working-class family during the interwar years from
1919 to 1939, the family, though presented as the site of conflict, is also
seen as the backbone of the nation. This family drama interweaves histor-
ical events with specific changes and personal tensions within the family.
The house itself is foregrounded visually and psychologically. The film
opens with Frank and Ethel Gibbons (Robert Newton and Celia Johnson)
moving into a new house with their children and Ethel's mother and sis-
ter. At the outset, the camera moves slowly from the London skyline to
the Gibbons house and into the private realm of the family, enunciating
the film's retreat from the external sphere toward the inner life of the
family. At the end of the film, the same shot is seen in reverse, moving
from the empty house back to the skyline.

The film follows the marriage of the son, Reg (John Blythe), and the
recalcitrance of the daughter, Queenie (Kay Walsh), who becomes in-
volved with a married man and experiences her mother's rejection but

finally returns home to marry Billy (John Mills), the son of a long-standing family friend (Stanley Holloway). The mother's complaints are part of the domestic landscape, as are the conflicts between the mother and her unmarried daughter. Tragedy also strikes the family through the loss of the Gibbons' son in an automobile accident. Later, Ethel's mother and sister die, diminishing the family further. These events undercut the film's ostensible project of presenting the family as an untroubled oasis, highlighting instead the contingent and fragile nature of family ties. In its characterizations, its metonymic identification of the house with the nation, its emphasis on historical continuity, its montage sequences which interweave historical events with the passage of time for the family, the film strives to present an image of unity in the face of hardship and disappointment. This treatment is predictable in a film produced during wartime when populist ideology was increasingly gaining importance and credibility, but by concentrating on those events that signify conflict and loss, the film exposes the tenuousness of consensus.

In its attempt to integrate the public and private spheres, the film interweaves domestic scenes with montage sequences of public events. Furthermore, the bitter memory of World War I is central to Frank Gibbons' character; however opposed he is to war, he comes around to accepting the inevitability of the coming conflict, speaking harshly of "appeasers" like Chamberlain. Politics are introduced in the figure of Sam Leadbitter, who utters militant socialist ideas annoying to the conservative Ethel. He then settles down, and, as Queenie says, "now that Sam is married, he's like everyone else, respectable." The character of Sam is an index to the film's attempts to water down political ideas. His political transformation is consonant with the film's supplanting of politics and history with domestic life. The montage sequences and the articulation of political sentiments by the characters, rather than merging public politics and the family, create a sense of tension between the public and the private.

This Happy Breed inscribes generational and class differences within a context of naturalness and inevitability by emphasizing childbirth, care of the elderly, deaths in the family, and reconciliation of personal differences. The notion of sameness within difference is central. Things end where they begin. While there are deaths, there are also births. Even the idea of war assumes a natural rhythm as the important notions of serving the nation and doing one's duty are invoked. The iconography of the characters also reinforces the notion of the representativeness and ordinariness of this family. The Gibbons family is meant to project decency, normalcy, and endurance. Commenting on the film's point of view, Andrew Higson states that the film's ideology is rooted in a conception of family stability: "By placing the family and the home firmly in the centre

of the narrative, the film effectively erases class as an issue or a problem, while reaffirming the 'ordinary man's' deference to, if at times slight unease with, the traditional forms of political power. At the same time, it reaffirms woman's place within the domestic sphere, her role being to transform house into home—which is precisely what we see Mrs. Gibbons and the other women doing throughout the film."[14] However, while the film seeks to project this image, it is clear that it also subverts it, if unintentionally. The domestic world portrayed in the film is no more secure than the external world alluded to in the montage sequences.

A closely related film, *Waterloo Road* (1945), directed by Sidney Gilliat, is also set in wartime, and, like the Lean film, focuses on potential threats to family stability, threats closely linked to female sexuality. But, in contrast to the claustrophobia of *This Happy Breed*, which keeps the characters confined to the family home, *Waterloo Road*, as its title suggests, moves outside the home to encompass other elements of community life. The physician, Dr. Montgomery (Alastair Sim)—a familiar figure in family melodrama—serves as the symbolic agent of community health and regeneration. According to Gilliat, " 'His [Sim's] part was based on what they used to call the penny doctors, who might live in a place like the New Cut, and, in the days before the National Health Service, would charge little or nothing for their services and have that reputation that the village cobbler had of being the local philosopher'."[15]

The film has been described as one of the most critically successful of the populist films produced during the 1940s.[16] The narrative focuses on the deprivations and emotional conflicts of a working-class family during wartime. Structured around a flashback (which Gilliat felt turned out to be unnecessary), the events are narrated by the physician. The camera follows as he walks through the rubble and talks of the battle waged with the bombs, but also of the personal battles of people in the neighborhood such as those of Jim and Tillie Colter (John Mills and Joy Shelton). Conflict is generated when Tillie, living with Jim's parents in overcrowded conditions while he is away on military service, becomes bored and impatient and takes up with Ted Purvis (Stewart Granger), a draft-dodger, womanizer, and small-time racketeer. On their honeymoon, Jim and Tillie argue about her desire to have a home and family of her own. She wants to start a family immediately, while Jim is more cautious, urging her to wait. Tillie's attraction to Ted is thus linked to her reaction to the deprivations of wartime. When Jim learns of Tillie's relationship with Ted, Jim goes AWOL in order to come home and settle affairs. With the help of the doctor, he arrives just in time to save Tillie from being seduced by Ted, by vilifying Ted and giving him a sound drubbing. The film ends with the doctor visiting Tillie and her baby boy. He tells her not to coddle the baby: "The more they are coddled, the more they cry, a vicious circle

that probably explains Hitler." He tells her that the boy will be a good citizen if she follows his advice, and that the country will need millions of such citizens. His final words are to the child: "My boy, you're the future." The ending of *Waterloo Road* illuminates the film. The stress is on discipline, the responsibilities of motherhood, and the importance of youth for the future. As with the documentary *A Diary for Timothy* (1945), the film ends with a question mark but also an expressed hope for the future. The film identifies the working-class family as the backbone of England, and, while dramatizing their fatigue from the war, also legitimates their sacrifices. Jim's French leave is treated positively in the context of his defending his country by defending his family.

Jim and Tillie Colter, who will bring children into the postwar society, are representative of the generation that must provide proper morals and settled family life for the next generation. Tillie's flirtation with Ted is thus traced to her lack of a child and a home of her own, and the film provides her with a family—a baby boy—to ward off her threatening promiscuity. The film divides its concerns between the male and female characters. The female characters are restored to home and motherhood, the male characters to familial and social responsibility. According to Christine Gledhill and Gillian Swanson, the film's ideological project concerns "the male both coming to understand his role inside the family and correctly disposing of his patriarchal power in relation to this role . . . in an actual war there is no room for the sexual impairment which seems to ground the expression of masculinity as virility in heroic fiction."[17] In order to ensure stability and continuity, the draft-dodger and sexually promiscuous Ted must be constrained and Jim must be disciplined into a sense of familial responsibility. His taking French leave is justified in the context of the imperative to bolster morale on the home front, to diminish threats to domestic stability.

The film also portrays other changes in the social environment. Canadians and Americans are now part of the landscape. The figure of Ted, in particular, assumes a prominence that is indicative of the changing landscape in society and in the cinema. Robert Murphy comments on how "one might expect that the development of a community spirit—and the conscription of large numbers of criminals—would result in a fall in the crime rate. But war conditions created their own opportunities for crime. Bombing raids left shops and homes open to the elements, and looting was more of a problem than the authorities were prepared to admit. Black market activity was a thorn in the side of the government from the beginning of the war."[18] In the cinema, too, a rise in the number of crime films was evident. Stewart Granger's role in *Waterloo Road* was a harbinger of a newfound interest in the underworld. Ted Purvis is a creation of the war and another reminder that the uncertain future that Dr. Montgomery

talks about will contain such characters. However, Ted's black marketing activities seem to be less dangerous than his roving eye, and it is for his promiscuity that he is finally punished.

The Ghost in the House

Many of the 1940s films produced during the war and after raise the question of whether the postwar world will return to prewar values and attitudes, and, in this context, the issue of the nuclear family becomes crucial. The traditional roles of women in reproduction, nurture, and family stability, and the roles of men as breadwinners and figures of authority, are invoked in an effort to salvage the past. The costume melodramas, with their emphasis on family and their regression to the past, corroborate the preoccupation with changes that particularly involve domestic conflict. These films are not so much regressions to the past as they are utilizers of the past to raise questions about the present, and in many of the melodramas, the idea of repetition is juxtaposed to the notion of difference and change. Gainsborough's *A Place of One's Own* (1945), directed by Bernard Knowles, is set in a contemporary context, but the film addresses the terror of repeating the past, a familiar concern in family melodrama. The film stars James Mason as a retired businessman, Smedhurst, who desires to live in rural comfort and buys his dream house. Upon the arrival of a young woman, Annette (Margaret Lockwood), whom Mrs. Smedhurst (Barbara Mullen) has hired as a companion, the couple learns that the house is haunted. The female ghost has designs on Annette, the vehicle through which the dead woman seeking her lover speaks. The ghost is identified by Smedhurst and exorcised, enabling Annette to a marry a young doctor, Selbie (Dennis Price), from the community.

In its focus on the haunted house, the film recalls such Gothic melodramas as Alfred Hitchcock's *Rebecca* (1940) and Mario Soldati's *Malombra* (1942), which feature an absent woman whose presence must be exorcised from the house if the house is to be saved from destruction. The house is most often regarded as female, signifying particularly the entrapment of the female body and voice. Smedhurst's wife is aware of the ghost long before her husband, who scorns her supernatural explanations. She claims that every house contains something of all the people that have lived in it and is the repository of family secrets. The film uncovers these secrets through a reenactment of the past. The history of the house includes the death of a young woman who was the victim of her father's power. Her father is accused of having turned her into an invalid, denying her a relationship with the man she loved. Annette begins to take on the identity and voice of the dead woman, and she also becomes, like the dead woman, physically incapacitated, a classic case of hysteria. No physical doctor is able to treat her ailment, and only with Smedhurst's sleuthing is

the mystery solved. The ghostly lover returns to free the house of the entrapped female.

The piano is the predictable instrument through which the dead communicate with the living. The ghost does not speak directly, but through playing the piano Annette assumes the voice of the past. Later she assumes the dead woman's illness. Through the actions of the bad father who has silenced his daughter, *A Place of One's Own* dramatizes the problem of women's identity in patriarchy. The good father, Smedhurst, is able to exorcise the ghost of the tyrannical father and his victimized daughter. The house thus presents the crushing weight of the past, which must be exorcised in order to make room for new life. The new life centers on a redefinition of parental and conjugal roles. Annette, who comes to the family like an orphan, acquires parents who guide her to a proper relationship with her doctor-fiancé. In *A Place of One's Own*, the metaphor of illness is important in the saving of the female protagonist. The apparition of the ghostly physician who was unable to heal the tyrannized daughter frees Annette to become the wife of yet another physician. Illness is thus associated with entrapment in the past, and healing with the escape from its claims. The reconstitution of the family is dependent on a therapeutic approach. Unlike the woman's film, which it appears to resemble, this family melodrama, which appears to focus on a female protagonist, is actually the drama of a male, seeking a place of his own and having to silence unsettled and unsettling female voices that haunt his house. Underlying the film is a darker nightmare world which speaks of unfulfilled desire.[19]

Paternal Tyrants

The paternal figure in the family melodrama alternates between the image of a father who seeks absolute authority over his offspring and one whose weakness is responsible for family conflict and competition. Robert Hamer's *Pink String and Sealing Wax* (1945) features a tyrannical father and dramatizes the consequences of his rigidity. The film opens in a newspaper office as the editor talks of Mrs. Hilda Jackson's poisoning of her husband, anticipating the subsequent poisoning by another woman of her overbearing husband. Edward Sutton (Mervyn Johns), a chemist, is appointed to the case as a chemical analyst. A self-righteous and rigidly moral man, a strict lawgiver in his family, he refuses to allow his talented daughter, Victoria (Jean Ireland), to embark on a musical career. He is abusive and humiliating to his son, David (Gordon Jackson), who writes poetry to a young woman of a respectable family. Sutton is adamant in refusing his daughter, Peggy (Sally Ann Howes), permission to give food to some guinea pigs on which he intends to experiment. He terrorizes his wife until she defies him, reminding him that although his father was a harsh man, that is no reason for him to treat his children harshly. The

children subvert his commands in differing degrees, but the most threat-
ening subordination is from his son.

In his dejection, David wanders into a local bar, where he meets Pearl
(Googie Withers). She is married to an abusive alcoholic and is having an
adulterous relationship with a man, Dan (John Carol), who is looking for
a woman with money. When David finds her bleeding from her hus-
band's ill treatment, he takes her to the chemist shop to tend her wounds.
When he leaves the room for a moment, she steals some strichnine, takes
it home, and kills her husband in the hope of now being able to form a
permanent relationship with Dan. When the police begin to uncover in-
consistencies in her testimony, she blames David for the crime. The elder
Sutton comes to see her and to confront her with the truth, threatening
her with exposure. Realizing that she has lost Dan, she commits suicide.
The film ends as it began, in the newspaper office as the editor talks of the
week's highlights among which figure David's marriage to Mary, the
daughter of Sir George Truscott, and a concert given by Miss Victoria
Sutton. The father's image is restored as he defends his son against the
false accusations. The "happy" ending of the film sits uncomfortably
with the bulk of the narrative, which is devoted largely to the brutality of
family life at the hands of two abusive and tyrannical male figures. The
extended scenes in the Sutton house in which the father lays down the law
and causes anguish for the rest of the family and the scenes depicting
Pearl's rough and physically brutal husband (Garry Marsh) are an un-
qualified critique of family life in both the middle and working classes.

While the film focuses on Pearl's manipulation of David and her mur-
der of her husband, she is not the central narrative preoccupation, though
she is important as the vehicle for the father's conversion. From the early
reference in the newspaper office to the woman who poisoned her hus-
band, to the other women in the film—Sutton's wife and daughters, the
alcoholic Miss Porter (Catherine Lacey), and Pearl—women are por-
trayed as victims of men. The postwar preoccupation with female repres-
siveness, if not malevolence, is tempered and subordinated to the focus on
the domestic tyranny of the male. For all of her machinations and even
her murder of her husband, Pearl remains a pathetic figure, a victim of the
various men who treat her badly. Similarly, the women in the Sutton fam-
ily are portrayed sympathetically as they undermine their father's power.

Significantly, the name of Charlotte Brontë's Mr. Rochester is evoked
in connection with Victoria's suitor, John, who wants, like the literary
character, to be more masterful, attributing his lack of success with Victo-
ria to his lack of assertiveness. The issue of male authority is also drama-
tized in the relationship between father and son. In his desperation to
escape his father's restrictions, David seeks out Pearl and persists in a
self-destructive relationship with her. The focal point of the film is the
father.[20] In its presentation of paternal authority, the film distinguishes

between authority and tyranny in the conversion of Sutton. As regards women, the film seems to suggest the potential malevolence of women, but attributes this to their oppression at the hands of men. The concern with establishing a balance of power between men and women seems consistent with much of the literature and film of the late 1940s and with its preoccupation with renovating marriage through the redefinition of centers of power. The resolution of the family conflict is ambiguous. The father's conversion, the elimination of Pearl from the narrative through her suicide, and the marriages of both daughters is unbalanced by the aggression and vindictiveness which characterize family relationships. "The happy ending," says Barr, "is very equivocal. Like *Dead of Night*, the film has conjured up a world of violence and sexuality with which the respectable characters simply can't come to terms."[21] Like many of the 1940s films, *Pink String and Sealing Wax* raises the question of altered familial relations. The Victorian paterfamilias has given way to a more democratic portrait of power in the family, but underlying this benevolent resolution is a darker image of family violence and sexual repression, especially as represented by David's relationship to Pearl and her relationship to her husband.

POSTWAR FAMILY MELODRAMAS

As in the United States, postwar representations of the family in Britain were inflected by publicly articulated concerns about the future of the family. The wartime declining birthrate, and the officially expressed need to strengthen the family, led to a series of legal and social practices designed to increase the population and to provide a psychosocial climate that would encourage reproduction and familial responsibility. According to Weeks, "The creation of a Welfare State in the 1940s, based, however tenuously, on an ideology of social (and even sexual) reconciliation, inevitably involved a major reassessment of the whole field of sexuality."[22] Measures like the Beveridge Report in 1942, the Curtis Committee on Children in Care (1949), and the Population Commission (1949) testify to the state's intervention in the arena of domestic life. It is therefore not surprising that the cinema should have found the family a challenging subject, exploring such themes as disruptions to the family by the return of men from the service, the threat of divorce, the plight of the neglected child, and the effects of female independence.

The Returning Serviceman

In an upper-class setting, Compton Bennett's *The Years Between* (1946) explores the disruption of family life, first by the loss of the man of the house and then later by his unexpected return. Bennett is most often asso-

ciated with Gainsborough melodramas such as the highly successful *Madonna of the Seven Moons* (1944), *The Seventh Veil* (1945), and *Daybreak* (1946). Raymond Durgnat finds *The Years Between* to be one of the "interesting weirdies, in the Joan Crawford class."[23] Durgnat's cryptic labeling identifies the film as a melodrama and suggests the film's affinity with the highly stylized portrayals associated with Joan Crawford in such melodramas as *Daisy Kenyon*, in which personal relationships are tortured and convoluted. Following the formulas of the family melodrama, *The Years Between* poses conflict in terms of a collision between the old and the new and finds its path through compromise between the two.

The film concerns the reported death of Michael Wentworth (Michael Redgrave) and his wife Diana's (Valerie Hobson) attempt to construct a life without him, including running for his parliamentary seat at the urging of her friends and family. He returns from the war, having spent his time in a prisoner-of-war camp, and attempts to resume his prewar life, only to find that his wife is engaged to another man and that she has taken over his political activities. Though the film portrays her successfully undertaking political work with dedication and intelligence, Michael disparages her successes, saying that her winning an election was due to "widow's weeds. Sob stuff." Moreover, he says, he wants to have the "wife he left behind," and asks her if she'll mind giving everything up. He claims that the servicemen need to come back to the life they knew. Diana counters with "Life is different," and tells him that she has an important job to do, to which he curtly retorts, "Mine." His stance appears rigid and uncompromising. Diana's grievance becomes focused on the years of silence rather than on his demand to return to the status quo of their former married life. His explanation for withholding knowledge from her is military orders. They decide to separate, and Nanny (Flora Robson) intervenes, asking them what they will do about their son. She recounts her own history, informing them that the man she was to marry was killed in World War I, and that there are hundreds of women like her whose men will not be coming back. "The point," she tells them, "is that someone's got to start a little give and take." Quoting the prime minister, she says that nations have to collaborate and so do individuals. There is peace in the world, but if Michael and Diana are any example, "We've lost the peace." The final scene shows Michael back in the House of Commons with Diana in the gallery.

While refusing the solution of having the couple go their separate ways and advocating a course of compromise, the film dramatizes domestic conflicts in the immediate postwar period. In the character of Diana, the issue of women's competence in traditionally male positions is presented directly, and in Diana's speeches, such issues as women's rights, child care, and work are presented. The film also portrays, in undiluted fash-

ion, the perceived threat of the competition between men and women for positions of responsibility. Michael's assumption of his right to his parliamentary seat and his desire for the return to traditional family life are portrayed unambiguously as conflicting with the new life created by Diana.

In the first part of the film, with the flashback to the early years of their married life, Diana, through a reading in voice-over from her diary, presents herself as centering her life around Michael through childbearing and assisting him in his bid for Parliament. The images are of her, with only a rear shot of Michael facing her, as if to suggest that she is a mirror for his words and actions. His silence about his capture, as if no words were necessary between married people, represents unspoken expectations about marriage that will haunt the text. And it is his silence that she comes most to resent. Finally, she herself is reduced to silence after having experienced an active life. The film reveals that the postwar period is not the harbinger of a totally new society, since old obligations and demands have reasserted themselves.[24] Nanny, the faithful family retainer and link to the past, articulates the view that the "new life" is a matter of adjustments and compromises in an attempt to preserve the family. Nanny's strategy of generating guilt in the name of the men who have died in both wars and in the name of women who, like her, must accept that loss, serves to situate domestic harmony and stability in a familiar context of sacrifice.

Family Dissolution

Brian Desmond Hurst's costume melodrama *Hungry Hill* (1947), based on a Daphne du Maurier novel and produced by Two Cities Films, is more aggressive and critical in its treatment of the issue of family and social class than many of the films of the time. The film is set in Ireland, where an adamant and controlling English landlord, John Brodrick (Cecil Parker), is determined to sink a copper mine in Hungry Hill. He clashes with a villager, old Donovan, who prophecies trouble and sorrow if Brodrick persists, telling him that there will be struggle over the Irish land, for "the land belongs to us." In his family, Brodrick is also domineering, refusing to listen to similar warnings from his son, Greyhound John (Dennis Price). Trouble breaks out in the mine, and the favorite son of Brodrick is killed in the melee. Greyhound John goes off to London to study law but is convinced to return to Ireland by his younger sister, and, after a stormy courtship, he marries Fanny Ross (Margaret Lockwood). She becomes an exemplary wife, even reconciling John to his father.

Conflicts at the mine continue to escalate, and John tries to make peace with a rebellious Irish family, the Donovans, but is spurned. After his visit to the Donovans' house, John comes down with typhoid, from which he dies, leaving Fanny to look after the family. The young Johnny grows up

but is a curse to his grandfather, since his mother has spoiled him. He drinks, gambles, and is cruel to his mother and grandfather. Moreover, he falls in love with the woman whom his brother, Harry, is going to marry, and, after her refusal of his offer of marriage, he becomes more difficult than ever. Wild John, as he is called, puts Fanny out of the house, has an affair with a daughter of the Donovans, and gets into a fight with one of the Donovan sons. Fanny, who has gone to England, has been gambling away the family money, and John goes to England to bring her home. Her other son, Harry, decides to close the mines, where a fight breaks out between Donovan and Johnny, who falls down a mine shaft to his death. At first determined to exact vengeance for the death of her son, Fanny finally relents and clears young Donovan of the accusation of murder. She leaves Ireland, expressing the wish that Hungry Hill will become green again and that the Brodricks and Donovans can finally live in peace.

The film orchestrates a number of conflicts: between men and women, different generations, landowners and workers, Irish and Anglo-Irish, and radicals and liberals, and these conflicts stem from Brodrick's misappropriation of the land, which early in the film provokes the curse on the family by the Irishman, a curse that seems fulfilled in the premature death of two Brodrick sons. The disease that kills Greyhound John and the violence that destroys his son is a metaphor for a society destroyed by the curse of paternalism and industrial greed. The film does not provide a happy ending. The family disintegrates, and the mine fails. *Hungry Hill* is one of the rare films that trace domestic conflicts to a number of social conflicts, including the economic and social effects of colonialism. Family strife is inextricably tied to the father's greed and exploitation of the land and of its inhabitants. In this respect, the film directly addresses links between family, generational, and class conflict. Raymond Durgnat faults the film for its upper-class point of view, regarding it as politically tilting to "right of centre—albeit a chastened, conciliatory right."[25] His political reading, which hinges on Fanny Rosa's act of pardon as a gesture of upper-class concession to the lower orders, does not address the larger portion of the narrative with its linking of economic exploitation to family conflict and dissolution. Moreover, as in *Pink String and Sealing Wax*, disruption and violence are traced to an unreconstructed father figure whose actions have produced the violence which the film does not redress.

In the following year, Jack Lee's *The Woman in the Hall* (1947), another portrait of family dissolution, focused on the domestic havoc created by the absence of a father figure. The film starred Ursula Jeans as a mother with two daughters who learns that she can support her family by visiting the homes of well-to-do people and presenting herself as a distant relative who must support her children without a husband. Lorna Blake, a woman who has seen better days both economically and socially, takes

one or the other of her daughters with her to provide the proper sentimental tone. She is not arbitrary or cruel with her daughters. Her ostensible motivation is to provide them with a decent environment. Her household consists of Jay (Jean Simmons), Molly (Jill Raymond), and a housekeeper-friend, Susan (Joan Miller). She is successful enough to send her favored daughter, Jay, to a good school, and to finally marry a wealthy and titled man, Sir Hamar (Cecil Parker). Her actions begin to catch up with her, however. Jay gets a job and embezzles money, not for herself but to make others happy. When Sir Hamar learns about Jay's legal difficulties and about Lorna's other swindles, he tells Lorna that she is "no wife, no mother. You're a cheat. Go away, I never want to see you again." In the final dramatic scene, as Jay appears before the court, Lorna intervenes and assumes responsibility for Jay's behavior. After Lorna's confession, Sir Hamar takes Jay from the courtroom.

Lorna is punished, disciplined, and abandoned by respectable society. Her one-time friend and servant leaves her to stay with Sir Hamar as his housekeeper. As in many family melodramas, the mother is punished by the loss of her daughters. One daughter marries the man Lorna had claimed to be her husband; the other is taken in by the man Lorna married, and Lorna is left to the mercies of the law. The link between the maintenance of the family and the law is explicit here. Jay's mother is replaced by a moral, well-to-do, and responsible father figure. The family life that Lorna had created is condemned as a desecration of property, child-rearing, morality, and family respectability. Her lack of a husband, her parasitism on the wealthy, and her use of her daughters as decoys are all marks of her illegitimacy and clues to the proper values associated with authentic family life, namely, a benevolent father figure, honestly earned income, and a respect for other people's property. In spite of its conventional closure of the punishment of the mother for the daughter's crimes, the film can be read against the grain as exposing the problems of the single woman rearing two daughters and living by her wits as well as portraying the inevitable and harsh separation of mothers and daughters exacted by the culture. Lorna's pitiful and abrupt rejection by Sir Hamar, and his appropriation of her child, is excessive and serves to expose the narrative's disciplinary strategies, which are directed toward the identification of female assertiveness with criminal behavior.

Children in the Family

The effects on children of neglect or family discord was a matter of some concern in the family literature of the 1940s, and the cinema also explored these themes. Carol Reed's *The Fallen Idol* (1948) features a young boy, Felipe (Bobby Henrey), who is left by his parents in the care of the butler, Baines (Ralph Richardson), and his wife (Sonia Dresdel). The child is witness to the constant quarrels of Baines and his wife. He

also learns that Baines is having an affair with a young Frenchwoman, Julie (Michele Morgan). Mrs. Baines is not only angry with her husband, but she has no patience with children. She pretends to leave the house for the weekend, but then returns to entrap Baines and his lover. During her surveillance of the lovers, she falls to her death from a window ledge. The boy rushes out of the house after he sees the quarrel and the woman's fall and ends up in a police station. The police return home with him and begin their investigation of the death, regarding Baines as their prime suspect. Also believing that Baines is guilty, the boy tries to cover up the crime but succeeds only in making the police more suspicious. Baines has wanted to protect Julie, but the story of his affair and of Julie's presence in the house comes out. Before Baines is taken away by the police, he confesses to Felipe that the stories he had told him about having killed a man in Africa were lies. He tells the boy that they both told a lot of lies. The film ends with the return of Felipe's parents and with Felipe still unwilling to accept the evidence of Mrs. Baines's death as an accident.

Male oedipal conflict is the core of the film. The child is in the position of having to abandon his idealized notions of the male adult. The departure of his upper-class parents is symbolic, for the oedipal conflict is acted out on less exalted figures, namely, the hired help, dramatizing the reduction of these former figures of power standing in for the boy's absent father and mother. Mrs. Baines's killing of the snake reinforces her castrating role and Baines's impotence to protect Felipe. She is the source of dread and anxiety that has to be eliminated. Julie, on the other hand, seems to represent the postitive but ineffectual maternal image as she seeks to protect Baines and the boy. The child's viewing of the illicit meeting of Baines and Julia is only one of a number of incidents that feature the boy in the position of voyeur, seeking to understand the secrets of the adults.

Baines's story to the boy about having killed a man in Africa is related to his general efforts to escape the stigma of powerlessness, and in this respect he misleads the child into overestimating the importance of aggression in relation to male power. Through the experience of viewing the effects of violence in the adult world, the boy is initiated into the darker side of becoming a man. Resisting the knowledge that Mrs. Baines's death was accidental, the consequence of her rage toward her husband, the boy seeks to protect Baines and finally wishes to assume the responsibility himself. The final image of Felipe is one of impotence as the police refuse to listen to him. Thus, the film idealizes neither childhood nor manhood. The world, like the house, and like the behavior of Mrs. Baines, is represented as castrating and ominous. Generational or class differences do not affect the sense of male impotence. Men of all classes and ages are, in fact, linked by their vulnerability.

In *The Rocking Horse Winner* (1949), a film directed by Anthony

Pelissier and based on the D. H. Lawrence story, a young boy, Paul (John Howard Davies), is acutely sensitive to his parents' marital conflict and particularly to his mother's (Valerie Hobson) dissatisfaction with his father. Ominously, the house takes on human qualities as the boy hears it echo the mother's words, "There must be more money." Paul develops a relationship with a hired man, Bassett (John Mills), who introduces him to the world of horse racing. Paul's receipt of a rocking horse as a Christmas present becomes his means to silencing the house's whispering. The boy rides his horse with a frenzy, and his wild riding is the source of his good luck, enabling him to select winners of various races. He amasses a great deal of money, but destroys his health in the process.

The boy's demise is linked to the father's impotence and to the mother's obsessive preoccupation with commodities. The sexual implications of the family romance are dramatized in the father's weakness, his work failures, and his addiction to gambling; the wife's indifference to him; and the boy's surveillance of and unrest about his parents' relationship. But the mother is the source of the family tragedy. It is her voice that the boy hears whispering through the house, and it is this voice that he seeks to still. Her extravagance is presented largely as a preoccupation with clothing, a focus on her own body to the point where she completely disregards husband and family. The boy's obsessive riding of his hobbyhorse mirrors the obsessiveness of the family situation, and those who observe his frenetic galloping comment that there is something not quite "natural" about his behavior. The riding is masturbatory as in its literary source, and a substitute for the sexual relations that are absent from the couple's marriage. The boy's death is the film's vehicle for punishing the mother. By focusing on the mother and the young boy and not on the father, the film validates Foucault's analysis of the central mechanisms which have been deployed to ensure the continuance and integrity of the bourgeois family: the hysterical woman and the masturbating child. In this film, the two are fused, the child's masturbatory behavior directly linked to the woman's hysteria. The house as the maternal symbol is engulfing and threatening, and the boy's behavior is traced to the female's influence, which infects everything and everyone despite the efforts of Bassett and the boy's uncle. While the film is yet another expression of the dread of woman, a moral parable of female narcissism and family neglect, it provides a particularly striking example of the strategies used to silence women.

Dramas of Family Recuperation

The rejuvenation of the upper-class family fortune and ethos through the efforts of a lower-class female is common in films of the period. Gainsborough's *Jassy* (1947), a costume melodrama directed by Bernard Knowles, stars Margaret Lockwood as Jassy, a Gypsy, who is befriended

by an upper-class young man, Barney Hatton (Dermot Walsh). Barney's family has fallen on hard times owing to his profligate father (Dennis Price), who gambles away the family estate to Nick Helmar (Basil Sydney), a violent man responsible for the death of Jassy's father, cruel to his tenants, and abusive to his wife and his daughter. The elder Hatton commits suicide after a bout of gambling. Jassy goes to work for Barney's family but is dismissed by the mother, who does not approve of Jassy's friendship with her son. Finding employment at a girls' school, Jassy meets Dilys (Patricia Roc), Helmar's daughter, who takes Jassy home with her, introducing her as a friend. Helmar is now a widower. He takes a liking to Jassy, who shows him how to run his household efficiently. Eager as always for sexual adventure, Dilys develops a relationship with Barney, though her father wants her to marry a wealthier man. Only toying with Barney, Dilys obeys her father and marries the man selected by him, turning her back on Jassy. Jassy agrees to Helmar's marriage proposal on one condition: that he sign the house over to her before they are married. She wants the house not for herself but to restore it to Barney. After the marriage, she refuses Nick's sexual advances. In a rage, he rides off and has a nasty fall from his horse. Jassy nurses him with the help of a mute servant, Belinda Wickes (Esma Cannon), who has been brutalized by her father and is unable to speak. Belinda poisons Nick, and at the moment of her sentencing, Belinda regains her voice, assumes responsibility, and dies. Jassy turns the house over to Barney, and they plan to marry.

Fathers are associated with brutality and violence and are eliminated from the narrative. Jassy becomes the agent of direct retribution by acquiring the house that Helmar had misappropriated from Barney's father, thus avenging both fathers simultaneously. Barney, like many of the sons in the costume melodramas, is powerless, and it is the woman who restores the Hatton family fortune. In contrast to Dilys, who is irresponsible and disloyal, also a victim of her father's cruelty, Jassy's strength and independence are placed in the service of the family and family property. A Gypsy girl redeems the corrupt society. By contrasting Jassy to the traditional notion of the female scatterbrain and seductress, the film makes a concession to women by praising the enterprising qualities of independent women, while directing them into traditional paths. Moreover, unlike many of the films of the prewar and war era that restrict coupling to members of the same class, *Jassy, The Courtneys of Curzon Street* (1947), and *Trottie True* (1949) hold out the promise of upward mobility for the female as a reward for her loyalty and service. *Jassy* deviates from the woman's film in several significant ways. While it features Margaret Lockwood, her part is quite different from her usual role as the headstrong female who is willing to violate convention in her quest for pleasure. Instead, her desires are channeled into more familiar directions as the

agent of purification of the family home and restoration of the scion to his proper place. The film portrays her as a disciplinary figure, identified with her father and more generally with patriarchy. In fact, female roles are reversed in the film. Patricia Roc, an actress usually associated with sexual restraint and familial duty, is the disruptive force and disciplined into conformity. While the film holds out the promise of a more egalitarian relationship between classes, it does this at the expense of female pleasure.

Herbert Wilcox's *The Courtneys of Curzon Street* (1947) dramatizes the threats to the upper-class family in the face of changing economic and social conditions. Associated with historical films such as *Nell Gwyn* (1934), *Victoria the Great* (1937), *Sixty Glorious Years* (1938), and *Nurse Edith Cavell* (1939) as well as a number of musical films and comedies starring his wife, Anna Neagle, Wilcox's films are a celebration of tradition and history. *The Courtneys of Curzon Street*, a family chronicle, begins in the pre–World War I era with Edward Courtney's (Michael Wilding) marriage to the Irish parlor maid, Cathy (Anna Neagle), and the mother's and society's refusal to accept the marriage. Feeling that she is a hindrance to her husband's army career (the Courtney men have always served in the army), Cathy disappears and makes a career for herself on the stage while caring for her young son, Edward. The couple are reunited in France during World War I when Cathy sings for the servicemen. When Edward returns home, he becomes acquainted with his son, Edward. In the interwar period, the son joins the army, marries, and goes off to serve in India. He is killed and his wife dies in childbirth, but the child survives and there is yet another Edward, who grows up and joins the service during World War II. He, too, has met a young woman, a factory worker, and the film ends with Sir Edward's blessing the marriage of his grandson and commenting how the times have changed from when he tried to marry out of his class.

The film dramatizes the survival of the upper classes, who have accommodated changes in the class structure. Through the portrayal of Cathy, the film reveals that family stability is built on the efforts of the working class to save the family. This is seen most graphically after the stock market crash, when Sir Edward contemplates selling the family home and Cathy refuses to relinquish the house, especially repelled by their vulgar parvenu buyer, saying, "The house was in the family and somehow we're going to keep it," which she makes possible when she returns to the stage. The upper-class women in the film are presented as sniping and vicious or, like Cynthia, unable to endure the hardships of life, while Cathy is presented as the perfect servant, even as a Courtney, of family, country, and tradition. The men are portrayed as more egalitarian than the women, even during the Victorian period, and it is they who are the beneficiaries of her service. The film bows to social change in its acknowledg-

ment of the possibility of marrying out of one's class, but it also reveals, in spite of its optimism, that entry into the upper-class milieu entails a commitment to traditional values.

The issue of family legitimacy and property is recapitulated in the Gothic melodrama *Blanche Fury* (1948), in which a young woman becomes involved in conflict over the ownership of an estate. Blanche (Valerie Hobson), after having served as a companion to an arbitrary and abusive older woman, is invited to become governess to her niece, Lavinia Fury. (The family has adopted the Fury name after taking over the debt-ridden estate.) Still living on the property and serving as groom, Philip Thorn (Stewart Granger), the illegitimate son of the Furys, seeks to reclaim the title to his estate. He is maltreated by the elder Fury (Walter Fitzgerald), whose son, Lawrence (Michael Gough), is also treated poorly by his father. Blanche marries Lawrence at the father's insistence, but she falls in love with Philip. The marriage falls apart when Lawrence seeks to impose his will on her and she defies him. Desperate to reclaim the house after learning from the solicitor that he has no formal title, Philip kills both Fury father and son, making the crime look as if it were the work of horse-stealing Gypsies. He then comes to claim Blanche. Knowing that he is the murderer, Blanche is afraid that if they are seen together so soon after her husband's death, the police will become suspicious. Philip is not to be placated; he cannot wait any longer to take his rightful place as heir. He rants about the house now belonging to Lavinia, the Fury heiress, and Blanche begins to suspect that he will kill Lavinia. She goes to the police and tells them the truth about the murder, her relationship with Philip, and Philip's designs on Lavinia's life. (She had seen him urging Lavinia to take her small horse over hurdles that she claimed were too difficult.) Philip is put on trial, convicted, and hanged. Lavinia is killed when she goes out riding alone and attempts a difficult jump. Blanche dies in childbirth, but she leaves behind a son, Philip Fury, who will be recognized as the rightful heir to the house.

The men in the film are portrayed as flawed—the tyrannical elder Fury, the malicious and weak younger son, and the obsessed Philip—and they are all eliminated. Women are presented as more strong-willed but are eliminated after serving the family in a reproductive or morally redemptive capacity. The film begins and ends with women dying in childbirth. The first child is the girl, Lavinia, who is killed to make way for the second child, Philip, the son Blanche has by the dispossessed heir to the Fury name. After all of the adults complicit in the illegitimate usurpation of name and title are dead, Blanche becomes the instrument for regenerating the family, providing a son to carry on the Fury name before she, too, dies. The police describe her as courageous because she is willing to sacrifice reputation and love in order to see that justice is done, and justice resides in the restitution of the family name and property. Again, the fe-

male is the instrument of justice, restoring the family honor at the expense of her own life. Moreover, as in *The Woman in the Hall*, the film testifies to the contradictory position of the female in the films of the late 1940s. On the one hand, she is portrayed as clever, strong-willed, and independent, but it is these very attributes that lead to her containment or demise. Once family legitimacy is established, the narrative has no further use for her.

The formula of the intermarriage of the upper classes and the lower classes is reiterated in Brian Desmond Hurst's *Trottie True* (1949), but this time with the female protagonist as entertainer. Jean Kent plays the title role of a young woman who succeeds on the stage and then marries an aristocrat, Digby (James Donald). The protagonist is not initially identified with an upper-class ethos; she is portrayed as a down-to-earth young woman who plays to the crowds. Uninterested in jewels, titles, or commodities, she is the envy of theatrical colleagues who have unsuccessfully set their caps for a lord. At first, she falls in love with a balloonist, but the relationship fails because of his hesitancy about getting married. Trottie's relationship with her husband also almost fails, over his concern with appearances. She tells him that the working classes are not concerned with appearances but with respectability, a value that she shares with them. When Digby is seen with a former female friend, she publicly expresses her disapproval. His mother praises her by calling her a duchess in her scorn for appearances, but then lectures to her that rules and conventions have meaning. In anger, Trottie runs off with the balloonist, only to learn that he is engaged to another woman. She and Digby are reconciled and she returns to her upper-class existence.

The film focuses less on the issue of class snobbery than on class differences and the mediation of those differences. Moreover, the issue of family legitimacy is not the major conflict. What is in contention is the quality of relationships within the family and the restoration of the conjugal bond. Compromises are demanded from both men and women, worker and aristocrat. As in these other films that feature the restitution of the family, this film places a female at the center of the narrative, but it does not explore her desires but subordinates them to familial stability and harmony. The transformation of the working-class female into an aristocrat is at the expense of her pleasure. In exchange for vitalizing the family, she is initiated into the rules and conventions that she must now adopt and live by.

Working-Class Family Tribulations

Ken Annakin's *Holiday Camp* (1947) offers a version of British life and familial relations in a contemporary and everyday context. The film was to generate spin-offs on film, radio, and television. In its use of multiple intersecting narratives, its dispersal of interest among several characters,

and its blending of melodrama and comedy, the film resembles soap operas. According to Robert Murphy, the critics objected to the introduction of a murder into this "otherwise light-hearted film." But it is precisely this "new element" that distinguishes this film from traditional domestic comedies and links it to the family melodrama.[26] The critics' inability to appreciate the importance of the element of violence is an indication of a condescending attitude toward the trials and tribulations of working-class life.

The holiday camp, according to John Stevenson, offered "'all in' holidays based on chalets and providing modern catering and leisure facilities. The first holiday camps were set up by individual firms, trade unions and philanthropic bodies."[27] Set within this context, *Holiday Camp* focuses on the stories of a young woman (Hazel Court) who has lost her husband in the war; a young man (Jimmy Hanley) who has lost his female friend; an older woman, Esther Harman (Flora Robson), who lost her lover in World War I only to discover later that he was not dead; a young couple who are depressed because of parental disapproval of their marriage; a criminal, the notorious Mannequin Murderer sought by the police who is masquerading as a war hero (Dennis Price); a young man who falls into the hands of card sharks and has to be rescued by his father; and his parents, the Huggetts (Kathleen Harrison and Jack Warner), who have not had a holiday in a long time and are determined to enjoy themselves, though problems with their children threaten to spoil their pleasure.

The blind announcer, who turns out to be the man Esther Harman had thought dead, articulates the value of the holiday camp as a place that mitigates the alienating and frightening experiences of mass society. He tells Esther that at first he was frightened by the prospect of all these people at the camp fighting for happiness, but then he saw himself as helping them to forget their unhappiness. Having been wounded in 1918, losing his sight and memory, he does not have any recollection of the past or of Esther, who does not reveal her identity. Like her former lover, she seeks to mitigate the unhappiness of others, adopting the young despairing couple and offering them a place to live when she learns that the young woman's aunt will have nothing to do with her pregnant niece.

Other conflicts are also resolved. Joan Martin and Jimmy Gardner fall in love and after a stormy relationship decide to marry. After a quarrel with his wife when Huggett refuses to give his son money to bail him out of his gambling debts, the Huggetts are reconciled. The Mannequin Murderer is caught, but only after another murder has been committed. For the most part, the revelers return home, purged and rejuvenated. Only the criminal and his victim are eliminated from the community. Everyone else

is paired. The holiday camp as a microcosm of society thus offers the hope of familial relations as the antidote to the frightening world described by the announcer. Men get their women; women get their men; and the childless woman belatedly gets two children. The negative effects of the war as represented by Joan's widowhood are overcome through her relationship with Jimmy. The film reveals its therapeutic strategy in its linking present discontents to the past and to the war in particular. Personal disaffections are ameliorated through domestic reconciliation and through efforts to create a sense of collectivity. The older generation, in particular, is portrayed as needing to guide, protect, and sustain the younger. The Huggett family is reconciled, and a new family is spawned in the coupling of Joan and Jimmy. The film is addressed primarily to the question of postwar readjustment as it evokes memories of loss due to the war, images of dislocation, the disaffections of youth, the existence of violence and criminality, and poses the recuperated family and the community as the arbitrators of existing social conflicts. The holiday camp itself is a metaphor for social unity based on mutual recognition of sexual, economic, and domestic problems. The sex murderer is not just another character in the gallery of types represented in the holiday camp: he is the embodiment of threats to the stability of the community. Single, of uncertain origins, sexually promiscuous, he is the antithesis of the familial values that the film seeks to promote.

Following the success of *Holiday Camp*, Annakin directed a sequel, *Here Come the Huggetts* (1948), also produced at Gainsborough by Betty Box. This film concentrates on the Huggett family, and it, too, has the same portmanteau quality as the earlier film in its exploring several narrative lines through the various family members. The conflicts surround the arrival of a cousin, Diana (Diana Dors), who creates havoc for all of the members of the family. She refuses to live according to the family routines, devotes herself to her clothing and makeup, and when she gets a job at the father's firm she gets him into trouble with the boss. The youngest daughter (Petula Clark) assumes that the father is having an affair with Diana and unwittingly makes trouble between Susan (Susan Shaw) and her boyfriend. Jane (Jane Hylton) is resisting the idea of marriage to Jimmy, who has been away at war, and develops a relationship with Harold (David Tomlinson), who dabbles in psychology and attempts to use psychology to keep her from marrying because he does not believe in marriage. In the end, after an emotional and not very comic scene in which Jane locks herself in the bathroom to escape her family's pressures, she succumbs to marrying Jimmy. The film ends with Jane and Jimmy's wedding, which parallels the royal wedding of Elizabeth and Philip alluded to earlier in the film when the Huggetts join the crowds on the streets waiting for the royal procession. Ironically, the Huggetts never

get to see the event, since Grandma, whom they have brought along, cannot tolerate the cold, and they have to leave.

The film portrays the family as a battleground between children and parents, between conforming to expectation and rebellion. For the father, work is inextricable from domestic discord. Forced to find a position for Diana in his firm, he suffers the negative consequences of her presence. For Jane, the contemplation of marriage is portrayed as a frightening and unwelcome event, acceptable only after traumatic struggle and her realization of the absence of alternatives. Yet marriage is celebrated in the film in the parallel between the royal wedding and Jane's. Harold, who voices an alternative to marriage, is portrayed in negative terms and his point of view discounted. Jane's problem, as she acts out her dissatisfactions with marriage and the family, is regarded by the family as "normal" resistance, which should be overcome through marriage; however, the scenes of her struggling to escape and finally submitting have the effect of undercutting the taken-for-granted quality of her struggle and resignation. The excessiveness of these scenes is disruptive to the film's commonsense orientation.

The narrative is structured around a series of internal and external threats to each member of the family. The internal threats concern each family member's dissatisfaction with an aspect of domestic life; the external threats concern work and the bewildering quality of urban life. The shots of the crowds on the street waiting for a view of the royal couple are also portrayed as intimidating. Harold and his strange ideas about psychology and marriage, and the pleasure-seeking, irresponsible Di, challenge the notion of the inevitability and naturalness of the Huggetts' way of life, but these are challenges that must be eliminated. Both *Holiday Camp* and *Here Come the Huggetts*, while only peripherally addressing the war in their reminders of dead or returning servicemen, dramatize a fragile environment in which people are aware of their disaffections, aware of the precariousness of relationships, and struggling, as Jane does, with alternatives but finally remaining within the arena of the familiar and the familial. The two female characters, Di and Jane, are the major sources of disruption in the narrative. In the case of both characters, sexuality, predictably female sexuality, is the alien and disturbing element that creates an excess that undermines the film's domestic resolution.

Despite the promise of a new and better life in the postwar world as exemplified in the rhetoric of the war films, the films of the postwar era, especially those at the end of the 1940s, dramatize failure in both private and public spheres. In the case of a film such as *It's Hard to Be Good* (1948), even the recollection of the war turns out to be disappointing. The film begins during the war when James Gladstone Wedge (Jimmy Hanley) performs a heroic feat for which he receives the Victoria Cross. The "he-

roic deed," he is later told by a war comrade, actually involved the smuggling of contraband goods. He is wounded and while in the hospital meets and falls in love with his nurse, Mary (Anne Crawford). He also determines to undertake a crusade to make people good so that there will never be a war again. Finally discharged, he takes every opportunity to lecture others about his fear that "we're slipping back to the same old relations as before the war. . . . If people can't get on, how can nations get on?" His audiences seem little moved by his sermonizing. When he returns to his relatives' home, he finds discord. His aunt is resentful that he is taking away her room. The family worry about his staying too long, and the clergyman comes immediately to see if he can find him work. The scenes of family life, not only in his house but in the neighbors', are antagonistic. Wedge tries to make peace among the neighbors when they argue with each other, but creates a free-for-all in which he becomes the butt of their rage. Like Don Quixote, everyone he tries to help gets into worse trouble and rails against him. He is told by his family that he has done enough good for one day, and they hope that "this will be the end of peace and good will in the house."

At first Wedge fails at getting a job on the newspaper, but when it is learned that he has been awarded the VC, he gets the job, and his family also begin to treat him with deference. He decides to leave the house and go to live in a run-down house that he has inherited along with some squatters whom he has not the heart to throw out. He marries Mary, but they soon have serious differences about his politics. She wants a quiet life, a proper wedding and honeymoon, and a proper place to live. Above all, she wants him to give up his struggle to convert others. He has been exploited by his editor, who uses Wedge's reputation as a war hero to advance a scheme he has of amalgamating this town with a neighboring town. Wedge learns of this and determines to fight. At a community meeting, he tells the audience that there can only be peace if there is good will and urges people to resist the authorities. His speech causes a commotion and fights break out. He tells Mary that just talking of peace makes people want to fight, and she tells him, "Perhaps it's the way you put it. You want them to do it your way and no other. . . . People resent being helped."

At Christmas, he goes out to spread good will; all his efforts backfire until he says that he is finished with good will. The style of the film mimes the protagonist's simplicity and his tendency to speechify. The narrative dramatizes Wedge's step-by-step retreat from idealism, first through a demystification of wartime ideals as he learns what his heroism was really about, then retreat from the challenge of trying to reform his family, and finally retreat from the public arena when he fails to expose corruption and appeal to people's good will. His wife voices the attitudes of the com-

munity when she tells him that the ways he seeks to convert others are antagonistic, though he seeks to be helpful. Mary is the realist. She advocates the virtues of family life, though the film has already portrayed the family as a battleground. In its portrayal of the community, the film suggests that aggression is inevitable and takes a negative view about commitment, advocating personal politics and personal safety as the only alternative. The couple finally retreats into the family, more specifically into the bedroom, where presumably they will retaliate by having a child to enlarge their collectivity.

The film pinpoints a number of issues even as it abandons them—the relationship between war and profiteering, the fear of another war, the interrelationship between the public and private spheres, and the loss of a collective ethos. *It's Hard to Be Good* captures the sense of the failure of idealistic notions of reform, anticipating the satires of the 1950s. The same kind of rhetoric that during the war had animated and inspired audiences is now portrayed as antagonizing them.

Vindication: The Family and the Law

There are films of the postwar era that portray a more cohesive and benevolent social climate. In *The Winslow Boy* (1948), directed by Anthony Asquith, the link between the family and the British system of justice is clearly reinforced. Moreover, if many of the melodramas present the father as brutish or as impotent, this film seeks to restore the paternal image, and also to establish a bond between a father and his son. The "Edwardian feel" of this film lies particularly in Cedric Hardwicke's portrayal of the father as the indefatigable crusader for justice for his son Ronnie (Neil North), the innocent victim of false accusations. The household itself as supervised by the father is the epitome of middle-class respectability. The film constructs a view of heroism which depends on an ethos of self-sacrifice and service.

The film begins with the father's retirement after many years of service in a bank. His desire for a peaceful retirement is frustrated by his male children. His eldest son, more interested in doing the bunny hug than studying, is wasting time and money at Oxford. The younger son, Ronnie Winslow, of whom the father is immensely proud, attends a naval school and is dismissed for stealing a postal order. Kate, the daughter closer to her father than to her mother, is involved in the suffragist movement and considers herself a feminist. Her mother is eager to have her marry the young man next door, whose father is in the Royal Artillery. To the mother's delight, the young people become engaged, but all is disrupted with Ronnie's appearance and news of his expulsion from the academy.

The father confronts the son in restrained fashion, appearing stern but not betraying anger, asking him to tell the truth. "A lie cannot be hid-

den," he says. The boy says that he did not steal the money order, and the father believes him. From here on the father sacrifices everything to save the boy's reputation and to vindicate the family name. He hires a famous barrister, Sir Robert Morton (Robert Donat), to plead his case. At first it appears that the father will not get the case heard, for there is no precedent for his civil complaint against the service. Morton invokes the Magna Carta, which stipulates that no subject can be condemned without a trial. The Winslow case goes to the House of Commons and becomes a cause célèbre with people divided about the appropriateness of the claims that Winslow is making for a trial.

The daughter (Margaret Leighton) is suspicious of Sir Robert Morton. She sees him as a Tory aligned with property and big business, but her father tells her she is wrong and that time will tell which is right, "a father's instinct or her reason." Sir Robert establishes to his own satisfaction the innocence of the boy and is willing to proceed by petition of right. The defense will be carried out according to the formulaic phrase "Let right be done." During the struggle, Winslow exhausts his available funds and even his borrowing power. His daughter breaks off her relationship with her fiancé, whose family disapproves of Winslow's action. Winslow's wife is annoyed with her husband's persistence, and finally his health breaks down. Nevertheless, he is undeterred. In the speech that the equally ailing Sir Robert gives in the courtroom, he states that it is not guilt or innocence which is at stake but a citizen's right to be heard and to present a grievance even against the king: "Let them not rest until the time-honored phrase that stirs an Englishman in his castle, backyard, humble street—'Let right be done.'" Justice is done in the name of the king and on behalf of a modest citizen of the land and of his family.

By using the Winslow case, involving a young boy and a minor misdemeanor, the film seeks to reinforce the idea that British rightmindedness and practice of justice reaches down into even the seemingly remotest corners of the land. Moreover, the system is not biased, but embraces all classes. The film also establishes that this quest for morality is in the interests of continuity, dramatized in the passing on of the father's good name to the son and the son's safekeeping of that name. The contrast between the two Winslow boys is essential to clarifying the nature of merit. Ronnie, unlike his pleasure-seeking brother, is clearly deserving of the father's sacrifice, since he shares the father's values.

The female members of the family are treated like the unwanted son. The mother is portrayed as vain and uninterested in the father's crusade, more concerned about clothing and money than about her son. The daughter's feminism becomes an ambiguous entity challenged by the men. She is proved wrong about Sir Robert, thus establishing, in her father's terms, that her reason is inferior to her father's instinct. Her en-

gagement is treated cursorily, useful only to advance the idea that she will have to sacrifice her wedding to the "cause." Her feminism is treated condescendingly by Sir Robert, and the final lines of the film involve a verbal sparring contest between the two, in which he tells her that feminism is a lost cause. Kate responds that she probably will not see him again, and he replies, "How little she knows men." Thus, Kate's judgments are still in question. Her virtue lies in her steadfast support of her father's cause. The most awkward portrayal is of a female reporter, who is presented as rude, garrulous, and voyeuristic, concerned only with household trivia, and physically unattractive. She is aligned with the mother, whose values and behavior the film calls into question, in contrast to the heroic and self-sacrificing father.

Along with the film's allusions to feminism are allusions to the Irish Civil War, but the film's concern with that war is minor compared with its concern with the rights of the free-born Englishman. In its references to feminism and to the Irish conflict, the film seems to be aware of political issues at the periphery, but it subordinates these larger issues of social injustice to the father-son relationship. The issue of the father's rights is linked to the rights of all subjects. Feminism and colonialism are secondary. In the narrative's unswerving commitment to the father's cause, the film reveals its single-minded preoccupation with national identity, legitimacy, the law, and, above all, the patriarchal family.

FAMILY MELODRAMAS IN THE 1950s

Increasingly throughout the late 1940s and early 1950s, the family is portrayed as under siege. Though some films will seek to rationalize or contain threats to the family, the disparity between the conflicts posed and the traditional reconciliations offered only heightens contradictions between disruptive elements and the imposition of the traditional "solutions" of marriage and an emphasis on continuity. The threats to family stability are inextricably tied to questions of sexual morality, translated often in generational terms. As in the Gothic family melodramas, the house is a central metaphor, and the characters trapped within its confines. In *The Holly and the Ivy* (1952), directed by George More O'Ferrall, the melodrama begins and ends within the domestic sphere, literally remaining within the family house. The film takes place during the Christmas season with the reluctant reunion of family members, and exposes generational, parental, and sexual conflict in the family. The paternal figure is the familiar Church of England clergyman (Ralph Richardson), who inhabits many British melodramas. The eldest daughter, Jenny (Celia Johnson), will not leave home to marry because of her sense of duty

to her father, a widower, although her young man, David, tells her that
the old must give way to the young. David is played by John Gregson, an
actor who usually assumes uncomplicated amd earnest male roles. His
greatest difficulty is getting the girl or, if he has her, appeasing her. Celia
Johnson, as the faithful daughter who runs the household but threatens to
become a harsh spinster, plays a female role that, as we have seen, be-
comes familiar in this era.

As the family congregates, tensions between members mount. The son,
Michael (Denholm Elliott), who is in military service, clashes with his
father over drinking and over the father's lack of communicativeness. The
other daughter, Margaret (Margaret Leighton), who is in business in
London, returns, but she is suffering from alcoholism attributed to a
sense of estrangement and loneliness. The truth finally comes out that she
has had an illegitimate son who has died. Jenny, who has resented her
because Margaret has not wanted to help her out with the vicar, is sur-
prised when Margaret agrees to take her place and tend the father, freeing
Jenny to marry David. After a confrontation in which the son castigates
his father for being excessively moral, the son and father are reconciled.
The widowed aunt states that "loneliness can do terrible things to peo-
ple," citing the unmarried and crotchety Aunt Bridget as an example of its
effects. But Bridget also experiences a conversion: she is the one who tells
Jenny to leave and marry David. The final scene depicts the family enter-
ing the church. The family reconciliation mitigates the numerous prob-
lems that the film has exposed—the failure of traditional rituals, the in-
cursions of commerce, and alcoholism, which is attributed to the sense
of anomie, dissatisfactions with work, and the failure to find personal
gratification.

The women in the film are presented as having missed, or being in
danger of missing, their chance for personal happiness through marriage
and a family of their own. The more fundamental problem of the charac-
ters is repressed sexuality. Jenny is portrayed as reluctant to get a house-
keeper for her father and marry David; she attributes her reluctance to
familial responsibility. Yet her refusal to marry seems to have a more
profound basis, related to her attachment to her father. (The mother is
dead.) She resists David's gestures of affection, and at one point she says,
after he kisses her, that it is like "falling asleep in the snow." David re-
sponds that he never heard of anyone "freezing to death from a kiss."
Sexuality seems to constitute a problem for the other characters as well.
At another point, a young serviceman is reprimanded by his commanding
officer for climbing over a fence to kiss a young woman. Jenny refers to
her sister, Margaret, as a "frozen queen," and Aunt Bridget's rigidity and
supermorality are traced to her being single. In a covert way, the film
exposes the underlying sexual implications of Jenny's overattachment to

her father as well as the repressed lives of the other women. In its conscious commitment to the preservation of the family, the film identifies sexuality with reproduction and reproduction with the continuance of the family. The presence of children in the Christmas celebration is an illustration of David's comment, "What is between you and me is what human life depends on."

Melodrama and Satire

The excessive stylization and affect of family melodrama can be converted to satire or comedy, especially when narratives turn away from confronting the disjunctions between social and psychic determinations in family conflict, seeking to externalize and dissipate them. Moreover, the caustic and corrosive treatment of the characters undermines the forms of identification necessary for melodrama. *Meet Me Tonight* (1952), based on three short plays by Noel Coward, is an omnibus film that traces the deterioration of familial and social relationships. Its episodic nature works to disperse the concentrated effects of melodrama. The first episode, "The Red Peppers," involves a couple (Ted Ray and Kay Walsh) working in a revue with performers who have seen better days. The couple quarrel constantly with one another, but present a united front against their manager, destroying a performance and producing mayhem in the theater. The second episode, "Fumed Oak," portrays a long-suffering husband (Stanley Holloway) who is driven to leave home after years of living with a complaining mother-in-law (Mary Merrall), a nagging wife (Betty Ann Davies), and a whining daughter (Dorothy Gordon). Having saved some money, he confronts his wife with her past and present failures, citing especially how she forced him to marry her by claiming that she was pregnant. He lashes out at the duplicity and quarrelsome nature of the women and their ruining of the child, and determines to strike out before it is too late to find a "real life," as opposed to what he describes as their "tawdry melodrama." "Fumed Oak" portrays with extreme venom the claustrophobic life of the petit bourgeoisie, with its argumentativeness, anality, absence of affection, and hypocrisy. The third episode, "Ways and Means," is set in the upper-class milieu of the Riviera, where a young penniless couple (Valerie Hobson and Nigel Patrick) are sponging off an eccentric rich woman (Jessie Royce Landis). Jack Warner plays the role of the chauffeur who is, in his spare time, a robber. Desperate for funds, the couple decide to pawn some of the wife's jewelry and try their luck at a gambling casino. Just as the husband is about to bet, his hostess inveigles her way to the table, takes his place, and wins. After she leaves, he steadily loses the little money that he had. The couple decide to avenge their hostess's act, but are outsmarted by the chauffeur, who is, in turn, outwitted by the police.

The film offers examples of two conceptions of family: a beleaguered family pitted against a hostile world, and a hostile family. The misogyny of "Fumed Oak," in particular, is reminiscent of many films of the 1950s that portray men stifled by controlling women and identify the women as the source of family conflict. In many of the films that focus on the family, the narratives vainly seek a scapegoat to account for familial conflict, and, in some instances, the proliferation of television sets in the home provides a convenient target. While films as early as the 1930s, such as *Elstree Calling* (1930) and Elvey's *The Tunnel* (1935), incorporate images of television, using television, as Charles Barr indicates, "for its novelty value . . . it was not until well into the 1950s that cinema addressed itself in a sustained way to a rival medium."[28] In Muriel Box's *Eyewitness* (1956) and *Simon and Laura* (1955), for example, it is a television set linked to family discord that initiates the violence in the film. In the Ealing film *Meet Mr. Lucifer* (1953), television becomes a diabolic force in the lives of the characters it portrays, responsible for destroying family harmony. Ironically, television, more than cinema, could be considered a family medium, since it is viewed within the home by all members of the family, and yet it is identified as a primary source of family disintegration. The animus toward television and the charge of its corrupting influence recalls the earlier animus toward cinema on similar grounds. The hostility toward television expressed in these films can be traced specifically to the cinema's threat of competition and more generally to the ongoing contempt for and denigration of mass culture, couched in terms of threats to the integrity of middle-class culture and male hegemony. In the case of *Meet Mr. Lucifer*, characteristic of the studio's preoccupation with community and tradition and its antipathy to modern industrial organization, television becomes the vehicle for attacking a consumerist society. The film is consonant with prevailing ideological concerns about the deterioration of traditional British values, especially those values centered on the family unit.

The omnibus film begins with a down-and-out stage performer, Sam Hollingsworth (Stanley Holloway), awakened by his landlady from a drunken sleep to go to the theater. At the theater his audiences are meager, and he spends his spare time drinking. In a drunken haze, he meets Mr. Lucifer, who seeks in his professional role as devil to make people unhappy. He has discovered the perfect instrument of torture—television. The television begins as a retirement gift to a clerk, Mr. Pedelty (Joseph Tomelty). Like a bad talisman, the television monopolizes his time and drains his finances as others in the neighborhood visit him to watch the television and he becomes impoverished through providing liquor and food for all his guests. The television then passes to a young couple, Kit and Jim (Peggy Cummins and Jack Watling), whose marriage is almost

destroyed by Kit's obsession with the infernal machine. Jim, who is study-
ing to better himself as a chemist, can find no quiet space to study. Kit is
portrayed as neglecting him. Pedelty's daughter and Jim are caught in a
compromising kiss, which costs Jim his position and causes the couple's
separation. The final recipient of the television is Hector (Gordon Jack-
son), who experiences several character transformations as he becomes
addicted to a Miss Lonely Hearts program, perceiving the television
image to be created for him only and confusing actual experience with
representation.

In each of the episodes, the film explores various arenas of modern
discontent in which television is the prime culprit. Technology becomes
an obstacle to interpersonal relations. Mr. Pedelty's preference for the
abacus over the adding machine renders him redundant. His firm's pref-
erence for the modern instrument is portrayed as an instance of society's
preference for machines over humans. The theater, too, suffers from the
audience's abandonment. Barr states, "The TV set is shown creating fake
community, fake togetherness in two ways. First, it brings people to-
gether into the house of the set owner, but they are parasites rather than
true friends. . . . The second kind of fake togetherness is the communion
between the viewer and the screen."[29] In all instances of the characters'
response to the television, personal involvement with the screen becomes
a substitute for relations with one another. In the case of Kit and Jim, in
particular, the film dramatizes the destructive consequences of this new
technological device for conjugal relations. Television is thus a scapegoat
in the numerous attempts to account for the failure of familial and com-
munity relations. In Box's *Simon and Laura*, it also becomes the vehicle
for reconciling family discord.

In encyclopedic fashion, David Lean's *Hobson's Choice* (1954) orches-
trates a number of familiar motifs of the era that center in familial rela-
tions—a tyrannical father, rebellious offspring, sibling rivalry, class snob-
bery, property conflict, and the relation of work to family. Hobson
(Charles Laughton) runs his house with an iron hand, refusing to allow
his younger daughters to marry until his eldest, Maggie (Brenda de
Banzie), finds a husband, but he opposes the idea of her marrying when
she finally finds a man. The man, Willie Mossup (John Mills), is employed
by Hobson in his boot shop. Using Willie as her weapon against her fa-
ther, Maggie marries him, frees her sisters to marry, helps him set up in
business, and sees to it that he becomes a rival of her father. After their
marriage, the sisters refuse to care for Hobson, whose business and health
have failed. With Maggie's encouragement, Willie bargains with Hobson
to make himself a partner in the firm. Now a self-respecting and domi-
nant male, Willie magnanimously allows Hobson to live with him and
Maggie.

The film is a mixture of traditional narratives—the motif of the miser's reformation, the Lear motif of the father with the deserving and undeserving daughters, and the conversion of the weak male into a figure of strength and power. The focal point of the narrative is Maggie, who uses her wit and ingenuity to rescue both men and save the family. She is an instrument in resolving the generational conflict by assuming power over her father, but she does this not through her own agency but by using Willie as the instrument of discipline. In this way, she also acts in the interests of altering traditional class prerogatives. By helping Willie to become a self-respecting husband and businessman, she helps to transform him from his lowly occupation as worker to a self-employed and successful entrepreneur.

Class conflict also asserts itself through the sisters, who marry upward but want nothing to do with either Hobson or Willie, though, here again, Maggie asserts her authority to curb their snobbishness and indifference. Maggie also embodies the middle-class values of hard work, productivity, and respectability that come from commercial success. These virtues are traced to the efforts of a strong woman. Maggie is a "man's woman," the power behind the man, and the rehabilitator of the family. Her power is exercised not in her own person but covertly, through men. Not only is she instrumental in transforming the public sphere, but she also transforms a commercial relationship with Willie into one of romance and companionship, initiating the reluctant male into sexuality. But as Willie rises in power and self-confidence, she begins to assume a less dominant position, permitting him to be the master. She has rid herself and the family of a tyrannical master, but instead of assuming authority, she makes room for a new master. For all of its satiric cast, the film appears consonant with the other 1950s films in asserting the rights of men and of the family. The film's ideology expresses the familiar social attitude of allowing women power but restricting it to the domestic sphere. The female becomes the instrument for transforming the traditional image of the patriarchal family while still maintaining patriarchy.

The family melodramas, like the women's films and the tragic melodramas, reveal that British cinema has always been cognizant of and addressed issues concerning British culture. In spite of the assertions that the British cinema prior to the 1960s was studious in avoiding serious social issues confronting its audiences, these melodramas from the 1930s through the 1950s provide a wealth of information about British society. The melodramas of the pre–World War II era provide an image of the family as the mainspring of British social life and are concerned with issues of tradition, continuity, class integrity, and generational harmony. Even in the films of the war era can be seen the attempt to maintain a sense of the viability of domestic relationships in spite of the separations

and sacrifices required by the war. However, conflict is evident in the
tenuousness of the relationships between men and women who find them-
selves confronting new situations and demands as a consequence of the
changed life-styles brought about by women's involvement in the public
sphere and their greater sexual freedom. For men, too, the separation
from wives and lovers brought new temptations and challenges in rela-
tion to sexuality and identity.

With the end of the war, films did not merely return to prewar repre-
sentations of love and marriage. The cinema that during the war had also
catered to a female audience was now largely addressed to men or to the
family, and, to a lesser extent, to young people.[30] Surprisingly, even where
they seek to recover the past, the narratives portray the contradictions
confronting men, women, and children in a world that is portrayed as
unfamiliar, if not threatening. The focus on the domestic sphere is indica-
tive of a retreat from the public sphere and of the displacement of con-
cerns onto the family and the immediate community. Yet the films can be
read as addressing broader social problems in their preoccupation with
such issues as troubled male authority and identity, the unstable position
of the female in the family, the role of young people unlikely to accept
familial pressures without resistance, and, above all, the disrupting effects
of sexuality.

For the most part, the films stress compromise rather than coercion in
creating an image of familial roles that can satisfy the needs of men,
women, and children in the audience. In order to produce a more stable
familial image, women must be presented as accepting the constraints of
romance and marriage. Where they are unable to conform, they are elim-
inated from the narrative. Men, who are more frequently the objects of
concern and desire, are portrayed as in need of support as they seek to
gain a sense of power and authority. In the case of overbearing men, they
are humbled; in the case of men who struggle to find a place for them-
selves, they are, with the assistance of women, brought to a sense of
personal power. These films offer a picture of a society struggling to
maintain a sense of continuity and consensus, but the conflicts portrayed
reveal the fragility of the compromises between men and women, parents
and children, and family and community. In particular, the emergence in
the late 1950s in Britain of films that focused on the working-class family
male signaled general discontent with the culture in relation to family,
marriage, gender roles, work, leisure, and patterns of consumption and
anticipated the assault on family life as the backbone of British society
that would be heralded by the films of the 1960s.

Film Comedies

AS A MAJOR genre in the British cinema, comedy is represented in a variety of forms: romantic comedies, comedian films, musicals, genre parodies, comedies of manners, family comedies, and satires. Though this genre is a staple of British cinema, and though production of comedy films continued unabated from the 1930s through the 1950s, there are few studies devoted solely to the subject aside from certain studies of British comedy stars, the influence of the music hall on the cinema, and studies of the Ealing films. The low esteem in which British cinema has been held, the predilection for the realist aesthetic as opposed to the cinema of genres, and the priority given to films and filmmakers that have received international acclaim have been in part responsible for this situation. Neglect may also be due to the tendency in general to accord attention to individual texts rather than to genre analysis, a situation which is gradually changing. In disinterring neglected genres and stars, current critical revaluations of British cinema are beginning to address the contributions of such 1930s figures as Gracie Fields and George Formby. As yet, there is little to be found on the comedies of Jack Hulbert and, surprisingly, Will Hay, though the latter's *Oh, Mr. Porter!* is often cited in passing as an exemplary film comedy. An analysis of the comedies of the 1930s reveals that there were, in fact, distinctively British films that caught the imagination of British audiences owing to the commanding personalities of particular performers. In fact, these comedy performers can be considered in the context of auteurism with their distinctive vision of the world and personal style of self-presentation.

That comedy was an important genre in the 1930s is corroborated by Jeffrey Richards' listing of the types of films produced; for example, the year 1932 alone saw the production of "60 comedies, 32 crime films, 21 musicals, 16 dramas, 15 romances, 4 adventure films, 1 war film, 1 sports film, 1 horror film."[1] The ratios of the genres remain roughly similar throughout the decade. As with other genres, British film comedy has been indebted to literature and to the theater, but the most important source for 1930s comedy was the British music hall. In attempting to address the evolution of British cinema, Andy Medhurst has commented

on the importance of the music hall for the development of silent film comedy. He says: "The most important link between cultural modes forged in the halls and the new possibilities of film was, of course, silent comedy. In the early days of the halls, comedy had been confined to comic songs, but with the expanding range of performers and the influx from circus and fair traditions, comic sketches had found immense popularity."[2] Medhurst traces the relationship between the music hall and clowning, the prevalence of certain stereotypes that were based on regional differences, and parody. The silent cinema's emphasis on the chase, on gags, on bodily movement, on physical traits, can be traced to music hall humor. The early sound cinema was also heavily indebted to the performers and the routines forged in the music halls.

The film revue *Elstree Calling* (1930), directed by Adrian Brunel with interludes by Alfred Hitchcock, provides confirmation for the structure as well as the nature of some British comedy of the early 1930s. The film offers an array of prominent singers, dancers, dramatic actors, and stand-up comics performing in various skits. The film is essentially plotless, relying on the progression of the performers with comic interludes in the form of an ongoing unsuccessful struggle with a television set to receive the performance. The eclectic nature of *Elstree Calling*, bringing together West End performers such as Jack Hulbert and variety stars such as Lily Morris, serves to call attention to the contrasts between live entertainment and cinema. At the same time that the film acknowledges the role of the variety performer in the revue format, the film also acknowledges differences between variety performance and cinema, and, as Medhurst suggests, this difference inscribed in the film reveals the inevitable movement toward the development of cinematic genres. The film, an exploration of the possibilities of sound in film, even includes a humorous critique of the very new medium of television. Above all, the vitality of the individual acts creates a link with music hall performance, while at the same time sounding a note of nostalgia for the passing of this medium of entertainment. Commenting on Lily Morris's performance, Medhurst asserts that "her songs might strike the modern viewer as the most impressive and vital moments of an otherwise plodding film, but there is a sense in which she is being positioned by the text as some kind of curio, a hangover from more 'earthy' days set against the numb glamor of the lines of chorus girls. Music hall is thus referred to as something historical; something, by implication, superceded."[3]

As in the case of early Hollywood musicals that feature the revue format, the British use of this format is indicative of a regression from complex narrative forms developed during the silent cinema due in part to the attempt to accommodate the new sound technology, but it is also characteristic of the cinema's evolution to graft older forms of entertainment

onto the new medium. The coming of sound was no exception. In the case
of comedy, the music hall offered opportunities for the sound cinema,
particularly in the form of musical numbers. As Medhurst states, "Now,
at last, the true center of the music hall experience, the comic and senti-
mental song, could be incorporated into cinema."[4] The traces of music
hall comedy were equally evident in the billing of certain comedians who
had established their reputations in variety acts, and in the episodic na-
ture of comedy films, which focus more on the individual than on narra-
tive development. The films of music hall stars such as Gracie Fields and
George Formby were tailored to suit their particular personalities and
talents. Thus, the narratives that were subordinated to their perform-
ances have been denigrated as episodic, lacking in the narrative unity and
coherence associated with classic cinema. But the comedy films of these
performers become more comprehensible when set in the context of their
music hall antecedents.

Toward the end of the decade, the eclectic revue film was supplanted
by other forms: the short film, which allowed for the shorter comic acts,
and the ninety-minute film, which made greater or lesser concessions to
narrativity. Those revue films that persisted were tied more closely to a
narrative line, as became the case in Hollywood cinema.[5] While the dom-
inant form of comedy to emerge was to depend on a more complex narra-
tive than the revue film, the traces of music hall comedy were not totally
obliterated in the narrative film and can be located in the comedian films
that starred such performers as Gracie Fields and George Formby. The
films of these music hall stars were tailored to conform to their particular
musical talents, and as Medhurst indicates, "These films were never par-
ticularly trying to be seamless narrative texts; they were unabashed vehi-
cles for the talents of their stars."[6]

In particular, the personality of the star is central to an understanding
of the ways in which the films work. For example, the characters will
often adopt their own names or a name that carries over from film to film,
such as "Gracie," "Norman," "Gert and Daisy," or "Old Mother Riley."
Moreover, the performer's character and personality do not change from
film to film but remain constant. In effect, even where the narratives may
seem to differ, as in the Fields films, the basic format is the same, with just
a change in locale, costume, songs, and supporting actors. The comedian
star is also associated with a certain way of talking. In the case of Gracie
Fields and George Formby, it is their Lancashire dialect which is distinc-
tive, as well as their consistent way of confronting conflicts with the use
of aphorisms and certain homespun forms of wisdom. Their songs are an
extension of their dialogue and their practical assessment of the world.
They are also associated with a specific way of standing, walking, and
dancing, and with a certain form of physical clumsiness which is predicta-

ble, endearing, and a sign of their lack of guile. Their costumes are clues to their sex, class, and personalities. Gracie's suits, her sweaters, and her spit curl are her signature, and when she appears in something more sophisticated, this signals her playing a role. Formby's ill-fitting suit is as integral to his character as his ukelele.

The plots of the films in which these performers were featured were, as Roy Armes states, "straightforward, with the prime objectives—the capturing of the crooks (or whatever) and the winning of the girl—pursued with grinning gormless animation."[7] In the films featuring Gracie, the plots involved overcoming obstacles to being an entertainer, or more altruistic objectives of saving the dispossessed in her community. The films address different classes and usually inscribe representatives of the various classes, offering treatments of the upper classes that range from positive to parodic. The comedy is generated out of the characters' cornucopia of impersonation skills, their exposure of the pretensions and malevolence of others, and their personalities, which become excessive to the point of being a parody of others of their class and those of other classes. At moments of crisis, the performers resort to conventional gags, if not outright slapstick.

Other major comedian stars of the 1930s and 1940s were Jack Hulbert, Will Hay, Arthur Lucan, the Crazy Gang, and the Waters sisters. Each of them cultivated a particular comic persona and each was associated with a particular form of narrative constructed to suit the performer's talents. Their personalities were an amalgam of their individual physical traits, eccentricities of gesture, dependence on regional dialects, and skills of impersonation, which enable them to reproduce prevailing cultural stereotypes. They are the agents responsible for creating a topsy-turvy world in which, in M. M. Bakhtin's terms, carnival prevails, a festive sense of the world that violates the high seriousness of conventional attitudes and behavior. In examining the transformation of genres in the modern world, Bakhtin finds that while "all high and serious genres, all high forms of language and style, all mere set phrases and linguistic norms were drenched in conventionality, hypocrisy, and falsification, laughter alone remained uninfected."[8] These comments apply equally to the film comedy of these performers, who are able, through generating laughter, to ridicule and parody social rituals, as well as the various genres that embed these rituals. The vitality of these comic performers can be accounted for by the greater closeness of their comedy to everyday and commonplace experience than that achieved by melodrama.

While a good share of British cinema of the 1930s and 1940s derives from these comedians, the British comedy of this period is not exclusively associated with the music hall and its working-class personalities and audiences, but also with the theater. The cinema turned to the theater for

material, and audiences were treated to the comedies of Shakespeare, Oscar Wilde, and George Bernard Shaw as well as to contemporary West End comedies. The British cinema of the period had its share of upper-crust romantic comedies. Korda's London Films produced sophisticated comedies along the lines of Hollywood's *Trouble in Paradise* (1932), *Design for Living* (1933), and *Dinner at Eight* (1933). Like Hungarian and Italian white telephone films, named for the ubiquitous white telephone that decorated their sets, these comedies, based on contemporary English and European plays, featured the follies and foibles of the rich.

Romantic comedy and comedies of manners were to continue into the 1950s, while the comedian films were to diminish in number and in popular appeal, represented mainly in the work of Sid Field, Norman Wisdom, and Benny Hill. In the post–World War II era, the cinema boasted a host of comedy talents in the work of the writer-directors Frank Launder and Sidney Gilliat, the Boulting brothers, and Ealing directors Alexander Mackendrick, Robert Hamer, and Charles Crichton. Actors Alec Guinness, Joyce Grenfell, Margaret Rutherford, Alastair Sim, and Peter Sellers are also responsible for the success of these films. While their film personalities are distinctive, they differ from the personality comedians in being associated with their various comic roles rather than with their own personalities. The protean quality of Guinness and Sellers, their ability to impersonate a large number of different roles within one film and from film to film, distinguishes their work from that of most of their predecessors.

The Ealing comedies and the films of Launder and Gilliat, at their best, are carnivalesque. They focus on dominant social institutions—the public school, the world of commerce and industry, political parties—and turn them on their head. In these narratives, the complacency of the status quo and the rigidity of social structures is threatened by eruptions of physical and psychic energy. Ian Green stresses the importance of comedy in the "overcoming of inhibitions," thus enhancing the potential for a social and political critique. He states: "The problem, or the inbuilt contradiction of the comic framework then, is that it can be seen simultaneously (1) to overcome censorship, both in the straight social meaning of the term and in the Freudian sense of the censorship of conscious and pre-conscious processes, and thus can treat the sensitive issues of varying natures; and (2), through its mechanism, to avoid, repress or displace the treatment of sensitive issues by, so to speak, drowning them in laughter. The first process negotiates; the second avoids possible unpleasure through a comic form. Both, of course, aim to give pleasure."[9] The prevalence and success of British comedy, to follow Green's suggestions, must be related to contradictions in the culture. The existence of rigid and hierarchical social forms lends itself to a carnival atmosphere, for there would be no

need to turn the world upside down if it were not so insistently ordered and controlled. The pleasure of comedy is thus related to the subversion of the mechanisms of repression.

The British comedies of the 1930s and, in particular, the films of Gracie Fields have been identified by such critics as Jeffrey Richards as a cinema of consensus.[10] Within this context, how is it possible to see their comedy as subversive in the way that Green suggests? The answer lies in part in the ways in which these comic figures expose social conflicts at the same time that they work magically to overcome them. The films are not simpleminded homilies. The clowning of the characters, their stylized self-presentations, and, above all, their disingenuousness allow the narratives to penetrate sacrosanct areas of family and social behavior. The comic protagonists are the embodiment of integrity, representatives of community spirit. The later Ealing comedies did not introduce the preoccupation with community; it was already amply displayed in the films of Gracie Fields, in which even the spectator's role is a participatory one. The internal audience, which is not a mere observer but interacts with the protagonist, is a surrogate for the external audience. This era, which ranges from the early comedian films to the satires of the late 1950s, foregrounds transformations that take place in representations of gender, sexuality, class, and notions of social cohesiveness in the cinema. By the 1950s, the sense of community celebrated in the Gracie Fields films, the consensus generated by the wartime ideology that had lingered into the immediate postwar years with the Ealing comedies, had disappeared, and in their place appeared a generalized discontent with all aspects of British social institutions ranging from the family to schools, law, commerce, and politics.

FILM COMEDY IN THE 1930s

Personality Comedians: Gracie Fields

In *Sally in Our Alley* (1931) and *Sing as We Go* (1934), Gracie Fields is the vital center, the embodiment of community cohesiveness and of the potential of society to renew itself in spite of family tensions, economic hardship, and class conflict. The world she inhabits is not a reflection of the external society of the 1930s but rather an expression of an ideology characteristic of that time. The ideology is not monolithic; it is rife with contradictions in relation to the conflicts it presents, and at the center of these contradictions is the figure of Gracie herself and what she represents. First of all, Gracie's character is constructed on a dual sense of her being just like everybody else and yet different. This fusion of ordinariness and specialness is intrinsic to the star image. Gracie's ordinariness is

broadcast in her appearance, her actions, and her commonsense approach to conflicts, but her specialness is manifested also in her talent, her ability to entertain. As Richard Dyer indicates, "One of the problems in coming to grips with the phenomenon of stardom is the extreme ambiguity/contradiction between the star-as-ordinary and the star-as-special. Are they just like you and me, or do consumption and success transform them into (or reflect) something different?"[11] The comic performer as star depends also on this combination of the mundane and the exceptional. Physical appearance, which is always important in cinema, tends in comedy to become even more prominent, because comedy itself is so physical. Gracie Fields' awkwardness, her androgyny, her unglamorous though not eccentric personal appearance serve to enhance the sense of the ordinary, but her largesse and her talents elevate her above others. Increasingly, this image is compromised as she is transformed in her later films into a more glamorous figure with costumes not unlike the one she makes fun of in *Sally in Our Alley*. Fields' musical comedies offer a different class perspective of women's representations. Unlike Jessie Matthews, Gracie's image violates conventional notions of glamour.

As Rachael Low describes her, "Her hair, make-up and clothes were natural and inconspicuous and the mugging and raucous singing which were to be so marked in some of her films were not allowed to get out of hand and make the romantic ending appear incongruous . . . some sort of love interest was expected in a film. Each of her pictures tackled this question differently, but attempts to make her more glamorous, with hard lipstick and eye make-up, tightly-waved hair and fussy clothes, were inconsistent with the slapstick, the grimaces and clowning and the caricatured delivery of the comic songs."[12] However, the inconsistency to which Low refers between glamour and slapstick, as we shall see, functions as a metacommentary on Fields' position in the narrative as a female and as a typification of a working-class female, introducing elements of masquerade. Fields' persona and her appearance were at odds with conventional notions of beauty, and her position within the narrative is rarely one of subordination. She serves as a catalyst for the action, setting situations to right that none of the men seem capable of even addressing. The earmarks of Fields' comic mode are her mastery of slapstick, her energetic delivery of songs, and her skill at impersonation. But the combination of the mundane and the exceptional is not only what links her to her audiences but also what finally separates her from them. In this way, the films both offer a sense of hoped-for transformation and at the same time indicate its remoteness.

Sally in Our Alley (1931), Gracie's third film, which Basil Dean produced and Maurice Elvey directed, is a romantic comedy. Sally's (Fields) young man, George Miles, played by Ian Hunter, goes off to war, is

wounded, and decides that he does not want to be "half a man" to Gracie and will, therefore, let it be known that he has died. Sally struggles on in her working-class milieu, working as a waitress in a restaurant and also entertaining the customers. As in other films, her singing usually turns out to be a community enterprise in which the members of her audience sing along with her. She lives in extremely modest surroundings and is sensitive to the plight of her neighbors, always eager to support others in trouble. She takes in a young woman battered by her father, Florrie (Florence Desmond). Florrie steals, lies, manipulates others, and even vilifies Sally for helping her. But Sally does not turn on her. Even in the face of Florrie's lying to George, trying to seduce him, and stealing his wallet when he returns, having changed his mind about playing dead, Sally remains loyal. Florrie threatens to break Sally's possessions, and Sally tells her to do it, if it will make her feel better. Florrie destroys everything in the room, but softens in her attitude to Sally. Sally's relationship to Florrie provides a specific instance of the ways in which Fields occupies a transformative position. Florrie's major occupation is reading movie magazines, and the film makes an implicit contrast between the life of glamour and the more commonplace aspect of life in the alley. Sally, however, does not abandon Florrie but rather helps her to express her pent-up rage.

Fields is often placed in situations that take her out of her working-class milieu, with varied results. In this film, they are negative. She is asked to perform for upper-class clients who have come "slumming" to the restaurant. Delighted with her, they ask her to entertain for a party. Sally is brought to the house, dressed in a slinky backless dress, which embarrasses her. When she performs, the audience treats her with condescension, as a freak. Their singing along with her is presented as noblesse oblige and as voyeurism, in contrast to the community involvement with her singing in her neighborhood. With the upper-class audience, she is on stage, clearly separated from the spectators.

The street setting is central to the idea of community. Sally is, as the title implies, a member of the alley, but she is also singled out by her resilience and generosity. The film is not predicated on upward mobility but on the protagonist's amazing ability to survive. Believing that her young man is dead, she continues to struggle bravely until he returns. Her work as a waitress is a combination of universal mother and entertainer, and her singing becomes the signifier of her special ability within the narrative to create a sense of belonging for others. In contrast, the sequence in which she performs for an upper-class audience reveals the way she is depersonalized by them and treated as an object of voyeurism. The film is a comedy of reconciliation which depends on the elimination or transformation of dissonant elements that would undermine collectivity, but,

like Gracie's persona, the film exposes itself as a fiction. As Stephen Neale writes, "What comedy does, in its various forms and guises, is to set in motion a narrative process in which various languages, logics, discourses, and codes are, at one point or another—at precisely the points of comedy itself—revealed as fictions."[13]

Sing as We Go (1934) can be invoked in support of an assault on certain generalizations about British cinema, namely, that it was totally colonized by Hollywood, that it was deprived of vitality by British censors, that it was not popular with British audiences, and that it was removed from British values, attitudes, and dominant myths.[14] Basil Dean's Associated Talking Pictures was responsible for some of the most popular working-class comedies of the era, including those featuring stars such as Fields and Formby, and for hiring writers with populist inclinations. *Sing as We Go* features Gracie as a worker at the Greybeck Mills. She and her coworkers are laid off because the management can no longer make a profit. But the workers are not portrayed as dejected. They sing as they leave, a jarring image in the context of their situation but consonant with the star's persona.

Gracie, who lives with her devil-may-care Uncle Murgatroyd, undertakes a number of jobs to survive—kitchenmaid and later girl in a vanishing act—and the comedy derives from her mimicking abilities as well as from the slapstick. As in *Sally in Our Alley*, she befriends a young woman, Phyllis, and guides her through the moral quagmires of Blackpool. The mill is finally reopened and Gracie is rewarded with a position as welfare officer. She and the others sing the theme song as they return to work, thus recalling the initial scenes in the film and seeking to validate the workers' faith. A montage of scenes of work blending with the workers marching back to the factory accompanied by Gracie's singing and her image in medium close-up ends the film.

Tony Aldgate reads the film as a "stirring and patriotic assurance that all will be well in the end," but this reading makes assumptions about the spectator's experience of filmic events. The implication that the comic ending resolves the film's conflict flies in the face of the insoluble problems posed by the film, namely, the contingent situation of the workers, the unlikelihood of magical "cures" for the depression, and the hand-to-mouth unpredictable experience of being out of a steady job. Moreover, the assumption that audiences confused conventional comic closure with "reality" is as untenable as the assumption that they unambiguously believed the 1930s myth of consensus. The slapstick in the film masks the struggle to survive, which involves Gracie in a number of situations threatening to her integrity and well-being. The humorous treatment of Gracie's escapades softens but does not mitigate the conflicts. While the film draws on conventional rescue myths and dominant social myths re-

lating to images of productivity and collective effort, it also reflexively makes a distinction between the world of fiction and the external world of the audience.

Working-class spectators of that era might have understood and empathized with the heroine's conflicts. Gracie functions as a symbol of the working class. She comes from working-class origins. The milieu in which she moves is working class. Her appearance and behavior are devoid of pretension; in fact, they are geared to exposing pretensions. Her character is presented as self-effacing rather than personally ambitious; her actions are usually on behalf of others. Of Gracie Fields, Basil Dean wrote, "Gracie's ability to portray sentiment and in the same breath to make fun of it expressed her affinity with that North Country view of life that enables the hard pressed to face difficulties with a laugh."[15] There is nothing about her personality in the narrative that marks her as unusual. She does not fight the status quo, but is an agent in the service of family, work, and sexual morality, attitudes which are associated with the working classes as much as with the middle classes. Where she diverges from middle-class characters is in her lack of driving ambition, her sense of class solidarity, and her identification with her community. Gracie's survival strategies are practicality, common sense, and a quick tongue. As a working-class female, she is independent and suffers little of the psychological conflicts of her middle-class sisters as represented by Phyllis, the woman Gracie saves in this film.

In the progression of the Fields films, one can see changes in her persona from the films she made for Basil Dean to those she made for Monty Banks. The earlier films are marked by more restraint and a more proletarian treatment of the star. The films after 1936, like *Queen of Hearts*, are more elaborately scripted. In this backstage musical, she is a stage-struck seamstress who falls in love with a film idol, Derek Cooper (John Loder). She saves him during a drunken car ride, takes him home, mends his clothes, and keeps him out of trouble with the police. Upon returning his clothes to the theater, she is mistaken for a wealthy woman, Mrs. Vandeleur, who is to audition for a role. She wins the part under false pretenses and becomes a success. The seamstress leaves the workaday world and enters the world of make-believe and entertainment. The comedy is generated out of the misunderstandings that arise in the protagonist's attempts to move out of her world and into the professional entertainment world. She is threatened with legal action for impersonation, but her talent wins over the manager, and in a frantic finale he keeps the police at bay while Gracie makes theatrical history. At the end, she is also reconciled with her mother. She has overcome family opposition, the law, competition with another leading lady, and doubts about her talent, but her role as a professional entertainer in the film places her above her audiences as a star, not with them as in many of her other films.

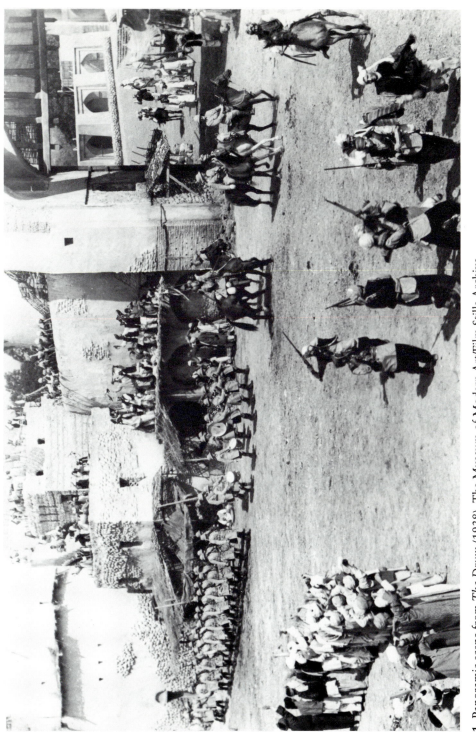

1. Panoramic scene from *The Drum* (1938), The Museum of Modern Art/Film Stills Archive

2. Jessie Matthews in *Evergreen* (1934), The Museum of Modern Art/Film Stills Archive

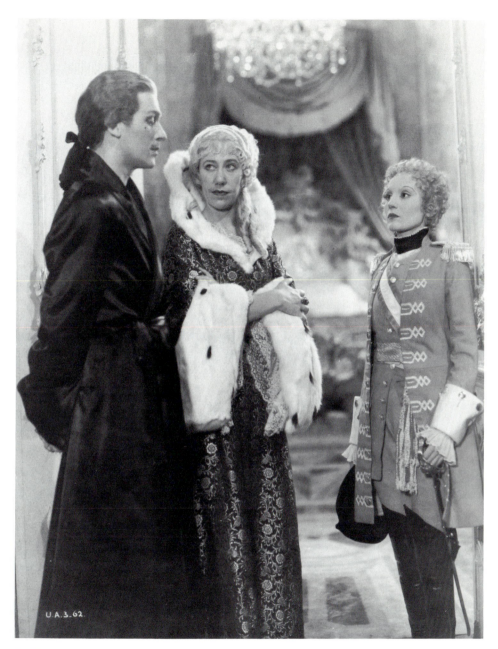

3. Elisabeth Bergner, Flora Robson, and Douglas Fairbanks, Jr., in *Catherine the Great* (1934), The Museum of Modern Art/Film Stills Archive

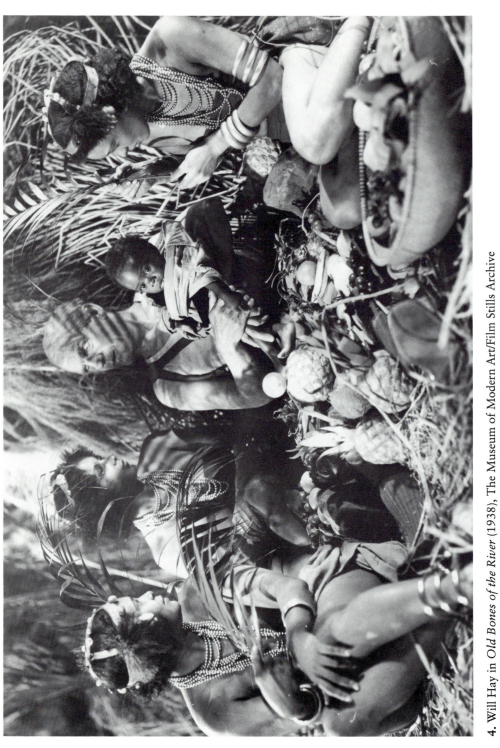

4. Will Hay in *Old Bones of the River* (1938), The Museum of Modern Art/Film Stills Archive

5. Paul Robeson and Leslie Banks in *Sanders of the River* (1935), The Museum of Modern Art/Film Stills Archive

6. Music hall scene from *The 39 Steps* (1935), British Film Institute (Courtesy of Rank Enterprises)

7. *On the Night of the Fire* (1939) with Ralph Richardson, The Museum of Modern Art/Film Stills Archive

8. Wilfrid Lawson in *Pastor Hall* (1940), The Museum of Modern Art/Film Stills Archive

9. Arthur Lucan as *Old Mother Riley* (1937), British Film Institute (Courtesy of Butcher's Film Distributors)

10. *They Were Sisters* (1945) with Phyllis Calvert, Anne Crawford, and Dulcie Gray, The Museum of Modern Art/Film Stills Archive

11. Wartime factory scene from *Millions Like Us* (1943), The Museum of Modern Art/Film Stills Archive

12. Stewart Granger and John Mills in *Waterloo Road* (1945), The Museum of Modern Art/Film Stills Archive

13. Roger Livesey and Anton Walbrook standing beneath a painting of
Deborah Kerr in *The Life and Death of Colonel Blimp* (1943), The Museum of
Modern Art/Film Stills Archive

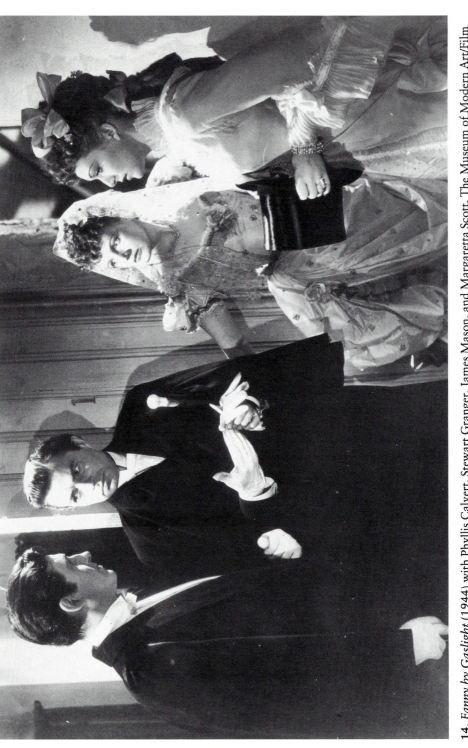

14. *Fanny by Gaslight* (1944) with Phyllis Calvert, Stewart Granger, James Mason, and Margaretta Scott, The Museum of Modern Art/Film Stills Archive

15. Ann Todd, Herbert Lom, Albert Lieven, David Horne, and Manning Whiley in *The Seventh Veil* (1945), British Film Institute (Courtesy of Twickenham Studios)

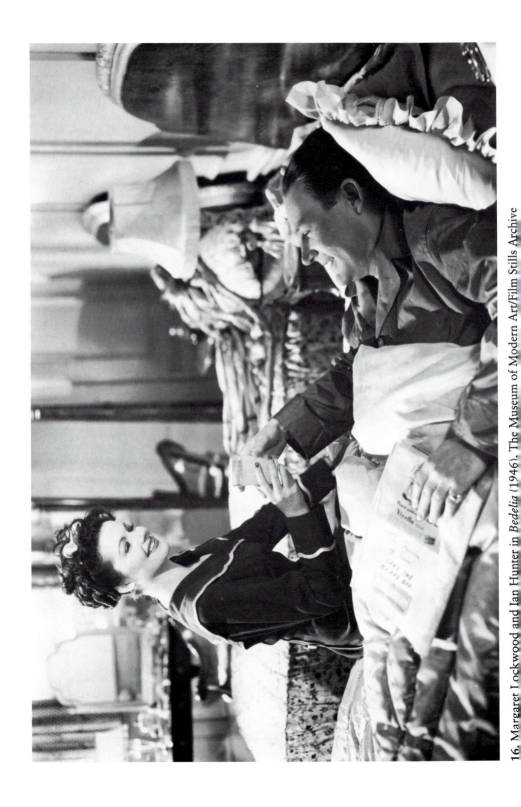

16. Margaret Lockwood and Ian Hunter in *Bedelia* (1946). The Museum of Modern Art/Film Stills Archive

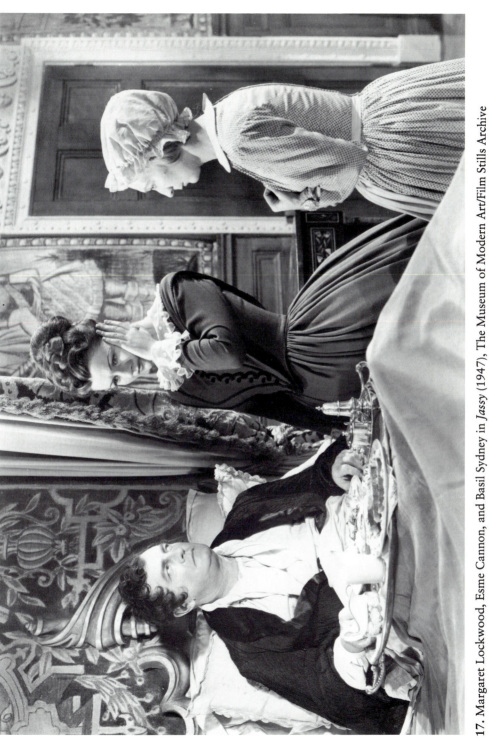

17. Margaret Lockwood, Esme Cannon, and Basil Sydney in *Jassy* (1947), The Museum of Modern Art/Film Stills Archive

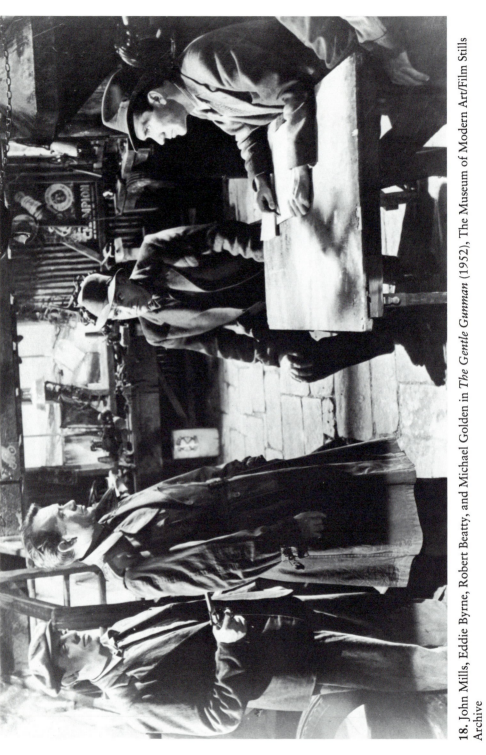

18. John Mills, Eddie Byrne, Robert Beatty, and Michael Golden in *The Gentle Gunman* (1952), The Museum of Modern Art/Film Stills Archive

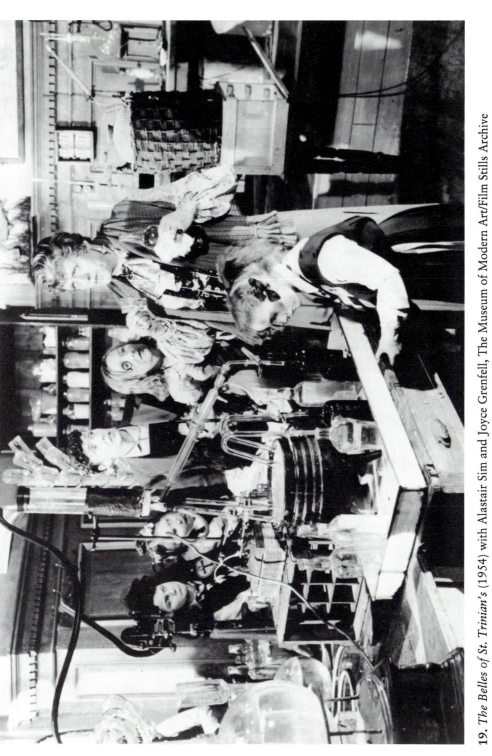

19. *The Belles of St. Trinian's* (1954) with Alastair Sim and Joyce Grenfell, The Museum of Modern Art/Film Stills Archive

20. *The Stranglers of Bombay* (1959) with George Pastell as the High Priest, The Museum of Modern Art/Film Stills Archive

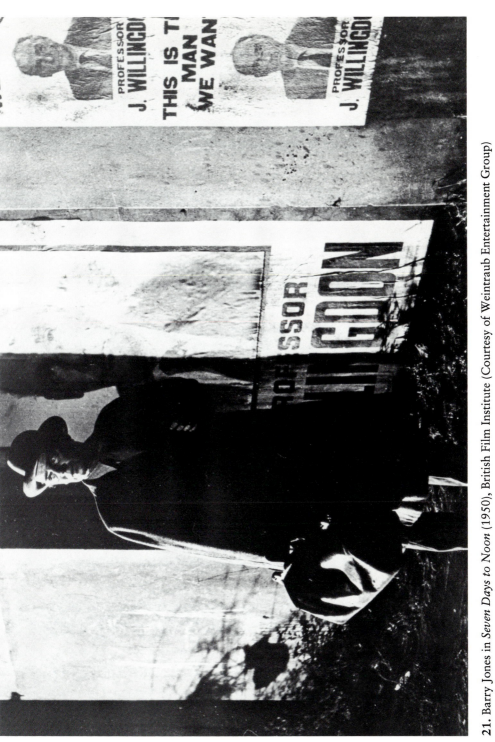

21. Barry Jones in *Seven Days to Noon* (1950), British Film Institute (Courtesy of Weintraub Entertainment Group)

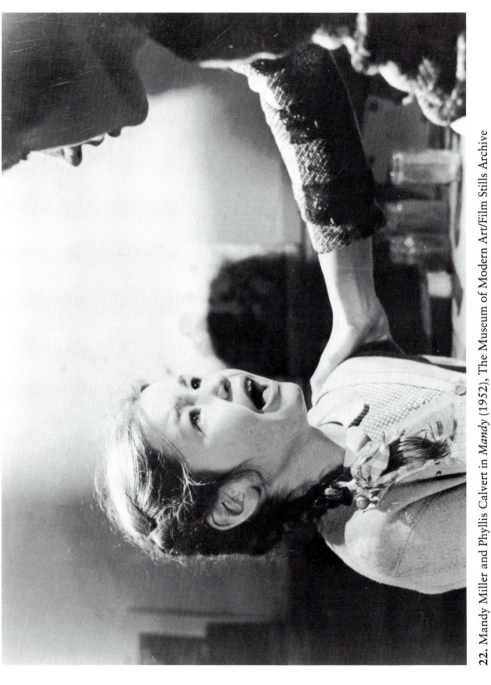

22. Mandy Miller and Phyllis Calvert in *Mandy* (1952), The Museum of Modern Art/Film Stills Archive

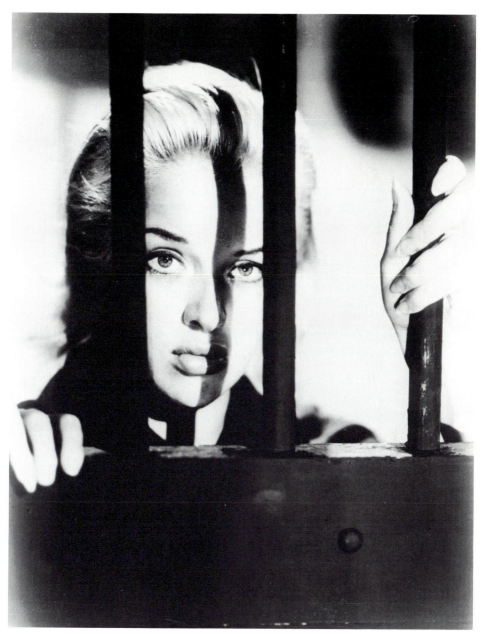

23. Diana Dors in *Yield to the Night* (1956), The Museum of Modern Art/Film Stills Archive

24. Dirk Bogarde in *Victim* (1961), The Museum of Modern Art/Film Stills Archive

FILM COMEDIES **339**

Keep Smiling (1938) also features Gracie as an entertainer. She is the instigator of the cast's insurrection against the theater manager when they discover that he has been holding back their salaries under false pretenses. Gracie's initial number is as a soldier who looks and acts like Charlie Chaplin. After the performance a woman tells her that she "looks like an ordinary woman," and Gracie responds, "What did you think I'd look like, a French poodle?" The manager fires Gracie and the cast when Gracie turns the proceeds from the production over to a group of philanthropic women rather than allowing the manager to pocket the money. From here on the film becomes a series of adventures as she and the cast seek to support themselves. They first go to stay with Gracie's grandfather, who hates performers. They try a showboat but are sabotaged by their former manager, who floods the boat, but a dog turns out to be the source of the comedy and the key to resolving the film's conflicts. The dog belongs to a famous pianist who, when he finds his dog among the performers, is taken by their itinerant life and decides to join them. After some of the cast sabotage the performance by kidnapping the pianist, on whom all depends, the show goes on, and the performers are financially rescued. Gracie's songs seem designed to reveal her versatility. She sings variety-style songs, hymns, and conventional lyrics. In all instances, the audience's reaction to her singing is highlighted. The relationship between her songs and the narrative development resides primarily in the ways that they enhance aspects of her persona—as competent entertainer, as exemplar of religious and moral values, and as the cement that binds the troupe to her (with the exception of one character, an ambitious American). The film also establishes the material basis of their struggles. Gracie and the others need money. From the outset, the issue of monetary reward is highlighted; thus the film does not make entertainment a matter of mere self-enhancement or altruism but ties it to survival, an important feature of the Fields films.

Gracie is also permitted to display her skills as an impersonator when she goes to the hotel to return the dog but is denied entrance and is forced to resort to a number of disguises to get past the manager and others. Her appearance in the film is more akin to that in *Sally in Our Alley*, in which glamour is downplayed and Fields' "ordinariness" stressed. She is not a romantic figure but rather the agent of broader community reconciliation. The conclusion of the film reconciles her grandfather, the lovers, the performers and town authorities, and the audience, eliminating those elements that create dissension. Moreover, the androgynous quality of Gracie's appearance also seems to suggest that she is also a reconciler of sexual difference. Women in comedy generally tend to violate the more blatant aspects of the culture's sexual objectification, and Gracie is no exception. Her role in the narrative as a figure of reconciliation is dependent on her physical appearance as well as on her talent, which allows her

to play an active role in resolving conflict. Unhampered by the baggage of excessive femininity, she is freer to be an instigator of rebellion, a leader of the group, and a solver of men's and women's problems. In another sense, Gracie is a stand-in for the film's director, creating pleasure and banishing conflict through entertainment.

Though *Shipyard Sally* (1939) harks back in motif to *Sing as We Go*, it marks a further stage in the mythification of Fields. It was the last film she was to make in England before she left for Hollywood.[16] Again, the workers are unemployed, this time at the Clydeside Shipyards, and Sally undertakes at the bequest of the workers to go to the head of a parliamentary investigative committee and plead for the opening of the shipyard. Through the machinations of her ne'er-do-well father, she finds herself the owner of a pub that loses business with the closing of the yard. Having won the hearts of her customers, she is elected to speak to the chairman of a parliamentary committee, Lord Randall, about saving the shipyard. Her father accompanies her on this trip to London, almost undermining the project. After a series of escapades in which she impersonates a man in order to get into a club to find Randall and then later impersonates an American popular singer in order to get into his home, she succeeds in reversing the decision. Ultimately the shipyards are again opened in an ending that features the image of Sally conjoined to an image of the Union Jack. In this film it is not only the working classes who sing as they go but also the upper classes. Sally becomes the symbol for interclass solidarity. The film celebrates patriotism and preparedness, appealing to the working class in terms of promises of employment. But the film also portrays the specter of unemployment and the contrasts between working-class indebtedness and economic failure and the indolent life of the upper classes as portrayed at the men's club and at the party.

Sally's relationship to her father is by no means a negligible factor in the narrative. He is responsible for placing her in the precarious position of owner of a failing pub and depriving her of work as a performer. Through his dishonest gambling, he also threatens several times to undermine her project of converting Randall. She is put in the position of having to control him at the same time that she must entertain and appease Randall in order to gain concessions. Thus she must do battle in both public and private arenas.

If *Sally in Our Alley* portrays her as alien in the world of the upper classes, in this film she brings the upper classes along with her. She converts Lord Randall, ingratiates herself with his family and friends as she had with the workers at the shipyard, and returns to Clydeside a heroine. The element of interclass cooperation has insinuated itself, owing perhaps to the impending war as well as to changes in Gracie's self-presentation. She belongs not only to the workers, but to all classes. The finale

shows a montage of work, of a ship christening, and of Gracie superim-
posed on these images as she sings "Land of Hope and Glory." The film
seems also to be making a reflexive comment on entertainment and on
Gracie as entertainer, portraying her as the vital force that keeps the show
going. As in her other films, Gracie is a figure of service, but service is
extended to the nation at large.

Gracie Fields' films are not only about her role as a rescuer and savior
of the community; they also portray her as a survivor, though survival is
not the same as overt resistance. Self-consciously, her independence and
opposition to injustice and economic hardship are distinguished from
more radical forms of opposition. For example, *Shipyard Sally* includes a
brief scene in which Sally interacts with a chauffeur who is a Communist.
His diatribe against the ruling class is portrayed as irrelevant to a context
in which survival rather than resistance is the dominant preoccupation.
Sally's populism is proposed as more consonant with the needs and pref-
erences of the workers.

Jessie Matthews

Another popular female comedy star of the era was Jessie Matthews, who
appeared in a number of highly successful musical comedies—*The Good
Companions* (1933), *Evergreen* (1934), *First a Girl* (1935), *It's Love
Again* (1936), *Head over Heels* (1937), *Sailing Along* (1938), and *Climb-
ing High* (1938). Like Gracie, Jessie was from the working class. Both
women began their careers on the stage. In the roles they played, "both
were seen as independent strong-willed working women achieving suc-
cess in a hard, competitive world."[17] But here the similarities end. Where
Gracie's films primarily situate her in a working-class milieu and focus
on issues of community, Jessie Matthews' are geared toward romance
and individual aspirations. Describing the Matthews films as "Art Deco
fantasies" which take place in the "hermetically sealed black and
white world of ritzy night clubs, radio studios, theatres and mansions,"
Richards views them as producing "an ambivalence of response, both as
a middle-class symbol in the Thirties and since then as a symbol of frivol-
ity and the willful disregard of the real world."[18] The label of escapism
inhibits an understanding of the films' concerns, implying that fantasies
have no substance. But an analysis of many of these comedies reveals their
basis in identifiable psychological and social conflicts involving personal
needs and aspirations. The major difference between the Fields and the
Matthews films lies in their treatment of gender and sexuality. The never-
never land of the Jessie Matthews films enables them to entertain less
commonly addressed sexual conflicts, but sexual conflicts nonetheless.

First a Girl (1935), as its title suggests, is a comedy that self-con-
sciously calls attention to questions of sexual identity. Based on the Ger-

man film *Viktor und Viktoria* (1934), the film involves the motif of male and female impersonation. (The film was remade by Blake Edwards in 1982.) Directed by Victor Saville, for whom Matthews made her most successful films, *First a Girl* stars Jessie Matthews as Elizabeth, an employee at a high-fashion establishment who aspires to be a performer. Elizabeth borrows a dress she is asked to deliver to a customer and goes to an audition, where she has no luck but where she meets Victor (Sonnie Hale), who fancies himself a Shakespearian actor but earns his living as a female impersonator. Elizabeth is caught in a downpour, ruining the dress, and Victor takes her to his room to dry out. There he discovers that he has lost his voice and cannot perform that evening, and he begs her to perform for him. Giving her men's clothes, he takes her to the theater and introduces her as a young man. The act is spoiled when a group of geese are let loose and a bucket filled with water tips over and the stage is flooded, causing Elizabeth to slip and fall. The audience is amused by the act and the manager offers "Victor" a contract. When the manager leaves, Elizabeth tells Victor that she refuses to "be a man all her life," but he convinces her to play the role. Thus begins her successful career in top hat and tails.

Complications begin when she meets Robert (Griffith Jones), escort to the princess (Anna Lee) whose dress Elizabeth was to have delivered. He develops an antipathy to Elizabeth, saying, "I detest men who make marvelous girls." Elizabeth tries to play the part of a manly man, giving Robert her worldly wisdom about women. She competes with him in drinking and gets drunk, endearing herself to him. He later tells the princess that "Bill is a great guy," though she scornfully says that he is "effeminate." Suspecting that Victor is really a woman, the princess plans an outing with Elizabeth and Victor in which the three "men" will share a room and in that way, Robert can discover Victor's sexual identity. Elizabeth maintains her imposture, but he discovers her identity when he observes her swimming. He withholds the information from the princess, but Elizabeth exposes herself when she goes to her to plead her love for Robert. The princess threatens to give her away. Finally, with Victor's assistance, Elizabeth and Robert are reconciled, but a new problem arises in the form of a newspaperman who has gone to the police to report that Elizabeth is falsely impersonating a man. At the finale, Victor appears in her place and is hired by the manager to play Victoria. Now that he has succeeded, the princess tells him he can play Hamlet as he has always desired, but he counters by saying that he will play Cleopatra. Robert and Elizabeth, who have eloped, are stopped at passport control, where Elizabeth is quizzed about having a man's passport, but Robert assures the official she is "first a girl," and she adds, "Always a girl."

As in *Evergreen* (see Chapter 5), the notion of entertainment as allowing for flexibility within roles—for the purposes of successful com-

merce—is central. The appearance of Jessie Matthews as a man is a matter of clothes and lyrics. Literally, clothes make the man. She does not, except when she is sparring with Robert, play her role as a man. Her numbers are clearly designed for her to appear as a woman masquerading as a man. But there is an element in that portrayal that does more than merely exploit male impersonation as an in-joke shared by the audience. The film hinges, as do other Jessie Matthews films, on the issue of identity, but, more specifically, sexual identity. There is no question that Elizabeth is first a girl, but her masquerading as a man raises the specter of androgyny, which in turn raises the question, What is a woman? For that matter, Victor in the conventional manager/father figure role invites a counterpart question: What is a man?

Though homophobic comments are commonplace in the film, and though the film affirms traditional heterosexual roles, the notion of male and female impersonation and the questions it raises about social identity were challenging for a British audience of the 1930s. Moreover, while the film restores Elizabeth to her female identity, it refuses to reform Victor completely. The issue of a man falling in love with a man who is really a woman and of a woman falling in love with a man who is a female impersonator recalls the myth of sexuality in Plato's *Symposium*, which assaults rigid distinctions between male and female, heterosexual and homosexual. Comedy flourishes on doubling and the violation of accepted roles. Female and male characters often disguise themselves as the opposite sex until a new social balance is effected, but the action is usually confined to the private sphere. This film comes dangerously close to equating this form of impersonation with mainstream entertainment. This equation is attributable to the original German 1930s text, which contains elements of the cabaret subculture, but also to Saville's and Matthews' ability to make the cross-dressing appear unpremeditated, naive, and motivated by economic necessity.

The Perennial Youth: Jack Hulbert

Among male stars, Jack Hulbert was a popular comic actor. Hulbert's persona was dependent on his physical appearance. He was tall, long-legged, and exceedingly thin, with elastic body movements, and his countenance was distinguished by his exceptionally long and sharp chin. His performance was dependent on "the nonchalant dance, the wry song, the lopsided smile and the touch of romance."[19] His comedy was more sophisticated than Gracie Fields', more obviously geared to middle-class situations, language, and humor. In *Jack's the Boy* (1932), he plays Jack, the son of the police commissioner, who wants to follow in his father's footsteps but is obstructed by his own incompetence as well as by his father's opposition. Without his father's knowledge, he joins the police force, but he hides this fact from him under the guise of going fishing.

Unable to explain to his father the real reason for refusing to escort a young woman, Ivy (Winifred Shotter), from the train station to his home, he later sees her while he is on duty near the Loch Lomond Cafe, which is owned by a Scottish woman (Cicely Courtneidge) and her husband. He falls in love with Ivy, unaware that she is the same woman his father had asked him to meet. When he sees her again as a guest of his father's, and tries to woo her, he learns that she is engaged. Also at his father's party are some jewel robbers plotting their next crime, but their identity is undetected by either the father or the son. While on duty as a traffic policeman, Jack witnesses the robbery of the jewelry store. He follows the men but arrests the wrong man, which gets him suspended from the police force by his father, who learns in this way that his son is also a policeman. Jack insists that he knows the guilty party, shouting as he leaves his father's office, "An Englishman and a policeman. That can't be wrong." Undeterred, he and Cicely Courtneidge undertake an independent investigation. They finally track the crooks to Madame Tussaud's, where, as waxwork figures, they successfully photograph the robbers and expose them to the police. Jack's father now concedes that Jack is a policeman born and bred. Jack is also reconciled with Ivy, who had resented his casting aspersions on her suitor, Jules, finally exposed as a member of the gang.

The film centers on the traditional generational conflict between fathers and sons. The son is put in the position of having to prove himself to his father, and the gaining of the woman is integrally related to this enterprise. The criminal elements are eliminated. Property is restored, father and son reunited, and the young couple reconciled. Among other things, like *Bulldog Jack* (1935), the film is a parody of crime detection films. As opposed to the ratiocination of the straight detective film, *Jack's the Boy* proceeds through a series of episodes that introduce the role of misunderstanding, dogged persistence, and physical dexterity in solving the crime. Like so many films that portray British ingenuity, the emphasis is less on efficiency and rationality than on the sense of muddling through. Jack's physical awkwardness and bumbling are responsible both for getting him into trouble and for solving problems. Cicely Courtneidge as Jack's assistant also adds a different note to the conventional relationship between the detective and his sidekick. Not only does she introduce the element of the mundane as she pretends to be a professional cleaner, but she also provides a more convincing and practical witness to the dangers that she and Jack confront.

The climax of the film in Madame Tussaud's Waxworks generates the conventional comic dilemma of the struggle between animate and inanimate objects. Confusion arises about what is authentic and inauthentic, real and imaginary. Not only is comedy produced through the confusion

that arises through the struggle between people and things, reproductions and originals, but in this way the comedy undermines facile assumptions about the nature of the real. The victory of the comic protagonist is associated with the successful overcoming of mystifying and intractable objects. Jack (and the audience) can finally distinguish between the fake and the real, and this distinction carries over into the primary conflicts in the film, which are generational and sexual. In proving himself to his father and to Ivy, Jack establishes his claims to knowledge and competence and undermines his father's conventional opposition. In this way, he challenges his father while at the same time remaining within the orbit of paternal expectations.

If the comedy in *Jack's the Boy* is generated out of traditional comic conflicts associated with notions of continuity and competence, *Love on Wheels* (1932), directed by Victor Saville, adopts a more experimental mode associated with Continental and American comedy, particularly featuring the sights and sounds of urban life. The film begins with a scene that evokes experimental city films such as Ruttmann's *Berlin, Symphony of a Great City* (1927) and Vertov's *Man with a Movie Camera* (1928). The montage sequences of Fred's (Jack Hulbert) awakening draws visual parallels between the cleaning, gassing, and revving up of a car and the protagonist's awakening, washing, brushing, shaving, dressing, and leaving the house. In general, the film foregrounds modern machines and appliances. The scenes of the city, the emphasis on working people, the concern with rising modestly on the ladder of success, the emphasis on commodities, on advertising and selling, all mark this comedy as being in a different mode from that of many of the British comedies of the era.

The bus trip to work each morning is presented in terms of a familiar community. The passengers know each other. The conductor (Gordon Harker) is a benevolent father figure who plays the role of a Pandarus figure to Fred and the object of Fred's desire, Jane (Leonora Corbett), a student of music. The passengers sing as the bus takes them off to their places of employment. Fred works in a department store. His job is to blunt customers' complaints by assuming responsibility for any error. He is fired for incompetence when a complaint is lodged and rehired when the customer leaves. When Jane asks why he was selected for this position he says because he has a "suitable face." This reference to his face, a face presumably familiar to British audiences of the time, is only one of the numerous instances in which the film, in a manner typical of Saville's work, calls attention to the film as a film.

Fred is fired in earnest when he protests against his job, but realizes that he has now ruined his chances of courting Jane, and when she gets a temporary position selling music in the store, he pretends to be an excecutive in order to impress her. Their burgeoning romance is conveyed

through a musical number in the furniture department as the salesman (Roland Culver) tries to sell them a bedroom suite, but the idyll is shattered when Jane learns that Fred is a lowly employee. Finally, Fred gets his chance to rise in the world when he goes to a haberdasher to buy a hat and ends up as the window dresser for the establishment. His innovative windows bring in customers and he is rehired by the head of the department store as their window dresser, with unlimited authority. Jane, however, has disappeared, but with the help of his bus conductor friend, Fred finds her working as a pianist in a tough section of London. He brings her back and hires her to head the music department.

Cast in the mold of romantic comedy, this musical features the predictable conflicts associated with this genre—the desire of the male protagonist for a young woman who seems unattainable, the various obstacles that must be overcome in winning her, such as class differences, economic problems, and personal antipathies, and the various stages whereby the female is brought to overcome her objections, usually with the help of a third party who supports the protagonist. The song and dance numbers serve to identify the protagonist's state of mind as well as the progress of the courtship. Two audiences are usually apparent—the characters within the film which observe the progress of events (bystanders, employees, and audiences at performances) and the external audience, which is implicated in the process of looking by being made conscious of the need to look.

The film romanticizes machinery, gadgets, and city life. Selling commodities in the department store takes the place of the exoticism of upper-class comedies with their emphasis on the world of the rich. The film also sells itself as a commodity, since, through the musical numbers, the notion of entertainment is inscribed in the film in an equation between romance, upward mobility, and entertainment. The populist emphasis of the film, its focus on the plight of the little people with their aspirations to succeed, minimizes the role of class differences. Through the protagonist and the bus conductor, the film dramatizes the ingenuity, resourcefulness, and humanity of these people who are identified with the life and movement of the city and the department store, which is presented as a microcosm of modern urban life. Unlike the protagonists in Hollywood comedies of the time but like German, Italian, and Hungarian characters, British characters are usually not portrayed as escaping their class by marrying upward; rather, they are positioned in comfortable economic terms and united with members of their own class. *Love on Wheels* shares qualities with other comedies directed by Victor Saville. In the musical comedies he directed for Jessie Matthews, he blends a Continental style, if not a Continental scenario, with a particularly British cast of characters and locale.

Love on Wheels constitutes a significant departure from the classic type of comedy associated with Hulbert, while Walter Forde's 1935 *Bulldog Jack* is a variation on *Jack's the Boy*, with Hulbert again playing a detective in a spoof of the popular crime detection series with Bulldog Drummond. Jack Hulbert is joined by his brother, Claude. Jack is asked to impersonate the injured Drummond and solve a jewel forgery case. The woman in distress is Fay Wray, whose grandfather (Paul Graetz) is an expert jeweler who is being forced to duplicate a famous necklace from the British Museum. Drummond and his inept sidekick become involved in a series of false leads and threats to their lives as they track down the criminals. The film also uses quotations from other films, such as Lang's *Dr. Mabuse* (1922).

The villain of the film, Morelle (Ralph Richardson), is modeled on the German archcriminal, and the setting of the film recalls Lang's use of the metropolitan setting. The narrative is organized in episodic fashion in order to highlight slapstick and parody and appears to be a series of skits strung together. The idea of impersonation becomes complicated as Jack, who is impersonating Bulldog, later assumes the identity of Morelle, and the comedy is generated in part out of the confusion of identities. The comedy is also generated from the confusion between the identities of police and criminals. The comedy abounds in verbal gags, puns, chases, and slapstick. The scenes in the Bloomsbury Underground and in the British Museum not only are parodies of the classic detective and thriller film, but also are reminiscent of the way in which Hitchcock utilizes the London milieu in his British thrillers. The underground scenes and the British Museum episode call to mind the climactic episodes of such films as *Blackmail* (1929). The editing of the film alternates between long takes involving dialogue and the chase scenes, which are cut so as to create the proper sense of suspense and movement. Like his *Rome Express* (1932), Forde's *Bulldog Jack* successfully integrates character and milieu. The success of the spoof is dependent on the effective way that the film first re-creates the sights, sounds, and conventions of the crime detection film before it overturns them.

The Jester: Will Hay as Comic Scourge

The crime detection genre's emphasis on physical action, on double entendres, and on disguises and impersonation made it a perfect vehicle to display the talents of comedians, and many of the British comedies featuring comedians involve police and crime detection. The films starring Will Hay, for example, another comic personality of the 1930s, invariably portray him as involved with criminals. The notion of law is integral to comedy. In its license to expose cultural transgressions, in its emphasis on deviancy and marginality, comedy is involved with funda-

mental issues of social and antisocial behavior. The comedian is both the cause of social upheaval and the force that restores balance. Raymond Durgnat describes Hay as follows: "Throughout the thirties, the vintage, the unforgettable, Will Hay, with his dour, crafty, suffering face, his disreputable combination of Dickensian fruitiness and Greenian seediness, his stern yet apprehensive smirk, topped by the pince-nez and mortarboard of desperate pretension, best puts on the screen an amoral and weary indomitability which is at once truly proletarian and truly shabby genteel."[20]

Women are conspicuously absent in the Hay films. Not only is there no romantic interest in these films, but they are set in locales where the absence of women is taken for granted—boys' schools, prisons, and schools for spies. Unlike Jack Hulbert, who appears with Cicely Courtneidge as his sidekick, Hay's comic foils are men. When women appear in such Hay films as *Good Morning, Boys* (1937) and *Convict 99* (1938), they are usually seductresses working against Hay's objectives or, as in *Oh, Mr. Porter!* (1937), officious and shrewish. Hay's persona seems to depend on his chaste and virginal demeanor.

Boys Will Be Boys (1935), directed by William Beaudine, an American, is a typical Will Hay film. Will Hay as Dr. Alec Smart gets a position through forgery as headmaster in a boys' school, Narkover Academy. The school is portrayed as the breeding ground for future criminals, and the parent of one of the boys, Brown (Gordon Harker), the forger of Smart's letter, is, in fact, a notorious criminal. Through blackmailing Smart, Brown gets hired and brings his cohorts in as part of a play to rob the wealthy supporters of the school, such as Lady Dorking (Norma Varden). The contested object becomes a necklace stolen from Lady Dorking, and, after a battle between Brown, his son (Jimmy Hanley), and Smart, the necklace is returned to its rightful owner. The climax of the film, in which mayhem reigns, satirizes the traditional public school's Founders' Day ritual.

The school as a locus for carnival is not particularly original, but in Hay's hands the equation between the school and criminality becomes a source of satire as well as laughter. The arrival of Smart triggers the saturnalia in which everything considered to be out of bounds for educational institutions is pursued with a vengeance—women, gambling, drinking, and theft. The school is more explicitly a correctional institution, a breeding ground for future criminals, and the criminals are not clearly demarcated from the respectable and naive members of society like Lady Dorking or from the vicious like Colonel Crableigh, who opposes the appointment of Smart as headmaster, wanting to hire one of his own relations instead. The film draws a caricature of traditional public school practices in the hazing of the new teacher, the pompous ceremony for the

new headmaster, the scenes in the dining room, and particularly the Founders' Day ritual.

The Hay films also are distinguished by their use of double entendres, malapropisms, and puns. The motto of the school is revealed on a shield that appears under the title: "Quid pro quo." The school motto usually intended to dignify and idealize education is in *Boys Will Be Boys* a reminder of the naked commerce that is mystified in the education of the young. Puns are also part of the film repartee, as a student asks Twist, "How high is a Chinaman?" Twist's claim to knowledge is also spurious. For example, he lectures on "lepidoptera," claiming that the word comes from the Latin, in spite of a student's corrections. Physical humor, however, predominates in the film in the numerous blows accorded to Smart and in the climactic scene in the struggle for the necklace hidden in the football. The final shot is of Hay being thrown up and down again on the trampoline. As always, the final scenes in these films involve some kind of incident that physically undermines the notion of order restored. *Oh, Mr. Porter!* and *Old Bones of the River* end with explosions. In *Boys Will Be Boys*, Hay is violently shaken up on the trampoline; in *Convict 99*, he falls through a hole in the ground into a tunnel. Rarely in the endings of his films is he given any reward for helping to restore property or propriety; rather, he usually experiences a drubbing for his pains.

In *Good Morning, Boys* (1937), directed by Marcel Varnel, a director for whom Hay was to make several films, Hay again plays the part of a roguish teacher, Dr. Benjamin Twist, in a school for young boys. He was to use the name in several of his films. (The film was remade in the 1950s as *Top of the Form* with Ronald Shiner in the role of the schoolmaster.) The boys at the school are, like the young women in the later Launder and Gilliat St. Trinian's series, disruptive and undisciplined. The boys' favorite pastimes are drinking, gambling, and smoking. They have no respect for authority. The new schoolmaster becomes the butt of their sadistic jokes. His life is also made miserable by Colonel Willoughby Gore (Peter Gawthorne), a member of the school board, who is opposed to Twist's newfangled methods. Gore, a proponent of empire, upholds the world of facts and military discipline. Twist saves his job by assisting the boys in winning a trip to Paris through cheating. Unknown to him, the boys are being used as accomplices in a plot to steal the *Mona Lisa* from the Louvre. He tries to keep the boys in the hotel room, but the crooks lure them to a nightclub, where they enjoy the drinking and the floor show. Twist follows them to the club, where Yvette (Lilli Palmer) tries to distract him. The evening ends in his discovery of his charges and a free-for-all on the dance floor. At the Louvre, he discovers the theft, but he is accidentally left with the stolen painting. The boys bail him out and help to bring the true culprits to justice. The comedy arises from the paradox

of Hay's total incompetence, which turns out, after all, to work in his favor. He is not a paragon of virtue, and is willing to participate in a certain amount of corruption. He is not above helping the boys to cheat, but he stops short of stealing property. His peccadilloes are minor in comparison to the unscrupulousness and mean-spirited nature of others. Hay's films usually erupt into a carnival atmosphere in which everything that is considered respectable and predictable is turned upside down. Twist unintentionally helps to correct this topsy-turvy state of affairs.

There is a strong element of anti-intellectualism in Hay's films. Pretentious knowledge is satirized, and a good deal of the humor comes from the double entendres generated out of the misuse of words and concepts. For example, he asks the boys, "What is a watt of electricity?" He also plays on the word *ohm*, which the students define as a house. The school system is satirized through the portrayal of the befuddled and misguided people who administer exams, the trifling and pedantic questions that are asked, the ingenious forms of cheating that take place, and the smug view that winning a prize demonstrates the possession of knowledge. Practical knowledge, however, seems to be rewarded, enabling Twist and the students to uncover the crime. After all the insubordination and undermining of authority by the boys, they turn out to be staunch defenders of property and justice, saving their teacher and the *Mona Lisa*.

Hay's comedy can be characterized as one that "plays on the languages, logics, discourses, and codes which the text highlights within the diegesis and the fictional characters' relationship to them. This mode of comedy plays on verbal 'wit', confronting or overlaying one discursive logic with another. . . ."[21] The pleasurable quality of Hay's films derives from their irreverence, their willingness to assault the most sacred and pompous social institutions—the innocence of the young, the incorruptibility of teachers, the importance of cultural monuments. Hay's persona functions as a positive disruptive force in the midst of a stagnant and hidebound situation. His entry on the scene unintentionally destroys the solemnity of institutional rituals and practices. In *Oh, Mr. Porter!* (1937) he does not deviate from this portrait. In this film he is not a teacher but an incompetent railway worker who is a source of embarrassment to his respectable sister, who will not have her family boast a menial tapper. He is found a job as stationmaster in the little Irish town of Buggleskelly, where he meets his two assistants, Jeremiah Harbottle (Moore Marriott) and Albert (Graham Moffatt), who are living off the goods deposited at the railway. Thin, wiry, and sharp-tongued, Moore Marriott is a perfect foil to both gull Hay and then become the victim of his abuse. Physically and in behavior, Harbottle is the opposite of Albert, who is pudgy, innocent-looking, greedy, and not very smart. Albert is a deserving scapegoat for both Hay and Marriott.

Porter, the new stationmaster of Buggleskelly, is no sentimental egalitarian. He demands the respect due to his status, and comedy is generated out of his pathetic attempts to establish his respectability. He reminds Harbottle and Albert of their subordinate positions, but he also profits from their illegal ventures. He attempts to put the railroad on a working basis but finds that he is being subverted by a ghost who turns out to be the leader of a gang of gunrunners whom he finally brings to justice. Again, his incompetence has its competent side, or perhaps he appears more competent in a world that is portrayed as filled with incompetents and subverters.

The sequences involving the trio's attempts to get the trains running again, the chase sequences in which they trace the gunrunners to the old windmill, their attempts to get down from the turning windmill, and their capture of the culprits put them in a number of physically harrowing situations. The humor in the film is thus divided between slapstick and verbal punning, but the underlying seriousness portrays a world that is as threatening and explosive as the objectives of the gunrunners themselves. In the final scene Porter taps the engine, which he predicts will last another fifty years, but the engine explodes, demonstrating the volatility and instability of his world.

This film, like Hay's other films, neither superficially nor subliminally celebrates the basic decency and placidity of society but flirts with the darker and more subversive aspects of institutional behavior, which, if tapped, explode. The film's humor is aggressive and menacing, and the protagonist is not innocent. He is, like Harbottle and Albert, corrupt. The film seems to play with degrees of corruption rather than with a polarization between the innocent and the guilty. Unlike Gracie Fields' films, Hay's do not offer the promise of transformation, merely of containment within the law. Conversion is an alien phenomenon. The films' presentation of community is not idyllic, not a portrait of consensus, but rather a darker picture of a divided society held together by the efforts, often inept, of a few individuals who uncover the disrupting forces.

In *Convict 99* (1938), also directed by Marcel Varnel and featuring familiar Hay sidekicks, Moore Marriott and Graham Moffatt, Hay returned to his Benjamin Twist impersonation. More than in other Hay films, the humor and irony hinge in *Convict 99* on misrecognition. The film begins with a newspaper article announcing the "resignation" of Dr. Benjamin Twist from St. Michael's School. In fact, he has been sacked. Driven to find a new position by his brother's wife, Mabel (Kathleen Harrison), he applies for work at a school for backward boys but ends up, through a confusion between first and last names, as warden of a men's prison. When he arrives at the prison, he is still under the mistaken impression that this is a boys' school, but the prison authorities decide that

he is a mentally deranged criminal, and he is locked up. No one will believe that he is the warden, and he is coerced into signing a statement of guilt.

The mistake is discovered by the authorities, and he is reinstated. When he gets a letter addressed to John D. Benjamin, Twist finally understands that the job was not intended for him, but, upon learning the salary, he decides to suppress his identity. His first act as warden is to quell a riot. He tells the men that he is "going to make this prison a place fit for Englishmen," and that "the walls are not meant to keep you in but the riffraff out." The prison begins to look like the world outside: the men have coffee in their cells, begin to play the stock market, and even have a dance to which they invite women. At the dance, the prison idyll is shattered as Twist is blackmailed into giving one of the female visitors (Googie Withers) a check for £50, which she rewrites to read £5000. He and some of the prisoners leave the prison to track down the culprits, and a chase ensues between them and the police as they return the money to the bank. As he is praised for his efforts in behalf of prison reform, he falls through a hole made by Jerry the Mole (Moore Marriott), an inmate who compulsively attempts ingenious prison breaks.

This comedy is a saturnalia in which all of the conventional expectations of prison life are turned upside down. Prison life is first satirized as a repressive system in which the men are unjustly locked up and regimented. The indifference to their identity is dramatized by the unnoticed escape of a prisoner and his replacement by Twist without proper verification, the object of the authorities being to fill the cells, whether the person is guilty or innocent. The tables are then turned and the film satirizes prison reform when the prisoner, Twist, becomes the warden. Twist runs the prison as he would a school, and his adoption of the honor system, while producing confusion and corruption, brings out the sense of collectivity among all but the most hardened prisoners. The notion of mistaken identity is compounded to the point where no one can tell the difference between criminals and police, prisoners and jailors. The British notion of muddling through is here exposed as damning both to traditional notions of and to liberal attitudes toward reform. The film seems to be not only a parody of prison dramas, but, more profoundly, a satire on British justice. According to Rachael Low, this film "provoked an attack by E. W. and M. M. Robson in *The Film Answers Back*, claiming that he [Twist] was supporting authoritarianism by mocking liberal views, an interesting early example of the earnest interpretation of film as a text."[22]

The Little Man as Hero: George Formby

One of the highest paid comedy stars in the 1930s and early 1940s was George Formby. Like Gracie Fields, his character was built on his regional dialect and humor.[23] George Formby's experiences in comedy

were, like those of so many British comedians, in the music hall. His language is not cultivated, and his comedy is dependent on his Lancashire accent and a type of humor associated with north country people. In fact, comedy is one of the few British genres in the 1930s (with the exception of minor characters in melodrama) to feature regional speech. Formby was often labeled by critics as simple and "gormless," judgments representing a lack of understanding of working-class characters. Formby's seeming simplicity, in contrast to Hay's craftiness, masks his aggressive and energetic struggle to survive and to succeed. He appears childlike and innocent, and the roles he plays usually feature him as a romantic rescuer, but Formby has ambitions. He seeks to rise in the world. Usually beginning in a menial position, he manages through ingenuity as well as his earnest intentions to establish his credentials. Formby's persona is built on familiar gestures and objects. His broad grin, his funny, ill-fitting suits, and his ukelele constitute his signature.

More than other comedians, he appears concerned with his identity. His actions on behalf of himself and others expose his desire to belong and to establish his self-worth. In *It's in the Air* (1938), directed by William Beaudine, who also directed Will Hay, he dreams of joining the Royal Air Force. The film begins with his unsuccessful attempt to become air warden. Putting on his friend's RAF uniform, he finds himself at the airfield, where he is mistaken for a recruit. He manages to create mayhem at the base, but in the end exhibits courage and ingenuity at the controls of a plane and is admitted to the force. He also manages to win the affections of the sergeant major's daughter, Polly (Polly Ward), in spite of her boyfriend's vicious treatment of him. The narrative is loosely constructed out of a series of episodes that mark the obstacles that stand in the protagonist's way in achieving his romantic and career objectives. Initially, he is an object of ridicule, a victim of his physical limitations as well as others' scorn, but his determination to achieve his goals transforms him from a pathetic figure to a heroic one. The contrast between him and other men, men who are bigger and more forceful, makes his success all the more remarkable. Furthermore, George is not only able to overcome the intimidating men who threaten him, but he is able to establish his credentials with women.

Trouble Brewing (1939), directed by Anthony Kimmins, for whom Formby made a series of films, features George working in a newspaper office as a typesetter. In this film, the dominant problem is tied to crime detection. George has invented a device that enables him to identify the fingerprints of criminals without leaving a telltale trace. Particularly concerned with the activities of counterfeiters, he plans to use his invention in tracking down these "slushers." He tells a fellow worker, Mary Brown (Googie Withers), about his invention. She is enthusiastic, but his supervisor, Mr. Brady, belittles his work. George, always helpful, entertains

Miss Brown with his ukelele as she writes the horoscope for the day, in which he helps project the lucky numbers for the races. At the races, where he goes with a fellow worker and wins money, he sees the slushers and begins to track them down. This chase takes him to a cocktail party, where, impersonating a servant, he crawls about trying to locate a counterfeit bill with his invisible ink markings. Clues lead him to the chief of police's home, where he spies the chief taking counterfeit money from the safe and concludes that he is implicated in forgery. George finally tracks the criminals to a brewery, where he rescues Mary and captures the men, discovering that Brady (his boss) too is part of the counterfeiting operation.

George's success lies in his cleverness (though not deviousness) and not in his physical prowess. His invention of the crime detection device, as well as his ability to pick the lucky numbers at the races, takes him out of the ranks of comedians like Will Hay and Jack Hulbert, who muddle their way through situations. Formby's character is marked by superior common sense linked to talent, as expressed in his musical ability. While he appears to be oppressed by people like his sidekick, Bill, who wants to exploit him, the threat of his actually being used in this fashion proves to be unfounded. His talents appear unlimited. If he gets involved in a wrestling match, he is able to win. He is able to take on many men single-handedly at the brewery and one by one send them flying into the vat of beer, despite the fact that he is a small man. Part of our appreciation for the comedian comes from viewing him from Mary's perspective as a resourceful individual rather than as a fool.

Racing plays an integral part in the Formby scenario. Other sports are also featured in his films—flying, skating, and gymnastics. In general, unlike other male and female comedians who appear more androgynous, his persona appears to be more rigidly structured around conventional images of masculinity, and, as Jeffrey Richards says about *Trouble Brewing*, "The film shows its awareness of the need to remain in touch with the mass audience by building the film's action around such archetypal working-class leisure activities as horse race betting, wrestling, and beer."[24]

Female Impersonation: Old Mother Riley

Sexuality presents itself in a different form from other comedies in the Old Mother Riley films, starring Arthur Lucan as Old Mother Riley. Lucan's music hall act, in which he played an elderly Irish washerwoman with a sentimental fondness for her daughter, was presented in the cinema in 1937 with *Old Mother Riley*, directed by John Baxter, and from this initial film followed others.[25] Lucan, with his costume and highly stylized gestures and movements, looks like a cross between a scarecrow and a comic book character. In *Old Mother Riley in Society* (1940), the

theatrical success of Mother Riley's daughter, Kitty (Kitty McShane), triggers Kitty's marriage to a rich, upper-class young man. Mother Riley impersonates a maid in their household in order to be near her daughter without embarrassing her by having to acknowledge her lower-class origins. When the secret is exposed, the mother leaves without telling her daughter where she is going. She lives a pathetic existence until she becomes ill. The daughter tracks her down, and the two are reconciled.

The narrative is melodramatic, highly sentimental, and conventional, but the element that disturbs the conventionality is the knowledge that Old Mother Riley is a man. The idea of a man impersonating a woman is not unusual in comedy in general or in British comedy in particular, and later successful examples of female impersonation include Alastair Sim's role as Miss Fritton in the St. Trinian's films, Sid Field's impersonations in *London Town* (1946) and *Cardboard Cavalier* (1949), and Alec Guinness's impersonation of Lady Agatha in *Kind Hearts and Coronets* (1949). However, in these films impersonation of the opposite sex is only a momentary impulse within the narrative, not consistent as in the Old Mother Riley films, in which the narrative itself serves as a parody of female melodramas. Not only does the scenario utilize melodramatic conventions involving class differences and the pathos that results from a mother's desire to do what is best for her daughter in the renunciatory vein of the woman's film, but the sentiments uttered by Mother Riley are a caricature of proverbial wisdom about a young woman's chastity, respect for her parents, and the notion that blood is thicker than water. Everyone in the film describes Mother Riley as "a strange creature," but they are referring to her traditional sentiments and her working-class habits. For the audience, this reference to strangeness is a reflexive reference also to the impersonation.

Commenting on female impersonation in the cinema, Rebecca Bell-Metereau finds that "our urge to laugh is, in part, a natural outgrowth of our own confusion, our inability to reconcile the apparent femaleness of the character with our knowledge that he is in fact a man. At the same time, inside knowledge gives the audience an advantage over the characters in the film; as we take part in the impersonator's conspiracy our response is one of satisfied laughter at the superiority of our position."[26] But Bell-Metereau adds that the film "cannot challenge the viewer's sense of propriety too greatly or he or she will reject the portrayal as tasteless and, consequently, not very funny."[27] In the case of Mother Riley, this propriety is preserved in the ways that Mother Riley does not exaggerate the qualities of femininity. That the character is old rather than young also mitigates the outrageousness of the impersonation, since androgyny is more pronounced among the elderly and the very young. Female impersonation of an older, motherly figure does not, therefore, violate conven-

tional notions of gender appearance and behavior as radically and vio-
lently as impersonation of a young woman. In the tradition of the music
hall, such acts were not considered shocking or offensive, and the popu-
larity of the Old Mother Riley films suggests that Lucan's female imper-
sonation posed no problems for the audiences. That the character posed
no difficulties for the audience speaks, in part, to the existence of a cul-
tural consensus about the position of older women with little status or
power within the society. To impersonate them poses no real threat to the
prevailing representations of women.

In *Old Mother Riley in Society*, the protagonist tries to maintain power
over her daughter, only to discover that she can no longer control her
daughter's destiny. The mother's struggle with Kitty introduces the ele-
ment of pathos as well as lending a certain dignity to her role. Her loss of
familial power initially takes the form of tyranny in Mother Riley's insis-
tence on controlling Kitty's movements. Later she desperately seeks to
hold onto her daughter through her impersonation as a maid in Kitty's
house (thus compounding the element of impersonation). Finally, she
leaves Kitty alone, which only makes Kitty feel guilty, but mother and
daughter are reconciled in the final scenes. The film thus adopts all the
classic ploys of maternal melodramas, with the difference that mother is
a man and not a woman. Lucan's portrayal has a double edge. It evokes
traditional and conservative notions of women's position, but, because
the character is played by a man, the film also becomes a parody of the
characters and virtues it portrays. Lucan's persona overrides the con-
sciousness of transvestism, though the viewer cannot totally dispel the
knowledge of the crossover. His role calls attention to sexual difference,
making a mockery of prevailing conceptions of femininity as belonging
exclusively to biological females.

In discussing the Mother Riley comedies, critics take Lucan's female
impersonation for granted, referring to it only in passing. The discussions
of Lucan's films focus, rather, on the issue of class, indicating that the
films are representative of a populist stance and of the existence of work-
ing-class attitudes and forms in the British cinema.[28] For example,
Durgnat finds that Old Mother Riley's vitality derives from British music
hall comedy.[29] Low comments on Lucan's earthiness.[30] One critic, in re-
ferring to *Old Mother Riley's Ghosts* (1940), finds the portrayal of this
Irish character "crudely direct."[31] But what is the impact of female imper-
sonation? Underlying the androgynous portrayal is the awareness of the
inevitable difference necessary to make the comedy work. By adopting
the persona of an old woman, Lucan usurps cultural images that are
threatening to both men and women—the elderly Irishwoman and the
mother. He plays with the freedom that age and marginality grant to her
to attack prevailing social practices. Since Mother Riley has so little in-

vested in the social order, she can flout middle-class conventions and pretensions. She can assault institutions and stubbornly obstruct the status quo. As Simone de Beauvoir states, "Old women take pride in their independence; they begin at last to view the world through their own eyes; they note that they have been duped and deceived all their lives; sane and mistrustful, they often develop a pungent criticism."[32] Lucan's performance relies on this knowledge. His adoption of the maternal persona transgresses conventions of gender, sex, and age.

Clown Comedy and the Crazy Gang

A different type of comedy was associated with the Crazy Gang, whose films were directed by Marcel Varnel. The films of this group, consisting of three pairs of comedians, belong to the same genre as the Hollywood films of the Marx brothers and the Three Stooges, films with a collective comic protagonist.[33] In *The Frozen Limits* (1939), the six "Wonder Boys" embark on a gold-digging expedition in the Yukon based on an advertisement for the gold rush which is forty years old. While there, they meet Indians, desperadoes, a friendly cowboy, Tex O'Brien, who is reminiscent of Bronco Billy Anderson and Tom Mix, and an old man (Moore Marriott) who owns a gold mine but cannot remember where it is. They help to locate the mine, and protect his granddaughter from the evil machinations of Bill McGrew. While the members of the group are not clearly individuated in terms of personal identity, they are distinguished by roles. One of them plays the inevitable scapegoat; another organizes group activities; some are more verbal; others are more physical. They are heavily dependent on slapstick and on punning and double entendre. The comic effect, however, depends most broadly on their collective effort. For example, in the sequence in which they all march to bed in the bunk house to the strains of music from *Snow White and the Seven Dwarfs*, the humor derives from the synchronization of their actions. When they all dress like grandpa to throw McGrew and his sidekick off the scent, the confusion is compounded by the sheer number of impersonators. The melodramatic skit that they do is also enhanced by their collective efforts. Moreover, in the ways they interact with the internal audience, they evoke the atmosphere of the music hall. Their comedy in general appears spontaneous. Their impersonations and disguises are devised loosely to suit the exigency of the moment, and the narratives themselves are loosely constructed in order to allow for gratuitous gags.

The film is also structured around a parody of the Hollywood western, and the characters with whom the group members interact are caricatures of stock characters in the genre. The scene in which the Royal Mounted Police are brought in by Tex to save the day is drawn out. The parody of the classic rescue is developed through drawing attention to the obvious

rear-screen projection, portraying the Mounties on their horses singing as they approach the town, retarding the moment of their arrival, and then having them arrest the wrong man as they arrive late. In general, the position of the Crazy Gang within the films is a defensive one in which they are struggling to survive in the face of hostile forces. They are not aggressive toward others except as a consequence of trying to protect their own interests. The sense of collectivity is as important as the ways one or another of the group may occasionally frustrate the group's objectives.

Female Clown Comedy: The Waters Sisters

Many of the comedians—Hay, Formby, and Lucan—were to make films on behalf of the war effort, feature films that would involve intrigue, civil defense, and attempts to contribute to the services. The Waters sisters, Elsie and Doris, also contributed their comic talents to the wartime cinema. The image that they project is different from those of the comedians discussed previously. Their style of comedy is less stylized. Their physical demeanor, gestures, and dialogue are not mannered but down to earth, and their costumes are consonant with their particularly domestic concerns. They wear modest and inconspicuous clothes that are in keeping with working-class women's wartime clothing. The humor that they generate is usually not aggressive, not directed at their own personal appearance. The comedy involves misunderstandings, confusion of identity, and class contrasts that usually indicate their superiority to the upper classes.

In *Gert and Daisy's Weekend* (1941), the sisters volunteer to take a group of young and unruly wartime urban evacuees to a country estate, Little Pipham Hall. The film begins with the inevitable queues associated with wartime and with the sisters' attempts to seek restitution for a rancid fish they have been sold. In this introductory scene, the atmosphere of the working-class neighborhood is evoked. One axis of the plot involves disruptions in the community caused by Ma Butler (Iris Vandeleur). The other involves the adventures of the sisters in the country. Gert and Daisy's difference from the upper-class guests is brought out at a small party arranged by Lady Plumtree (Annie Esmond) where they meet the vicar, his wife, and another couple, who turn out to be jewel thieves. At the party, each person is asked to entertain, and while the other guests perform classical music, Gert and Daisy sing a song about illegitimacy. The guests' hyperbolic and flowery language is contrasted to Gert and Daisy's more literal type of speech. In the city, Maisie, her friend, and their two young sailors encounter difficulties and obstacles in trying to get married created by Ma Butler. When they receive an anonymous letter from Ma Butler about the illicit use of Gert and Daisy's house and their loose morals, Gert and Daisy decide that they must get home. While the sisters are gone, two guests steal Lady Plumtree's jewels. Gert and Daisy

are suspected of the crime but eventually exonerated. The immediate suspects are the working-class characters and not Lady Plumtree's genteel guests.

Gert and Daisy are portrayed as figures of reconciliation. They are able to win over the children and help them to get accustomed to their new surroundings. The film portrays the problems of adjustment for young people away from their homes, problems inherent in the removal of the children from their urban and working-class settings. The children are rebellious, tear up the flowers in the garden, complain about the food, do not observe bedtimes, and are homesick, but the sisters are able to bring them around. The sisters hold their own in their confrontation with the upper classes; their heads are not turned by the display of wealth and the attraction of being waited on. Gert and Daisy also help Maisie to outsmart tyrannical Ma Butler. Thus, the melodramatic elements of the narrative involving Ma Butler and the lovers in the city and the jewel robbery in the country are interwoven with the more mundane aspects of wartime life—queuing for food, sleeping in shelters, restrictions on traveling, lack of housing, and evacuation of children. The contrast between the country and the city, the working-class and the upper-class environments, helps to situate Gert and Daisie as mediators between extremes. They mediate between generations as well as classes, and the attitudes they represent are egalitarian. The images and situations in the film are geared to women and to domestic life, stressing the struggle to survive in the face of adverse circumstances and generating humor out of hardship.

Comedians in the Postwar Era

One film comedian who specialized in sentimental comedy and impersonations was Sid Field, often supported by Claude Hulbert and Jerry Desmonde. *London Town* (1946), produced by the Rank Organization, was part of Rank's ambitious postwar attempt to capture the American market. Directed by the American director Wesley Ruggles, the film is Britain's first Technicolor musical, and it attempts to reproduce the spectacle and variety of the Hollywood backstage musical. Sid Field plays an entertainer, Jerry, who has come to London with his daughter. His attempt to get to the top is thwarted by the revue's comedian (Sonnie Hale), a has-been who refuses to relinquish his position even though the show suffers. Hale, the onetime husband of Jessie Matthews and director in her later musicals, was in real life experiencing the waning of his career. His parallel position in the film serves to reinforce the traditional blurring of the connections in the musical between the world of the performer and "the real world."

The film's narrative is loosely constructed around the machinations of Jerry's daughter (Petula Clark), who succeeds in making her father the star of a London revue. She plays a precocious mother figure to him as she

dresses him, advises him, and engages in trickery to give him his big chance. Her machinations are exposed, she is absolved, and her father is able to enjoy success. The sentimental attachment between father and daughter is one aspect of the narrative, and several musical numbers are devoted to developing their relationship. The other aspect is the performances themselves, including big production numbers involving singing and dancing.

Field performs a number of comic skits. In one, he reflexively works out his act with the help of his audience. In another, he impersonates an inept professor of music. In still another, he plays an effeminate photographer. His persona is dependent on self-deprecation and on caricaturing traditional occupations and roles; on a combative relationship with others, including the audience; and on verbal games. In a golf skit, the comedy arises from his too literal use of words. He is a mimicker of others, and the mimicry has an aggressive component. Unlike other comedians, he does not have a particular costume to distinguish him, nor is he distinguished by particular physical characteristics. His humor, largely deriving from his miming, is particularly aimed at men who are effeminate.

Cardboard Cavalier (1949), a comic swashbuckler directed by Walter Forde, reinforces Field's talents for impersonation, slapstick, and sentimentality. The film parodies the usual pompous openings of historical films, beginning with a voice-over explaining conflicts between Cavaliers and Roundheads, accompanied by maps. A tableau scene of Charles II and his followers introduces their plans to overthrow the Cromwellians. Sidcup is presented as a poor, abused citizen who finds himself pilloried by the Roundheads for protecting Nell Gwyn (Margaret Lockwood). The two of them join forces, align themselves with the Cavaliers, and are instrumental in defeating the vicious Puritans. The film's parody of costume films includes street processionals, intrigue in the castle, ceremonial dinners, lusty scenes of life on the streets with fishmongers, and dueling scenes.

Sid Field is the "innocent dupe" who becomes a hero. At first, he appears to be a mere buffoon who is buffeted about, verbally abused, and physically beaten. With the help of Nell, however, he is able to outsmart the humorless Puritans. His physical awkwardness is the source of humor often directed against his own person. As in *London Town*, his impersonation involves sexual stereotypes. He dons a dress and impersonates Cousin Mathilda, a caricature of a garrulous female. In general, the targets of his humor are eccentrics, those with intellectual pretensions, "unmanly" men, bullies, and unattractive women. His character is aligned with the virtues of loyalty, family, and service. His doggedness, capacity to tolerate abuse, and willingness to please are basic to his persona.

The Puritans are identified with behavior that is reminiscent of the war films' portrayals of Nazis, while the Royalists are associated with pleas-

ure and wit. The Royalists offer Sidcup and Nell the means to rise in the world, and in the last scene Sidcup is knighted. In some ways, Field's persona recalls Formby's awkwardness and energetic efforts to rise in the social world, though, unlike Formby, Field does not represent a definable regional group and social class. Field's comedy is also more aggressive. Moreover, the incisive caricature of class pretensions so characteristic of Will Hay and Arthur Lucan films is consequently blunted in Field's attacks on helpless or socially marginal characters.

COMEDY IN THE 1950s

Comedian Comedy in the 1950s: Norman Wisdom

In the 1950s, the appearance of Norman Wisdom was an indication that comedian comedy was not totally defunct. Like other comedian comedies, Wisdom's films are built around his persona, and his character in the films is usually named Norman. He wears ill-fitting clothes and is small, childlike, and physically awkward. In *Trouble in Store* (1953), directed by John Paddy Carstairs, he plays a stock boy in a department store who aspires to be a window dresser. Constantly in trouble with the store owner, Mr. Dawson (Jerry Desmonde), who calls him "a clumsy big elephant," he manages to trap a gang of thieves in the toy department. He also succeeds in winning the girl who is his ally in ferreting out the crooks. His targets, which seem fortuitous, are actually people who are pretentious. For example, during a formal dinner for employees, he accidentally sets himself on fire, ruining the event.

Margaret Rutherford plays the role of a shoplifter whose refined demeanor deflects suspicion and even encourages the employees to help her as she stashes away loot in a suitcase. Jerry Desmonde as the store owner is the deserving object of much of Norman's passive aggression, and his officious secretary turns out to be the internal link to the robbers. The film draws a distinction between haves and have-nots, and the have-nots, including the shoplifter, are treated sympathetically. In the tradition of the working-class comedian, Norman is not intellectual or intentionally witty, but through his blundering he manages to expose trouble and to act ethically in destroying the enemies of order. He has a romantic side, which is portrayed through his singing; the lyrics are usually about himself and his desires: "Don't laugh at me 'cause I'm a fool. I know it's true, yet I'm a fool. No one seems to care. I'd give the world to share my life with someone that really loves me." His request for love and recognition, along with his clumsiness, mitigates his aggressiveness toward others.

In *Up in the World* (1957), also directed by Carstairs, Norman is a window washer who gets a job at Banderville Manor, unaware that he is taking the place of a member of a gang who is planning to kidnap the

young heir to the manor, Sir Reginald (Michael Caridia), for ransom. His work is under the supervision of Major Willoughby (Jerry Desmonde), whom he tortures as he had tortured Dawson in *Trouble in Store*. Norman, in turn, is the butt of tricks played on him by Sir Reginald. The young boy sends him to the wrong rooms, leads him to break windows, and causes him to disgrace himself in front of upper-class guests whom Norman takes for fellow workers. When he is fired, Sir Reginald insists on having him reinstated. When the kidnappers arrive, they do not find the young heir, who has blackmailed Norman into taking him to a nightclub. Norman saves the boy from the kidnappers only to get arrested himself as a kidnapper. Sir Reginald, who has been hit on the head, develops amnesia and cannot identify Norman, but with the help of Jeannie, a young woman who works on the estate, the truth surfaces. Again, Norman saves the day and gets the girl. He aligns himself with youths and with women in distress and undermines bureaucrats, hypocrites, philistines, and stuffed shirts. The film's setting at a great house allows Norman the opportunity to have jokes at the expense of the upper classes—at a soccer game, at a tea, and at a costume ball. In contrast to the films of Sid Field, the comedy in Wisdom's film derives in large part from Norman's selecting as his objects of aggression characters who wield social and economic power and are enemies of pleasure.

More Crazy Gangs: The Comic World of Launder and Gilliat

The comedian comedy films are built around the personalities of their stars, even when the comedians are a group, as in the case of the Crazy Gang. The identity of the comedian is more important than the fictional character in the loosely constructed narratives in which these stars appear. There is, however, another comic mode in British cinema built around fictional characters whose identity is dictated by specific roles, such as Alastair Sim in the role of Miss Fritton in the St. Trinian's films or as Inspector Hornleigh. The comedy films of Launder and Gilliat are built not around an individual but around the group, creating a carnival atmosphere which focuses not only on different types but on the social group as a "crazy gang."

Launder and Gilliat are exemplary in British film production for their versatility, range, ingenuity, and high quality of scenarios. As writers and as directors, in some instances together, in others separately, their films span half a century. They worked for British International Pictures, Gainsborough, and finally independently. In the 1930s they worked on successful thrillers with such directors as Alfred Hitchcock in *The Lady Vanishes* (1938) and Walter Forde in *Rome Express* (1932). They wrote for Will Hay's comedies in *Good Morning, Boys* and *Oh, Mr. Porter*! They were involved in *The Young Mr. Pitt* and *Night Train to Munich*

with Carol Reed as director. At Gainsborough, they directed three of the most popular and interesting films of the war years—*Millions Like Us*, *Two Thousand Women*, and *Waterloo Road*. In the postwar years, they directed thrillers such as *Green for Danger* (1946), the historical *Captain Boycott*, and a number of comedies.

The identifying features of their comedies, whether as directors or as writers, are a concern for British images and characters, an irreverent attitude toward British institutions, and an avoidance of sentimentality. While their films veer toward irony and satire, there is a consistent and studied attempt to create recognizable contexts. Their choice of actors provides the proper distance and distortion necessary for satiric commentary. Margaret Rutherford, Alastair Sim, Joyce Grenfell, Richard Wattis, George Cole, Terry-Thomas, and later Rex Harrison, in such films as *The Rake's Progress* and *The Constant Husband*, are responsible for making the familiar world strange through their distinct character types. The eccentricity of their characters is heightened by the contrast between the familiar situations in which they are placed and their own idiosyncratic behavior. In the final analysis, their eccentricity is only a vehicle for exposing behavior that is, after all, not so uncommon.

In the work of Launder and Gilliat, the school is a prime site for intrigue and comedy. The films are usually predicated on a "what would happen if" question which generates the fantasy. In the case of *The Happiest Days of Your Life* (1950), directed by Launder and produced in collaboration with Sidney Gilliat, the comedy is based on the question, What would happen if a group of girls was introduced into a boys' school? The answer is: Chaos. The film is an assault on the customs and traditions so integral to the functioning of public schools. The confusion is generated by a mix-up at the Ministry of Education, a target of satire in the later St. Trinian's films. The incompetence of the Ministry is matched by the hypocrisy and duplicity of the headmaster, Wetherby Pond, played by Alastair Sim. The teachers are a caricature of school faculties. One sleeps most of the time. Another is a womanizer and a gambler. In contrast to Will Hay's school films, the focus is more on the faculty than on the students. With the entry of Miss Whitchurch (Margaret Rutherford), her faculty, and the female students, the battle of the sexes begins, particularly between Pond and her. As she explores the strangeness of the environment, she tells her teachers, "We are moving in a descending spiral of iniquity." The females manage to displace the males, disrupt their teaching schedules, take over their sleeping quarters, and distract the young boys.

The climax comes when Miss Whitchurch is notified that the parents of the girls are coming to visit, and she threatens Pond if he does not cooperate. Then he is notified that he is to have a visit from the governors of

Harlingham, who have come to examine his suitability as headmaster of their school. The remainder of the film is a mad race to keep the boys' and girls' activities separate, so that the visitors will see only what they are supposed to see. The film explores sexual differentiation as it identifies the different books, sports, skills, and values that are associated with the school. Even language is self-consciously treated so that the viewer is made aware of how all references in this context have a double meaning. For example, one of the male teachers asks, "How many mistresses have you got?" At another point one of the parents comments about his daughter, "She was always weak on dates."

The combat between the two principals derives not only from their sexual differences but from the specific actors who play the roles. Margaret Rutherford's eccentric behavior is pitted against Alastair Sim's eccentricities. Their antagonisms spring from their determination to each get their own way. Both of them are undermined at the end, each left out in the cold. They each represent particular excesses of authority figures. The supporting actors are also selected so as to emphasize their foibles. In behavior, gesture, and physical appearance, they literally embody their particular folly. Joyce Grenfell as Miss Gossage ("Call me Sausage") is the gawky games mistress, a role she was to re-create in other comedies. Richard Wattis plays the role of Billings, a harassed teacher who reappears in other Launder and Gilliat films as a harassed bureaucrat. The film's humor and satire are derived from the verbal wit, the unrelenting and energetic slapstick, the incisely aimed attack on traditional forms of behavior, and, above all, from the undermining of rigid sexual and gender differences.

The Belles of St. Trinian's (1954) and *Blue Murder at St. Trinian's* (1957) have the same carnival atmosphere in which morality, sexuality, and all social conventions are turned on their head. From the portrayal of the headmistress, Miss Fritton, played by Alastair Sim, to that of the schoolboys, the films not only satirize the myths of British educational institutions but also turn their attack on the family, the police, government bureaucrats, journalists, and economic exploitation. From top to bottom, everyone is corrupt and self-serving. The world of these films is one of embezzlement, crass commercial schemes, spying, violence, and manipulation. The film explodes the myth of childhood innocence and, for that matter, any notion of innocence. The humor deriving from the British school setting is possible, in part, because of the particularly rigid and class-based structure of the British educational system, and because of the ways in which educational institutions are closely tied to myths of British sportsmanship, fair play, self-discipline, continuity, and service. The school as the training ground for character is treated melodramatically in such films as *Tom Brown's Schooldays* (1951).

Like many of the 1950s melodramas, these comedies turn their attention to traditional institutions, especially schools and the legal profession, but view each from a critical perspective. Those aspects of education and the law that were representative of the stability and integrity of British cultural life now appear as objects of satire. The girls' school setting seems more appropriate to puncture public school myths and avoids direct comparisons. Durgnat comments that "girls don't quite fit the public school spirit, they're marginal, slightly free, and, therefore, sinister."[34] On the one hand, the females have no interest in learning, are intent on subverting whatever interferes with their pleasure, and are vulnerable to seduction; this portrayal could be construed as representing dominant attitudes toward females. But Sim's female impersonation casts the films in another light, signaling the reversal of all roles and therefore all behavioral expectations about males and females. His impersonation also divests power and authority of its solemn aura. Will Hay's school films featured boys' schools with himself as the headmaster, but whereas his films focused on class conflicts, the Launder and Gilliat comedies of the 1950s introduce sexual conflict as the dominant concern.

In *Lady Godiva Rides Again* (1952), directed by Launder and scripted by him and Val Valentine, the satiric vehicle is the beauty contest. The film sets up a contrast between the drab lives of a working-class family and the world of entertainment, beginning on a Sunday when the only excitement in town is a film, *Shadow of the Orient*, which Marjorie (Pauline Stroud) coerces her date into seeing yet another time. The signs advertise the film as "Brooding! Sultry! Exotic!" Marjorie's placid life changes when she is selected as Lady Godiva in the local pageant, leading to yet another twist in her fortunes as she wins a swimsuit contest with the help of Dolores August (Diana Dors), who prefers marriage to a wealthy man to winning the contest. Along with a mink coat, Marjorie gets a film contract. From here on, the film is devoted to exposing the seamy underside of the entertainment world. Her movie idol, Simon Abbott (Dennis Price), the star of *Shadow of the Orient*, turns out to be a bald-headed seducer who determines to wreck her career after her father (Stanley Holloway), tracking her to Abbott's yacht, throws the film actor overboard. She begins to have difficulty finding work, and ends up having to appear on stage as a nude Godiva, but she is rescued from her sordid life in the theater by her family and a young man (John McCallum). As the last lines indicate, "Home-loving hearts are happiest."

But the film is not a simple celebration of home and hearth. Marjorie is the vehicle for exposing the manipulation of the working class and of working-class women in particular. The beauty contest is a pretext for exploring the exploitation of the female body. Sexual exploitation is a vehicle, in turn, for exposing the various institutions that profit from ex-

posing females—advertising, theater, the cinema, and girlie shows. The media capitalize on their discontent, on the drabness of their lives. Marjorie's sister, Sylvie (Kay Kendall), is one such victim who seeks to live vicariously through Marjorie's escape from the family. The sisters' father is tyrannical and puritanical in the extreme. Her mother and sister are oppressed by economic and domestic constraints. The town officials are hypocritical, and the town itself is drab and unprepossessing.

Against this vision of domestic misery is set the vision of the world outside the home, which features rigged beauty contests, monetary and material inducements such as fur coats, publicity, and movie contracts that are dead ends, only momentary diversions. The women are portrayed as valued for their youth and beauty, but as the agents cynically indicate, they have no talent and will end up getting married. Marjorie's quest leads her to observe the seamy side of filmmaking as she goes to the bankrupt producer of Optimum Films (Alastair Sim) and learns he can no longer afford to make films. Marjorie's salvation from the peep show is a magical ending. She neither needs to return home nor is forced to stay as Lady Godiva. She is whisked away to her never-never land—an Australian farm. As in other satires, the resolution is irrelevant. Corruption is inescapable in the public sphere; the family does not offer a viable escape, either. The image of the nude Lady Godiva signifies several things. On the one hand, it alludes to an event in British history when a woman used her body as a means of protest and contrasts that event with the town officials' contemporary exploitation of a woman. The satire focuses on nudity as a means of exposing social corruption, using the female body as the vehicle for indicating how modern consumerist society is built on the commodification of the female. More specifically, the film's satire is directed at the media as the instiller of unattainable needs and desires. Commenting on the problem of maintaining a balance between comedy and satire, Launder stated, "Satire is a tricky field to tread in, and from time to time we got bogged down in it. Then we thought, the public by and large don't understand satire, so let's put the accent on comedy. The mixture was not 100% satisfactory."[35] The exposure of the darker side of sexual and social relationships threatens all too frequently not to be funny.

In *Folly to Be Wise* (1952), also directed by Launder and produced by Gilliat, the sprawling narrative of *Lady Godiva* with its focus on entertainment is transplanted to another milieu, the army camp, but the concern with entertainment remains. This film stars Alastair Sim as an army chaplain and entertainment officer responsible for keeping the troops entertained. Recognizing that chamber music groups do not bring out audiences, he decides to stage a "Brains Trust," in imitation of the very popular BBC program of the time. The panel, chaired by Captain Paris

(Alastair Sim), consists of an artist, George Prout (Roland Culver), and his wife, Angela (Elizabeth Allan); their friend, Professor Mutch (Colin Gordon); a slightly deaf physician (Miles Malleson); a Labour MP (Edward Chapman); and the eccentric Lady Dodds (Martita Hunt). Paris, who has barred any questions relating to religion and politics, is determined to keep the program at the level of trivia but is thwarted when his zealous assistant, Jessie (Janet Brown), introduces the question, "Is marriage a good idea?" The precarious relationship of the Prouts is publicly exposed and Angela's clandestine relationship with Professor Mutch provokes a quarrel between the husband and the lover. The audience also becomes unruly and Jessie insists on an answer to her question. Paris tries to restore equilibrium, but the squabbling between husband and wife goes on. He finally closes the session by saying, "Marriage is not a subject for mixed audiences," and announces the return of the Qualthorp quartet. The film ends with a chase as Paris and others try to stop the fleeing husband.

In challenging institutional complacency, the target of the satire is not merely the "Brains Trust" and the vapidity of its conventional format but, more profoundly, the "what if" question: What would happen if people actually confronted intellectuals with questions that related to the everyday concerns of people? The audience as goaded by Jessie and comprised of working-class individuals sees the program as an opportunity for education. The middle-class panel members are forced to confront their inability to address questions of immediate practical concern, not mere factual data. In this film, marriage becomes the vehicle to expose the complacency of the society, and a woman is responsible for upsetting the status quo.

The characters act out their marital conflict on stage, and thus Jessie gets the answer to her questions. As a surrogate for the external audience (and the film places us in the position of the internal audience), Jessie and her colleagues are treated to a vision of marriage that exposes its limitations. Paris, wanting to keep the lid on, tries to silence Jessie and shield the audience from the truth. Ironically, he wanted a form of entertainment that would hold an audience, but when he learns what the audience wants, he cannot cope with the conflict that is exposed. The film's dual focus on entertainment and marital conflict works in two directions. The marital conflict becomes the means of exposing the failure of entertainment to grapple with issues that affect people, and the entertainment becomes the pretext for exploring the failure of marriage. Silence is exposed as the ally of equilibrium and the status quo, and communication as its enemy. By breaking silence, everyone can see the fragility of social institutions. The film ends with the reconciliation of George and Angela and with Jessie deciding to marry in spite of her for-

mer reservations about marriage. The traditional comic ending with the lovers reconciled suggests the inescapability of repetition rather than renewal. In relation to the representation of women, the film seems to be more concerned than most films of the 1950s to confront women's struggle to have access to language as a means of understanding their subordination. The film "solves" nothing, but, like most of Launder and Gilliat's satires, it challenges the institutions that safeguard people from access to knowledge—marriage, the army, the church, and, above all, the entertainment industry.

Comedy Series

The 1950s saw two successful comedy series. The first began with the highly successful *Doctor in the House* (1954), directed by Ralph Thomas and starring Dirk Bogarde, spinning off *Doctor at Sea* (1955), *Doctor at Large* (1957) and others until 1970. The most popular series, however, was the "Carry On" series, which lasted until 1980. As the titles suggest, the target of humor was always a particular British institution—the army, the medical profession, and the schools in particular. The cast carried over from film to film, as did the producer, Peter Rodgers, and the director, Gerald Thomas. The writers were fairly stable as well, and the films were built according to certain formulaic requirements in terms of character stereotyping as well as of stock situations. *Carry On Nurse* (1959) is reminiscent of the Crazy Gang comedies in its focus on a group of characters as opposed to one or two protagonists. The film features an array of comic figures representing different classes, types of humor, social types, and sexual preferences. In this film the group comprises, among others, the middle-class Henry Bray, who is obsessive about appearances; Hinton, who spends his time conducting music heard from the radio and later impersonates a female nurse; the intellectual Oliver, who sickens after he falls in love; and Percy, a worker with a broken leg. Among the women are the big-bosomed and intimidating matron, the desexualized head nurse, the physically awkward Dawson, the naive student nurse with the large glasses, and the glamorous female doctor.

The plot is episodic and interweaves the different plights of these characters, usually involving the expression of bodily needs. The film is quite uninhibited in portraying those aspects of hospital life that are usually effaced, referring to such phenomena as constipation and vomiting, the shaving of the lower parts, and the taking of rectal temperatures—with a daffodil. The raucous humor derives also from the fact that this is a male ward tended by females, which places the men in abject and dependent positions. The subversive element of the film is the way in which the film points to the ineptness of institutional functioning—mismanagement, abuse of authority, incompetence, and blatant self-interest. Even more

significant, as Marion Jordan has indicated, "The source of the humour, then, is to be found in the contrast between the impossibly repeated, identical, stereotypical human beings for whom the institution's rules are devised, and the diverse and unpredictable 'real' people who arrive there. . . . What the institution typically fails to cater for is the animal nature of human beings; their sexuality (the institutions are typically segregated by sex), their excretory functions, their preference for idleness as opposed to pointless physical strain."[36]

A large share of the humor centers on sex roles and sexual preferences. The characters show the gamut of sexual responses, from repressiveness to promiscuity, from overidentification with the opposite sex to identification with the same sex. The stereotypes cut across gender and class lines, but because the representations of women are stereotypes built on unexamined social attitudes, any defamiliarization of the types becomes problematic. Accounting for the popularity of these films, Jordan writes, "in their day, and despite denying any place to women in their pantheon—portraying them, indeed, as gaolers, sexual objects, or unnatural predators—they nonetheless asserted by their themes, and by the gusto with which they were presented, a lower class, masculine resistance to 'refinement'; an insistence on sexuality, physicality, fun; on the need for drink in a kill-joy world, for shiftiness in an impossibly demanding industrial society, for cowardice amid the imposed heroism."[37] In this respect, the Carry On series shares with other British genres of the 1950s a problematic attitude toward women, a preoccupation with sexual repression, and a concern with prevailing institutional practices.

Ealing Comedy

In the late 1940s and early 1950s, Ealing Studios was synonymous with comedy. While Ealing had been in existence since 1929 and had produced a wide range of films—comedies, melodramas, literary classics into film—the arrival of Michael Balcon to replace Basil Dean as head of production marked the beginning of a new era for the studios as well as for British cinema. Ealing had been, under Dean, the home of such comedians as Gracie Fields, George Formby, and Will Hay, with their unique form of music hall comedy, and Balcon continued to make Will Hay films in the 1940s. Charles Barr finds these earlier comedies to "have a different feel from later Ealing comedy, much more vulgar (in a way that can be bracing to return to, after a surfeit of the later films), but there is a continuity in the values of the small community that they celebrate."[38] The pre-Balcon comedy was associated primarily with the stars of the films. The structure was much more episodic, the class divisions between working class and bourgeoisie were more prominent, and the conflicts presented were often more volatile as well as more romantic than the later Ealing

comic narratives. By bringing in new people as producers, directors, and writers who were able to work with him, Balcon was able to create a distinctive type of British cinema.

World War II helped further to forge Ealing's identity. The mode of production at Ealing was related to the issues that were dramatized in the films produced and in the values celebrated. As Charles Barr has said, "Insiders and outsiders alike commented upon Ealing's 'family' atmosphere. On the walls was the slogan, 'The studio with the Team Spirit'. For the film-makers whom Balcon employed, job satisfaction and security commonly made up for the modesty of the pay; the symbol of the Ealing system became the Round Table at which, every week, producers, writers, and directors consulted freely together. The values acknowledged were those of quality and craftsmanship."[39] In spite of differences in the talent and outlook of the personnel, the films share certain preoccupations that stamp them as products of Ealing Studios. They are, first of all, not lavish or spectacular in appearance. They were distinctively middle class in their outlook, and they probed tradition, loyalty, community, and social responsibility, expressing a distaste for overreaching and crass materialism. Rooted in a populist ethos, the films disdain rugged individualism, and are characterized by the struggle to overcome class and generational divisions. The negative figures in the films are bureaucrats, unyielding authoritarian figures who obstruct the sense of collectivity. At their worst, the Ealing films are weighed down by their populist ideology. At their best, they are mordant dramatizations of a hierarchical society in which upward mobility can be achieved only through drastic means.

One of the most carnivalesque and playful of the Ealing comedies, a film that exuberantly challenges social stagnation, is Henry Cornelius's *Passport to Pimlico* (1949), with script by him and T.E.B. Clarke. The film is not centered around one major figure but depends on ensemble acting, featuring such familiar comedians as Stanley Holloway, Margaret Rutherford, Hermione Baddeley, Naunton Wayne, and Basil Radford, and the tension in the film is generated out of the interactions among these characters. Moreover, the films treats the community, even as a crowd, not as a menace but as a collectivity, and many of the scenes show the crowd as active participants rather than mere spectators.

The film plays with the familiar comic motif of the world turned upside down. One extremely hot day in Pimlico, children playing in a bomb crater fall into the hole and must be rescued. Pemberton (Stanley Holloway) runs to their assistance, and, while he is in the crater, discovers a treasure and an ancient document. The document establishes the treasure, and hence the area, as belonging to the Duchy of Burgundy. Professor Hatton-Jones (Margaret Rutherford) is brought in and testifies to the authenticity of the document, and the inhabitants now secede, identifying

themselves as Burgundians. Celebrating the fact that London has no jurisdiction over them, the people celebrate their freedom from restrictions. Bars remain open; rationing is suspended. Some of the inhabitants take advantage of the situation to further their own interests, while others, like Pemberton, are concerned and begin to talk of capitulation.

Now foreign territory, Pimlico becomes the haven of vendors and buyers who wish to escape rationing and to shop on Sundays, a situation which encourages some of the inhabitants to establish their own rules. Whitehall, however, strikes back, and the people learn that they must pay customs and also have identity cards to leave Pimlico. Events escalate and there is talk of closing the frontier. The Burgundians determine to fight back, since "Burgundians are a fighting people." One woman says that if the Nazis with their doodlebugs could not get her, the government will not succeed either: "Because we're English, we're sticking up for our rights to be Burgundians." A condition of war prevails. Children are evacuated, and a newsreel portrays "The Siege of Burgundy." Food and water become scarce, and there is talk of people starving to death. A paper headline announces, "World Sympathy for Crushed Burgundians." Outsiders throw oranges at the inhabitants, and there is an airlift to help the beleaguered Burgundians. Finally they capitulate, and the film ends with a banquet welcoming Pimlico back into England. The heat wave is broken as rain pours down on the banquet celebrants.

The complexity of the film is in the allegory, in the parallels between the situation prevailing in Pimlico and the conditions of the postwar world. The film evokes specific aspects of postwar England in the long hot summer, the existence of black marketeering, the continuing expansion of state controls, and an indifferent and hostile state bureaucracy. The film also evokes memories of the war years in numerous ways: the fighting spirit of the Burgundians, the Churchillian militant rhetoric, the evacuations, shortages, airlifts, and even the newsreels echoing wartime reportage. The populist ideology of the war years is reenacted as the Burgundians seek to resist a foreign and dictatorial government.

The heat wave is symbolic of the fever gripping the population, which is finally broken by the rainstorm, coinciding with the return to normalcy. The heat is the gauge of the intensity of this topsy-turvy world, which turns out to pose complications not only for the government but for the inhabitants of Pimlico. The film can be read as a critique of postwar England, with its nostalgic look backward at the collective ethos of wartime England; however, because it is not a polemic but a comedy, the film can be seen in the same vein as *Whiskey Galore!* as exploring more fundamental questions of the relationship between past and present history, between subjection to authority and release from restrictions, remaining suspended between the oppositions it dramatizes.

Whiskey Galore! (1949), based on a novel by Compton Mackenzie, who appears in a minor role in the film, replays many of the themes of *Passport to Pimlico* in less encyclopedic and allegorical fashion. Directed by Alexander Mackendrick, the film was shot on location in the Outer Hebrides on the island of Barra. Among the many distinctions of the film are its use of the islanders and its effective creation of the sense of place as an integral part of the film's point of view. Based on an actual incident involving a ship containing 50,000 cases of whiskey bound for the United States foundering off the island of Eriskay, *Whiskey Galore!* portrays a community sorely hit by the war and the shortage of the "water of life." The community is revitalized by the appearance of the ship, and the men join together to retrieve what they can from the sinking vessel.

The main antagonist to the islanders is the scrupulous Captain Paul Waggett (Basil Radford), who is determined to deprive the men of the whiskey they have garnered. Waggett cannot understand the islanders, their customs, and their language. He measures their culture against his own English culture and finds theirs deficient. Even his own wife cannot understand his obsession with discipline, and she is permitted one of the final comments in the film as she laughs raucously at Waggett's being exposed while sending back what he believes to be ammunition to the mainland that turns out to be whiskey subject to excise. His rigidity produces nothing but blunders. The only character with whom he shares an affinity is Mrs. Campbell, a rigid disciplinarian who rules her son with an iron hand until the whiskey liberates his tongue, enabling him to stand up to her and become engaged.

The comedy in the film arises from the pleasure at seeing Waggett's authority undermined, even by Colonel Linsey-Woolsey, who appreciates the whiskey more than Waggett's official rectitude. Whiskey symbolizes the lifeblood of the community and a freedom from restraint, exemplified by Waggett's English efficiency. Waggett is increasingly isolated, and his position is set in direct contrast to that of the islanders, who are brought closer together as they seek to protect their precious cargo. The villagers celebrate the regaining of the whiskey at an engagement party for the daughters of the postmaster. The party is the occasion for music and dance, symbolizing freedom from restraint. The celebration is interrupted by the arrival of the excisemen, but not before the islanders quickly hide the whiskey in every possible storage container, including cash registers, baby carriages, pots, and spigots. They even manage to use Waggett's own home guard devices against him to keep him from catching them as they move the cases of whiskey from their cave to the town.

The use of actual villagers, the highlighting of local customs, the images of the sea and the town, all give the film a sense of authenticity and redeem the Scottish characters from their usual quaintness in British

films. Moreover, the British, as exemplified by Waggett, are seen in rare fashion as a caricature of efficiency, service, and duty to the nation. While Waggett seeks to remind the islanders of the war and their duty to England, his constant attention to duty is counterproductive. He is incapable of gaining the cooperation of the people, and literally becomes a laughingstock, both for the islanders and for the film audience. He is the typical spoilsport who, ironically, is responsible for bringing people together in opposition to what he represents. While the film is a celebration of community, its sense of community is not simplistic. It is based on the reality of privation and restriction, but also on the necessary struggle against institutional power. The conflict over the whiskey is the pretext encouraging the viewer to imagine alternatives to present social practices. The film explores the particularly timely issue of state power as it encroaches on private life, seeking to legislate pleasure—a familiar theme of the postwar period. However, the film's vitality lies in its carnival atmosphere, its loosening of restraints.

Kind Hearts and Coronets (1949), directed by Robert Hamer, shares with *Passport to Pimlico* and *Whiskey Galore!* a contempt for the abuse of privilege, but this film offers a more trenchant psychological as well as social exploration of the nature and effects of social class. Louis Mazzini (Dennis Price), the protagonist, succeeds in eliminating eight members of the d'Ascoyne family who stand in the way of his acquiring the title to a dukedom and recovering his role in the family hierarchy. His mother, though of the aristocracy, had married an Italian street singer and was dispossessed. Louis is determined to seek revenge, and for each of the d'Ascoynes he invents a murder that is appropriate to the individual. The various d'Ascoynes are played by Alec Guinness, who is sequentially a banker, a suffragist, a canon, a military man, a photographer, and a duke. Louis also experiences humiliation at the hands of Sibella (Joan Greenwood), who, not believing in his potential to rise in the world, marries a pedestrian man, Lionel, but regrets her choice after Louis begins to recuperate his fortune. After disposing of Edith's husband, another d'Ascoyne, Louis proposes to Edith (Valerie Hobson), to Sibella's chagrin. In retaliation, Sibella has Louis arrested for Lionel's death, but she finally has him exonerated, since Lionel actually committed suicide. Ironically, Louis is not arrested for all of his murders, but he gives himself away by leaving his memoirs in the prison cell.

The film utilizes voice-over narration, like many of the Ealing dramas and comedies, but Mazzini continues throughout to develop his story. His narration distances the spectator from the situations and inhibits identification, allowing for a suspension of moral judgment about Mazzini's actions. The tone of the narration, like the actions of Mazzini, is precise and unemotional. The elimination of the various d'Ascoynes is

described by Dennis Price with detachment, focusing on detail rather than affect. For that matter, most of the characters are calculating, cold, and self-possessed, since they are seen from Mazzini's perspective and told through his narration.

Alec Guinness's portrayal of the roles of the d'Ascoyne victims not only is a virtuoso opportunity for the actor, but is in keeping with the satiric leveling of difference. All of the d'Ascoynes appear the same, suffer from the same pompousness, and merit the same treatment. Louis's confrontation with the d'Ascoynes thus becomes an encounter with an institution rather than with individuals. The portrait of each d'Ascoyne, with Guinness in each role, enables the viewer to focus on the caricature rather than on the specific character, since one does not have to contend with a new personality. However, the women in the film are contrasted with each other. Sibella is feline, sensual, and unscrupulous, while Edith is the inscrutable image of correctness. Louis's attachment to his mother is the ostensible motive for his revenge. Her humiliation at the hands of her family for having married outside her class, aligned with Sibella's rejection of him for Lionel, hardens Louis in his quest. Charles Barr asserts that "the mother is as important to *Kind Hearts and Coronets* as to *Citizen Kane*: seen only briefly, but frequently recalled and psychologically central. . . . Simply by the shock of his entry into the world, Louis kills his father; he thereafter settles down to an exclusive loving relation with his mother. Lacking a father from this point, he can't work through the Oedipal conflict."[40] With the exception of Lady Agatha, a suffragist (also played by Guinness), the d'Ascoynes are all male, and emblematic of a class that is characterized by male prerogative and the rule of the father. Despite Louis's murderous acts, he is within this context a sympathetic figure, acting in the name of his mother to destroy the rigid and arrogant figures who are seen as destructive social forces.

The Lavender Hill Mob (1951), directed by Charles Crichton and written by T.E.B. Clarke, also focuses on a man who puts into practice the fantasy of escaping his social position. In the case of the Hamer film, the protagonist's motives stem from personal injury and the desire for revenge. In the case of the Crichton film, the protagonist imagines a more capacious and hedonistic life, freed from the restraints of routine. Alec Guinness stars as a mild bank clerk, Holland, who has secretly harbored plans for robbing the gold which he has for so many years faithfully guarded. He joins forces with Pendlebury (Stanley Holloway), who manufactures souvenirs, and two crooks, Shorty (Alfie Bass) and Lackery (Sidney James), to transform the gold bullion into small, transportable Eiffel Towers. During the robbery, Pendlebury is arrested for walking off absentmindedly with a painting from a street exhibit. At the police station, Pendlebury sees Holland, rescued by the policy after having been

blindfolded (according to plan) and falling into the water. Thinking that Holland has been arrested, Pendlebury confesses to the robbery. The painter who has pressed the charges, and the police, interpret the confession as applying to the theft of the painting and not to the bullion robbery. When he hears Pendlebury say that he could not resist this "golden opportunity," the painter rushes off to sell his work and drops the charges. Pendlebury is released, and the men cast, crate, and have the towers transported to Paris. The next and more serious difficulty arises in Paris, where the gold Eiffel Towers are inadvertently mixed up with regular souvenirs. Now the men have to track down the authentic pieces, which have been bought by some English schoolgirls. The men return to England and, through a series of hair-raising escapades, track down all the pieces but one. They locate the last one at a police exhibition, and the final mad chase begins, in which Pendlebury is caught but Holland escapes, only to be caught in Rio de Janeiro.

The film is framed by Holland's narration. He is first seen, a picture of success, in a South American environment, telling his story to a man at his table. At the end, we learn that his audience is the detective who has finally caught up with him. The film relies heavily on the use of double entendre as well as on classic chase sequences, but the comedy resides more subtly on character. Holland first portrays himself as the loyal employee who has no desire but to serve his employers, who loves work for its own sake. He has earned a reputation for dependability to the point of being a laughingstock among his fellow workers, and only gradually does it come out that he has been biding his time. At the Balmoral Private Hotel, where he lives, he reads detective stories to one of the tenants, Mrs. Chalk (Marjorie Fielding), and the motif of fantasy is reinforced. Not only Holland but others are caught up in the fantasies of violating the status quo.

None of the mob is vicious; the four members are presented as having diverse motives in the robbery. Holland's ambitions are the most clearly developed as a rebellion against the rigidity, bureaucracy, and anality of the commercial world. Unlike his fellow workers, he does not want a token "leg up." His imagination entertains more lavish fantasies, exemplified by his life in Rio, involving racing, partying, women, and even philanthropy. Through his character, money is exposed as signifying a way of life that is guarded, hoarded, and locked up. His theft is a challenge to the sterility and routinization of daily life, a potential source of pleasure, if only transient pleasure. Pendlebury, by contrast, is an aesthete, a naive and inefficient follower, who is easily intimidated by authority. He articulates no ambition; as he tells the police, "I'm no thief, Officer. My character is an open book." Shorty and Lackery, who are members of the working class, are willing and useful accomplices in the

theft, but also without Holland's desire to live on a grand scale, preferring modest family life. But, in spite of their defection, the film exposes the existence of a disruptive and volatile world that threatens the smugness of middle-class respectability. The rhythm of the narrative corroborates this volatility as the action moves from the comic blunders of the mob as they carry out the theft, to Holland's and Pendlebury's quest to reclaim the gold, and finally to the fast-paced scenes of the police chase as they pursue Pendlebury and Holland.

The language employed in the film, particularly the use of double en-tendre, suggests that the world of the mob and that of the relevant social institutions are actually interconnected. For example, in a voice-over re-port on the robbery, the announcer comments on how "everyone who traffics in stolen gold will find it too hot to handle." He also refers to "cast iron evidence" being "forged," thus using language specifically revealing of the crime. Likewise, as in Pendlebury's earlier confession, the "truth" of the robbery is available to the police but rejected. It would appear in these telltale moments, which could be attributed to mere word play or conventional comic confusion, that a more serious issue is being ex-plored: namely, the notion that the bureaucratic social world is charac-terized not by ignorance but by a refusal to look and to listen. Though the film's alliance of workers and underworld against the forces of respecta-bility is subversive, the narrative, utilizing the comic mode of the world turned upside down, turns not to a utopian solution but to a sober resto-ration of law and order. *The Lavender Hill Mob* is not mired in a pro-grammatic sense of responsibility and moral rectitude but displays a more ambivalent attitude toward conventional morality and behavior, as do many of the comedies of the 1950s.

If the protagonists of *Kind Hearts and Coronets* and *The Lavender Hill Mob* are rogues, *The Man in the White Suit* (1951), directed by Alexander Mackendrick, features a more idealistic protagonist who is obstructed in his objectives by the combined forces of the bourgeoisie and the aristoc-racy. In contrast to Louis Mazzini and Dutch Holland, Sidney Stratton (Alec Guinness) is the traditional *vir bonus*, filled with social idealism and totally naive about power. His obsession with creating a fabric that is indestructable, however, violates the workings of industrial capital and labor. Living on the periphery of society, having no personal life, totally dedicated to his invention, Sidney is willing to suffer any privation in the hope of success. His objectives appear to be not social power or wealth but making a contribution to society. He is the perfect foil for the unscru-pulous industrialist Birnley (Cecil Parker) and his colleagues, such as the aged Sir John Kierlaw (Ernest Thesiger), who upon realizing the implica-tions of Sidney's invention for the workings of capitalism, gang up on him, along with representatives of labor, headed by Bertha (Vida Hope).

"Capital and labor are hand and hand in this," is the cry of the mob as Sidney tries to evade his enraged pursuers.

In his quest to gain the materials he needs to proceed with his work, Sidney manages to gain the support of Daphne (Joan Greenwood), Birnley's daughter, and is able to produce a glittering white suit that radiates light like a halo. He looks like a knight, and Daphne is as much seduced by his purity as by the opportunity to thwart her father and her fiancé, Michael (Michael Gough), a junior version of her father. Despite her mixed motives, she represents resistance to the massive forces of containment. She, too, is finally a tool of her father. Sidney's only allies are female—Daphne and the child who helps him to escape the mob—which seems appropriate since, like them, his demeanor is childlike, though not guileless. In his anarchic behavior he throws the world he inhabits into disarray. He is the antithesis of the paternalistic, smug, self-satisfied, bureaucratic society that is motivated by profit, power, and self-interest. As an individual, he cannot undermine the power of the industrialists or the mob, but can only engage in subversion.

The film does not make any claims to portray class conflict. Like a later, non-Ealing satire, *I'm All Right Jack* (1959), all classes, all institutions, and both sexes are subject to the same critique. Also, like the protagonist of the Boulting film, Sidney is a graduate of Cambridge, and the film seems equally critical of his naivete, his lack of preparation to understand the corruption of the world of commerce and industry. As a crusader, he is out of touch with the wheeling and dealing of the bosses as well as of labor in collusion with capital. The irony, of course, is that if he were to understand the cash nexus of capitalism, he would never have invented the one item designed to undermine the system. The comedy in the film, as well as the pathos, arises from the specific product that he invents. The white suit is symbolic of his innocence. It is also symbolic of the ineffectuality of the crusader, who cannot single-handedly overcome the arrayed forces of commerce, and the film seems to provide a double-edged critique of Sidney as well as of Birnley and his colleagues. The comedy also derives from the classic role of the satiric protagonist who, in his naivete, exposes for the audience the corruption around him. His obsession becomes a source of humor and even farce as he struggles physically to position himself in places where he is unwanted. The burbling and gurgling sounds in the film function in complex fashion as a means for distinguishing Sidney from others as an anarchic force in the midst of repression. The various explosions from his experiments are similarly connected to the disruptive elements unleashed by him. These sounds act as yet another form of narration in contrast to the voice-over.

The use of voice-over, characteristic of Ealing comedy, is also ironic. The narration, however, is not Sidney's. It is Birnley's, and this makes

Sidney's escapades appear all the more disruptive and threatening, but also more sympathetic, since he does not even plead his own case. Above all, the comedy is dependent on the acting of Alec Guinness. His physical appearance as the enigmatic and obsessive inventor is that of an overgrown child. His walk is loping, his gestures awkward. But what most characterizes Guinness's appearance in this film is his look of wide-eyed earnestness and his half-smile. Durgnat, who sees Guinness as the "figure-head of fifties comedy," describes him as a "comedian of pathos."[41] This pathos is most evident in Guinness's portrayal of Sidney's continuing battle with physical and psychological obstructions, which places him constantly in danger of exposure and betrayal.

Several critics have commented on the film's reflexivity. Sidney's "invention" is, like British filmmaking in the postwar era, threatened by inertia, bureaucracy, and misapplied finances. The film is consonant with the ideology of many of the 1950s films which dramatize the conflict of the individual against organized society, and present that society as massively corrupt with few redeeming qualities. Like most satires, the film offers no consolation, but is unremitting in its portrayal of social disintegration. After *The Man in the White Suit*, Ealing comedies themselves begin to disintegrate.[42]

The Titfield Thunderbolt (1953), directed by Charles Crichton, is representative of this disintegration. The film shares a kinship with the earlier comedies insofar as it, too, directs its critique against the profit motive and bureaucracy. Also an allegory, the film involves the maintenance of a train that has served the community but is threatened with obsolescence in the dawning age of new and speedier forms of transportation. The train is the symbol not only of an older form of transport but also of a traditional way of life. The community is divided between those enthusiasts bent on maintaining the railway line and those determined to bring in the buses. The local preacher (George Relph), the squire (Naunton Wayne), and the wealthy village eccentric (Stanley Holloway) unite to galvanize the community in their effort to salvage the train. They organize entertainment to collect funds for their project, spearhead public meetings, and even run the train.

The film's narrative is simply constructed around the quest to save the train, the elimination of obstacles to success, and the ultimate triumph of the enterprise against those who would sabotage the effort. The tensions in the film arise from the conflict between the forces of conservation and the forces of modernity. The film makes a link between business and criminality with its emphasis on the civic bureaucracy emanating from London, which aligns itself with the most corrupt and unscrupulous elements in the community. Modernity is also portrayed as associated with Americanization, exemplified most particularly in television programming that

features American westerns. A segment from an American western film operates as a reflexive reference and suggests an implicit contrast between Hollywood cinema and Ealing films.

The film emphasizes the beauty of the landscape, which serves by extension to dramatize the beauty of the agrarian way of life as opposed to modern urban complexity. Above all, the amalgamation of the squire, clergyman, and wealthy eccentric identify the film's sense of community, which is conceived of along the lines of traditional English pastoral mythology. Their "resurrection" of the train is, like the film's enterprise, a resurrection of a museum portrait of an earlier England. Instead of celebrating the utopias of community as it seeks to do at the end, the film reveals, in spite of itself, the efforts on the part of a few conservatives to salvage a way of life that is not merely passing but is actually gone.

One of the last of the roguish films produced by Ealing, *The Ladykillers* (1955), conveys the same sense of having retreated from the present. The cast is a comic cornucopia, starring Alec Guinness as Professor Marcus, Cecil Parker as Major Courtney, Herbert Lom as Louis, Peter Sellers as Harry, and Danny Green as One-Round. They are a gang of robbers from different backgrounds and classes who have selected Louisa Wilberforce's (Katie Johnson) old Victorian home as their headquarters, passing themselves off as a chamber music group. She is only too happy to have company in the house, and is at first taken in by their appearance of respectability. She unwittingly becomes an accomplice in the robbery, and when she learns the men's true identity, they determine to get rid of her. The men fail in their attempt to kill her, instead knocking each other off one by one. Mrs. Wilberforce attempts to report the theft to the police, and Jack Warner, in one of his many police roles for Ealing, humors her and sends her home. Outside, she buys a new umbrella and donates money to a street artist who is doing a portrait of Winston Churchill.

The comedy hinges on the interaction between the men and the old woman. As the genteel Mrs. Wilberforce, Katie Johnson, along with the house, represents an aged, prim and proper image of rectitude and respectability. And, like the house, which is the sole survivor of another time, hemmed in by the images of modernity, she is a relic, a survivor from another world. Everything in her house is original and authentic, in contrast to the disguises and impersonations of her lodgers. She is the incarnation of a sense of history, duty, and gentility. But she is ineffectual. She does not bring the men to justice, hard as she tries. She cannot convince the police that a robbery has taken place. In short, it is almost as if she were invisible to everyone except the audience. The men do themselves in with no thanks to her. The film begins as a parody of a horror film, and her house appears the perfect setting for a crime as it personifies age and decay.

The men inhabit a microcosm of a society where robbery and criminality are conceived of as the way to get ahead, but, ironically, the men are blunderers. Although they are able to commit the crime, they cannot profit from the theft because they cannot trust each other. As the professor states, "It was a good plan but for the human element." They go through the pretense of having democratic procedures, but in the final analysis they destroy each other. Moreover, it is appropriate that they do not die in the house but outside and by that ultimate symbol of modernity, the railroad. Like modern politicians, the men rationalize their theft to Mrs. Wilberforce, telling her that they are spreading around the wealth in a way similar to social welfare enterprises.

In the vein of other Ealing comedies, the film is allegorical. Just as the train and the trio of men in *The Titfield Thunderbolt* represent rural England, so the house and its inhabitants in *The Ladykillers* are representative of the nation. The difference between the two films, however, resides in the tone and treatment of the allegory. Whereas the earlier film attempts to resurrect the past, this film is an elegy for its passing. Moreover, there is no sense of community in *The Ladykillers*. Rather, the film is like a dream, or rather a nightmare, in its style, in the use of chiaroscuro lighting, the play on shadows, the skewed perspective on the house, and the tight framing of the scenes. Finally, as Richards and Aldgate state, "the film is a paean to old age. . . . Mrs. Wilberforce's world is an apt metaphor for mid-1950s England, a cul-de-sac slumbering peacefully but shortly to be violently awakened."[43]

The last Ealing comedy, *Who Done It?* (1956), was directed by Basil Dearden and featured Benny Hill. The film revolves around the figure of Hill. While generally considered a poorly made film indicative of Ealing's loss of vitality and sense of audience, the film is interesting as a specimen of cold war comedy. Garry Marsh plays the police inspector who always arrives too late to find the evidence. The plot involves an ice rink attendant, Hugo Dill (Hill), who aspires to become a detective. Assisted by Belinda Lee, he discovers a gang of Russian spies who are planning to eliminate British atomic scientists at a conference. He impersonates one of the spies and saves the day. He also saves Belinda Lee and finally convinces the police that they should arrest the conspirators.

Hill's comedy is generated from his desire to be something other than he is; from his proneness to mishear, misrecognize, and misunderstand; and from his ability to do impersonations. In the film, he is disguised alternately as a German professor, religious figure, salesman, and female contestant in a game show. The satiric targets in the film are technology, weather control, advertising, and radio and television, especially game shows. The satire does not extend, however, to the treatment of the spies, which is mainly a reproduction of the typical spy figures in the espionage

films of the time. The structure of *Who Done It?* is a throwback to a traditional comic narrative, embellished by the more timely espionage sequences involving cold war antagonists and the updating of the scenes involving modern technology.

Family Comedy

Family comedy was a familiar genre in the 1950s. Its popularity can be attributed to a convergence of factors: official and media encouragement of familialism in images designed to strengthen family relationships; sociological concerns about crime and juvenile delinquency traced to inadequate family bonds and care of the young; a concern about broken homes—more generally, a retreat from the public arena into the home; the rise of television as a form of family entertainment; and the film industry's attempt to woo straying audiences. The family comedies address a number of concerns that are evident in the melodramas and the social problem films: marital conflict, youthful disaffection, generational conflict, and domestic entrapment. The familiar characters in these films are rebellious teenagers seeking to escape parental dictates, housewives overwhelmed by domesticity, and men struggling to assume a paternal role. The films often border on satire, and the tone is often quite somber.

Young Wives' Tale (1951) explores marital madness through tracing the conflicts of two complementary characters. One woman, Sabina (Joan Greenwood), is romantic, totally devoted to her husband, Rodney (Nigel Patrick), and to domesticity. Mary (Helen Cherry), on the other hand, is a professional woman who leaves her child-rearing to Sabina and to nurses, much to her husband Bruce's (Derek Farr) consternation. Sabina, feminine and "fluffy," derives her pleasure from the admiration of men and enlivens her marriage through constant conflict and reconciliation with her husband, often through provoking his jealousy. Mary, severe and unemotional, avoids contact with her husband, who wants her to be more like Sabina, emotional, dependent, and maternal. First succumbing to the blandishments of a male friend (Guy Middleton) who flatters her with attention and gifts, Sabina later seduces Mary's husband, thus raising Rodney's ire, causing him to leave her as well as awakening Mary's jealousy. This episode turns out to be "therapeutic" for Mary and Bruce. He finally witnesses her humbling and her transformation into the emotional woman he desires. Ultimately both couples are reconciled, but the final images of the film portray the reduction of the domestic environment to chaos as Mary's child floods the house. The dog runs off with the meat for supper as the radio announcer comments on the great debt the nation owes to the British housewife. The film thus portrays misalliance and the discontents of professional and domestic women. The chaotic physical environment serves as a metonymy for marriage, and chaos

rather than order is the film's final word on domesticity. In the portrayal of both women, the film reveals the oppressiveness of all alternatives available to women, and the chaos at the end of the film speaks eloquently to both the insolubility of the problems posed and to the inability of the comic form to contain the conflicts.

The claustrophobia of domestic life is portrayed with a vengeance in Muriel Box's *To Dorothy a Son* (1954), which explores the financial and personal vicissitudes of a young couple, Tony and Dorothy (John Gregson and Peggy Cummins). Dorothy is pregnant, a rare phenomenon in British films of the 1930s and 1940s. That the film addresses pregnancy and the banalities of domestic life can be attributed to its being directed by a woman. The husband, Tony, a composer, works day and night in order to meet a deadline, and the couple is threatened with being evicted from their dwelling. He is sabotaged in his work by the bill collectors and by the frequent requests of his wife, who never leaves her bed, even after she finally delivers her child. Their lives are complicated by the return of Tony's former wife, Myrtle (Shelley Winters), an American. Myrtle needs his signature so that she can inherit $2 million from her uncle provided that her former husband does not have a male child. The race is on to see if Dorothy will deliver her child by the deadline specified in the uncle's will. She does, first a girl and then, in the nick of time, a boy, and the couple shares the money with Myrtle.

According to Raymond Durgnat, the film "sets its cap for the distaff side of the box-office, apparently on the assumption that women relish the spectacle of thoroughly hen-pecked males. . . . This battle of the Amazons, a whiningly self-righteous one versus a glittering American, might have been quite Homeric. Alas, a boring plot fobs us off with tittle-tattle about an inheritance."[44] Durgnat's language betrays a lack of sympathy with "the distaff side" of the audience. The focal point of the film is not the inheritance; the inheritance is a pretext for exploring unsatisfactory and constraining female roles. Directed by one of the few British female directors, Muriel Box, the film unrelentingly portrays the oppressiveness of the only alternatives available to women: domestic claustrophobia and consumerism.

Shelley Winters as Myrtle La Mar is one in a string of buxom blondes who were to become prominent in the British cinema of the 1950s and culminate in Diana Dors, figures traditionally associated with Hollywood and with images of sex and material acquisition. Christine Geraghty's description of the persona of Dors can be applied to Winters in this film: "Dors embodied both the down-to-earth recognition that money was crucial to getting on and the heady notion that it could all be thrown away on having a 'good time.'"[45] Winters is also energetic and resourceful on her own behalf. She wants money and pleasure. She is seductive,

and the way she dresses advertises her sexuality and her quest for the good life. She is the incarnation of the American "sex symbol" of the 1950s, and in the context of Box's film, she signifies the threatened Americanization of British culture and institutions, but she also serves as an alternative to Dorothy's domestic entrapment.

Dorothy, on the other hand, played by Peggy Cummins, is attractive, but in domestic and maternal fashion. Her life revolves around the home, and the film exposes the material and psychological constraints of family life, exaggerating them to the extent that she never leaves the bedroom. Muriel Box, the director, not only pits these two women against each other, but portrays the male as an ineffectual intermediary. The cultural difference between the British housewife and the American siren is central to the narrative. At the end of the film, Dorothy is left with her two babies and Myrtle with her furs as she coos to them, "You're mine, all mine." Both women are given the means to attain the female power they are portrayed as desiring. What becomes glaringly obvious is that both women have to be satisfied with the "payoff," for there is nothing more by way of satisfactory relations with men. Both women are materially compensated, but nothing has changed. Dorothy is still the eternal housewife and mother, while Myrtle remains the eternal "good-time-girl." Sexuality and motherhood seem to be irreconcilably opposed. The dominant male figure in the film, Tony, is one of a host of nondescript males in the 1950s films, his ineffectuality only reinforcing the poverty of heterosexual relations in the film.

In the context of the 1950s films that are obsessively preoccupied with male anxieties, Box's films are more women-centered, and dramatize, in particular, the cultural constraints experienced by women. Box's film does not offer alternatives but exposes the impossibility of satisfactory sexual relationships between women and men, and her portrayals of women are far more developed and empathic than those of many of the dominant male directors.

Wendy Toye was another notable 1950s female director. Her comedies include *All for Mary* (1955), *Raising a Riot* (1955), and *True as a Turtle* (1956). *Raising a Riot* is a family comedy that places the male in a temporary position of nurture. The protagonist, Tony (Kenneth More), is left to care for his brood of children while his wife, Mary (Shelagh Frazer), goes off to care for an ailing parent. He goes to stay with his irascible father in a converted windmill, and has to assume full responsibility for feeding, tending, entertaining, and disciplining the children and confronting the everyday tensions of domestic life. He becomes responsible for the housecleaning, shopping, cooking, and cleaning, learning that he has no time left for his own work. When his wife returns, he tells her, "I wouldn't be a woman if the entire United Nations got down on their knees and begged

me. You know what a woman has to be—a saint and a drayhorse, a diplomat and a washing machine, a psychiatrist and a bulldozer, a sanitary engineer and a mannequin." To which his wife responds, "Darling, I do know what a woman has to be."

The film is structured around a series of episodes that constitute crises with the children. This loose organization allows for the deliberate development of different aspects of women's position as enacted by the male. By means of the role reversal, the film defamiliarizes and lends a certain drama to the everyday tasks associated with women's work in the home, which are acceptable as commercial entertainment only through placing the male in the female position. Moreover, the film does not portray Tony as improving on the woman's role, as competing for competence with the woman; the focus, rather, is on the difficulties that he confronts and the problems that he fails to resolve. The familial scene is not presented as a pastoral idyll but remains throughout the film a site of struggle. The comedy is generated from Tony's awkwardness in this unfamiliar terrain, from the confusions generated by his frustration, and from the familiar domestic mishaps that are defamiliarized as a result of the role reversal. Unlike many of the comedies that portray familial conflicts, *Raising a Riot* does not dramatize marital conflict or rebellious youth but rather the more mundane aspects of domestic life. Although the wife is absent, she is very much present in the representation of the nature and demands of domesticity.

Political Satire

In the late 1950s, the Boulting brothers turned from melodrama and espionage to satire, directing such films as *Private's Progress* (1956), in which their satiric target was the army. In *Brothers in Law* (1957), they turned their attention to the legal profession. *Lucky Jim* (1957), based on Kingsley Amis's novel, tackled the academic world, but in 1959, they took on capital and labor. The films often starred Ian Carmichael, the actor in the late 1950s who best embodies the young male ingenu as the agent for exposing the failure of British institutional practices. In *I'm All Right Jack*, we see him as Stanley Windrush, a young, overprotected Oxford graduate, who attempts to find a place for himself in the world of industry only to discover that his honesty clashes with the self-seeking behavior of his employers—Uncle Bertram (Dennis Price) and his unscrupulous crony, Sidney de Vere Cox (Richard Attenborough).

But the film does not merely expose the corruption of the capitalists and their shady manipulations of Third World markets; it also attacks labor. Peter Sellers as Kite, the shop steward, represents the decadence of British labor. He calls men out on strike at the slightest provocation. He is an absolute tyrant over the men while mouthing democratic platitudes. He talks about the respect for work in the Soviet Union, while he governs

a shop in which the men seek any excuse to avoid work. He even con-
spires with capital in order to rid the shop of Windrush, who is, after all,
a worker. His pretensions to social consciousness are undermined by his
pompous appearance and demeanor, and his pretensions to culture are
undermined by his platitudes and malapropisms. In his library he boasts
works by Marx and Lenin and other treatises on workers and social class
which he attempts to pass on to Stanley, but which his wife derogates. His
paternalistic behavior is finally thwarted by his wife and daughter, who
decide after he turns on Stanley to go on strike in the home and leave him
to fend for himself.

The women in the film represent different values. Mrs. Kite (Irene
Handl) is pragmatic and does not agree with her husband's rigid and
hypocritical politics, taking every opportunity to expose his folly. Their
daughter, Cynthia (Liz Fraser), is a full-bosomed blonde in search of plea-
sure and has no interest in her father's tirades and machinations. Aunt
Dolly (Margaret Rutherford), Stanley's eccentric aunt, wants nothing
more than for Stanley to do right by his class and his upbringing. When
she comes to bring Stanley home after his dismissal at the factory, she
meets Mrs. Kite. Though initially leery of one another, the two women
discover that they share attitudes toward work, responsibility, and duty.
The women represent a constellation of values that are sharply in contrast
to those of the men and can be read as a critique of the men's unscrupu-
lousness, ambitions, and pretentiousness. The film exempts the women
from the satire reserved for the men but situates them in a reductive and
anti-intellectual position.

The climax of the film takes place, appropriately, during a television
program hosted by Malcolm Muggeridge in which each of the men at-
tempts to make a case against Stanley. Stanley, however, takes on all the
men—Uncle Bertie, Sidney, and Kite—throwing the blackmail money in
the air and disrupting the programming as the audience scrambles for the
loot. Stanley finds himself before a judge, where he is declared mentally
unfit, and he retires to the nudist colony where he had earlier visited his
father. The mass media—newspapers, billboards, radio, and documen-
tary footage—are also included in this critique of the "new age." The film
is similar in many ways to *The Man in the White Suit*. In its choice of an
idealistic and naive protagonist, its attack on both capital and labor, and
its portrayal of the stasis and corruption of contemporary society, the
Boultings' film is more encyclopedic. The film ends at a nudist camp with
father and son. The image of Stanley running for his life from a group of
enthusiastic women evokes a Swiftian disgust for the body, especially the
female body. Not even sexuality is all right in *I'm All Right Jack*.

Launder and Gilliat took their stab at 1950s British society in their
Left, Right and Centre (1959). The film opens with an appropriate motto
from Shakespeare written on a wall: "A plague on both your houses."

The object of the satire is political parties, and the film begins at Westminster during a by-election as the voice-over announces, "Every nation gets the government it deserves." The apathy of the voters is highlighted as a narrator recounts how the voters are alert to the social issues of the day while the image of a sleeping man (Sidney Gilliat) is shown. Other shots undercut any sense of voter knowledge or enthusiasm. The narrative involves two political candidates, one for the Conservatives (Ian Carmichael) and one for Labour (Patricia Bredin), who meet on their way to electioneering at Earndale, fall in love, fight out their differences, and finally, despite interference by their managers, marry.

John Hill finds the film to be "the most eloquent of the dominant assumptions of the period. . . . Affluence, consensus, political convergence, mass culture and the position of women are all neatly intertwined in the comic treatment of a Westminster by-election."[46] As in *I'm All Right Jack*, the film fuses all of these concerns, but, as Launder said, " 'Television and the media prove to be the key factors in the Earndale campaign.' "[47] Robert Wilcott (Ian Carmichael) is a television personality who has absolutely no credentials for the post except his familial history. He has been put up by Lord Wilcott (Alastair Sim), his uncle, who thinks that Robert's election will be good for the business of Wilcott Priory, now a tourist attraction profitable to the owner. His lack of preparation for the post seems to bother no one, except occasionally the candidate himself, and certainly not the electorate.

The candidates' speeches are roughly similar, and as their romance deepens, their differences vanish further, which is a source of consternation to their managers. Glimmer asks Stella, "If we were all to behave like this, what would happen to parliamentary government?" The managers unite in their effort to keep their candidates from each other. They bring Annabel (Moyra Fraser), a model who is enamored of Robert, to Earndale in order to separate Robert and Stella, and their plan succeeds until Annabel becomes smitten with Stella's admirer, a physical culture addict. Annabel is responsible for bringing a Conservative speaker from the train station to the hall, but by mistake she brings the Labour speaker. No one knows the difference. Similarly, the Conservative speaker is brought to the Labour hall, and his speech is delivered to great applause. The election count reveals Bob to be the winner, but the news arrives that Lord Wilcott is dead. Robert must now move into the House of Lords and a new election held.

The film uses the political campaign to attack the apathy of the 1950s and to trace that apathy to the new materialism and to the recognition that real differences have been obliterated by the packaging of the media, where competence and knowledge of political issues take a back seat to affability and personal charm. The marriage of the oppositional candi-

dates is symbolic of the absence of difference, and Stella's conversion from a staunch feminist to Robert's female satellite also suggests that her own political position was determined by the necessity for a political position different from that of the Conservatives rather than by substantial political belief. Even in the mating of the lovers, similarity rather than difference guides their choices. Annabel, the model who is preoccupied with her body, marries Bill, who is similarly preoccupied with his body, and Stella and Robert are united by their own similarities.

In contrast to the comedies of consensus produced during the 1930s and the war years, these satiric comedies portray the world of the late 1950s as a time of apathy, stagnation, crass materialism, and intellectual bankruptcy. The films make no pretense of resurrecting a community, but rather, as the Boultings' film shows, a philosophy of "You scratch my back, I'll do the same for you, Jack," a message Lord Wilcott in *Left, Right and Centre* would endorse. The object of attack in these films is no longer a particular class but the society at large, and the media, particularly television, become the scapegoats for a social environment devoid of difference, engagement, and integrity. Like the melodramas, the comedies of the late 1950s validate the changing landscape of the cinema in the appearance of new comic types, language and situations that are more boldly sexual, and representations of institutional life that leave little room for envisioning amelioration and compromise. In fact, the tendency to compromise seems to be the major object of attack.

Horror and Science Fiction

IN THE STUDY of genre, horror films have, until very recently, suffered in comparison to other genres. Their stylization, seeming preoccupation with a psychic—not overtly social—landscape, popularity with audiences, roots in mass culture, and focus on violence had served to dismiss them from serious consideration. One of the earliest critics to read the horror film as expressive of profound cultural malaise was Siegfried Kracauer in his *From Caligari to Hitler*, an examination of the social and political significance of the popular German cinema from a psychological perspective.[1] Such horror films as *The Student of Prague* (1913 and 1926), *The Cabinet of Dr. Caligari* (1919), *The Golem* (1920), and *Nosferatu* (1921) were discussed by Kracauer as prefigurations of nazism. His readings of the films were animated by the sense that cinema is a reflection of deep-seated collective psychosocial conflicts which inhere in the national mentality. He discussed, in particular, how pre-Nazi German films expose the German penchant for paternal authoritarianism, generational conflict, and the preoccupation with power. His book opened the way to the exploration of more sophisticated readings of horror, although such studies were not undertaken until recent decades in the works of such critics as Robin Wood, David Pirie, Charles Derry, Andrew Tudor, and James Twitchell, among others.

The French avant-garde filmmakers of the 1920s were drawn to horror, and especially to the works of Edgar Allan Poe, but their films have been considered apart from the mainstream popular cinema in most histories of film, associated primarily with modernist texts and indicative of the ways in which avant-garde and mass culture are set off from each other.[2] In the Hollywood cinema of the 1930s and 1940s, horror was a lucrative and popular genre, although the films of the era now considered horror film classics—*Frankenstein* (1931), *Dracula* (1931), *Dr. Jekyll and Mr. Hyde* (1931), *The Bride of Frankenstein* (1935), and *The Wolf Man* (1940)—were not regarded as important cultural documents and were mainly appropriated by film buffs. With the increased interest in genre production at present, most critical work on the horror genre is devoted to Hollywood films. With the exception of Pirie's ground-breaking *A Heritage of Horror*, a study of extremely popular horror films pro-

duced by Hammer Films, many of which were directed by Terence Fisher, there has been little sustained study of British expressions of the horror genre.

If the cinema of genres was relegated to the despised realm of popular culture, the horror film was most vulnerable, since it was the most opaque and seemingly ahistorical. Its traffic in the world of the supernatural and the occult contributed most to its marginality, since these subjects are not directly translatable into social terms. As one critic affirms, "The mechanics of the horror movie did not provide the material for the elaboration of the existential/moral dramas central to early attempts to regain classic Hollywood for serious critical consideration."[3] While the horror films seemed to elude any straightforward discussion of their social significance, the science fiction films, especially those of the post–World War II era, have seemed more amenable to identification of the ways in which they address specific and threatening social and political issues.

It would seem that the problem does not reside in the horror genre but rather in the ways in which critics have sought to identify social meaning in cinema. If an analysis of film becomes the basis for a direct correlation between social context and filmic representation, for seeing films as untroubled reflections of specific conditions, then the horror film continues to escape analysis. If, however, one begins with the assumption that representation is a heterogeneous locus of official and unofficial articulations, of public and private desires and their prohibition, of conformity and resistance to conformity, then the horror genre, like other genres, is expressive of social life and its contradictions. The British horror film is a rich source of exploration of the ways in which conceptions of sexuality, class, power, and even race are a site of contention in British culture.

The British cinema of the interwar and World War II period cannot rival the Hollywood cinema of the same years in the horror genre, even though much of Hollywood horror can be traced to British sources. The early horror "classics" in Hollywood cinema were based on the work of British writers such as Mary Shelley, Robert Louis Stevenson, and Bram Stoker. Moreover, one of the leading directors in Hollywood, James Whale, was British. A major actor in horror films, Boris Karloff, was also British, and the London urban landscape was a popular setting for Hollywood horror films. Given the strengths and popularity of British horror fiction, and its successful adoption by Hollywood, it may seem surprising that the early British cinema did not exploit its own "heritage of horror."[4] While the German, French, and Hollywood cinemas were quick to capitalize on the visual and narrative possibility of the genre, the British cinema was not. That there were so few British horror films in the 1930s has been attributed to censorship practices, but official censorship can only be a partial explanation for this lack. Self-censorship arising from cultural taboos is also responsible, as well as the unadventurous technical nature

of many films of the era. Such films as *It's Never Too Late to Mend* (1937) and *The Face at the Window* (1939) were old-fashioned melodramas that did little to visualize and develop the possibilities of the horror film. Nonetheless, the British Board of Film Censors was quite active in restricting the showing of horror films. Boris Karloff starred in *The Ghoul* (1933), but the film was never distributed in England, though Brian Desmond Hurst's *The Tell-Tale Heart* (1934) was shown. *Dark Eyes of London* (1939), starring Bela Lugosi, was the first British horror film to receive an "H" certificate from the censors. Prior to that, the "H" designation had been applied to foreign horror films that the censors felt were deleterious to young people.[5] In order to receive an "A" certificate, which allowed a film to have general distribution, many Hollywood horror films had to submit to cutting, as in the case of Mamoulian's *Dr. Jekyll and Mr. Hyde* (1931). Censorship practices can certainly be blamed for the paucity of horror films in the pre–World War II period. In fact, between 1942 and 1945 there was also a ban on the importation of all horror films.

The restriction on horror films was rationalized in terms of the effect that their subjects could have on the impressionable minds of the young, but formal censorship alone cannot account for the paucity of horror films. The practices of the British Board of Film Censors were symptomatic of more deep-seated social fears relating to the existence and representation of deformity, sexuality, violence, and political disruption. In contrast to British cinema, Hollywood was more willing to entertain marginality within the bounds of formal censorship prescriptions. The impact of the war and later of the cold war on Britain was to facilitate the production of horror and science fiction films. Corresponding changes in censorship practices and the changing composition of audiences in the 1950s created a more favorable climate for these genres, and the British cinema began to create horror films that would rival those of Hollywood. The classic literary works of British horror, the entire Gothic tradition, untapped in the 1930s British cinema, are recuperated by Hammer Films. The films are characterized by their strong emphasis on sexual themes and a style that is self-conscious not only with regard to the sexual conflicts in the films but also with respect to the sexual connotations of looking at horror narratives. The Hammer horror films do not arise out of a vacuum. Their themes and treatment are prefigured in the Gainsborough melodramas of the 1940s, and Hammer's leading director, Terence Fisher, had worked for Gainsborough. Hammer Films had been a small operation in the 1930s, but its success did not come until later, the consequence of external social changes and internal ideological and production decisions.

Science fiction fared a little better in the British cinema of the 1930s.

Alexander Korda's *Things to Come* (1936) combined a socially conscious thematic, based on an H. G. Wells narrative, with a daring use of camera and editing techniques. Korda also produced *The Man Who Could Work Miracles* (1936), another Wells work. Elvey's *The Tunnel* (1935) explores a futuristic world reminiscent at times of *Metropolis* (1926). These films dramatized social catastrophes arising out of authoritarianism, war, mismanaged technology, and human error, but they were more didactic than dramatic and, as such, unthreatening. They focused less on individuals than on the general sense of social threat and potential community disintegration. They did not develop the psychological conflicts central to Gainsborough melodrama. Like the war films concerning World War I, these films anticipate conflict at the same time that they seek rational alternatives. In fact, the element of rationality stands in the way of their developing a complicated treatment and critique of power. In the 1950s, the science fiction/horror film became profitable for British filmmakers, and by the last years of the decade it was a major genre. Along with the resurgence of classic horror monsters, audiences witnessed the creation of new monsters in films demonstrating the terror and anxieties accompanying science and technology. The cold war, the fear of nuclear annihilation, and the concern with the effects of radiation all found their place in the cinema. What Charles Derry calls "the horror of Armageddon" is represented in films that focus on the possibility of nuclear holocaust, on prehistoric creatures who are revivified as a consequence of natural imbalance, and on the appearance of human, animal, and insect mutations. The scientist becomes a major actor in the cold war narrative either as a possible source of salvation or as a major figure responsible for the creation of monstrosities.

In recent attempts to explore the traditional denigration and marginalization of popular culture, critics have identified ways in which horror and science fiction are expressive of social attitudes and values. Utilizing methods derived from the study of myth and from psychoanalysis, writers such as Robin Wood have explored how these films speak to the fears and desires of their audiences. In *The American Nightmare*, Wood reclaims the horror genre, demonstrating how it addresses basic taboos in American culture: "One might say that the true subject of the horror genre is the struggle for all that our civilisation *r*epresses or *op*presses: its re-emergence dramatized as in our nightmares, as an object of horror, a matter for terror, the 'happy ending' (when it exists) typically signifying the restoration of repression."[6] For Wood, the monsters of horror and science fiction are recognizable as those groups within the culture that, like the genres themselves, have been marginalized—women, deviants from heterosexual norms, the proletariat, other cultures, ethnic groups, children, and the physically deformed. Moreover, Wood's analysis takes

into account the historical specificity of various representations of monstrosity, their changing character, rather than regarding them as universal and timeless expressions of human fears. Wood's comments are equally applicable to the British horror and science fiction film.

Horror and science fiction meet in their concern with power, violence, and monstrosity. Their protagonists are often scientists who are the creators of monstrous forms of life. But Vivian Sobchack claims, "One major difference between the genres lies in their sphere of exploration, their emphasis. The horror film is primarily concerned with the individual in conflict with society or with some extension of himself, the SF film with society and its institutions in conflict with each other or some alien other. . . . Both genres deal with chaos, with the disruption of order, but the horror film deals with moral chaos, the disruption of natural order (assumed to be God's order) and the threat to the harmony of the hearth and home; the SF film, on the other hand, is concerned with social chaos, the disruption of social order (manmade), and the threat to the harmony of civilized society going about its business."[7] Like Wood, Sobchack sees the landscape and character of horror and science fiction as involving immediate personal and social conflicts. Moreover, her examination of the genres exposes significant differences in representation and emphasis, revealing changing historical imperatives and changing audiences. In general, recent genre study has recognized the importance of identifying and accounting for these differences rather than reading them for their universal and archetypal dimensions.

The horror film, like other genre films, is characterized by the expectation of the eruption of violence; however, the violence has a different valence in horror than in other genres of order. In horror, as Stephen Neale has written, "the specificity of this particular genre is not the violence as such, but its conjunction with images and definitions of the monstrous. What defines its specificity with respect to the instances of order and disorder is their articulation across terms provided by categories and definitions of 'the human' and 'the natural'."[8] While the films of empire and espionage are concerned with the redemption of the community through the law, the horror film operates across the axis of inclusion and exclusion based on distinctions between the monstrous and the natural. Images of pollution, illness, and contamination are therefore more intrinsic to horror than to other genres, and the resurgence of horror films can be linked in large part to the postwar preoccupation with clinical discourses concerning definitions of acceptable and unacceptable behavior and social roles.

The genesis of the horror film can be traced to the late eighteenth century and to Gothic literature. The figures who inhabit its gloomy landscape are brooding and compulsive, heirs of Milton's Satan who seek power. Their victims are defenseless young people, more often than not

women, and such narratives as Lewis's *The Monk* recount their excesses of cruelty. Their motivation, while often resulting in their illegitimate expropriation of their victims' property, is more broadly attributed to a curse or to certain pathological aspects of character that condemn them to a psychic hell. Isolated and lonely figures, their pleasure resides in the pain they inflict. In appearance they are not far removed from the pale vampire whose burning eyes betray his diabolic desires. Associated with death and corruption, his sadistic treatment of women is a crucial sign of a sexuality that finds its gratification in sadism and the contemplation of decay. Incest is often evident and a signifier of unstable family relations, which, in turn, are symptomatic of broader social upheaval characteristic of changing attitudes toward power and social class.

The preoccupation with monstrosity is already evident in the visual arts of the eighteenth century in such paintings as Hogarth's *The Four Stages of Cruelty*. According to James B. Twitchell, Hogarth's "mid-century prints may be satirical and topical in subject matter, but his vision was not; his serial engravings like *Marriage à la Mode* are almost documentary film strips recording the life cloaked behind Augustan good manners and genteel decorum. *Beer Street* and *Gin Lane* show the other side of the town, the part 'across the tracks' or, for us, the ghetto hidden by the skyscrapers. Here horrors can no longer be masked by powdered wigs; here we see the face of the barbaric; here degradation and degeneration are a way of life."[9] Hogarth's victims confront the spectator with the horror of impotence. Most particularly, these works address the horror of class oppression, focusing as they do on class differences and the brutalization of the lower classes. Horror is thus inextricably linked to the modern landscape, and it is the technology of modernity that enables its representation. The potential of printing itself, its ability to reproduce images and make them popularly accessible, must be counted as another source of the growth of an aesthetics of horror.

The early part of the nineteenth century saw the appearance of one of the enduring British literary classics of the genre—Mary Shelley's *Frankenstein*. In this novel, the monster is not supernatural but the offspring of a human creator. The symbiotic relationship between creator and creation evokes the classic idea of doubling so central to horror fiction. The monster constitutes the return of the repressed in which the creator is haunted by and enacts his own deep-seated desires and fears. In its exploration of the doctor's anxieties about his own sexual identity, the novel exposes the author's anxieties about the identity of her own literary creation. According to Twitchell, the enduring quality of Shelley's story can be attributed to its androgyny, which makes it appealing to both male and female audiences. In its dramatization of the birth of the Other and of the agonies of self-division and marginalization, the novel enacts the horror and violence that are the consequences of repression. The social

and psychological implications of the Frankenstein myth still haunt the culture, as attested by the constant resurrection of the narrative in literature and film.

While the middle era of the nineteenth century saw little that was innovative in the production of British horror fiction, the end of the century witnessed the creation of such literary classics as *Dr. Jekyll and Mr. Hyde*, *Dracula*, and *The Picture of Dorian Gray*. Critics who have sought to account for the popularity of such genres as melodrama link its appearance and appeal to the existence of ideological crisis. The last part of the nineteenth century was such a time, and the horror novels that appeared are symptomatic of crisis, particularly of a crisis in personal and social identity. It is therefore not surprising that Bram Stoker and Oscar Wilde were Irish, members of a marginalized culture. "Horror art was revived," says Twitchell, "because although in the long run it may drive for stasis, in the short run its emphasis is not on stability, but on rapid degeneration; not on greater coherence, but on insanity; not on health, but on neurosis; not on self-actualization, but on fragmentation."[10] In short, horror provides an assault on traditional notions of personal identity, family, and community.

The male figures who inhabit the landscape of horror are tormented, enraged, and divided: werewolves, vampires, exhibitionists, peeping toms, physically and mentally scarred creatures; the females are associated with feline animals and insects (spider women) and with exotic and sensual rituals. For the most part, they are objects of seduction and violence. In the pre–World War II horror film, the focus was largely on the dichotomy between the upper-class respectable female and the demimondaine often from the working class. The women are often victims of a vampire who unleashes their sexuality or of a crazed scientist waging a war on female pleasure. Other marginal figures (either as monsters or victims) include children and members of different ethnic and racial groups. At stake was the expulsion of the "perverse" and "abnormal," the restoration of social balance in favor of the family, authority, and stable social customs. As Robin Wood has written, "The foreignness of horror in the Thirties can be interpreted in two ways: simply, as a means of disavowal (horror exists, but is un-American), and, more interestingly and unconsciously, as a means of locating horror as a 'country of the mind,' as a psychological state."[11] The postwar horror films situate horror not in an alien or foreign context but in the everyday and in the psyches of presumably "normal" figures. What was implied in earlier horror films, namely, issues of gender identity, sexuality, and the ambiguous role of family life, has now become more explicit. Moreover, if the prewar films strove to suppress the threat of abnormality, the postwar films focus rather on the abnormality of normality.

The revival of horror and science fiction in the postwar British cinema

can be attributed to the existence of ideological crisis and also to the introduction of the "X" certificate at the beginning of the decade to allow for more adult subjects. The postwar melodramas, with their focus on male and female identity conflicts, troubled authority figures, images of youth in trouble, if not in rebellion, and presentations of disintegrating family and community life, are evidence of a concern on the part of film-makers and interest on the part of the audience in films that addressed changing values. The horror genre offered a medium with which to explore these public and private discontents. The science fiction films (*Seven Days to Noon* [1950] and *The Quatermass Xperiment* [1955]) focus on broad social instability, the false promises of science, and cold war threats, much like their American postwar counterparts (*The Thing* [1951], *Them!* [1954], *Invasion of the Body Snatchers* [1956]), though the British films do not seem as virulently anti-Communist. The horror in the films is both internal and external. As in the Hammer horror films, the elements that have been added are sexuality and violence.

There are no safe places to hide in an unfamiliar and frightening world. The return of the repressed confronts the characters time and again in the mirror and in the many shapes of the monstrous Other. Images of the past do not offer solace but are, rather, poignant reminders of the nonalignment of social and personal ideals and values. From Ealing's *Dead of Night* (1945) to Michael Powell's *Peeping Tom* (1960), the British horror film has offered its viewers a mirror in which to locate its dreams and nightmares, its wishes and fears. In both of these films and in the many intervening ones, the image of the "haunted mirror" reappears, inviting viewers to examine a world that threatens to undermine the "normality" of the world they inhabit. The divided and obsessive vampires that haunt the world of Terence Fisher are not simplistic representations of evil, they are the incarnation of thwarted pleasure turned against itself and others. These deadly figures are also a reminder that social conformity exacts a price, and even though they may be thwarted in the end, their very existence testifies to profound personal and social discontents. Despite the critics' revulsion at many of the horror films, the audiences who flocked to see them must have recognized their cogency.

THE 1940s HORROR FILM

Déjà Vu *and Gothic Horror*

One of the most complex of British horror films, *Dead of Night* (1945), prefigures many of the preoccupations of the horror films that were to come. The film exploits the element of the uncanny. The frame of the narrative as well as the tales themselves are structured around the experience of déjà vu. *Dead of Night* was the first postwar Ealing film that

did not take the war as its subject. A portmanteau film, it was the work of several directors (Alberto Cavalcanti, Basil Dearden, Robert Hamer, and Charles Crichton), and it remains one of the best British contributions to the horror genre prior to the 1950s. The individual stories are set in motion by an architect, Walter Craig (Mervyn Johns), who comes to a house where people are gathered for a party. Uneasy because he experiences the sensation that he has been there before, in his discomfort he provokes various guests to recount their own experiences with horror and the supernatural. One of the guests is a psychiatrist who seeks to counter Craig's and the other guests' belief in supernatural occurrences. The tale "The Hearse Driver," directed by Basil Dearden, involves a hospital patient who is recovering from an automobile accident. From his hospital window he sees a hearse and the driver beckoning to him. When he is released, and waiting for a bus, he sees the same driver, who repeats the words, "Just room for one inside, sir." He refuses to go on board, and the bus then collides with a truck and breaks through a bridge. Prior to the experience of the hearse he had proposed marriage to his nurse. The two incidents seem unrelated, but, as in the other stories to come, the element of seduction is linked to violence. The defense against the experiences of violence are obliquely associated with women.

The tale "The Christmas Story," directed by Alberto Cavalcanti, is a ghost story, narrated by a young girl (Sally Ann Howes). While at a birthday party at an old house and playing hide-and-seek, she strays into the upper regions and discovers a room with a crying boy, who she finds out later was murdered a century earlier by his older sister. In this story, prior to Sally's confrontation with the ghost, she had been sequestered by one of the young men, who seductively put his arm around her. She complained of the cold, which he describes as "no mortal cold." When she confronts the young victim, Francis, she soothes him and sings to him until he rests. He wishes that his sister were like her. In this story, the images of doubling are implied in the comparison between Sally and the boy's violent sister, and between the seductive relationship between the young man and Sally and her maternal relationship to the boy. Violence appears to be just below the surface of male-female relationships not only in this tale but also in "The Hearse Driver." In fact, the equation between violence, sexuality, and anxiety over death seems to underpin all of the tales.

In "The Haunted Mirror," directed by Robert Hamer, a young woman, Joan (Googie Withers), who is about to be married, buys an antique mirror for her future home. Her fiancé, Peter (Ralph Michael), begins to see himself in the mirror in the shape of another person in a Victorian environment. His wife cannot see what he sees, though she begins to note transformations in his personality. After the wedding the

image of the room in the mirror disappears, and their relationship stabilizes. After Joan leaves for a weekend, Peter becomes increasingly irritable, jealous, and abusive. Joan learns from an antique dealer that the mirror came from the home of a man who had killed his wife and himself during the 1840s. When Peter is about to strangle his wife, thus realizing that other scenario, Joan comes to see what he sees and shatters the mirror, and her husband resumes his former personality.

Though the tale closes with the destruction of the mirror and the restoration of normality, the real horror remains in the couple's refusal to confront the nature of their "normality," which is based on denial and the repression of what they have experienced. The mirror has revealed to them an image of a relationship that is not at all complacent and harmonious. Like all effective horror narratives, the film does not explain away the otherness of the mirror's image. The "something that is monstrously evil on the other side" is an actual reflection of the part of their relationship that involves sexuality and violence, which Peter identifies as something within himself. His transformation into that other man is prefigured in passing comments about Joan's relationship with another man, even before the mirror exercises its sway, and, ironically, Joan tells him that she thought he would like "to look at himself." When he does look at himself, neither he nor Joan can tolerate what he sees. This episode recalls such Hollywood classic Gothic films as *Suspicion* (1941) and *The Two Mrs. Carrolls* (1947).

"Golfing Story" (Charles Crichton) stars Basil Radford and Naunton Wayne as competitors for a woman. In order to resolve who will get her, they decide that they will have a golf game in which the loser must eliminate himself through suicide. After Wayne kills himself, clearing the path for Radford, he returns to haunt his friend, who had cheated to win. This tale is lightly handled, without the ghost tale's usual forbidding environment and eerie manifestations of the supernatural, but it does conform to the other tales in its unmasking of normality and in its identification of sexuality as the instigator of disruption. The final tale, "The Ventriloquist's Dummy," directed by Cavalcanti, stars Michael Redgrave as Maxwell Frere, a ventriloquist who assumes the identity of his vicious, verbally abusive, and vengeful dummy. Unlike "The Haunted Mirror," the threat of possession is not averted. The personality of the dummy finally occupies the ventriloquist. The horror of the tale resides in the complete engulfment of the individual by the Other. Triangulation does not involve a woman but two males—another ventriloquist, Kee (Hartley Power), Frere, and Hugo, the dummy. The dummy plays on Frere's insecurity, threatening to abandon him and finally driving him to shoot Kee. Frere violently destroys Hugo, and hence his former identity as Frere is completely obliterated.

In this story, it is the possessive relations between men that generate

violence. Women are incidental to the tale: the only woman in the film is a black singer who introduces Kee to Frere and sings while the men quarrel over Hugo. The film ends with the fulfillment of Craig's own déjà vu experiences. He enacts the events of his dream to their conclusion. A montage sequence lacing together the different episodes precedes his awakening and finding his wife. The phone rings and the events of the dream once again unfold. The psychiatrist in the film functions as the voice of rationality as he seeks to explain in clinical terms the experiences recounted. The most stylized episode in the film is "The Haunted Mirror," in which the decor of the "other room" conjures up a world diametrically opposed to the world associated with cloying domesticity. "The Ventriloquist's Dummy," with its noir style and its portrayal of the claustrophobic and violent relations of the men, relies on the classic horror of the monstrous creation that turns on its master. The Hamer episode, in particular, anticipates the mid-1950s, and particularly Hammer Films' preoccupation with the "eerie, violent nineteenth-century world which is glimpsed briefly in the mirror."[12]

The Victorian era is the setting for the Gothic horror film *Uncle Silas* (1947), based on a work by Sheridan le Fanu in which repressive sexuality and the attempted expropriation of a young woman's wealth are linked. This Two Cities film contains all the classic conventions of Gothic horror—an old house with subterranean passages, a malevolent patriarch, a sinister governess, and a young, helpless heiress. Caroline Ruthyn (Jean Simmons) is left alone after the sudden death of her father. She goes to live with her Uncle Silas (Derrick de Marney), whom her father designated as her guardian in his will, in spite of Silas's having been accused of murdering a man. Before he dies, Mr. Ruthyn tells Caroline that he believes Silas has undergone a change of heart and has become more gentle and humane. At Silas's house, she again finds Madame de la Rouggiere (Katine Paxinou), a woman who had made her life miserable at home and who was present at the death of her father. Silas's son is also a reprobate and in league with his father and the governess to gain Caroline's inheritance. The uncle is intent on blocking Caroline's growing relationship with Richard, Lord Ibury (Derek Bond), and when she leaves to visit her cousin Monica at Christmastime, her uncle recalls her on the pretext of illness. Madame de la Rouggiere becomes more prominent as the plans to spirit Caroline away are put into effect by the conspirators. After harrowing experiences in which Caroline seeks to escape her captors, and Madame is mistakenly killed, she is finally rescued. A young boy, the gamekeeper's son, whom she had tried to protect, informs Ibury of her plight, and he defeats Silas's son, who is trampled to death by the carriage horses. When Caroline learns of Silas's plot to deprive her of her inheritance, she also learns that he is a drug addict and that he wants her money

to pay for his considerable gambling debts. Silas is finally exposed and apprehended.

Silas is cast in the mold of the Gothic villain who not only is bent on squandering his wealth and that of others, but is also sexually promiscuous. His relations to women are sadistic. He seeks to destroy Caroline and is responsible for the accidental and gruesome death of the governess. His addiction to an unusual drink that produces strange states of mind is in the tradition of Sheridan le Fanu's other tales, in which the characters' malevolence and personality transformations are often traced to their addictions. The respectable and ordered world associated with Ibury, Cousin Monica, and Caroline herself contrasts sharply with the decadent world associated with Silas and his allies. The narrative is structured around the urgency of rescuing the heroine from the powers of darkness and illegitimacy. Finally, the disrupting influences are overwhelmed by the forces of social legitimacy.

Like many Gothic horror narratives, this film has its share of creaky and sensational devices to portray threats to Caroline's integrity, but it is the family romance that is central. Silas and Madame are the inverted figures of Caroline's dead mother and father. At stake is Caroline's inheritance, which is both material and spiritual. By appropriating her wealth and by attempting to ruin her, the uncle represents the threat to familial continuity. Ibury, her champion, is the traditional savior of female chastity and respectability. He restores Caroline to her proper place as a woman of her class.

The familiar Gothic motif of doubling is directly relevant to the character the imprisoned female and of the men who seek to undermine or save her. The male characters are paired—Silas's brutal son and high-minded Ibury, malevolent Silas and his trusting brother. Caroline is placed in the familiar position of needing to escape the constraints of paternal authority and power. Her rescue by Ibury restores her to a more acceptable and less threatening family environment. The maternal figure is also split between the tyrannical governess and the benevolent Cousin Monica. The woman's "inheritance" is inextricably bound in the Gothic narrative to familial stability, and the female's integrity is at the center of this stability. Horror is linked to degeneracy, and degeneracy is in turn linked to the victimization of the female. Unlike the protagonists of such family melodramas as *Blanche Fury* and *Jassy*, the female protagonist in *Uncle Silas* is much less strong-minded and much more vulnerable to attack by the male, though the conflict over family legitimacy and property rights are also evident. *Uncle Silas* corroborates the growing trend in the British cinema of the period to explore threats to the sanctity of the family. The villains of the film, both male and female, are governed by uncontrollable sexual desires and an insatiable lust for power. These characters are indic-

ative of the general tendency of the films of the late 1940s to displace external social discontents onto the personal and domestic terrain. They are identified as the scapegoats in a world that is precarious and untrustworthy.

Madness and the Occult

The exploration of various forms of madness is central to the horror film, which is not infrequently linked to the supernatural or the occult. *Spellbound* (1941), directed by John Harlow, begins like a documentary, with a commentator who warns the audience of the controversial nature of the subject matter. The question that the film poses is, Does spiritualism make you mad? The issue of the occult does not enter the film until the death of Laurie Baxter's fiancée, a young working-class woman, Amy (Diana King), of whom his upper-class mother does not approve. Mrs. Baxter (Winifred Davis) wants him to marry a woman of his own class, Diana Hilton (Vera Lindsay). Amy's mysterious illness and death provokes a rupture between Laurie and his mother. His hysterical attachment to the dead woman finally drives him to a spiritualist, who claims that he can materialize her. The spiritualist, Mr. Vincent (Frederick Leister), is a Svengali figure who gathers around him wealthy women who are faddists and desperate young men like Laurie.

Laurie's initial response to Amy's death is rage and depression. He accuses his mother of being glad that she is dead. Diana, who has been invited by the mother to visit, seeks to comfort him, but he is withdrawn and inaccessible. In his obsession with Vincent, he neglects his family and his studies, though he comes to depend on Diana for companionship. In a seance, Amy speaks through Laurie, and he is encouraged by Vincent's promise to materialize her completely. Laurie's tutor, Mr. Morton (Felix Aylmer), consults Mr. Cathcart (Hay Petrie), a lecturer in theology and an enemy of spiritualism, but Laurie is enraged when he meets him and continues to see Vincent. After Amy's materialization, Laurie's personality is totally transformed. He becomes morose, verbally abusive, and violent. The climax of the film comes after Cathcart tells Diana that she can help in Laurie's cure. He tells her that Laurie is possessed: "Out of the infinitely mysterious void has come a personality, strong, depraved, and whose purpose is to deprave." Cathcart struggles to exorcise the spirit, but it is Diana who sits alone with Laurie in the dark and clings to him as the spirit leaves his body.

Laurie's possession is symptomatic of his struggle with his mother. His insanity is linked to her attempts to make him shoulder his familial responsibilities. The identity he assumes is aggressive and violent, and his resistance to traditional family and communal responsibilities is exorcised through the combined efforts of Diana and Cathcart. His repressed

misogynist desires, fanned by Vincent, are finally contained. The horror elements in the film, as expressed through his possession, seem transparently the product of his denial of his place in society as a successful student, sportsman, and propertied heir. The "devil" that possesses him makes him a class renegade and a destroyer of the family. His exorcism returns him to his proper position in the family and in society. The conflict between religion and spiritualism, a familiar conflict in the horror film, is resolved in favor of religion and its alliance with traditional values.

As a horror film *Spellbound* fails. While all the familiar elements of the horror film are present—the diabolic transgressor, the possessed victim, the threatened female, and the exorcist—the film does not develop them but restricts itself to a narrow moralistic context. Visually, the power and appeal of horror are never made palpable. The physical sense of monstrosity associated with the outcast is never evident, nor is the sense, as Charles Derry indicates, that "monsters are horrible because they present alternatives to the tenuous human equilibrium."[13] In spite of its inability to evoke a sense of the monstrosity of Laurie's situation, *Spellbound* does introduce issues that are congenial to the horror film and to British postwar society. The family is shown as threatened by forces over which it has tenuous control, dramatized in the film's exploration of the subversive potential of spiritualism as an enemy of traditional religion. Ultimately, the film borrows from practical psychology to banish the threat and restore Laurie to "normality."

HORROR IN THE 1950s

Ealing and the Occult

In 1955 Ealing returned to the subject of the occult with *The Night My Number Came Up*. Directed by Leslie Norman, the film loosely follows the pattern of *Dead of Night*—in particular, Dearden's segment, "The Hearse Driver." The film opens with the abrupt appearance at an airport of Commander Lindsay (Michael Hordern), who is attempting to get news about the flight of a DC-3 flying northward. He insists that the lives of the people on the plane depend on his getting answers to his questions about the plane's whereabouts. In flashback, he recounts the events that have motivated him to seek help. His narrative begins in China, where he was a dinner guest of Robertson (Alexander Knox), a civil servant. After dinner, the group discusses the Chinese Ceremony of the Returning Spirit, in which "the evil spirits are driven away so that the good can return." Lindsay describes how, through dreams, the Chinese believe that events are prefigured and preordained, and he tells of his own premonitory

dream in which he describes the flight of a Dakota, recounting in detail the events leading to the crash of the plane. Among the fated group are members of his present audience—Air Marshal Hardie (Michael Redgrave), Mackenzie (Denholm Elliot), and Robertson. The listeners are disbelieving, since Lindsay talks of others on the plane who are not scheduled to be on the flight. However, the first sign of the dream's realization comes when Lord Wainwright (Ralph Truman), one of the men in Lindsay's dream, calls and asks to be taken on board.

Other pieces of the dream fall into place as the group sets out for the journey. The passengers are uneasy, looking for signs that could refute the dream, but as new passengers are taken aboard and as the weather begins to worsen, they become more anxious. Hardie, who seeks to maintain rationality, insists that they carry aboard two businessmen who had been envisioned in the dream. His motive for getting Bennett (George Rose) and his colleague on board is: "If we left the men behind, we would be taking ourselves back a hundred years to when men were slaves to witchcraft." The total number of passengers is now thirteen. As the plane experiences difficulty, the passengers become hysterical. The plane crashes, and the dream appears to be fulfilled, but the ending of the film with Lindsay at the airport alters the scenario. Lindsay is congratulated because it was his premonition that enabled the rescue crew to save all the passengers.

The pretext for the film is the dream, associated with the Chinese, the "strange men" alluded to by Robertson. The conflict between rationality, duty, logic, and efficiency as opposed to premonitions and mysticism is the province of the horror film, and *The Night My Number Came Up* seeks to exploit this conflict, exposing a nightmare world as the events in the dream are corroborated. The dream and the anticipation of disaster unsettle relationships among the men, and they begin to crack under the pressure. The dream explodes the complacency of the characters, surfacing their fears and anxieties, calling into question their ability to control and interpret events. But, like the shattering of the mirror in *Dead of Night* and the return of the husband to normalcy, this film restores the rational world and validates emotional restraint.

Rather than predestination or the supernatural, the film seems preoccupied with the fear of emotionalism. The real nightmare seems to be the loss of personal control. Like Robertson, many of the characters are disappointed with their lives, and in the face of danger they allow their feelings free rein, indulging their rage and terror. Under the guidance of Hardie, however, they are restrained. In its character portrayals, as well as in its frame structure, the film exhibits the same emotional inhibition that Charles Barr finds characteristic of Ealing films. Horror resides in the abandonment to strangeness, in succumbing to one's fears, and the pro-

tagonist as well as the film itself seeks to ward off the experiences evoked by the exposure of an alien reality. Of *The Night My Number Came Up* George Perry finds that "some of the dramatic possibilities of the plot were lost in the structure of the film. The story was told in flashback, so it was known right from the start that the plane had crashed, leaving only the question of how it all happened."[14] Actually, the problem of the structure is merely symptomatic of the more fundamental issue of the film's resistance to confronting the horror that it surfaces.

The Mad Scientist

The war years had witnessed the growth of science and technology. According to John Stevenson, "the first half of the twentieth century saw a growing awareness of the potential influence of science upon society at large. In areas such as biology, nutrition and genetics, scientists were already raising some profound ethical and political questions."[15] The biological as well as the human and social sciences were increasingly called upon to ameliorate pressing environmental and social problems. But the enthusiasm for rational solutions through science coexisted uneasily with fears of social disintegration and global conflict. The Boultings' *Seven Days to Noon* (1950) addresses the threat of nuclear annihilation. While there are no lurking monsters and a catastrophe is averted, the film explores the strains of the arms race and especially its effects on a nuclear physicist. The protagonist of the film, Professor Willingdon (Barry Jones), decides to take matters into his own hands and threatens the city with annihilation if the government does not destroy its nuclear arsenal. In a small bag he carries a bomb which he threatens to detonate if his ultimatum is not met within a week. The film recounts his odyssey through the city as he seeks to elude the authorities.

The professor is not presented as a raving lunatic, but rather as a man driven to desperation. His daughter (Sheila Manahan), his assistant Lane (Hugh Cross), and the vicar describe him as "a troubled man who lost faith in the value of his work." They also describe him as alone and isolated. "We placed this burden on his shoulders," says the vicar, "and left him alone to deal with it." Willingdon's behavior is increasingly psychologized by his family and by the police. Inspector Folland (Andre Morell) says that "he was heading for a breakdown for a long time." The one person who confronts Willingdon is a prostitute, Miss Goldie (Olive Sloane), whose room he shares and whom he later holds hostage. She asks him why he started "all this in the first place," and accuses him of tampering with nature. He tells her that he saw science "as a way to serve God and men," but his dream has now become a nightmare. The film is organized around the week's chronology. It begins with the delivery of the letter to the prime minister (Ronald Adam) and moves to the police, then to the

laboratory, and finally to the professor. The remainder of the film in-
volves the manhunt and the professor's attempts to elude the combined
forces of the government, the military, and the police. The film's alternat-
ing episodes are punctuated with images of London, first as a hub of
activity, then as deserted except for howling animals. Reminders of
World War II are evoked in the characters' speeches but also in the images
of evacuation, which are accompanied by the sound of drums.

The other characters in the film, with the exception of Miss Goldie,
who is as much of an outcast as the professor, are unattractive and threat-
ening. They obey as others give them orders and direct their movements,
and when some are singled out, they appear self-preoccupied or hostile,
as in the case of the woman in the group of evacuees who scolds her
weeping son, telling him, "I told you to 'go' before we got here," or the
man in the bar who aggressively tells his barmates to "load the bloody
planes and blast their cities to hell." The unsympathetic treatment of
members of the community serves to make Willingdon's plan seem less
lunatic. In contrast with the other characters, he is the only one who
seems, as he himself indicates, to understand and be concerned with the
changes that have taken place in the world as a consequence of atomic
warfare, but the film neutralizes his position through insisting that he is
the victim of stress.

Religion is invoked several times: in Willingdon's asseverations that he
became a scientist "to serve God and man," in the allusions to Milton's
Samson Agonistes, and in the final moments in the film in which he seeks
refuge in a church. The religious allusions function to stress the scientist's
loss of faith, to exonerate him from evil motives, and to suggest the neces-
sity of faith to overcome contemporary anxieties. Willingdon is presented
as psychically unbalanced rather than malevolent or power-hungry. The
end comes when a trigger-happy soldier shoots Willingdon as he runs
from the church without the bomb. The film thus conveys the nightmar-
ish quality of the man with his little black bag which can destroy the
center of London, the violence or indifference of the populace, and the
streets that look like the aftermath of a nuclear war. The pressure of living
in the nuclear age are central to this paranoid environment. It is appropri-
ate that the professor's behavior should be described in psychological
terms, since psychology in the 1950s was often the antidote to social anx-
iety as well as to the threats posed by marginal or oppositional behavior.

In discussing the emergent role of science in the American cinema of the
1940s, Dana Polan finds that "in the rationalism of the forties, the things
to wonder about are increasingly not so much alien forces or exotic other
places but quite the contrary, the places in which one lives, the 'mystery'
or 'horror' of an everyday world. If there is at all the possibility of the
representation of threat in the forties, it is not so much the threat of a

world in which incurable monsters roam; rather, whatever horror appears in this new world is merely the possible horror of feeling a disjunction between ends and means in this world, rather than a disjunction between this world and another."[16] These attitudes are evident in *Seven Days to Noon*. The professor is not an alien creature. He is not a monster, and the film does not pose an invasion from without. The danger is from within in his own desperation and in the desperation of the society that is ill-equipped to understand the new threats confronting it. The film does not present a reassuring picture of individual or collective effort. Rather, it dramatizes the blindness of the masses, the ubiquitous threatening sense of modern urban life and of modern technology and mass society. In particular, it casts a negative eye on the efforts to seek amelioration, portraying them as misguided. The film does not identify the Russians as the enemy; the enemy is modern life itself.

Hammer Horror

The general ideology of Ealing, its mode of production, and the particular personalities of Michael Balcon, its guiding force, and of the directors who worked with him, did not lean toward the exploitation of the horror film. It was left to another small studio, Hammer, to exploit the possibilities of the genre. In his comparison of the two production companies, Vincent Porter emphasizes how they were both geared to creating a particular identity for their productions. They both were small, operated with limited budgets, and were overseen by determined and strong managing directors who helped to shape the companies. However, the differences between Michael Balcon and James Carreras are decisive. As Porter states, "Despite the number of structural factors which are common to the histories of the two British screen companies, it is of course quite clear that the ideological intentions of the two studio heads were completely different. Balcon wanted to make pictures that brought a form of documentary naturalism to the screen during the war, and, later on, acted as ambassadors of the British people. Carreras, on the other hand, simply wanted to turn out fairy tales—many designed to frighten, to horrify, or to shock. If Balcon, to use his own terms, was turning out realism, then Carreras was turning out tinsel."[17] In the final analysis, both studios turned out films that are revealing of their particular class-bound and ideological interests, and each in its own way offers a revealing insight into the fantasies and myths of British society. The Ealing films at their best are portraits of British life marked by "the celebration of the little man . . . against a soulless wider world of commerce."[18] Whether melodramas, war films, or comedies, the Ealing films are preoccupied with a sense of community and disruptions to the social fabric produced by the imposition of restraints on individuals who try to renovate the social

order. In contrast, the Hammer films are preoccupied with the fragility of relationships, the ubiquitous and threatening disruptions to conventional social existence that cannot be rationalized away. Most particularly, the Hammer films are far more direct about the existence of psychic and sexual threats to the integrity of the individual, portraying them as insuperable obstacles to the realization of benevolent and rational notions of social life.

The initial films produced by Hammer in their prehorror period were mainly "B" features, low-budget films often drawn from radio scripts or modeled along Hollywood genre films, often utilizing less popular Hollywood actors. The films were made in hired houses, and it was not until 1951 that the company moved to Bray Studios, where their most successful horror films were to be made and where they were made.

Terence Fisher was one of Hammer's most successful directors. He had made an earlier horror film during the time he was employed at Gainsborough, directed in conjunction with Anthony Darnborough. *So Long at the Fair* (1950) involves the mystery of a young man's (David Tomlinson) disappearance from a hotel in Paris. All traces of Johnny's whereabouts and even of his existence have been obliterated His sister, Vicki, played by Jean Simmons, sets out to find him and keeps encountering obstacles, particularly from the sinister woman (Cathleen Nesbitt) who manages the hotel. With the assistance of a young English artist (Dirk Bogarde) living in Paris, the sister finally learns at a monastery that her brother had been removed there when he contracted the plague. Paris is presented as a place of intrigue. Prior to the young man's disappearance, he had sought to impress on his sister the treacherous face of the city, and the plague symbolizes the decadence and corrupting influence of Paris.

According to David Pirie, "*So Long at the Fair* could easily have been re-shot, sequence for sequence, as a vampire movie without making any difference to its basic mechanics, for the same dualistic structure pervades every frame. Presumably the film would then end with the staking of the brother to purify and purge the alien 'infection' to which he has succumbed."[19] *So Long at the Fair* capitalizes not only on the sense of duality alluded to by Pirie but also on the ubiquitous threat of the eruption of alien elements in the world of commonplace and predictable relations. These alien elements are associated with the body and with physical symptoms that generally cannot be rationalized or explained away. Illness is a metaphor for the disruptive effects of sexual desire, which are expressed in terms of violence. Vicki's brother has been identified with puritanical sentiments about the dangers of Paris as a den of iniquity, and his contracting the plague seems to be the narrative's revenge for the young man's refusal to look beneath the straitjacket of his prim morality. Many of the Hammer films appear to be on a crusade against narrow

morality while espousing their own morality, which usually entails a more permissive view of sexual relations.

After *Never Look Back* (1952) and *Wings of Danger* (1952) for Exclusive Films (the earlier name of Hammer Films), Fisher directed *A Stolen Face* (1952), starring Lisabeth Scott and Paul Henreid. This was the first film made at Bray, Hammer's new home. The protagonist is a plastic surgeon, Ritter (Henreid), who falls in love with a concert pianist, Alice (Scott). Unable to convince her to marry him, he reproduces her face on a young criminal, Lily, whom he later marries. Ritter is presented as a compulsive man who works himself to the point of almost killing himself and his colleague in an automobile accident. His pursuit of Alice reveals the same compulsion. He works day and night to produce the ideal face for Lily, a woman scarred in the war, and then he compulsively seeks to reproduce Alice's behavior in Lily. Lily rebels against his regimen, turning again to her former haunts and playmates and to stealing. Finally she screams at him, "Why don't you stop making me something I'm not?" When Alice returns from a concert tour, freed by the man she had felt obligated to marry, Lily's vengefulness and jealousy run rampant. She finally destroys herself when she seeks to thwart what she believes is a clandestine meeting between Ritter and Alice. She falls out of the door of a moving train, and her disfigurement in death provokes the police to say, "She'll never know what it is to go through life disfigured."

The enigma in the film appears to be the nature of disfigurement. The "experiment" undertaken by Ritter in conjunction with the prison doctor is based on the notion that women's criminality arises from physical unattractiveness, a motif that is tied to the fetishizing of the woman's body and is explored also in Hitchcock's *Vertigo* (1958). The prison doctor has evidence that criminals with changed appearances undergo personality transformations. Ritter's making Lily a copy of Alice violates the experiment, since he tampers with Alice and Lily's uniqueness. Thus the issue is clouded. Is Lily evil because she is criminal at heart, or is she evil because Ritter has sought to make her over into Alice?

Lily is presented as a blighted victim of the war, a woman reared in poverty with no education. Alice, by contrast, is middle class, cultured, and bound by moral obligation. The class contrasts in the film are set up early with the arrival of a rich older woman who seeks to have plastic surgery so that she can marry again and look as young as she feels. Ritter resists her blandishment of money and tells her to "live with herself." Though a successful practitioner, Ritter donates time to poorer patients and especially to the underprivileged inmates at the prison. While the inmates, and Lily in particular, are thieves, it is the physician himself who becomes the thief by stealing Alice's face. He, not Lily and her deformity, is the focal point of the film. Lily represents his own moral disfigurement.

He has tampered with helpless members of society for his own ends. A more profound issue is raised in his reproducing Alice. While he has taken Alice's face, he has grafted it onto a woman who is sexually promiscuous, and he is almost destroyed by this double. In contrast to Lily, Alice is riddled with guilt by her conventionality, which leads her to withhold herself from the men who desire her. The doctor's desire for her face on a different woman's body raises the issue of his own sexual desires. Though the women's appearances are identical, their personalities are not, and he is tormented by the monster he has created in the form of his own sexual fantasies, which he cannot admit or tolerate. Moreover, Lily's thefts are a mirror of his own crime. Her rebellion is the inevitable revenge by his creature, which, like Dr. Frankenstein, he has rejected. He is driven to contemplate suicide, but Alice intervenes to save him, and Lily is destroyed. Through the familar motif of the double, the film dramatizes his self-division. In general, the film is quite restrained in its treatment of its protagonists and their conflicts. Unlike later Hammer productions, the film does not capitalize on excessive violence, nor is there any emphasis on the supernatural. The images are less lurid and sexually provocative than those in the horror films that were to follow. But the idea of doubling, the focus on fixation, the flirtation with criminality and cruelty, the tampering with human life, and the moral consequences of acting contrary to divine providence are all present.

In *The Four-Sided Triangle* (1953), also directed by Fisher, the same doubling motif reappears but is couched in a more blatant science fiction context. The film is narrated by the physician, Dr. Harvey (James Hayter), who brought the male protagonists into the world. Robin (John Van Eyssen) is the scion of a wealthy family, while Bill (Stephen Murray) is the son of a poor drunkard. In childhood skirmishes with Robin, Bill is the loser. The major source of their childhood contention is Lena (Barbara Payton), and Bill is a loser with her, too. Dr. Harvey becomes Bill's mentor, and when the boys reach adulthood, they experiment in an old barn with the idea of producing a machine that can duplicate matter. Robin's father, Sir Walter, a strict disciplinarian, disapproves of the work and refuses to support them further, wanting Robin to go into business instead. The men persist, and with Lena's aid they are successful in reproducing a watch. Jubilantly, the trio inform Sir Walter of their success, and he agrees to help them with the proviso that he inform the government authorities first, for he fears the secret falling into the hands of people who would reproduce atom bombs and poison gas. Bill, an idealist, wants the knowledge and benefits to be international and not constitute another British monopoly.

The trio, with better equipment, continue to work successfully on their duplication experiments, but Bill's personality begins to change when he discovers that Lena and Robin are to get married. He becomes withdrawn

and begins to spend most of his time alone in the laboratory while they are on their honeymoon. Only the doctor is aware of his experimentation, and he is uneasy. Eventually, Bill is able to reproduce life. He uses the equipment to reproduce a rabbit. He gets Lena's permission to submit to making a duplicate of herself. The successful experiment produces a copy, whom he calls Helen and whom he marries. After the wedding, difficulties arise. Helen is suicidal and several times he saves her from destroying herself. The flaw is that Helen has Lena's memory and therefore is not in love with him but with Robin. Bill becomes obsessed with correcting her problem by operating on her to remove her memory in order to "empty her mind and give her a new beginning." The film is unrelenting in its exposure of the male quest for control and possession of the female.

A fire rages in the barn, and one of the women inside dies along with Bill. At first it is not clear whether the survivor is Lena or Helen, but Robin finally identifies the woman as his wife, Lena. Thus, through the device of doubling, the narrative eliminates the disruptive characters, those who are representative of the false appropriation of power. *The Four-Sided Triangle* appears to be a traditional religious allegory. For example, the film begins and ends with the image of a church. The title "God hath made men upright but they have sought out many inventions" appears at the opening of the film, and the film ends with the lines, "You shall have joy or you shall have power, said God. You shall not have both." The allegory explores the familiar notion of men seeking to create life, in this case the reproduction of a female. Bill's fall results from his desire for a woman who belongs to another man. As opposed to usual scenarios of doubling in which the copy turns out to be the antithesis of the original, Helen is an exact duplicate. Thus the conflict in the film is focused more on the male desire to reproduce than on the disruptive nature of the female.

The focal point of the narrative is Bill's desire to fuse with Robin. Lena is the battleground in Bill's attempts to become like his friend, to possess what he has. The women are duplicated like the rabbits, but they have no individual identities. The common motif in the horror film of the male assuming creative powers and of giving birth turns out to be catastrophic. Bill's being consumed by fire in the barn, the retribution for his violating the laws of nature, signifies the destructive nature of his passion. What is at stake is male identity; the film is a drama of sons against fathers, another variant on the overreacher, and of males in competition with one another. The physician, the spectator to these events, is the benevolent but impotent father who is unable to intervene and keep Bill from destroying himself. Bill is yet another incarnation of the scientist gone awry. The overt morality of the film conceals more complex attitudes toward relationships. Given the Manichean world of the Fisher films, the protagonists are doomed to self-destruction. Their dissolution occurs at the

point at which they realize their frustrations and are forced to take drastic measures to achieve their objectives, only to be defeated.

While *A Stolen Face* and *The Four-Sided Triangle* are films that utilize the horror genre to explore themes germane to the period in a style that was to become identified with Hammer horror, they were not singled out as exceptional films. It was *The Quatermass Xperiment* (1955), directed not by Terence Fisher but by Val Guest, that turned the tide for Hammer. (The film was called *The Creeping Unknown* in the United States.) The film begins innocently with a couple walking in the country. At the moment at which they are about to make love, a catastrophe occurs. A flash of light, a strange sound, and the collapse of a house prefigure the horror. Soon ambulances arrive to inspect the rocket that has fallen to earth as the people observe the coming of the police and military and government officials. Quatermass, the American scientist (Brian Donlevy) who is responsible for creating the rocket and sending it into space, supervises the removal of one survivor. Inspector Lomax (Jack Warner) is suspicious of Quatermass and insists on conducting the investigation, but the scientist counters that this is "his work."

The survivor, Victor (Richard Wordsworth), is hospitalized and remains unresponsive to others, including his wife (Margie Dean). His appearance begins to change, and the scientists discover that he no longer has human fingerprints. Moreover, the remains of two astronauts appear more plantlike than human. Victor escapes from the hospital after killing a detective, who also turns into a plant. As Victor roams the city, he becomes progressively more desperate and more physically transformed. Aware now of what they are confronting, Quatermass explains that the rocket passed through space and came into contact with a new form of energy. Victor is a carrier of a new life form invading the earth. Half-plant and half-animal, he can multiply at will, but he must have food to live. The monster shambles through the city, killing and transforming others, seeking help to end his life and being thwarted in his attempts at suicide. Like Frankenstein, he confronts a child who wants to play, but he does not kill her. He is traced to the zoo, where he, now merely a blob, seeks food. The climax of the film comes in Westminster Abbey, where the monster has found a hiding place. Using electric cables, Quatermass electrocutes the monster, who is consumed by flames. Unrepentant, he walks away from the scene of disaster and talks of needing to begin his experiment again.

The familiar battle in science fiction between science and conventional moral and theological wisdom is exemplified in the conflict between Quatermass and Lomax. Quatermass, who has been responsible for the misery of the creature, is, like most of the creators of horror, unmoved by his creation's sufferings; he is more interested in prolonging its life for the

benefit of science. A modern Prometheus, with full confidence in his power to know and control, Quatermass is free of any moral qualms. Victor's wife accuses him of having destroyed her husband, and he responds that there is no room for personal feelings in science and that she should be proud of her husband. In contrast to Quatermass, Lomax is a family man who talks of "praying in my simple Bible way."

The power of the film is conveyed through Victor, who drags himself through the city, unable to end his torment, a lonely and desperate figure who has lost his human form and the capacity for speech. Unable to destroy himself, he preys on other forms of life. His doomed existence is most dramatically exemplified in his interaction with the small child who wants to play and does not comprehend the danger she is in. His own isolation is communicated through his inability to express what he wants. His loss of his human form and his reduction to an undifferentiated blob signifies, as in so many horror films, the loss of all of the recognizable boundaries on which social life depends. In describing the nature of horror art, James B. Twitchell says that "we are transported to the threshold, to the margin, to the crest, to be caught in what Jean Cocteau has called *la zone*. The art of horror is thus the art of generating breakdown, where signifier and signified can no longer be kept separate, where distinctions can no longer be made, where old masks fall and new masks are not yet made."[20] Victor's decomposition into a blob dramatizes the process of breakdown, and his inarticulateness represents the breakdown of the process of signification. Language as a meaning-producing enterprise is at the basis of social life, and Victor evokes the horror of the loss of meaning and of identity. Moreover, like so many monstrous creations, he multiplies in uncontrolled fashion, reproducing asexually like a plant. He reduces those with whom he comes into contact to a similar undifferentiated condition.

As in many monster films, the monster's transformation is associated with reproduction. The film thus plays on basic fears concerning loss of identity and of consciousness, but it also plays on specific social fears generated by scientific experimentation, particularly that associated with atomic testing, radiation, and space travel. Like many nonhorror films of the period, the film addresses anxieties about the possible breakdown of familiar and traditional institutions as well as personal anxieties about survival in the nuclear age. Scientific knowledge is portrayed as capable of drastically altering life, and the film, through the figures of Quatermass and Lomax, dramatizes the confrontation between two systems of thought which do not seem reconcilable. Traditional values do not seem powerful enough to intervene and control the changes. In this context, Victor is also the embodiment of cultural anxieties. The film seems especially cogent in the context of recent work on the disunified subject. In

particular, the writings of Deleuze and Guattari on the schizophrenic nature of contemporary society are useful for understanding the disjunctions of familial and social life portrayed in these films.[21]

Hammer and Frankenstein

Capitalizing on the success of *The Quatermass Xperiment*, Hammer produced *X the Unknown* (1956) and *Quatermass II* (1957), both monster movies involving alien presences, mutations, and the issue of possession. In 1957, with the appearance of *The Curse of Frankenstein*, the company turned from science fiction to the field of classic horror. The Technicolor film was an immediate success.[22] Directed by Terence Fisher, scripted by Jimmy Sangster, and starring Peter Cushing as Dr. Frankenstein and Christopher Lee as the creature, *The Curse of Frankenstein* was based on the Mary Shelley novel rather than on the classic Hollywood film.

The film begins in prison with Victor Frankenstein recounting his story to a priest. The flashback begins with the young Frankenstein after the death of his mother. His imperiousness is demonstrated in his cold dismissal of his Aunt Sophie and her daughter, Elizabeth, though he receives a young man, Paul, who is to be his tutor. The time shifts to Victor as an adult working in his laboratory, determined to create a human being. Paul plays the role of the moralist who warns about the dangers of transgression, though he assists Frankenstein in cutting down the body of a hanged man. Victor beheads the corpse and takes the body to his laboratory, where he places it in a solution. At the charnel house, he purchases the necessary eyes, but he acquires the brain by murdering a scientist and removing his brain. In the scuffle that ensues between Victor and Paul as Paul tries to keep Victor from performing the experiment, the jar with the professor's brain is dropped. Victor transplants the brain into his creature. Fearing for Elizabeth, Paul begs her to leave, but she refuses to go. The monster, now enlivened, is a gruesome scarred creature who is aggressive and violent. He escapes and begins to destroy helpless individuals such as a blind man and a child. Victor and Paul track him down, shoot him, and bury him.

Obsessed with achieving his goal of creating life, Victor is determined to resurrect the creature, but is at first obstructed in his work by his maid, with whom he has had an affair. Pregnant with Victor's child and having learned that Victor is planning to marry Elizabeth, she threatens to expose his research to the village authorities. He challenges her to get the proof. In the familiar night scene of the isolated female in her nightgown holding a candle, the maid is killed by the monster as she enters the lab. Frankenstein stands outside and listens as she screams. The scene cuts directly to Elizabeth and Victor having breakfast. The juxtaposition of the violent murder and the benign breakfast scene serves to emphasize

Frankenstein's sadistic character. Such scenes of cruelty followed by scenes of eating, fusing ordinary and extraordinary events, are quite frequent in the film and underscore the integral relationship between the daylight world and the world of horror.

Frankenstein's cruelty continues to escalate and is mirrored in the behavior of the monster. When Paul returns for the wedding, Victor shows him the revived and raging monster. The men fight as the monster escapes, endangering Elizabeth. When Victor is himself menaced by the monster, he shoots and Elizabeth falls. The monster turns on him, but he throws a lantern at him. The burning creature falls through the window into a vat of acid. The film returns to the present and to Frankenstein in his cell with the priest. Paul enters, and Victor begs him to tell the priest that the story of the monster is true and that he, not Victor, murdered the girl. Paul refuses and returns to Elizabeth, who, it turns out, is not dead. The film ends with Victor walking to the guillotine, and the final shot is of the guillotine with the blade poised, ready to drop.

One of the major innovations from the original story and from the Hollywood version is the alteration of Frankenstein's character. He is colder, more calculating, and has fewer moral qualms. Like Quatermass, Frankenstein is obsessed with his work and has little room in his life for sentiment. His misogyny is already evident in his treatment of his aunt when he was young, and becomes more pronounced in his adult relations with the maid. In the portrayal of the young Frankenstein as well as the adult there is an element of dandyism in his appearance and of hedonism in his behavior. His dallying with the maid, however, does not carry over to his relationship with Elizabeth, whom he leaves alone on their wedding night to work on his creature. The monster, rather than offering a counterpoint to his creator as in the Hollywood version of the story, is actually an extension of Frankenstein's aggressiveness and rage. He is, like Dorian Gray, the externalization of the scientist's desires. Victor is the predator who violates the dead, exploits working-class women, and kills for his own profit. His murder of Professor Bernstein, who has lost his family and is alone, evokes the atrocities against Jews, not only in his murder but in the use of his brain for experimentation.

David Pirie has remarked how "Christopher Lee's monster, which comes into the world so abruptly, late in the film, and attempts to strangle its creator as soon as it is born, is certainly the most brutal and depraved in any Frankenstein film. Yet Lee still somehow contrives to make it seem pitiful and wretched, so that he is one of the tiny number of actors that have given the part depth and subtlety, despite the fact that the monster's appearances are extremely brief."[23] The film was made in color, and the scenes of mutilation are heightened by the blood-red color. The gruesomeness is not merely hinted at, as in earlier classics in which the specta-

tor is left to imagine violence, but made explicit. In *The Curse of Franken-stein*, the spectator observes along with Frankenstein the direct conse-quences of cruelty and depravity. The film confronts spectators with these images of violence as if to force them to acknowledge their own fears and propensities toward cruelty.

The success of the Hammer formula depends, as critics have indicated, on sensationalism, but the films also depend on more subtle elements, including what Raymond Durgnat describes as "the icy idealism of the bad Baron," which derives from the Marquis de Sade. The films repro-duce the Sadean world with its reveling in poetic injustice: goodness is not rewarded but punished. The Baron himself "represents both the cold cru-elty, and the courage of science, thus paraphrasing that unmoved detach-ment from one's atrocities which . . . is one of the aspirations of Sade's debauchees. And just as the Sade libertine becomes the unmoved mover, matching God, so this Frankenstein reproduces not only the hubris, but the coldness, of materialism."[24] The style of the film and the acting of Cushing and Lee are elegant, "frozen and libidinous." The unsentimental world portrayed in the film violates smug and traditional bourgeois val-ues relating to altruism, familial solidarity, and rationalism.

The sequel, *The Revenge of Frankenstein* (1958), dramatizes the return of the Baron. Working as a physician at a clinic for the poor, he again obtains body parts, this time to ameliorate the physical condition of his misshapen assistant through surgery. He is thwarted in his enterprise by the untimely escape of the creature, who causes havoc in the community. The people of Carlsbad are portrayed as the real monsters, people who have no compassion or understanding for the sufferings of the creature. More than in *The Curse of Frankenstein*, the doctor's experiment be-comes the pretext for exposing the cruelty of the community. The scene that most vividly dramatizes the return of the repressed occurs when the suffering Hans disrupts a ball by throwing himself through the windows, forcing the community to confront his disfigured self. Frankenstein's creature forces the community to directly confront the Other and to see it as part of its own world. The doctor in this film, as Pirie states, has "begun to take on the role not only of a hero but of a martyr."[25] His creation, too, is more sympathetic than the earlier monster and more the product of a warped society than of the doctor alone.

Hammer and Dracula

Through the next few years, the doctor would return in other Hammer films, but would share the stage with another archetypal horror figure, Count Dracula. *Dracula* (1958) was as financially successful as the Frankenstein films. According to Halliwell, "The publicity tag line for *Dracula* was 'The Terrifying Lover Who Died Yet Lived!' It was apt

enough: love, terror and death were the principal ingredients."[26] Also in Technicolor, the film starred Peter Cushing as Dr. Van Helsing and Christopher Lee as Count Dracula. As with his treatment of Mary Shelley's *Frankenstein*, Fisher took liberties with the Bram Stoker novel in the interests of his own thematic and stylistic concerns.

The initial image in the film is the castle. This image then dissolves to Count Dracula's crypt and the dripping of blood, which becomes the red diary of Jonathan Harker (John Van Eyssen). When Harker arrives at the castle, there is no one to greet him. Orientalism is conveyed in the arches and ornate twisted pillars of Dracula's castle. The moving camera tracks Harker as he reads the note from Dracula telling him to make himself comfortable. His isolation is disrupted by the arrival of a woman who pleads for his assistance and then disappears. Then the Count arrives, first announced by his shadow, dapperly dressed in black and wearing a cape. He greets Harker with graciousness and urbanity, and then excuses himself, saying that he will return at sundown. In this film Dracula becomes, writes Pirie, "the villain . . . he was always meant to be, the charming, intelligent, and irresistible host who is on the point of turning the cosy Victorian world upside down."[27]

On his return, Dracula comes to Harker's room and admires the picture of his fiancée, Lucy Holmwood. When he leaves, Harker reveals through his diary that he has come "to end Dracula's reign." That evening, a female vampire approaches him, throws her arms about him, and attempts to sink her teeth into his neck, but Dracula arrives in time to save him and takes her away as Harker falls into a faint. On the following day, according to his intentions, Harker goes to the crypt and drives a stake through the vampire's heart, the method prescribed for their destruction, whereby she is transformed into an old woman, blood spurting from her heart. Harker's ultimate objective is the destruction of Dracula. Unfortunately, the sun is setting, and Dracula now attacks him. Dr. Van Helsing, who has followed Harker, comes to an inn where the host and guests are hostile and refuse to give the doctor information about Harker. From a young woman who waits on tables, however, he gets the copy of Harker's diary and learns of his fate. Returning home, Van Helsing comes to the Holmwood house and gives Mina and Arthur Holmwood the news of Harker's death. Lucy (Carol Marsh) cannot be told, as she has been ailing with anemia.

Arthur Holmwood (Michael Gough), suspicious of Van Helsing, refuses to let him see Lucy. Alone, Lucy opens her windows, takes the cross off her neck, and returns to bed, looking toward the French doors with a smile on her face, awaiting Dracula's arrival. His victim now, she takes a turn for the worse. Van Helsing orders Lucy's windows shut and the placing of garlic in her room, but she subverts his plans and convinces the

maid to open the windows and remove the garlic. The following morning, she is found dead. After her death, the housekeeper's young daughter, Tania, who is brought home by the police after having been found wandering, tells of having seen Lucy. Arthur, who has been skeptical about Van Helsing's description of vampirism, agrees to use Tania as a decoy to trap Lucy. Seeing the empty crypt and confronting his sister, who tries to seduce him, he agrees to let Van Helsing destroy her by putting a stake through her heart. Mina now becomes the target of Dracula, who spirits her away to his castle. Van Helsing and Arthur follow, and Dracula is vanquished by the daylight as Van Helsing tears down the heavy drapes and threatens him with two crossed candlesticks. Dracula disintegrates into dust, leaving only his ring behind.

The film is structured by polarities: Van Helsing and Dracula, Arthur and Van Helsing, Mina and Lucy, Dracula's castle and the Holmwood house, science and religion against the power of the supernatural, and the healer against the destroyer. The separate poles meet through Dracula, who violates the normally safe spaces. He undermines the sanctity of the home, transforming domestically placid women into sensual creatures. The scene that most explicitly dramatizes the notion that the threat to the family is internal is Dracula's invasion of the lower regions of the Holmwood house. While Arthur and Van Helsing are busy guarding the house from outside, Dracula is inside seducing Mina. The women are portrayed as succumbing willingly. In contrast to Dracula, Arthur and Harker are presented as ineffectual. Arthur in particular is petulant and peremptory, a typical Victorian head of household, resistant to new ideas and unwilling to accept the important information Van Helsing gives him. Arthur is presented as a male prude, which makes Mina's succumbing to the suave Dracula all the more understandable.

Dracula's unleashing of sexuality is not restricted to women. Through Lucy's vampirism, children are also vulnerable to attack. Lucy's luring of the child suggests not only sexual seduction but also a subversion of maternal behavior. In her embracing of her brother, Lucy's behavior also suggests incest. Van Helsing as the mediator between the world of Dracula and the Holmwoods is not a bland moralist. He is the only one who understands the power of Dracula, and hence the only one capable of being a fitting antagonist. According to Pirie, "Van Helsing (played so superbly by Peter Cushing) takes up the familiar stance of the renaissance mastermind, and represents for a fleeting and nostalgic moment the union of scientific exploration with religion."[28] A fitting antagonist to Dracula, Van Helsing is urbane and indefatigable, though not always capable of outsmarting the Count.

The film derives its power not only from the humanization of Dracula, but from the portrayal of the claustrophobic world that he threatens. The scene in which Lucy suffocates in her sealed room permeated with garlic

is only one example of the closed spaces which invite penetration and spoliation. The ubiquity of the color red, interwoven throughout the film, acts as a reminder of the life that erupts, violently threatening to destroy the neat and repressive practices of characters like Arthur who refuse to admit of a world beyond the confines of their tidy middle-class lives. The film makes clear that women are the most vulnerable to suggestion and subversion, since they are the most repressed and oppressed. Even the housekeeper, Gerda, appreciates Lucy's plea for fresh air. If Dracula is the most attractive character, it is because he opens up the closed spaces of the other characters' lives.

Like *The Curse of Frankenstein*, *Dracula* engendered numerous sequels. Peter Cushing was to reappear in 1960 in *The Brides of Dracula* without Christopher Lee as the deadly Count. David Peel replaced Christopher Lee, who was not to make another Dracula film until 1968 when he acted in *Dracula, Prince of Darkness*. The vampire became a staple of Hammer productions, as did the figure of the crazed or benighted scientist. Dr. Frankenstein also reappeared in a number of guises. The popularity of *Dracula* is not surprising given that the film parallels issues common to the melodramas and social problem films of the 1950s—the focus on deviance and its threat to domestic stability, on portraits of disintegrating familial relations, and on an incompetent or repressive community. These horror films also feature a character increasingly common to the films of the period, the physician as priest or psychiatrist, who is associated with restoration of order in the community and the elimination of disruptive and monstrous threats to its well-being.

Aside from its exploitation of these horror classics, Hammer also indulged its penchant for Orientalism. *The Abominable Snowman* (1957) develops a familiar opposition between Tibetan and Western culture, and the film has a strongly didactic cast. The juxtaposition between East and West, Africa and Europe, is a staple of the horror film, and in Hammer the Europeans come out badly by contrast with people from these other cultures. Doctor Rollason, played by Peter Cushing, a guest of a Tibetan lama, is looking for medicinal plants to bring home to England. He joins up with a group of three men, two Americans and an Englishman, who are looking for the Abominable Snowman, the Yeti. The lama and Rollason's wife (Maureen Connell) seek to dissuade him and the others from the enterprise. The Americans are presented as crass and vulgar, willing to endanger each other in order to get their specimen for commercial reasons. The Englishman is obsessed with the idea of seeing the creatures. Rollason is tempted by the project and joins the party. On the trek, he discovers the men's brutality. His pleas on behalf of the creatures fall on deaf ears, and one by one the men die. They are not killed by the creatures but destroy themselves. As Rollason tells Tom Friend (Forrest Tucker), "It isn't what's out there that's dangerous, so much as what's within us."

He finally concedes that it is man that is violent, destructive, and dangerous, not the Yeti. Converted to the point of view of the lama, he finally denies the existence of the creatures.

The film is a moral parable, dramatizing the greed, ambitions, and violence of Western thought and behavior. In contrast to Western rationality, the Tibetan world as exemplified by the lama is mystical and peaceful, critical of aggression and acquisition. As in *The Night My Number Came Up* and *The Purple Plain*, *The Abominable Snowman* expresses discontent with the aggressive behavior of Western males and uses traditional stereotypes of Eastern culture to undermine Western attitudes. The "Orientalism," the portrayal of the Eastern way of life that is usually negative in the empire films of the 1930s, is in these 1950s films inverted. The culture of the East is now seen as offering a corrective to that of the West. Women are portrayed as aligned with the Eastern mentality.

The portrayal of the "monsters" is an index to the point of view of the film. They are not the true source of the horror but the men themselves as they ascribe malevolent motives to the snowmen and justify their aggression in the name of self-protection. The film's treatment of West and East is not merely another instance of the horror film's traditional dichotomy between opposing cultures and the threat of otherness. The traditional moral format involving "forbidden knowledge" takes on more specific connotations in the context of this late 1950s film. In the film's location in the frigid environment of the Himalayas and in the characters' aggressive attitudes toward difference, it is tempting to see the film as a cold war allegory. The men grapple in the snow with an enemy that is of their own making, attributing hostile and aggressive tendencies to their unknown quarry, and the film adopts a moral stance, condemning the men's violence and their projection of this violence onto others, and portraying their destructiveness as ultimately suicidal.

Hammer's 1959 film *The Stranglers of Bombay* also capitalizes on the exoticism of a non-Western culture, but the film can also be read as a critique of British imperialism. The prologue of the film announces: "For years there existed in Bombay a perverted religion, dedicated to the wanton destruction of human life. . . . So secret was this savage cult that even the British East India Company, rulers of the country at the time, was unaware of their existence." The film begins with a ritual of initiation, dedicated to the goddess Kali. The alien environment is underscored by the sound of drums, incantations, and the image of the goddess herself. At headquarters, British officers listen to the complaints of merchants about the loss of merchandise. An Indian headman affirms their complaints, emphasizing that things were different when he was in charge.

Captain Lewis (Guy Rolfe), a man aware of local customs and concerned about the disappearance of people and goods, urges the reluctant colonel to organize a detachment to investigate. Lewis hopes to be the

leader of such a group but is passed over, the post going to an officer of the colonel's social class, Captain Connaught-Smith (Allen Cutherbertson), who refuses to give credence to Lewis's belief in a conspiracy. Connaught-Smith prefers to humiliate the indigenous people and to extort information from them. When the severed hand of his former servant, who had gone to find his missing brother among the followers of Kali, is thrown into his house, Lewis goes to the colonel but receives neither help nor sympathy. Lewis resigns from the service, determined to track down the perpetrators of the crimes himself. On a tiger hunt with a neighbor, he finds a mass grave, which he attributes to the Thuggee cult, but Connaught-Smith ridicules him, telling him that he has merely found a cemetery.

Lewis follows two suspicious men to the ceremonial site of Kali and is taken prisoner. About to be attacked by a deadly snake, he is saved by a mongoose, an animal feared by the followers of Kali, and he is released. The climax of the film occurs after his neighbor, mistaken for Lewis, is brutally killed. He learns of a caravan about to be infiltrated and attacked by the Thuggees and tries to save the caravan but is led astray by on of the Indian officers who is in reality a member of the ritual group. He arrives to find only the mass graves. He is again captured by the headman, but is saved by his servant's brother, who recognizes a pendant that Das, his servant, had given Lewis. Lewis kills the leader, returns to the village to the acclaim of the colonel, and is finally given the long-withheld promotion. The epilogue to the film reads: "Major General Sir William Sleeman, the officer of the East India Company actually responsible for their capture, wrote of his fellow officers: 'If we have done nothing else for India, we have done this good thing.'"

According to Pirie, "The structure of the film is similar to that adopted in The Hound of the Baskervilles (though it is much less stylized and in black and white), beginning with the legend of Kali, the great mother, and showing her influence spreading into the present in the form of mass murder and mutilation."[29] Kali's human incarnation is in the form of a beautiful woman who "presides over the severing of limbs, the cutting out of tongues, and several castrations."[30] As in other Hammer films, the element of torture and mutilation is stressed, and the film is not reticent in its portrayal of the effects of the rituals. In contrast to the Indians, Lewis is portrayed as the trueborn Englishman in the tradition of the empire films, dedicated to his work. Despite the lack of recognition by his superior officer, his shabby and humiliating treatment at the hands of Connaught-Smith, he single-handedly exposes the affair.

The usual stark antithesis between the "natives" and the white man is accompanied by the portrayal of the few good natives—Lewis's servant, Ram Das, and his brother, Gopali. The head man is as treacherous as Chief Mofalaba in Sanders of the River, inciting the followers of Kali to

undermine the white institutions. The ritual to Kali is the sinister counterpart of the rituals of the rebellious tribesmen in *Sanders*. There are, however, significant differences from the early empire films. The British community is no longer unified. The colonel is corrupt and inefficient. His relationship to Connaught-Smith is represented as exemplary of the old boy system, which refuses to give credence to Lewis's information based on his knowledge of local customs. In his upper-class disdain for Lewis's information about the local customs, Connaught-Smith employs cruel and coercive methods of investigation, based on his assumption that the natives willfully withhold information and on his refusal to learn anything about their customs and traditions.

The most striking difference between this film and the empire films is the direct link that this one makes between commerce and imperialism. The killing of innocent people is portrayed as the joint enterprise of the leaders of the Thuggee gang in complicity with military officers whose function is to protect the company but who have neither the knowledge nor the interest to perform their job. The horror of the film arises from the scenes that catalogue the grisly mutilation perpetrated by the sect. The violence and destruction is not supernatural or fortuitous but linked to the desire for profit. The Indians are portrayed as seeking to reappropriate what has been expropriated from them, and the violence of their methods, when read against the grain, is a distorted mirror of the methods of the expropriator, best exemplified in the figures of Lewis's superior officers. The erotic figure of the woman, Karim (Marie Devereaux), with huge breasts who observes with relish the maiming and destruction of human beings is the incarnation of the savagery attributed to the natives. The woman, in this context, represents the destructiveness of a religion distorted by colonialism and the profit motive. As a surrogate also for the external spectator, she is portrayed as totally immersed in the spectacle of cruelty. Through her, the film self-consciously demonstrates its awareness of the audience's fascination with eroticism and violence. Moreover, in contrast to the British officers (Lewis excepted), she represents what they refuse to see and yet, through their blindness and ethnocentrism, permit to exist. Lewis's wife, too, is a spectator, albeit a passive one, to the horrors of British rule. The film opens up the terrifying world of the colonial Other in such a way as to implicate the British characters as well as the external spectator, casting doubts in 1959 on any lingering notions of reviving the glories of the British Empire. However, while the film is critical of the crass use of force by the British and particularly sensitive to the link between the economic and political mastery endemic to colonialism, the film does not escape a condescending tone in its treatment of indigenous religious practices. The representation of the worship of Kali is treated as an exotic phenomenon linked to primitivism, violence, and sex-

uality. Although it is suggested that the worship is a response to exploitative colonial practices, ritual is not portrayed as a constructive force in the lives of the people. Thus, at the same time that the film seeks to present a moral position from which to assess British involvement in India it dramatizes how the liberal Englishman must still regard the colonial Other from a position of rational superiority. The white man must save the Indians from themselves.

In *The Man Who Could Cheat Death* (1959), Fisher returned to a traditional Promethean theme. A physician, Dr. Georges Bonner (Anton Diffring), has succeeded in remaining young. Physically handsome, attractive to women, a talented artist, he appears to have everything. However, in order to stay young, he needs an operation every ten years in order to restore his pituitary gland. His colleague, Ludwig Weisz (Arnold Marle), is no longer able to perform the operation, since, unlike Bonner, he has chosen to age. Weisz enlists the services of Dr. Pierre Girard (Christopher Lee) to perform the operation, but, after the disappearance of Weisz, Girard begins to suspect Bonner of criminal activities. Moreover, the police are also suspicious of Bonner, since he has been linked with the disappearance of women every ten years. Girard, coerced into performing the operation after Bonner threatens him with danger to Janine (Hazel Court), only pretends to follow Bonner's directions for the transplant. When Bonner awakens, he realizes that he has been tricked. He ages rapidly, and, in a fire set by one of the women imprisoned in a warehouse where Bonner has kept the statues of the women he has sculpted over the years, the 104-year-old man burns to death.

The character of Bonner as played by Diffring is urbane, suave, and sensual. He represents the pleasures of hedonism, immorality, and sensuality. Women are desperate to be with him. Janine is totally under his spell and resists the sensible admonitions of Girard. Girard is the antithesis of Bonner, decorous, restrained, and, above all, moral. He, more than the police, is responsible for the end of Bonner's life and career as a womanizer. The third physician in the film is played by another veteran Hammer actor, Arnold Marle, who represents the voice of morality common in so many Hammer films. He reminds Bonner that their experiment was for the benefit of humanity, asking him, "What is death that it should be feared?" He castigates Bonner for destroying others to enhance his own life. Desperate to live, Bonner destroys him.

Bonner's murders are not presented as brutish and gruesome but rather as restrained and inevitable, the outcome of his desperate struggle to survive. The character of Bonner establishes yet again that the villains in Hammer films are more attractive and appealing than the heroes. The women are not set up in terms of conventional oppositions between chaste and unchaste, but are voluptuous and large-breasted, their cos-

tumes designed to accentuate their bosoms. The fin-de-siècle settings emphasize the plushness and sensuous quality of Bonner's world. In general, the film displays what Julian Petley has described as "a sensation of powerfully negative, barely suppressed desires, in which violence, sexuality, and death are inextricably mixed, almost dripping from the screen."[31]

Independent Horror Films

Hammer Films was not the only source of horror films. Other independent companies, such as Tigon, Amicus, Tempean, and Anglo-Amalgamated, vied with Hammer and turned out interesting examples of the horror genre. For example, *Corridors of Blood* (1958), directed by Robert Day for MGM Producers Associates, takes the historical figure of the physician-inventor, Thomas Bolton, and constructs a grisly narrative of suffering and mutilation around the struggle to invent anesthesia. Pirie describes the film as "little more than an excuse for the detailed coverage of some utterly gruesome operations."[32] The film is punctuated with scenes (or flashbacks) of patients on the operating table having their limbs removed. The element of voyeurism is manifested not only in the focus on mutilation and disfigurement but also in the deterioration of the protagonist as he slowly sinks into a life of crime resulting from drug addiction. The film calls attention to the internal audience of the operating theater as much as it does to the doctor and his patients.

Like so many of the scientists in the horror film, Bolton (Boris Karloff) is obsessed with his work. When not working at the hospital, he is working at a charity clinic; at home, he works in his laboratory. He is obsessed with disproving his colleagues' belief that "there is no surgery without pain." Toward that end, he neglects his family, unwittingly becoming involved with a group of unsavory individuals, masterminded by a disfigured and unscrupulous criminal, Resurrection Joe (Christopher Lee), who murders people and sells their bodies for use in medical experiments. Joe is himself horribly disfigured, and the Hammer correlation between criminality and disfigurement is once again invoked. The physician, who experiences extreme guilt at seeing the results of his surgical knife, becomes an easy target for Joe and his cohorts. As the doctor experiments on himself with the drugs, he begins to lose his memory. His notebook, which is stolen from him as he returns to the Seven Dials, the haunt of the murderers, is the vehicle of his undoing. In exchange for its return, he agrees to sign more death certificates.

Humiliated by his colleagues when his demonstration fails, he becomes even more withdrawn. The drugs that he takes regularly begin to affect his work as a surgeon, and he is asked to leave the hospital. At this point, he cannot even face people without taking his drugs, and he quarrels violently with his son over his experiments. The hospital refuses him any

more drugs, and he is driven to the group at the Seven Dials, who help him to break into the hospital and steal the drugs. Joe is responsible for murdering the guard. Bolton is completely addicted and unable to do anything but sustain his habit. The police, discovering the faulty death certificates, trace him to the Seven Dials, where they find him mortally wounded after a struggle with Resurrection Joe. On his deathbed, he is reconciled to his son, who promises to carry on his work. The final scene balances the opening scene by depicting the operating theater, where it is now the son who operates on a man who is anesthetized.

The doctor is a victim of his colleagues' intransigence and unwillingness to entertain change. He is also a victim of his own highly developed sense of guilt. Unable to tolerate the mutilation that he produces and recoiling from himself as a butcher, he is distinguished from his callous colleagues as well as from the cold-blooded criminals who casually destroy life. In his alienation and frustration, he destroys himself. Bolton's degeneration is presented as the consequence of several factors—a society that produces inequities in wealth (the contrast between the doctor's home and the haunts of the poor are visually stressed); the ignorance of the poor (as in the case of the mother who promises to keep her daughter off her wounded foot but breaks her word); the economic desperation of criminals who kill for money; and especially the refusal of respectable members of society to entertain innovation and who, in their sanctimoniousness, are cruel and tyrannical.

The telltale scene that reveals the doctor's addiction occurs, significantly, when he is asked to entertain a colleague and his wife at an evening social in his home. He spies on them, then retreats to his lab to inhale the gas before confronting them in his usual guise. The metaphor of addiction is directly related to that of mutilation, and mutilation to cruelty. His colleague's gleeful and self-satisfied assertion that "there is no surgery without pain," which echoes in Bolton's mind, drives him to desperate measures. The images of mutilation come to represent the consequences of cruelty, which are acceptable to most of the respectable characters in the film. They are also a sign of the general disfigurement of society, exemplified through its criminal elements.

Pain is the subject of the film, and Bolton becomes a martyr to the elimination of pain while ironically producing pain for himself. The highlighting of pain and mutilation in a film that takes as its pretext the amelioration of pain invites a less literal, and certainly a less judgmental, reading of the film. Undermining the conventional historical narrative and the sensational images of mutilation, the film probes the more subtle and less spectacular aspects of social and personal mutilation. While the film lacks the erotic emphasis of a Terence Fisher film, which invokes the Sadean hero, *Corridors of Blood* probes the subject of masochism. The

protagonist of the film in no way engages in deliberate and celebratory acts of cruelty. Even performing his legitimate job is a source of pain, and the film is obsessed with his desperation, self-mutilation, and final destruction.

Blood of the Vampire (1958), produced by another independent company, Tempean, and directed by Henry Cass, appeared in the same year as *Corridors of Blood*. Unlike the Hammer films, with their ambivalent attitude toward scientists, this film portrays the scientist as a totally villainous figure who is devoted to nothing more than his own self-perpetuation. He does not wish to improve humanity through creating a new form of life. He cold-bloodedly pursues science for its own sake. He does not wish to help his disfigured and inarticulate assistant. He only seeks to cure himself. The prologue, like the title, leads the audience to anticipate another vampire film: "The most loathsome scourge ever to afflict this earth was the vampire, nourishing itself on warm blood; the only known method of ending a vampire's reign of terror was to drive a stake through its heart." The narrative proper begins with the driving of a stake through the heart of a dead man, and the murder of a grave digger. The scene shifts to a Gypsy bar, where a horribly misshapen man comes to collect a doctor for an operation. The doctor goes with the man and performs a heart transplant on the man who had been killed as a vampire. After the operation, the doctor is himself killed. In the following sequence, yet another physician, Jean Pierre (Vincent Ball) is sentenced to prison for the murder of a patient. Without explanation, he is sent to a hospital for the criminally insane. There he encounters the misshapen man who is the assistant to Dr. Callistratus (Donald Wolfit), the director of the hospital.

The inmates are not only cruelly treated by the guards, but the doctor performs experiments on them. He separates Pierre from the others and employs him as his aide for his experiments in mixing various blood types. Through his fiancée, Madeleine (Barbara Shelley), who passes herself off as a housekeeper to Callistratus, Pierre learns that he was acquitted of wrongdoing, but that Callistratus not only had him wrongfully committed but has told the officials that Pierre is dead, along with his cell-mate, who was brutally mutilated by the vicious dogs guarding the hospital. Later Pierre learns that the inmates are drained of blood for the doctor's experiments. Callistratus's ultimate objective is to find a cure for the blood dyscrasia he had contracted when he was restored to life through the heart transplant. In the laboratory are the testimonials to the doctor's cruelty—a man encased in ice, another man kept alive without a heart, and the mutilated, half-alive cell-mate who has been selected for another transplant.

The film presents a totally paranoid world. Callistratus himself was sentenced for experimenting with blood transfusions and destroyed as a vampire by the authorities. High legal officials are engaged in corrupting

the legal system. The community that sentenced first Callistratus and later Pierre is presented as inhumane. The inmates in the first jail where Pierre is taken are taunting and sadistic. The hospital for the criminally insane is run by callous and brutal guards who enjoy inflicting pain on the inmates, and Callistratus is totally indifferent to human suffering and pain, preoccupied only with destroying life in order to save himself. Finally, even his devoted Carl (Victor Maddern) turns against Callistratus when he brutalizes Madeleine.

In this film, vampirism is voided of its supernatural meaning. Instead it comes to signify the ways in which institutions drain individuals of life, subjecting them to the most hideous indignities. The doctor's blood experiments graphically depict the way in which deviants are treated as subhuman. The experiments that the doctor performs have a double-edged significance. On the one hand, with their experiments on the hapless inmates, they evoke the horrors of imprisonment and, more particularly, of the concentration camps. On the other hand, they dramatize the arbitrary cruelty of authority. Callistratus does not even have the excuse of wanting to benefit society, but cares only for self-aggrandizement. The film presents a grim picture of science and a society with little redeeming value. The grotesque imagery of the film, its monstrous characters, and its blatantly antirealistic style are a companion to the Gainsborough costume melodramas, which refuse a comforting portrayal of individuals and social institutions. *Blood of the Vampire* is obsessed with negative images of power, violence, and the predation of authority figures on helpless and terrorized victims.

Such films seem to be a response to meliorist concerns portrayed in such films as *The Blue Lamp* and *I Believe in You*. The tendency of social problem films to present such issues as juvenile delinquency, homosexuality, prostitution, and racism in a rational, benign, and therapeutic way is undermined in the horror film. The world portrayed by the horror films challenges rationality, and especially the notion of the efficacy of environmentalism and therapy. The hospital for the criminally insane in *Blood of the Vampire* is a microcosm of a society in which the insane are not the inmates but the administrators. The social problem film's focus on the recuperation of marginality, like the government's efforts to rationalize inequities and the erosion of traditional social norms in the postwar era, is subverted in the horror film which indicts science and institutional power, shifting the blame from the victim onto the creators of victimization. The antirealistic style of the films does not normalize tensions but rather calls attention to the irrationality of normality.

A sadistic and crazed scientist is again the central character in *Womaneater* (1958), an inexpensive independent production directed by Charles Saunders. Dr. Moran (George Coulouris) is in search of a fluid that can restore life to the dead, and women are his vehicles for producing the fluid

from a plant acquired on a trip to the Amazon. As the title suggests, the plant devours the female victims. The Brazilian segment features the usual trek through the jungle, drums, snake dances, and a female sacrificial victim. When Moran returns to England and his laboratory, he brings the native, Tanga (Jimmy Vaughan), who feeds Englishwomen to the monster. Moran spurns his housekeeper and seeks to share his expected fame with Sally (Vera Day), a young woman. After killing the housekeeper, he attempts to bring her back to life, but discovers that the native has only given him the formula to restore the body and not the mind. Setting fire to the plant, he is then killed by Tanga.

Moran's motives are mixed. Curiosity and the desire to share his fame with a beautiful young woman fuel his ambition. While the native seeks to feed women indiscriminately to the plant, Moran uses only women separated from their families, women who, like Judy (Joy Webster), appear to be rejected by others and of questionable morals. Sally appears to be an appropriate victim, but he prefers to spare her for himself. Unlike the native, he is not sexually aroused by the sacrificial ritual. While the film is cryptic in developing his character (he is described by several characters merely as a "strange" man whose family has a hereditary taint of madness), the plant and the ritual murder appear to have sexual implications. Before being thrown to the plant, the female is put into a trance, a state resembling sexual ecstasy, and she awakens only at the moment at which she approaches her annihilation. Her femaleness, gained at the cost of her death, is distilled into the fluid. Thus, Moran's quest to resurrect the dead is associated with female sexuality and its power, and his misogyny with his desire to possess the secret of life. The police are totally irrelevant to his capture. The conflict is primarily between the native and Moran. The native outwits the white man, and ultimately females defeat the male. The structure of the film is loose and elliptical, and what is especially interesting is the way in which conventional narrative strategies of resolution are subverted by the foreigner and the young woman, both marginal figures, rather than by the traditional forces of law and order.

In the manner of most horror films, *Womaneater* is based on an oppositional structure: the doctor and Tanga, the older woman and the younger, England and the Amazon, the English town and the African jungle, the typical English house and the basement that reproduces the jungle environment, conventional relationships and the doctor's world. The film depicts the invasion of the familiar world by the exotic, and the exoticism signals the existence of attitudes that conflict with conventional behavior and wisdom. In *Womaneater*, these attitudes are unambiguously linked to sexuality.

In 1960, Michael Powell's *Peeping Tom* created a storm of controversy. Now considered one of the most complex and self-reflexive examples of the horror film, upon its release critics described the film only as

perverse. According to William Whitebait, "'*Peeping Tom* stinks more than anything else in British films since *The Stranglers of Bombay*. Of course, being the work of Michael Powell it has its explanation, its excuse. Not so had *The Stranglers*; it was "history", you remember. *Peeping Tom* is "psychology'.'"[33] More vehement about the film, Derek Hill complains that "'The only really satisfactory way to dispose of *Peeping Tom* would be to shovel it up and flush it swiftly down the nearest sewer. Even then the stench would remain.'"[34] The film was also accused of being "phoney cinema," of exploiting "fear and inhibition for the lowest motives," "so-called entertainment," and of wallowing "in the diseased urges of a homicidal pervert."[35]

Ian Christie asserts that these negative responses to the film can be attributed to the predilection in British cinema for uncritical realism. *Peeping Tom* defies the label of cinematic realism associated with familiar location settings, immediately identifiable characters, and clearly identified social problems. Neither can the film be classified as pure entertainment or as propaganda. Like the earlier Gainsborough melodramas, the film eludes prevailing standards of taste, but responses to *Peeping Tom* are illuminating about formal and informal modes of censorship of those films that do not comfortably fit into accepted aesthetic and cultural preconceptions. The censoring of those productions that stray from a "utilitarian aesthetic . . . divorces cinema from any effective involvement in the social formation, yet also seeks its justification in a 'relevance' to certain narrowly prescribed concerns—those of liberal humanism."[36]

Like the Hammer horror films, *Peeping Tom*, from the first shots of the murderer as he photographs and kills his helpless and terrified female victim, accumulates travesties, forcing spectators both to observe acts of aggression and violence and to contemplate the act of gazing at these transgressions. The protagonist, Mark Lewis (Carl Boehm), is the instigator of acts of cruelty, but he is also, with his camera and tripod, their recorder. The narrative is straightforward. Lewis, an introverted young man who works as a focus puller for a small film company and as a photographer for a newsagent, also a seller of pornographic pictures, selects his female victims for their blatant sexuality and stabs them as he photographs their death agonies.

The film's complexity arises from its self-reflexivity, from the spectator's awareness that the film is referring to itself and the aggressive nature of cinema. As Jean-Paul Torok states, *Peeping Tom* can be seen as a "'delicately nuanced psychological study of an authentic film *auteur*, who pushes a particular conception of the direction of actors to its limits. For voyeurism alone is not enough to explain the character of Lewis: he is also, and at one and the same time, a sadistic film-maker and murderer, with these different facets forming a coherent whole.'"[37] These "different facets" are inscribed throughout the film in its conjunction of fictional

and "documentary" footage, alternation of Technicolor and black and white film, fusion of past and present, and linking of sexuality and aggression. The film follows four simultaneous and overlapping lines. The first line is the murders themselves in their execution and ultimate exposure. The second is the history of the protagonist and the "explanation" for his actions. The third is the issue of voyeurism, both the protagonist's and the spectator's. And the fourth is, Torok indicates, the self-conscious exploration of cinema. The film offers itself as a text that seeks to deconstruct the dynamics of classic cinema as conveyed through the horror genre. Like the later *The Eyes of Laura Mars* (1978), "its dense and allusive surface proposes it as a veritable discourse on the issues of violence toward women and the psychosexual dynamics of sight."[38]

The film traces Mark's aggressive relations with women to his relationship with his scientist father. The oedipal conflict is expressed in the portrayal of his father's destructive and castrating gaze as he, for clinical purposes, provokes the boy's fright. The specific vehicle of the father's control is his constant surveillance of the boy's actions. In a house wired for sound, he also tapes as well as photographs the boy's responses to fear for his experiments on nervous reactions to fright. Mark's mother's death deprives the boy of a mediating figure. Mark then becomes fixated on his father's second wife, a young and voluptuous woman. On this level, the film appears to offer a psychoanalytic explanation for Lewis's fixation on women, his misogyny, and his specific choice of young, beautiful, and erotic females. His identification with his father is reenacted in his recapitulation of his father's experiments. His Hamlet-like revenge on women is thus identified with the loss of his mother and the usurping of her place by the sexually provocative second wife. More profoundly, his identification with the patriarchal figure reenacts the aggressive structures of patriarchy associated with the threat of castration. His tripod, containing the mirror in which the victim sees herself and the knife that impales her, recapitulates the oedipal scenario. The protagonist forces the female, the incarnation of his father's wife, to confront her own lack through the mirror image and in killing her with his phallic instrument vicariously commits the transgressive incestuous act.

Mark's relationship to Helen Stephens (Anna Massey), a tenant who lives in his house, contrasts sharply with his relationships with his victims. Helen is a chaste-looking and hesitant female who lives vicariously through her work. Identified with her mother, with whom she lives, she is also more closely aligned with Mark's deceased mother than with his father's second, more sexual, wife, linked to the world of women rather than men. Her mother, Mrs. Stephens (Maxine Audley), is blind, and her blindness, in a film that links vision, aggressivity, and patriarchy, comes to signify another way of knowing, associated with the female body and

particularly with auditory and tactile sensations. Mark has specialized in vision, but Mrs. Stephens, and by implication Helen too, represent alternatives to his obsession with looking. His relationship to the mother and daughter allows for the exposure of his obsession, but it also exposes another aspect of the oedipal conflict enacted by the film. If his homicidal relationship to his victims reveals his identification with his father, his relationship to Helen and her mother exposes his self-destructive identification with his mother. In saving Helen from himself, he must adopt the female position and destroy himself in the same manner in which he has destroyed his victims and in which he perceives his father has destroyed his mother. Mark is thus finally portrayed not as a cold-blooded monster, but, like the women he destroys, as a victim of patriarchy.

Spectatorship in this film is expressly linked to pornography. Mark's work as a photographer for a newsagent who sells pornography allows the film to make connections between pornography, the exploitation of the female body, and violence against women. One of the models he photographs and later murders is disfigured on one side of her face, the consequence of another man's brutality. Mark's own practice of arousing his victims before he murders them is a more blatant instance of the link between female sexuality, male aggression, and the pleasures of pornography, which are based on a violation of the female body, literally and representationally. The comment by one of his models, "I do feel so alone in front of it [the camera]," seems to touch the core of the pleasure derived from looking at the female as she experiences her sexuality but also is isolated and impaled by the male gaze.

Yet the film does not remain on the level of psychologizing individual pathology or attempting to present a clinical portrait. Instead it extrapolates from Mark's case to develop broader cultural and personal implications. Powell himself appears in the film as Mark's father, and his son appears as the young Mark. There are allusions to other Powell films in the text, particularly in the use of Moira Shearer and other red-haired females. Moira's dancing prior to her death is a reminder of her role in Powell's film The Red Shoes (1948). By including himself and his son, and by his numerous allusions to filmmaking, Powell links himself to his protagonist to the craft of filmmaking. The reflexiveness enlarges the film's scope and makes it more than a study in psychological aberration.

If Mark is a sympathetic character, it is not only because his behavior evokes clinical curiosity. It is because he is also a surrogate for the filmmaker and, by extension, for the spectator, who participates in this enactment of looking. As many critics have asked, "Who is the real voyeur?" The spectator is implicated in the act of looking at transgressive images. Like the woman in The Stranglers of Bombay who lingers with pleasure on the scenes of torture and mutilation, the spectator, along with the

protagonist in *Peeping Tom*, is invited to contemplate the pleasure derived from observing the infliction of pain, a pleasure that is invoked by the aggressive instrument of the camera, which figuratively impales its subjects with the gaze. The traditional subject of this art of looking is the female, and, contrary to other ripper/slasher films, *Peeping Tom*, in its self-reflexivity, does not merely reproduce this phenomenon but calls attention to it.

Peeping Tom shares an affinity with Hammer horror films of the late 1950s in that it employs all of the familiar devices of the horror genre—the sadistic scientist who creates a monster in his own son, the motif of experimentation as a form of dehumanization, the presence and impotence of the rational doctor in the psychoanalyst who offers to help Mark, the juxtaposition of the normal and the abnormal and the blurring of the boundaries between them, the fascination with cruelty and the film's refusal to restrict its existence to the perverse few. In *Peeping Tom*, as in *Dracula*, sexuality is taken out of the closet and exposed to sight. No wonder critics described the film as perverse. Sex is portrayed as threatening, as aligned with institutional power. The patriarchal family is seen as a reproducer of socially and personally repressive forces, but so is the practice of clinical science, and, for that matter, the cinema.

The film validates Foucault's observations in *The History of Sexuality* about the relationship between social power and the regulation of sexuality. The film can be read as a gloss to Foucault in its insistence on linking sexuality to a number of social practices involving the family, the medical profession, the surveillance of the young, pornography, and the cinema. It is through these apparatuses of sexual representation that individuals are formed. *Peeping Tom* reveals the mechanisms of control but also the ways in which they do not necessarily produce the desired social ends. Thus *Peeping Tom*, like the Hammer horror films, even to the extent that they are exploitative of the growing preoccupation in the cinema with sex and violence, exposes the relationship between sexuality and the apparatuses of power. In one respect, they are not aberrations at all, but symptoms of deep-seated social processes. Not only do the films reveal the repressive aspects of psychosocial behavior, but by virtue of their very existence they also reveal resistance to traditional forms of discourse. Moreover, the horror films challenge liberal and moral representations of sexuality and their attempts to pacify and normalize discontents. With *Peeping Tom*, as with many of the Hammer films, the British cinema surfaces cultural issues that have always been present, though not always addressed in such overt, blatant, and self-conscious fashion.

The horror films are not an aberration from the mainstream of British cinema. Their preoccupations are drawn from a common fund of attitudes, values, and images deeply ingrained in British cinema and in seg-

ments of British culture. Their representations of monstrosity and devi-ance acknowledge underlying cultural anxieties about gender identity, sexuality, and power. The most effective films of the 1940s and 1950s expose traditional cultural values as clichés that cannot be borne out in practice. The traditional humanistic and rationalistic views of science, religion, commerce, the family, and even artistic production as providing the backbone of a stable British society are called into question.

These films acknowledge time and again the existence of and the destructiveness of repression, the existence of and the inherently violent nature of sexuality. They are particularly concerned with unmasking the benevolent face of power, exposing its cruelty and brutality. The mon-strous figures of the Hammer horror films are often more credible than the banal authority figures to whom they are opposed. In this respect, the films share an affinity with the social problem films discussed in the next chapter. Along with the therapeutic strategies of the social problem film, which features scientists, physicians, social workers, and police, the hor-ror film shares a similar thematic, especially in its preoccupation with social and sexual deviance, criminality, and a community imperiled by desires that it finds difficult, if not impossible, to explain or contain.

The Social Problem Film

THE POST–WORLD WAR II era saw the development and popularization of the British social problem film. The social problem film was directed toward the dramatization of topical social issues—capital punishment, prison life, juvenile delinquency, poverty, marital conflict, family tension, and, to a lesser degree, racism. Unlike the prewar genres—films of empire, comedies, and melodramas—these films were eclectic in nature, fusing melodrama, docudrama, and social realism. According to Peter Roffman and Jim Purdy, "The problem film combines social analysis and dramatic conflict within a coherent narrative structure. Social content is transformed into dramatic events and movie narrative adapted to accommodate social issues as story material through a particular set of movie conventions. These conventions distinguish the social problem film as a genre."[1] This eclecticism, which also characterizes the Hollywood cinema of the postwar era, is a response to a variety of social and economic conditions that reveal the sensitivity of genre production to change. Such change was the consequence of a number of factors: the war itself, the austerities of the immediate postwar reconstruction, and later the cold war and the new affluence and consumerism of the mid-1950s. Changing patterns in work and leisure life and the threat of emergent patterns of morality concerning the family, sexuality, and gender converged with concrete concerns about the drastic fall in audience attendance at the cinema and were an impetus to the creation of new forms of representation, a situation that was to become part of the landscape of post-1950s cinema.

However, the British social problem film did not arise in a vacuum. More often than has been acknowledged, the British cinema of the 1930s addressed social issues and, in particular, the condition of workers.[2] Such films as *Jericho* (1937), *The Citadel* (1938), *South Riding* (1938), *There Ain't No Justice* (1939), and *The Stars Look Down* (1939) touched themes of poverty, unemployment, and exploitation of workers and their effect on the individual, the family, and the community. These films shared with the Hollywood social problem films of the same era (*I Am a Fugitive from a Chain Gang* [1932], *Our Daily Bread* [1934], *You Only*

Live Once [1937], and *You Can't Take It With You* [1938]) a stylized, melodramatic treatment. The characters and the social conflicts were polarized, the treatment of the social issues subordinated to the emotional conflicts experienced by the protagonists, and the conflicts often resolved through a populist benefactor or through the efforts of an exceptional individual who overcame economic and social constraints in the interests of the community.

The form of the 1930s social problem film is exemplified in *The Citadel*, based on the A. J. Cronin novel, produced by Victor Saville, and directed by King Vidor. The protagonist is a young doctor who seeks idealistically to improve the lot of miners but becomes disillusioned with their resistance to his methods and is temporarily seduced by money and status. The film is a conversion drama in which the focus is on the protagonist and on the various stages of his return to a sense of manhood, service, and duty. The condition of the workers and the protagonist's problematic relations to his wife are subordinated to his individual struggle to recover a sense of moral integrity. *They Drive by Night* (1938), modeled on Hollywood social problem films of the 1930s such as *I Was a Fugitive from a Chain Gang* and French film noir of the same period, dramatizes the plight of the social outcast who is persecuted by the police and by his untrustworthy former accomplices in crime. The world inhabited by the lower classes is portrayed as threatening, and the protagonist's only salvation lies in the help of a "lorry girl" and his own perseverance in the face of social prejudice. The film fluctuates between melodrama and realism as the protagonist fights for his life in a threatening world. *There Ain't No Justice* (1939), a film that is modeled on the Hollywood fight film, explores the exploitation of young working-class males by criminal elements in society. Boxing becomes a metaphor for a society that should be collective, just, and economically equitable but is corrupt and exploitative. The protagonist distinguishes himself by "fighting" for his family and the community and exposing the criminals. The social problem film is more likely than other genres to feature working-class protagonists and marginal figures. While the British films may not pose radical social alternatives to oppression, and while they are not as virulently critical of entrenched wealth and privilege as many of their Hollywood counterparts, they provide a complex sense of cultural and social contradictions.

Jeffrey Richards has argued that British films of the 1930s seem generally committed to portraying a conservative image of society. He attributes this conservatism to the social and economic situation in Britain. "For one thing," he states, "Britain was not universally depressed. The old heavy industries of Britain's industrial preeminence, mining, shipbuilding, and textiles, may have been in decline and with them the areas

that sustained these activities. But the Midlands and the South, revitalized by the rise of motor manufacture and the arrival of new light industry, were flourishing. The middle classes were enjoying greater affluence than ever, and overall the standard of living was rising."[3] Moreover, as John Stevenson indicates, "The number of unemployed began to fall after 1933 and, in spite of the deflationary policies of the government, an upswing in world trade, policies of cheap money, protection and the restoration of financial confidence all contributed to rapid economic growth in the mid-thirties which provided the basis for a rise in living standards for those in work and prosperity for some parts of the country."[4] In the arena of politics, the Conservatives were the dominant political force and evidence of the "underlying conservatism and cohesiveness of British society."[5] Hence, it has been assumed that there was no widespread resistance to prevailing conservative attitudes represented through images of monarchy, nation, and empire. The media—press, radio, and cinema—were, as in the United States, largely devoted to promulgating a sense of social stability and cohesiveness. Direct and indirect censorship served, too, to contain oppositional views. However, the films described above and the melodramas of the 1930s and the comedies, especially the comedies of Gracie Fields, Will Hay, and Arthur Lucan, provide evidence that British cinema was not merely an instrument of conservatism. While the resolutions of the films may conform to official positions and to traditional notions of family and nation, the narratives and the characters that inhabit them address social conflicts which cannot be contained by a simple equation between cinema and ideology.

Opposition to the cinema of genres and adherence to the canons of social realism have been responsible, in part, for promulgating the idea that British cinema was primarily an instrument of escapism on the one hand and of consensus on the other. In past evaluations of British cinema, realistic texts have been regarded as superior to genre films, which, it is claimed, distort reality and misrepresent "actual" social conditions, and the social problem film must be seen in the context of this controversy. Its genealogy is linked to the documentary film movements of the 1930s, to the work of John Grierson and his organization but also to that of more radical filmmakers. Bert Hogenkamp explains, "The economic crisis of the 1930s opened the eyes of a number of professional film makers who developed a commitment to the socialist cause and offered their services to the working class movement. Such professional people, coming from outside the workers' movement, were often met with initial suspicion, but in many cases they were able to overcome this and gain acceptance as equal comrades. One such—the documentary film maker Paul Rotha—sought to convince the leadership of the Labour Party that film was an indispensable tool in its propaganda armoury."[6] The number of films

treating unemployment, hunger, the condition of miners, the Spanish Civil War, and fascism increased as the decade progressed. Recent criticism has recuperated these films in an effort to reevaluate the different dimensions of filmmaking in Britain and to explode long-standing myths about British documentary which concentrated attention on the documentaries of John Grierson and the group he brought together under the General Post Office Unit.[7] The existence of these documentary movements attests to the presence of a more diverse film culture than has heretofore been acknowledged in studies of British cinema. Moreover, these documentary movements were to play a crucial role in the transformation of the British cinema during the war years.

According to Andrew Higson, "Documentary played an absolutely key role in the consolidation of wartime British film culture." Higson further asserts that "three sets of practices form the contexts in which these various films—both narrative features and documentaries—address the nation. Firstly, there are the needs and interests of a wartime state propaganda machine; secondly, there is the relatively autonomous development of the culture of populism; and thirdly, there is the longer term struggle to establish British cinema as a 'genuine' national cinema."[8] There is no doubt that the feature films were given a transfusion as a consequence of the war and of the government's (and many filmmakers') insistence on the production of films that not only dramatized the public face of the war but also presented a picture of everyday life and of ordinary people struggling to survive (see Chapter 4). The emphasis on family, on community, and on the link between the public and private spheres is couched in a discourse of realism, dependent on modes of address that seek to involve the spectator and provide a sense of participation and immediacy. Moreover, the images of the family and of work and leisure, the use of location settings, and the blending of history and fiction are strategies for "authenticating the narrative."[9]

Such films as *Waterloo Road, Millions Like Us, The Gentle Sex, The Next of Kin,* and *49th Parallel* are distinguished by their populist emphasis on unity across classes, their concern to include working-class characters, their attention to authenticity of locale, and their focus on the mundane struggles of their characters, which involve questions of family and community survival, work, the changing position of women, and transformations in the family. Many of the war films have an omnibus format, focusing not on one protagonist but on several. The emphasis is on overcoming difference, elevating the notion of community, and creating a sense of common objectives. Though the films establish closure through elevating values of family, nation, and self-discipline, they also indicate that the war has generated or exacerbated problems in the private sphere. The move toward realism is in itself indicative of the intrusion of new

discourses that incorporate the language of the social sciences, in particular sociology and psychology.

Among the many lines of influence that intersect in the rise of the social problem film, Italian neorealism must be considered as a major force in the turn toward realism and away from studio-produced genre films. Italian filmmakers in the last stages of fascism and in the immediate postwar era sought to create a sense of a cinema actively engaged in everyday social concerns that directly involved the lives of their spectators. Films such as *Shoe Shine* (1946), *Bicycle Thieves* (1948), and *Umberto D* (1952) featured dispossessed, often working-class protagonists struggling with survival in the postwar world, confronting unemployment, bureaucratic indifference, and poverty. The films were shot on location, and the urban or rural settings become signifiers of a changed and threatening world in which the characters seek, often vainly, for economic, moral, and psychological amelioration of their situation.[10] In particular, the tendency of these films to focus on the moral conflicts of the characters, to link psychological concerns to institutional practices, was especially appealing to postwar filmmakers.

In the immediate postwar era, the preoccupation with the war and its attendant problems shifted to a concern with the transformation from a wartime to a peacetime society. The increased participation of the government in areas of private life concerning the administration and regulation of health care, reproduction, family allowances, and education was a further indication of the film industry's (and the state's) continuing attempt to acknowledge pressing social problems, if not to solve them. The films' preoccupation with disrupted family life, law enforcement, generational relationships, juvenile delinquency, and poor "social adjustment" is consonant with concerns expressed by lawmakers, sociologists, and popular journalists. The style of these films bears the marks of the wartime documentary and of the feature films that strove to create a sense of common purpose and of attention to the problems of everyday existence. As in the melodramas, psychiatrists and social workers play a central role as intermediaries between the protagonist and the law.

The social problem film incorporated location shooting and the foregrounding of ordinary protagonists in its attempt to create authenticity and to naturalize its fictions by locating its actions in a "real" context. Unlike Italian neorealism, with its frequent use of nonprofessional actors, the social problem film employed professional actors but introduced a new type of acting, less mannered than in the prewar films. What makes these texts different from their precursors is not only their overt sociological orientation, their striving for topicality, but the ways in which their quest for realism only exacerbates tensions in the texts, revealing a disjunction between the ostensible sociological concerns of the films and the

contradictory meanings generated. What is memorable about the films is not their dissection of a particular social problem so much as their exposure, mainly unconscious, of their failure to resolve the problems they pose. Their failures, however, provide access to more fundamental issues concerning the ways in which these films are mired in ideological positions that do not admit of reconciliation along the lines of the classic narrative. There are no happy endings even where the films posit rehabilitation, and the ways in which they seek to suppress contradictions only call attention to their unresolvable conflicts. These films differ from their precursors especially in their choice of marginal, most often young, protagonists—working-class youths, potential or actual delinquents, condemned criminals, women who cannot assimilate into domestic roles, and institutional misfits. While the narratives seek to assimilate these figures into the community, the films reveal the disjunction between the desires of the protagonists and community values. The marginalized and troubled characters in these films correspond to Michel Foucault's designation of socially vulnerable groups—women, children, and homosexuals—in the development and deployment of new discourses of sexuality.

The Hollywood social problem film of the 1940s and 1950s also provided models for the development of the British social problem film. Such films as *The Search* (1948), *Knock on Any Door* (1949), *The Blackboard Jungle* (1955), *Rebel Without a Cause* (1955), *East of Eden* (1955), *I'll Cry Tomorrow* (1955), and *The Defiant Ones* (1958) addressed postwar dislocation, youthful disaffections, juvenile delinquency, alcoholism, and racism, issues that are identified with British social problem films. The Hollywood actors associated with such films—Marlon Brando, James Dean, Montgomery Clift, Sidney Poitier, Susan Hayward—represented a new iconography and a new type of naturalistic acting. The directors of these films, especially Elia Kazan, Nicholas Ray, and Stanley Kramer, were associated with films that aggressively challenged old Hollywood formulas.

The British cinema also introduced new faces and new types of acting. Richard Attenborough, Dirk Bogarde, Jimmy Hanley, Diana Dors, Jean Kent, and Joan Collins became synonymous with working-class, marginal figures and psychologically disaffected characters. Gainsborough and Ealing Studios became the home for many of these films, featuring such directors as Basil Dearden, Charles Frend, J. Lee Thompson, Jack Lee, and Muriel Box. Such films as *The Lost People* (1949), *The Blue Lamp* (1950), *I Believe in You* (1952), *The Weak and the Wicked* (1954), *Sapphire* (1959), and *Victim* (1961) are exemplary of the eclectic British social problem film, which, like the Hollywood films, mingles melodrama, film noir, social topicality, and a concern with rehabilitation. If the Hollywood films place greater emphasis on melodrama and psychic

malaise, the British films are more preoccupied with social rehabilitation. However, though the films purport to examine the social landscape, the position of characters in various institutional structures, economic and class issues are submerged as the films concentrate on questions of adjustment. In their treatment of social issues, these social problem films display a tendency, direct in some instances, covert in others, to adopt a psychological treatment of the characters, linking their marginality and aggressive behavior to unresolved oedipal conflicts and to repressed sexuality. As in the family melodramas, the narratives see the causes of conflict in family relationships, in disturbed relations to authority figures, and in conflicts over identity.

To describe the social problem film as a genre is to acknowledge that, like other genres, it has its own formulas and conventions. Though these films may treat contemporary social issues more directly than blatantly stylized melodramas, they have developed a style that makes them identifiable as a genre in their association with certain narrative structures, themes, actors, directors, studios, and a particular institutional mise-en-scène. They reveal the attempt to preserve aspects of the genre film while at the same time making concessions to the need to alter its conventions to suit contemporary audiences at a time when cinema audiences were rapidly dwindling.

Films of Peacetime Readjustment

The tenuousness of the popular wartime ideology of consensus in the immediate postwar era was evident in the social problem films that dramatize the consequences of the growing cold war and its effects on individuals. Like the cold war espionage films (see Chapter 4), these films depict growing international tensions and their effect on individuals caught in the midst of contending ideologies. *The Lost People* (1949), directed by Bernard Knowles with additional scenes directed by Muriel Box, involves a group of displaced persons in a Dispersal Center at the end of the war. However, unlike the espionage films that capitalize on intrigue, this film presents a less polarized and more analytic portrayal of conflicts and characters. The officer in charge of the camp, Ridley, is played by Dennis Price. It is a benign role, disconsonant with Price's repertoire of roués, rakes, cowards, and jaded sophisticates. The other characters in the film who represent "the whole of Europe under one roof" include Marie (Siobhan McKenna), a radical Resistance fighter, an Irish widow who had married a Frenchman from the International Brigade and who is determined to enact revenge on collaborationists; a young displaced Eastern European woman, Lili (Mai Zetterling); Jan (Richard Attenborough), a displaced Western European who falls in love with Lili; a professor who carries a weapon to protect himself against the Russians, whom he calls imperialists; and a priest whose hands have been broken by the Nazis.

The characters are presented as physically and psychically maimed. Having spent the war stealing in order to keep herself alive, Lili does not trust anyone and would rather steal than be given things. Marie's anger against the Germans and against German collaborators has made her into the type of person she has fought against—a Fascist. The professor in his fear is presented as having lost his trust in people. The priest whose hands have been rendered useless by the Nazis has retreated into silence. For a moment people forget their individual misery when they learn that one of the Russians has the plague. The group coalesces in the face of the threat, but when it passes, conflict once again breaks out. The climax of the film involves Lili and Jan, who have been married with the cooperation of Ridley and others in the community. Mistaken for Marie, Lili is stabbed by one of Marie's political opponents. She is laid out before the group and Ridley addresses the people: "Lili died because your prejudice and fears are greater than your common sense. When you were frightened of the same things, you worked like friends and neighbors. There was peace on earth. That was only an hour ago and you have forgotten the lesson. When you fight, it's the little people that get hurt." His speech ends with a plea that was to be characteristic of the 1950s: "Will it be peace or war, madness or sanity?"

The film's director, Knowles, had directed Gainsborough comedies and melodramas, and Muriel Box began her work at Gainsborough by assuming responsibility for reshooting scenes in feature films requiring changes. Later she became scenario editor responsible for finding new film scripts. Some of her films were comedies, but others were clearly within the mold of the developing social problem film. Of her work at Gainsborough, she said, "We were not under contract to Rank to make films with overt statements on social problems or those with strong propaganda themes. . . . We were not engaged to indulge our own political or socialist views, however much we should have found satisfaction in doing so."[11] Yet *The Lost People* is an overtly didactic film. It seeks to create a sense of collectivity through the recognition of the need to overcome growing political differences. The rising cold war hysteria is addressed in the film's linking of partisans and collaborationists, socialists and Fascists, Eastern and Western Europeans, Russians and other Eastern Europeans, in a common effort to mitigate the effects of the war. Ridley articulates the need of individuals to overcome ideological differences in the face of crisis. As is characteristic of the social problem film's fusion of melodrama and didacticism, Lily's sacrifice is necessary to restore order and subdue the rebellious elements. A female is responsible for the upheaval; the victim is also a female, while the peacemaker is the British male lawgiver. *The Lost People* addresses a number of issues common in the social problem film: personal failure, the failure of conventional romantic relationships, and the ubiquitous threat of social conflict raised to

the level of an international crisis. Its attempt to create a sense of common purpose is overwhelmed by the massiveness of the conflicts that it poses.

While the international setting is a familiar context for exploring postwar conflicts, a sense of the loss of wartime solidarity and purpose is also conveyed through the portrayal of conflicts experienced by servicemen in peacetime. In *Morning Departure* (1950), directed by Roy Baker and starring John Mills, the memory of the war is invoked as a positive contrast to present civilian life. A disaster aboard a submarine becomes the vehicle for escaping the banality of civilian existence. The film begins with a scene of low-key marital conflict. The baby is crying, and neither husband (John Mills) nor wife (Helen Cherry) rises to tend it. When the couple get up, they disagree about his work. The wife wants her husband to resign from the navy and his work on submarines to take a business position with her father; she urges him to settle down and abandon the dangers and unpredictability of life in the service. In a parallel scene, a young stoker aboard the submarine, Snipe (Richard Attenborough), is portrayed as having unsatisfactory marital relations. In Snipe's case, his wife is interested in other men and dissatisfied with the money that he provides her.

Aboard the submarine, the men escape their domestic conflicts into an all-male world. The submarine is damaged by a wartime mine, and the remainder of the film portrays the attempts to rescue the men. Not all are rescued; since there is inadequate equipment, the men must draw lots. Snipe becomes hysterical when he loses, and the captain asks one of the men to step aside for him. When the time comes for the men to go, Snipe claims he has hurt his arm and is unable to go, thus marking the first stage of his conversion. The men remaining wait to be rescued, but the weather turns against them. As they await their end, they reminisce about their pasts. Through his bonding with the first officer, Manson (Nigel Patrick), who also suffers from a lack of "self-confidence," Snipe acquires a sense of self-respect, dignity, and concern for others. He comes to be respected as a man by the captain and his mates. In the final scene, the captain holds a service for the remaining men, telling Snipe that death is not an ending but a beginning. As the ship goes down, the captain can be heard reading from the Bible. Raymond Durgnat describes the film as a "stiff upper lip naval film."[12] Actually, the film does more than reproduce the clichés of military service. From the very outset it is clear that relations with women constitute a source of disruption and conflict for these men, and even in the submarine during the disasters, Snipes and Manson's fears are more interesting than the motif of sacrifice and service. The bond between the two men, which is generalized as a lack of confidence, dramatizes the issue of intimate and affective relations between men which can flourish only under conditions of crisis.

While the film seeks to reproduce the ethos of collectivity that is associated with conditions of the war and danger, it is more interested in exploring issues of male identity so prominent in the male melodrama. The men who die are least suited to survive in the postwar society. The captain's domestic life does not seem a viable alternative to his life on the sub. Snipe's domestic life is as problematic as his masculinity; Manson has no capacity for personal relations beyond his work; and Higgins (James Hayter), who has appeared most scornful of Snipe, learns about other kinds of male relationships. The film employs the motif of life and death on the submarine for more covert purposes of dramatizing the failure of peacetime domestic relations and of capturing the intensity of relationships under crisis conditions reminiscent of the war years. The men's discovery of each other in the face of death offers a more satisfactory alternative than conventional heterosexual and familial relations.

In 1953, Jack Hawkins appeared in *The Intruder*, directed by Guy Hamilton, a film that also addressed the assimilation of servicemen into civilian life. Unlike *Morning Departure*, however, *The Intruder* uses criminality as its melodramatic ploy to develop its concern with maladjustment and the need for rehabilitation, a common strategy of the social problem film. Playing a retired officer, Wolf Merton, Hawkins is again thrust into contact with men in his regiment when he confronts a former subordinate, Ginger (Michael Medwin), attempting to rob his house and asks him, "What turns a good soldier into a thief?" Ginger becomes the film's excuse to rehearse the wartime past and to instill meaning in the present. Merton's faith in Ginger, based on Merton's assessment of the former soldier's war record, leads him on an odyssey that ends in his successful attempt to rehabilitate the young man, who is from a working-class background and is portrayed as having had rotten luck in his attempts to readjust to civilian life. On his investigative journey, Merton learns more about the men's relationships to each other and their ambivalence toward his own leadership. In contrast to the cowardly, snobbish, and deceptive Leonard Pirry (Dennis Price), Ginger is a model of loyalty, courage, and competence. When Merton finally tracks Ginger down on a farm owned by one of his former men, he is able to convince him to "go straight."

This film portrays the debilitating effects of the social environment and takes a philanthropic and socially minded corrective attitude, particularly emphasizing the necessity of mutual support. The use of the flashback scenes and the images of the war become a way of making the war an ever-present reminder of the responsibility of leadership and of the men's mettle. Durgnat tersely describes the film as an attempt to "transpose military paternalism into civilian life."[13] But Durgnat's assessment does not address *how* the film attempts to modify "military paternalism" so as

to make it more consonant with contemporary sociological concerns for readjustment. As the pivotal figure, Merton occupies the role of psychiatrist and priest, offering the necessary therapeutic cure for adjustment—confession, trust in institutions, and especially respect for the law. The film is also an attempt to transplant male wartime relationships into civilian life, a life in which women are either perfidious or irrelevant. In its focus on youthful offenders, *The Intruder* reinforces the notion that the postwar cinema was increasingly a cinema addressed to the problems of the young, but in the context of melioration.

Youthful Rebellion: The Young Male

A fair number of British social problem films in the late 1940s and 1950s are especially preoccupied with criminality and crime detection, and in particular with young offenders, both male and female, as in such films as *Brighton Rock* (1947), *Good Time Girl* (1948), *The Boys in Brown* (1949), and *The Blue Lamp* (1950). The war years and the years immediately following the war saw a rise in crime, with looting, black marketing, and malfeasance in government, which may, in part, account for the increased concern in cinema with criminality and juvenile delinquency. The 1960s films, with their emphasis on youth and social deviance and rebellion, did not arise in a vacuum but had been preceded by a number of films that addressed the problems of youth and especially of working-class young people. The representation of youthful discontents is a significant indication of changes in British postwar society, revealing a range of social concerns involving issues of authority, community, family, class, and gender. As one critic has described it, "Youth was . . . a powerful but concealed *metaphor* for social change: the compressed image of a society which had crucially changed in terms of basic life-styles and values . . . changed in ways calculated to upset the official political framework, but ways *not yet calculable in traditional political terms*." [14]

The Boulting brothers' *Brighton Rock* (1947), based on the Graham Greene novel, features a young and rebellious protagonist who constitutes a threat to the community. The film is introduced by images of Brighton and a printed prologue: "Brighton today is a large, friendly seaside town in Sussex, exactly one hour's journey from London. But in the years between the two wars, behind the Regency and crowded beaches, there was another Brighton of alleyways and festering slums. From the hill, the poison of crime and violence and gang warfare began to spread until the challenge was taken up by the police. This is the story of that other Brighton—now happily no more." The primary disrupter of this community is Pinkie Brown, played by Richard Attenborough. A small-time crook, he attempts to compete with older and more experienced criminals. His undoing occurs as a consequence of his cold-blooded kill-

ing of a newspaperman. He attempts to destroy all evidence of his connection to the man, which involves him in a relationship with a young waitress, Rose (Carol Marsh), whom he intimidates and later marries in order to silence her. His downfall comes, however, from the determined efforts of Ida (Hermione Baddeley), a performer, who was the last person to be seen with the murdered man. She is determined to expose Pinkie and to save Rose.

The film, while ostensibly concerned with crime detection and with the salvation of a community, is more a study of the pathology of Pinkie, and, in this respect, reveals an affinity with film noir not uncommon in the social problem films. His relationship to other men is competitive. His constant concern, by his own admission and according to the comments of others, is that he is not "big enough." His contempt for his cohorts, Dallow (William Hartnell), Cubitt (Nigel Stock), and Spicer (Wylie Watson), is expressed in his cruelty toward them. Pinkie is portrayed as a key figure in a paranoid world where men prey on each other. Like many gangsters, he is portrayed as nervous and capricious. He plays nervously with a string, is obsessively preoccupied with his size, is extremely sensitive to noise, and is a misogynist. His relationship to Rose is fused with his relationship to his past and to Catholicism. His belief in hell and damnation matches her belief in the power of the sacraments. His hatred and fear of sexuality is encapsulated in his recorded message to Rose on their wedding day: "You want me to say I love you, but I hate you, you little slut. Why don't you go back to Nelson Place and leave me be." He has much in common with Prewitt, the shyster lawyer (Harcourt Williams) who is obsessed with having married beneath him and who describes himself as weighed down by sin.

Pinkie's actions do not seem to spring from a desire for wealth, power, or sexual gratification. Rather, he is made to appear a figure of cruelty and negativity, a lethal killer who is filled with contempt for weakness and vulnerability, particularly for anything that seems to be associated with dependency and frailty. His aggressiveness and brutality are thus linked to more fundamental psychic conflicts, most particularly to troubled sexuality. Significantly, it is not the police who are primarily responsible for trapping Pinkie, but a woman. In this moribund world of hunter and hunted where men prey on one another, the Hermione Baddeley character who obstinately tracks down the young criminal exposes the real "crime" of the narrative, namely, Pinkie's hatred of women, which she, not Rose, detects and is determined to expose.

As in other social problem films, the male's aggressiveness and brutality are inextricably linked to women. They represent what he seeks unsuccessfully to repress in himself and what finally destroys him. One critic described the ending of the film as "a lamentable copout."[15] Rose finally

listens to the recorded testimonial of Pinkie's feelings for her, which he
has withheld, but the needle gets stuck on the phrase "I love you" and she
never hears the remainder of the misogynistic message. But the ending
confirms that the film's concern is finally less with the social aspects of
crime, with legal crime and punishment, than with the underlying psy-
chology of male and female marginality. Rebellious, youthful behavior
has to be "explained" in psychological terms, contained through thera-
peutic strategies, and, when therapy fails, corrected. The excessiveness of
the affect embodied in Pinkie and Rose's relationship raises questions not
about the motives for the crime but about the film's motives for linking
sexuality and criminality.

The Boulting brothers' film *The Guinea Pig* (1948) also features young
people, but in the context of the school rather than of law enforcement.
The British public school, an arena for the training of the upper classes as
rulers and administrators, has been represented in the British cinema as
the site of contention for a number of political and social concerns involv-
ing issues of social class, generational conflict, discipline, and power.
While before World War I there were attempts to address inequities in
education for young people, which culminated in the Fisher Education
Act of 1918, according to John Stevenson there was no major legislation
until the Butler Education Act of 1944,[16] which was the catalyst for an
examination of public and private education in the postwar years. "For
those who saw the role of education as lying in the field of democratic
social engineering—promoting a 'classless society'—it was inevitable that
1944 should only be a starting point for a debate that was to reverberate
during the post-war years."[17] In the final analysis, the benefits of change
went largely to the middle classes and to only a minority of bright work-
ing-class young people.

The protagonist of *The Guinea Pig*, Jack Read (Richard Attenbor-
ough), is a bright young "scholarship boy" from the lower middle class
who is enrolled in a public school for upper-class youths. From the mo-
ment he enters, he defies the school rituals and customs. His unrefined
eating manners, his lack of decorum in conversation, and particularly his
resistance to serving the upperclassmen mark him in the eyes of his peers
and especially of Mr. Hartley, the older housemaster (Cecil Trouncer), as
unfit for this environment. Hartley's motto is "Tradition is knowledge
based on experience," and he is adamant about the need to conform to
the rituals, customs, and practices of the school. Fortunately, Jack is be-
friended by the younger housemaster, Mr. Lorraine (Robert Flemyng),
and Hartley's wife. Lorraine, supportive of the notion of educating the
lower classes, seeks to initiate Read into the culture of a public school.
The conflict in the film thus centers around the different views of educa-
tion as represented by Hartley and Lorraine.

With Lorraine's assistance, Read overcomes his resistance and learns to adopt the manners of his peers. In the process of Jack's conversion, his parents play a major role. At Commemoration Day, to which Mr. and Mrs Read are invited, Hartley and Mr. Read (Bernard Miles) discover that they share similar values concerning discipline, work, and communal spirit. The film does not fundamentally challenge the values of the British public school. Rather, it seeks to rationalize them and make them more broadly applicable. Despite class differences, Read's family shares the values that the headmaster is trying to inculcate—deference to authority, self-discipline, perseverance, good manners, and service. Moreover, Hartley and Lorraine's views are mediated so that Lorraine's succession is seen as proper rather than competitive with an older man. Each sees the need to temper his absolutism. Jack wins the scholarship to Cambridge. Lorraine, moreover, convinces the school authorities that scholarships rather than a war memorial would best serve the needs of the school and of society.

Jack is the most transformed of all the characters. He has assimilated the proper attitudes and ways of speaking that mark him as a proper public school graduate. The film's point of view is reformist, and Jack, the guinea pig, is exemplary of the possibilities for bourgeoisification of the working class. Though he changes, the social values represented by the school remain intact. At the center of the film and representative of the school as a national institution is a traditional emphasis on sexual restraint, respect for the past, sportsmanship, male camaraderie, patriarchy, continuity, and family unity. Jack's unreconstructed behavior prior to his conversion is presented as a disruptive force, and his family and headmasters work to transform him. While the film mediates, in conventional fashion along the lines of 1950s consensus, between the upper and lower classes, modifying the snobbery of the public school on the one hand, and the undisciplined individualism of the working-class boy on the other, the film is most revealing in its exposure of its recuperative strategies. As in so many of the films involving young people, the family and the educational institution functioning as a surrogate family become the instruments for taming and redirecting behavior disruptive to traditional values. However, the film's "resolution," its alignment of dissident forces, its meliorative strategies, serve in the final analysis only to dramatize that Jack's rebellion must be overwhelmed, rather than explored, in the interests of continuity.

The disruptive character of youth and particularly of lower-class young people is also addressed in the context of the reform school, another familiar institutional setting in the postwar film. *The Boys in Brown* (1949) takes place in a correction center and stars Jimmy Hanley, Richard Attenborough, Dirk Bogarde, and Jack Warner, actors increas-

ingly identified with social problem films addressing juvenile delin-
quency, law enforcement, and education. As is characteristic of prison
dramas, narrative interest in *The Boys in Brown* is distributed among
several characters. The film begins with the robbery of a jewelry store.
Jackie Knowles (Richard Attenborough), the driver of the getaway car, is
finally apprehended at his home as he tries to escape the police. At the
Borstal, Jackie meets Alfie Rawlins (Dirk Bogarde) and Bill Foster (Jimmy
Hanley). Alfie, an experienced inmate, tells Jackie that life can be easier
"if you have a pal." Alfie, as can be anticipated, represents resistance to
reformation projects. The third character, Bill Foster, is potentially re-
deemable. In spite of Alfie's description of the world outside the Borstal
as unforgiving, he is determined to conform. The governor (Jack Warner)
tells the boys, "Our job is to teach you boys to behave yourselves and
become decent citizens. If you behave, we'll help you all we can."

The film stresses the importance of family life as a determining factor
in separating the incorrigible boys from those who are socially salvagea-
ble. The governor goes to visit Bill Foster's real mother in an effort to get
her to acknowledge her son and thus save him from the bad influence of
his foster family, but she refuses. The motherless young man is unable to
find himself when released from the Borstal. He falls hopelessly in love
with Kitty, who loves Jackie. He loses his job, and is once again returned
to the Borstal, where Alfie enlists a group of the boys in plans for an
escape. Jackie is reluctant to participate, but Alfie manipulates him into
agreeing to cooperate by suggesting that Kitty has been unfaithful with
Bill. In drawing lots for the getaway, Jackie draws the winning straw and
is designated to steal a prison officer's clothes. In the process, Jackie in-
jures the man. Coerced into escaping, he is caught, along with others; the
boys are now threatened with the possible charge of murder.

Though the officer recovers, the governor is determined that the group
must be punished. When Kitty and Jackie's mother come to visit the
prison to see Jackie, they are denied permission. The mother angrily de-
nounces the disciplinary practices of the Borstal, claiming that they have
made her son worse. The governor relents and allows Jackie to see Kitty.
Repentant, Jackie reconciles with her and his mother and determines to
lead a reformed life. The final words of the film are the governor's, as he
ponders, not which of the boys are wheat and which chaff, but, "The
thing is to find out which is the chaff and why." As in many of the social
problem films of the era, this film is structured by generational opposi-
tions and corresponding oppositions in value systems that are mediated
by a benevolent male authority figure. The governor is presented as a
champion of reform, not as a blind disciplinarian. As with the social
worker in *Good Time Girl* and the headmaster in *The Guinea Pig*, he
represents social enlightenment, an awareness of current psychological

and social theories concerning deviance, and ascribes criminality to a poor familial environment.

The possibility that the boys' rebellion is more profoundly psychosexual enters the film only briefly and through the figure of Alfie. The rebellion against becoming decent citizens is presented as pathological, if not unnatural. Naturalness is associated with a proper deference to authority and with familial legitimacy, as exemplified by Jackie. Alfie, who is associated neither with family nor with affectional ties, is excluded from such consideration. The family cooperates with the law and, in turn, the law cooperates with the family. That Jackie has no father seems appropriate, since the space of the missing father is filled by the governor. Jackie is also paired with a female, Kitty, constituting another argument for his normality and salvageability, in contrast to Alfie, who is a loner. Bill Foster is "adopted" and converted. Thus the delinquency is attributed to a "bad environment," and bad environment is conflated with inadequate family life, and especially with the failure, as in the case of Bill Foster's mother, to acknowledge kinship and hence responsibility.

The maternal figure is the hinge on which all turns. If, as with Bill Foster's mother, she is unwilling to cooperate with the law, she is responsible for the young man's failure to respect authority. On the one hand, the film wants to make a special case for the recognition of youthful rebellion and the need for humane treatment, but on the other, it finds itself imprisoned in reductive images of amelioration. Issues of class and gender are so buried in the film's overidentification with familial figures that the boys' conflicts are trivialized, if not lost.

The casting of the three main figures sets up a disjunction in the viewer's perception of the characters. The actors are clearly older than the characters they play, but the narrative asks the viewer to accept them as boys. Hanley sports a middle-aged spread; Bogarde and Attenborough also look older than Borstal boys. This lapse in "realism," however, serves to call attention to the film's difficulty in confronting the issue of youth. The age of the actors, consonant with the film's ending, reveals that, though the pretext of the film may be juvenile delinquency, the film is not concerned with the issue of their youth per se so much as with its disruptiveness and its containment. The use of older actors thus serves the interests of the social problem. In this respect, the film betrays that realism often takes a back seat to ideology.

One film that orchestrates issues of youth, delinquency, family, and social class is Gainsborough's *A Boy, a Girl and a Bike* (1949), directed by Ralph Smart. The predominant characters in this film are working class, with the exception of David Howarth (John McCallum), who becomes involved with a young working-class woman, Susie Bates (Honor Blackman). Scripted by Ted Willis, who also wrote *Good Time Girl* and

is associated with many social problem films, *A Boy, a Girl and a Bike* follows the personal conflicts of a number of characters. Susie, who is expected to marry Sam Walters (Patrick Holt), complicates her life by succumbing to the ardent attentions of David. Ada (Diana Dors), always on the lookout for male companionship, focuses her attention on Frankie Martin (John Blythe), who is more interested in his male peers and in stealing bicycles for his father, which the father and son refurbish and sell. Nan (Thora Hird), who is widowed, resists the attentions of Steve (Leslie Dwyer). Nan's son, Charlie (Anthony Newley), filches money from his mother, money belonging to a cycling club which is in her safe-keeping. Concerned about him, Nan confesses to Steve that he has been acting this way ever since they left London, but she seems unable to control him.

With the exception of David, these characters are united by their membership in the cycling club, which sponsors races and outings. The key image of the film, the bicycle, is contrasted with the car associated with David and the upper classes. At first, David is antagonistic toward bikes, but the way he and Susie meet is through his denting her bike with his car. For a while, he will abandon his car for the bike, but he will later abandon the bike as he abandons her. The obstacle in the way of Susie's marriage to Sam is finding housing. Her home is overcrowded, housing her mother and father, grandmother, sister, and herself, leaving little room for lovers' privacy and generating constant quarreling. In contrast, David's home is spacious and his family snobbish. In spite of his parents' disapproval, David is determined to court Susie.

At a race of the cycling club, Charlie is coerced by Mr. Martin into stealing a bike in order to repay money that he owes him for gambling. The race itself is portrayed as a collective enterprise, and Charlie's stealing of the bike is a violation of the community spirit of the club. Mr. Martin takes the bike, repaints it, and sells it to David. Ada discovers the theft when she comes to ask Frankie to a dance and threatens him with exposure if he does not meet her. At an outing of the cycling club, where Nan and Steve assume the roles of parental guides of the group, relationships disintegrate. Sam learns that Charlie stole the bike. Frankie, after trying to destroy the bike, hides from everyone. Susie and Sam have a quarrel over David, who has proposed marriage to Susie. After learning of Charlie's theft, Steve proposes to Nan, claiming that he can then keep an eye on her and Charlie.

The climax of the film comes during the bicycle race. Bert, one of the men who has tried to stay out of the limelight, is apprehended by the police as an army deserter. He has been on the run for three years and is relieved that his ordeal is over. David takes his place in the race and, after the race, tells Susie, "Guess I'm just not the marrying sort." He gives Susie

and Sam a place on his estate to live, and the film ends with the couple examining the cottage and making plans for its refurbishment. Disagreements are reconciled, and the cycling club is strengthened through the resolution of long-standing conflicts. The concept of family is reaffirmed in the impending marriages of Nan and Steve, Susie and Sam. Charlie, who has gone astray, is not only chastened but has acquired a father and will receive the firm hand that his mother has been unable to provide. The potential family conflict arising from the mixing of upper and lower classes is resolved by David's abrupt decision not to marry Susie. In addition to its concern with family conflicts, the film addresses other social problems such as profiteering and poor housing conditions. The profiteering is exposed by Sam and Steve and squelched. The familial conflicts at the Bates house are resolved by Sam and Susie's acquisition of housing (with David's help). Young people are guaranteed a more stable context, and disruptive elements in the community are excluded.

Cycling is a signifier for the working-class community in the film, testing the mettle and morality of the men and serving as a means of eliminating discordant elements. As an outsider, David's attempt to acquire a bike and gain entry to the community is dramatized as artificial: the bike he purchases is stolen merchandise and, therefore, not authentically his any more than he belongs authentically to the community. When the bike is destroyed, he again becomes an outsider. As a metaphor for community, the bike also becomes the vehicle for undermining collectivity, as exemplified through the bicycle thieves, Mr. Martin and his son, who seek to profit from their stolen bikes, caring nothing for community esprit. The film adheres to a rigid notion of community. Susie does not get her rich man and abandon her social class. Though the film flirts with such an alliance, it ultimately frustrates hopes for a Cinderella ending and aligns itself with the working class characters. There are lines assigned to Susie that redeem the film from sentimentality and condescension. For example, Susie attacks David for his ignorance and condescension about working women, querying, "Don't you think mill girls know how to dress?" The conflicts in the Bates house over program preferences and space convey an interest in the everyday lives of the characters and their struggles. But the film harbors a tension between realism and melodrama. The realism opens up a space to see the characters as struggling over issues of economy, family, and gender, but the melodrama insists on the maintenance of the family as the cohesive force that binds this community, curing the disruptiveness generated by generational, sexual, and class differences.

The melodramatic nature of the social problem films, with their emphasis on emotional excess, on oedipal conflict, and on moral dilemmas, is also evident in the social problem films of J. Lee Thompson, films that

focus on discontented, if not criminal, women and children. In *The Yellow Balloon* (1952), the protagonist is a young child trapped between a mother who has upwardly mobile aspirations for her son, a father who is ineffectual in countering her strong will, and a criminal who exploits the boy for his own ends. The film begins with the child, Frankie (Andrew Ray), framed by a window, looking out at the activities on the street but forbidden by his mother (Kathleen Ryan) to leave and join the other children. When his father (Kenneth More) comes home, he gives the child money for a balloon. On the street the boy loses the money and steals a balloon from a neighborhood boy. As the boys chase each other in the ruins, Frankie sees the other child fall from the scaffolding. As he runs away, he is stopped by Len (William Sylvester), who plants the notion in Frankie's mind that Frankie has killed the other child. Insidiously, Len, an American, tells Frankie that they are alike, that the police suspect him, too, of something he has not done. He takes the boy home and enjoins him to deny everything. The film alternates between the boy's terror at home as he tries to conceal his actions from his parents and his ambivalence toward Len, who drives the boy to steal his mother's savings.

The focal point of the film is children and the ambivalent, if not exploitative, attitudes of adults toward them. One attitude is summed up by the father's comment, "Kids is improper little savages, even the best of them. Nothing bothers them much at least until they get their own kids to look after." The mother, who has insisted on stringent discipline and has sought to undermine the father's authority, asks, "How could he do this? Stealing from his own . . ." In the Sunday school scene in which the children are treated to the story of Cain and Abel, Frankie suffers pangs of guilt and is driven to run out of the room, only to be caught by his father and beaten as the mother looks on. After a robbery, in which Frankie is used by Len as a decoy, Frankie runs away and meets a woman, Mary (Hy Hazell), on the street, who takes him in, telling him, "If my little boy had told me anything, no matter what, if he told me about it truthfully, I would have gotten him out of it somehow." She gently guides the boy home, but his parents are gone and he is dragged away by Len. In a dramatic chase scene in the underground, Len falls to his death and Frankie is reunited with his remorseful parents.

The film is preoccupied with the creation of social misfits. The emphasis on youth, as in so many of the social problem films, serves to dramatize the various social forces and alternatives that are hypothesized as determinants of juvenile delinquency. Frankie is not presented as a bland victim. He, too, is capable of aggression and competitiveness, as witnessed in his taunting of the child from whom he steals the balloon and in his attempts to subvert familial discipline. His susceptibility to Len's threats and blandishments are thus not merely a matter of childhood in-

nocence but an extension of his struggle with parental controls. The family represents not merely an agent of discipline but a site of domestic struggle between husband and wife. The different attitudes and values of the male and female portrayed through the wife's repressiveness and insistence on respectability and upward mobility, her control of her husband, and the husband's inability to resist her pressures are also identified as important aspects of repressive family life.

Len, on the other hand, is a totally marginal figure. He manipulates women and children with no moral compunction. Guilt, a primary instrument of socialization, as represented by the Sunday school episode, is for Len merely an instrument to exploit the child's vulnerability. The police as seen through the child's eyes are further agents of exposure and discipline. The characters in the film are dichotomized between the repressive agents of the family linked to the law and religion, and the equally threatening and repressive forces of criminality. If it were not for the existence of Mary, the film would remain suspended between these two unattractive alternatives. Mary introduces a new dimension beyond that of her acting as a benign intermediary. A woman alone, more clearly sexual than Frankie's mother, she is associated with dancing. She tells Frankie that she teaches dancing and that the neighbors always complain of her music. In every way—appearance, physical movements, and speech—she is the antithesis of Frankie's mother.

By making a young boy rather than a girl the protagonist, by presenting the male characters as either completely subordinated or completely rebellious, the film appears to be ascribing criminality to female repressiveness. In particular, Frankie's mother, obsessed as she is with respectability, seems to be the dominant agent of repression within the claustrophobic environment of the home, ruling her husband and son with an iron hand. She listens to classical music and recoils from roughhousing between father and son. Ultimately, the boy's delinquency becomes a response to her behavior and a guilt-producing device to restrain her, but the end of the film reconciles the boy to his chastened family, restoring it along with law and order.

The reconciliation of the family and the elimination of Len's disruptive presence does not eradicate the underlying problems that the film has surfaced. Frankie's recovery does not mitigate the identification of the family as a site of conflict and contradiction. The clash of values between husband and wife, their lack of reciprocity, and the absence of desire in their relationship is unchanged. Through Mary, the film presents an alternative to the repressive portrait of the nuclear family. Her sexuality stands in opposition to the violence that is at the core of Len's actions and also of the boy's, and heightens the critique of family life. The Sunday school scene can thus be construed, consonant with the film itself, as an

ineffectual effort to paper over problems of male identity and sexuality
which the film cannot conceal. The film's ending only reinforces the dis-
parity between the problems posed and the solutions adopted, function-
ing as closure rather than as resolution.

Troubled and Rebellious Young Females

The portrayal of young women as signifiers of destructive social tenden-
cies and the need to contain their disruptiveness can be seen particularly
in the films of the late 1940s and the 1950s that focus on female law-
breakers, setting up an opposition between law enforcement officials
working for the restoration of familial values and young women in quest
of pleasure. Pleasure is stigmatized by being associated with acts of crimi-
nality. *Good Time Girl* (1948), directed by David Macdonald for Gains-
borough, capitalizes on a connection between women's sexuality and
lawbreaking. The film begins in juvenile court, where Lyla, a potential
delinquent (played by Diana Dors in a role with which she was to be
associated in both the cinema and public life) is being lectured to by a
social worker (Flora Robson). Through flashback, Lyla is told the story
of Gwen Rawlings (Jean Kent), a young woman who also wants to escape
a brutal familial situation and poverty. Gwen becomes involved with
criminals who exploit her. She is framed by one of the men and sent to a
school for delinquent girls in spite of the efforts of Red (Dennis Price), a
pianist who had befriended her. She learns from one of the inmates,
Roberta (Jill Balcon), to play the game. Escaping from the school, she
returns to the criminal milieu, where she begins to drink heavily and is
eventually responsible for killing a man while intoxicated. Her final esca-
pade is with two American army deserters who hijack a car and kill the
driver, who, it turns out, is Gwen's friend, Red. The film ends with Lyla
promising Miss Thorpe, the social worker, that she will go home.

 The film has many of the features of the social problem films of the
era—the presence of a social worker, the focus on juvenile problems, the
attribution of cultural problems to the family and to uncaring institutions
such as the girls' school, the linking of poverty and social deviance, and
the emphasis on the need for intervention on the part of caring represen-
tatives of society such as Miss Thorpe. The fascination with lower-class
life and with criminality seems integral to these films, though there is a
concerted attempt to situate the conflicts in a moral context. In recording
negative reaction to these films, Robert Murphy asserts that one critic
"claimed to have vomited at the sight of *Good Time Girl*."[18] Many critics
wanted to see films that dealt with ordinary people and with "normality."
The social problem film, however, not only was there to stay but would
undergo various permutations.

 In *Good Time Girl* one can see several tendencies at work. The film
seems to belong with other postwar films that stress the restoration of

female integrity and decry deviant behavior. Gwen is a victim of her family, of economic dependence, of male exploitation, and of an indifferent society; but, as with the social worker's treatment in the film, her oppression counts for less than her criminality. Her real crime, as John Hill suggests, the one for which she is actually punished and for which Lyla is subjected to this admonitory narrative, is her sexuality. She is punished for being attractive, articulate, and independent. The basis of the film's appeal, which was not lost on the hostile critics, was its prurient nature. Since films such as *Good Time Girl* are involved with exposing social problems, since the social issues are usually related to marginal behavior, and since marginality is often associated with sexuality, upholders of morality are quick to identify and excoriate, but not explore, the sexual elements. The social problem film thrives on the image of the offender in relation to the law, and an opposition is set up between fruitless discipline, as represented by the governor of the girls' school, and the more clinical, psychological intervention of the social worker, Miss Thorpe. While the film identifies Gwen's struggles as economic, this is belied by the film's preoccupation with the disruptive and violent nature of sexuality set in motion by the female quest for pleasure.

J. Lee Thompson's *The Weak and the Wicked* (1954) is also concerned with criminality, this time through the portrayal of women in prison. Based on Joan Henry's novel *Those Who Lie in Gaol*, a record of her own experiences, the film opens with the sentencing of Jean Raymond (Glynis Johns); she is reprimanded by a judge who takes a dim view of her criminality, since she has had "a good home and education." In prison, she becomes friendly with Betty Brown (Diana Dors). The cause of her incarceration is shown in flashback. Addicted to gambling to the point where she alienates her fiancé, Michael (John Gregson), Jean falls deeply into debt and is finally framed by the owner of a casino when she refuses to give him her ring in partial payment of the debt. Her first experience of prison life is in Blackdown, where she and the other women are subjected to harsh disciplinary measures. The women are locked in their cells, are restricted in their communication with each other, and perform activities in military fashion. The film contrasts Jean and Betty with the other inmates, who are murderers, bigamists, and hardened offenders.

Jean's relationship to Michael is presented in ambiguous fashion as she first tries to hold on to him and later relinquishes him. He feels a sense of guilt and responsibility toward her, but when the opportunity arises, he leaves to do medical work in Rhodesia. Betty, on the other hand, who admits that she is in prison for not being "smart" when it comes to Norman, the man she loves, insists that he loves her and continues to wait for him to appear, in spite of evidence that she has been rejected. If Jean's relationship to Michael is presented as one of ambivalence on each side, Betty's is totally one-sided. The film focuses on several other inmates

whom Jean meets in the prison hospital—Pat (Rachel Roberts), who is
pregnant and must look forward to relinquishing her baby four months
after it is born; an older woman who insists on her prerogatives as a
"British subject from Salisbury," and Babs (Jane Hylton), in prison for
criminal neglect of her child. In a flashback, Babs is shown going dancing
with an American and leaving her two children alone in a locked room.
One of the children dies, leading to her arrest.

The scenes of prison routine are intercut with scenes depicting the
women's relationships with each other. While Jean's and Babs's histories
are developed through flashback, Betty's is not. Her relationship with
Jean is further cemented when they are transferred to a modern experi-
mental prison, the Grange, where there are no locked doors. The film uses
documentary footage to demonstrate the progressive nature of the prison.
With an accompanying voice-over, images are presented of women walk-
ing freely, going to church, and especially working at various creative
occupations. The narrator emphasizes the therapeutic nature of work.
Moreover, Jean is told that the women are allowed a day in the commu-
nity as a preparatory stage to their release. She takes Betty with her, but
Betty disappears to hitchhike to London to see Norman. As Jean is being
reprimanded for being the first inmate to violate the trust placed in her, a
repentant Betty appears and vindicates the honor system. Upon Jean's
release from prison, she finds Michael waiting for her outside the prison.

This film, in line with many dramas of women in prison, traces the
women's deviance directly or indirectly to their relationships with men.
Michael and Jean's alienation is portrayed as the outcome of her addic-
tion to gambling rather than a result of their incompatibility. She resists
the respectable alternatives that he offers. Gambling is posed directly as
an alternative to her finishing her studies and her celebrating his having
won his medical degree. Her losses at the gambling table take on a
broader meaning. By refusing respectability, she is marked as a loser in
life, and the film, which does not explore her obsession, moves rather to
dramatize the stages in her conversion to respectability. Betty is also ad-
dicted, but to men. Babs's addiction to pleasure results in the death of her
child. The film also singles out female offenders who are not linked to
men and who are not monogamous. The prison chaplain at Blackdown
warns Jean not to wait too long before marrying, and she reassures him
that she knows that "to live for someone else is the finest thing in the
world."

The film is preoccupied with the ways in which these women have
strayed from respectability and the idea that they must be punished for
their deviant behavior. While it can be seen as making a plea for more
humane treatment of the social offender, it deals more fundamentally,
and perhaps unconsciously, with the question of resistance to the status

quo. In focusing on women, it addresses the constraints of a society that refuses to acknowledge the desires of young people and women. Not only does the film link the women's offenses to rebellion against a "good home," but it also explores women's relationships with each other. The men portrayed or alluded to in the film—Michael, the chaplain, Babs's American fling, and Norman—are presented as insensitive, excessively moral, or exploitative. The women, especially in Jean's relationship with Betty and, to a lesser degree, with Babs, demonstrate the potential for a different form of understanding and caring.

The farewell scene between Jean and Betty is one of those crucial moments characteristic of the social problem film, disrupting its complacency and the reductive solutions that it offers. Coming as its does immediately before the surprising reunion of Michael and Jean as they ride off to their life of respectability, it seems to undermine the conventional ending. There is an extended tearful separation in which Jean sits on Betty's bed and promises, "We'll keep in touch, won't we? Wherever I am or wherever you are." After she leaves Betty, Jean stops to see the governor, who tells her that a surprise awaits her, and Jean finds Michael waiting for her outside. His totally unmotivated return, coming after the tender scene between Betty and Jean, seems gratuitous. His reentry into the film blatantly calls attention to itself as an interruption, a purposeful form of self-censorship, but also as a commentary on the interdiction of female relationships and sexuality outside the heterosexual marital sphere.

As might be expected, one reviewer found the least effective aspect of the film to be the women's portrayal, complaining that "against these backgrounds are paraded a prize collection of familiar feminine character types (alternately comic, sad, and hysterical)—two dimensional, observed without real insight or real compassion. The introduction of raucous comedy into several of the flashbacks, which involve shoplifting and the planning of murder, also seems in dubious taste in such a context. . . . The facile ending, reuniting Jean and Michael, provides a final glib compromise with reality."[19] The reviewer's judgments seem based on a preference for the realist elements in the film over the melodrama, which invites a more complex reading of the tensions between the real and the melodramatic. Though the film can be read straightforwardly as a plea for more humane treatment of women offenders in its portrayal of the contrast between the two penal institutions, its effectiveness lies in the presentation of the women themselves. In the context of the social problem film and its preoccupation with social adjustment, the melodrama offers itself as the only language available to address the unnamed conflicts confronted by women's desire.

In a similar vein, J. Lee Thompson's *Yield to the Night* (1956) takes as its pretext the issue of capital punishment. Focusing on the last moments

of Mary Hilton's (Diana Dors) life before she is executed for murder, through flashbacks the film constructs the history that has brought her to this confrontation with death. More than *The Weak and the Wicked*, this film traces the woman's possible motives in committing the crime. The film begins with the murder itself, Mary's murder of another woman, her rival for the affections of Jim Lancaster (Michael Craig). The scene is shot from Mary's position so that the spectator is invited to assume her place. The landscape is fragmented, shot through various obstructions, especially bars. Throughout the film, the editing highlights the fragmented body and the disjointed images that constitute Mary's perceptions of her environment. The spectator becomes conscious of legs, arms, doors, the overhead lamp, and the bed. The guards' table, separated from the prisoner's part of the cell, reinforces the sense of her isolation. At stake is the familiar destruction of the female body by the authorities (and by the camera).

The female body assumes other connotations in the images of the murder victim and the prisoner, in the care that Mary at first gives herself and then later in her increasing dishevelment. She develops a foot ailment that makes locomotion difficult, and the numerous images of feet in the film call further attention to her fragmentation. The narrative's movement toward Mary's execution is disrupted by flashbacks, juxtaposing past and present. From the perspective of the camera, the woman's body becomes a site of conflicting images with which to read the nature of her motivation and responses to her impending death. From the perspective of the prison guards and the physician, her body is the symptom of her deviance. On the pretext of the exceptional circumstance of awaiting death, the film is able to explore the numerous and contradictory fragments of a woman's life which are normally presented as unified.

Diana Dors' star image is suited to the Mary Hilton character. Dors' identity as a sex symbol both on and off the screen generated a different sense of British women, one that challenged the traditional images of women as ice maidens and icons of service. In the character of Mary Hilton, Dors sheds her glamorous aura but not her image as a flouter of social propriety, associated with both her on-screen persona and her personal life. As Christine Geraghty writes, "The sullenness and obstinacy which are as much a part of her roles as the humorous resignation she also displayed signify characters who want more from life than their apportioned lot and resent others who have escaped boredom and poverty."[20] Her acting and appearance as much as the narrative itself call attention to the problematic nature of women's sexuality, and the price that women pay in their quest for pleasure.

Through the flashback sequences, a collage is constructed of a working-class woman, unhappily married, dissatisfied with the the banality of

her life and work. Her meeting with Jim, an intellectual, opens up a world to her that is dominated by music and books. Jim, however, is portrayed as cynical. His plans to become a composer have faded. His relationship with her is characterized by evasiveness. When she talks of leaving her husband, he insists that she cannot stay with him, and he says of marriage that it is like a "coal mine, dark and dirty." The turning point in their relationship occurs when Lucy Carpenter, a wealthy woman with whom he had had a relationship, comes back into his life. Learning of the conflicts between Jim and Lucy, Mary asks, "What kind of love is this when you are not happy?" She begs him to forget Lucy, and when he comes to her distraught over being stood up by Lucy and wanting to commit suicide, she tries to dissuade him. Ultimately, however, he locks himself in his room and turns on the gas. His death prompts her to kill Lucy with the gun that he left in her apartment.

In prison, the authorities seek to reconcile her to death. The chaplain exhorts her to accept her fate, telling her that it will be easier for her to "yield to the night" than fight for her life. A prison reformer, Miss Bligh (Athene Seyler), like the chaplain, urges her to accept punishment, and acts as a liaison between Mary and her family. In short, all the forces within the prison and in society attempt to subdue her rebelliousness, forcing her to see her family, to accept her punishment, and to embrace her own death. The intercutting of her past life and her last moments in prison conflate past and present, making it possible to view her punishment as preceding the actual crime. Her fate can be read as the inevitable punishment of the female who seeks to escape the prison of her life, and the words of the prison authorities extend beyond the immediate concern to reconcile her to her impending death: they become a judgment on women's search for alternatives to marriage and family life.

It is significant that her story is told in voice-over for the external audience rather than to one of the guards, as if to underscore her isolation from her environment. In the final analysis, the onus for her crime is distributed among several figures in the film—the woman she murders, Jim, her husband, the jailors. Her blind attachment to Jim is symptomatic of her desire to escape her class and domestic prison. If the agents of law enforcement and her family are any indication of the lack of meaning in her life, her obsession with Jim offers an alternative. In his introduction of the world of music and poetry to her, he is also initiating her into middle-class melodrama. The film portrays the essentially one-sided nature of her relationship to him, but also her heightened emotional involvement in his own suffering. Her overidentification with him leads her to commit the act of murder, but, paradoxically, the murder and her punishment are finally the means of her escape. Thus, capital punishment takes on a new meaning. It is not only the legalistic act of a society that

demands punishment for murder but also an indictment of a society that conspires with the law to reinforce conformity. In relation to the representation of the female, the film can be read as a broader allegory of society's retaliation against female desire through all of its institutional channels.)

The social problem film abounds in dramas of young women, but less often undertakes the portrayal of girls. Alexander Mackendrick's *Mandy* (1952) focuses on the struggles of a young girl and her family with the problem of deafness. Initially, the mother, Christine Garland (Phyllis Calvert) expresses concern over Mandy's (Mandy Miller) inability to speak, but the father, Harry Garland, denies that a problem exists. When he finally acknowledges that the child's hearing is impaired, he plays an obstructive role, refusing to send the child to a school for the hearing-impaired. He insists on keeping Mandy with the family at his parents' home even when it becomes obvious that the child is becoming increasingly isolated and aggressive in her frustration. Like most social problem films, *Mandy* purports to take a concentrated look at a specific problem, namely, the care and socialization of children like Mandy and the adjustment of the parents to Mandy's difference; however, like most of the 1950s social problem films, the film is actually more complicated. The complication is shown in the representation of the husband and wife's relationship. The crux of their marital conflict can be understood with the assistance of recent feminist theory, which focuses on the issue of women's access to language. Though the film ostensibly presents the child as the one in need of acquiring language, it is the wife who must gain access to it in order to free the child. Bereft of language, neither Christine nor Mandy can enter into any meaningful relationships with others. The problem of access to language is thus displaced from the parents onto the child. The film dramatizes the couple's escalating verbal aggression toward one another, which finally leads Christine to seek help for Mandy by defying Harry's commands.

The film makes connections between language, gender, and sexuality in indirect fashion through Mandy's teacher, Searle (Jack Hawkins). Searle is a figure of contention for some members of the school board, a target for slander by one of them, Ackland (Edward Chapman), and a source of jealousy on the part of Christine's husband. Ackland attempts to implicate Christine and Searle in an affair, and almost succeeds when his paid informants report that Searle has been seen going to Christine's residence. His visits are part of a strategy to teach Mandy after hours in order to hurry along the child's progress before the husband can accomplish his threat of removing her from the school. However, though the relationship between Christine and Searle does not develop into a romantic liaison, they are seen by the landlady embracing after Mandy has spo-

ken her first word ("mama"). The two also go dancing to celebrate the occasion. The film treats the relationship between these two ambivalently. With the exception of two scenes, the encounters between Christine and Searle suggest a growing attraction between the two which the narrative disavows but the images of the two together do not. This ambivalence is functional: it serves to heighten the contrast between the two men in relation to Christine. In contrasting the men, the film sets up two different male positions: one that, through Harry, serves as a critique of his old-fashioned notions of family and male authority, and another that, through Searle, serves to establish a liberal, more acceptable and accepting, image of a paternal figure. In this way the film seeks to recuperate the integrity of male authority and the family. Ironically, Harry, a family man, is the prime obstacle to changes in the family in his refusal to cooperate with Christine in freeing Mandy from her silence, whereas Searle, who is divorced, provides the means for both the woman and the girl to speak and hence empower themselves. Harry's excessive rage and recalcitrance can be seen as a displacement from his relationship with Christine (and hence with women) onto the child. His relationship with his wife is presented from the outset as one in which they do not interact in any significant fashion. His unwillingness to hear her, his attempts to silence her and Mandy, can be construed as his way of managing his familial role. By centering on the issue of hearing and speaking, the film exposes the strategy whereby women are rendered powerless. Thus, the relatively straightforward problem of the child's deafness takes on more complex meaning in relation to the family and the community. The gossip surrounding a possible liaison between Christine and Searle, which threatens to undermine Christine's attempts to have the child taught, suggests that the conflicts of the adults can be traced to another form of control, namely, sexual repression.

In her article "Mandy: Daughter of Transition," Pam Cook explores how the film seeks to negotiate a number of social changes, "marking a shift from a pre-war period of austerity, presided over by a Labour government dedicated to welfare capitalism, to the consumer boom of the 1950s managed by a new tough breed of conservatives. The shift can also be characterised in terms of changing national values, community spirit giving way to individualism and an increasing emphasis on the private domain of home and family."[21] Ealing's postwar films express both a concern for and a malaise over change, seeking to mediate conflicts between tradition and innovation, and *Mandy* is a symptomatic text to gauge Ealing's social contradictions; particularly in the film's representations of women. In its portrayal of family and especially of mother-daughter relations, the film explores, on the one hand, the struggle of women to find a voice. On the other hand, it exposes how changes affect-

ing women must be contained under the aegis of the traditional nuclear family, of existing social institutions, and of a male authority figure. Thus, the film can be read as uneasily balancing the wartime emphasis on providing women more of a voice in the public and domestic spheres with the postwar concern for the preservation of the nuclear family; like many other postwar Ealing films, *Mandy* exposes the incompatibility of these two positions.

Films of Work and Leisure

The tendency to address social problems was not limited to Ealing and Gainsborough. John Grierson's Group Three Productions, funded by the National Finance Corporation through the Eady Levy and derived from exhibition monies redirected to production, was also to produce social problem films. Philip Leacock's *The Brave Don't Cry* (1952) focuses on the lives of Scottish miners, taking the inevitable mining disaster as its point of departure. Shot on location, like Leacock's other films (for example, *The Kidnappers* [1953], filmed in Nova Scotia), the film dramatizes the effects of a cave-in on the small mining community. The disaster itself, which traps the men, occupies a small portion of the film in comparison with the exploration of the rescue efforts. Four groups interact in the rescue operations—the men below who struggle with each other as they make decisions about how to protect themselves and get help; the women, who see to it that the needs of the men and of the community are answered; the men above the mine, who through their communication by telephone with the trapped miners translate their situation to others; and the rescue workers, who interact with the miners as the men are led to safety.

In contrast to Tennyson's *The Proud Valley*, this film avoids the usual emphasis on romance, on the unitary, if not sacrificial, hero, and on the economic aspects of work in the mines. Consonant with its realist emphasis, the film seems to want to play with many of the elements associated with the documentary film. Relying on location shooting, actors and non-actors, and a minimal narrative, the film gives the impression of wanting to reproduce the feel of immediate and actual events. The relations of the men below touch an such issues as leadership, generational differences, attitudes toward work, and attitudes toward the confrontation of crisis. The film is geared toward resolving differences. The tension in the narrative derives from the mounting danger of the men's exposure to the dangerous gas and the drama of their eventual release. But the primary emphasis in the film is shown by the constant intercutting among the groups in the community working together for their salvation. The film is dedicated "to the rescue brigades who stand behind the miners all over the world."

The Brave Don't Cry shares with the other social problem films of the era a concern for community and collectivity, but, unlike the others, it minimizes the discontents of the individuals, attributing discord to the exceptional circumstances in which the men find themselves. As in many of the Grierson-style documentaries, the narrative's focus on work, collective struggle, and interclass cooperation covers up a number of more fundamental issues relating to the personal and work lives of the men and their relationships with the women who sustain them. The film seems to imply that crisis challenges but ultimately stabilizes a community. The focus on the mining disaster diverts attention from other conflicts in the miners' lives, which pale in comparison to the immediate threats. The film highlights the miners' conflicts with each other as they struggle to survive, the relationships of the miners to their wives, and the attitude of the men toward the "professionals" who are responsible for their salvation, rather than focusing on the conditions that have produced the disaster. In the final analysis, the film is a celebration of professionalism, exemplified by the rescue workers who bring the men to safety.

Dance Hall (1950), Ealing's contribution to the portrayal of working-class life, leisure, and generational conflict, was directed by Charles Crichton and scripted by E.V.H. Emmett, Diana Morgan, and Alexander Mackendrick. The focus is not just one but four different women. The film begins with images of the women at work in the factory reminiscent of such wartime films as *The Gentle Sex*. Also, as in *Holiday Camp*, the film fuses narrative with elements of the popular leisure culture. The personal conflicts centering in the home and in the dance hall are punctuated by scenes at work. The dance hall is the place where the women meet and struggle with the men in their lives. Carol's (Diana Dors) relationship to men is seductive, but she finds herself with unsuitable men and threatens that she is "through with men." Ultimately she settles unromantically for Mike as she continues to complain that she is off men for good.

Eve's (Natasha Perry) relationship to men is more complicated. She loves to dance, but Phil (Donald Houston), the man who claims to love her, does not share her enthusiasm for dancing and is offended when she dances with other men. The source of conflict in their relationship is Alec (Bonar Colleano), who, unlike Phil, has no interest in marriage but enjoys dancing. Eve marries Phil after she sees Alec with another woman, even though Mary (Jane Hylton) would have been be a more compatible partner for him. After their marriage, Phil is away from home frequently on business, and Eve becomes bored. She arrives at the dance hall in time to see her sister Georgie (Petula Clark) enter a dance competition. When she returns home, she and Phil have a row but then reconcile. Georgie, who now has her chance to perform, receives a new dress for the occasion from her parents. At the dance hall, the manager gives her a more stylish

dress to wear, and, wrongly thinking that her parents will not see her, she accepts the outfit. She loses the contest and is crestfallen over having deceived her parents about the dress and over her loss, but she is compensated for her pain and humiliation by Pete's (Douglas Barr) affection. But Eve and Phil's relationship continues to deteriorate. They again quarrel, more violently this time, over some kippers that Alec has given Eve. Phil wants a divorce, and, remorseful over his past treatment of Eve, Alec proposes marriage to her. The men fight while Eve is locked out on the fire escape in the rain. When she is finally let in, she enters the dance hall and reconciles with Phil. Of the three women, Mary is the only one without a man as she walks past the dancers. In spite of the New Year's celebration at the end, the film seems to end on a somber note.

Dance Hall stresses the incompatibility of men and women. With the exception of Georgie, all the women are discontented with their lives. They settle for the wrong man or do not get the "right man" or even the man they want, as in Mary's case. Mike is aggressive toward Carol. Phil's relationship to Eve is argumentative and restrictive; he is jealous, possessive, and dully domesticated. Alec elicits more emotion from him than Eve does. In contrast, Alec is presented as a womanizer who claims to be afraid of developing serious relationships with women. The dance hall is not a site of pleasure for most of the characters, but rather heightens the sense of the characters' inability to gratify their desires. John Hill comments on Ealing's resistance to popular culture, how it comes to be associated with a fear of sensuality.[22] In the context of the women's fantasies about their lives, the dance hall comes to represent their settling for far less than they want from life and heterosexual relationships.

Basil Dearden and the Social Problem Film

Basil Dearden's work as director constitutes a sustained body of films that are exemplary of the social problem film in the postwar era. At Ealing, Dearden worked on a wide range of topics—postwar reconstruction, generational conflict, juvenile delinquency, racial tension, and homosexuality—but his work is characterized by a consistent vision deriving in part from Ealing's emphasis on social issues and community. His work owes much to the Grierson documentary movement in its emphasis on film as an educational medium for addressing social change, but his own concerns are evident in his treatment of the various problems posed by his films. As John Hill states, "at the heart of the social problem in Dearden's films lies an excess of sex and violence, which constantly belies the programme of rational control and containment."[23] The central tension resides in the disjunction between the movement to ameliorate the problems posed and the sexual conflicts, which cannot be contained by conventional institutional means.

Ealing's *Frieda* (1947) is exemplary of these tensions in Dearden's work, tensions that threaten to undermine the well-meaning efforts of the film toward the amelioration of the problems posed. Starring Mai Zetterling, a Swedish actress who was to appear in several British postwar films, the film ostensibly poses the delicate problem of the assimilation of foreigners into British society, but addresses the even more difficult problem of postwar attitudes toward Germans. Beginning in Poland in 1945, the film portrays the marriage of a British soldier, Robert (David Farrar), to a German woman who has saved his life. He tells her about his home and family in England, his "ordinary town, like any town in England" where the people are good-natured and accepting. A flashback depicts the marriage of his brother to Judy (Glynis Johns), a sketch of his ambitious sister, Nell (Flora Robson), who will "end up in the war cabinet," his mother, and the dependable housekeeper, Edith (Gladys Henson). Reverting to the present, the film shows Frieda and Robert's arrival home.

The return is radically different from Robert's description of home. The family and the community are remote and stiff with Frieda. When Robert returns to teaching, his classes are unruly. Several of the students are absent owing to their parents' disapproval of his relationship with a German, and he resigns from his job. Publicly, Nell goes on record as disapproving of Frieda and all Germans: "War is not a football match. You don't shake hands and wish the enemy good luck. Maybe in some earlier wars, but not in this one." After seeing a newsreel from Gaumont News entitled "Horror in Our Time," showing German atrocities at Bergen-Belsen, Robert asks Frieda if she knew about the atrocities, and she is silent. His interrogation of her past and his reluctance to proceed with their remarriage in a church create ambiguity about their relationship. Their relationship is further complicated by the arrival of her brother, Ricky (Albert Lieven), who is a Nazi and bitter about defeat. Frieda's Germany, she says, is not Nazi but rather the Germany of Heine, Goethe, Schiller, Beethoven, and Brahms. The brother's Nazi identity is exposed when a serviceman recognizes Ricky from the prison camp as his torturer. Robert captures Ricky as he tries to escape, conceding that Nell was right about Frieda and all Germans. Disconsolate, reeling from Robert's rejection and Nell's contempt, Frieda tries to drown herself, but Nell's scream alerts Robert, who saves her. Nell finally concedes that you cannot treat humans as less than human without becoming dehumanized.

The familiar Ealing formula of the trials and transformations of the community is complicated by making Frieda a German. While addressing the issue of the treatment of a former enemy, the film has to tread the delicate path of developing distinctions between good and bad Germans. In order to assimilate Frieda, she has to be made subject to a number of often cruel trials to determine her worthiness. The community is made to

appear as intolerant as the Nazis, but Frieda is actually the one on trial. She is humiliated by everyone—the villagers, Nell, her brother, and especially Robert. Charles Barr notes, for example, that Robert's treatment of Frieda is "unconsciously sadistic. Indeed he is not very far from the common type of forties protagonist represented by Cary Grant in *Suspicion*, Anton Walbrook in *Gaslight*, and Charles Boyer in the remake of that film: the charmer who may or may not be 'killing' his own wife."[24] Robert's callous attitude toward Frieda raises more fundamental questions about the film's project. The war, nazism, and tolerance toward Germans turn out to be a pretext for the community's difficulty in assimilating difference, a difficulty that is never overtly addressed. The hysteria generated by Frieda's entrance into the community appears excessive and, therefore, raises the question of what is being displaced. Robert's treatment of Frieda provides a more personal clue, hinting at his own unexamined resistance to family, community, and marriage. The film shows the unraveling of wartime discourses of unity and the resurfacing of profound sexual and political differences.

The film bypasses the issue of wartime culpability, focusing rather on the threat of its violence and sexuality in the family. Commenting on the film's resolution, Terry Lovell finds that "paradoxically, the film achieves its bland humanist resolution which removes the taint of both sexuality and evil from the British character and the bourgeois family, by fudging the issue of Frieda's political responsibility. The terms of the resolution require only that Frieda be good in herself—almost irrespective it seems of what she may have done, known, or condoned."[25]

Frieda is exemplary of Ealing's concern to address postwar reconstruction and particularly attitudes toward former belligerents. According to Barr, "On the surface, the film is a fairly straightforward social problem drama."[26] However, a closer examination of the film reveals that *Frieda* addresses a more fundamental question than the assimilation of Germans or putting the war into perspective. The unanswered question in the film concerns Robert's position in the family, if not the very nature of the family itself. The ending is indeed reminiscent of the horror film. Frieda is the Other who threatens the stability of the family and, by extension, the community. Her presence unleashes the cruelty of others, especially Robert. The "normal" family and community become monstrous, thus giving the lie to Robert's earlier idealization of "home." While nazism appears to be the external threat to the sense of community, the real enemy is Robert, whose actions are the source of conflict. The film not only explodes the notion of an integrated community, it also locates the source of discontent in the protagonist's inability to confront his actions and his desires. The challenge of Dearden's film lies in its exposure of underlying sexual and class conflict, which is in no way mitigated by the film's resolution.[27]

THE SOCIAL PROBLEM FILM

Whereas the films of the war years could assume a common goal—a desire for unity—the films of the postwar era, even when they strive to resolve their conflicts, seem preoccupied with an awareness of loss, failure, and sexual incompatibility. The women in the films are either absent, disruptive, or negligible. When present, they are singled out for creating havoc by opposing their individual wills to the good of the family and the community. Sue Aspinall comments that these films "prove that even self-sufficient women cannot manage without men."[28] In the postwar concern with the declining birthrate, the presumed conflict between motherhood and career, and the reintegration and stability of the family, many of the films exhibit a tendency to return to traditional conceptions of women's social obligations. But in the exploration of women's unsettling influence on the community, the films also reveal the impossibility of solutions to the problems that they set out to explore. In their dramatizations of the disruptive nature of women's autonomy, the positioning of women serves to divert attention from more profound social unrest resulting not only from the fear of women's sexuality but from that of male sexuality as well.

One of the most popular social problem films of the 1950s, which spawned imitations and was also to find its way into television, was Ealing's *The Blue Lamp* (1950), scripted by T.E.B. Clarke, who was also responsible for the scripts of many of the studio's comedies. Clarke, who was a member of the "team," was as important to the identity of Ealing as many of the directors associated with the films. *The Blue Lamp* presents an image of community, but one that is, in Barr's term, a "daydream," but a daydream that is cinematically effective. The social problem disrupting communal stability is juvenile delinquency. Collectivity is dramatized through the relationships of the police with each other, with their families, and with the broader community. The voice-over that speaks of the domestic effects of the war is reinforced by images of London that evoke a memory of destruction and suffering, and the relationships in the film gain cogency from the context of the immediate past. It is still possible in 1948 to draw on the wartime experience of national unity, but with a difference. The wartime preoccupation with the interdependence of the public and private spheres gives way to a concentration on the private sphere.

The film hinges on generational difference and its potential disruptiveness. The relationship between the older and experienced P.C. Dixon (Jack Warner) and the young rookie, P.C. Mitchell (Jimmy Hanley), is a model of paternal and filial relations, recapitulated in Mitchell's treatment of the young rookie at the end of the film. The young criminal, Tom Riley (Dirk Bogarde), represents the threat to continuity. His crime against Dixon is not merely cop-killing, but, more fundamentally, patricide. As Barr says, "What Mitchell has been absorbed into is a family.

First, a literal one: he finds lodgings with Dixon and his wife, and comes to fill the place of their son of the same age who was killed during the war. Second, a professional family: the close community of the police station in Paddington, characterised by convivial institutions—canteen, darts team, choir—and by bantering but loyal relationships within a hierarchy. Third, the nation as a family, which may have its tensions and rows but whose members share common standards and loyalties."[29] Thus, it can be seen that while the film's preoccupation is still with issues of social solidarity, its primary vehicle to express these concerns is the metaphor of family. However, unlike in the family melodramas, the equations between family and society work, as in other social problem films, in a reverse direction. If the family melodramas absorb social conflicts into the family, *The Blue Lamp* assimilates the family into other social institutions.

Jack Warner and Jimmy Hanley were icons of British working-class fathers and sons. On the other hand, Dirk Bogarde, who was to attain stardom after this film, introduced a male image that was to become increasingly popular and particularly associated with his own film persona for over two decades: the neurotic and sexually threatening young male. "Where *The Blue Lamp* is strikingly unusual," writes Andy Medhurst, "is that the transgressive sexuality is male, and that the intensity is Bogarde's."[30] Through the Dixon household, the family is portrayed as desexualized and without conflict. Comradeship rather than sexuality is at the basis of the Dixons' relationship with one another. In contrast, Tom Riley's relationship with Diana Lewis (Peggy Evans), the young woman who, like Gwen in *Good Time Girl*, has abandoned her family, is fraught with sexual aggression. Diana is an intermediary figure who belongs neither to the conventional family nor to the rebellious world of the young criminals. In the context of paternal-filial relations, the issue of female sexuality is one of reaction rather than action, either contained within the family or threatened when seen outside the domestic sphere.

One reviewer responding positively to the film attributes its success to its "attempt to create what one might call the human background; to weave with fictional characters the texture of London life."[31] In particular, the film successfully amalgamates "the real and the reconstructed," which has its roots in the "documentary proper." The reviewer's emphasis on the film's realism, its fidelity to "the feeling of London life," is based on the notion of realism as "document," a photographic reproduction of the social world. Inherent in this notion is the idea that there is an untroubled consensus about the nature of reality and that this "truth" is accessible empirically. What is masked in this view is that "things are seldom what they seem," that the "real" is socially and, in Michel Foucault's terms, discursively constructed in the interests of power. An exam-

ination of the uses of language reveals that constructions of the real are historically specific and, hence, sensitive to change, while appearing to be natural and immutable. What is not said, who does not speak, and who is spoken for are indices to the partial and ideological nature of representations of the real.

The social problem film promises to address the "real" problems of society, often using a sociological, at times ethnographic, mode for documenting the conflicts it poses. Its invocation of clinical, legal, and juridical languages lends an aura of authenticity to its presentation, but it is in its use of these discourses that one can locate its implication in power. The films speak on behalf of young people, workers, women, the elderly, and other marginalized groups as they conflict with society, but the major preoccupation is the assimilation of these groups into the social fabric of the family and the state. The social problem film's treatment of landscape, character, institutions, and situations reveals that its fidelity to "real life" lies not in its attempts at mimesis but in its inadvertent exposure of "tensions in the text," those moments when familiar and natural representations are revealed as self-interested and as socially constructed. These moments are characterized by the slippage from institutional representations to more specific sexual, gender, and class conflicts which collide in an unreconcilable manner with official positions. In the intersection between the world of social institutions and the socially disruptive behavior of individuals and groups, the films expose their contradictions and the inadequacies of any resolution, given the nature of the social world portrayed and its institutional representatives. While *The Blue Lamp* presents its dilemma in the guise of a collection social problem—juvenile rebelliousness attributed to the disruptions of the war—the film's strategies reveal that assimilation into existing structures takes precedence over a concern for young people. Through the figures of the young criminals, especially in the excessive behavior of Diana and Riley, another text emerges that cannot be assimilated into a tame narrative of social amelioration. The issues of sexuality and violence expressed in the young people's behavior cannot be reduced to legal and familial categories. They mask deeper symptoms relating to another discourse—one of repressed and repressive sexuality, shared by both the mainstream and marginalized characters—which are antithetical to existing conceptions of the family and the law. It is this knowledge that the film both recognizes and seeks to mitigate.

Many of Dearden's films graft aspects of film noir onto the social problem film. In their claustrophobic mise-en-scène and ambiguous treatment of character, these films explore an unstable world; however, as in Dearden's *Cage of Gold* (1950), they encyclopedically address issues of marriage, family life, community, and the law in ways most characteristic

of the social problem film's everyday concerns. Their eclecticism creates a tension that makes it possible to read the texts as more than straightforward social analysis. *Cage of Gold* stars Jean Simmons as Judith, an artist, whose life is complicated by her misguided rejection of a physician, Alan (James Donald). Alan's life is dedicated to service, as was his father's before him: service to workers, to women, and to family continuity. Not greedy for money, Alan ultimately prefers the National Health Service to private medical practice. Judith, however, falls in love with an ex–Navy man, Bill (David Farrar), whom she had known during the war. The antithesis of Alan, Bill is addicted to pleasure, resistant to monogamy, willing to go to any length to get money, and unscrupulous in his treatment women. After Judith marries him and becomes pregnant, she learns that he married her thinking she was wealthy. When he discovers that she does not have money, he leaves her and returns to his former haunts in Paris, where there are other women willing to indulge his appetites in ways that Judith cannot and later will not. Bill's conquests include the chanteuse of a nightclub, the Cage d'Or, Madeleine (Madeleine Lebeau), and the daughter of a banker, both of whom he exploits for money.

When Judith learns that she is pregnant with Bill's child, she goes to Alan for help, and when she reads a newspaper report announcing Bill's death, she and Alan marry. Their marriage is portrayed as placid and conventional, centering around family responsibilities and having none of the unsettling romantic elements associated with Bill's courtship. Again their relationship is disrupted by Bill's return. Having merely sold his passport to a gentleman who was killed in a plane crash, Bill has returned to England to blackmail Judith after seeing a newspaper story featuring her as a model mother, doctor's wife, and talented painter. He creates dissension by making Alan believe that Judith still loves him. Frightened about being exposed, Judith steals her father-in-law's gun and determines to kill Bill, but loses her nerve. Later, however, Bill is found dead. Alan is arrested when the police find him at the scene of the crime, and, thinking that Judith is the murderer, assumes responsibility for Bill's death. Judith, in turn, confesses to being Bill's killer, but the police exonerate them both when they get a confession from Madeleine, who, on her return trip to Paris, commits suicide.

The narrative is structured around oppositions between England and France, the Kern house and the Cage of Gold nightclub, Judith and Madeleine, Bill and Alan, innocence and guilt. These oppositions set up a contrast between the conventional domestic and communal values upheld by the film and the threatening world of deviancy stigmatized by the narrative as criminality. Associated with dancing, entertainment, flowers, and drink, and also with glamorous images of military service (enshrined in a painting that Judith does of him in his wartime naval uniform), Bill

is the incarnation of female desire and also, as the narrative would have it, the nemesis of women. The image of Madeleine at the center of a golden cage is an image of a woman trapped by desire. In contrast, Judith finally accepts the sedateness of family life. Lovable as the father-in-law may appear to be, he is an obtrusive presence, aware of his daughter-in-law's movements, giving orders to her from his sickbed, and critical of commerce and modernity. He is especially critical of the popular culture as he scornfully disparages the "comics and crooners" that he hears blaring on the radio. While the patriarchal figure is a commanding presence in the house and hence in the affairs of his son and daughter-in-law, he is also an invalid, and his invalidism serves to call into question the patriarchal values that the film seems overtly to endorse, exposing their fragility.

In many ways, the film is reminiscent of *The Blue Lamp*. "What she [Judith] settles down to, then," says Barr, "is life in a large, enveloping dark house, with her baby son, her old Nanny (Gladys Henson, a solid Ealing presence—Mrs. Dixon in *The Blue Lamp*) and her worthy husband. Also, at the top of the house, there is her aged father-in-law, bedridden, demanding but lovable, a constant reminder of the right values."[32] Family responsibility takes precedence over personal desire. Bill is the alien presence, reminding Judith of youth and desire. His attractiveness to women is inextricable from his exploitation of them. Unlike Alan, he is sexually potent, and, therefore, lethal. He is banished only to return, and the film must take steps to eliminate him. Judith's and Alan's attraction to him implicates them in criminality from which they must be exonerated. Judith's initial error of letting herself be seduced by Bill is expiated through her domestication, her functioning as a nurse to her father-in-law, a mother to her child, and a chastened wife. As John Hill says, "Just as Alan's life is one of doctoring, so Judith's lot (in a sort of expiation for her sins) becomes the nursing of her invalid father-in-law."[33]

Alan is chastened for his prurience. His interest in Judith is inextricable from his curiosity about the state of her feelings for Bill, and at the climax of the film, instead of being supportive of her, he accuses her of dallying with Bill, an accusation he later regrets. The couple's reunion at the end of the film restores them both to a relationship now based on a recognition of their complicity and on an acceptance of reduced desire. Sexual desire, which has been represented as a disruptive element, has, through the elimination of Bill, been circumscribed, but the image of Alan and Judith in the house at the end of the film suggests that the house is the real cage. In its portrayal of Bill, a former naval man identified with the romantic aspects of wartime existence, the film seeks to dissociate itself from the sexually promiscuous ethos of the war films and align itself with more traditional social values, but Alan and Judith's relationship as represented in the final moments of the film does not offer a comforting

image of conventional conjugal relations. In this manner, the film subverts the very values that it has sought to endorse.

In 1951 Ealing released *Pool of London*, directed by Basil Dearden. This film also focuses on working-class characters but introduces the race issue, a rare concern in British cinema of the era. As George Perry states, the film involves three different elements: "First, the life of the river, its workings presented in the revelatory style of the documentary; second, a dramatic plot involving a jewel robbery and murder, courage and betrayal, with insights into the routines of customs men and river police; third, social responsibility with an attempt to grapple with the problems of a coloured man and a white girl, probably for the first time in a British film."[34] The context of the film is established with a ship's arrival at the docks and its investigation by customs agents for contraband items. The illegal activities that the film explores are anticipated through the men's attempts to withhold items from the agents. The characters selected to follow through the London weekend are Dan, an American (Bonar Colleano), who is both the instigator of the illegal activities that develop and their victim, and Johnny, a Jamaican (Earl Cameron), who is Dan's friend and will unwittingly be enmeshed in Dan's intrigues.

Dan becomes involved with an acrobat who wants to smuggle jewels out of the country. The robbery, which is carefully planned, goes awry when the thief murders the watchman. Johnny gets the loot from one of the conspirators and goes to see Maisie (Moira Lister), a woman with whom he has been having a relationship. Her sister overhears the two talking of the jewel robbery and exposes Dan to the police. Later Maisie refuses to shelter him when he is on the run. Finding his friend Johnny, he gives him the jewels, which Maisie had inserted into a jar of cold cream, and he turns to another woman, Sally (Renee Asherson) for protection. Sally urges him to find Johnny, get the loot, and go to the police. A chase ensues in which he is able to evade the police until he finds Johnny. He takes the jewels from him and then gives himself up.

Johnny's narrative runs parallel to the robbery. As he is waiting for Dan, who is negotiating with the robbers at a theater, he is abused by a worker and told not to "hang around." Pat (Susan Shaw), the cashier, intervenes and she and Johnny eventually spend a chaste weekend together going to a dance. Later on, they take a sightseeing tour of London. Thinking that he must return to the ship, Johnny says goodbye to Pat, indicating that now he does not want to leave, but her responses to his overtures are tepid. When he returns to the ship, he learns that the departure has been delayed. Taking the jar from Dan, Johnny returns to the city. At a bar, his money is stolen, although no one bothers to investigate the jar. He returns to the ship in time for Dan to relieve him of the jewels and be arrested.

The world portrayed is one of loneliness, betrayal, and failure. The captain of the ship refuses to go ashore, preferring to drink heavily and read the *Oxford Book of English Poetry*. He comments on how the city looks like "a jewel from afar," though "up close you find squalor." The actions of the men are subject to constant surveillance from customs agents and police. Familial relations are presented in antagonistic terms through the two brothers who are part of the jewel robbery and through Maisie and her sister. Love relationships fare no better. Dan's relationship with Maisie is the source of his betrayal, and Sally's relationship to Dan is maternal. The most problematic relationship of all is Pat and Johnny's. While the text presents Pat as treating the black man more kindly than others do, it also depicts many awkward moments. The element of her withholding takes on connotations far beyond the simple assumption of her sexual disinterest, since the audience cannot help but attribute racial motives to her restraint in a narrative that sexually problematizes other relationships. In discussing the figure of Johnny, John Hill comments that "Johnny . . . represents the model 'coon'—polite, deferential and reflective, trusting to a point that he becomes unwittingly involved in crime. As such, Johnny represents no 'threat' and this is underlined by the film's treatment of sexuality."[35] Neutral interracial and heterosexual relationships become the model of decorum and restraint in the face of the sexually disruptive elements that the film invokes.

Commenting on the role of this film in the Ealing repertoire, Barr asserts that "if only one film could be preserved for posterity, to illustrate the essence of Ealing from the time before decadence set in, this would be a good choice, with its clear-cut embodiment of Ealing attitudes to women, violence, social responsibility, and cinematic form."[36] The film does not isolate a single social problem such as juvenile delinquency, nor even the issue of race, but rather portrays a social milieu, the physical environment of the city, seething with criminality, racism, and violence that cannot be resolved merely through the stringent application of law and order. In contrast to *The Blue Lamp*, which juxtaposes the benign and personalized image of the police against the alien forces of crime, *Pool of London* personalizes the criminals and depersonalizes the various law enforcement officers. The film also eschews the familiar therapeutic figures, the physician or social worker. In their place, the film offers a black man and a maternal female as instruments of melioration. They are an alternative to the restrictive practices of law enforcement. Through Sally's conversion of Dan, Johnny is saved. Moreover, neither Sally nor Johnny is a sexually threatening figure, in contrast to the other characters on the ship and in the city. Thus, the film's therapeutic antidote to criminality, violence, and sexuality is embodied in these characters who represent familiar virtues of sexual restraint linked to morality. That women

and blacks are placed in this position exposes a major feature of the social problem film: its concern to reconfigure social conflict in psychological and moral terms. The film places the burden of change on characters who occupy socially subordinate positions.

In a more familiar and didactic version of the social problem film, Ealing's *I Believe in You* (1952) focuses both on the guardians of social morality and on the marginal and unsettling figures. The protagonist of the film is Phipps (Cecil Parker), a retired official in the colonial office who on his return to England is dissatisfied with his life of leisure and wants to do something "worthwhile." In the course of initiation into his work as a probation officer, he comes across a variety of social ills—theft, alcoholism, prostitution, aging, mental instability. Matty tells Phipps that he does not like the people he must work with, and that he does not listen to them. She calls him pompous, advising him that he must take his clients on their own terms. His conversion is based on the recognition of his insulation from the people he is asked to help. His transformation is aided by the efforts of Matty (Celia Johnson), an experienced social worker, and an ailing veteran of the profession, Mr. Dove (George Relph).

One of Phipps's first experiences with a juvenile offender takes place in his apartment. Norma (Joan Collins) is being chased by the police and seeks shelter in Phipps's apartment in exchange for sexual favors. With the arrival of Matty, Norma's probation officer, Phipps is told not to be shocked: "A probation officer's life is full of disappointments." But Norma's presence in the film is consistently associated with sexuality, which the officers try to channel first into work and later into matrimony. At first she is involved with Jordie (Laurence Harvey), a young psychopath and one of the unregenerate characters in the film whose presence signals trouble for those who are trying to adjust to conventional social life. Norma's fate is later linked to that of Hooker (Harry Fowler), Phipps's charge. Hooker resents being placed in a hostel for a year while his accomplices in crime receive only three months in prison. The young man is also rejected by his family, and has little confidence in the ability of Phipps to help him. Phipps learns to pay attention to family relations and psychology as major determinants in the lives of young people. He identifies Hooker's rebellious behavior in the young man's response to his stepfather, whom Hooker resents for taking the place of his biological father, telling him that his resentment is "a natural psychological response."

Hooker and Norma meet in the corridor outside Matty and Phipps's offices, and their relationship blossoms. Each of them begins to think in more conventional terms about marriage and respectability, though their probation officers are concerned about their premature plans. Just as they are beginning to be more amenable to the idea of a new life, Jordie reen-

ters the picture. Norma goes dancing with him, and Hooker, jealous, begins to think again of a life of crime. The climax of the film involves Phipps in a chase in which he is accidentally beaten by the police and Jordie and Hooker are arrested. Intervening on behalf of Hooker, he goes to Pyke, the judge (Godfrey Tearle), to prevent the young man's going to prison. The judge at first refuses to be lenient, but in the courtroom, while he sentences Jordie to prison, he merely extends Hooker's probation by another six months.

What the film adds to the familial ideology of *The Blue Lamp* is its exploration of the various forms of psychosocial behavior that it catalogues in its presentation of the various characters. Among the problematic characters are an elderly woman, Miss Macklin (Katie Johnson), who complains that the neighbors are poisoning her cat. When Phipps visits her at home, he learns that her fabrication is most likely a product of her loneliness and need for attention. Through his experience with an elderly man who refuses to live with his son in spite of Phipps's urgings, Phipps learns (with Dove's help) to respect people's wishes. His contact with Mrs. Crockett (Ada Reeve) opens his eyes to the history of the people in the neighborhood. She comes with her photo album and shows him pictures of herself as a young model for a famous painter. Dove explains to him that Mrs. Crockett has no problems but simply wants someone to talk to. Other failures are represented by a young debutante who is an alcoholic, and a young man who is mentally deficient and must be put away.

In contrast to the needy characters, the social workers and the judge are figures of service and commitment. Dove is seriously ill and forced to retire, but he accepts his fate without complaint. Matty's history is alluded to briefly. She has a picture of a naval man in her office who died during the war. As reticent as she is to speak about herself, Phipps is equally reluctant to pry into her life. The judge is a stern but just disciplinarian. The reserve of these public servants stands in direct contrast to the volatility of their clients. There is ambiguity about their motives for undertaking rehabilitation work. Their authority is based on a number of factors: their self-control, their celibate lives, the "pathology" of their clients, and their age. George Perry finds that the film "reinforces the patronizing view taken by so many British films, which can only see the world through the eyes of the middle aged middle class."[37] Charles Barr, in describing Ealing's preoccupation with deference to authority, states, "There is virtually no defiance or even enterprise on the part of youth, no confrontation between father and son figures. At least, if there is, the defiance is safely 'placed' or absorbed (e. g. *I Believe in You*) on the workings of the probation service, or on a wider social canvas."[38] But the film offers more than a middle-aged perspective and a vision of British defer-

ence to authority. Much of the conflict centers on the young, and their presence counteracts the film's polemics. An indication of the film's failure to explore the marginal characters to which it is drawn is the presence of Joan Collins, which points to other elements that the film introduces but does not directly confront: "The sullen, electric presence of Joan Collins dominates the whole film precisely because her grace, vigour, and insolent *savoir-vivre* validate her character's subversive attitudes as the result, not of being 'misled' as the script imagines, but of a culture, of truths and experiences from which the film is insulated."[39]

If the film is read from the perspective of the triumvirate of probation officers, it is quite easy to challenge its refusal to confront social conflicts at the same time that it proposes to address social issues. In order to learn something about the film, it is necessary to shift the focus from its reformist elements to the deviant characters and the issues that they represent. By not constructing expectations of the film as a realist text that not only mirrors society but also resolves social problems, we may learn about its conceptions of the imaginary but real conditions that constitute not only the milieu of the film but also the audience's expectations. Both Norma and Jordie represent elements disruptive to the integrity of the community. Norma's threat is a sexual one, and the narrative severs her attachment to Jordie and, hence, ends her quest for pleasure. Jordie is identified as the force that must be eliminated; with Norma, he generates desires; with Hooker, violence and rebellion. Norma's sexuality can be disciplined, channeled into work and ultimately marriage. Hooker's rebelliousness, diagnosed as resulting from familial rejection, is tamed through his acquisition of a new paternal model, Phipps. But, as John Hill states, "the 'cure' for delinquency and the price of rehabilitation into the community is once again a suppression of sexuality, a reduction of sensation."[40] And women and young people are central both as instruments of and as victims of that suppression.

If an abiding concern in Dearden's films, in the first decade after the war, is the restructuring of a peacetime community in Britain, many of his films are reluctant to address the effects of the war except through passing allusions, as in *I Believe in You*. However, *The Ship That Died of Shame* (1955) directly addresses the issue of survival in the postwar world. Based on a work by the author of *The Cruel Sea*, Nicholas Monsarrat, the film begins during the war with the crew of a gunboat. The early sequences dramatize the sense of vitality and excitement of wartime life. After the war, the men are shown to have no sense of purpose. The ship that had served in the war effort and is now rehabilitated to serve as a smuggling ship becomes the dominant character in this allegory of British contemporary society, signifying the contrast between the purposive social environment of the war era and the disappointing world of contemporary civilian

life. Unable to find their niche in civilian life, the men turn to criminal activities. The relationships that bonded the men during the war are portrayed as disintegrated, illicit, and violent.

The structuring absence of women is central to the film's preoccupation with the failure of conventional social relations. The only woman in the film, Helen (Virginia McKenna), Bill's wife, dies early on; her death prefigures the death of the ship. Her sense of malaise in her temporary home before she is killed by a bomb is paralleled by the ship's later "ailments" and final destruction. The elimination of the female, as in other Dearden films, shifts the focus from heterosexual relations to the world of men, which is portrayed as violent. The center of this exclusively male world is Bill (George Baker), who is unable to return to civilian life yet finds the life of crime in which he becomes involved equally intolerable. In the postwar society that Dearden portrays, men such as George Hoskins (Richard Attenborough) are now in charge of the ship, and Bill takes orders from him. George's behavior is characterized by greed, the desire for power, and gratuitous violence. In contrast, Bill is portrayed as struggling to retain a sense of integrity and mateship in his protective relations toward the third member of the crew, Birdie (Bill Owen). George is thus identified as the rapacious force who is finally responsible for destroying the ship by his ruthless appropriation of it for his own violent purposes, and he is eliminated from the narrative.

The key to the film's conflicts is Helen. Her absence, and the absence of any other women, heightens the sense of an all-male world where violence predominates. For Bill, the ship seems to be associated with Helen and the past, a past that he has refused to relinquish and that he has betrayed through his violation of the ship. At the end of the film, as Birdie and Bill contemplate the wreckage of the ship, Bill recalls Helen's admonition not to do "anything silly with that ship," and he adds, "Well, Birdie, we did do something useless, silly, and futile. So she died. She gave up and died." The film dramatizes the men's inability to relinquish the past. In trying to re-create it, they do violence to it and to themselves. The death of the ship frees the men from their attachment to the past, although they are left adrift at the end. The ship, a symbol for the wife, becomes a figure of reproach, signifying that without a sense of purpose these men have no identity.

George Perry finds that the idea of "a sentimental ship with a soul" is "a concept that might appeal to a few nautical experts but seems absurd and bewildering to the great mass of landlubbers."[41] Perry is thus criticizing the film's abandonment of realism instead of examining how its departures from realistic representation are important clues to its underlying psychosexual conflicts. Jim Cook's assessment of the film seems closer to the mark: "Consciously concerned about the continuing value of mas-

culine heroics and the war, its particular form of narrative organisation results in the film's not only offering a critique of such looking back in others, but also finding itself neurotically locked into a past where only the erotic can signify completion and fulfillment, and from which the only escape can be through violence and excess."[42]

Many of Dearden's social problem films focus on women not as protagonists but as symptomatic of a wide spectrum of social conflicts. Dearden's *Sapphire* (1959) ostensibly addresses the issue of racism, though finally it appears that the film is more concerned with sexual than racial deviance in ways reminiscent of *Pool of London*. The film takes as its focus the investigation of the murder of a young woman. It begins with the discovery of the body, and the remainder is devoted to investigating the identity and race of the body and of the murderer. Commenting on the film's adoption of the investigative format of the crime detection film, John Hill states that "while this structure provides the veneer of 'entertainment' felt necessary to hold an audience's attention, it also embodies a number of the film's values. For the principle of rational deduction upon which the classic detective formula is based in turn embodies the spirit of rationalism which the film wishes to apply to the problem of racial prejudice."[43]

During the course of Inspector Hazard's (Nigel Patrick) and his assistant Learoyd's (Michael Craig) investigation, a number of clues offer themselves involving the clothing of the dead woman, a torn photograph, a nightclub called Tulips, music and dancing, and a torn doll. The succession of white and black characters helps to establish that Sapphire was "passing" for white, that she moved between white and black elements of society, that she was pregnant, and that her murder is related to the question of racism. In the course of their travels, the police confront a spectrum of attitudes toward Sapphire. Her brother, Dr. Robbins (Earl Cameron), is exemplary of the educated black man, the professional who is respectable, polite, and clearly identified with the aims of the law. He contrasts sharply with the arrogant Paul Slade (Gordon Heath), a former dancing partner of Sapphire who expresses his contempt for white society and the men associated with the violent and illegal activity of the black community. The scenes in the nightclub and in the black men's apartment contrast sharply with the white environment.

Hazard is convinced early in the film that what killed Sapphire was "hate, not fear." And as the investigation proceeds, the finger points at the young man, David (Paul Massie), whom Sapphire was planning to marry. An architecture student, David was planning to study in Rome until he learned about Sapphire's pregnancy. From David, the suspicion shifts to his family, and, ultimately, to David's sister, an embittered woman with two children whose husband is described as "a lad-o."

Milly's passionate hatred of Sapphire, her identification with her father and brother, and her desire to keep David and Sapphire apart constitute the ostensible explanation of the murder. After Milly is taken away, Hazard offers a commentary on the action, saying that he has seen all kinds of sickness in his practice, but he has never seen the kind that "you can cure in a day.... We didn't solve anything. We just picked up the pieces."

The film, like Sapphire's identity, is divided into two separate spheres determined by racial difference, and the two detectives are intermediaries between these two environments. One is associated with white society and with the world of respectability associated with the police, Sapphire's landlady, David and his family, and Sapphire's brother. The other is associated with Sapphire's body, her black acquaintances, her red petticoat and torn photograph, and the world of the nightclub with its fast music and dancing. The film links card playing and music and dancing to the blacks, the blacks to sexuality, and sexuality to violence. The two worlds meet in the figure of Sapphire, who belongs to neither world. The issue of her racial identity is solved by Learoyd's investigation of her behavior, her family relationships, her tastes, and her identification with other blacks. In particular, her association with sexual promiscuity is defined by her relationships and activities that situate her in the world of blackness. The issue of racial identity, concealed by her white appearance, is exposed in the stereotypical images of black culture evoked by the film.

The fundamental issue that the film raises about Sapphire is her identity as a black and as a woman. The black individual is often the pseudo-center of a discourse that hinges on biological determinism and sexuality in particular. *Sapphire* fuses the notion of blackness with female desire and sexuality. There are many instances in the film of male investigation of the female body, and the body of the mulatto female provides an even more exotic field. The two male detectives (and the severe female detective that examines Sapphire's red petticoat) are licensed to look. According to Carrie Tarr, "the murder mystery constitutes a further red herring to keep us from spotting that the film is about women's sexuality."[44] The racial issue, in effect, is a further red herring in diverting the spectator from the issue of female sexuality. By associating female sexuality with blackness, and by segregating the blacks, the film relegates female pleasure to "passivity, silence, and absence." Ironically, it is not the men who silence Sapphire but another woman, and, as Tarr indicates, "by offloading the guilt onto Milly, the film again sidesteps any serious confrontation with the issue of racism."[45] Milly's hysteria, her fears of contamination, her obsession with Sapphire's dangling legs and impudence, seem therefore to be the result of her own sexual repression rather than of racist hatred. In mutilating Sapphire's body, she destroys her own.

On the one hand, the film traces the murder to sexual jealousy, frustration, and mental instability linked, after all, to a female, and thus dilutes the racist clues that have ensnared the viewer. On the other hand, although the racist issue, like Sapphire's appearance, blurs the issue of race, the gender issue, which was not the ostensible focus of the film, appears, yet again, as the real question of unresolved identity. The film begins with a dead female body and ends with the removal of another female. Also, the image of the torn doll comes to represent the violated female body. Moreover, the issue of "passing" as white becomes more than an issue of denying racial identity, but serves also to represent the duplicity of women which the film exposes through Milly. In *Sapphire*, again, many of the problems posed by the social problem film—racism, violence, criminality, delinquency—are masks for the more fundamental problem of sexual repression.

With *Victim* (1961) Dearden approached yet another explosive social and sexual issue—homosexuality. The increasing frankness concerning sexual behavior can be attributed, in part, to changes in censorship practices. The revamping of the censorship code in 1951 also acknowledged and contributed to the changing focus of British films. The creation of the "X" category, replacing the old "H" rating, allowed for the release of films that addressed adult themes for exclusively adult audiences. This category permitted the exhibition of European films that had a more explicitly sexual focus, and enabled the production of British films that addressed such concerns.[46]

While the issue of race had been addressed in *Pool of London* and then in *Sapphire*, homosexuality was still buried under a mass of oblique references, disguised and marginalized through representations of mateship, comic female impersonation, and, above all, British male eccentricity. The appearance of *Victim* was timely. According to Jeffrey Weeks, "The real change in the 1950s was the growth of official concern and public anxiety to which the police zeal was a response. This in turn cannot be divorced from the heightened post-war stress on the importance of monogamous heterosexual love, which threw into greater relief than ever before the 'deviant' nature of both prostitution and homosexuality (though the overwhelming emphasis was on *male* homosexuality)."[47] The increased focus on homosexuality was accompanied by a rhetoric condemning such behavior, trials exposing famous homosexuals, and newspaper and magazine articles demanding stricter enforcement of laws. As in the case of official concern for females and family life, where the government sought to direct women into socially desired channels utilizing a psychological language, the Wolfenden Committee set to work to address homosexuality from a psychosocial perspective: "The problem the Committee was established to consider was not how to liberalise the law

(though many outside and on the Committee had that question in mind) but whether the law was the most effective means of control."[48] The Committee did not, in fact, liberalize the law, but it did recommend research into physical and psychological treatment, while rejecting the notion that homosexuality was criminal. In many ways, the Dearden film must be seen as a timely venture into a difficult and sensitive area.

The Motion Picture Association of America objected to the film's treatment of homosexuals, to its " 'candid and clinical discussion of homosexuality and its overtly expressed plea for social acceptance of the homosexual to the extent that [he] be made tolerable.' "[49] *Victim* was released only after the liberalization of the Production Code. The film stars Dirk Bogarde as a promising young lawyer, Melville Farr, whose past catches up to him in the person of Jack Barrett (Peter McEnery), who seeks Farr's help. In their brief relationship, they had been photographed together by blackmailers who seek to extort money from the young man. Farr, thinking that Barrett himself is a blackmailer, refuses his calls. The young man is arrested, and he hangs himself in his cell. Farr, called upon by the police to provide information about the young man, learns of Barrett's efforts to protect him by paying off a ring of blackmailers. He now undertakes his own investigation in an attempt to learn the identity of the ringleaders and bring them to justice. His investigation uncovers an array of individuals who represent different classes and ages—a barber, an actor, a government official—who are linked not only by their fear of exposure but by the threat of violence from the criminal gang that harasses them.

Farr gets little cooperation from the intimidated victims. When he seeks to get a barber to help him, the man tells him that he has himself to think of and laments that "nature played me a dirty trick." When Farr leaves, the blackmailers destroy the shop and beat the barber to death. Farr tries unsuccessfully to enlist the cooperation of Calloway (Dennis Price), an actor, and learns that his lover, Lord Fulbrook, is a member of Farr's men's club. Both men are adamant that they must pay and angry with Farr for wanting to jeopardize their social positions. Moreover, they accuse him of shrouding himself through marriage.

Farr's marriage begins to disintegrate when Laura (Sylvia Syms) confronts him about his relationship with Barrett. As John Hill points out, "What characterises the Farr marriage is its absence of children, and, although not explicitly addressed as a topic, is constantly alluded to by a repetitive use of images of children."[50] Laura's work at a school for handicapped children provides an oblique commentary not only on her relationship with her husband but also on the status of the family. One episode reinforces the film's problematic treatment of the position of women, showing a young male child with a picture of a woman that he has obliterated. More directly, Laura's relationship with her husband is

characterized by her inability to comprehend or understand his relations to men, her persistence and prurience amounting to sadism as she extorts the truth from him, and her frustration over his attachment to young men. Ultimately, he sends her away, telling her that he does not want her to witness his final humiliation, but promising that he will need her after the affair is over. Her comment, "Need, that's a bigger word than love," are the final words in the film, reflecting back on the desexualized terms of their relationship.

Hill suggests that "the film conforms to the parameters established by Wolfenden, fearing the consequences of homosexuality for family life and refusing to endorse it morally but, in so far as it is an 'affliction', counselling treatment rather than punishment."[51] The film, however, not only explores the consequences of homosexuality for family life, but also implies that family is one major source of the "problem." Women, if they are not identified as a cause of the "affliction," are certainly seen as problematic and even vindictive. More blatantly than in Dearden's other social problem films, *Victim* portrays a world based on extortion, repression, and violence and identifies homosexuality as the site of the social war against deviance. In this film, as in *Sapphire*, women are the source of the problems. The blackmailer turns out to be an unmarried woman whose rage arising from her sexual frustration is redirected toward gay men.

Also as in *Sapphire*, the issue of "passing" is central. Concealing one's identity is anathema in the context of many British films that seek to equate appearance and essence, word and deed. Throughout the film, the question of who is and who is not homosexual is uppermost. As Calloway and Fulbrook tell him, Farr has shrouded himself in the conventional trappings of marriage. Everyone in the bar that Farr visits could be "one." The blackmailers and the representatives of the law reinforce concealment and the necessity of passing. The style of the film plays with the game of identification. Not only does the film postpone recognition of the characters' gayness, but it denies the audience access to information. One effect of this denial of visual access at crucial moments is to problematize the links between naming and identity.

The question of whether Farr is or is not gay hangs over the film, both reinforcing the issue of invisibility and providing the mystification necessary to make his character acceptable to the audience. By segregating Farr from the other gay men, the film, in ways characteristic of the social problem films, tends to personalize a collective problem. As Richard Dyer says, "*Victim* makes clear how the law operates on the lives of gay men. Yet . . . the central articulation is still the individual versus society as a whole, not the individual as a member of an oppressed group."[52] In this fashion, the film maintains its fragile hold on the world of respectability.

Farr's ambiguous status allows him to act as a representative of a more benign conception of the law and of familial relations. His sexless relationship with Barrett qualifies him to adopt the mantle of the crusading hero without becoming tainted, as the others are tainted, by complete complicity. The other gay men in the film are presented rather as victims not only of harsh laws and of blackmailers, but of their own desires. Gayness is presented as a compulsion, a burden, and a personal problem. Following the pattern of the social problem film, which restricts its focus to the legalistic and moral aspects of social issues and remains within the constraints of conventional institutional structures, *Victim* as a film is itself a victim of the problems that it seeks to investigate. Yet the film, like others of its kind, opens spaces for alternative readings. Not only does it explore the ways in which gayness cuts across class boundaries, but it also calls into question conventional conceptions of normality concerning the operations of the law, the primacy of heterosexuality, and the sanctity of the family. In certain ways *Victim* is not a radical ideological departure from earlier British cinema that sought to legitimate the primacy of law, the role of the family, male relationships, female subordination, and social institutions. Where this film differs is in its surfacing, though not resolving, the contradictory nature of these institutions. In the final analysis, the "realism" deconstructs itself. Rather than offering a transparent "slice of life," the film calls attention to the difficulty of trying to resolve the problem it set out to investigate.

The social problem film is an appropriate place to end my examination of British genres. These eclectic films combine traditional and modern attitudes, realism and melodrama, nostalgia for the past and a recognition of its irrecoverability. The films often regress to prewar attitudes and behaviors, at the same time that they recognize, if only inchoately, that the contemporary world they portray is incompatible with the notions of family and community that they often resurrect in the final moments. And attempts at mediating conflicts appear as what they are, a refusal to confront the implications of the problems posed. The films' invocation of intermediary agents—doctors, lawyers, police, and social workers—constitutes a recognition of change and an attempt to direct and manage this change.

The existence of the social problem film is yet another indication that the British cinema never really evaded social and ideological conflicts. From the 1930s through the 1950s, the British cinema of genres confronted and helped to shape dominant notions of sexuality, family, and community. Even at their most legitimizing, as in the films of empire and in the Gracie Fields comedies, the films are not completely silent about their strategies for gaining adherence, nor are they totally misguided in their projection of images of unity and consensus. These films, along with

so many others of the pre–World War II era, are evidence of the British cinema's attempts to give the British audiences what British filmmakers thought was profitable, entertaining, and socially acceptable.

The war films, which can be considered the precursors of the social problem film, are not quite as complacent about their audiences. Their projection of a society mobilizing to meet unprecedented challenges inevitably involved the films in exposing contradictions produced, on the one hand, by the need to acknowledge conflicts and differences, and, on the other, by the need to eliminate the threat of difference. The existence of sacrifice, separation, and death had to be rationalized in the common interest, but no matter how much the films sought to create a sense of commonality and to naturalize disasters, they could not conceal the inevitable threats to traditional conceptions of social life. Nor could these films conceal that traditional genre representation was no longer adequate to the changing times, and they already anticipate the eclecticism of the postwar cinema.

Thus, the British cinema of the postwar period is not a radical departure from the subjects and styles of wartime cinema but rather part of a continuum. The social problem films, along with melodramas, comedies, and horror films, convey a sense of urgency and anxiety, aggressively probing changes in the society concerning gender identity, sexuality, and race. Adopting the discourses of the social sciences, the films express concerns about the family and about young people. Their treatment of the social problems they identify is a contradictory one. On the one hand, they gingerly broach the subject of the existence of marginal groups and their conflicts; on the other hand, they seek to manage the discontents by invoking a humane face of institutional authority and seeking to locate the problems in personal maladjustment. The films reveal, more often than not, that the underlying tensions can be traced, not to the ostensible problems demarcated, but to sexuality and especially to the threat of female sexuality. In effect, the films dramatize the convergence, in Raymond Williams' terms, of dominant, residual, and emergent attitudes in the culture, where old and new, past and present collide.[53] While offering an index to social and ideological transformations concerning youth, race, sex, and social class that will surface in more direct fashion in the popular culture of the late 1960s and 1970s, the films remain committed to traditional institutional structures. Their eclectic style betrays their divided allegiances.

A NEW LOOK at British cinema through the lens of genre challenges long-held prejudices: that the British cinema was not a popular cinema, that it was a monolithic instrument of upper-class ideology, that it made no contact with history, that it was a cinema of repression, that it was inferior to Hollywood genres, and, above all, that it offered little in the way of pleasure. Ironically, although the British discovered their cinema only recently, Hollywood discovered it decades ago. In raiding British studios for actors, in emulating British historical and adventure films, and later in capitalizing on the immense popularity of the Gainsborough and Hammer films, Americans acknowledged contributions of British cinema and culture.

Reflecting backward on this thirty-year period of British cinema, one can put forward a number of hypotheses. An examination of dominant genres reveals that the strengths of British cinema are not to be located in the realist aesthetic but rather in the highly conventionalized operations of the genre system. The historical films, films of empire, war films, melodramas, comedies, horror films, and social problem films offer a wealth of information on British culture. Rather than constituting an evasion and escape from social issues, the films' styles offer indices to the lived if imaginary realities of their creators and audiences. If it is true that British cinema largely departed from a realist aesthetic except in the occasional narrative films and the films of the documentary movement, it is not true that the commercial genre films ignored reality.

It has been customary to regard the commercial cinema and the cinema of genres that has been its major instrument of representation as offering false promises and spurious pleasures to its audiences, fixing spectators in a position of subjection to vulgar, banal, and false images of the world. But these judgments have less to tell us about the films than about British critics and filmmakers, who, though desiring a national and popular cinema, had a very negative attitude toward their existing cinema, which was, after all, a national and popular cinema.

There is no doubt that British genres are indebted to Hollywood genres; there is also no doubt that Hollywood was indebted to many of the British genres. For the detractors of mass culture and the cinema of genres, this mutual influence only provided evidence of failure to create a

strong national cinema. And yet, as recent studies of Hollywood genres have revealed, the genre system, when properly examined, offers a way of understanding the complex interaction between cinematic texts and their audiences. It is the case with mass cultural production, as Walter Benjamin has taught us, that its texts are dependent on their reproducibility, and one form of reproduction is the genre system, a formalized mode of narration dependent on a circuit of exchange between producers, directors, stars, and their audiences. The attack on the genre system was part of a larger ideological conflict tied to a belief in the antithetical nature of modernism and mass culture. The predilection for "realism" was inextricable from the quest for a purer cinema untainted by the standardized and formulaic qualities of popular cultural production. Moreover, inherent in the prejudice against this form of commercial filmmaking was the notion of elevating the masses, of the cinema as a pedagogical instrument. However, this pedagogical outlook is closely allied to the long-standing belief that learning is the province of the reality principle and not the pleasure principle—in fact, is often positioned in opposition to the pleasure principle. The cinema of genres, if nothing else, is associated with pleasure. This stark dichotomy between pleasure and work, play and learning, obscures the possibility of understanding the complexity of genre and the hold that it has on audiences and how pleasure is its instrument for reaching the audience. The equation between pleasure and debasement has stood as a major obstacle to understanding how genres negotiate personal and social experience, exposing contradictions, if not resistances to social conformity.

A much less monolithic view of how audiences receive these texts would suggest, first of all, that the spectator is not mindless. The films do not place the spectator in a position of total subordination to the text. The experience of a genre film is akin to the workings of common sense. The world presented to the spectator is a not a totality but a composite of different and often conflicting attitudes, a collage of beliefs. Hence, the appeal of these texts must reside in their capacity to evoke central contradictions concerning attitudes, values, and behaviors. The narratives replay situations that have their roots in the world familiar to the spectator, the world within the film and the world in which the spectator lives. In particular, the generic codes, like language more generally, are tied to primary social, psychic, and sexual conflicts. Psychoanalytic research into the cinema has alerted us to the inextricability of language and sexual difference.

The British genre films of the 1930s—the historical films, melodramas, comedies, and films of empire—are not innocent texts, representative of an untroubled time in which social consensus was assured. With their eyes facing both the internal landscape of the characters and the social

milieu, the films address the conflict between desire and social expectations. Dividing British genres between the pre–World War II period and the postwar era does not do justice to the earlier films. While the postwar films, especially the family melodramas, the horror films, and the social problem films, increasingly allow contradictions to come to the surface, the conflicts they pose can already be discerned to some extent in the cinema of the 1930s and of the World War II years despite their attempts to create a sense of collectivity and common purpose.

My examination of British genres suggests that whether the British critics wished to acknowledge it or not, Britain did in fact have a viable national cinema. This national cinema was, of course, highly dependent on Hollywood, as were other popular national cinemas, but while similarities in overall form can be discerned, the differences are instructive, as can be seen through an examination of the ways in which British cinema negotiated the codes of the historical film and the film of empire, genres common to British and Hollywood cinema. In the case of melodrama, it is clear that the differences between the Hollywood and the British films are not evidence of the inferiority of British cinema but are useful for understanding what is particularly British about British genres. One of the advantages of genre analysis is that it allows for an understanding of difference due precisely to the cross-fertilization of formulas. The concept of a national cinema is tricky, since cinema is not a hermetic form of representation but is dependent on international influences. British cinema, no less than the Italian and Japanese cinemas, bears the marks of other cultures. The Hollywood influence on British filmmaking is certainly important, but so is the influence of the German cinema of the pre-Nazi era, as we have seen in the pre–World War II films, especially those of Hitchcock and Saville.

What makes the British films distinctive is the ways in which they utilize the conventions of genre to speak to particularly British national and social concerns. For example, from the Korda historical films to the social problem films of the 1950s, the British cinema has offered its own versions of social class conflicts, and their presentation has not been untroubled even when the films seem, as in *South Riding* or the war films, to be striving for a populist orientation. Moreover, from maternal melodramas such as *Illegal* to the comedies of Gracie Fields, the musicals of Jessie Matthews, and the highly stylized Gainsborough melodramas, the films exploit and call into question women's anomalous position, much as the films of empire exploit and call into question the otherness of non-British cultures. The vast array of melodramas range from a daring flaunting of female sexuality to horrific Gothic representations of women, especially in the postwar era. Many more melodramas address the issue of male identity, exploring the reverse side of honor, service, and duty,

and, increasingly after World War II, male desire and male relationships. In the horror film, especially those produced by Hammer Films, the issue of sexuality becomes central; as Andrew Higson has indicated, the films are not so much agents of repression as they are portrayers of repression. The eclectic social problem film, which sits on the cusp of genre production, is a consummate example of the coming together of the psychological and the social, the personal and the collective, the family and other social institutions. The impact of these films, which foreground the question of identity in the broader context of social relations, has less to do with their "resolutions" to the conflicts they pose than with their acknowledgment of long-standing differences and antagonisms in British culture, differences having to do with sexuality, gender, generation, race, and regional identity. The problems these films bring to the surface are not new; what is new is the critical perspective on them.

Notes

INTRODUCTION

1. In his Introduction to *All Our Yesterdays: 90 Years of British Cinema*, ed. Charles Barr (London: BFI Publishing, 1986) Barr discusses major resistances to a serious examination of British films.

2. Ibid., pp. 2–3.

3. Roy Armes, *A Critical History of British Cinema* (New York: Oxford University Press, 1978), p. 95.

4. John Hill, *Sex, Class and Realism: British Cinema 1956–1963* (London: BFI Publishing, 1986), p. 57.

5. According to Christine Gledhill, "generic forms were one of the earliest means used by the industry to organise the production and marketing of films, and by the reviewers and the popular audience to guide their viewing. In this respect, genres—like stars a decade later—emerged from the studio system's dual need for standardisation and product differentiation" ("Genre," in *The Cinema Book*, ed. Pam Cook [London: BFI Publishing, 1985], p. 58).

6. Theodor Adorno, *Prisms* (London: Neville Spearman, 1967), p. 26.

7. Thomas Schatz, *Hollywood Genres: Formulas, Filmmaking, and the Studio System* (New York: Random House, 1981), p. 6.

8. Antonio Gramsci, *Selections from the Prison Notebooks*, ed. Quintin Hoare and Geoffrey Nowell-Smith (New York: International Publishers, 1978), p. 324.

9. Adorno, *Prisms*, p. 34.

10. Jean Baudrillard, *Selected Writings*, ed. Mark Poster (London: Polity Press, 1988), pp. 208–9.

11. Andreas Huyssen, "Mass Culture as Woman: Modernism's Other," and Tania Modleski, "The Terror of Pleasure: The Contemporary Horror Film and Postmodern Theory," in *Studies in Entertainment: Critical Approaches to Mass Culture*, ed. Tania Modleski (Bloomington: Indiana University Press, 1986), pp. 188–207, 155–66.

12. Gramsci, *Selections from the Prison Notebooks*, pp. 305–6.

13. Ibid., p. 306.

14. Huyssen, "Mass Culture as Woman," p. 199.

15. Christine Gledhill, "The Melodramatic Field: An Investigation," in *Home Is Where the Heart Is: Studies in Melodrama and the Woman's Film*, ed. Christine Gledhill (London: BFI Publishing, 1987), p. 38.

16. Thomas Elsaesser, "Tales of Sound and Fury: Observations on the Family Melodrama," in *Movies and Methods*, ed. Bill Nichols (Berkeley: University of California Press, 1985), 2:165–89.

17. Stephen Neale, *Genre* (London: BFI Publishing, 1983), pp. 6–12.

18. Gledhill, "Genre," p. 63.

19. Ibid.

20. Rick Altman, *The American Film Musical* (Bloomington: Indiana University Press, 1987), p. 5.

21. Schatz, *Hollywood Genres*, p. 35.

22. John Stevenson, *British Society, 1914–1945* (Harmondsworth, Middlesex, England: Penguin Books, 1984), p. 462.

23. Arthur Marwick, *The Explosion of British Society, 1914–1970* (London: Macmillan, 1971), p. 104.

24. Ibid., p. 128.

25. Barr, Introduction to *All Our Yesterdays*, ed. Barr, p. 25.

26. Marion Jordan, "Carry On . . . Follow That Stereotype," in *British Cinema History*, ed. James Curran and Vincent Porter (London: Weidenfeld and Nicolson, 1983), p. 326.

27. Hill, *Sex, Class and Realism*, p. 67.

28. Geoff Hurd, "Notes on Hegemony, the War, and Cinema," in *National Fictions: World War Two in British Films and Television*, ed. Geoff Hurd (London: BFI Publishing, 1984), p. 19.

CHAPTER ONE: BRITISH CINEMA HISTORY

1. Michael Chanan, "The Emergence of an Industry," in *British Cinema History*, ed. Curran and Porter, pp. 44–45.

2. Ibid., p. 56.

3. Rachael Low, *The History of the British Film, 1929–1939: Film Making in 1930s Britain* (London: Allen and Unwin, 1985), pp. 33–53.

4. Margaret Dickinson and Sarah Street, *Cinema and State: The Film Industry and the British Government 1927–84,* (London: BFI Publishing, 1985). See also Michael Chanan, *Labour Power in the British Film Industry* (London: BFI Publishing, 1976).

5. Robert Murphy, "Under the Shadow of Hollywood," in *All Our Yesterdays*, ed. Barr, p. 59.

6. Margaret Dickinson, "The State and the Consolidation of Monopoly," in *British Cinema History*, ed. Curran and Porter, p. 74.

7. James C. Robertson, *The British Board of Film Censors: Film Censorship in Britain, 1895–1950* (London: Croom Helm, 1985), pp. 10–13.

8. Ibid., p. 22.

9. Ibid., pp. 34–35.

10. Nicholas Pronay and Jeremy Croft, "British Film Censorship and Propaganda Policy During the Second World War," in *British Cinema History*, ed. Curran and Porter, 144–45.

11. Ibid., p. 152.

12. Ibid., p. 146.

13. Janet Wolff, *The Social Production of Art* (New York: New York University Press, 1985), p. 136.

14. Christine Saxton, "The Collective Voice as Cultural Voice," *Cinema Journal* 26 (Fall 1986): 29.

15. Low, *The History of the British Film, 1929–1939: Film Making in 1930s Britain*, p. 139.

16. Jeffrey Richards and Anthony Aldgate, *British Cinema and Society, 1930–1970* (Totowa, N.J.: Barnes and Noble Books, 1983), pp. 29–43.

17. Tom Ryall, *Alfred Hitchcock and the British Cinema* (Urbana: University of Illinois Press, 1986), p. 121.

18. Tania Modleski, *The Women Who Knew Too Much: Hitchcock and Feminist Theory* (New York: Methuen, 1988), pp. 62–64.

19. Raymond Durgnat, *A Mirror for England: British Movies from Austerity to Affluence* (London: Faber and Faber, 1970), p. 208.

20. Geoff Brown, *Launder and Gilliat* (London: BFI Publishing, 1977), pp. 3–4.

21. Durgnat, *A Mirror for England*, pp. 242–43.

22. For a recent study of Dickinson's work, see Jeffrey Richards, *Thorold Dickinson: The Man and His Films* (London: Croom Helm, 1986).

23. Durgnat, *A Mirror for England*, p. 229.

24. Armes, *A Critical History of British Cinema*, p. 210.

25. Richards and Aldgate, *British Cinema and Society*, p. 90.

26. Hill, *Sex, Class and Realism*, pp. 68–95.

27. Richard Dyer, *Stars* (London: BFI Publishing, 1986), p. 38.

28. Sue Aspinall, "Women, Realism and Reality in British Films, 1943–1953," in *British Cinema History*, ed. Curran and Porter, p. 277.

29. Jeffrey Richards, *The Age of the Dream Palace: Cinema and Society in Britain, 1930–1939* (London: Routledge and Kegan Paul, 1984), pp. 225–35.

30. Geoff Brown, "Sisters of the Stage: British Film and British Theatre," in *All Our Yesterdays*, ed. Barr, pp. 143–67.

31. For a genealogy of music hall stars in the cinema, see Michael Chanan, *The Dream That Kicks: The Prehistory and Early Years of Cinema in Britain* (London: Routledge and Kegan Paul, 1980).

32. Anthony Aldgate and Jeffrey Richards, *Britain Can Take It: The British Cinema in the Second World War* (Oxford: Basil Blackwell, 1986).

33. Aspinall, "Women, Realism and Reality," p. 277.

34. Christine Geraghty, "Diana Dors," in *All Our Yesterdays*, ed. Barr, pp. 341–45.

35. Jeffrey Richards, "'Patriotism with Profit': British Imperial Cinema in the 1930s," in *British Cinema History*, ed. Curran and Porter, p. 255. See also Richards and Aldgate, *British Cinema and Society*, pp. 13–28.

36. Alan Wood, *Mr. Rank: A Study of J. Arthur Rank and British Films* (London: Hodder and Stoughton, 1952).

37. Robert Murphy, "A Brief Studio History," in *Gainsborough Melodrama*, ed. Sue Aspinall and Robert Murphy (London: British Film Institute, 1983), pp. 4–6. See also his *Realism and Tinsel: Cinema and Society in Britain, 1939–1948* (London: Routledge, 1989), pp. 34–35, 42–46, 87–89.

38. Pam Cook, "Melodrama and the Women's Picture," in *Gainsborough Melodrama*, ed. Aspinall and Murphy, pp. 14–28.

39. Sue Aspinall, "Sexuality in Costume Melodrama," in *Gainsborough Melodrama*, ed. Aspinall and Murphy, p. 30.

40. Murphy, "A Brief Studio History," p. 10.

41. Charles Barr, *Ealing Studios* (Woodstock, N.Y.: Overlook Press, 1980); George Perry, *Forever Ealing: A Celebration of the Great British Film Studio* (London: Pavilion Books, 1981).

42. Wood, *Mr. Rank*, pp. 69–72, 173–76.

43. Ian Green, "Ealing: In the Comedy Frame," in *British Cinema History*, ed. Curran and Porter, p. 301.

44. Barr, *Ealing Studios*, p. 44.

45. Vincent Porter, "The Context of Creativity: Ealing Studios and Hammer Films," *British Cinema History*, ed. Curran and Porter, p. 205.

46. David Pirie, *A Heritage of Horror: The English Gothic Cinema, 1946– 1972* (New York: Avon Books, 1973).

47. Durgnat, *A Mirror for England*, p. 226.

48. Stephen G. Jones, *The British Labour Movement and Film, 1918–1939* (London: Routledge and Kegan Paul, 1987), pp. 22–23.

49. Marwick, *The Explosion of British Society*, p. 121.

50. Ibid., p. 111.

51. Hill, *Sex, Class and Realism*, p. 6.

52. Armes, *A Critical History of British Cinema*, p. 184.

53. David Robinson, *The History of World Cinema* (New York: Stein and Day, 1974), p. 295.

54. Annette Kuhn, "British Documentaries and 'Independence': Recontextualising a Film Movement," in *Traditions of Independence: British Cinema in the Thirties*, ed. Don Macpherson, in collaboration with Paul Willemen (London: BFI Publishing, 1980), p. 4.

55. Don Macpherson, Introduction to *Traditions of Independence*, ed. Macpherson, p. 5.

56. Stuart Hood, "John Grierson and the Documentary Film Movement," in *British Cinema History*, ed. Curran and Porter, p. 107.

57. Gledhill, "The Melodramatic Field," p. 33.

58. Ryall, *Alfred Hitchcock and the British Cinema*, p. 177.

CHAPTER TWO: THE HISTORICAL FILM

1. Jean Gili, "Film storico e film in costume," in *Cinema italiano sotto il fascismo*, ed. Riccardo Redi (Venice: Marsilio, 1979), p. 129.

2. Ibid., p. 130.

3. Hayden White, "The Value of Narrativity in the Representation of Reality," in *On Narrative*, ed. W.J.T. Mitchell (Chicago: University of Chicago Press, 1981), p. 4.

4. Paul Monaco, "Movies and National Consciousness: Germany and France in the 1920s," in *Feature Films as History*, ed. K.R.M. Short (Knoxville: University of Tennessee Press, 1981), p. 65.

5. Gramsci, *Selections from the Prison Notebooks*, pp. 326–28.

6. Marcia Landy, *Fascism in Film: The Italian Commercial Cinema, 1931– 1943* (Princeton, N.J.: Princeton University Press, 1986).

7. Richards, *The Age of the Dream Palace*, p. 260.

8. Peter Stead, "The People as Stars: Feature Films as National Expression," in *Britain and the Cinema in the Second World War*, ed. Philip M. Taylor (New York: St. Martin's Press, 1988), pp. 62–83.

9. Nigel Mace, "British Historical Epics in the Second World War," in *Britain and the Cinema in the Second World War*, ed. Taylor, p. 119.

10. Low, *The History of the British Film, 1929–1939: Film Making in 1930s Britain*, p. 167.

11. Richards, *The Age of the Dream Palace*, pp. 260–64.

12. Ibid., p. 259.

13. For a discussion of a Hollywood treatment of the female monarch, see Jane Gaines, "The Queen Christina Tie-Ups: Convergence of Show Window and Screen," *Quarterly Review of Film and Video* 11 (1989): 43. Gaines's essay links the Mamoulian film to the fashions and consumerism of the time and to female representation.

14. Ibid., p. 51.

15. Low, *The History of the British Film, 1929–1939: Film Making in 1930s Britain*, p. 140.

16. Richards, *The Age of the Dream Palace*, pp. 274–75.

17. Low, *The History of the British Film, 1929–1939: Film Making in 1930s Britain*, p. 123.

18. Ibid., p. 218.

19. Susan Rubin Suleiman, *Authoritarian Fictions: The Ideological Novel as a Literary Genre* (New York: Columbia University Press, 1983), pp. 64–68.

20. Richards, *Thorold Dickinson*, p. 89.

21. Ibid.

22. Durgnat, *A Mirror for England*, p. 106.

23. Brown, *Launder and Gilliat*, p. 103.

24. Robin Cross, *The Big Book of British Films* (London: Sidgwick and Jackson, 1984), p. 64.

25. Sue Aspinall and Robert Murphy, "Filmography," in *Gainsborough Melodrama*, ed. Aspinall and Murphy, p. 91.

26. Barr, *Ealing Studios*, p. 78.

27. Perry, *Forever Ealing*, p. 109.

28. John Hill, "Images of Violence," in *Cinema and Ireland*, ed. Kevin Rockett, Luke Gibbons, and John Hill (Syracuse, N.Y.: Syracuse University Press, 1988), p. 175.

CHAPTER THREE: EMPIRE, WAR, AND ESPIONAGE FILMS

1. Schatz, *Hollywood Genres*, p. 34.

2. Armes, *A Critical History of British Cinema*, p. 124.

3. Richards and Aldgate, *British Cinema and Society*, pp. 14–15.

4. Jeffrey Richards, "'Patriotism with Profit,'" p. 252.

5. Michael Korda, *Charmed Lives: A Family Romance* (New York: Avon Books, 1979), p. 326.

6. Richard Dyer, *Heavenly Bodies: Film Stars and Society* (Houndmills, Basingstoke, Hampshire: Macmillan, 1986), p. 96.

7. Richards and Aldgate, *British Cinema and Society*, p. 18.

8. Low, *The History of the British Film, 1929–1939: Film Making in 1930s Britain*, p. 226.

9. Edward Said, *Covering Islam: How the Media and the Experts Determine How We See the Rest of the World* (New York: Pantheon Books, 1981), p. 4.

10. Low, *The History of the British Film, 1929–1939: Film Making in 1930s Britain*, p. 223.

11. Rosaleen Smyth, "Movies and Mandarins: The Official Film and British Colonial Africa," in *British Cinema History*, ed. Curran and Porter, p. 135.

12. Ibid., pp. 129–43.

13. Ibid., p. 135.

14. Ibid., p. 136.

15. Durgnat, *A Mirror for England*, p. 79.

16. Barr, *Ealing Studios*, p. 47.

17. Hill, *Sex, Class and Realism*, p. 78.

18. Low, *The History of the British Film, 1929–1939: Film Making in 1930s Britain*, p. 121.

19. Durgnat, *A Mirror for England*, p. 140.

20. Simone de Beauvoir, *The Second Sex* (New York: Bantam Books, 1970), p. 552.

21. Low, *The History of the British Film, 1929–1939: Film Making in 1930s Britain*, p. 220.

22. Ryall, *Alfred Hitchcock and the British Cinema*, p. 118.

23. Ibid., p. 4.

24. Ibid., p. 78.

25. Andy Medhurst, "Music Hall and British Cinema," in *All Our Yesterdays*, ed. Barr, p. 170.

26. Aspinall, "Women, Realism and Reality," p. 227.

27. Ryall, *Alfred Hitchcock and the British Cinema*, p. 124.

28. Aldgate and Richards, *Britain Can Take It*, p. 79.

29. Ibid., p. 59.

30. Neale, *Genre*, p. 21.

31. Schatz, *Hollywood Genres*, p. 35.

CHAPTER FOUR: THE WAR FILM IN WAR AND PEACE

1. Dana Polan, *Power and Paranoia: History, Narrative, and the American Cinema, 1940–1950* (New York: Columbia University Press, 1986), p. 18.

2. Stevenson, *British Society*, p. 444.

3. Ibid., p. 453.

4. Ibid., p. 456.

5. Aldgate and Richards, *Britain Can Take It*, p. 4.

6. Pronay and Croft, "British Film Censorship and Propaganda Policy," pp. 144–63.

7. Ibid., p. 150.

8. Michael Powell, *A Life in the Movies: An Autobiography* (London: Heinemann, 1986), p. 333.

9. Christine Gledhill and Gillian Swanson, "Gender and Sexuality in Second World War Films: A Feminist Approach," in *National Fictions*, ed. Hurd, p. 57.

10. Andrew Higson, "Addressing the Nation: Five Films," in *National Fictions*, ed. Hurd, p. 22.

11. Gledhill and Swanson, "Gender and Sexuality in Second World War Films," p. 57.

12. Ian Christie, ed., *Powell Pressburger and Others* (London: BFI Publishing, 1978), p. 29.

13. Ibid., p. 30.

14. Pronay and Croft, "British Film Censorship and Propaganda Policy," p. 158.

15. Ibid., p. 156.

16. Aldgate and Richards, *Britain Can Take It*, p. 86.

17. Ibid., p. 47.

18. Ibid., p. 71.

19. John Ellis, "Watching Death at Work: An Analysis of *A Matter of Life and Death*," in *Powell Pressburger and Others*, ed. Christie, p. 94.

20. Ibid., p. 103.

21. Cross, *The Big Book of British Films*, p. 17.

22. Polan, *Power and Paranoia*, p. 65.

23. Perry, *Forever Ealing*, p. 61.

24. Barr, *Ealing Studios*, p. 61.

25. David Lusted, "*Builders* and *The Demi-Paradise*," in *National Fictions*, ed. Hurd, p. 30.

26. Perry, *Forever Ealing*, p. 74.

27. Barr, *Ealing Studios*, pp. 31–32.

28. Perry, *Forever Ealing*, p. 82.

29. Barr, *Ealing Studios*, p. 63.

30. Ibid., p. 149.

31. Edward Said, *Orientalism* (New York: Vintage Books, 1979), p. 7.

32. Marwick, *The Explosion of British Society*, p. 133.

33. Stevenson, *British Society*, p. 468.

34. Dickinson and Street, *Cinema and State*, pp. 100–102, 140–49, 228–33.

35. Marwick, *The Explosion of British Society*, pp. 133–44.

36. Janey Place, "Women in Film Noir," in *Women in Film Noir*, ed. E. Ann Kaplan (London: BFI Publishing, 1980), p. 41.

37. Durgnat, *A Mirror for England*, p. 70.

CHAPTER FIVE: THE WOMAN'S FILM

1. Peter Brooks, *The Melodramatic Imagination: Balzac, Henry James, and the Mode of Excess* (New York: Columbia University Press, 1984), p. 15.

2. Michel Foucault, *The History of Sexuality: An Introduction* (New York: Vintage Books, 1980), 1:100.

3. E. Ann Kaplan, *Women and Film: Both Sides of the Camera* (New York: Methuen, 1983), p. 25.

4. Cook, "Melodrama and the Women's Picture," p. 19.

5. Maria Laplace, "Producing and Consuming the Woman's Film," *Home Is Where the Heart Is*, ed. Gledhill, p. 147.

6. E. Ann Kaplan, "Mothering, Feminism, and Representation: The Maternal Melodrama and the Woman's Film, 1910–40," in *Home Is Where the Heart Is*, ed. Gledhill, p. 116.

7. Laura Mulvey, "Notes on Sirk and Melodrama," in *Home Is Where the Heart Is*, ed. Gledhill, p. 75.

8. Molly Haskell, *From Reverence to Rape: The Treatment of Women in the Movies* (Harmondsworth, Middlesex, England: Penguin Books, 1974).

9. Huyssen, "Mass Culture as Woman," pp. 188–207.

10. Haskell, *From Reverence to Rape*, pp. 153–88.

11. Mary Ann Doane, *The Desire to Desire: The Woman's Film of the 1940s* (Bloomington: Indiana University Press, 1987), p. 284.

12. Tania Modleski, " 'Never to be Thirty-Six Years Old': *Rebecca* as Oedipal Drama," *Wide Angle* 5 (1982): 34.

13. Durgnat, *A Mirror for England*, p. 178.

14. Murphy, "A Brief Studio History," p. 5.

15. Sue Harper, "Interview with Maurice Carter," in *Gainsborough Melodrama*, ed. Aspinall and Murphy, p. 59.

16. Sue Harper, "Art Direction and Costume Design," in *Gainsborough Melodrama*, ed. Aspinall and Murphy, p. 43.

17. Ibid., p. 50.

18. Tania Modleski, *Loving with a Vengeance: Mass Produced Fantasies for Women* (New York: Methuen, 1982), p. 79.

19. Low, *The History of the British Film, 1929–1939: Film Making in 1930s Britain*, p. 133.

20. Ibid., p. 139.

21. Jane Feuer, *The Hollywood Musical* (London: BFI Publishing, 1982), pp. 23–26.

22. Low, *The History of the British Film, 1929–1939: Film Making in 1930s Britain*, p. 137.

23. Doane, *The Desire to Desire*, p. 74.

24. Christian Viviani, "Who Is Without Sin: The Maternal Melodrama in the American Film," in *Home Is Where the Heart Is*, ed. Gledhill, p. 86.

25. Stevenson, *British Society*, pp. 159–81.

26. Ibid., pp. 172–73.

27. Ibid., p. 177.

28. Lucy Fischer, "Two-Faced Women: The 'Double' in Women's Melodramas of the 1940s," *Cinema Journal* 23 (Fall 1983): 24–43.

29. Aspinall, "Women, Realism and Reality," p. 280.

30. Brown, *Launder and Gilliat*, p. 108.

31. Richards and Aldgate, *British Cinema and Society*, p. 116.

32. Brown, *Launder and Gilliat*, p. 108.

33. Aspinall, "Women, Realism and Reality," p. 283.

34. Ibid.

35. Cook, "Melodrama and the Women's Picture," p. 22.

36. Marwick, *The Explosion of British Society*, p. 121.

37. Stevenson, *British Society*, p. 174.

38. Aspinall, "Sexuality in Costume Melodrama," pp. 30–31.

39. Sue Harper, "Historical Pleasures: Gainsborough Melodrama," in *Home Is Where the Heart Is*, ed. Gledhill, p. 178.

40. Ibid., p. 179.

41. Aspinall, "Women, Realism and Reality," p. 276.

42. Aspinall, "Sexuality in Costume Melodrama," p. 33.

43. Ibid., p. 36.

44. Doane, *The Desire to Desire*, p. 44.

45. Ibid., pp. 62–64.

46. Harper, "Historical Pleasures," p. 184.

47. Ibid.

48. Ibid., p. 188.

49. Janice A. Radway, *Reading the Romance: Women, Patriarchy and Popular Literature* (Chapel Hill: University of North Carolina Press, 1984), p. 134.

50. Harper, "Historical Pleasures," p. 181.

51. Aspinall and Murphy, "Filmography," p. 75.

52. Ibid.

53. Ibid., p. 76.

54. Kaplan, *Women and Film*, p. 38.

55. Low, *The History of the British Film, 1929–1939: Film Making in 1930s Britain*, p. 121.

56. Cook, "Melodrama and the Women's Picture," p. 26.

57. Gramsci, *Selections from the Prison Notebooks*, p. 323.

58. Gledhill and Swanson, "Gender and Sexuality in Second World War Films," p. 57.

59. Doane, *The Desire to Desire*, p. 47.

60. See Janet Walker, "Hollywood, Freud, and the Representation of Women: Regulation and Contradiction, 1945–Early 60s," in *Home Is Where the Heart Is*, ed. Gledhill, pp. 197–214.

61. Claire Johnston, "Myths of Women in the Cinema," in *Women and the Cinema: A Critical Anthology*, ed. Karyn Kay and Gerald Peary (New York: E. P. Dutton, 1977), p. 411.

62. Stevenson, *British Society*, p. 467.

63. Doane, *The Desire to Desire*, p. 122.

64. Aspinall and Murphy, "Filmography," p. 77.

65. Barr, *Ealing Studios*, p. 57.

66. Aspinall, "Women, Realism and Reality," p. 288.

CHAPTER SIX: TRAGIC MELODRAMAS

1. Cook, "Melodrama and the Women's Picture," p. 18.

2. Brooks, *The Melodramatic Imagination*, p. 57.

3. Ibid., p. 49.

4. Cook, "Melodrama and the Women's Picture," p. 19.

5. Elsaesser, "Tales of Sound and Fury," p. 185.

6. Cook, "Melodrama and the Women's Picture," pp. 18–19.

7. Foucault, *The History of Sexuality*, p. 103.

8. Jeffrey Weeks, *Sex, Politics and Society: The Regulation of Sexuality Since 1800* (London: Longman, 1981), p. 10.

9. Ibid., p. 40.

10. Caroline Sheldon, "Lesbians and Film: Some Thoughts," in *Gays and Film*, ed. Richard Dyer (New York: Zoetrope, 1984), p. 6.

11. Richard Hoggart, *The Uses of Literacy: Aspects of Working-Class Life with Special Reference to Publications and Entertainment* (New York: Oxford University Press, 1957), p. 48.

12. Vito Russo, *The Celluloid Closet: Homosexuality in the Movies* (New York: Harper and Row, 1987), pp. 5–6.

13. Christie, *Powell Pressburger and Others*, p. 21.

14. Durgnat, *A Mirror for England*, p. 214.

15. Low, *The History of the British Film, 1929–1939: Film Making in 1930s Britain*, p. 169.

16. Nina Epton, *Love and the English* (Cleveland: World Publishing, 1960), pp. 370–71.

17. Ibid., pp. 369–70.

18. Richards and Aldgate, *British Cinema and Society*, p. 32.

19. Ibid., p. 34.

20. Ibid., p. 39.

21. Durgnat, *A Mirror for England*, p. 48.

22. Hoggart, *The Uses of Literacy*, p. 247.

23. Low, *The History of the British Film, 1929–1939: Film Making in 1930s Britain*, p. 255.

24. Jeffrey Richards, "The Black Man as Hero," in *All Our Yesterdays*, ed. Barr, p. 339.

25. Dyer, *Heavenly Bodies*, p. 129.

26. William K. Everson, Program Note to *On the Night of the Fire* (New York: Museum of Modern Art, 1986).

27. Ibid.

28. Low, *The History of the British Film, 1929–1939: Film Making in 1930s Britain*, p. 214.

29. Christine Geraghty, "Masculinity," in *National Fictions*, ed. Hurd, p. 64.

30. Durgnat, *A Mirror for England*, p. 144.

31. Richards, *Thorold Dickinson*, pp. 139–49.

32. Durgnat, *A Mirror for England*, p. 232.

33. Andy Medhurst, "Dirk Bogarde," in *All Our Yesterdays*, ed. Barr, p. 347.

34. For a discussion of this film in relation to other versions of the Isherwood work, see Linda Mizejewski, "Sally Bowles: Fascism, Female Spectacle, and the Politics of Looking," Ph.D. diss., University of Pittsburgh, 1988.

35. Barr, *Ealing Studios*, p. 121.

36. Durgnat, *A Mirror for England*, p. 216.
37. Aspinall and Murphy, "Filmography," p. 80.
38. Richards and Aldgate, *British Cinema and Society*, p. 84.
39. Brown, *Launder and Gilliat*, p. 116.

CHAPTER SEVEN: FAMILY MELODRAMAS

1. David Rodowick, "Madness, Authority and Ideology: The Domestic Melodrama of the 1950s," in *Home Is Where the Heart Is*, ed. Gledhill, p. 271.
2. Weeks, *Sex, Politics and Society*, p. 28.
3. Lucy Bland, Trisha McCabe, and Frank Mort, "Sexuality and Reproduction: Three 'Official' Instances," in *Ideology and Cultural Production*, ed. Michèle Barrett, Philip Corrigan, Annette Kuhn, and Janet Wolff (New York: St. Martin's Press, 1979), pp. 90–91.
4. Stevenson, *British Society*, pp. 178–79.
5. Weeks, *Sex, Politics and Society*, p. 236.
6. Rodowick, "Madness, Authority and Ideology," p. 270.
7. Richard de Cordova, "A Case of Mistaken Legitimacy: Class and Generational Difference in Three Family Melodramas," in *Home Is Where the Heart Is*, ed. Gledhill, p. 266.
8. Robin Wood, Introduction to *American Nightmare: Essays on the Horror Film*, by Andrew Britton, Richard Lippe, Tony Williams, and Robin Wood (Toronto: Festival of Festivals, 1979), p. 8.
9. Low, *The History of the British Film, 1929–1939: Film Making in 1930s Britain*, p. 260.
10. Foucault, *The History of Sexuality*, p. 124.
11. Ibid., p. 125.
12. Robertson, *The British Board of Film Censors*, pp. 83–85.
13. Robert Murphy, "Riff-Raff: British Cinema and the Underworld," in *All Our Yesterdays*, ed. Barr, p. 288.
14. Higson, "Addressing the Nation: Five Films," p. 23.
15. Brown, *Launder and Gilliat*, p. 111.
16. Durgnat, *A Mirror for England*, pp. 50–51.
17. Gledhill and Swanson, "Gender and Sexuality in Second World War Films," p. 58.
18. Murphy, "Riff-Raff," p. 291.
19. Wood, Introduction to *American Nightmare*, pp. 13–16.
20. Barr, *Ealing Studios*, p. 67.
21. Ibid.
22. Weeks, *Sex, Politics and Society*, p. 232.
23. Durgnat, *A Mirror for England*, p. 181.
24. Aspinall, "Women, Realism and Reality," pp. 284–85.
25. Durgnat, *A Mirror for England*, p. 21.
26. Murphy, *Realism and Tinsel*, p. 215.
27. Stevenson, *British Society*, p. 394.

28. Charles Barr, "Broadcasting and Cinema 2: Screens Within Screens," in *All Our Yesterdays*, ed. Barr, p. 209.

29. Ibid., pp. 210–11.

30. Aspinall, "Women, Realism and Reality," p. 288.

CHAPTER EIGHT: FILM COMEDIES

1. Richards, *The Age of the Dream Palace*, p. 253.

2. Medhurst, "Music Hall and British Cinema," p. 171.

3. Ibid., p. 174.

4. Ibid., p. 173.

5. Altman, *The American Film Musical*, p. 132.

6. Medhurst, "Music Hall and British Cinema," p. 175.

7. Armes, *A Critical History of British Cinema*, p. 82.

8. M. M. Bakhtin, *The Dialogic Imagination: Four Essays* (Austin: University of Texas Press, 1981), p. 236.

9. Green, "Ealing: In the Comedy Frame," p. 297.

10. Richards, *The Age of the Dream Palace*, pp. 169–90.

11. Dyer, *Stars*, p. 49.

12. Low, *The History of the British Film, 1929–1939: Film Making in 1930s Britain*, p. 152.

13. Neale, *Genre*, p. 40.

14. Anthony Aldgate, "Comedy, Class and Containment: The British Domestic Cinema of the 1930s," in *British Cinema History*, ed. Curran and Porter, pp. 257–71.

15. Basil Dean, *Mind's Eye: An Autobiography, 1927–1972* (London: Hutchinson, 1973), p. 210.

16. Low, *The History of the British Film, 1929–1939: Film Making in 1930s Britain*, p. 262.

17. Richards, *The Age of the Dream Palace*, p. 208.

18. Ibid., p. 209.

19. Low, *The History of the British Film, 1929–1939: Film Making in 1930s Britain*, p. 137.

20. Durgnat, *A Mirror for England*, p. 172.

21. Neale, *Genre*, p. 41.

22. Low, *The History of the British Film, 1929–1939: Film Making in 1930s Britain*, p. 247.

23. Alan Randall and Ray Seaton, *George Formby: A Biography* (London: W. H. Allen, 1974), p. 9.

24. Richards, *The Age of the Dream Palace*, p. 203.

25. Ibid., p. 186.

26. Rebecca Bell-Metereau, *Hollywood and Androgyny* (New York: Columbia University Press, 1985), pp. 21–22.

27. Ibid.

28. Richards, *The Age of the Dream Palace*, p. 299.

29. Durgnat, *A Mirror for England*, p. 172.

30. Low, *The History of the British Film, 1929–1939: Film Making in 1930s Britain*, p. 186.

31. Hill, "Images of Violence," p. 149.

32. de Beauvoir, *The Second Sex*, p. 561.

33. Low, *The History of the British Film, 1929–1939: Film Making in 1930s Britain*, p. 245.

34. Durgnat, *A Mirror for England*, p. 148.

35. Brown, *Launder and Gilliat*, p. 129.

36. Jordan, "Carry On . . . Follow That Stereotype," p. 316.

37. Ibid., p. 327.

38. Barr, *Ealing Studios*, p. 14.

39. Ibid., p. 6.

40. Ibid., p. 126.

41. Durgnat, *A Mirror for England*, p. 174.

42. Barr, *Ealing Studios*, p. 145.

43. Richards and Aldgate, *British Cinema and Society*, pp. 111–12.

44. Durgnat, *A Mirror for England*, p. 182.

45. Geraghty, "Diana Dors," p. 345.

46. Hill, *Sex, Class and Realism*, p. 145

47. Brown, *Launder and Gilliat*, p. 144.

CHAPTER NINE: HORROR AND SCIENCE FICTION

1. Siegfried Kracauer, *From Caligari to Hitler: A Psychological History of the German Film* (Princeton, N.J.: Princeton University Press, 1974).

2. Richard Abel, *French Cinema: The First Wave, 1915–1929* (Princeton, N.J.: Princeton University Press, 1984), pp. 463–71.

3. Christine Gledhill, "Genre: The Horror Film," in *The Cinema Book*, ed. Cook, p. 99.

4. Pirie, *A Heritage of Horror*, pp. 22–23.

5. Robertson, *The British Board of Film Censors*, pp. 56–59.

6. Wood, Introduction to *American Nightmare*, p. 10.

7. Vivian Carol Sobchack, *The Limits of Infinity: The American Science Fiction Film, 1950–1975* (South Brunswick, N.J.: A. S. Barnes, 1980), pp. 29–30.

8. Neale, *Genre*, p. 21.

9. James B. Twitchell, *Dreadful Pleasures: An Anatomy of Modern Horror* (New York: Oxford University Press, 1985), p. 29.

10. Ibid., p. 50.

11. Wood, Introduction to *American Nightmare*, p. 18.

12. Pirie, *A Heritage of Horror*, p. 24.

13. Charles Derry, *Dark Dreams: A Psychological History of the Modern Horror Film* (South Brunswick, N.J.: A. S. Barnes, 1977), p. 17.

14. Perry, *Forever Ealing*, p. 164.

15. Stevenson, *British Society*, p. 428.

16. Polan, *Power and Paranoia*, p. 187. See also Andrew Tudor, *Monsters and Mad Scientists: A Cultural History of the Horror Movie* (London: Basil Blackwell, 1989).

17. Porter, "The Context of Creativity," p. 205.

18. Barr, *Ealing Studios*, p. 6.

19. Pirie, *A Heritage of Horror*, p. 55.

20. Twitchell, *Dreadful Pleasures*, p. 16.

21. Gilles Deleuze and Felix Guattari, *Anti-Oedipus: Capitalism and Schizophrenia* (New York: Viking Press, 1972).

22. Peter Cushing, *Peter Cushing: An Autobiography* (London: Weidenfeld and Nicolson, 1986), p. 126.

23. Pirie, *A Heritage of Horror*, p. 72.

24. Durgnat, *A Mirror for England*, p. 223.

25. Pirie, *A Heritage of Horror*, p. 73.

26. Leslie Halliwell, *The Dead That Walk: Dracula, Frankenstein, the Mummy, and Other Favorite Movie Monsters* (New York: Continuum, 1988), p. 57.

27. Pirie, *A Heritage of Horror*, p. 87.

28. Ibid.

29. Ibid., p. 108.

30. Ibid.

31. Julian Petley, "The Lost Continent," in *All Our Yesterdays*, ed. Barr, p. 116.

32. Pirie, *A Heritage of Horror*, p. 109.

33. Christie, *Powell Pressburger and Others*, p. 54.

34. Ibid.

35. Ibid., pp. 54–56.

36. Ibid., p. 58.

37. Ibid., p. 60.

38. Lucy Fischer and Marcia Landy, "*The Eyes of Laura Mars*: A Binocular View," in *American Horrors*, ed. Gregory Waller (Urbana: University of Illinois Press, 1987), p. 70.

CHAPTER TEN: THE SOCIAL PROBLEM FILM

1. Peter Roffman and Jim Purdy, *The Hollywood Social Problem Film: Madness, Despair, and Politics from the Depression to the Fifties* (Bloomington: Indiana University Press, 1981), p. viii.

2. Jones, *The British Labour Movement and Film*, p. 23.

3. Richards, *The Age of the Dream Palace*, p. 172.

4. Stevenson, *British Society*, p. 114.

5. Richards, *The Age of the Dream Palace*, p. 173.

6. Bert Hogenkamp, *Deadly Parallels: Film and the Left in Britain, 1929–1939* (London: Lawrence and Wishart, 1986), p. 93.

7. Macpherson, Introduction to *Traditions of Independence*, ed. Macpherson, p. 5.

8. Higson, "Addressing the Nation: Fire Films," p. 22.

9. Ibid., p. 26.

10. Millicent Marcus, *Italian Film in the Light of Neorealism* (Princeton, N.J.: Princeton University Press, 1986), pp. 3–29.

11. Sue Aspinall and Robert Murphy, "Interview with Lady Gardiner (Formerly Muriel Box)," in *Gainsborough Melodrama*, p. 65.

12. Durgnat, *A Mirror for England*, p. 240.

13. Ibid., p. 53.

14. Iain Chambers, *Popular Culture: The Metropolitan Experience* (London: Methuen, 1986), pp. 41–42.

15. Cross, *The Big Book of British Films*, p. 72.

16. Stevenson, *British Society*, p. 263.

17. Ibid., pp. 263–64.

18. Murphy, "Riff-Raff," p. 295.

19. Hill, *Sex, Class and Realism*, p. 183.

20. Geraghty, "Diana Dors," p. 345.

21. Pam Cook, "Mandy: Daughter of Transition," in *All Our Yesterdays*, ed. Barr, p. 355.

22. Hill, *Sex, Class and Realism*, pp. 71–95.

23. Ibid., p. 70.

24. Barr, *Ealing Studios*, p. 75.

25. Terry Lovell, "*Frieda*," in *National Fictions*, ed. Hurd, p. 34.

26. Barr, *Ealing Studios*, pp. 74–75.

27. Hill, *Sex, Class and Realism*, p. 70.

28. Aspinall, "Women, Realism and Reality," p. 285.

29. Barr, *Ealing Studios*, p. 83.

30. Medhurst, "Dirk Bogarde," p. 348.

31. *Programme Notes for "Made in London"* (The Museum of London and the National Film Archive, n.d.).

32. Barr, *Ealing Studios*, p. 151.

33. Hill, *Sex, Class and Realism*, p. 74.

34. Perry, *Forever Ealing*, p. 150.

35. Hill, *Sex, Class and Realism*, p. 83.

36. Barr, *Ealing Studios*, p. 190.

37. Perry, *Forever Ealing*, p. 154.

38. Barr, *Ealing Studios*, p. 149.

39. Durgnat, *A Mirror for England*, p. 138.

40. Hill, *Sex, Class and Realism*, p. 77.

41. Perry, *Forever Ealing*, p. 165.

42. Jim Cook, "*The Ship That Died of Shame*," in *All Our Yesterdays*, ed. Barr, p. 366.

43. Hill, *Sex, Class and Realism*, p. 83.

44. Carrie Tarr, "'Sapphire', 'Darling' and the Boundaries of Permitted Pleasure," *Screen* 26 (January/February 1985): 54.

45. Ibid., p. 56.

46. George Perry, *The Great British Picture Show* (Boston: Little, Brown, 1985), p. 158.

47. Weeks, *Sex, Politics and Society*, p. 240.

48. Ibid., p. 242.

49. Russo, *The Celluloid Closet*, p. 128.

50. Hill, *Sex, Class and Realism*, p. 91.

51. Ibid.

52. Richard Dyer, "Stereotyping," in *Gays and Film*, ed. Dyer, pp. 36–37.

53. Raymond Williams, *Marxism and Literature* (London: Oxford University Press, 1977), pp. 121–27.

Filmography

THE FILMOGRAPHY includes only those films that I have discussed in some detail. Information about production, direction, scenario, and cast members has been gleaned from the films themselves and from three important sources: Denis Gifford, *The British Film Catalogue, 1895–1985: A Reference Guide* (Newton Abbot: David and Charles, 1986); Leslie Halliwell, *Halliwell's Film and Video Guide*, 6th ed. (New York: Charles Scribner's Sons, 1987); and Rachael Low, *The History of the British Film, 1929–1939: Film Making in 1930s Britain* (London: Allen and Unwin, 1985). D = director, P = producer, S = source, SC = scenario, PC = production company, A = actors (major).

CHAPTER TWO: THE HISTORICAL FILM

Bad Lord Byron, The, 1949, D, David Macdonald, P, Aubrey Baring, Sydney Box, S, Terence Young, Anthony Thorne, Peter Quennell, Laurence Kitchin, Paul Holt, PC, Sydney Box, A, Dennis Price, Mai Zetterling, Joan Greenwood.

Beau Brummell, 1954, D, Curtis Bernhardt, P, Sam Zimbalist, S (play), Clyde Fitch, SC, Karl Tunberg, PC, MGM-British, A, Stewart Granger, Elizabeth Taylor, Peter Ustinov.

Blossom Time, 1934, D, Paul Stein, P, Walter C. Mycroft, S, Franz Schulz, SC, John Drinkwater, Roger Burford, Paul Perez, G. H. Clutsam, PC, British International, A, Richard Tauber, Jane Baxter, Carl Esmond, Athene Seyler.

Captain Boycott, 1947, D, Frank Launder, P, Frank Launder, Sidney Gilliat, S (novel), Philip Rooney, SC, Frank Launder, Wolfgang Wilhelm, Paul Vincent Carroll, Patrick Campbell, PC, IP-Individual, A, Stewart Granger, Kathleen Ryan, Cecil Parker, Robert Donat.

Catherine the Great, 1934, D, Paul Czinner, P, Alexander Korda, Ludovico Toeplitz, S (play), Melchior Lengvel, Lajos Biro (*The Czarina*), SC, Lajos Biro, Arthur Wimperis, Marjorie Deans, PC, London (UA), A, Elisabeth Bergner, Douglas Fairbanks, Jr., Flora Robson.

Fire over England, 1937, D, William K. Howard, P, Erich Pommer, Alexander Korda, S (novel), A.E.W. Mason, SC, Clemence Dane, Sergei Nolbandov, PC, London-Pendennis, A, Laurence Olivier, Leslie Banks, Raymond Massey, Vivien Leigh, Flora Robson.

Great Mr. Handel, The, 1942, D, Norman Walker, P, James B. Sloan, S (radio play), L. Du Garde Peach, SC, Gerald Elliott, Victor MacClure, PC, IP-GHW, A, Wilfrid Lawson, Elizabeth Allan.

Henry V, 1945, D, P, Laurence Olivier, S (play), William Shakespeare, SC, Lau-

rence Olivier, Alan Dent, PC, Two Cities, A, Laurence Olivier, Robert Newton, Leslie Banks, Renee Asherson.

Iron Duke, The, 1934, D, Victor Saville, P, Michael Balcon, S, H. M. Harwood, SC, Bess Meredyth, PC, Gaumont, A, George Arliss, Gladys Cooper.

Lady with a Lamp, The, 1951, D, P, Herbert Wilcox, S (play), Reginald Berkeley, SC, Warren Chetham Strode, PC, Imperadio, A, Anna Neagle, Michael Wilding.

Magic Box, The, 1951, D, John Boulting, P, Ronald Neame, S (book), Ray Allister, SC, Eric Ambler, PC, Festival, A, Robert Donat.

Pastor Hall, 1940, D, Roy Boulting, P, John Boulting, S (play), Ernst Toller, SC, Leslie Arliss, Anna Reiner, Haworth Bromley, John Boulting, Roy Boulting, PC, Charter, A, Nova Pilbeam, Wilfrid Lawson, Marius Goring.

Penn of Pennsylvania, 1941, D, Lance Comfort, P, Richard Vernon, S (book), C. E. Vulliamy (*William Penn*), SC, Anatole de Grunwald, PC, British National, A, Clifford Evans, Deborah Kerr.

Prime Minister, The, 1941, D, Thorold Dickinson, P, Max Wilder, S, Brock Williams, Michael Hogan, PC, WB-FN, A, John Gielgud, Diana Wynyard, Fay Compton.

Private Life of Henry VIII, The, 1933, D, Alexander Korda, P, Alexander Korda, Ludovico Toeplitz, S, Lajos Biro, Arthur Wimperis, SC, Arthur Wimperis, PC, London, A, Charles Laughton, Robert Donat, Binnie Barnes, Elsa Lanchester.

Queen Is Crowned, A, 1953, D, P, Castleton Knight, S, Christopher Fry, PC, Rank, A, Laurence Olivier (narrator).

Rembrandt, 1936, D, P, Alexander Korda, S, Carl Zuckmayer, SC, Lajos Biro, June Head, PC, London, A, Charles Laughton, Gertrude Lawrence, Elsa Lanchester.

Scott of the Antarctic, 1948, D, Charles Frend, P, Michael Balcon, Sidney Cole, S, Ivor Montagu, Walter Meade, Mary Hayley Bell, PC, Ealing, A, John Mills.

Sixty Glorious Years, 1938, D, P, Herbert Wilcox, S, Robert Vansittart, Miles Malleson, SC, Charles de Grandcourt, PC, Imperator, A, Anna Neagle, Anton Walbrook, Aubrey Smith, Felix Aylmer.

Tom Brown's Schooldays, 1951, D, Gordon Parry, P, Brian Desmond Hurst, S (novel), Thomas Hughes, SC, Noel Langley, PC, Talisman (Renown), A, John Howard Davies, Robert Newton, Diana Wynyard.

Tudor Rose, 1936, D, S, Robert Stevenson, P, Michael Balcon, SC, Robert Stevenson, Miles Malleson, PC, Gainsborough, A, Cedric Hardwicke, Nova Pilbeam, John Mills.

Victoria the Great, 1937, D, P, Herbert Wilcox, S (play), Laurence Houseman, SC, Miles Malleson, Charles de Grandcourt, PC, Imperator, A, Anna Neagle, Anton Walbrook.

Waltzes from Vienna, 1934, D, Alfred Hitchcock, S (play), Heinz Reichart, Ernst Marischka, M. Willner (*Walzerkrieg*), SC, Alma Reville, Guy Bolton, PC, Tom Arnold, A, Jessie Matthews, Edmund Gwenn.

Young Mr. Pitt, The, 1942, D, Carol Reed, P, Edward Black, S, Viscount Castlerosse, SC, Frank Launder, Sidney Gilliat, PC, Twentieth Century, A, Robert Donat, Robert Morley, Phyllis Calvert, John Mills.

CHAPTER THREE: EMPIRE, WAR, AND ESPIONAGE FILMS

Captain Boycott, 1947, D, Frank Launder, P, Frank Launder, Sidney Gilliat, S (novel), Philip Rooney, SC, Frank Launder, Wolfgang Wilhelm, PC, Individual, A, Stewart Granger, Kathleen Ryan, Cecil Parker, Robert Donat.

Dark Journey, 1937, D, Victor Saville, P, Alexander Korda, S, Lajos Biro, SC, Arthur Wimperis, PC, London–Victor Saville, A, Conrad Veidt, Vivien Leigh, Joan Gardner.

Drum, The, 1938, D, Zoltan Korda, P, Alexander Korda, S (novel), A.E.W. Mason, SC, Lajos Biro, Arthur Wimperis, Patrick Kirwan, Hugh Gray, PC, London-Denham, A, Sabu, Raymond Massey, Valerie Hobson, Roger Livesey.

Elephant Boy, 1937, D, Robert Flaherty, Zoltan Korda, P, Alexander Korda, S (story), Rudyard Kipling, SC, John Collier, Akos Tolnay, Marcia de Sylva, PC, London, A, Sabu, Walter Hudd, Alan Jeayes.

Elusive Pimpernel, The, 1950, D, SC, Michael Powell, Emeric Pressburger, P, Samuel Goldwyn, Alexander Korda, S (novel), Baroness Orczy, PC, London-BLPA-Archers, A, David Niven, Margaret Leighton, Jack Hawkins, Cyril Cusack.

Forever England, 1935, D, Walter Forde, Anthony Asquith, P, Michael Balcon, S (novel), C. S. Forester, SC, Michael Hogan, Gerald Fairlie, PC, Gaumont, A, Betty Balfour, John Mills.

Four Feathers, The, 1939, D, Zoltan Korda, P, Alexander Korda, Irving Asher, S (novel), A.E.W. Mason, SC, R. C. Sheriff, Lajos Biro, Arthur Wimperis, PC, London, A, John Clements, Ralph Richardson, C. Aubrey Smith, June Duprez.

Gentle Gunman, The, 1952, D, Basil Dearden, P, Michael Relph, S (play), Roger Macdougall, SC, Roger Macdougall, PC, Ealing, A, John Mills, Dirk Bogarde, Elizabeth Sellars, Robert Beatty.

I See a Dark Stranger, 1946, D, Frank Launder, P, Frank Launder, Sidney Gilliat, S, Frank Launder, Sidney Gilliat, Wolfgang Wilhelm, SC, Frank Launder, Sidney Gilliat, Liam Redmond, PC, IP-Individual, A, Deborah Kerr, Trevor Howard.

King Solomon's Mines, 1937, D, Robert Stevenson, Geoffrey Barkas, S (novel), H. Rider Haggard, SC, Michael Hogan, Roland Pertwee, A. R. Rawlinson, Charles Bennett, Ralph Spence, PC, Gaumont, A, Paul Robeson, Anna Lee.

Lady Vanishes, The, 1938, D, Alfred Hitchcock, P, Edward Black, S (novel), Ethel Lina White, SC, Frank Launder, Sidney Gilliat, PC, Gainsborough, A, Margaret Lockwood, Michael Redgrave, Dame May Whitty.

Men of Two Worlds, 1946, D, Thorold Dickinson, P, John Sutro, S, E. Arnot Robertson, Joyce Cary, SC, Thorold Dickinson, Herbert W. Victor, PC, Two Cities, A, Phyllis Calvert, Eric Portman, Robert Adams.

Next of Kin, The, 1942, D, Thorold Dickinson, P, Michael Balcon, S. C. Balcon, S, Thorold Dickinson, Basil Bartlett, Angus Macphail, John Dighton, PC, Ealing, A, Mervyn Johns, Nova Pilbeam.

Old Bones of the River, 1938, D, Marcel Varnel, P, Edward Black, S, (novels) Edgar Wallace, SC, Marriott Edgar, Val Guest, J.O.C. Orton, PC, Gainsborough, A, Will Hay, Moore Marriott, Graham Moffatt.

Pimpernel Smith, 1941, D, P, Leslie Howard, S, A. G. MacDonnell, Wolfgang Wilhelm, SC, Anatole de Grunwald, Roland Pertwee, Ian Dalrymple, PC, British National, A, Leslie Howard, Francis L. Sullivan, Mary Morris.

Q Planes, 1939, D, Tim Whelan, P, Irving Asher, Alexander Korda, S, Brock Williams, Jack Whittingham, Arthur Wimperis, SC, Ian Dalrymple, PC, Harefield, A, Laurence Olivier, Valerie Hobson, Ralph Richardson.

Sanders of the River, 1935, D, Zoltan Korda, P, Alexander Korda, S (novel), Edgar Wallace, SC, Lajos Biro, Jeffrey Dell, Arthur Wimperis, PC, London, A, Paul Robeson, Leslie Banks, Nina Mae McKinney.

Scarlet Pimpernel, The, 1934, D, Harold Young, P, Alexander Korda, S (novel), Baroness Orczy, SC, Robert E. Sherwood, Sam Berman, Arthur Wimperis, Lajos Biro, PC, London, A, Leslie Howard, Merle Oberon, Raymond Massey.

Secret Mission, 1942, D, Harold French, P, Marcel Hellman, S, Shaun Terence Young, SC, Anatole de Grunwald, Basil Bartlett, PC, IP-Excelsior, A, Hugh Williams, James Mason, Michael Wilding.

Secret People, 1952, D, Thorold Dickinson, P, Sidney Cole, S, Thorold Dickinson, Joyce Cary, SC, Thorold Dickinson, Wolfgang Wilhelm, Christianna Brand, PC, Ealing, A, Valentina Cortese, Serge Reggiani, Audrey Hepburn.

Seekers, The, 1954, D, Ken Annakin, P, George H. Brown, S (novel), John Guthrie, SC, William Fairchild, PC, Group-Fanfare, A, Jack Hawkins, Glynis Johns.

Shake Hands with the Devil, 1959, D, Michael Anderson, P, George Glass, Walter Seltzer, S (novel), Reardon Conner, SC, Ivan Goff, Ben Roberts, Marian Thompson, PC, Troy-Pennebaker, United Artists, A, James Cagney, Don Murray, Dana Wynter, Glynis Johns, Cyril Cusack.

Simba, 1955, D, Brian Desmond Hurst, P, Peter de Sarigny, S (novel), Anthony Perry, SC, John Baines, Robin Estridge, PC, Group, A, Dirk Bogarde, Donald Sinden, Virginia McKenna, Earl Cameron.

Spy of Napoleon, The, 1936, D, Maurice Elvey, P, Julius Hagen, S (novel), Baroness Orczy, SC, L. Du Garde Peach, Frederick Merrick, Harold Simpson, PC, J.H., A, Richard Barthelmess, Dolly Haas, Frank Vosper, Francis L. Sullivan.

Tell England, 1931, D, Anthony Asquith, Geoffrey Barkas, P, H. Bruce Woolfe, S (novel), Ernest Raymond, SC, Anthony Asquith, PC, British Instructional, A, Fay Compton, Tony Bruce, Carl Harbord.

Thief of Bagdad, The, 1940, D, Michael Powell, Ludwig Berger, Tim Whelan, P, Alexander Korda, S, Lajos Biro, Miles Malleson, PC, London-Korda, A, Conrad Veidt, Sabu, June Duprez.

39 Steps, The, 1935, D, Alfred Hitchcock, P, Michael Balcon, Ivor Montagu, S (novel), John Buchan, SC, Charles Bennett, Ian Hay, Alma Reville, PC, Gaumont, A, Robert Donat, Madeleine Carroll, Godfrey Tearle, Lucie Mannheim.

West of Zanzibar, 1954, D, S, Harry Watt, P, Leslie Norman, SC, Jack Whittingham, Max Catto, PC, Ealing-Schlesinger, A, Anthony Steel, Sheila Sim.

Where No Vultures Fly, 1951, D, S, Harry Watt, P, Leslie Norman, SC, Ralph Smart, W. P. Lipscomb, Leslie Normar, PC, Ealing, A, Anthony Steel, Dinah Sheridan.

CHAPTER FOUR: THE WAR FILM IN WAR AND PEACE

Against the Wind, 1948, D, Charles Crichton, P, Michael Balcon, S, J. Edgar Wills, SC, T.E.B. Clarke, Michael Perwee, PC, Ealing, A, Robert Beatty, Jack Warner, Simone Signoret.

Bridge on the River Kwai, The, 1957, D, David Lean, P, Samuel Spiegel, S (novel), Pierre Boulle, SC, Pierre Boulle, Carl Foreman, Michael Wilson, PC, Horizon, A, William Holden, Alec Guinness, Jack Hawkins, Sessue Hayakawa.

Canterbury Tale, A, 1944, D, P, S, Michael Powell, Emeric Pressburger, PC, IP-Archers, A, Eric Portman, Sheila Sim, Dennis Price, Sgt. John Sweet.

Captive Heart, The, 1946, D, Basil Dearden, P, Michael Balcon, S, Patrick Kirwan, SC, Angus Macphail, Guy Morgan, PC, Ealing, A, Michael Redgrave, Jack Warner, Rachel Kempson.

Colditz Story, The, 1955, D, Guy Hamilton, S (books), P. R. Reid (*The Colditz Story, The Latter Days*), PC, Ivan Foxwell, A, John Mills, Eric Portman.

Cruel Sea, The, 1953, D, Charles Frend, P, Leslie Norman, S (novel), Nicholas Monsarrat, SC, Eric Ambler, PC, Ealing, A, Jack Hawkins, Donald Sinden, Virginia McKenna, Moira Lister.

Dam Busters, The, 1955, D, Michael Anderson, P, Robert Clark, W. A. Whitaker, S, Paul Brickhill, Guy Gibson, SC, R. C. Shariff, PC, ABPC, A, Richard Todd, Michael Redgrave.

Dangerous Moonlight, 1941, D, Brian Desmond Hurst, P, William Sistrom, S, Shaun Terence Young, SC, Shaun Terence Young, Brian Desmond Hurst, Rodney Ackland, A, Anton Walbrook, Sally Gray, Derrick de Marney.

Demi-Paradise, The, 1943, D, Anthony Asquith, P, S, Anatole de Grunwald, PC, Two Cities, A, Laurence Olivier, Penelope Dudley Ward, Margaret Rutherford, Felix Aylmer.

49th Parallel, 1941, D, Michael Powell, P, John Sutro, Michael Powell, S, Emeric Pressburger, SC, Emeric Pressburger, Rodney Ackland, PC, Ortus, A, Leslie Howard, Raymond Massey, Laurence Olivier, Anton Walbrook, Eric Portman.

Halfway House, 1944, D, Basil Dearden, P, Michael Balcon, S (play), Denis Ogden, SC, Angus Macphail, T.E.B. Clarke, PC, Ealing, A, Françoise Rosay, Tom Walls, Mervyn Johns, Glynis Johns.

Highly Dangerous, 1950, D, Roy Baker, P, Anthony Darnborough, S, Eric Ambler, PC, Two Cities, A, Margaret Lockwood, Dane Clark.

High Treason, 1951, D, Roy Boulting, P, Paul Soskin, S, Frank Harvey, Roy Boulting, PC, Conqueror, A, Andre Morell, Liam Redmond, Mary Morris, Kenneth Griffith.

In Which We Serve, 1942, D, Noel Coward, David Lean, P, Noel Coward, Anthony Havelock-Allan, S, Noel Coward, PC, Two Cities, A, John Mills, Bernard Miles, Celia Johnson.

Johnny Frenchman, 1945, D, Charles Frend, P, Michael Balcon, S. C. Balcon, S, T.E.B. Clarke, PC, Ealing, A, Françoise Rosay, Tom Walls, Patricia Roc.

Journey Together, 1945, D, SC, John Boulting, S, Terence Rattigan, PC, RAF Film Unit, A, Richard Attenborough, Edward G. Robinson.

Key, The, 1958, D, Carol Reed, P, Carl Foreman, Aubrey Baring, S, Jan de Hartog (*Stella*), SC, Carl Foreman, PC, Open Road, A, William Holden, Sophia Loren, Trevor Howard.

Life and Death of Colonel Blimp, The, 1943, D, P, S, Michael Powell, Emeric Pressburger, PC, IP-Archers, A, Anton Walbrook, Deborah Kerr, Roger Livesey.

Lion Has Wings, The, 1939, D, Michael Powell, Desmond Hurst, Adrian Brunel, P, Alexander Korda, S, Ian Dalrymple, SC, Adrian Brunel, E.V.H. Emmett (narrator), PC, London-Korda, A, Merle Oberon, Ralph Richardson, June Duprez.

Man Between, The, 1953, D, P, Carol Reed, S (novel), Walter Ebert, SC, Harry Kurnitz, Eric Linklater, PC, London-BLPA, A, James Mason, Claire Bloom, Hildegarde Neff.

Matter of Life and Death, A, 1946, D, P, S, Michael Powell, Emeric Pressburger, PC, IP-Archers, A, David Niven, Roger Livesey, Raymond Massey, Kim Hunter.

One of Our Aircraft Is Missing, 1942, D, P, SC, Michael Powell, Emeric Pressburger, S, Emeric Pressburger, PC, British National–Archers, A, Godfrey Tearle, Eric Portman, Googie Withers, Joyce Redman.

Private's Progress, 1956, D, John Boulting, P, Roy Boulting, S, Frank Harvey, John Boulting, PC, Charter, A, Ian Carmichael, Terry-Thomas, Dennis Price, Richard Attenborough.

Purple Plain, The, 1954, D, Robert Parrish, P, John Bryan, S (novel), H. E. Bates, SC, Eric Ambler, PC, Two Cities, A, Gregory Peck, Win Min Than, Brenda de Banzie.

San Demetrio London, 1943, D, Charles Frend, P, Michael Balcon, Robert Hamer, S, F. Tennyson Jesse, SC, Robert Hamer, Charles Frend, PC, Ealing.

Ships with Wings, 1941, D, Sergei Nolbandov, S. C. Balcon, S, Sergei Nolbandov, Patrick Kirwan, Austin Melford, Diana Morgan, PC, Ealing, A, John Clements, Leslie Banks, Jane Baxter, Ann Todd.

State Secret, 1950, D, Sidney Gilliat, P, Frank Launder, Sidney Gilliat, SC, Sidney Gilliat, PC, London Films, A, Douglas Fairbanks, Jr., Glynis Johns, Jack Hawkins.

Third Man, The, 1949, D, Carol Reed, P, David O. Selznick, Alexander Korda, S (novel), Graham Greene, SC, Graham Greene, PC, London-BLPA, A, Joseph Cotten, Alida Valli, Orson Welles, Trevor Howard.

Way Ahead, The, 1944, D, Carol Reed, P, John Sutro, Norman Walker, S, Eric Ambler, SC, Eric Ambler, Peter Ustinov, PC, Two Cities, A, David Niven, Stanley Holloway.

Way to the Stars, The, 1945, D, Anthony Asquith, P, Anatole de Grunwald, S, Terence Rattigan, Richard Sherman, SC, Terence Rattigan, Anatole de Grunwald, PC, Two Cities, A, Michael Redgrave, John Mills, Rosamund John.

We Dive at Dawn, 1943, D, Anthony Asquith, P, Edward Black, S, J. B. Williams, Val Valentine, Frank Launder, PC, Gainsborough, A, Eric Portman, John Mills.

Went the Day Well? 1942, D, Alberto Cavalcanti, P, Michael Balcon, S. C. Balcon, S, Graham Greene, SC, Angus Macphail, John Dighton, Diana Morgan, PC, Ealing, A, Leslie Banks, Elizabeth Allan, Mervyn Johns.

Wooden Horse, The, 1950, D, Jack Lee, P, Ian Dalrymple, S (book), Eric Williams, SC, Eric Williams, PC, BLPA-Wessex, A, Leo Genn, David Tomlinson, Anthony Steel.

Young Lovers, The, 1954, D, Anthony Asquith, P, Anthony Havelock-Allan, S, George Tabori, SC, Robin Estridge, PC, Group, A, Odile Versois, David Knight.

CHAPTER FIVE: THE WOMAN'S FILM

Bedelia, 1946, D, Lance Comfort, P, Isadore Goldsmith, S (novel), Vera Caspary, SC, Vera Caspary, Herbert Victor, PC, John Corfield, A, Margaret Lockwood, Ian Hunter.

Black Narcissus, 1947, D, P, SC, Michael Powell, S, Rumer Godden, PC, IP-Archers, A, Deborah Kerr, Sabu, Flora Robson.

Brief Encounter, 1945, D, David Lean, P, Noel Coward, S (play), Noel Coward, SC, David Lean, Ronald Neame, PC, IP-Cineguild, A, Celia Johnson, Trevor Howard.

Caravan, 1946, D, Arthur Crabtree, P, Harold Huth, S (novel), Lady Eleanor Smith, SC, Roland Pertwee, PC, Gainsborough, A, Stewart Granger, Jean Kent, Anne Crawford, Dennis Price.

Carnival, 1946, D, Stanley Haynes, P, John Sutro, William Sassoon, S (novel), Compton Mackenzie, SC, Stanley Haynes, Peter Ustinov, Eric Maschwitz, Guy Green, PC, Two Cities, A, Sally Gray, Michael Wilding.

Evensong, 1934, D, Victor Saville, P, Michael Balcon, SC, Edward Knoblock, Dorothy Farnum, PC, Gaumont, A, Evelyn Laye, Fritz Kortner.

Evergreen, 1934, D, Victor Saville, P, Michael Balcon, S (play), Benn W. Levy, SC, Emlyn Williams, Marjorie Gaffney, PC, Gaumont, A, Jessie Matthews, Betty Balfour.

Fanny by Gaslight, 1944, D, Anthony Asquith, P, Edward Black, S (novel), Michael Sadleir, SC, Doreen Montgomery, Aimee Stuart, PC, Gainsborough, A, Phyllis Calvert, James Mason.

Gentle Sex, The, 1943, D, Leslie Howard, Adrian Brunel, P, Derrick de Marney, Leslie Howard, S, Moie Charles, SC, Moie Charles, Aimee Stuart, Roland Pertwee, Phyllis Rose, PC, Two Cities–Concanen, A, Joan Greenwood, Rosamund John, Lilli Palmer.

Illegal, 1932, D, William McGann, P, Irving Asher, SC, Roland Pertwee, PC, WB–FN, A, Isobel Elson, Margot Grahame.

Loves of Joanna Godden, The, 1947, D, Charles Frend, P, Michael Balcon, AP, Sidney Cole, S (novel), Sheila Kaye-Smith (*Joanna Godden*), SC, H. E. Bates, Angus Macphail, PC, Ealing, A, Googie Withers, Jean Kent, John McCallum.

Love Story, 1944, D, Leslie Arliss, P, Harold Huth, S (novel), J. W. Drawbell, SC, Leslie Arliss, Doreen Montgomery, Rodney Ackland, PC, Gainsborough, A, Margaret Lockwood, Stewart Granger, Patricia Roc.

Madonna of the Seven Moons, 1944, D, Arthur Crabtree, P, R. J. Minney, S (novel), Margery Lawrence, SC, Roland Pertwee, Brock Williams, PC, Gainsborough, A, Phyllis Calvert, Stewart Granger, Patricia Roc.

Man in Grey, The, 1943, D, Leslie Arliss, P, Edward Black, S (novel), Lady Eleanor Smith, SC, Margaret Kennedy, Leslie Arliss, PC, Gainsborough, A, Margaret Lockwood, James Mason, Phyllis Calvert, Stewart Granger.

Millions Like Us, 1943, D, S, Frank Launder, Sidney Gilliat, P, Edward Black, PC, Gainsborough, A, Eric Portman, Patricia Roc, Anne Crawford.

Perfect Strangers, 1945, D, P, Alexander Korda, S, Clemence Dane, PC, MGM-London, A, Robert Donat, Deborah Kerr.

Personal Affair, A, 1953, D, Anthony Pelissier, P, Anthony Darnborough, S (play), Lesley Storm, PC, Two Cities, A, Gene Tierney, Leo Genn.

Seventh Veil, The, 1945, D, Compton Bennett, P, John Sutro, Sydney Box, S, Muriel Box, Sydney Box, PC, Theatrecraft-Ortus, A, James Mason, Ann Todd, Herbert Lom.

Stolen Life, A, 1939, D, Paul Czinner, P, Anthony Havelock-Allan, S (novel), Karel J. Benes, SC, Margaret Kennedy, George Barraud, PC, Orion, A, Elisabeth Bergner, Michael Redgrave.

They Were Sisters, 1945, D, Arthur Crabtree, P, Harold Huth, S (novel), Dorothy Whipple, SC, Roland Pertwee, Katherine Strueby, PC, Gainsborough, A, Phyllis Calvert, James Mason, Hugh Sinclair, Anne Crawford.

This Was a Woman, 1948, D, Tim Whelan, P, Marcel Hellman, S (play), Joan Morgan, SC, Val Valentine, PC, Excelsior, A, Sonia Dresdel, Barbara White.

Two Thousand Women, 1944, D, Frank Launder, P, Edward Black, S, Frank Launder, Sidney Gilliat, SC, Frank Launder, Michael Pertwee, PC, Gainsborough, A, Phyllis Calvert, Flora Robson, Patricia Roc, Anne Crawford, Jean Kent.

Wicked Lady, The, 1945, D, Leslie Arliss, P, R. J. Minney, S (novel), Magdalen King-Hall, SC, Leslie Arliss, Aimee Stuart, Gordon Glennon, PC, Gainsborough, A, Margaret Lockwood, James Mason, Patricia Roc.

Woman in a Dressing Gown, 1957, D, J. Lee Thompson, P, Frank Godwin, J. Lee Thompson, SC, Ted Willis, PC, Godwin-Willis-Lee Thompson, A, Yvonne Mitchell, Anthony Quayle, Sylvia Syms.

CHAPTER SIX: TRAGIC MELODRAMAS

Brothers, The, 1947, D, David Macdonald, P, Sydney Box, S, (novella) L.A.G. Strong, SC, Muriel Box, Sydney Box, David Macdonald, Paul Vincent Carroll, PC, Triton, A, Patricia Roc, Maxwell Reed, Finlay Currie, John Laurie.

Browning Version, The, 1951, D, Anthony Asquith, P, Teddy Baird, S, SC, Terence Rattigan, PC, Javelin, A, Michael Redgrave, Jean Kent, Nigel Patrick.

Constant Husband, The, 1955, D, Sidney Gilliat, P, Frank Launder, Sidney Gilliat, S, Sidney Gilliat, Val Valentine, PC, Gilliat-Launder, A, Rex Harrison, Margaret Leighton, Kay Kendall.

Daybreak, 1948, D, Compton Bennett, P, Sydney Box, S (play), Monckton Hoffe, SC, Muriel Box, Sydney Box, PC, Triton, A, Ann Todd, Eric Portman, Maxwell Reed.

Dear Murderer, 1947, D, Arthur Crabtree, P, Betty E. Box, S (play), St. John Leigh Clowes, SC, Muriel Box, Sydney Box, Peter Rogers, PC, Gainsborough, A, Eric Portman, Greta Gynt, Dennis Price.

Edge of the World, The, 1937, D, S, Michael Powell, P, Joe Rock, PC, Rock, A, Niall MacGinnis, John Laurie, Finlay Currie.

Fame Is the Spur, 1947, D, Roy Boulting, P, John Boulting, S (novel), Howard Spring, SC, Nigel Balchin, PC, Two Cities, A, Michael Redgrave, Rosamund John.

Flanagan Boy, The, 1953, D, Reginald Leborg, P, Anthony Hinds, S (novel), Max Catto, SC, Richard Landau, Guy Elmes, PC, Hammer, A, Barbara Payton, Frederick Valk, Tony Wright.

Her Last Affaire, 1935, D, Michael Powell, P, Simon Rowson, Godfrey Rowson, S (play), Walter Ellis (*SOS*), SC, Ian Dalrymple, PC, New Ideal, A, Hugh Williams, Viola Keats, Francis L. Sullivan.

High Command, The, 1937, D, Thorold Dickinson, P, Gordon Wong Wellesley, S (novel), Lewis Robinson (*The General Goes Too Far*), SC, Katherine Strueby, Walter Meade, Val Valentine, PC, Fanfare, A, Lionel Atwill, Lucie Mannheim, Steven Geray, James Mason.

History of Mr. Polly, The, 1949, D, SC, Anthony Pelissier, P, John Mills, S (novel), H. G. Wells, PC, Two Cities A, John Mills, Sally Ann Howes, Finlay Currie, Megs Jenkins.

Hunted, 1952, D, Charles Crichton, P, Julian Wintle, S, Michael McCarthy, SC, Jack Whittingham, PC, BFM–Independent Artists, A, Dirk Bogarde, Jon Whiteley.

I Am a Camera, 1955, D, Henry Cornelius, P, Jack Clayton, S (play), John Van Druten, SC, John Collier, PC, Remus, A, Julie Harris, Laurence Harvey.

Kipps, 1941, D, Carol Reed, P, Edward Black, S (novel), H. G. Wells, SC, Sidney Gilliat, PC, Twentieth Century, A, Michael Redgrave, Diana Wynyard, Phyllis Calvert.

Long Memory, The, 1953, D, Robert Hamer, P, Hugh Stewart, S (novel), Howard Clewes, SC, Robert Hamer, Frank Harvey, PC, Europa, A, John Mills, John McCallum, Elizabeth Sellars.

Men Are Not Gods, 1936, D, S, Walter Reisch, P, Alexander Korda, SC, G. B. Stern, Iris Wright, PC, London, A, Miriam Hopkins, Gertrude Lawrence, Sebastian Shaw, Rex Harrison.

My Brother Jonathan, 1948, D, Harold French, P, Warwick Ward, S (novel), Francis Brett Young, SC, Leslie Landau, Adrian Arlington, PC, ABPC, A, Michael Denison, Dulcie Gray.

My Brother's Keeper, 1948, D, Alfred Roome, Roy Rich, P, Anthony Darnborough, S, Maurice Wiltshire, SC, Frank Harvey, PC, Gainsborough, A, Jack Warner, Jane Hylton, David Tomlinson.

October Man, The, 1947, D, Roy Baker, P, SC, Eric Ambler, S (novel), Eric Ambler, PC, Two Cities, A, John Mills, Joan Greenwood, Edward Chapman, Kay Walsh.

Once a Jolly Swagman, 1948, D, Jack Lee, P, Ian Dalrymple, S (novel), Montagu Slater, SC, Jack Lee, William Rice, Cliff Gordon, PC, Pinewood-Wessex, A, Dirk Bogarde, Bonar Colleano, Renee Asherson.

On the Night of the Fire, 1939, D, Brian Desmond Hurst, P, Josef Somlo, S (novel), F. L. Green, SC, Brian Desmond Hurst, Terence Young, Patrick Kirwan, PC, G&S, A, Ralph Richardson, Diana Wynyard.

Private Life of Don Juan, The, 1934, D, P, Alexander Korda, S (play), Henri

Bataille, SC, Lajos Biro, Frederick Lonsdale, PC, London, A, Douglas Fairbanks, Merle Oberon, Benita Hume, Binnie Barnes.

Proud Valley, The, 1940, D, Pen Tennyson, P, Sergei Nolbandov, S, Herbert Marshall, Alfredda Brilliant, SC, Roland Pertwee, Louis Golding, Jack Jones, PC, Ealing-CAPAD, A, Paul Robeson, Edward Chapman.

Queen of Spades, The, 1949, D, Thorold Dickinson, P, Anatole de Grunwald, S (novel), Alexander Pushkin, SC, Rodney Ackland, Arthur Boys, PC, ABPC–World Screenplays, A, Anton Walbrook, Edith Evans.

Rake's Progress, The, 1945, D, Sidney Gilliat, P, SC, Frank Launder, Sidney Gilliat, S, Val Valentine, PC, IP-Individual, A, Rex Harrison, Lilli Palmer.

Sleeping Tiger, The, 1954, D, Joseph Losey, P, Victor Hanbury, S (novel), Maurice Moisiewitsch, SC, Carl Foreman, PC, Insignia, A, Dirk Bogarde, Alexis Smith, Alexander Knox.

South Riding, 1938, D, Victor Saville, P, Alexander Korda, Victor Saville, S (novel), Winifred Holtby, SC, Ian Dalrymple, Donald Bull, PC, London, A, Ralph Richardson, Edmund Gwenn, Ann Todd, John Clements.

Spider and the Fly, The, 1949, D, Robert Hamer, P, Maxwell Setton, Aubrey Baring, S, Robert Westerby, PC, Pinewood-Mayflower, A, Eric Portman, Guy Rolfe, Nadia Gray.

Stars Look Down, The, 1939, D, Carol Reed, P, Isadore Goldschmidt, S (novel), A. J. Cronin, SC, J. B. Williams, A. J. Cronin, PC, Grafton, A, Michael Redgrave, Margaret Lockwood, Emlyn Williams.

There Ain't No Justice, 1939, D, Pen Tennyson, P, Sergei Nolbandov, S (novel), James Curtis, SC, Pen Tennyson, James Curtis, Sergei Nolbandov, PC, Ealing-CAPAD, A, Jimmy Hanley, Edward Rigby, Mary Clare.

They Drive by Night, 1938, D, Arthur Woods, P, Jerome Jackson, S (novel), James Curtis, SC, Derek Twist, PC, Sydney Box, A, Emlyn Williams, Ernest Thesiger, Anna Konstam.

Upturned Glass, The, 1947, D, Lawrence Huntington, P, Sydney Box, James Mason, S, Jno. P. Monaghan, SC, Jno. P. Monaghan, Pamela Kellino, PC, Triton, A, James Mason, Rosamund John, Pamela Kellino.

CHAPTER SEVEN: FAMILY MELODRAMAS

Blanche Fury, 1948, D, Marc Allegret, P, Anthony Havelock-Allan, S (novel), Joseph Shearing, SC, Audrey Erskine Lindop, Hugh Mills, Cecil McGivern, PC, IP-Cineguild, A, Stewart Granger, Valerie Hobson.

Courtneys of Curzon Street, The, 1947, D, P, Herbert Wilcox, S, Florence Tranter, SC, Nicholas Phipps, PC, Imperadio, A, Anna Neagle, Michael Wilding.

Fallen Idol, The, 1948, D, Carol Reed, P, David O. Selznick, Carol Reed, S (story), Graham Greene, SC, Graham Greene, Lesley Storm, William Templeton, PC, London-Reed, A, Ralph Richardson, Michele Morgan, Sonja Dresdel, Bobby Henrey.

Here Come the Huggetts, 1948, D, Ken Annakin, P, Betty E. Box, SC, Mabel Constanduros, Denis Constanduros, Peter Rogers, Muriel Box, Sydney Box, PC, Gainsborough, A, Jack Warner, Kathleen Harrison, Diana Dors.

Hobson's Choice, 1954, D, P, David Lean, S (play), Harold Brighouse, SC, David Lean, Wynyard Browne, Norman Spencer, PC, London-BLPA, A, Charles Laughton, John Mills, Brenda de Banzie.

Holiday Camp, 1947, D, Ken Annakin, P, Sydney Box, S, Godfrey Winn, SC, Muriel Box, Sydney Box, Peter Rogers, Mabel Constanduros, Denis Constanduros, Ted Willis, PC, Gainsborough, A, Flora Robson, Dennis Price, Jack Warner, Hazel Court.

Holly and the Ivy, The, 1952, D, George More O'Ferrall, P, Anatole de Grunwald, Hugh Perceval, S (play), Wynyard Browne, SC, Anatole de Grunwald, PC, London-BLPA, A, Ralph Richardson, Celia Johnson, Margaret Leighton.

Hungry Hill, 1947, D, Brian Desmond Hurst, P, Wiliam Sistrom, S (novel), Daphne du Maurier, SC, Daphne du Maurier, Terence Young, Francis Crowdy, PC, Two Cities, A, Margaret Lockwood, Dennis Price, Cecil Parker.

It's Hard to Be Good, 1948, D, S, Jeffrey Dell, P, John Gossage, PC, Two Cities, A, Anne Crawford, Jimmy Hanley.

Jassy, 1947, D, Bernard Knowles, P, Sydney Box, S (novel), Norah Lofts, SC, Dorothy Christie, Campbell Christie, Geoffrey Kerr, PC, Gainsborough, A, Margaret Lockwood, Patricia Roc, Dennis Price, Basil Sydney.

Laburnum Grove, 1936, D, Carol Reed, P, Basil Dean, S (play), J. B. Priestley, SC, Gordon Wellesley, Anthony Kimmins, PC, ATP, A, Edmund Gwenn, Cedric Hardwicke, Victoria Hopper, Ethel Coleridge.

Love on the Dole, 1941, D, P, John Baxter, S (play), Ronald Gow, (novel) Walter Greenwood, SC, Walter Greenwood, Barbara K. Emary, Rollo Gamble, PC, British National, A, Deborah Kerr.

Meet Me Tonight, 1952, D, Anthony Pelissier, P, Anthony Havelock-Allan, S (plays), Noel Coward, PC, British Film Makers, A, Valerie Hobson, Jack Warner, Stanley Holloway.

Meet Mr. Lucifer, 1953, D, Anthony Pelissier, P, Monja Danischewsky, S (play), Arnold Ridley, SC, Monja Danischewsky, Peter Myers, Alec Graham, PC, Ealing, A, Stanley Holloway, Peggy Cummins, Joseph Tomelty, Kay Kendall.

Pink String and Sealing Wax, 1945, D, Robert Hamer, P, Michael Balcon, P, S. C. Balcon, S (play), Roland Pertwee, SC, Diana Morgan, Robert Hamer, PC, Ealing, A, Mervyn Johns, Googie Withers.

Place of One's Own, A, 1945, D, Bernard Knowles, P, R. J. Minney, S (novel), Osbert Sitwell, SC, Brock Williams, Osbert Sitwell, PC, Gainsborough, A, Margaret Lockwood, James Mason.

Poison Pen, 1939, D, Paul Stein, P, Walter C. Mycroft, S (play), Richard Llewellyn, SC, Doreen Montgomery, William Freshman, N. C. Hunter, Esther McCracken, PC, ABPC, A, Flora Robson, Robert Newton, Ann Todd.

Rocking Horse Winner, The, 1949, D, SC, Anthony Pelissier, P, John Mills, S (story), D. H. Lawrence, PC, Two Cities, A, John Mills, Valerie Hobson, John Howard Davies.

This Happy Breed, 1944, D, David Lean, P, Noel Coward, Anthony Havelock-Allan, S (play), Noel Coward, SC, David Lean, Ronald Neame, Anthony Havelock-Allan, PC, Two Cities–Cineguild, A, Robert Newton, Celia Johnson, John Mills.

Trottie True, 1949, D, Brian Desmond Hurst, P, Hugh Stewart, S (novel), Caryl Brahms, S. J. Simon, SC, C. Denis Freeman, PC, Two Cities, A, Jean Kent, James Donald.

Waterloo Road, 1945, D, SC, Sidney Gilliat, P, Edward Black, S, Val Valentine, PC, Gainsborough, A, John Mills, Stewart Granger, Alastair Sim, Joy Shelton.

Wings of the Morning, 1937, D, Harold Schuster, P, Robert T. Kane, S, (story) Donn Byrne, SC, Tom Geraghty, John Meehan, Brinsley Macnamara, PC, New World, A, Annabella, Henry Fonda, Leslie Banks.

Winslow Boy, The, 1948, D, Anthony Asquith, P, Anatole de Grunwald, S (play), Terence Rattigan, SC, Terence Rattigan, Anatole de Grunwald, Anthony Asquith, PC, London-BLPA, A, Anthony Asquith, Robert Donat, Margaret Leighton, Cedric Hardwicke.

Woman in the Hall, The, 1947, D, Jack Lee, P, Ian Dalrymple, S (novel), G. B. Stern, SC, G. B. Stern, Ian Dalrymple, Jack Lee, PC, IP-Wessex, A, Ursula Jeans, Jean Simmons, Cecil Parker.

Years Between, The, 1946, D, Compton Bennett, S (play), Daphne du Maurier, SC, Muriel Box, Sydney Box, PC, Sydney Box, A, Michael Redgrave, Valerie Hobson, Flora Robson.

CHAPTER EIGHT: FILM COMEDIES

Belles of St. Trinian's, The, 1954, D, Frank Launder, P, Frank Launder, Sidney Gilliat, S (cartoons), Ronald Searle, SC, Frank Launder, Sidney Gilliat, Val Valentine, PC, British Lion, A, Alastair Sim, Joyce Grenfell, George Cole.

Blue Murder at St. Trinian's, 1957, D, Frank Launder, P, Frank Launder, Sidney Gilliat, S (cartoons), Ronald Searle, SC, Frank Launder, Sidney Gilliat, Val Valentine, PC, John Harvel, A, Terry-Thomas, George Cole, Joyce Grenfell, Alastair Sim.

Boys Will Be Boys, 1935, D, William Beaudine, P, Michael Balcon, S, J. B. Morton, SC, Will Hay, Robert Edmunds, PC, Gainsborough, A, Will Hay, Gordon Harker, Claude Dampier.

Bulldog Jack, 1935, D, Walter Forde, P, Michael Balcon, S, Jack Hulbert, SC, H. C. McNeile, Gerald Fairlie, J.O.C. Orton, Sidney Gilliat, PC, Gaumont, A, Jack Hulbert, Fay Wray, Claude Hulbert, Ralph Richardson.

Cardboard Cavalier, 1949, D, P, Walter Forde, S, Noel Langley, PC, Two Cities, A, Sid Field, Margaret Lockwood.

Carry On Nurse, 1959, D, Gerald Thomas, P, Peter Rogers, S (play), Patrick Cargill, Jack Beale, SC, Norman Hudis, PC, Beaconsfield, A, Wilfrid Hyde-White, Charles Hawtrey, Shirley Eaton, Joan Sims, Terence Longdon.

Convict 99, 1938, D, Marcel Varnel, P, Edward Black, S, Cyril Campion, SC, Marriott Edgar, Val Guest, Jack Davies, Ralph Smart, PC, Gainsborough, A, Will Hay, Moore Marriott, Graham Moffatt, Googie Withers.

Elstree Calling, 1930, D, Adrian Brunel, Alfred Hitchcock, Andre Charlot, Jack Hulbert, Paul Murray, S, Adrian Brunel, Val Valentine, Walter C. Mycroft, PC, BIP, A, Cicely Courtneidge, Jack Hulbert, Lily Morris.

First a Girl, 1935, D, Victor Saville, P, Michael Balcon, S (play), Reinhold Schuenzel, SC, Marjorie Gaffney, PC, Gaumont, A, Jessie Matthews, Sonnie Hale, Griffith Jones, Anna Lee.

Folly to Be Wise, 1952, D, Frank Launder, P, Frank Launder, Sidney Gilliat, S (play), James Bridie, SC, Frank Launder, John Dighton, PC, London-BLPA, A, Alastair Sim, Roland Culver, Martita Hunt, Miles Malleson.

Frozen Limits, The, 1939, D, Marcel Varnel, P, Edward Black, S, Marriott Edgar, Val Guest, J.O.C. Orton, PC, Gainsborough, A, The Crazy Gang, Moore Marriott.

Genevieve, 1953, D, P, Henry Cornelius, S, William Rose, PC, Sirius, A, Kay Kendall, Dinah Sheridan, John Gregson, Kenneth More.

Gert and Daisy's Weekend, 1941, D, Maclean Rogers, P, F. W. Baker, S, Maclean Rogers, Kathleen Butler, H. F. Maltby, PC, Butcher, A, Elsie Waters, Doris Waters, Iris Vandeleur.

Good Morning, Boys, 1937, D, Marcel Varnel, P, Edward Black, S, Anthony Kimmins, SC, Mariott Edgar, Val Guest, PC, Gainsborough, A, Will Hay, Lilli Palmer, Martita Hunt.

Happiest Days of Your Life, The, 1950, D, Frank Launder, P, Frank Launder, Sidney Gilliat, S (play), John Dighton, SC, John Dighton, Frank Launder, PC, BLPA-Individual, A, Alastair Sim, Margaret Rutherford, Joyce Grenfell.

Hey! Hey! U.S.A.! 1938, D, Marcel Varnel, P, Edward Black, S, Howard Irving Young, Jack Swain, Ralph Smart, SC, Marriott Edgar, Val Guest, J.O.C. Orton, PC, Gainsborough, A, Will Hay, Edgar Kennedy.

I'm All Right Jack, 1959, D, John Boulting, P, Roy Boulting, S (novel), Alan Hackney, SC, John Boulting, Frank Harvey, Alan Hackney, PC, Charter, A, Ian Carmichael, Terry-Thomas, Peter Sellers, Richard Attenborough, Margaret Rutherford, Dennis Price, E.V.H. Emmett (narrator).

It's in the Air, 1938, D, SC, Anthony Kimmins, P, Jack Kitchin, PC, ATP, A, George Formby, Polly Ward.

Jack's the Boy, 1932, D, Walter Forde, P, Michael Balcon, S, Jack Hulbert, Douglas Furber, SC, W. P. Lipscomb, PC, Gainsborough, A, Jack Hulbert, Cicely Courtneidge.

Keep Smiling, 1938, D, Monty Banks, P, Robert T. Kane, S (story), Sandor Frago, Alexander Kemedi ("The Boy, the Girl, and the Dog"), SC, William Conselman, Val Valentine, Rodney Ackland, PC, Twentieth Century, A, Gracie Fields, Roger Livesey.

Kind Hearts and Coronets, 1949, D, Robert Hamer, P, Michael Balcon, Michael Relph, S (novel), Roy Horniman, SC, Robert Hamer, John Dighton, PC, Ealing, A, Dennis Price, Valerie Hobson, Joan Greenwood, Alec Guinness.

Lady Godiva Rides Again, 1952, D, Frank Launder, P, Frank Launder, Sidney Gilliat, S, Frank Launder, Val Valentine, PC, London-BLPA, A, Dennis Price, John McCallum.

Ladykillers, The, 1955, D, Alexander Mackendrick, P, Seth Holt, S, William Rose, PC, Ealing, A, Alec Guinness, Cecil Parker, Herbert Lom, Peter Sellers.

Lavender Hill Mob, The, 1951, D, Charles Crichton, P, Michael Balcon, Michael Truman, S, T.E.B. Clarke, PC, Ealing, A, Alec Guinness, Stanley Holloway.

Left, Right and Centre, 1959, D, Sidney Gilliat, P, Frank Launder, Sidney Gilliat, S, Sidney Gilliat, Val Valentine, PC, Vale, A, Ian Carmichael, Alastair Sim.

London Town, 1946, D, S, Wesley Ruggles, SC, Elliot Paul, Sigfried Herzig, Val Guest, PC, Wesley Ruggles, A, Sid Field, Petula Clark, Kay Kendall.

Love on Wheels, 1932, D, Victor Saville, P, Michael Balcon, S, Franz Schulz, Ernst Angel, SC, Victor Saville, Angus Macphail, Robert Stevenson, Douglas Furber, PC, Gainsborough, A, Jack Hulbert, Edmund Gwenn.

Man in the White Suit, The, 1951, D, Alexander Mackendrick, P, Michael Balcon, Sidney Cole, S (play), Roger Macdougall, SC, Roger Macdougall, Alexander Mackendrick, John Dighton, PC, Ealing, A, Alec Guinness, Joan Greenwood, Cecil Parker.

Oh, Mr. Porter! 1937, D, Marcel Varnel, P, Edward Black, S, Frank Launder, SC, Marriott Edgar, Val Guest, J.O.C. Orton, PC, Gainsborough, A, Will Hay, Moore Marriott, Graham Moffatt.

Old Mother Riley, 1937, D, Oswald Mitchell, P, Butcher's at Walton, S (story), John Argyle, SC, Con West, PC, Butcher's, A, Arthur Lucan, Kitty McShane.

Old Mother Riley in Society, 1940, D, John Baxter, P, John Corfield, S, Kitty McShane, Bridget Boland, SC, Austin Medford, Barbara K. Emary, PC, British National, A, Arthur Lucan, Kitty McShane.

Passport to Pimlico, 1949, D, Henry Cornelius, P, Michael Balcon, E.V.H. Emmett, S, Henry Cornelius, T.E.B. Clarke, PC, Ealing, A, Stanley Holloway, Hermione Baddeley, Margaret Rutherford.

Private's Progress, 1956, D, John Boulting, P, Roy Boulting, S (novel), Alan Hackeny, SC, John Boulting, Frank Harvey, PC, Charter, A, Richard Attenborough, Dennis Price, Terry Thomas, Ian Carmichael, E.V.H. Emmett (narrator).

Queen of Hearts, 1936, D, Monty Banks, P, Basil Dean, S, Clifford Grey, H. F. Maltby, SC, Anthony Kimmins, Douglas Furber, Gordon Wellesley, PC, ATP, A, Gracie Fields, John Loder.

Raising a Riot, 1955, D, Wendy Toye, P, Ian Dalrymple, Hugh Perceval, S (novel), Alfred Toombs, SC, Ian Dalrymple, Hugh Perceval, James Matthews, PC, London-Dalrymple, A, Kenneth More, Ronald Squire, Mandy Miller, Olga Lindo.

Sally in Our Alley, 1931, D, Maurice Elvey, P, Basil Dean, S (play), Charles McEvoy, SC, Miles Malleson, Alma Reville, Archie Pitt, PC, ARP, A, Gracie Fields, Ian Hunter, Florence Desmond, Ivor Barnard.

Shipyard Sally, 1939, D, Monty Banks, P, Edward Black, SC, Karl Tunberg, Don Ettlinger, PC, 20th-Century-Fox, A, Gracie Fields, Sydney Howard.

Sing as We Go, 1934, D, Basil Dean, Roland Brown, P, Basil Dean, S, J. B. Priestley, SC, Gordon Wellesley, PC, ATP, A, Gracie Fields, John Loder.

Titfield Thunderbolt, The, 1953, D, Charles Crichton, Terry Bishop, P, Michael Truman, S, T.E.B. Clarke, PC, Ealing, A, Stanley Holloway, George Relph, Naunton Wayne, John Gregson.

To Dorothy a Son, 1954, D, Muriel Box, P, Ben Schrift, Sydney Box, S (play), Roger Macdougall, SC, Peter Rogers, PC, Welbeck, A, Shelley Winters, Peggy Cummins, John Gregson.

Trouble Brewing, 1939, D, Anthony Kimmins, P, Jack Kitchin, S, Anthony Kimmins, Angus Macphail, Michael Hogan, PC, ATP, A, George Formby, Googie Withers.

Trouble in Store, 1953, D, John Paddy Carstairs, P, Maurice Cowan, S, John Paddy Carstairs, Maurice Cowan, Ted Willis, PC, Two Cities, A, Norman Wisdom, Margaret Rutherford.

Up in the World, 1957, D, John Paddy Carstairs, P, Hugh Stewart, S, Jack Davies, Henry Blyth, Peter Blackmore, PC, Rank, A, Norman Wisdom, Maureen Swanson, Jerry Desmonde.

Whisky Galore! 1949, D, Alexander Mackendrick, P, Michael Balcon, Monja Danischewsky, S (novel), Compton Mackenzie, SC, Compton Mackenzie, Angus Macphail, PC, Ealing, A, Basil Radford, Joan Greenwood, James Robertson Justice, Finlay Currie (narrator).

Who Done It? 1956, D, Basil Dearden, P, Michael Relph, S, T.E.B. Clarke, PC, Ealing, A, Benny Hill, Belinda Lee.

Young Wives' Tale, 1951, D, Henry Cass, P, Victor Skutezky, S (play), Ronald Jeans, SC, Anne Burnaby, PC, ABPC, A, Joan Greenwood, Nigel Patrick, Derek Farr.

CHAPTER NINE: HORROR AND SCIENCE FICTION

Abominable Snowman, The, 1957, D, Val Guest, P, Aubrey Baring, S (TV drama), Nigel Kneale, SC, Nigel Kneale, PC, Hammer-Clarion, A, Forrest Tucker, Peter Cushing.

Blood of the Vampire, 1958, D, Henry Cass, P, Robert Blake, Monty Berman, S, Jimmy Sangster, PC, Artistes-Alliance-WNW, A, Donald Wolfit, Barbara Shelley.

Corridors of Blood, 1958, D, Robert Day, P, John Croydon, S, Jean Scott Rogers, PC, Producers Associates, A, Boris Karloff, Betta St. John, Christopher Lee.

Curse of Frankenstein, The, 1957, D, Terence Fisher, P, Anthony Hinds, S (novel), Mary Shelley, SC, Jimmy Sangster, PC, Hammer-Clarion, A, Peter Cushing, Christopher Lee, Hazel Court.

Dead of Night, 1945, D, Basil Dearden, Charles Crichton, Alberto Cavalcanti, Robert Hamer, P, Michael Balcon, S (story), E. F. Benson, SC, Angus Macphail, John Baines, T.E.B. Clarke, PC, Ealing, A, Mervyn Johns, Miles Malleson, Googie Withers, Michael Redgrave.

Dracula, 1958, D, Terence Fisher, P, Anthony Hinds, S (novel), Bram Stoker, SC, Jimmy Sangster, PC, Hammer-Cadogan, A, Peter Cushing, Christopher Lee, Michael Gough.

Four-Sided Triangle, The, 1953, D, Terence Fisher, P, Michael Carreras, Alexander Paal, S (novel), William F. Temple, SC, Terence Fisher, Paul Tabori, PC, Hammer, A, Barbara Payton, James Hayter.

Man Who Could Cheat Death, The, 1959, D, Terence Fisher, P, Anthony Hinds, S (play), Barre Lyndon (*The Man in Half Moon Street*), SC, Jimmy Sangster, PC, Hammer-Cadogan, A, Anton Diffring, Hazel Court, Christopher Lee.

Night My Number Came Up, The, 1955, D, Leslie Norman, P, Tom Morahan, S (article), Victor Goddard, SC, R. C. Sheriff, PC, Ealing, A, Michael Redgrave, Sheila Sim, Alexander Knox.

Peeping Tom, 1960, D, Michael Powell, P, Michael Powell, Albert Fennell, S, Leo Marks, PC, Michael Powell, A, Carl Boehm, Anna Massey.

Quatermass Xperiment, The, 1955, D, Val Guest, P, Anthony Hinds, S (TV serial), Nigel Kneale ("The Quatermass Experiment"), SC, Val Guest, Richard Landau, PC, Hammer-Concanen, A, Brian Donlevy, Jack Warner, Margie Dean.

Seven Days to Noon, 1950, D, Roy Boulting, P, John Boulting, S, Paul Dehn, James Bernard, SC, Roy Boulting, Frank Harvey, PC, London-BLPA, A, Barry Jones, Andre Morell.

So Long at the Fair, 1950, D, Anthony Darnborough, Terence Fisher, P, Betty E. Box, S (novel), Anthony Thorne, SC, Hugh Mills, Anthony Thorne, PC, Gainsborough, A, Jean Simmons, Dirk Bogarde, David Tomlinson.

Spellbound, 1941, D, John Harlow, P, R. Murray Leslie, S (novel), Robert Benson, SC, Miles Malleson, PC, Pyramid Amalgamated, A, Derek Farr, Vera Lindsay, Hay Petrie.

Stolen Face, A, 1952, D, Terence Fisher, P, Anthony Hinds, S, Martin Berkeley, Richard Landau, PC, Hammer-Lippert, A, Lisabeth Scott, Paul Henreid.

Stranglers of Bombay, The, 1959, D, Terence Fisher, P, Anthony Hinds, S, David Z. Goodman, PC, Hammer, A, Guy Rolfe, Allan Cutherbertson.

Uncle Silas, 1947, D, Charles Frank, P, Josef Somlo, Laurence Irving, S (novel), Sheridan le Fanu, PC, Two Cities, A, Jean Simmons, Katina Paxinou, Derrick de Marney.

Womaneater, 1958, D, Charles Saunders, P, Guido Coen, S, Brandon Fleming, PC, Fortress, A, George Coulouris, Vera Day.

CHAPTER TEN: THE SOCIAL PROBLEM FILM

Blue Lamp, The, 1950, D, Basil Dearden, P, Michael Balcon, S, Jan Read, Ted Willis, SC, T.E.B. Clarke, Alexander Mackendrick, PC, Ealing, A, Jack Warner, Jimmy Hanley, Dirk Bogarde.

Boy, a Girl and a Bike, A, 1949, D, Ralph Smart, P, Ralph Keene, S, Ted Willis, PC, Gainsborough, A, John McCallum, Honor Blackman.

Boys in Brown, The, 1949, D, SC, Montgomery Tully, P, Anthony Darnborough, S (play), Reginald Beckwith, PC, Gainsborough, A, Jack Warner, Richard Attenborough, Dirk Bogarde, Jimmy Hanley.

Brave Don't Cry, The, 1952, D, Philip Leacock, P, John Grierson, S, Montagu Slater, PC, Group 3, A, John Gregson, Meg Buchanan.

Brighton Rock, 1947, D, John Boulting, P, Roy Boulting, S (novel), Graham Greene, SC, Graham Greene, Terence Rattigan, PC, ABPC, A, Richard Attenborough, Hermione Baddeley, Carol Marsh.

Cage of Gold, 1950, D, Basil Dearden, P, Michael Balcon, S, Jack Whittingham, SC, Jack Whittingham, Paul Stein, PC, Ealing, A, Jean Simmons, David Farrar.

Citadel, The, 1938, D, King Vidor, P, Victor Saville, S (novel), A. J. Cronin, SC, Frank Wead, Emlyn Williams, Ian Dalrymple, Elizabeth Hill, John Van Druten, PC, MGM-British, A, Robert Donat, Rosalind Russell.

Dance Hall, 1950, D, Charles Crichton, P, E.V.H. Emmett, S, E.V.H. Emmett, Diana Morgan, Alexander Mackendrick, PC, Ealing, A, Donald Houston, Bonar Colleano, Petula Clark, Natasha Parry, Jane Hylton, Diana Dors.

Frieda, 1947, D, Basil Dearden, P, Michael Balcon, S (play), Ronald Miller, SC, Ronald Miller, Angus Macphail, PC, Ealing, A, David Farrar, Mai Zetterling, Glynis Johns, Flora Robson.

Good Time Girl, 1948, D, David Macdonald, P, Sydney Box, Samuel Goldwyn, Jr., S (novel), Arthur la Bern, SC, Muriel Box, Sydney Box, Ted Willis, PC, Triton, A, Jean Kent, Dennis Price, Flora Robson.

Guinea Pig, The, 1948, D, Roy Boulting, P, John Boulting, S (play), Warren Chetham Strode, SC, Warren Chetham Strode, Bernard Miles, Roy Boulting, PC, Pilgrim, A, Richard Attenborough, Bernard Miles, Joan Hickson, Cecil Trouncer.

I Believe in You, 1952, D, Basil Dearden, P, Michael Relph, S (book), Sewell Stokes (*Court Circular*), SC, Michael Ralph, Basil Dearden, Jack Whittingham, Nicholas Phipps, PC, Ealing, A, Celia Johnson, Cecil Parker.

Intruder, The, 1953, D, Guy Hamilton, S (novel), Robin Maugham, SC, Robin Maugham, John Hunter, Anthony Squire, PC, Ivan Foxwell, A, Jack Hawkins, George Cole, Dennis Price, Michael Medwin.

Lost People, The, 1949, D, Bernard Knowles, Muriel Box, P, Gordon Wellesley, S (play), Bridget Boland (*Cockpit*), SC, Bridget Boland, Muriel Box, PC, Gainsborough, A, Dennis Price, Mai Zetterling, Richard Attenborough, Siobhan McKenna.

Mandy, 1952, D, Alexander Mackendrick, P, Leslie Norman, S (novel), Hilda Lewis (*The Day is Ours*), SC, Jack Whittingham, Nigel Balchin, PC, Ealing, A, Phyllis Calvert, Jack Hawkins, Mandy Miller.

Morning Departure, 1950, D, Leslie Parkyn, P, Roy Baker, S (play), Kenneth Woollard, SC, William Fairchild, PC, Jay Lewis (GFD), A, John Mills, Richard Attenborough, Nigel Patrick.

Pool of London, 1951, D, Basil Dearden, P, Michael Balcon, Michael Relph, S, Jack Whittingham, John Eldridge, PC, Ealing, A, Bonar Colleano, Susan Shaw, Renee Asherson, Earl Cameron.

Sapphire, 1959, D, Basil Dearden, P, Michael Relph, S, Janet Green, SC, Janet Green, Lukas Heller, PC, Artna, A, Nigel Patrick, Yvonne Mitchell, Michael Craig.

Ship That Died of Shame, The, 1955, D, Basil Dearden, P, Michael Relph, S (novel), Nicholas Monsarrat, SC, Michael Ralph, Basil Dearden, John Whiting, PC, Ealing, A, Richard Attenborough, George Baker.

Victim, 1961, D, Basil Dearden, P, Michael Relph, S, Janet Green, John McCormick, PC, Parkway, A, Dirk Bogarde, Sylvia Syms, Dennis Price.

Weak and the Wicked, The, 1954, D, J. Lee Thompson, P, Victor Skutezky, S (novel), Joan Henry, SC, J. Lee Thompson, Joan Henry, PC, Marble Arch, A, Glynis Johns, John Gregson, Jane Hylton, Diana Dors.

Yellow Balloon, The, 1952, D, J. Lee Thompson, P, Victor Skutezky, S, Anne Burnaby, SC, J. Lee Thompson, Anne Burnaby, PC, Marble Arch, A, William Sylvester, Kenneth More, Kathleen Ryan, Andrew Ray.

Yield to the Night, 1956, D, J. Lee Thompson, P, Kenneth Harper, S (novel), Joan Henry, SC, Joan Henry, John Cresswell, PC, Kenwood, A, Diana Dors, Yvonne Mitchell.

Bibliography

Abel, Richard. *French Cinema: The First Wave, 1915–1929*. Princeton, N.J.: Princeton University Press, 1984.

Adair, Gilbert, and Nick Roddick. *A Night at the Pictures*. Bromley, Kent, England: Columbus Books, 1985.

Addison, Paul. *The Road to 1945: British Politics and the Second World War*. London: Jonathan Cape, 1975.

Adorno, Theodor. *Prisms*. London: Neville Spearman, 1967.

Affron, Charles. *Cinema and Sentiment*. Chicago: University of Chicago Press, 1982.

Aldgate, Anthony. *Cinema and History: British Newsreels and the Spanish Civil War*. London: Scolar Press, 1979.

———. "Comedy, Class and Containment: The British Domestic Cinema of the 1930s." In *British Cinema History*, ed. James Curran and Vincent Porter, 257–71. London: Weidenfeld and Nicolson, 1983.

Aldgate, Anthony, and Jeffrey Richards. *Britain Can Take It: The British Cinema in the Second World War*. Oxford: Basil Blackwell, 1986.

Altman, Rick. *The American Film Musical*. Bloomington: Indiana University Press, 1987.

Anderegg, Michael. *David Lean*. Boston: Twayne Publishers, 1984.

Armes, Roy. *A Critical History of British Cinema*. New York: Oxford University Press, 1978.

Aspinall, Sue. "Sexuality in Costume Melodrama." In *Gainsborough Melodrama*, ed. Sue Aspinall and Robert Murphy, 29–39. London: British Film Institute, 1983.

Aspinall, Sue. "Women, Realism and Reality in British Films, 1949–1953." In *British Cinema History*, ed. James Curran and Vincent Porter, 272–93. London: Weidenfeld and Nicolson, 1983.

Aspinall, Sue, and Robert Murphy. "Interview with Lady Gardiner (Formerly Muriel Box)." In *Gainsborough Melodrama*, ed. Sue Aspinall and Robert Murphy, 63–66. London: British Film Institute, 1983.

Auty, Martin, and Nick Roddick. *British Cinema Now*. London: BFI Publishing, 1985.

Bakhtin, M. M. *The Dialogic Imagination: Four Essays*. Austin: University of Texas Press, 1981.

Balcon, Michael. *Michael Balcon Presents: A Lifetime of Films*. London: Hutchinson, 1968.

Balcon, Michael, Ernest Lindgren, Forsyth Hardy, and Roger Manvell. *Twenty Years of British Film, 1925–1945*. London: Falcon Press, 1947.

Barr, Charles. *Ealing Studios*. Woodstock, N.Y.: Overlook Press, 1980.

———. "Broadcasting and Cinema 2: Screens Within Screens." In *All Our Yester-*

days: 90 Years of British Cinema, ed. Charles Barr, 206–24. London: BFI Publishing, 1986.

———, ed. *All Our Yesterdays: 90 Years of British Cinema*. London: BFI Publishing, 1986.

Barrett, Michèle, Philip Corrigan, Annette Kuhn, and Janet Wolff, eds. *Ideology and Cultural Production*. New York: St. Martin's Press, 1979.

Barrow, Kenneth. *Mr. Chips: The Life of Robert Donat*. London: Methuen, 1985.

Barsam, Richard. *Nonfiction Film: A Critical History*. New York: E. P. Dutton, 1973.

Bartlett, C. J. *A History of Postwar Britain*. New York: Longman, 1977.

Baxter, John. *Science Fiction in the Cinema*. London: Tantivy Press, 1974.

Baudrillard, Jean. *Selected Writings*. Ed. Mark Poster. London: Polity Press, 1988.

Bell-Metereau, Rebecca. *Hollywood and Androgyny*. New York: Columbia University Press, 1985.

Betts, Ernest. *The Film Business: A History of British Cinema, 1896–1972*. London: Allen and Unwin, 1973.

Bland, Lucy, Trisha McCabe, and Frank Mort. "Sexuality and Reproduction: Three 'Official' Instances." In *Ideology and Cultural Production*, ed. Michèle Barrett, Philip Corrigan, Annette Kuhn, and Janet Wolff, 78–111. New York: St. Martin's Press, 1979.

Bolitho, Hector. *Their Majesties*. London: Max Parrish, 1951.

Bordwell, David. *Narration in the Fiction Film*. Madison: University of Wisconsin Press, 1985.

Bourget, Jean Loup. "Faces of the American Melodrama: Joan Crawford." *Film Reader* 3 (February 1978): 24–34.

———. *Le mélodrame hollywoodien*. Toulouse: Stock, 1985.

Brandeth, Gyles. *John Gielgud: A Celebration*. Boston: Little, Brown, 1984.

Britton, Andrew, Richard Lippe, Tony Williams, and Robin Wood. *American Nightmare: Essays on the Horror Film*. Toronto: Festival of Festivals, 1979.

Brooks, Peter. *The Melodramatic Imagination: Balzac, Henry James, and the Mode of Excess*. New York: Columbia University Press, 1984.

Brosnan, John. *The Horror People*. New York: New American Library, 1977.

Brown, Geoff. *Launder and Gilliat*. London: BFI Publishing, 1977.

———. "Sisters of the Stage: British Film and British Theatre." In *All Our Yesterdays: 90 Years of British Cinema*, ed. Charles Barr, 143–67. London: BFI Publishing, 1986.

Brown, Geoff, Lawrence Kardish, and Michael Balcon. *The Pursuit of British Cinema*. New York: Museum of Modern Art, 1984.

Butler, Ivan. *The War Film*. South Brunswick, N.J.: A. S. Barnes, 1974.

Calder, Angus. *The People's War: Britain, 1939–1945*. New York: Pantheon Books, 1969.

Carmichael, Ian. *Will the Real Ian Carmichael . . . An Autobiography*. London: Macmillan, 1979.

Carroll, Noël. *The Philosophy of Horror or Paradoxes of the Heart*. New York: Routledge, 1990.

Cawelti, John G. *Adventure, Mystery, and Romance: Formula Stories as Art and Popular Culture*. Chicago: University of Chicago Press, 1976.

Chambers, Iain. *Popular Culture: The Metropolitan Experience*. London: Methuen, 1986.

Chanan, Michael. *Labour Power in the British Film Industry*. London: BFI Publishing, 1976.

———. *The Dream That Kicks: The Prehistory and Early Years of Cinema in Britain*. London: Routledge and Kegan Paul, 1980.

Chanan, Michael. "The Emergence of an Industry." In *British Cinema History*, ed. James Curran and Vincent Porter, 39–58. London: Weidenfeld and Nicolson, 1983.

Christie, Ian, ed. *Powell Pressburger and Others*. London: BFI Publishing, 1978.

———. *Arrows of Desire: The Films of Michael Powell and Emeric Pressburger*. London: Waterstone, 1985.

Clarens, Carlos. *An Illustrated History of the Horror Film*. New York: Capricorn Books, 1967.

———. *An Illustrated History: The Story of the Gangster Genre in Film from D. W. Griffith and Beyond*. New York: W. W. Norton, 1980.

Coates, David. *The Context of British Politics*. London: Hutchinson, 1984.

Cook, Jim. "*The Ship That Died of Shame*," in *All Our Yesterdays: 90 Years of British Cinema*, 362–67. London: BFI Publishing, 1986.

Cook, Pam. "Melodrama and the Women's Picture." In *Gainsborough Melodrama*, ed. Sue Aspinall and Robert Murphy, 14–28. London: British Film Institute, 1983.

———. "Mandy: Daughter of Transition." In *All Our Yesterdays: 90 Years of British Cinema*, ed. Charles Barr, 355–61. London: BFI Publishing, 1986.

———. ed. *The Cinema Book*. London: BFI Publishing, 1985.

Coultass, Clive. *Images for Battle: British Film and the Second World War, 1939–1945*. London: Associated University Presses, 1989.

Cross, Robin. *The Big Book of British Films*. London: Sidgwick and Jackson, 1984.

Curran, James, and Vincent Porter, eds. *British Cinema History*. London: Weidenfeld and Nicolson, 1983.

Cushing, Peter. *Peter Cushing: An Autobiography*. London: Weidenfeld and Nicolson, 1986.

Dean, Basil. *Mind's Eye: An Autobiography, 1927–1972*. London: Hutchinson, 1973.

de Beauvoir, Simone. *The Second Sex*. New York: Bantam Books, 1970.

de Cordova, Richard. "A Case of Mistaken Legitimacy: Class and Generational Difference in Three Family Melodramas." In *Home Is Where the Heart Is: Studies in Melodrama and the Woman's Film*, ed. Christine Gledhill, 255–67. London: BFI Publishing, 1987.

de Lauretis, Teresa. *Alice Doesn't: Feminism, Semiotics, Cinema*. Bloomington: Indiana University Press, 1984.

———, ed. *Feminist Studies/Critical Studies*. Bloomington: Indiana University Press, 1986.

Deleuze, Gilles, and Felix Guattari. *Anti-Oedipus:. Capitalism and Schizophrenia*. New York: Viking Press, 1972.

Derry, Charles. *Dark Dreams: A Psychological History of the Modern Horror Film*. South Brunswick, N.J.: A. S. Barnes, 1977.

Dickinson, Margaret. "The State and the Consolidation of Monopoly." In *British Cinema History*, ed. James Curran and Vincent Porter, 74–95. London: Weidenfeld and Nicolson, 1983.

Dickinson, Margaret, and Sarah Street. *Cinema and State: The Film Industry and the British Government, 1927–84*. London: BFI Publishing, 1985.

Doane, Mary Ann. *The Desire to Desire: The Woman's Film of the 1940s*. Bloomington: Indiana University Press, 1987.

Doane, Mary Ann, Patricia Mellencamp, and Linda Williams. *Re-Vision: Essays in Feminist Film Criticism*. Frederick, Md.: University Publications of America, 1984.

Dors, Diana. *Dors by Diana*. London: Queen Anne Futura Press, 1981.

Dunbar, Janet. *Flora Robson*. London: George G. Harrap, 1960.

Dundy, Elaine. *Finch, Bloody Finch: A Biography of Peter Finch*. London: Michael Joseph, 1980.

Durgnat, Raymond. "Ways of Melodrama." *Sight and Sound* 21 (1951): 34–40.

———. *A Mirror for England: British Movies from Austerity to Affluence*. London: Faber and Faber, 1970.

Dyer, Richard. "Stereotyping." In *Gays & Film*, ed. Richard Dyer, 27–39. New York: Zoetrope, 1984.

———. *Heavenly Bodies: Film Stars and Society*. Houndmills, Basingstoke, Hampshire: Macmillan, 1986.

Dyer, Richard. *Stars*. London: BFI Publishing, 1986.

———, ed. *Gays & Film*. New York: Zoetrope, 1984.

Eagleton, Terry. "Ideology, Fiction, Narrative." *Social Text* 2 (Summer 1979): 62–81.

Ellis, John. "Watching Death at Work: An Analysis of *A Matter of Life and Death*." In *Powell Pressburger and Others*, ed. Ian Christie, 79–104. London: BFI Publishing, 1978

———. *Visible Fictions: Cinema: Television: Video*. London: Routledge and Kegan Paul, 1982.

Elsaesser, Thomas. "Tales of Sound and Fury: Observations on the Family Melodrama." In *Movies and Methods*, ed. Bill Nichols, 2:165–89. Berkeley: University of California Press, 1985.

Epton, Nina. *Love and the English*. Cleveland: World Publishing, 1960.

Everson, William K. Program Note to *On the Night of the Fire*. New York: Museum of Modern Art, 1986.

Eyles, Allen, Robert Adkinson, and Nicholas Fry, eds. *The House of Horror: The Complete Story of Hammer Films*. New York: Lorrimer, 1984.

Falk, Quentin. *The Golden Gong: Fifty Years of the Rank Organisation, Its Films and Its Stars*. London: Columbus Books, 1987.

Feuer, Jane. *The Hollywood Musical*. London: BFI Publishing, 1982.

Fields, Gracie. *Sing as We Go: The Autobiography of Gracie Fields*. London: Frederick Muller, 1960.

Fischer, Lucy. "Two-Faced Women: The 'Double' in Women's Melodramas of the 1940s." *Cinema Journal* 23 (Fall 1983): 24–43.

———. *Shot/Countershot: Film Tradition and Women's Cinema*. Princeton, N.J.: Princeton University Press, 1989.

Fischer, Lucy, and Marcia Landy. "*The Eyes of Laura Mars*: A Binocular View." In *American Horrors*, ed. Gregory Waller, 62–78. Urbana: University of Illinois Press, 1987.

Fisher, Nigel. *Harold Macmillan: A Biography*. London: Weidenfeld and Nicolson, 1982.

Foucault, Michel. *The History of Sexuality: An Introduction*. Vol. 1. New York: Vintage Books, 1980.

Fraser, George Macdonald. *The Hollywood History of the World*. Harmondsworth, Middlesex, England: Penguin Books, 1988.

Fraser, Peter. "The Musical Mode: Putting on *The Red Shoes*." *Cinema Journal* 26 (Spring 1987): 44–55.

Gabbard, Krin, and Glen O. Gabbard. *Psychiatry and the Cinema*. Chicago: University of Chicago Press, 1987.

Gaines, Jane. "The Queen Christina Tie-Ups: Convergence of Show Window and Screen." *Quarterly Review of Film and Video* 11 (1989): 35–60.

Geraghty, Christine. "Masculinity." In *National Fictions: World War Two in British Films and Television*, ed. Geoff Hurd, 63–67. London: BFI Publishing, 1984.

———. "Diana Dors." In *All Our Yesterdays: 90 Years of British Cinema*, ed. Charles Barr, 341–45. London: BFI Publishing, 1986.

Gerould, Daniel. "Russian Formalist Theories of Melodrama." *Journal of American Culture* 1 (1978): 152–68.

Gielgud, John. *Gielgud: An Actor and His Time*. New York: Clarkson Potter, 1968.

Gifford, Denis. *British Cinema: An Illustrated Guide*. London: A. Zwemmer, 1968.

———. *A Pictorial History of Horror Movies*. London: Hamlyn, 1973.

———. *The British Film Catalogue, 1895–1985: A Reference Guide*. Newton Abbot: David and Charles, 1986.

Gili, Jean. "Film storico e film in costume." In *Cinema italiano sotto il fascismo*, ed. Riccardo Redi, 129–44. Venice: Marsilio, 1979.

Gledhill, Christine. "Genre." In *The Cinema Book*, ed. Pam Cook, 58–64. London: BFI Publishing, 1985.

———. "Genre: The Horror Film." In *The Cinema Book*, ed. Pam Cook, 99–105. London: BFI Publishing, 1985.

———. "The Melodramatic Field: An Investigation." In *Home Is Where the Heart Is: Studies in Melodrama and the Woman's Film*, ed. Christine Gledhill, 5–39. London: BFI Publishing, 1987.

Gledhill, Christine, and Gillian Swanson. "Gender and Sexuality in Second World War Films: A Feminist Approach." In *National Fictions: World War Two in British Films and Television*, ed. Geoff Hurd, 56–62. London: BFI Publishing, 1984.

Gloversmith, Frank, ed. *Class, Culture and Social Change: A New View of the 1930s*. Sussex, England: The Harvester Press, 1980.

Glyn, Anthony. *The British: Portrait of a People*. New York: G. P. Putnam's Sons, 1970.

Gramsci, Antonio. *Selections from the Prison Notebooks*. Ed. Quintin Hoare and Geoffrey Nowell-Smith. New York: International Publishers, 1978.

Granger, Stewart. *Sparks Fly Upward*. New York: G. P. Putnam's Sons, 1981.

Green, Ian "Ealing: In the Comedy Frame." In *British Cinema History*, ed. James Curran and Vincent Porter, 294–302. London: Weidenfeld and Nicolson, 1983.

Grenfell, Joyce. *Joyce Grenfell Requests the Pleasure*. London: Futura Publications, 1986.

Guinness, Alec. *Blessings in Disguise*. London: Hamish Hamilton, 1985.

Hall, Stuart, Dorothy Hobson, Andrew Lowe, and Paul Willis, eds. *Culture, Media, Language: Working Papers in Cultural Studies, 1972–79*. London: Hutchinson/Centre for Contemporary Cultural Studies, University of Birmingham, 1984.

Halliwell, Leslie. *Halliwell's Film and Video Guide*. 6th ed. New York: Charles Scribner's Sons, 1987.

——————. *The Dead That Walk: Dracula, Frankenstein, the Mummy, and Other Favorite Movie Monsters*. New York: Continuum, 1988.

Harper, Sue. "Art Direction and Costume Design." In *Gainsborough Melodrama*, ed. Sue Aspinall and Robert Murphy, 40–52. London: British Film Institute, 1983.

——————. "Interview with Maurice Carter." In *Gainsborough Melodrama*, ed. Sue Aspinall and Robert Murphy, 55–59. London: BFI Publishing, 1983.

——————. "Historical Pleasures: Gainsborough Melodrama." In *Home Is Where the Heart Is: Studies in Melodrama and the Woman's Film*, ed. Christine Gledhill, 167–96. London: BFI Publishing, 1987.

Haskell, Molly. *From Reverence to Rape: The Treatment of Women in the Movies*. Harmondsworth, Middlesex, England: Penguin Books, 1974.

Heath, Stephen. *Questions of Cinema*. Bloomington: Indiana University Press, 1981.

Hewison, Robert. *In Anger: British Culture in the Cold War, 1945–1960*. New York: Oxford University Press, 1981.

Higham, Charles. *Charles Laughton: An Intimate Biography*. London: W. H. Allen, 1976.

Higham, Charles, and Roy Moseley. *Princess Merle: The Romantic Life of Merle Oberon*. New York: Coward-McCann, 1983.

Higson, Andrew. "Addressing the Nation: Five Films." In *National Fictions: World War Two in British Films and Television*, ed. Geoff Hurd, 22–26. London: BFI Publishing, 1984.

Hill, John. *Sex, Class and Realism: British Cinema, 1956–1963*. London: BFI Publishing, 1986.

——————. "Images of Violence." In *Cinema and Ireland*, by Kevin Rockett, Luke Gibbons, and John Hill, 147–93. Syracuse, N.Y.: Syracuse University Press, 1988.

Hogenkamp, Bert. *Deadly Parallels: Film and the Left in Britain, 1929–1939*. London: Lawrence and Wishart, 1986.

Hoggart, Richard. *The Uses of Literacy: Aspects of Working-Class Life with Special Reference to Publications and Entertainment.* New York: Oxford University Press, 1957.

Hood, Stuart. "John Grierson and the Documentary Film Movement." In *British Cinema History,* ed. James Curran and Vincent Porter, 99–112. London: Weidenfeld and Nicolson, 1983.

Hurd, Geoff. "Notes on Hegemony, the War, and Cinema." In *National Fictions: World War Two in British Films and Television,* ed. Geoff Hurd, 18–19. London: BFI Publishing, 1984.

———, ed. *National Fictions: World War Two in British Films and Television.* London: BFI Publishing, 1984.

Huss, Roy, and T. J. Ross. *Focus on the Horror Film.* Englewood Cliffs, N.J.: Prentice-Hall, 1972.

Huyssen, Andreas. "Mass Culture as Woman: Modernism's Other." In *Studies in Entertainment: Critical Approaches to Mass Culture,* ed. Tania Modleski, 188–207. Bloomington: Indiana University Press, 1986.

Johnston, Claire. "Myths of Women in the Cinema." In *Women and the Cinema: A Critical Anthology,* ed. Karyn Kay and Gerald Peary, 407–11. New York: E. P. Dutton, 1977.

Jones, Stephen G. *The British Labour Movement and Film, 1918–1939.* London: Routledge and Kegan Paul, 1987.

Jordan, Marion. "Carry On . . . Follow That Stereotype." In *British Cinema History,* ed. James Curran and Vincent Porter, 312–27. London: Weidenfeld and Nicolson, 1983.

Kaplan, E. Ann. *Women and Film: Both Sides of the Camera.* New York: Methuen, 1983.

———. "Mothering, Feminism and Representation: The Maternal Melodrama and the Woman's Film, 1910–40." In *Home Is Where the Heart Is: Studies in Melodrama and the Woman's Film,* ed. Christine Gledhill, 113–37. London: BFI Publishing, 1987.

———, ed. *Women in Film Noir.* London: BFI Publishing, 1980.

Klein, Michael, and Gillian Parker, eds. *The English Novel and the Movies.* New York: Frederick Ungar, 1981.

Kleinhans, Chuck. "Notes on Melodrama and the Family Under Capitalism." *Film Reader* 3 (February 1978): 40–47.

Knight, Derek, and Vincent Porter. *A Long Look at Short Films: An A.C.T.T. Report on the Short Entertainment and Factual Film.* Oxford: Pergamon Press, 1972.

Knight, Stephen. *Form and Ideology in Crime Fiction.* Bloomington: Indiana University Press, 1980.

Korda, Michael. *Charmed Lives: A Family Romance.* New York: Avon Books, 1979.

Kracauer, Siegfried. *From Caligari to Hitler: A Psychological History of the German Film.* Princeton, N.J.: Princeton University Press, 1974.

Kuhn, Annette. "British Documentaries and 'Independence': Recontextualising a Film Movement." In *Traditions of Independence: British Cinema in the Thirties,* ed. Don Macpherson, in collaboration with Paul Willemen, 24–33. London: BFI Publishing, 1980.

————. *Women's Pictures: Feminism and Cinema*. London: Routledge and Kegan Paul, 1982.

Landy, Marcia. *Fascism in Film: The Italian Commercial Cinema, 1931–1943*. Princeton, N.J.: Princeton University Press, 1986.

Laplace, Maria. "Producing and Consuming the Woman's Film." In *Home Is Where the Heart Is: Studies in Melodrama and the Woman's Film*, ed. Christine Gledhill, 138–66. London: BFI Publishing, 1987.

Lee, Christopher. *Tall, Dark, and Gruesome: An Autobiography*. London: W. H. Allen, 1977.

Lesley, Cole. *The Life of Noël Coward*. London: Jonathan Cape, 1976.

Lockwood, Margaret. *Lucky Star: The Autobiography of Margaret Lockwood*. London: Odhams Press, 1955.

Longmate, Norman. *How We Lived Then. A History of Everyday Life During the Second World War*. London: Arrow Books, 1977.

Lovell, Alan, and Jim Hillier. *Studies in Documentary*. New York: Viking Press, 1972.

Lovell, Terry. "*Frieda*." In *National Fictions: World War Two in British Films and Television*, ed. Geoff Hurd, 30–34. London: BFI Publishing, 1984.

Low, Rachael. *The History of the British Film, 1929–1939: Films of Comment and Persuasion*. London: Allen and Unwin, 1979.

————. *The History of the British Film, 1929–1939: Film Making in 1930s Britain*. London: Allen and Unwin, 1985.

Lusted, David. "*Builders* and *The Demi-Paradise*." In *National Fictions: World War Two in British Films and Television*, ed. Geoff Hurd, 27–30. London: BFI Publishing, 1984.

MacCabe, Colin. *Theoretical Essays: Film, Linguistics, Literature*. Manchester, England: Manchester University Press, 1985.

Mace, Nigel. "British Historical Epics in the Second World War." In *Britain and the Cinema in the Second World War*, ed. Philip M. Taylor, 101–20. New York: St. Martin's Press, 1988.

Macpherson, Don, ed., in collaboration with Paul Willemen. *Traditions of Independence: British Cinema in the Thirties*. London: BFI Publishing, 1980.

Maeder, Edward, ed. *Hollywood and History: Costume Design in Film*. New York: Thames and Hudson, 1987.

Manvell, Roger, and R. K. Neilson Baxter, eds. *The Cinema, 1952*. Harmondsworth, Middlesex, England: Pelican Books, 1952.

Marcus, Millicent. *Italian Film in the Light of Neorealism*. Princeton, N.J.: Princeton University Press, 1986.

Marwick, Arthur. *Britain in the Century of Total War: War, Peace, and Social Change, 1900–1967*. Boston: Little, Brown, 1968.

————. *The Explosion of British Society, 1914–1970*. London: Macmillan, 1971.

————. *Class: Image and Reality in Britain, France, and the USA Since 1930*. New York: Oxford University Press, 1980.

Mast, Gerald. *The Comic Mind: Comedy and the Movies*. Indianapolis: Bobbs-Merrill, 1973.

Matthews, Jessie. *Over My Shoulder: An Autobiography*. London: W. H. Allen, 1974.

Mayer, J. P. *British Cinemas and Their Audiences, Sociological Studies*. London: Dennis Dobson, 1948.

Medhurst, Andy. "Dirk Bogarde." In *All Our Yesterdays: 90 Years of British Cinema*, ed. Charles Barr, 346–54. London: BFI Publishing, 1986.

———. "Music Hall and British Cinema." In *All Our Yesterdays: 90 Years of British Cinema*, ed. Charles Barr, 168–88. London: BFI Publishing, 1986.

Mills, John. *Up in the Clouds, Gentlemen Please*. New Haven, Conn.: Ticknor and Fields, 1981.

Minney, R. J. *The Films of Anthony Asquith*. South Brunswick, N.J.: A. S. Barnes, 1976.

Mitchell, Juliet, and Jacqueline Rose. *Feminine Sexuality: Jacques Lacan and the Ecole Freudienne*. New York: W. W. Norton, 1985.

Mizejewski, Linda. "Sally Bowles: Fascism, Female Spectacle, and the Politics of Looking." Ph.D. diss., University of Pittsburgh, 1988.

Modleski, Tania. *Loving with a Vengeance: Mass Produced Fantasies for Women*. New York: Methuen, 1982.

———. " 'Never to Be Thirty-Six Years Old': *Rebecca* as Oedipal Drama." *Wide Angle* 5 (1982): 34–41.

———. "The Terror of Pleasure: The Contemporary Horror Film and Postmodern Theory." In *Studies in Entertainment: Critical Approaches to Mass Culture*, ed. Tania Modleski, 155–66. Bloomington: Indiana University Press, 1986.

———. *The Women Who Knew Too Much: Hitchcock and Feminist Theory*. New York: Methuen, 1988.

Monaco, Paul. "Movies and National Consciousness: Germany and France in the 1920s." In *Feature Films as History*, ed. K.R.M. Short, 62–75. Knoxville: University of Tennessee Press, 1981.

Morley, Sheridan. *Tales of the Hollywood Raj: The British, the Movies, and Tinseltown*. New York: Viking Press, 1983.

Moss, Robert F. *The Films of Carol Reed*. New York: Columbia University Press, 1987.

Mulvey, Laura. "Notes on Sirk and Melodrama." In *Home Is Where the Heart Is: Studies in Melodrama and the Woman's Film*, ed. Christine Gledhill, 75–79. London: BFI Publishing, 1987.

———. *Visual and Other Pleasures*. Bloomington: Indiana University Press, 1989.

Murphy, Robert. "A Brief Studio History." In *Gainsborough Melodrama*, ed. Sue Aspinall and Robert Murphy, 3–13. London: BFI Publishing, 1983.

———. "Riff-Raff: British Cinema and the Underworld." In *All Our Yesterdays: 90 Years of British Cinema*, ed. Charles Barr, 286–305. London: BFI Publishing, 1986.

———. "Under the Shadow of Hollywood." In *All Our Yesterdays: 90 Years of British Cinema*, ed. Charles Barr, 47–71. London: BFI Publishing, 1986.

———. *Realism and Tinsel: Cinema and Society in Britain, 1939–1948*. London: Routledge, 1989.

Nairn, Tom. *The Breakup of Britain: Crisis and Neonationalism*. London: New Left Books, 1977.

Neale, Stephen. *Genre*. London: BFI Publishing, 1983.

Nichols, Bill, ed. *Movies and Methods*. Vols. 1 and 2. Berkeley: University of California Press, 1976 and 1985.

Oakley, C. A. *Where We Came In: Seventy Years of the British Film Industry*. London: Allen and Unwin, 1964.

O'Connor, Garry. *Ralph Richardson: An Actor's Life*. New York: Atheneum, 1982.

Olivier, Laurence. *Confessions of an Actor: An Autobiography*. New York: Simon and Schuster, 1982.

Park, James. *Learning to Dream: The New British Cinema*. London: Faber and Faber, 1984.

Penley, Constance. *Feminism and Film Theory*. New York: Routledge, 1988.

Perry, George. *Forever Ealing: A Celebration of the Great British Film Studio*. London: Pavilion Books, 1981.

————. *The Great British Picture Show*. Boston: Little, Brown, 1985.

Petley, Julian. "The Lost Continent." In *All Our Yesterdays: 90 Years of British Cinema*, ed. Charles Barr, 98–119. London: BFI Publishing, 1986.

Pettigrew, Terence. *British Film Character Actors: Great Names and Memorable Moments*. London: David and Charles, 1982.

Pirie, David. *A Heritage of Horror: The English Gothic Cinema, 1946–1972*. New York: Avon Books, 1973.

Pistagnesi, Patrizia. "La scena familiare nel cinema fascista." In *Cinema italiano sotto il fascismo*, ed. Riccardo Redi, 99–106. Venice: Marsilio, 1979.

Place, Janey. "Women in Film Noir." In *Women in Film Noir*, ed. E. Ann Kaplan, 35–67. London: BFI Publishing, 1980.

Polan, Dana. *Power and Paranoia: History, Narrative, and the American Cinema, 1940–1950*. New York: Columbia University Press, 1986.

Polhemus, Ted, and Lynn Proctor. *Fashion and Anti-fashion*. London: Thames and Hudson, 1978.

Porter, Vincent. "The Context of Creativity: Ealing Studios and Hammer Films." In *British Cinema History*, ed. James Curran and Vincent Porter, 179–207. London: Weidenfeld and Nicolson, 1983.

Powdermaker, Hortense. *Hollywood: The Dream Factory*. New York: Grosset and Dunlap, 1950.

Powell, Michael. *A Life in the Movies: An Autobiography*. London: Heinemann, 1986.

Pratley, Gerald. *The Cinema of David Lean*. South Brunswick, N.J.: A. S. Barnes, 1974.

Prawer, S. S. *Caligari's Children*. Oxford: Oxford University Press, 1980.

Programme Notes for "Made in London." London: The Museum of London and the National Film Archive, n.d.

Pronay, Nicholas, and Jeremy Croft. "British Film Censorship and Propaganda Policy During the Second World War." In *British Cinema History*, ed. James Curran and Vincent Porter, 144–63. London: Weidenfeld and Nicolson, 1983.

Quinlan, David. *British Sound Films, 1928–1959*. Totowa, N.J.: Barnes and Noble, 1984.

Radway, Janice A. *Reading the Romance: Women, Patriarchy and Popular Literature*. Chapel Hill: University of North Carolina Press, 1984.

Randall, Alan, and Ray Seaton. *George Formby: A Biography*. London: W. H. Allen, 1974.

Redgrave, Michael. *In My Mind's I: An Actor's Autobiography*. New York: Viking Press, 1983.

Reilly, Robin. *William Pitt the Younger*. New York: G. P. Putnam's Sons, 1982.

Renov, Michael. "*Leave Her to Heaven*: The Double Bind of the Post War Woman." *Journal of Film and Video* 35 (Winter 1983): 13–36.

Richards, Jeffrey. "'Patriotism with Profit': British Imperial Cinema in the 1930s." In *British Cinema History*, ed. James Curran and Vincent Porter, 245–56. London: Weidenfeld and Nicolson, 1983.

——. *The Age of the Dream Palace: Cinema and Society in Britain, 1930–1939*. London: Routledge and Kegan Paul, 1984.

——. "The Black Man as Hero." In *All Our Yesterdays: 90 Years of British Cinema*, ed. Charles Barr, 334–40. London: BFI Publishing, 1986.

——. *Thorold Dickinson: The Man and His Films*. London: Croom Helm, 1986.

Richards, Jeffrey, and Anthony Aldgate. *British Cinema and Society, 1930–1970*. Totowa, N.J.: Barnes and Noble Books, 1983.

Robertson, James C. *The British Board of Film Censors: Film Censorship in Britain, 1895–1950*. London: Croom Helm, 1985.

Robinson, David. *The History of World Cinema*. New York: Stein and Day, 1974.

Rockett, Kevin, Luke Gibbons, and John Hill. *Cinema and Ireland*. Syracuse, N.Y.: Syracuse University Press, 1988.

Rodowick, David. "Madness, Authority and Ideology: The Domestic Melodrama of the 1950s." In *Home Is Where the Heart Is: Studies in Melodrama and the Woman's Film*, ed. Christine Gledhill, 268–80. London: BFI Publishing, 1986.

Roehman, W. *Hitchcock: The Murderous Gaze*. Cambridge, Mass.: Harvard University Press, 1982.

Roelens, Maurice. *Pour une histoire du mélodrame au cinéma. Les cahiers de la Cinematheque* 28. Perpignan: Catalan, n. d.

Roffman, Peter, and Jim Purdy. *The Hollywood Social Problem Film: Madness, Despair, and Politics from the Depression to the Fifties*. Bloomington: Indiana University Press, 1981.

Rowse, A. L. *Appeasement: A Study in Political Decline, 1933–39*. New York: W. W. Norton, 1961.

Russo, Vito. *The Celluloid Closet: Homosexuality in the Movies*. New York: Harper and Row, 1987.

Ryall, Tom. *Alfred Hitchcock and the British Cinema*. Urbana: University of Illinois Press, 1986.

Said, Edward. *Orientalism*. New York: Vintage Books, 1979.

——. *Covering Islam: How the Media and the Experts Determine How We See the Rest of the World*. New York: Pantheon Books, 1981.

Salt, Barry. *Film Style and Technology: History and Analysis*. London: Starword, 1983.

Saxton, Christine. "The Collective Voice as Cultural Voice." *Cinema Journal* 26 (Fall 1986): 19–30.

Schatz, Thomas. *Hollywood Genres: Formulas, Filmmaking, and the Studio System.* New York: Random House, 1981.

Sellar, Maurice, Lou Jones, Robert Sidaway, and Ashley Sidaway. *Best of British: A Celebration of Rank Film Classics.* London: Sphere Books, 1987.

Shadoian, Jack. *Dreams and Ends: The American Gangster Film.* Cambridge, Mass.: MIT Press, 1979.

Sheldon, Caroline, "Lesbians and Film: Some Thoughts." In *Gays & Film*, ed. Richard Dyer, 5–26. New York: Zoetrope, 1984.

Short, K.R.M., ed. *Feature Films as History.* Knoxville: University of Tennessee Press, 1981.

Simmons, Dawn Langley. *Margaret Rutherford: A Blithe Spirit.* New York: McGraw-Hill, 1983.

Sinfield, Alan. *Literature, Politics, and Culture in Postwar Britain.* Berkeley: University of California Press, 1989.

Slide, Anthony. *Fifty Classic British Films, 1932–1982: A Pictorial Record.* New York: Dover Publications, 1985.

Smith, Eleanor. *Life's a Circus.* London: Longmans, Green, 1939.

Smyth, Rosaleen. "Movies and Mandarins: The Official Film and British Colonial Africa." In *British Cinema History*, ed. James Curran and Vincent Porter, 129–43. London: Weidenfeld and Nicolson, 1983.

Sobchack, Vivian Carol. *The Limits of Infinity: The American Science Fiction Film, 1950–1975.* South Brunswick, N.J.: A. S. Barnes, 1980.

Sorlin, Pierre. *The Film in History: Restaging the Past.* Totowa, N.J.: Barnes and Noble Books, 1980.

Stead, Peter. "The People as Stars: Feature Films as National Expression." In *Britain and the Cinema in the Second World War*, ed. Philip M. Taylor, 62–83. New York: St. Martin's Press, 1988.

Stevenson, John. *British Society, 1914–1945.* Harmondsworth, Middlesex, England: Penguin Books, 1984.

Suleiman, Susan Rubin. *Authoritarian Fictions: The Ideological Novel as a Literary Genre.* New York: Columbia University Press, 1983.

Swann, Paul. *The Hollywood Feature Film in Postwar Britain.* New York: St. Martin's Press, 1987.

———. *The British Documentary Film Movement, 1926–1946.* Cambridge: Cambridge University Press, 1989.

Taboori, Paul. *Alexander Korda.* London: Oldbourne, 1959.

Tarr, Carrie. "'Sapphire', 'Darling' and the Boundaries of Permitted Pleasure." *Screen* 26 (January/February 1985): 50–65.

Taylor, Philip M., ed. *Britain and the Cinema in the Second World War.* New York: St. Martin's Press, 1988.

Thomson, David. *England in the Twentieth Century.* Harmondsworth, Middlesex, England: Penguin Books, 1979.

Thornton, Michael. *Jessie Matthews: A Biography.* London: Hart, Davis, MacGibbon, 1974.

Truffaut, Francois. *Hitchcock.* New York: Simon and Schuster, 1967.

Tudor, Andrew. *Monsters and Mad Scientists: A Cultural History of the Horror Movie.* London: Basil Blackwell, 1989.

Turim, Maureen. *Flashbacks in Film: Memory and History*. New York: Routledge, 1989.

Twitchell, James B. *Dreadful Pleasures: An Anatomy of Modern Horror*. New York: Oxford University Press, 1985.

Vardac, A. Nicholas. *Stage to Screen*. Cambridge, Mass.: Harvard University Press, 1949.

Vermilye, Jerry. *The Great British Films*. Secaucus, N.J.: Citadel Press, 1978.

Viviani, Christian. "Who Is Without Sin: The Maternal Melodrama in the American Film." In *Home Is Where the Heart Is: Studies in Melodrama and the Woman's Film*, ed. Christine Gledhill, 83–99. London: BFI Publishing, 1987.

Walker, Alexander. *National Heroes: British Cinema in the Seventies and Eighties*. London: George G. Harrap, 1985.

———, ed. *No Bells on Sunday: The Rachel Roberts Journals*. New York: Harper and Row, 1984.

Walker, Janet. "Hollywood, Freud, and the Representation of Women: Regulation and Contradiction, 1945–Early 60s." In *Home Is Where the Heart Is: Studies in Melodrama and the Woman's Film*, ed. Christine Gledhill, 197–214. London: BFI Publishing, 1987.

Walker, John. *The Once and Future Film: British Cinema in the Seventies and Eighties*. London: Methuen, 1985.

Waller, Gregory A., ed. *American Horrors: Essays on the Modern American Horror Film*. Urbana: University of Illinois Press, 1987.

Warner, Jack. *Jack of All Trades: The Autobiography of Jack Warner*. London: W. H. Allen, 1975.

Weeks, Jeffrey. *Sex, Politics and Society: The Regulation of Sexuality Since 1800*. London: Longman, 1981.

White, Hayden. "The Value of Narrativity in the Representation of Reality." In *On Narrative*, ed. W.J.T. Mitchell, 1–23. Chicago: University of Chicago Press, 1981.

Wilcox, Herbert. *Twenty-five Thousand Sunsets: The Autobiography of Herbert Wilcox*. London: The Bodley Head, 1967.

Williams, Emlyn. *Emlyn: An Early Autobiography, 1927–1935*. New York: Viking Press, 1973.

Williams, Linda. " 'Something Else Besides a Mother': *Stella Dallas* and the Maternal Melodrama." *Cinema Journal* 24 (Fall 1984): 2–27.

Williams, Raymond. *Culture and Society, 1780–1950*. New York: Harper and Row, 1958.

———. *Marxism and Literature*. London: Oxford University Press, 1977.

———. *Problems in Materialism and Culture*. London: Verso, 1980.

Wolfenstein, Martha, and Nathan Leites. *Movies: A Psychological Study*. Glencoe, Ill.: Free Press, 1950.

Wolff, Janet. *The Social Production of Art*. New York: New York University Press, 1985.

Wood, Alan. *Mr. Rank: A Study of J. Arthur Rank and British Films*. London: Hodder and Stoughton, 1952.

Yacowar, Maurice. *Hitchcock's British Films*. Hamden, Conn.: Archon Books, 1977.

Index